Seeing Sodomy in the Middle Ages

Seeing Sodomy
in the Middle Ages

ROBERT MILLS

The University of Chicago Press : Chicago and London

Robert Mills is a reader in medieval art at University College London. He is the author of *Suspended Animation: Pain, Pleasure and Punishment in Medieval Culture* and coeditor of *Rethinking Medieval Translation: Ethics, Politics, Theory.*

The University of Chicago Press, Chicago 60637
The University of Chicago Press, Ltd., London
© 2015 by The University of Chicago
All rights reserved. Published 2015.
Printed in the United States of America

24 23 22 21 20 19 18 17 16 15 1 2 3 4 5

ISBN-13: 978-0-226-16912-5 (cloth)
ISBN-13: 978-0-226-16926-2 (e-book)
DOI: 10.7208/chicago/9780226169262.001.0001

Publication of this book has been made possible in part by a grant from the Scouloudi Foundation in association with the Institute of Historical Research, University of London.

Library of Congress Cataloging-in-Publication Data
Mills, Robert, 1973– author.
 Seeing sodomy in the Middle Ages / Robert Mills.
 pages : illustrations ; cm
 Includes bibliographical references and index.
 ISBN 978-0-226-16912-5 (cloth : alk. paper)—ISBN 0-226-16912-X (cloth : alk. paper)—
ISBN 978-0-226-16926-2 (e-book) 1. Sodomy—Europe. 2. Sodomy in art. 3. Art,
Medieval—Europe. 4. Sodomy in literature. 5. Vision in literature. 6. Literature,
Medieval—History and criticism. I. Title.
 HQ76.M56 2014
 306.77—dc23

 2014023239

♾ This paper meets the requirements of ANSI/NISO Z39.48-1992 (Permanence of Paper).

CONTENTS

ILLUSTRATIONS

ACKNOWLEDGMENTS

A decade or so has passed since I first began working on the material that eventually became this book. It would be impossible to mention everyone who has contributed to the project since its inception, but I'd like to take this opportunity to thank some of the many friends, colleagues, and institutions who have helped most during the process of writing. The project neared completion during my time in the Department of English at King's College London. I'm indebted to colleagues there who, over the years, contributed so much to my development as a scholar. Medievalists at King's whose input was especially crucial include Simon Gaunt, Clare Lees, and Sarah Salih. For his friendship and sage advice, Simon warrants special mention. Heartfelt thanks also go to other members of the Queer@King's collective, including John Howard, Ryan Powell, Lara Shalson, and Mark Turner. Graduate students on my "Queer Theories of the Past" module were sources of inspiration and ideas, notably Barry Byrne. In addition, I appreciate the support of my new colleagues in the History of Art Department at University College London. It's heartening to discover that my research still registers as "art history," despite my spending eleven years in an English department, and to know that interdisciplinarity isn't just a buzzword.

Institutional support of various kinds was provided by King's, and most recently by UCL. The British Academy funded two overseas conference trips that enabled me to present research on the *Bibles moralisées*.

Additional financial assistance came in the form of a Leverhulme Research Fellowship in 2007, which provided me with invaluable research time and enabled me to fund several—ultimately transformative—library visits. Much of the research for this book was conducted at the British Library, which granted access to relevant manuscripts and other material on reserve. I'm also very grateful to librarians at the Bibliothèque municipale in Rouen, the Bodleian Library in Oxford, and the Österreichische Nationalbibliothek in Vienna for allowing me to consult material in their collections.

I'm further indebted to the many scholars who invited me to present papers and lectures related to the book's contents. Particularly significant in this regard were talks delivered at the Universities of California, Los Angeles (James Schultz and Zrinka Stahuljak), Cambridge (Bill Burgwinkle), Cyprus (Stavroula Constantinou), Leicester (David Clark), Manchester (Anke Bernau), Queens Belfast (Malte Urban), St. Andrews (Bettina Bildhauer, Julian Luxford), Sussex (J. D. Rhodes), Swansea (Liz McAvoy), and York (Jason Edwards). In the summer of 2006, I delivered a paper at the Center for Medieval Studies at the University of Connecticut at Storrs and taught a graduate seminar on medieval friendship. I'd like to thank my hosts at UConn for an inspirational few weeks. Carolyn Dinshaw shared with me the experience of encountering, firsthand, the unbound pages of the *Belles Heures* of Jean de Berry when they were exhibited in New York in 2010. I'm grateful to Carolyn, too, for acting as respondent to a paper I presented at the Medieval Club of New York that day, and to Glenn Burger and Steve Kruger for hosting my visit. As well as inviting me to give a paper at Miami University (Oxford, Ohio), Anna Kłosowska asked me to speak as part of Miami's Dijon program; preparation for that talk led me to Vézelay and to the arguments of chapter 4.

Bettina Bildhauer, Emma Campbell, and Cary Howie offered guidance at various points concerning translations from French, German, and Italian; any remaining errors in the translations are, of course, my own. Emma Campbell has also been a stalwart friend and collaborator over the years, and I'm especially grateful to her for drawing my attention—largely unwittingly—to the fact that this project, too, is bound up with issues of translation. Other sources of inspiration in the field of medieval gender and sexuality studies include Ruth Evans, Masha Raskolnikov, Diane Watt, and Diane Wolfthal. An invaluable conversation with David Eng gave me some new ideas about Orpheus.

Two anonymous readers at the University of Pennsylvania Press applied themselves painstakingly to an earlier version of this book; while I wasn't able to respond to everything they suggested, the book has profited greatly from their input. Two others who read the manuscript in its entirety, and supplied detailed evaluations to the University of Chicago Press, are Bill Burgwinkle and Pamela Sheingorn. I'm grateful for their encouragement and stimulating

feedback. I appreciate, too, the editorial advice of Randolph Petilos at the University of Chicago Press, and the help of others at the Press, including Tadd Adcox, Micah Fehrenbacher, Renaldo Migaldi, and Susan Tarcov, whose efforts have enabled the book to see the light of day.

I also wish to thank those who have assisted on a more personal level. I'm grateful to my parents, and to my siblings and their spouses, for their continued support and interest in what I do. My research would have been inconceivable without the kindness and generosity of friends outside academia who have sustained me during the project's development. I'd especially like to thank Emma Pitt and Kee Somasiri in this regard. Neil Young accompanied me on various visits to churches and museums over the years, as well as lending camera equipment at a crucial juncture. Though I only met John Perrin shortly before completing a first draft, he's been a guiding light in the months that followed and I particularly appreciate his practical help in the final stages. Last but not least, George has been my canine companion pretty much from the outset of this project. I'm grateful to him, too—though he'll never know it!—for pestering me whenever he thought my research time would be better spent in a park instead of sitting behind a desk.

Portions of chapter 1 appeared in a different form in "Seeing Sodomy in the Bibles moralisées" in Speculum 87, no. 2 (2012): 413–68. In chapter 5, I reuse material from "Gender, Sodomy, Friendship, and the Medieval Anchorhold," Journal of Medieval Religious Cultures 36, no. 1 (2010): 1–27. Also reprinted as the final section of chapter 5 is a revised version of "Acts, Orientations and the Sodomites of San Gimignano," in Sex Acts: Practice, Performance, Perversion and Punishment in Early Modern Italy, ed. Allison Levy (Farnham, UK: Ashgate, 2010), 195–208. I'd like to thank the publishers for permission to reproduce this material in the present context. I'm grateful also to the editors of these publications, and anonymous reviewers, for their expert help: the present book has benefited immeasurably from all their incisive comments and suggestions.

Jerome in a Dress

In the opening decade of the fifteenth century three young brothers—Herman, Paul, and Jean de Limbourg—were charged by Jean de France, Duc de Berry (1340–1416) with illustrating a magnificent book of hours. The *Belles Heures of Jean de Berry*, completed in 1408 or 1409, contains within its richly decorated pages a remarkable series of narrative picture cycles devoted to saints for whom the patron had a particular affinity.[1] One of the figures singled out for this special treatment is the early church father Saint Jerome (ca. 340–420), whose life is condensed by the Limbourgs into twelve full-page miniatures. Among the scenes included in the Jerome sequence is an episode of twelfth-century origin, in which the saint is subjected to a mischievous practical joke (plate 1).[2] The Limbourg brothers' rendition of the episode is unprecedented in medieval art. To the right, Jerome lies sleeping beneath a vaulted chamber, while a monk, face hidden by his cowl and clothing blending with Jerome's blanket, sneaks into the room in order to plant a blue garment beside the bed. In the left foreground, Jerome wanders into church, carrying a lantern and dressed in this same blue clothing, which turns out, from its exposed neckline, figure-hugging waistline, and trailing skirt, to be a woman's dress. Behind him, in the choir stall, two monks stare intently at their colleague and appear to be indulging in whispered comment. What exactly are the pair seeing and saying? Is the sight of Jerome in a dress a source of innocent laughter, vengeful mockery, or plain confusion?

In common with the other pages of the Jerome cycle in the *Belles Heures*, four lines of text appear beneath the miniature outlining the scene's significance:

> Following the death of Pope Liberius, Jerome was considered by all to be worthy of the highest priesthood, but was mocked shamefully [*derisus turpiter*] by certain people, when he put on women's clothes instead of his own [*vestem muliebrem pro sua*], and was derided by them at <u>Matins</u> to such madness that he fled the place.³

The artists have fleshed out this briefest of texts with a series of aesthetic choices that direct the viewer's gaze. Prominent throughout the cycle is Jerome's long brown beard, a symbol of wisdom and scholarly attainment that contrasts starkly with the smooth chins of his monastic brothers. The beard functions not only to single Jerome out as a saint among men, but also, in this particular miniature, to highlight his embodied maleness. The apparent incongruity of placing a bearded male in a female outfit is further underscored by the use of color. The bright blue fabric, identical in hue to the dress worn by one of the dancing girls by whom Jerome is tempted three pages later (plate 2), stands out dramatically against the muted grays of the buildings in which the action takes place, as well as the browns of the monastic habits and Jerome's bedclothes. Symmetry further underscores the starkness of the saint's transformation. In church Jerome holds his head, encircled by a golden halo, at exactly the same height as his sleeping double in the bedchamber opposite, which, along with the architectural structure that divides the narrative in two, effectively accentuates the contrast. The saint's obliviousness to the trick is highlighted by the fact that he carries a lantern, which suggests he has traveled to church in darkness, and by the direction of his gaze, which fails to catch the eyes of the monks as they gossip in the choir. Although the Latin caption beneath the image makes no reference to whether the saint knowingly or unknowingly "put on women's clothes instead of his own," Jerome's cross-dressing is clearly being presented by the Limbourgs as an unwillful act.

I open with this evocation of Jerome in a dress because it helps articulate some of the book's central questions. To a twenty-first-century viewer, conditioned by long-standing associations between gender-variant behavior and sexual dissidence, it may well look as though the gossiping monks are being covertly homophobic. What motivates Jerome to go so far as fleeing the monastery, according to such an interpretation, would be the shame attached to being associated with homosexuality. Although a progressive effort has been made, in recent years, to unhook gender from sexuality in certain contexts (some modes of political activism, for example), the notion that gender presentation and sexual orientation are intimately connected continues to shape

popular cultural understandings of those categories. There is something just too *visible* about gender binaries, and about the transgression of those codes, to warrant their wholesale dismissal as markers of sexual selfhood. How, in a climate in which the "normality" of a particular sexual identity is asserted (the idea, for instance, that homosexuals are potentially no different in appearance and demeanor from anyone else), can sexuality—understood as private, invisible, perhaps even unconscious—be brought into view as a distinct dimension of identity and personhood? Gender transgression continues to function in some contemporary settings as an index of sexual deviance, and gender conformity as an index of sexual normativity, but how have these associations been mapped historically?

Sodomy in the Middle Ages was a fluid and wide-ranging category, which served only intermittently to refer to a clear variety of sexual activity or to evoke the behavior of a particular kind of person. In this book's title "sodomy" functions as a recognizable shorthand for a constellation of disparate but partially overlapping discourses, some of which have little to do with modern preconceptions about what it is. Factors such as gender and genre determine whether sodomy itself or a related word, phrase, or rhetorical framework applies in a given instance; in cases such as female homoeroticism, as discussed in chapter 2, writers often made use of alternative terminology. On the one hand, when the penitentials designed for the use of confessors in early medieval monasteries referred to penances due to those who had committed the sodomitic sin (*sodomiticum peccatum*), or intercourse in the sodomitical manner (*in sodomitico more*), much of the time they probably had in mind anal intercourse between males.[4] Thus, although the point of reference for such phrases is the account of the destruction of Sodom in Genesis 19, which associates the city's inhabitants with a grievous but vaguely defined sin, in the context of their enunciation these expressions often seem designed to convey one sexual activity in particular. On the other hand commentators might refer, rather more ambiguously, to a whole variety of sins against nature (*contra naturam*) as deserving of censure. Grouping together practices associated with the "waste" of semen, this latter idea could apply in theory to each and every act of fornication that failed to lead to human reproduction within the bond of marriage. The Carolingian theologian Hincmar of Reims (806–82), whose treatise on the divorce of King Lothair II (855–69) from his wife Theutberga may represent the earliest recorded use of the Latin word *sodomia*, defined sex *contra naturam* in this way. What Hincmar calls the sodomite sin (*peccatum sodomitanum*) constitutes, for him, any unnatural act committed by either man or woman, or any other deliberate act in which a man defiles himself "by rubbing, touching, or other improper actions," which spells a loss of semen.[5] Other layers of obfuscation might also be applied. Phrases such as the "unmentionable vice" (*crimen nefandum*) or

the "vice that should not be named" were used throughout the Middle Ages and beyond as code words for sodomy. Later in the period such rhetoric was taken up in confessional or judicial practice, since it facilitated discussion of illicit activities without initiating those being interrogated into otherwise unheard-of practices.[6] This lack of a definitional center endowed sodomy with enormous scapegoating potential, so that in time the term also came to be applied to political enemies, or to people guilty of religious crime (notably heretics); or it could even be used as a marker of ethnic or cultural difference.

Around 1050 the Italian monk Peter Damian (ca. 1007–72) abandoned circumlocutionary language in favor of frankness and specificity. In a polemical letter designed to persuade the pope to condemn all manifestations of sodomitic behavior among the clergy and in male monasteries, he attempted to steer a middle course between the particular and general meanings that sodomy had acquired in previous centuries. Peter's letter to Pope Leo IX ("Letter 31"), which circulated in the later Middle Ages under the heading *Liber Gomorrhianus* (Gomorrhan Book), was not the first recorded instance of the word *sodomia*, but it was undoubtedly one of the most influential.[7] This polemical tract, which was implicitly addressed not only to the pope but to a wider audience that included the very sodomites being berated, yokes together under the category of *sodomia* four sex acts that Peter saw as threatening the church's purity and the ability of its members to intercede on behalf of humanity. These were, in ascending order of sinfulness, self-pollution, mutual rubbing of manly parts (*virilia*), pollution between the thighs (*inter femora*), and fornication in the rear (*in terga*).[8] The churchman wanted to include even solitary masturbation under the heading of sodomitic sin because this, like all practices involving the spilling of semen, threatened the reputation of the church as pure and unpolluted.[9] At the same time, he wished to avoid some of the imprecision of previous discussions, which could apply the phrase *contra naturam* to almost anything besides a very narrowly circumscribed idea of what reproductive sexual intercourse should look like. This is why Peter confines his discussion to males, and why he names the four specific sex acts he wishes to condemn. The writer wants the recipients of his letter to be under no illusions about the sins being targeted.

Yet although Peter's letter is interested in attacking only male clerics, the author describes how, as soon as they engage in illicit activities, sodomites end up transforming from men into not-men. In this he draws on long-standing associations between sensual excess and effeminacy in ancient and medieval thought. A practitioner of the sodomite sin is described in the letter as being an unmanned man (*vir evirate*) or an effeminate man (*homo effeminate*), slurs apparently applicable to both penetrator and penetrated: any male who "vainly" seeks out in another male's body what he does not find in himself risks becoming *effeminatus*.[10] Additionally *sodomia*, which in the Latin language is

grammatically gendered feminine, is personified in Peter's letter as a pestilential Queen of Sodom (*pestilentissima sodomorum regina*), who forces men to fight unspeakable wars (*nefanda bella*) against God; taking the soul captive under the yoke of her domination (*dominationis iugo*), she "deprives her soldiers of the arms of the virtues and exposes them to the piercing spears of all the vices."[11] Accompanying this imagery of unmanning is the idea that carnality itself is, at base, perversely queeny: sodomy is allegorized as a sexually voracious woman. Ultimately, though, Peter's Queen of Sodom is more she-monster than conventional female, a phallic figure who plays the domineering role traditionally assigned to men. Sodomy thus not only attacks the gender of its (male) practitioners but is itself essentialized as the very embodiment of gender inversion.

More than a century after Peter penned his letter, another clerical writer, Alan of Lille (ca. 1128–1202), whose influential work *De planctu Naturae* (Plaint of Nature) we shall encounter several times in this book, also stressed the gendered implications of sex between males. Alan has his narrator reflect, in the opening lines of *De planctu*, on how the goddess Venus has initiated a deviation from the rules of Nature by changing "hes" into "shes" (*illos facit illas*) and unmanning men with her "magic arts" (*sui magica deuirat arte uiros*).[12] Although Alan never deployed the word "sodomy" in his text, homoeroticism is clearly the target of Nature's plaint.

The depiction of Jerome in the *Belles Heures* was produced more than two centuries after Alan of Lille issued his *Plaint*. Although there is evidence that such attitudes persisted into the fifteenth century and played a significant role in secular as well as clerical cultures, my point in beginning with this image of male cross-dressing is not to argue that it somehow constitutes an example of "seeing sodomy." From the perspective of a churchman such as Peter Damian, gender inversion might be the end to which sodomy leads, but we cannot assume that the whispering duo in the choir stall are making a similar connection in reverse. Indeed the life of Jerome contained in Jacobus de Voragine's thirteenth-century compilation the *Legenda aurea* (Golden Legend), a version of which seems to have provided the basis for the *Belles Heures* cycle, offers a quite different spin on the episode.[13] Jacobus begins by announcing how, following the pope's death, Jerome was acclaimed worthy of the papal throne. But the text also supplies additional information about the monks' motives for playing the trick: he had, the hagiographer announces, "denounced some monks and clerics for their lascivious lives, and they were so resentful that they began to lay snares for him." At this point Jacobus names a man called John Beleth as his source for the anecdote.[14] In Jacobus's summary of Beleth's account of the cross-dressing incident, readers are informed that woman's clothing was used "to create a false impression of him," and that his enemies had done this "in order to make it look as if he had a woman in his room."[15] These details are also

repeated in later, vernacular treatments of Jerome's life story based on the *Legenda aurea*.[16] The point of making people think that Jerome has a woman in his bedroom is to attack his reputation as a holy man; but it is chastity, not sodomy, that provides the interpretive key.

Thus, Jerome, himself a militant proponent of virginity, gets associated with the same fleshly vices that he accused the hostile Roman clergy of participating in themselves. The saint was particularly vulnerable to such accusations, given his dealings with devout women during his time in the Holy Land. After fleeing Rome Jerome retired to the desert for a few years, but later settled in Bethlehem for a life of scholarship and asceticism. There he was joined by a widow called Paula, who founded a convent in the town for disaffected women like herself.[17] Jacobus de Voragine does not dwell on Jerome's relations with female ascetics in Bethlehem, preferring to affirm the saint's lifelong chastity by announcing that he was "a virgin to the end of his life."[18] The cross-dressing episode acknowledges Jerome's companionship with women discreetly, but finally dismisses it as spiteful gossip. This confirms that for medieval readers and viewers already familiar with the *Legenda aurea* version of events, the joke would have been interpreted as an attack on Jerome's chastity. The dress poses a threat to the saint's sexual reputation, or at least that is the hope of the trickster monks. But principally it conjures up his relationships with women.

This, then, was the overt pretext for illustrating this episode from Jerome's life story in the *Belles Heures*. Judicial proceedings in various parts of Europe made a connection, rhetorically at least, between crimes against nature and gender-variant behavior or even morphology.[19] Natural philosophers and medical writers also continued to employ comparable arguments in discussions of homoeroticism and sexual anatomy.[20] But Jean de Berry and his contemporaries were not being asked to view this depiction of male cross-dressing in light of these associations. The miniature perpetuates the misogynistic thinking displayed in indictments of sodomy, by associating the saint himself with female embodiment via his clothing. But Jerome's humiliation was not associated with the shame of those who sin against nature. This example powerfully demonstrates how ideas about the significance of feminization differ according to context and time frame. In the Middle Ages male effeminacy could also convey other qualities, such as courtliness or libidinal excess, that were not necessarily or inevitably associated with homoeroticism.[21] Conversely, female masculinity could be valued and even promoted under certain circumstances (in tales of cross-dressing saints, for example) without conjuring up the specter of sodomy explicitly.[22] Moreover in some contexts, notably courtly love literature, ideas of sexual dimorphism seem to have been altogether less important. The bodies of courtly lovers, male or female, tend to be presented as variations on a common physical ideal, marked by differences of degree, not kind; what motivates

this erotic ideal is not so much attraction to the "opposite sex" as attraction to the idea of courtliness. This has implications for how we understand representations of cross-dressing and sex transformation in the period. If, as James Schultz has argued, the bodies of courtly lovers are "essentially the same," then the "same-sex attractions that cross-dressed bodies elicit are less transgressive than they often appear to modern readers."[23]

To make this argument Schultz is drawing on courtly rather than religious discourse, and the examples are textual rather than visual; what registers as sameness or androgyny in a courtly text may convey different meanings in an image in a book of hours. Contributing to a sense of disjunction in the *Belles Heures* miniature is the fact that Jerome's dress is secular as well as female: a figure-hugging garment of this kind signals a potentially scandalous infiltration of the feminine into an otherwise all-male, spiritual setting. Depictions of male religious dressing in women's robes are extremely rare compared with narratives about cross-dressing female saints and holy women. One textual reference roughly contemporary with the *Belles Heures*, which refers to a devout male wearing garments previously owned by a woman, is contained in a collection of biographical fragments and miracles about the English mystic Richard Rolle (d. 1349), prepared posthumously in 1381 in anticipation of his canonization. One of these anecdotes describes how the recluse borrows two of his sister's tunics, which he says he covets greatly, in order to "present a certain likeness to a hermit."[24] Such behavior may simply be designed to highlight Rolle's status as a man apart, but it could also be related to a recurrent identification in his writings with the bridal position in the Song of Songs. In medieval Christianity the Song was interpreted as figuring forth the relationship between a bridegroom (representing God or Christ) and a bride (representing the human soul, Church, or Virgin Mary), a reading given renewed impetus in the twelfth century by figures such as Bernard of Clairvaux, who used the imagery of *sponsa Christi* (bride of Christ) as a means of drawing devotees closer to God.[25] But there is a wealth of difference between deploying feminine imagery in sermons and other written texts and actually dressing in women's clothing, as Rolle himself discovers: the sister's reaction, on seeing her brother clothed in her tunics, is to declare him completely mad. Jerome's choice of costume is unintentional, unlike Rolle's, but both respond by fleeing from the mockery that ensues. This suggests that figurative identification with aspects of the feminine could be valued positively in male religious environments in a way that actual displays of androgyny and cross-dressing were not. There is something too spectacular, too visibly disjunctive, about the sight of a holy man in a dress to make it comprehensible within a framework such as bridal mysticism.

Although ostensibly Jerome's temporary assumption of femininity in the *Belles Heures* has nothing to do with sodomy, the saint's experience positions

him as unchaste and susceptible to fleshly vice in other ways. This aspect of the story might have provided an interpretive key for the Limbourgs' patron, Jean de Berry, when he viewed the miniature. As Michael Camille has shown, the duke himself was occasionally subjected to attacks on his moral standing that incorporated the language of sodomitic insult. The principal accusation is contained in an anonymous Parisian poem, the *Songe véritable*, composed in 1406 just two or three years before the *Belles Heures* were completed. The poem not only charges the duke with "oultrage" (outrage) against the order of nature but also characterizes him as a man with a penchant for soft servants, with whom he has shared delights; according to the *Songe*'s narrator, Jean will get his just deserts in hell by having a thousand stinking devils to serve his body, except that now, forever more, "Trop bien il sera baculé / Et bien ara le cul brulé" (he will be thoroughly flipped over/ass-fucked and have his bum well burnt).[26] There was also an earlier accusation, peddled by the chronicler Jean Froissart in an account of the duke's marriage in 1389, which recalled how he had fixed all his "plaisance" (pleasure) on a young male in his service and showered the boy with gifts.[27] As is so often the case with politically motivated accusations of this kind, it is not possible to cut through the hysteria to the facts of the duke's "sexuality." If we extend Camille's argument, though, it might be possible to interpret the miniature of Jerome in a dress in the *Belles Heures* in light of these references: perhaps Jean's personal experiences of malicious gossip would have caused him to take particular interest in Jerome's own encounter with sexual slander. Although sodomy is not an explicit frame of reference within the tale, in other words, its deployment as a term of abuse and insult might have informed the ways in which the miniature was received.

These arguments are obviously speculative: although Jean de Berry likely had a hand in the choice of certain subjects, it is impossible to know precisely how he viewed one of the manuscripts in his possession. Speculation aside, however, there is another miniature painted by one of the Limbourgs, in a different manuscript owned by Jean de Berry, that names and visualizes sins against nature directly. This scene, one of a series of images in the class of book known today as *Bibles moralisées* or moralized Bibles, features a cleric and a layman embracing within a crenellated building located beside a hell mouth (fig. 1). The scene is a commentary on the miniature above, which depicts the angels visiting Lot in the city of Sodom in Genesis 19. In the caption reproduced alongside this scene, a transposition of the Bible story into French, Sodom's inhabitants are called *les sodomites*, which the commentary text says signifies "libidinous men and women who unite between one another against nature." But in the accompanying miniature the practices associated with these "Sodomites" are not same-sex unions specifically: another, male-female couple embraces and kisses within the hell mouth, suggesting that unnatural unions

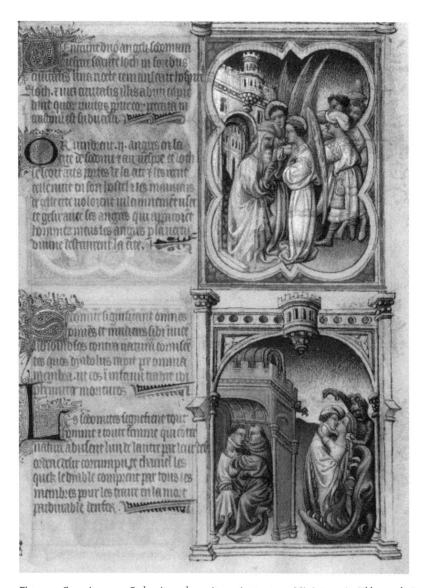

Figure 1. Genesis 19.1–11; Sodomites who unite against nature. Miniatures in *Bible moralisée* by Herman, Paul, and Jean de Limbourg. Paris, circa 1402–4. Paris, Bibliothèque nationale de France, MS français 166, fol. 7r (detail, lower right). Photo: Bibliothèque nationale de France.

could include other manifestations of fleshly disorder beside homoeroticism; the relationship between the male couple also transgresses the border between cleric and lay. In fact, as explored at length in chapter 1, the artist may be taking his lead here from efforts to visualize the sins of Sodom in earlier *Bibles mor-alisées* manuscripts, which not only show sodomites indulging in homoerotic behavior but also associate them with a host of other sinful practices. Jean de Berry's brother Philip the Bold had originally commissioned the Limbourgs, as

teenagers, to illustrate the Bible in 1402, but Jean took over the commission following Philip's death in 1404.[28] Yet although it is of an identical provenance and painted just a few years earlier, the *Bible moralisée* scene clearly "sees" sodomy in a way that the Jerome miniature does not. The *Belles Heures* scene, meditating on an episode in Jerome's life that ostensibly has nothing to do with sodomy, develops a humorous take on the climate of slander that led Jean de Berry himself, in his lifetime, to be accused of sins "against nature." The biblical image, a commentary on the Genesis story, condemns those same sins explicitly, by associating them with a category of person, the "Sodomite," whose fate is to be swallowed up in hell. The question of what the duke might have glimpsed in these two images therefore raises an issue to which we shall return throughout this book: how do you know a sodomite when you see one?

The primary theme of this book is the relationship between sodomy and motifs of vision and visibility in medieval culture, on the one hand, and those categories we today call "gender" and "sexuality," on the other. Substantial energy has already been devoted to examining the discursive formation of sodomy in the Middle Ages, including several book-length analyses.[29] The visual emphasis of the present study is designed to add a further dimension to these discussions: a handful of book chapters and articles on individual motifs and artworks aside, there has been no large-scale investigation of sodomitical themes in medieval art.[30] I make no claim to presenting a comprehensive survey of this material, which is too fragmented and dispersed to congeal into a unified iconographic corpus. Moreover the book places images on a parallel footing with texts, which also often rely, in their depictions of sodomy and analogous practices, on motifs of vision and visibility. Sodomy thus enters the imagination—is imaged—in a double sense. Sodomitical imagery resonates materially, inscribed in paint and stone; yet like all visual art it always has to be approached, through its mediation in language, sideways on.

The dissemination of the concept of *sodomia* coincided with and was crucially informed by metaphors of vision: Peter Damian's letter condemning the practice is strongly inflected by a visual rhetoric. Citing Genesis 19:9–11, which describes how the Sodomites were punished with blindness, Peter reflects on the spiritual blindness that afflicts modern-day sodomites who defile themselves with this filth.[31] "Consider," he later demands of the sodomite, "how much darkness [*obscuritas*] weighs on your soul; notice what thick, dark blindness engulfs you."[32] Yet despite these associations with darkness and sightlessness, the churchman is also adamant that he can meet "you face to face, sodomite, whoever you may be" (*te ore ad os quisquis es, sodomita*), an expression implying that the sodomite can both be seen and yet remain paradoxically invisible.[33] Peter's *quisquis es* formulation also provides a point of departure for what follows.

Whom are we seeing when, as modern readers and viewers, we encounter the sodomite in medieval text and image? What takes shape as a result of this encounter? This interrogation gives rise to further, methodological questions concerning the history and historiography of sex, gender, and sexuality, and the relationship of those categories to one another. What role has visibility politics played in the history of sexuality as a whole, and how has this shaped our understanding of what we call sexuality in the Middle Ages? What terms should we use to conceptualize the relationship between homoeroticism, gender variance, and vision in the period?

Following Michel Foucault's dictum that before the advent of modernity sodomy was "that utterly confused category," much research from the last two decades has been informed by the idea that we need to keep an open mind about what writers mean when they refer to sins against nature or sins that should not be named.[34] It is precisely these indeterminacies that made sodomy such a versatile and rhetorically useful vice in the period, ready to answer any number of political, moral, and social requirements. Scholars have amply documented textual evidence for these confusions in the medieval and early modern periods, and an investigation of sodomy's visualization does not necessarily clarify the situation.[35] I make no claims to have broken the code that seemingly confounded Foucault in his *History of Sexuality*, volume 1—to have found a way of seeing through all that confusion to the realities beyond. If anything, my argument is _Thesis_ that in certain well-defined areas of medieval art and literature—manuscript illumination, for instance—sodomy is even more multivalent than scholars have previously imagined. As Karma Lochrie has observed, mappings of sodomy's confusions have tended to be accompanied, in medieval scholarship, by a concomitant reduction of the category to something more specific. This process rests on a number of questionable assumptions. Not only are women rarely included in the category, but the sex acts with which sodomy is associated finally seem to boil down to one thing in particular: male anal penetration. What is more, sodomy tends to be identified primarily in these scholarly accounts as a sexual (rather than, say, gendered) category, so that what looks on the surface to be "utterly confused" turns out, in the last analysis, to be anything but.[36]

In this book, I likewise recommend that we maintain a focus on that dimension of experience we call "gender." Nonetheless I also wish to interrogate what it is that we think we are *seeing* when we label it as such. Many cultural historians now agree that the distinction between gender identity and what has come to be known as "sexuality" or "sexual orientation" in Western cultures is a very recent one.[37] Although during the nineteenth century associations between cross-dressing and sexual dissidence arguably began to dissipate, even into the second half of the twentieth century individuals who engaged in homoerotic behavior did not necessarily have need for a separate concept of homosexuality.

Either their difference was reconceptualized in gendered terms, as, for example, a mannish woman or effeminate male; or, by entering into sexual relations with ambiguously gendered individuals themselves, some people were able to participate in homoerotic acts without challenging their own sense of normativity.[38] Indeed, it is arguably only since the 1990s, with the coining of the umbrella term "transgender," that gender variance has come to be understood, in certain activist and institutional settings, as being ontologically different from homosexuality.[39] I take up the concept of transgender in chapter 2 and argue for its utility, particularly as a means of capturing the role of gender inversion in medieval encounters with homoeroticism; but I also acknowledge the risks in imagining the Middle Ages as a time of transgender. With the benefit of hindsight, after all, what looked like medieval "gay people" to scholars thirty years ago (say, in John Boswell's *Christianity, Social Tolerance, and Homosexuality*) may register more readily today as "transgender." To what extent, though, is transgender not only descriptive of certain modes of (what we call) gender identity, but also productive of the very distinctions it purportedly describes? This question is central to recent discussions of the emergence and institutionalization of transgender as a category; but it also raises the issue of whether gender is ever a fully separable dimension of human experience, one that can be isolated historically from sexuality. If those who visibly transgress conventional codes of masculinity and femininity ("gender") are fundamentally different in origin and being from those erotically drawn to people of the same sex ("sexuality"), when and where does this distinction hold? When is a mode of gendered presentation such as cross-dressing a code for something libidinal, and when is it not?

These are all issues taken up in this book, which aims not so much to disentangle gender and sexuality from one another in medieval sources as to emphasize the challenges in prizing them apart.[40] From the perspective of the visual, this may strike one as being counterintuitive. After all, sexuality is commonly understood as being more resistant to the burdens of ocular proof than gender: one is able to "see" gender in a way that one is not able to "see" sexuality; sexuality is taken to be the inner secret that gender openly declares. According to such criteria sodomy inevitably exceeds sexuality as a framework, since its visibility is always tied to some other organizing structure. Indeed, as demonstrated in this book, via a series of case studies, sodomy is not always *utterly* confused in premodern sources: its alignment with characteristics such as gender, physical appearance, age, religion, ethnicity, and of course sin creates a framework in which the invisible can be rendered visible. Yet this entry into visibility via extraneous systems of classification provides opportunities not only for clarification—for bringing identities and interiorities into the light of day—but also for further manifestations of obfuscation and ambiguity. Conversely

confusion itself can be a means of making things visible; incoherence and un-representability paradoxically bring to representation the very things (illicit erotic practices, for instance) that are purportedly outside the field of vision.

The second theme is an exploration of the "logics of sexual sequence" in medieval encounters with sodomy. This is Annamarie Jagose's expression for the ways in which *all* sexualities rely, in the last analysis, on sequential paradigms.[41] Indebted to Judith Butler's philosophical reflections on derivation and gender imitation, Jagose demonstrates how modern categories of sexual identification rely on securing heterosexuality as first-order and homosexuality as second-order through mechanisms of numerical ordering or chronological progression.[42] Contemporary depictions of lesbians as secondary and inconsequential are a case in point: "Widely assumed to have no natural order of her own, to derive her substance from more primary forms of sexual organization, the cultural profile of the lesbian depends on her derivative secondary character."[43] This sequential logic is directly related to the project of constructing lesbian histories. First, homosexuality is always already figured as imitative, a characterization that secures the originality of that supposedly more primary mode of sexual organization, heterosexuality. Second, the lesbian is presented in belated relation to her gay male cousin, chronologically behind him when she finally emerges into cultural legibility. Third, the retrieval of historical women as lesbian follows from a retrospective ordering of events, in which earlier manifestations of "lesbian" behavior such as female masculinity are read as a cause or originary moment in the development of the modern identity category to which that behavior apparently gestures.

Much as the politics of representation has been a powerfully enabling force in lesbian histories, however, Jagose is suspicious of the reification of visibility as an analytic framework in gender and sexuality scholarship. The idea that history somehow offers a corrective to the "invisibility" that previously confined certain individuals to the margins or rendered them incoherent rests on the belief that, once scholars have shined their illuminating spotlights on people or experiences previously "hidden from history," a more straightforward relationship to vision can somehow be negotiated. Lesbian historiography has been particularly invested in this rhetoric, stemming from the significance of representational politics in women's history as a whole. The title of Jacqueline Murray's seminal 1996 essay "Twice Marginal and Twice Invisible: Lesbians in the Middle Ages" conveys the dominance of such approaches, by implicitly positing as the solution to lesbian invisibility a wholesale reversal of that scenario. The implication is that those rendered marginal and invisible not once but twice (as women, as lesbians) can finally achieve recognition through the writing of history, and through the application of the elusive L-word to that history.[44] Here I suggest that visibility offers no easy corrective to the problem of

Handwritten margin notes:

Sequential logics of sexualities.

Can we ever enhance visibility of marginalized people in history?

Medievalisms may be one possible answer: instead of just looking back w/ a critical lens informed by identity politics, bring the past forward, revised and rewritten.

invisibility; seeing sodomy does not necessarily generate straightforward acts of looking. Moreover invisibility itself can be a powerful representational strategy in medieval sources: paradoxically, it sometimes operates as just one more way of seeing.

These arguments not only make sense as a framework for approaching contemporary historiography; they also bring into focus the sequential paradigms that shaped medieval concepts of desire. I have already suggested that sodomy often emerged into visibility by attaching itself to other categories, notably gender, religion, ethnicity, age, and social status. But this reliance on derivation in figurations of sodomy participates in a broader trend, one dictated ultimately by the biblical narrative that patristic authorities such as Augustine (354–430) termed the "fall." Taking inspiration from this scene of transgression in Genesis 3, which Christian commentators took to be a primal episode in the history of humankind, "Nature" was posited in the Middle Ages as an ideal from which all other possibilities are derived. Following Adam and Eve's contravention of God's commandment not to eat from the Tree of Knowledge, Nature was viewed as being corrupted and henceforth all manifestations of sexual activity potentially generated disorder. Sex after the fall was consequently understood to be merely a pale imitation of its Edenic forerunner, a lost ideal of "natural" behavior to which the good Christian should continually aspire.[45] Chapter 1 discusses a pair of manuscript miniatures depicting male and female homoeroticism in the two earliest *Bibles moralisées* that appropriate this frame narrative of the fall to articulate their vision of bodily corruption (plates 3 and 4). The miniatures act as a commentary on the Genesis story of Adam and Eve's temptation, a vision of postlapsarian embodiment that partly gets imagined, via the pictures themselves, as a breakdown in gender dimorphism. The visibility of illicit activities such as homoeroticism is thus symptomatic of the secondariness that conditions all medieval confrontations with fleshly desire. Similarly Peter Damian's attack on clerical sodomy characterizes sodomitical practices as being imitative of a preexisting order in which there are two distinct sexes. He thus characterizes male acts of femoral intercourse between the thighs as imitating "natural" sex acts between men and women: those who pollute masculine thighs (*masculina femora polluit*) do everything that, if nature had permitted it (*si natura permitteret*), they would have done with a woman.[46] And a logic of sequence also inflects perhaps the most influential source for sodomitical imagery in the Middle Ages besides the Bible, the *Metamorphoses* of the Roman poet Ovid (43 BCE–17 CE), which we shall encounter several times in this book. In Chapter 3 I consider medieval responses to Ovid's story of Orpheus, the legendary musician and poet, who was also sometimes condemned for his role as the "first sodomite"; these retellings provide another opportunity to interrogate the sequential paradigms that shape visualizations of sodomy in the period.

Returning to Jerome's depiction in the *Belles Heures*, we see that the scene juxtaposes two moments in a temporal sequence: the sleeping Jerome, comfortably inhabiting his male embodied self, and the waking Jerome, unwittingly feminized by the trick. The narrative relies on the assumption that only the second moment in the sequence is performative: literally performed by the gendered clothing he inhabits, Jerome's corporeal maleness—supposedly originary—is never seriously in doubt. Of course it could be argued that the dress transforms Jerome corporeally, at least in part: only a handful of other figures in the manuscript possess such a slender waistline and these are usually female.[47] But the accompanying text secures Jerome's maleness ("sex") as a permanent, first-order aspect of selfhood, while his excursus into femininity ("gender") is presented as secondary and temporary. Although, reading the image from left to right, this ordering is arguably subverted, since the cross-dressing episode is positioned as coming first, the text makes clear that the "women's clothes" he is wearing are not his "own," thereby conveying their derivative character.

The close ties between femininity and performativity also get reiterated just pages later, in the miniature depicting Jerome's temptation by dancing girls, one of whom wears a dress comparable in style and color to the one he wears to Matins (plate 2). A devil descends to point Jerome's gaze toward the pair, which, as the caption beneath makes clear, actually feature only in his dreams: "Scorpions were my only companions," the saint laments, "and I would often imagine myself to be among choirs of girls [*choris puellarum*] and so in the fire of my lusts [*libidinum incendia*]."[48] What is it about these "choirs of girls" that inspires such lusty thoughts? Turning their heads to face one another, their bodies curving inward at the hips, the girls in the miniature cast their eyes down demurely, focusing seemingly on each other rather than Jerome; it takes a devil to draw the saint away from his prayers.[49] This example highlights the predicament of what might be called, with the benefit of hindsight, the medieval femme. According to the inversion model of sodomy that circulated in certain legal contexts at the end of the Middle Ages, woman-loving women cross over into masculinity, making them "like" a man; as discussed in chapter 2 this perception even extended—very occasionally—to the use of the term "sodomy," thereby harnessing a language more generally associated with male sodomites. Insofar as Jerome's dancing girls are aligned with the lusts that corrupt all men, however, his imaginary pair fail to register as sodomitic: they conform instead to general stereotypes of femininity as a source of bodily perversion. I playfully evoke here the figure of the femme, with all its attendant anachronism, in order to draw attention to a potential cleft in the categories of cultural visibility as they relate to female homoeroticism: the masculinized woman's visibility, itself fragile and intermittent in the period, depends on the assumption of an overriding invisibility on the part of her feminine counterpart.

This opens up a third theme in this book, which is directed toward assessing the role friendship discourse plays in medieval visualizations of sodomy. It has become a cliché of research on premodern friendship that expressions of intimacy between males, even physical expressions, do not necessarily convey personal feeling or homoerotic attraction: they are expressions of what Stephen C. Jaeger calls "ennobling love," ostentatious displays of ritualized emotion that have little to do with same-sex erotic practice.[50] Others have drawn attention to circumstances in which those relations get tainted with sodomitic meanings, usually for political reasons: sodomy's associations with secrecy, scandal, and disorder could be harnessed strategically, under certain conditions, to cast suspicion on bonds of intimacy between men that would otherwise have been perfectly acceptable in public settings.[51] Chapter 4 explores these structures in male religious spaces and shows how they also affect the visual imagery produced in such environments. What, though, of female amity? To what extent were women's relationships with one another subject to an analogous regulatory framework? The border separating eroticism from friendship is usually assumed to be less visible in premodern depictions of female fellowship; women's relationships were simply not politically resonant enough to warrant the creation of a fully developed fault line.[52] Chapter 5 considers one situation when the distinction between chastity and its (homo)erotic shadow seems to have exerted pressure on a series of devotional texts originally aimed at enclosed women. Again we can approach this possibility from the perspective of derivation. Female sodomy's visibility in these examples seems to be belatedly related to its male counterpart, a secondary status symptomatic not only of the medieval sources but also of the historiography that surrounds those sources.

A fourth theme, then, is the relevance of gender-comparative analysis to discussions of sodomy in the Middle Ages. It has been taken as read that analyses of female homoeroticism and female masculinity in the period form a separate field of investigation from discussions of their male counterparts; research has tended to segment along gender lines, both from the perspective of the researchers themselves (whose gender identity usually lines up with the gender of the subjects under investigation) and in relation to the material under investigation (which tends to be dominated by accounts of male sodomy). Some of this has to do with the availability of sources: texts and images depicting women's relations with one another are not as voluminous or as forthcoming in the Middle Ages as those depicting male homosocial relations, which makes for a particularly fraught relationship to the question of visibility. If, as Terry Castle intimates in her polemical account of the "apparitional lesbian," even modern histories of women's friendship have been conditioned by a "morbid refusal to visualize" what is right in front of them (in Castle's reading, the possibility that friends may also be lovers), then how much greater are

the challenges confronting medieval scholars whose evidence base is so much smaller.[53] Of course Castle is right to be suspicious of accounts that simply fold discussions of female homoeroticism back into male homoeroticism, what she calls a "ghosting through assimilation"; the cultural representation of lesbianism in modernity demands its own analytic frameworks.[54] At the same time research conducted in a gender-comparative vein can be vital in challenging the assumption that relations between women before modernity were inevitably chaste: assessing the relative significance of factors such as social visibility reveals situations in which women's relationships could resonate politically and even erotically, albeit sometimes in different ways from those of men.[55] Another factor motivating gender separatist approaches to the history of sexuality is the emergence of discrete publishing "markets," which also tend to organize that history along period and national lines, as recent titles such as *A Gay History of Britain* and *A Lesbian History of Britain* bear witness.[56] Building the argument around a series of case studies, ranging across different periods, geographies, spaces, and genres, I have tried, as much as possible, to present alternatives to such teleological frameworks.

Fifth and finally, the book is concerned with the ways in which the entry or not of sodomy into the field of vision is reliant on its status as translation. I deploy the term "translation" here in several, interrelated senses. It functions metaphorically as a figure for the ways in which the history of gender and sexuality can be conceived as a dialogue between past and present, or between one past or culture and another; and it describes the ways in which sodomy is literally the product of a *translatio* or "carrying over" from one location to another, whether visually (between text and image), textually (between one language and another), or culturally (between, say, a classical or biblical past and a medieval present, or between the Arab-Muslim world and Christianity). One of the meanings associated with the Latin term *translatio* is "metaphor," defined as the appropriation of one concept or image to talk about another. Here I map sodomy's reliance on this structure as a means of seeing and saying. Sodomy is itself a metaphor: the sins associated with the biblical inhabitants of Sodom are transposed into new conditions of understanding via abstract terminology such as *sodomia, in sodomitico more*, sins *contra naturam*, or *crimen nefandum*, in order to avoid discussing an unspecified act or acts more openly. With this emphasis on sodomy as metaphor, as translation, I follow the lead of several recent studies that have highlighted the significance of cultural transmission in the construction of desiring subjects. Valerie Traub links the proliferation of texts on affective and sexual relations between women in the early modern period to a recovery of classical antecedents, using the label "renaissance" to describe this process; Sahar Amer explores the role of Arabic intertexts in the construction of female homoeroticism in Old French narratives, as well as showing

how some modern translations of Arabic writings work to efface sexual and gendered possibilities in the past.[57] This book likewise seeks to highlight the cross-cultural dimensions of same-sex intimacy and gender-variant behavior; but within the definition of what constitutes translation the visual is given particular prominence.

Until recently translation has produced relatively little discussion within the field of art history—this despite the fact that, in writing about visual images, art history *always* has to confront the impossibility of translating visual matter into textual matter in a way that generates "total" communication. Increasingly, however, scholars working with visual sources are turning to the necessity and impossibility of translation as a means of comprehending intermedial transfer, or translation across media. Among other things, thinking through the lens of translation potentially offers an alternative to iconographic analyses that rely on the idea of visual images as imitations or copies of other images and textual traditions.[58] In this book I take stock of these efforts to theorize the movement between texts and images as a mode of translation (as opposed to, say, a text-image "relation"), as well as asking how a focus on translation might shed new light on the visibility-invisibility polarity as it affects figurations of sodomy. Translation theorist Lawrence Venuti laments the tendency in today's commercial, English-language publishing to render the work of translation "invisible" by effacing its second-order status. Making a pitch for alternatives to this domesticating ethos, via the promotion of more "hospitable" approaches to cultural difference, Venuti raises the issue of the translator's visibility to the level of an ethical imperative.[59] The questions Venuti asks about translation partly overlap with issues identified by Jagose and others as critical to the formation of histories of sexuality. If the visibility or not of a category such as lesbianism is contingent on its status as a second-order derivation, on the fact that the lesbian is always conceived as a translation or bad copy of some putative original, what would be the benefit of subjecting that derivative logic to analytic scrutiny? If sodomy itself enters the field of vision via translation, how might the effacement of that translation's secondariness—its status as a copy of a copy—work to obscure the very thing it supposedly brings into focus?

Translation also returns us to one of the issues raised at the beginning of this introduction, about the relationship between critical categories such as gender and sexuality. The Latin word *translatio* obviously shares its "trans" prefix with the English term transgender, yet an investigation of the relationship between translation and gender transformation potentially goes beyond simply highlighting their parallel investment in border crossings. It was in translations of Ovid, after all, that late medieval authors found an excuse to articulate female homoeroticism as a possibility, albeit a foreclosed one. As discussed in chapter 2, these encounters with Ovidian sex transformation render erotic activity

Consider Doing Poject on Ovid

between women impossible, but not entirely unthinkable. I don't profess to saying anything new about translation in these contexts; nor is the book densely laden with references to medieval or modern translation theories (though these do lie behind some of my key arguments). The focus instead is on translation as a practice, an experience, and a multimedia form; on its appropriation by medieval writers as a metaphor and means of negotiating difference; and on its potential as a figure for my own negotiations of language, terminology, history, and the crossing of boundaries between text and image.

Returning to the depiction of male-to-female transition in the *Belles Heures*, it is worth remembering that Jerome, the subject of the transformation, was himself a great biblical translator. It was via Jerome that the Middle Ages inherited the idea of translating not word for word (the classic *non verbum pro verbo* formula) but rather sense for sense, an ancient model that, in Jerome's reception of it, promoted the ideal of unimpeded access to the absolute meaning of the sacred word.[60] In another miniature in the *Belles Heures* sequence, Jerome is depicted hard a work in this role (fig. 2), engaged in the "translation [*translacionem*] of the Bible and the sacred scriptures," which, as the textual caption confirms, occupied him for no less than fifty-five and a half years. The location for the scene is Bethlehem, and the saint's guide is the Virgin herself, who, although she does not appear in the accompanying image, is described by the text as remaining "enduringly by his side."[61] In the image itself, Jerome is joined by an additional set of figures: three prophets, whose words he has translated, stand in the crenellated parapet above him, while a lion sits watching him at work. This is the lion from whose paw the saint extracted a thorn in a previous episode in the *Belles Heures*, which recounts a story also recorded in the *Legenda aurea*.[62] Looking for all intents and purposes like a docile dog, the animal functions as a symbol of fidelity and loyalty, precisely the qualities to which Jerome aspires as a translator. So it is perhaps not without irony that a few pages earlier the translator has been subjected to the kinds of debased procedure that he stridently rejects in his own translation practice, forcibly removed from the austere habit of the male monk and squeezed into the figure-hugging contours of a brightly colored woman's dress. The viewer is confronted not with sense-for-sense substitution but *non*sense; the monks in the choir recognize something— what?—in the incongruity to which we and they bear witness, but Jerome himself has been rendered passive, muted, shamed, like a badly translated text. The dress also casts doubt on the saint's chastity by insinuating that he has been associating too closely with women. When the saint is shown inhabiting the role of translator a few folios later, order is restored: the lion models the kind of virile steadfastness with which Jerome devotes himself to the word of God.

The ensuing chapters focus on a number of locations, contexts, and genres. The book is built around a core of texts and images from high and late medieval

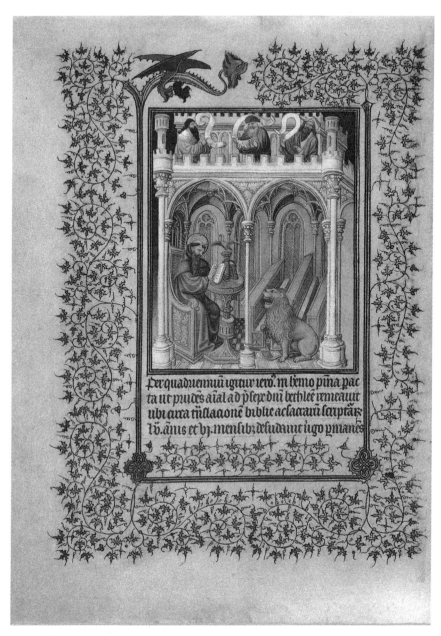

Figure 2. Saint Jerome translating the Bible. Miniature by Herman, Paul, and Jean de Limbourg in *The Belles Heures of Jean de France, Duc de Berry*. Paris, circa 1405–1408/9. New York, Metropolitan Museum of Art, The Cloisters Collection, 1954 (54.1.1a, b), fol. 187v. © Photo SCALA, Florence 2013. Image copyright The Metropolitan Museum of Art / Art Resource / Scala, Florence.

England, France, and Italy; occasionally it also takes in examples from regions such as Germany and Flanders. These reflect my training and areas of specialization as a medievalist, so the book neither constitutes a comprehensive overview of the "arts" of medieval sodomy nor probes all of the methodological questions they raise. Like Jerome himself as he stumbles into the choir for Matins, I inhabit the roles of both translator and translated; but unlike Jerome, I make no claim to mediating some final, unimpeded truth. Sodomy itself, that most medieval of inventions, has an afterlife that extends almost to the present day—an immersion in history and culture that affects its own ability to travel unproblematically between medieval and modern. There is simply no neutral lexicon with which to approach the phenomena outlined in this book, which is why I prefer to harness the enabling possibilities of so-called "anachronisms" such as transgender, butch and femme, lesbian, or sexual orientation, while simultaneously emphasizing their limitations as interpretive prisms.

One final word about terminology: "queer" became politically and institutionally significant almost at the same time as transgender, in the early 1990s, and I sometimes use it—as have several scholars before me—to capture those moments in medieval representations of sodomy where meanings become unstable. Ostensibly queer is itself an umbrella term, which permits a critical examination of a number of productive distinctions (sexuality, gender, race, nation, class) that shape perceptions of the sources. But like sodomy, in practice it has also tended to boil down to a more limited set of meanings. Set up in opposition to heteronormativity, queer risks simply becoming a byword in historical research for what previously went under the sign of homosexuality; in historical studies this has sometimes been accompanied by an overriding emphasis on male experiences of queerness. Work produced in a more theoretical mode has tended to focus obsessively on contemporary cultures in its explorations of queerness; what counts as "historical" in queer theory often turns out to be the history of the last fifty years. Queer, then, is no different from the other categories interrogated and appropriated in this study: the term is marked by the historical moment in which I write and warrants the same level of scrutiny and critique. At the same time, bearing these caveats in mind, "queer" has certain advantages too. Unlike other terms, such as "same-sex desire" and "homoeroticism," which are predicated on ideas of gender sameness, queer potentially operates as a third term, beyond the gender/sexuality opposition; compared with categories such as lesbian, gay, or transgender, it is not strongly marked as a category of selfhood, nor is it institutionalized as such (except perhaps within fairly limited academic settings). We need to be careful about what we mean by this, or by any of the other terms grappled with in this book, but queer is a concept I continue to find enabling.[63]

The book is arranged as follows. Chapter 1, "Translating Sodom," focuses on what is arguably the single largest corpus of images depicting sodomitical themes in medieval visual culture: a series of manuscripts, known as the *Bibles moralisées*, which were produced between the thirteenth and fifteenth centuries for members of the French royal family. Beginning with a well-known roundel representing two sinful couples in the earliest Vienna manuscript, the chapter situates this particular text-image sequence within the reading and viewing patterns that structure these unique manuscripts overall; reveals how references to the practices of "sodomites" elsewhere in the *Bibles moralisées* underscore the heterogeneous character of sodomy and the inconsistency with which the idea is applied specifically to homoerotic activity; draws attention to discourses of sodomy circulating in Paris around the time that the thirteenth-century Bibles were commissioned; and views the Bibles' sodomitic imaginary specifically through the lens of translation. Sodomy is always conceived, in the *Bibles moralisées*, via derivative structures: its visibility depends on its status as an imitation or bad copy of an originary ideal. Caught between the visible and the invisible, sodomy's status as a corruption of natural law is established primarily as an experience in translation.

In chapter 2, "Transgender Time," I consider the benefits of filtering medieval ideas of unnatural sex through the postmodern category transgender. What might the term's deployment as an interpretive framework add to or take away from analyses that treat homoeroticism principally as a category of sex acts? What happens when, as is frequently the case with relations between women, sodomy assumes less prominence as a rhetorical device or is even absent altogether as a word? The chapter begins by engaging with ideas of transgender time as it has been conceived within recent historiography, before turning to a detailed close reading of Hildegard of Bingen's reflections on cross-gendered performance and illicit sex in the *Scivias*. In the remainder of the chapter, I focus on the Ovidian myth of Iphis and Ianthe, a sex change narrative mediated in the Middle Ages via a number of moralized retellings of Ovid's *Metamorphoses*. The periodizing rhetoric of recent historiography resonates—sometimes problematically—with these medieval efforts to confront and suppress the story's homoerotic implications. In conclusion, I explore other responses to Ovid that present alternatives to these models, including a retelling of the Iphis narrative by the fifteenth-century poet Christine de Pizan and a recent "remixing" of the narrative by the British novelist Ali Smith. I show transgender's potential to be an enabling, even transformative category when applied to medieval texts; but the vision it affords is necessarily partial and provisional.

Chapter 3, "The First Sodomite," focuses principally on the myth of Orpheus and Eurydice as it was mediated in medieval culture, with particular reference to Ovid's discussion of Orpheus's turn to "tender males." How did moralizing

commentaries respond to this episode? How and when did artists render it visible to medieval viewers? Again here I consider medieval logics of sequence. One of the motifs the Orpheus story shares with the biblical narrative of the destruction of Sodom is that Orpheus's failure to win back Eurydice from the underworld is precipitated by a forbidden look, an act of retro-vision. Also punished for the crime of looking back, in Genesis 19, is Lot's wife, whose scopophilic tendencies echo those of her forerunner Eve. The chapter begins by interrogating the various responses to Orpheus's sexual history in the Middle Ages. Orpheus's turn to males provided some medieval writers and artists with opportunities to envision, via interpretation and translation, erotic possibilities that would otherwise remain unspeakable or visually incoherent. Moreover surprisingly, compared with discourses of homoeroticism and gender transformation discussed in the previous chapter, which linked unnatural, sodomitic, or otherwise nameless homoerotic practices indissolubly with shifts of gender, certain discussions of Orpheus treat a devotion to homoerotic behavior—reconfigured as a homosocial rejection of the company of women—as gender inversion's redress. I conclude by considering recent attempts to rehabilitate the Orpheus myth in queer and feminist scholarship, and ask why today the legend of Orpheus the "first sodomite" appears to have fallen by the wayside.

In the fourth chapter, "The Sex Lives of Monks," I turn to one of the central representatives of pederastic behavior in Orpheus's song, Ganymede, and put his own gender and sexuality under the spotlight. Considering also the relationships among age, power, sexual roles, and gender identity in medieval clerical culture, I demonstrate how another set of viewers—twelfth-century monks in the abbey church of Vézelay—experienced Ovid in translation. Undertaking a detailed analysis of carvings from the church's sculpted capitals with sexual themes, I focus on the medieval monastery as a site for what (after Virginia Burrus) might be called the "countererotics" of religious enclosure. Again, translation functions as an interpretive framework: it allows me to confront the transformative work of religious iconography as a means of fostering chastity and the love of God. In conclusion I focus on a dimension that makes some of the images discussed in this chapter and the last highly problematic from the perspective of contemporary sexual ethics: the role played by age hierarchy in the erotic scenarios that were ostensibly rejected, but also subtly reconfigured as spiritually meaningful, by monastic audiences reflecting on the arts of Orphic love. Why did age-structured pederasty—so troublesome from the perspective of modern sensibilities—occasionally play a symbolic role within medieval Christianity?

Chapter 5, "Orientations," considers the extent to which the concept of sodomy in the Middle Ages hinges on motifs of directionality and turning, and whether, in so doing, it might justifiably be viewed as a manifestation of "sexual

orientation." Here I also return to issues raised in earlier chapters concerning the relevance of the sodomy paradigm to depictions of female homoeroticism. In the wake of Foucault's arguments concerning the emergence of "homosexuality" in the late nineteenth century, it has become customary to declare the expression "sexual orientation" more or less irrelevant to any period before modernity. Taking off from Sara Ahmed's recent effort to pose the question of sexual orientation as a phenomenological question, I consider whether there is anything to be gained from viewing medieval sexualities through the prism of "orientations." What does it mean for sexuality to be lived as orientated? What happens when we pose the question of the "orientation" of "sexual orientation" as a historical question? The chapter considers two case studies that trouble modern assumptions concerning the reducibility of "sexual orientation" to homo- and heterosexuality. First I focus on the female anchorite, whose spatial orientation as a being traveling along a "straight" path to God intermittently conjures up the language of sodomy. Second, I turn to the infernal male sodomite, punished eternally in hell, whose disoriented actions congeal around the penetration of the anus. Building on this comparison between different modes of orientation, the book concludes by drawing together issues of terminology, anachronism, and the conceptual borders separating gender and sexuality.

I

Translating Sodom

Paris, in the decades around 1200, proved to be an especially vibrant location for the production of antisodomy discourse.[1] Toward the end of the twelfth century, the Parisian scholar Peter the Chanter (d. 1197) devoted a lengthy chapter in his *Verbum adbreviatum*—a practical moral guide for the Paris clergy—to the Sodomitic vice (*uicio sodomitico*).[2] Peter puts the practice on a par with murder, the only other sin he says "cries out" to heaven from earth. Whereas according to the scriptures God "created male and female for the multiplication of men" (paraphrasing Genesis 1:27-28), Sodomites, like murderers, destroy humanity by undermining this work (*opus*). The moralist pays particular attention to the effects of the practice on gender identity, arguing that since woman was fashioned from man's side in Eden—a reference to the account of creation in Genesis 2:21—God henceforth decreed that there would be intercourse only between men and women, lest any should think them androgynes (*androgeos*). In other words, precisely because there is a risk that differences between male and female may be blurred, stemming from the fact that female is effectively derived from male, sexual relations need to maintain a commitment henceforth to sexual dimorphism. Androgynous individuals should take care to conform to only one sexual role, dictated by the organ (*instrumentum*) by which she or he is most aroused (*calescit*) or the one by which she or he is most weakened (*infirmus*). And if this is not possible she or he must remain perpetually

celibate, because "alteration/inversion [*alternitatis*] is a sign of Sodomitic vice [*uicii sodomitici*], which is detested by God."[3]

Defined, with reference to Romans 1.26–27, as a variety of uncleanness in which women "changed the natural use into that which is unnatural" and "males, abandoning the natural use of the female, burned in their lusts, males doing evil with males," the vice in question is characterized by Peter as having devastating effects on the laws of nature, as attested by both the scriptures and historical example:

> Such men, passive and feeble [*patici et enervati*], who change themselves from males to females [*se masculos conuertunt in feminas*], abusing feminine coitus [*coitu femineo*], are kept as women by the pharaoh for his pleasure. They are inciters [*irritatores*] of Sardanapalus, a man who was more corrupt than any woman. Jeremiah also, at the end of Lamentations, adds to his long lament and sorrow over the ruin and captivity of the city a complaint and groan about Sodomitic vice [*uicio sodomitico*], saying, "They abused the young men indecently, and boys have perished on wood." Such men were struck not only dumb but blind knocking on Lot's door at noon, so that seeing, they did not see [*ut uidentes non uideant*].[4]

In this passage, the theologian compresses together ideas that will be encountered repeatedly throughout this book. First, sodomy—at least in its male form—is imagined as a mode of coitus that has gendered consequences for its practitioners. It mirrors corruption in general, embodied by the references to pharaoh and to the legendary last ruler of Assyria, Sardanapalus, whose downfall, according to the ancient Greek historian Ctesias, was attributable to the king's taste for luxurious living and effeminacy.[5] Also it echoes female embodiment specifically, since male sodomites engage in intercourse in "feminine" fashion. Second, the vice is rooted in a well-known but ambiguous biblical narrative, the story of the destruction of Sodom in Genesis 19, via a quotation from another biblical text, Lamentations 5:13, which is interpreted by Peter as referring to the abuse of male youths by the city's inhabitants. This reference highlights the significance of another category, age, in the vice's definition, while retaining a sense of vagueness about the precise practices involved. Third, the sin of Sodom is depicted as a variety of moral blindness, a mode of "seeing" that literally fails to see. This formulation, which is a citation from Luke 8:10, follows the reference in Genesis 19:9–11 to the Sodomites' punishment by blindness. Sodomy's status as a crime of corrupt looking is further underscored by the Chanter's reference, immediately prior to this passage, to the moment when Lot's wife looks back at the city, as she escapes its destruction with her family, and is turned into a pillar of salt. Interpreting the wife's fate

as a sign that God wishes to remove all memory of this crime, all "trace of its enormity," he portrays Sodom's punishment explicitly as a transition from visibility to invisibility.

Responses to the problems identified by Peter the Chanter in his chapter on sodomy in the *Verbum adbreviatum* were legion in subsequent decades, as several documents emanating from Parisian schools in the early thirteenth century attest.[6] One member of the Chanter's circle, Peter of Roissy (d. ca.1213), who toward the end of his life became head of the cathedral school at Chartres, touched upon the issue in several chapters of his *Manuale de mysteriis ecclesiae* (ca. 1208/11), where he pays particular attention to the perceived lenience with which unnatural crimes were being treated by church authorities at the time.[7] The roughly contemporary *Liber poenitentialis* (Penitential Book) of Robert of Flamborough (d. 1224), a manual of penance intended for the use of confessors, which was compiled in Paris and drew on work by other twelfth-century thinkers such as Alan of Lille (who himself probably spent time in the city), sets out a precise code of practice regarding the investigation of sins against nature. Presented as a sample interview between a priest and a sinner, Robert's text recommends a manner of questioning by the confessor that gathers all the necessary information from the penitent without giving the game away to those who might otherwise be corrupted by an awareness of previously unheard-of practices. What's important, as far as Robert's model interviewer is concerned, is the status of the penitent's partners in crime—whether they are men or women, cleric or lay, married or unmarried—and the length of time over which the crime was committed; the corruption of "innocents" is also singled out for attention. But we are not afforded a glimpse of the sexual activities themselves, for as Robert is quick to point out in his reflections on the sample dialogue he has provided, this might itself subsequently become a source of corruption. Reflecting on how afterward the penitent may be asked if he has sinned against nature (*contra naturam*) or had sex in an unusual way (*extraordinarie*), Robert adds that if asked what is meant by "unusual," he would not answer for the sinner would know (*non respondebo ei; ipse viderit*): "I never make mention of anything that might become an occasion for sinning, but rather speak of generalities [*generalibus*] that everyone knows are sins."[8] Robert thus follows the Chanter's lead in imagining sodomy as a crime of imitation, one that can be approached only obliquely through encounters with alternative categories. Putting a stop to sins against nature requires that they be rendered unspeakable, invisible; but this means approaching them via other, more knowable varieties of vice.

The Parisian intellectual obsession with sodomy culminated in the work of the master of theology at the University of Paris, William of Auvergne (ca. 1180–1249), who was appointed as the city's bishop in 1228. William's own penitential

manual, the *Summa de poenitentia*, treats sins against nature (which include, in his definition, masturbation, incest, and other behaviors that cause men to waste their seed outside the proper vessel) as a crime so terrible that the air itself is corrupted by its very mention. This motif of unspeakability, which William attributes to Gregory the Great, is embodied by the inhabitants of Sodom themselves, who the author declares became mute in their confessions before God. Corruptions of nature such as androgyny, itself one of the symptoms of *luxuria* or disorderly desire, are compared by William with the errors of pagans and idolaters; sodomites are depicted as "imitators" of nature, who destroy humanity with their debased forms of worship. In some parts of the world, unspecified by the author, the sin is practiced openly; but preachers themselves refuse to give it a name, describing it instead as the unmentionable vice (*crimen nefandum*).[9]

But what about when transgressions of the laws of nature such as this are represented not in speech or text but in art? This chapter focuses on a set of manuscripts, emanating from Paris at precisely the time when the city's scholars and clerics were devoting so much attention to the issue, that attempted to do just that. The earliest *Bibles moralisées* or "moralized Bibles," as they are now known, were produced in Paris in the 1220s and 1230s in a royal setting. Collectively they contain within their richly decorated pages what is arguably one of the largest collections of images visualizing "sodomitical" couplings in medieval western European art. The best known of these images (fig. 3 and plate 3) appears in the earliest example of the genre, Vienna, Österreichische Nationalbibliothek, cod. 2554 (hereafter Vienna 2554). In keeping with the overall aim of these books to moralize episodes from the Bible visually and textually, Vienna 2554 juxtaposes the temptation of Adam and Eve in Genesis 3:6 with a scene portraying two couples—one a pair of males, the other a pair of women or girls—embracing tightly, looking into one another's eyes, and, in the case of the female couple, engaging in an act of kissing. This pair of miniatures has been reproduced in several publications in recent years, including two prominent surveys of the history of homosexuality. One, James Saslow's *Pictures and Passions* (1999), an exploration of homosexuality in the visual arts from the ancient world to the present, argues that the moralizing scene "spotlights male and female homosexual couples equally," by showing how, just as Adam and Eve sinned through the mouth by eating from the tree of knowledge, "the kissing sodomites lying on their beds below take in the forbidden fruit of another's body."[10] The other, a world history of gay life and culture edited by Robert Aldrich (2006), uses the same moralization miniature to illustrate medieval social and religious attitudes to homosexuality.[11] Camille also discusses the miniature in two of his books, describing how the scene produces an "explicit" representation of homosexual sex, including a rare image of "lesbian" desire.[12]

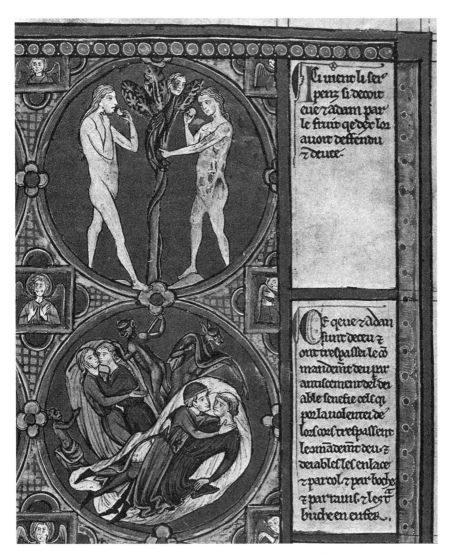

Figure 3. Genesis 3:1–6; transgressive bodily desires. Miniatures in *Bible moralisée*. Paris, circa 1220–25. Vienna, Österreichische Nationalbibliothek, cod. 2554, fol. 2r (detail, upper right). Photo: ÖNB Vienna.

The most "unmentionable" of crimes, which should not, according to Peter the Chanter and his followers, even be named, let alone visualized, enters into visibility in Paris at precisely the time when the reins were supposedly tightening regarding its knowability. Additionally the sinners in this particular scene have acquired a role, in contemporary scholarship, as the poster boys and girls of medieval homosexuality. Although they stand in for the great unknowable, the assumption is that we basically know what we're seeing when confronted with these images. Added to this is the fact that some of the most vigorous condemnations of unnatural sin in medieval Paris at this time were produced by

William of Auvergne, the city's bishop, who was also, as it happens, the personal confessor to the woman for whom the earliest *Bible moralisée* was probably made.[13] Blanche of Castile (d. 1252), wife and after 1226 widow of Louis VIII of France, has been identified as the patron behind at least one and possibly all four of the early thirteenth-century *Bibles moralisées*. The oldest surviving volume, Vienna 2554, which contains texts in Old French, is likely to have been produced for the queen herself in the 1220s; a much-expanded Latin version (Vienna, Österreichische Nationalbibliothek, cod. 1179, hereafter Vienna 1179) may well have been a gift from Blanche to her husband, King Louis, a few years later; the massive, three-volume set known as the *Bible of Saint Louis* (Toledo, Tesoro de Catedral MS 1) and its twin (comprising Oxford, Bodleian Library, MS Bodley 270b, hereafter Bodley 270b; Paris, Bibliothèque nationale de France, MS latin 11560; London, British Library, Harley MSS 1526 and 1527) were possibly commissioned by Blanche again, in the 1230s, as gifts for her son Louis— the future Louis IX—and the prince's own wife, Marguerite of Provence.[14] Each manuscript contains a series of images portraying homoerotic behavior, as well as depictions of other activities characterized as sodomitical. William of Auvergne's advice that crimes of this sort not even be named fails to apply in these instances, because the remarks are incorporated into a manual of penance. As such they do not extend to the regulation of visual images. It is nonetheless striking that members of the French royal family are being confronted with depictions of sodomitic behavior in such a context. Why were books made for, and probably commissioned by, one of William's own confessing subjects the place in which the unmentionable vice suddenly became representable?

One answer to this question would be to make a comparison with Foucault's evaluation of what he calls the "repressive hypothesis."[15] Although Foucault's main concern, in the first volume of his *History of Sexuality*, is with the period between the seventeenth and twentieth centuries, his argument also applies to medieval visual encounters with sodomy. The widely held idea among twentieth-century Westerners that in the nineteenth century sexuality was repressed and thereby rendered unspeakable is, Foucault submits, illusory; in actuality discourse on sexuality proliferated in the Victorian era usually associated with "repressive" attitudes. Similarly, for all its supposed unmentionability, sodomy was far from absent or unimagined in the Middle Ages. The images and texts discussed in this book, and indeed the critical literature that has built up around them, could not exist without a rich, multimedia presence for sodomy in European cultures before modernity. Likewise my argument in this chapter is that the *Bibles moralisées* need to be viewed in light of a surge of interest in the topic of sodomy in thirteenth-century Paris, a discursive explosion generating visual as well as verbal responses.

To understand why homoeroticism enters the field of vision at this juncture, we also need to understand what the owners of these manuscripts saw when they encountered such depictions within their pages. Beginning with the miniature moralizing the fall in Vienna 2554, this chapter will seek to complicate interpretations that view it simply through the lens of homosexuality, defined as a minoritarian identity category. I open with a detailed analysis of this scene, before discussing treatments of the fall and its commentaries in subsequent examples of the genre. Turning, in the section that follows, to the structures of dissemination themselves, I view the books' sodomitic imaginary specifically through the lens of translation. Sodomy is always conceived, in the *Bibles moralisées*, via derivative structures: its visibility depends on its status as an imitation or bad copy of an originary ideal. This ideal, according to the moral universe of the books' makers, conforms ultimately to the law of nature. Caught between the visible and the invisible, sodomy, as a corruption of natural law, is established as an experience in translation.

First Things First: Moralizing the Fall

If, according to John's gospel, "in the beginning was the Word," then the attitude adopted by the makers of the *Bibles moralisées* is at odds with such a line of thinking. Unusually for illuminated manuscripts in this period, these thirteenth-century volumes have texts that likely were added by scribes only after the images had been completed by artists. This conclusion is partly based on the fact that certain pictures spill out of the medallion frame into the area normally occupied by the texts; texts have been carefully written around these zones of pictorial overspill (fig. 4).[16] Taking account of this special status accorded to images, which disrupts the hierarchy traditionally understood between word and image, this investigation of the Vienna 2554 rendition of the fall will begin with the miniatures themselves. In Vienna 2554, more than any of the other *Bibles moralisées*, images take the lead.

Among the seven principal surviving models, Vienna 2554 is unique in that each page consists of two narrow columns of text, to the left and right, split into eight boxes; these eight captions correspond to the eight medallions in the central zone, which are arranged so that a scene illustrating a text from the Bible appears above a corresponding scene that comments on and offers a moralized interpretation of the biblical image (plate 3). This unique page layout yields multiple interpretations: images connect to texts, texts to images, texts to texts, and images to images, without a single dominant reading and viewing pattern. Users of the manuscript are confronted with a complex web of scanning possibilities; texts cannot be read sequentially without intermittently browsing

Figure 4. Genesis 45:17–22. Miniature in *Bible moralisée*. Paris, circa 1220–25. Vienna, Österreichische Nationalbibliothek, cod. 2554, fol. 13r (detail, lower right). Photo: ÖNB Vienna.

the intervening images. The implications of this interactive viewing process are potentially far-reaching.[17] If, as demonstrated here, the miniature moralizing the fall in Vienna 2554 is embedded in a relational structure, one that determines how individual scenes can be read and viewed, then analysis cannot be restricted to a single image-text combination. We also need to pan out, as it were, to gain a perspective on the Bible's overall *mise-en-page*.

Taking an overview of the folio in Vienna 2554 incorporating the fall miniatures, the viewer is confronted with a vision of symmetry and order. The page layout, interspersing textual zones to the left and right with a central zone of images, finds visual reinforcement within individual medallions, which similarly convey a strong sense of left-right polarity (plate 3). In the top left medallion (a), God stands between Adam to his right and Eve to his left and, taking their hands in his, brings them together as a couple. The French text describes the scene as a "marriage," a version of which is being enacted in the accompanying miniature.[18] Before the fall, according to the artists, Adam and Eve were virtually mirror images of one another: both possess thin, naked bodies, have almost identical postures, and wear their hair long. In the scripture itself, this vision of unity and nongendered hierarchy was famously characterized by Adam as a manifestation of "two in one flesh" (Genesis 2:24). However, the

scene to the right, depicting the moment of the fall (b), contrasts markedly with this idealized vision of equality before God. Now the mediating figure is the Serpent, which tips its head toward Eve, staring at the forbidden fruit in her hand. Here visible differences have been introduced. Gesturing toward Adam with an authoritatively outstretched left hand, Eve clearly now takes the lead in their relationship.

The accompanying commentary miniatures similarly make use of symmetry to convey their meanings. The joining of Adam and Eve in "marriage" is moralized (a) as the marriage of Christ and Ecclesia or "Holy Church," the latter being personified as a crowned, female figure. The left-right arrangement of the image parallels the structure of the scene above, but the vision of equality conveyed by the biblical union is juxtaposed with an affirmation of hierarchy. Christ reaches out commandingly toward Ecclesia in the moralization miniature, while Ecclesia herself models what is presumably a more appropriate attitude, by raising her right hand submissively in response. These actions serve to underscore the hierarchical relationship between Christ and Ecclesia, *sponsus* and *sponsa*, as well as that between male and female. Thus, whereas the biblical image emphasizes sameness, the corresponding moralization emphasizes difference. This overwrites the Genesis notion of male-female coupling as "two in one flesh" with the model of marriage promoted in the New Testament, as in Ephesians 5:23, where the husband is said to be "the head of the wife" just as Christ is head of the church. In turn, Eve's gesture to Adam in the fall medallion is presented as a corrupt imitation of Christ's dominant attitude to Ecclesia (plate 3). Eve's outstretched hand mimics Christ's own, an affront to her status not only as a human who should be following God's commandment but also as a wife who should be under the yoke of her husband. Eve is thus guilty of usurping male as well as divine privilege, a violation of gendered hierarchy further highlighted in the corresponding moralization. Unlike the upright or seated figures in the other medallions, here the couples are represented lying down in a diagonal axis, which disturbs the balance between left and right conveyed in adjacent scenes. Crisscrossing one another in this fashion, and beset on all sides by devils, the sinners are implicated in a scene of postlapsarian chaos.

As noted in the introduction, the activities condemned under the heading of sodomy in the Middle Ages were often believed to have gendered consequences for their practitioners. Representations of gender nonconformity provided a means of rendering visible what otherwise tended to be approached more obliquely—that is to say, the sex acts themselves. As Robert of Flamborough makes clear in his manual of penance, confessors should "never make mention of anything that might become an occasion for sinning, but rather speak of generalities that everyone knows are sins." The violation of gender hierarchy is precisely such a "generality." Moreover the notion that Eve transgressed her

gendered as well as human status is rooted in early Christian interpretations of the fall. In his first epistle to Timothy, the apostle Paul had used Genesis 3 as a justification for his view that women should not "teach" or "use authority over the man": she is, he says, to remain silent, "for Adam was formed first; then Eve. And Adam was not seduced; but the woman being seduced, was in the transgression" (1 Timothy 2:12–14). In their more extensive reflections on the Genesis story, patristic and medieval authors developed Paul's typology of the fall as a means of assigning Eve, and by extension women in general, a secondary status compared with Adam. Men in general, like Adam, were assumed to be intellectually superior and nearer in "likeness" to God. Although Adam himself was ultimately subordinate, subject to the rule of God, Eve was at the bottom in the three-tier hierarchy of God-Adam-Eve; and that, as Augustine states in his commentary on Genesis, is the proper order (*ordinatissime*) of things.[19] In the mind of biblical commentators Satan's own fall from grace precipitated this attempt to subvert divine authority: inhabiting the form of a serpent, he sought to undo God's laws, effectively transforming the hierarchy into Serpent-Eve-Adam.

The representation of the fall in Vienna 2554 develops these ideas and gives them visual as well as verbal support. Christ's gesture to Ecclesia in the marriage scene serves to emphasize, by way of contrast, Eve's status as a usurper of the role of teacher, which, according to Paul and later commentators, properly belonged to Adam. The text, which refers to the Serpent's deception of "eve et adam" (named in the other captions as "adam et eve"), further underscores the role reversal that has taken place. Additionally the diagonal arrangement of the sinful couples in the fall commentary medallion, which disrupts the ordered symmetry of the adjacent scenes, may contribute to this vision of gender trouble. Alan of Lille famously made analogies between the rules of grammar and the prescriptions of Nature regarding human copulation in his *De planctu Naturae*, arguing that violations of the command to reproduce represent a violation of the grammar of creation. Nature laments the fact that "Actiui generis sexus se turpiter horret / Sic in passiuum degenerare genus" (1:15–16) (the sex of the active kind shudders in disgrace at itself as it degenerates into the passive kind); she complains that the rules of Venus, according to which humans were created, have been inverted by introducing "in constructione generum barbarizans" (8:55–56) (barbarisms in the construction of gender).[20] The *Bible moralisée* depiction likewise communicates the crisis of category provoked by the trespass of God's "proper order": the sequence of texts and images promotes the maintenance of a clear gender dichotomy through matrimony, an ideal conveyed by the scenes showing Christ and Ecclesia being joined in "marriage." Sexual dissidence is thus mediated visually through gendered signs.

Looking to the bottom half of the folio, the eye is confronted with additional viewing possibilities. The four medallions in the lower half depict, to the left (c),

Adam placing the blame for his temptation on Eve, a scene accompanied by a moralizing image below, in which a cluster of sinners stand before God and excuse their sinful behaviors by maintaining, as the adjacent text makes clear, that they were born in such a time that it befits them to engage in covetous, lustful, and murderous acts; to the right (d), Adam and Eve are expelled from paradise, while below Christ drives a sinner into hell. The bottom left medallion, portraying the group of sinners excusing themselves, includes two figures representing lust and greed: a bearded male with a moneybag, who wraps an arm around a small child, and a female looking into a mirror who strikes a pose almost identical to that of Eve handling the forbidden fruit in the medallion on the top right. In the light of this echo, it is possible to envisage an additional, diagonal line of vision that serves to connect different modes of duplicitous self-loving in the scenes. In *De planctu Naturae* Nature lists Narcissus among those guilty of the *falsigraphus*, or "false-writing," that, she suggests, culminates in male homoeroticism: Narcissus is, in Nature's estimation, the archetypal self-lover, an individual who, catching sight of his image in a reflection and "seipsum credens esse se alterum, de se sibi amoris incurrit periculum" (8:77–78) (believing himself to be another self, incurred the danger to himself of loving himself). The circular logic Nature attacks here finds its match in the symmetrical circuits of desire represented in the individual medallions of this folio: the looks that transpire between the sinful, same-sex couples parallel the vain looks of the self-admiring female.

Images on this folio are also connected to one another via motifs of clothing and disease. A half-naked Adam is covered by God in the lower biblical image on the right (d), while the accompanying commentary miniature shows a scantily clad male being pushed into a gaping hell mouth by Christ and accepted by a gleeful devil. The doomed sinner's skin is covered in tiny dots or squiggles, which possibly represent leprous sores; the equivalent figure in Vienna 1179, the moralized Bible produced shortly after Vienna 2554, is similarly stricken (plate 4). Leprosy was viewed in the Middle Ages as a punishment for sin, and especially for sexual depravity.[21] In his letter attacking sodomy Peter Damian quotes a canon from the fourth-century Council of Ancyra linking bodily pollution with leprosy (*lepra*), describes the clerical sodomite as leprous (*leprosus*) in his soul, and concludes by asking his celibate brothers to keep their flesh immune from every libidinal plague (*peste libidinis*).[22] In light of these associations, viewers are invited to connect the sinful behaviors *of* the body (the same-sex couples) to inscriptions of sinfulness *on* the body (the diseased and scantily clad sinner). The idea is that the actions depicted in one scene lead to the bodily afflictions depicted in the other.

Looking back up toward the male same-sex couple in the fall commentary miniature in plate 3 (b), we see that one of these figures, dressed in red, is also

partially clothed: he reveals a rent in his robe, which exposes his white under-wear. The male in blue, who lies beneath his partner, likewise lifts the corner of his tunic as if he is about to expose his lower body to his partner's advances; the fact that the crumpled ends of the red tunic fall across the blue-clothed male's legs may imply that the latter adopts the more "passive" role in the encounter.[23] The corresponding medallion in Vienna 1179 (fig. 5 and plate 4) repeats these basic arrangements but with a twist.[24] To the left a woman in a red dress fon-dles the chin of her companion, dressed in white, as she presses up against her and stares into her eyes; but now she also places her legs between those of her partner, whose tunic appears to be hitched up as if it is open at the waist. To the right, two males of almost identical appearance embrace and appear to be about to kiss; but one of the men, crouching in an almost seated position, also has his clothes open at the waist, which affords viewers a tantalizing glimpse of his naked groin. In each instance one of the partners in the couple appears to be more dominant: partial removing of clothing or exposure of flesh seems to sig-nify passivity. A third, mid-fourteenth-century manuscript, Paris, Bibliothèque nationale de France, MS français 9561, which appears to have been partly mod-eled on a now lost *Bible moralisée* roughly contemporary with the Vienna Bibles, features an analogous scene showing two females and two males lying with one another diagonally within a rocky landscape and embracing and kissing, super-vised and caressed by demons (plate 5). In this later version, however, the scene comments on a different biblical narrative, Genesis 19:1-25, which describes Lot hosting angels in the city of Sodom and the city's subsequent destruction.[25] Possibly as a result of this change of context, the emphasis on nakedness and partial dress explored in the Vienna Bibles is no longer relevant here, and ho-moerotic activity is now being connected specifically with the sin of Sodom rather than with postlapsarian desire in general.

To return to the Vienna 2554 scene (fig. 3 and plate 3), another aspect of the male couple's dress is potentially significant: the figure to the left wears a round cap, headgear associated elsewhere in the manuscript with Jews and heretics.[26] His partner is tonsured and evidently a cleric, which implies a fur-ther manifestation of violated boundaries, this time between Christian and non-Christian.[27] The sexual sins of male religious are represented frequently elsewhere in *Bible moralisée* manuscripts by acts of kissing between a tonsured cleric and a female companion. But here the scene emphasizes modes of activity that extend to lying with one another as well as kissing.[28]

Two points follow from the foregoing analysis. First, the inverted logic noted by theologians such as Peter the Chanter clearly finds a visual counter-part in the image of the fall and its moralization. Just as in the *Verbum adbre-viatum* those guilty of sodomitic vice are depicted as inciters (*irritatores*) of a

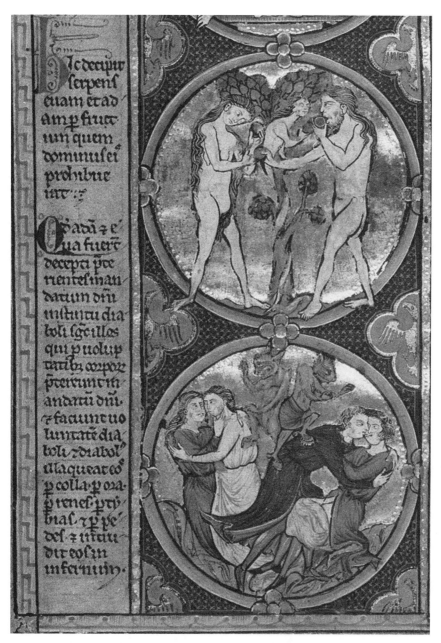

Figure 5. Genesis 3:1–6; transgressive bodily desires. Miniatures in *Bible moralisée*. Paris, circa 1220–25. Vienna, Österreichische Nationalbibliothek, cod. 1179, fol. 4r (detail, lower left). Photo: ÖNB Vienna.

depraved and womanish Assyrian ruler, Eve is depicted as someone who, led astray by the Serpent, abandons the subordinate status assigned to her by God; those females who sleep with other females, and males who sleep with other males, act like Eve themselves, to the extent that they pervert divine proscriptions of gender and power. Second, these images visualize not simply an illicit erotic practice but an affront to hierarchy in general: the disruption of aesthetic symmetry on the folio corresponds to the disruptions of order set in motion by original sin. The commentary text accompanying the image interprets the activities depicted in terms that foreground this more general concern with contraventions of God's law:

> Ce qeve et adam sunt deceu et ont trespassei le commandement deu par antiscement del deiable senefie cels qi por la volentei de lors cors trespassent le commandement deu et deiables les enlace et par col et par boche et par rains et les trabuche en enfer

> [That Eve and Adam were deceived and transgressed the commandment of God through the enticement of the devil signifies those who through the desire of their bodies transgress the commandment of God, and devils ensnare them by the neck and by the mouth and by the loins and pull them into hell.]

This text identifies the sins depicted as having potentially universal significance. Rather than singling out the "same-sex" component of the couplings, the composer of the text has drawn attention to the ways in which specific body parts—mouth, neck, and loins—lead humans into sin. The Latin text in Vienna 1179 adds a few additional details to this list of sinful body parts: the sinners will be dragged to hell not only by their neck, mouth, and loins, but also by their legs (*tibias*) and feet (*pedes*), which reinforces the emphasis in the miniature on physical activity below the waist.[29] In Vienna 2554 itself, the words used to convey these sinful body parts all have double meanings: the Old French for neck, *col*, could potentially also be read as *cul* (anus); *boche* might be translated as "vagina" as well as "mouth"; *rains* refers to "loins" in general but also can translate as "branch," which conjures up phallic associations.[30] Thus wordplay conveys a genital dimension that is visually absent. What we see when we encounter "homoeroticism" in this image is not, after all, the complete picture.

Additionally, in these scenes, fleshly corruption is portrayed as a mode of demonic spirit possession. Peter Damian characterized it thus in his reflections on clerical sodomy. Why, he asks, would men do such strange things to which they were "naturally" disinclined unless they were possessed by evil spirits? As he puts it: "When a male rushes to a male to commit impurity, this is not

the natural impulse of the flesh [*naturalis motus carnis*], but only the goad of diabolical impulse [*diabolicae stimulus impulsionis*]."[31] Damian's understanding of sodomy in these passages is underpinned by a long Christian tradition representing lust, and specifically same-sex relations, as the devil's work.[32] Demonology played a major role in lives of early desert fathers such as Saint Anthony, and continued to be influential in medieval monasticism, as discussed in chapter 4. More than a century before Peter Damian, Odo of Cluny (ca. 878–942) had explicitly connected sex acts between males, which he characterizes as beastlike or worse, with Lucifer's rebellion against the Creator, saying that since the fall the devil has striven to make man "worse than even he," driving human minds like horses and goading them "as if with spurs," until even the name "man" no longer applies.[33] Moreover in the later Middle Ages, as outlined in chapter 5, infernal demons could be portrayed in art and literature as violent sodomists, who abuse sexual sinners, penetrate them with phallic implements, or even literally "fuck" them or each other from behind. Damian's characterization of sodomy as a "diabolical impulse," and the *Bibles moralisées'* conception of homoeroticism as devilishly motivated, participate in this general climate of blaming sexual malpractice on demons and the devil. This explains why the makers of the Vienna *Bibles moralisées* paired the commentary image of corporeal transgression with a representation of the fall: the latter, too, was obviously precipitated by Satan.

Haziness and ambiguously gendered language work to universalize the sins depicted, by implying that any human is capable of succumbing to homoerotic passion. As Peter Damian puts it, evil spirits pour their "infernal poison" through the hearts of those they possess, so that they end up eagerly desiring "not what the natural motion of the flesh urgently demands, but what diabolical precipitation offers."[34] This universal theory of desire, which assumes that people will engage in fleshly practices such as sodomy only if they have been possessed by demons, sits in tension with efforts to minoritize such behavior, attributing to it a number of identifying features that transform it into a visual and moral other.[35] Acts of homoeroticism serve in the *Bibles moralisées* as an illustration of sexual sin in general, instances of a larger phenomenon in which all humans are implicated; the semantic narrowing is a function of the specificity of visual representation, which requires that a select group of behaviors stand in for many. In the resulting images same-sex intimacy is juxtaposed with marriage between male and female and found to be wanting; perceived as upsetting the grammar of gender; and connected with narcissism and circuitous self-love, the consequences of which are disease, death, and damnation. Sexual activity between males or between females is marked out as both visually and morally distinct, presented as the undesirable element in a representational

binary differentiating the sensual from the spiritual. At the same time, when we take into consideration images of illicit erotic couplings elsewhere in this manuscript and in subsequent *Bibles moralisées*, what is also regularly apparent is the inconsistency with which this logic is applied.

It is now time to turn to scenes in the manuscripts depicting figures named as "sodomites" in the texts. These demonstrate how sodomy itself regularly permeates borders and time frames, crossing between Christian and non-Christian, past and present, cleric and lay. In such visions, sodomy becomes a danger to which *anyone* is potentially susceptible—a changeable, chameleon-like entity that threatens to erupt repeatedly because God's laws have been corrupted in the fall.

Between a Rock and a Hard Place: *Bibles moralisées* and Translation

In what senses do the *Bibles moralisées* constitute "translations"? And what exactly do these transfers of meaning, whether between languages and media or between past and present, have to do with sodomy? To answer these questions, I will begin by exploring how biblical episodes in the manuscripts are shaped by their accompanying moralizations: in Vienna 2554 a seemingly inconsequential detail such as the Serpent's gender identity (unspecified in Genesis) is dependent on depictions of homoeroticism in the commentary image; reworkings of other passages from the Bible to include, for example, named references to "Sodomites" can also be viewed as participating in a medieval ethics of *translatio*, one in which old meanings are eclipsed by new ones through a process of projection, imaginative reconstruction, or displacement. From a modern perspective such reworkings might look like errors or acts of infidelity, but they are typical of other medieval biblical translations. Writing their own historical realities into a mutable if ostensibly authoritative "source," one replete with ambiguities and ellipses of its own, the makers of the *Bibles moralisées* seek to transform past into present, obscurity into clarity, through a process of visual and verbal substitution. Similarly the story of Sodom in Genesis 19 is curiously imprecise concerning the deeds that lead to the city's eventual destruction. The text fails to specify whether these deeds entail homoeroticism, inhospitality, violence, or some other social or sexual misdemeanor, or at least not in a way that would permanently settle the issue. But later commentators made efforts to bend the story to their own requirements, a process that continues to the present day. Likewise the makers of the *Bibles moralisées* carried over other texts in the Bible, notably an obscure narrative in the first book of Kings, into different languages and media, finding ways to generate, in so doing, visual and verbal clarity, and giving rise to new interpretive problems in the process. Translating Sodom, like these other acts of biblical commentary and dissemination, is

fueled by seemingly "untranslatable" elements in the so-called source; visual *translatio* adds yet one more layer to this proliferating discourse.

In some ways a more appropriate heading for this discussion would be "between a rat and a hemorrhoid." After all, my analysis of translation in the *Bibles moralisées* culminates in a discussion of a particularly wacky episode from the scriptures, which produces precisely such a moment of semantic confusion between rodents and bodily swellings. The phrase "between a rock and a hard place," however, captures better the overall point I am making. Interpreted metaphorically, first of all, it works to throw into doubt models of translation that assume two fixed reference points. How do the *Bibles moralisées* resist or impede models of textual fidelity that underscore the possibility of continuity between a supposedly static, authoritative "source" text (in this case, the Bible as it was defined by the medieval church) and its equally rigid and codified exegesis (the moralizing commentary)? If, as patristic writers such as Jerome and Augustine argue, the translation of scriptures is ultimately teleological, concerned with the preservation of textual meaning over and above linguistic multiplicity, to what extent did productions such as the *Bibles moralisées* sustain this motive of continuity? At the same time the expression "between a rock and a hard place," as deployed in popular parlance, also gets at the way in which one finds oneself stuck between two opposing, and often unsatisfactory, alternatives. It is precisely the experience of being stuck that interests me here. If, as some translation theorists have proposed, translation is a clarification that obscures (or, as Zrinka Stahuljak puts it, an "unveiling that veils"), what happens when we extend these ideas of resistance to translation—or untranslatability—to intermedial as well as interlingual and intercultural transfer?[36]

Turning to the *Bibles moralisées*, we see that we are dealing not just with modes of communication that can be decoded iconographically; these are not simply picture books, illustrating the Bible with a standard repertoire of images. The principal function of these manuscripts was to produce a textual and visual commentary that appropriated biblical events and motifs as a means of passing moral judgment on contemporary society. The effect this moralizing ethos has on the so-called source is often very dramatic. Time and again, biblical stories are manipulated, modified, or removed from their narrative context in order to make them cohere with the overall moral program. Ostensibly the Bible is an authoritative basis for the moral message. The texts refer to how the biblical episode "signifies" (*senefie/significat*) the transgressions detailed in the scenes below. On the surface, then, we are confronted with a straightforward case of *translatio*: meaning carries over from biblical past to medieval present. But when we look more closely, it is clear that the biblical stories have been modified to fit better with the moralizing format, constituting what, in the words of Augustine in his *Confessions*, is a "praesens de praeteritis" (present of

past things).³⁷ This "past presentness" is an enduring feature of the *Bibles moralisées*, creating a situation in which biblical time and contemporary time enter into a kind of perpetual feedback loop.

One feature of the Vienna 2554 representation of the fall that stands out in this respect is the depiction of the Serpent, which, with its long, wavy hair, is identifiably female. In Genesis itself the Serpent's gender identity is not specified, but from the thirteenth to the sixteenth centuries the creature was often represented visually as a hybrid, in the form of a snake with a woman's head, hair, and even torso.³⁸ Taken in isolation, then, the *Bible moralisée* depiction of a female tempter is hardly a radical innovation. In this particular setting, however, it also now conveys additional layers of meaning that work to intensify the overall moral message. First there is the fact that the Serpent itself, possessing a woman's face, physically embodies the androgynous qualities Eve's tempter had been thought to possess since patristic times. Gendered variously as masculine or feminine, depending on the interpretive needs of commentators, this ambiguity was further reinforced by allusions in early Christian biblical commentaries to the idea that the Serpent's body was violently entered and possessed by Satan.³⁹ The pair of miniatures representing and commenting on the fall in Vienna 2554 arguably registers this gendered interplay between the tempter's voice and the snakish body it ventriloquizes: the seduction of Eve in the biblical scene, which is visually coded as "feminine," finds its "masculine" counterpart in the pulls and pokes of the devils in the scene below. Second, just as in the biblical miniature a female Serpent is depicted seducing a female Eve, a woman in the moralization image below seduces another woman. This woman's act is precipitated by a prodding demon who, like Satan with the snake, effectively turns the sinner into his puppet. What is more, Eve's own temptation assumes homoerotic significance by association, in a visual embodiment of Augustine's "present of past things"; she herself, usurping the privileges accorded to men, effectively acts like a female sodomite. The Parisian intellectual Peter Comestor (d. ca. 1178) was the first explicitly to assign a woman's face to the Serpent. Spuriously or erroneously attributing the idea to Bede, his *Historia Scholastica*, an influential biblical abridgment and gloss originally produced for students in Paris, describes the Serpent and Eve as having identical appearances: Lucifer, envious of human embodiment, took the form of "quoddam genus serpentis, ut ait Beda, virgineum vultum habens, quia similia similibus applaudunt" (a certain kind of serpent, as Bede says, having the face of a virgin, because like favor like).⁴⁰ In context Peter Comestor's remark is probably directed at acts of self-loving rather than homoeroticism, though Peter Damian's reference to the Narcissus myth in his condemnation of male same-sex relations suggests that there was no necessary distinction between the two. The makers of Vienna 2554 take the theologian's logic to the next level, comparing Eve's preference for

someone "like" her to an overtly eroticized scenario in which two women engage in sexual acts.

The biblical texts on this folio likewise seem to have been bent into shape, or in Augustinian terms "presented," by the accompanying moralizations. One example would be the reference to Adam and Eve being joined together by God in "marriage." The use of the word *mariage* here makes best sense in light of the moralizing commentary depicting the joining together of Christ and Ecclesia. The Vulgate Old Testament, based on Jerome's translation into Latin of the Hebrew Bible, had been available to Western exegetes since around 400 CE, and a comparison between this version of the biblical text and the *Bibles moralisées'* paraphrases is instructive. In the Vulgate, the features of this so-called marriage are announced by Adam, who describes in Genesis 2:24 how "they shall be two in one flesh." The corresponding paraphrase in French bypasses the reference to "two in one flesh," with its promise of unity, indissolubility, and nongendered hierarchy, and instead deploys a word not included in the biblical source—marriage—which seems designed to correspond to New Testament references comparing Christ and Ecclesia's union to that of a husband and wife.[41] The biblical caption here translates the language of the moralization, rather than vice versa: the relationship between the biblical "past" (embodied in the so-called source) and its moralizing "present" (conceived of as an imitative "copy") is partially reversed.

Similar scenarios also play out repeatedly in other folios of the *Bibles moralisées*. Although spatially the commentary takes up roughly half the space in the manuscripts, conceptually it all but displaces the Bible itself. This dynamic of appropriation and substitution works on a number of levels. One very obvious way in which biblical texts are transformed into a contemporary register is through the updating of certain proper names. Perhaps the most striking instance of this process occurs in an extended sequence depicting Judges 19–20, which culminates in the defeat of the tribes of Israel by the Benjaminites and the subsequent massacre of the Benjaminites by Israel. Although, as the Vulgate elaborates, twenty-five thousand Benjaminites are slain, a small number escape and make it to a specific location: "And there remained of all the number of Benjamin only six hundred men that were able to escape, and flee to the wilderness: and they abode in the rock Remmon four months" (Judges 20:47). The makers of Vienna 2554 have included a medallion showing this flight into the wilderness (fig. 6), but a curious substitution has been made in the caption accompanying the biblical miniature: the Vulgate's children of Benjamin have become "Sodomites" (in Old French, *li sodomite*), and these Sodomites no longer abide in a single, named location—the rock of Remmon—but, as the scribe puts it, "habiterent en diverses montaignes" (live in different mountains).[42]

The shift from the rock of Remmon to different mountains is symptomatic

Figure 6. Judges 20:47; miscreants who abandon God and live among Christians. Miniatures in *Bible moralisée*. Paris, circa 1220–25. Vienna, Österreichische Nationalbibliothek, cod. 2554, fol. 63v (detail, lower left). Photo: ÖNB Vienna.

of the attitudes displayed by the makers of the *Bible moralisée* to biblical translation. Faced with a choice between treating the Vulgate as a timeless, unmovable rock, stuck forever in "the past," and mining it for its potential to shore up divergent moral interpretations, the makers have conceived of it within the frame of their own ever-unfolding present. In this particular instance, the change can be explained by the preceding episode recounting Judges 19, which partially echoes the Genesis story of the destruction of Sodom. In the Vulgate, a Levite, his

concubine, and his servant attempt to find lodging in Gibeah, a city inhabited by the Benjaminites. An old man offers the Levite's party lodging in his house in Gibeah, but the evil Benjaminite residents knock on the old man's door and ask him to bring the Levite to them so they can "abuse him"; the old man refuses the request, offers his own daughter and the Levite's concubine up as alternatives, and begs them not to commit this crime "contra naturam" (against nature) on his guest. Subsequently, the Levite hands over his concubine to the men, who abuse the woman all night and hand her back the next morning; the Levite finds his concubine dead on the doorstep and takes her body home. Once back, he takes a sword, cuts the woman's corpse into twelve and sends the pieces to "all the borders of Israel"; it is this that sparks the bloody war between the Benjaminites and the other tribes of Israel.

Again, in the French Vienna manuscript, the inhabitants of Gibeah are consistently labeled "Sodomites," as becomes clear once the vernacular text is placed alongside the Vulgate:

Judges 19:22–24

While they were making merry, and refreshing their bodies with meat and drink, after the labor of the journey, the men of that city, sons of Belial (that is, without yoke), came and beset the old man's house, and began to knock at the door, calling to the master of the house, and saying: Bring forth the man that came into thy house, that we may abuse him [*ut abutamur eo*]: And the old man went out to them, and said: Do not so, my brethren, do not so wickedly: because this man is come into my lodging, and cease I pray you from this folly. I have a maiden daughter, and this man hath a concubine, I will bring them out to you, and you may humble them, and satisfy your lust [*vestram libidinem conpleatis*]: only, I beseech you, commit not this crime against nature [*scelus hoc contra naturam*] on the man.[43]

Biblical paraphrase in Vienna 2554, fol. 65r

A. Ici vienent li sodomite de la vile et demandent le Dyakene et le vulent prendre por fere de lui lor vilenie et li proudom est a devant et le defent a son poor.

[Here the Sodomites come from the city and ask for the deacon and want to take him to do him harm, and the good man is before them and defends him with his power.]

B. Lors vienent li sodomite et prenent a force la fame au Dyakene et lenmeinent et li proudom le soffre et forment en dolanz et correciez.

[Then the Sodomites come and take by force the wife of the deacon and lead her away and the good man suffers for her and is greatly pained and angered.]

C. Ici vienent li sodomite et prenent la fame a Dyakene et jurent a li a force tant qi la tuerent et qe morte fu.

[Here the Sodomites come and take the wife of the deacon and they rape her with such force that they kill her and she dies.]

D. Ici vienent li sodomite et prenent la fame dont il avoent fet lor volentez qil avoent tuec et la mettent fors de lor ostel. Et li Dyakenes la recoit dolanz et correciz.

[Here the Sodomites come and take the woman whom they had their way with and killed, and they place her outside of the house, and the deacon receives her with pain and anger.]

This is a relatively unusual revision of the text. Medieval biblical commentators did occasionally link the narrative of Judges 19 to the destruction of Sodom in Genesis 19, which likewise concerns sins of inhospitality and rape. Nicholas de Lyra (1265–1349) makes the connection in his *Postilla super totam Bibliam*, but he does not go so far as labeling the inhabitants of Gibeah "Sodomites."[44] Several centuries earlier the Council of Paris in 829 had affirmed in one of its canons that the sin against nature was to blame not only for the destruction of the cities on the plain, but also for Noah's Flood and for the genocidal massacre of the Benjaminites: these incidents are viewed as "manifest proofs" of the detestability of the sin to divine majesty.[45] A collection of capitularies fabricated around 857 by a cleric going by the pseudonym "Benedictus Levita" falsely ascribes to the emperor Charlemagne (d. 814) a series of laws that were not his, including a spurious decree stipulating the burning of sodomites on the basis that they provoke divine wrath.[46] The fate of the Benjaminites is cited as justification for this extreme penalty; elsewhere in his capitularies, the churchman also quotes verbatim the Council of Paris canon linking the destruction of Sodom to the Flood and the Benjaminite massacre.[47] The biblical paraphrase in Vienna 2554 reproduces these efforts to connect the fate of the Sodomites in Genesis 19 to the fate of the Benjaminites in Judges 19, but takes the analogy to its logical conclusion: through an act of verbal substitution Benjaminites *are* now Sodomites, becoming one and the same in the minds of the manuscript's makers and readers. The alteration is a function of the moralizing commentary, which shoehorns the biblical narrative into a lesson about Christianity under threat.

Strikingly, while the Judges and Genesis stories are being treated by the book's makers as analogous episodes, the visual images accompanying this reworking of Judges 19 make no specific reference to same-sex sexual activity as an attribute of the Benjaminite "Sodomites." The inhabitants of Gibeah are depicted as ugly, scowling rapists, brutally assaulting their female victim by

Figure 7. Judges 19:22–23; heretics pull down sacraments of Ecclesia (*a, upper left*). Judges 19:25; heretics take Philosophy from pagans (*b, upper right*). Judges 19.25; heretics kill Philosophy (*c, lower left*). Judges 19:25–28; heretics trample Philosophy, and Jerome and Augustine receive her (*d, lower right*). Miniatures in *Bible moralisée*. Paris, circa 1220–25. Vienna, Österreichische Nationalbibliothek, cod. 2554, fol. 65r. Photo: ÖNB Vienna.

poking her eye, wrenching her arm, and lying on top of her in a bed (fig. 7).[48] Homoeroticism appears only in the commentary medallion accompanying the image representing the Benjaminites' flight in Judges 20:47 (fig. 6). This depicts a cluster of men behind a table, one of whom accepts a moneybag from a devil, while a short-haired male embraces a bearded man in a cap and, adopting the

chin chuck gesture, draws the pair together in a kiss; the accompanying text announces that the biblical scene signifies "un poi des mescreanz qi ont relenqi deu et sunt espart par le munde et habitent en divers leus entre les crestiens" (some of the miscreants who have abandoned God and are scattered through the world and live in different places among the Christians). In the images themselves the crimes of these "miscreants" are specified: they include avarice (the moneybag) and homoerotic lust (the kissing males), but also comprise religious heterodoxy, as denoted by the caps and beards that some of the wrongdoers wear (commonly signs elsewhere in the manuscripts for heresy and Jewishness). This moral vision of a world torn apart by perversion—whether spiritual, sexual, or financial—justifies the amendments to the Vulgate: from Benjaminites to Sodomites, from the rock of Remmon to "diverses" mountains. Terrorists *avant la lettre*, the biblical Benjaminites have been displaced by migrant, money-grabbing Sodomites, who threaten to infect Christian communities on a global scale.

It would be possible to cite numerous other instances of such appropriations. Whereas superficially the *Bibles moralisées* appear to serve their authoritative "source" (the Word of God) by translating biblical narratives into a language and conceptual framework that made sense to their royal patrons, the transposition ultimately remakes the primary text in such a way that the reverse situation seems to hold: the biblical narrative serves its moral master. Yet this inversion is not simply effected through textual displacement: the *Bibles moralisées* also disrupt the hierarchy traditionally understood between word and image, in which images follow, not lead. The casual attitude displayed by the books' makers to the Bible bears witness to this dominance of the visual over the verbal: the earliest two examples, now housed in Vienna, demonstrate that the scribes often had only a cursory knowledge of biblical events and that the texts they insert as captions actually translate the visions in the biblical medallions into a linguistic medium rather than making direct reference to—or quoting—the Bible itself.

Several scholars have drawn attention to this state of affairs, judging instances of the phenomenon "absurd": in his study of the making of the manuscripts, John Lowden describes these moments of confusion as "gross errors," which reveal a "truly stunning lack of knowledge."[49] Once again the unbiblical nature of the *Bibles moralisées* is symptomatic of the moralizing function of the volumes. The artists often connect commentary and biblical medallions visually, by drawing direct parallels between the respective layouts, or by making the gestures of the protagonists in one scene mirror those of the protagonists in the other. One obvious instance of this is a scene illustrating the moment in Genesis 4:8 when Cain suggests to his brother Abel, just before he murders him, that they "go forth abroad" into a field (fig. 8). Whereas the Vulgate says nothing

Figure 8. Genesis 4:8; Judas kisses Christ in betrayal. Miniatures in *Bible moralisée*. Paris, circa 1220–25. Vienna, Österreichische Nationalbibliothek, cod. 2554, fol. 2v (detail, lower right). Photo: ÖNB Vienna.

about Cain kissing his brother before they depart for the field, the *Bibles moralisées* add an image of the two brothers touching lips, a supplement endorsed by the textual translation of the vision, which announces: "Ici beise cayn son frere par traison et li dist: vien ioer o moi es chans, et il si fet; et cil le tue par traison" (Here Cain kisses his brother in betrayal, and says come play with me in the fields, and he does so; and he kills him in betrayal). The deviation can be explained not by ignorance but by design: the moralizing commentary sees in

Cain a typological parallel with Judas, who is shown kissing Christ as recounted in the Gospels; Judas's kiss of betrayal alludes, in turn, to all the other dangerous perverted kisses threatening Christian unity in the present, which include, but are not limited to, the "Sodomites" in the book of Judges.[50] Texts effectively translate images, the visual eclipsing the verbal as the medium of sense.

There is nothing necessarily surprising about this dynamic when viewed against the backdrop of medieval translation theory. Rita Copeland's survey of medieval hermeneutics demonstrates how, like ancient rhetoric, medieval commentaries refashion texts in ways that are appropriate to new conditions of understanding. Classical ideas of translation as displacement and substitution gained new importance in the Middle Ages with the carrying over of authority from Latin to vernacular culture. The Latin *translatio studii et imperii* formula, which links ideas of the transmission of learning to political transfer and the mediation of power and authority between cultures, was a theory of translation emphasizing disjunction over continuity; medieval understandings of the relationship between past and present cultures were heavily influenced by this notion of translation as displacement and replacement.[51] The *Bibles moralisées* arguably participate in such a process: they claim continuity with the biblical past while simultaneously operating in excess of it.

Nor are the *Bibles moralisées* out of step with other vernacular treatments of the Bible. It is worth recalling that even such a seemingly obvious detail of the fall story as the fact that the Serpent is a stand-in for Satan is an extrapolation from the scriptural account, which makes no explicit reference to the devil in either Hebrew, Greek, or Latin: Augustine was the first to identify Satan as speaking through the snake, an interpretation that affected all subsequent Christian interpretations of the story.[52] And one has only to look at a page of a medieval glossed Bible, in which the gloss all but displaces the biblical verses it is meant to be expounding, to see that the attitudes displayed by the makers of the *Bibles moralisées* to biblical translation are continuous with a wider cultural phenomenon.[53] Analyzing medieval encounters with Genesis 3 against this backdrop, Eric Jager thus makes a case for viewing the biblical story of the fall as "an imaginative construct or projection of medieval culture itself, which wrote its own historical reality into the mutable narrative details and symbolic values of this myth."[54] The same conclusion could easily be reached by analyzing the attitudes displayed to Genesis or indeed any other biblical book in the thirteenth-century *Bibles moralisées*.

Although the reading of the Bible in the vernacular had been prohibited by the church at the Council of Toulouse in 1229, these rulings did not apply to the royal household who commissioned the *Bibles moralisées*, the earliest of which, Vienna 2554, contains texts in Old French throughout.[55] As a vernacular

production, this book appears to have inherited a theory of translation based on rupture, one that appropriates the linguistic authority of Latin by effacing the lines separating the biblical past from a medieval, French-speaking present; in this instance, however, Latin authority is carried over not only to the vernacular texts but also to the visual domain. Yet such a procedure is not without its risks, given that the authoritative text being displaced, in this instance, is purportedly God's Word; the prominence afforded to images, and the opportunities for relating them to one another, provide opportunities for a more playful, even speculative interpretive procedure.[56] Just as Eve in Vienna 2554 transgresses her role as a human under the command of God (and implicitly her gender role in relation to Adam), images in the manuscript seem to have usurped textual authority as the medium of sense.

From the very beginning, of course, certain mechanisms of restraint were deployed by the makers of the Vienna Bibles to direct the viewing process, the use of textual captions being the most obvious example. Moreover in subsequent manuscripts of this type further efforts were made to rein in the disruptive potential of images. The first step in restoring the balance of power between text and image was to change the page layout itself. Thus in Vienna 1179, and subsequent Bibles, the eight medallions framed by vernacular text on either side have been replaced with a column of text (in Latin) to the left, juxtaposed with a column of medallions, followed by another column of text and medallions (plate 4). This more prescriptive layout seems designed to place greater emphasis on verbal authority, and to restrict the potential for multiple viewing patterns.[57] In addition, in Vienna 1179 the linguistic medium reverts to Latin (though here the Latin texts simply translate the Old French of Vienna 2554, rather than reproducing the Vulgate directly). Subsequently, with the multivolume sets now in Toledo and distributed between libraries in Oxford, Paris, and London, a progressive effort is made to revise and "improve" the biblical texts to bring them back into line with the Vulgate. Although the fourteenth- and fifteenth-century volumes provide captions in French as well as Latin, texts as a whole take up much more space in the later *Bibles moralisées*.

As has been demonstrated by Lowden in his survey of the treatment of the book of Ruth across all seven Bibles, the principal casualty of these attempts to restore biblical accuracy and textual dominance is the visual coherence witnessed in Vienna 2554.[58] In later Bibles the visual parallels between biblical and moralizing scenes can no longer be sustained, or if they are, there is a radical disjuncture between text and image. One example of this change, also discussed by Lowden, is a scene in Vienna 2554 directly adjacent to the one depicting the escape of Benjaminites into the mountains. This miniature illustrates the beginning of the cycle representing the book of Ruth. The relevant texts in the

Vulgate describe how Naomi, who escaped with her husband to the land of Moab as a result of a famine in their homeland, decides to return home following the death of her husband and two sons. She sends her two daughters-in-law, Ruth and Orpha, who have outlived their husbands—Naomi's sons—to their mothers in order to find new husbands. Initially both girls are unwilling to leave their mother-in-law, so again Naomi persuades them to leave. Whereas Orpha does eventually return home, Ruth remains behind, pledging never to leave Naomi. As the Vulgate puts it: "Orpha kissed her mother in law and returned. Ruth stuck close to her mother in law" (Ruth 1:14); after Naomi again asks Ruth to leave, the girl replies, "be not against me, to desire that I should leave thee and depart: for whithersoever thou shalt go, I will go" (Ruth 1:16).

The image in Vienna 2554 (fig. 9), on the same page as the scene showing the flight of the Benjaminites (fig. 6), illustrates this scene very clearly. To the left Orpha departs, with a miserable expression, while an equally miserable Ruth, to the right, clings to Naomi's tunic. But the text presents a wildly divergent reading from the Vulgate rendering of events:

> Ici a une fame qi a nom Booz qi a dous filles. Lune des filles se tient a li, et dist qele ira oliqe part qal alle, et lautre se part de li et de sa compaignie.

> [Here is a woman named Boaz who has two daughters. One of the daughters holds to her, and says that she will go wherever she may go, and the other parts from her and from her company.]

The differences between Vulgate and *Bible moralisée* text are obvious. First, the woman in the image is called Boaz, not Naomi. This seems even odder, when we consider that Boaz is not in fact a woman at all, but the man who appears later in the story and whom Ruth takes as her second husband! The relationship between the women has also changed: Boaz, so-called "woman," is said to have two daughters, whereas according to the Vulgate Ruth and Orpha were Naomi's daughters-*in-law*. The rest of the text here presents a reasonable enough paraphrase of the events of the Vulgate: the idea that one girl stays with the woman, while the other departs. The modifications to the Bible here (which in Lowden's terms constitute "gross errors") are remarkable. Visually, however, the arrangement of the scene ties very closely with the scene below representing the moralization, which, according to the text, interprets Orpha's departure as signifying those who renounce Ecclesia:

> la feme qi a dous filles dont lune se tient a li et lautre la lasse senefie Sainte Eglise qi a dous manieres de genz, li un se tienent a li et font sa uolontei, li autre se tornent de li et la renient.

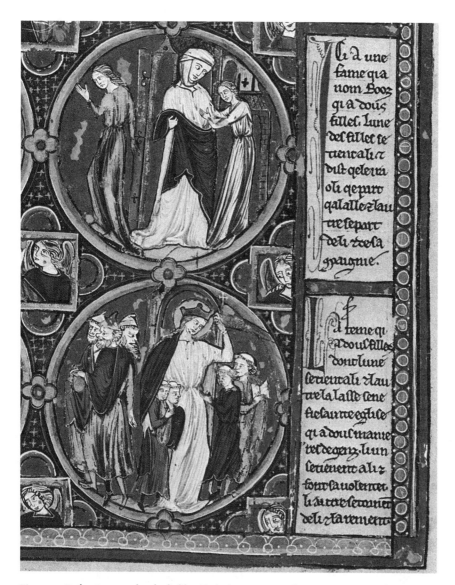

Figure 9. Ruth 1:6,14; people who hold to Ecclesia or renounce her. Miniatures in *Bible moralisée*. Paris, circa 1220–25. Vienna, Österreichische Nationalbibliothek, cod. 2554, fol. 63v (detail, lower right). Photo: ÖNB Vienna.

[The woman who has two daughters of whom one holds to her and the other leaves her signifies Holy Church which has two kinds of people, some hold to her and do her will, others turn away from her and renounce her.]

The image corresponds closely to the text, depicting in the middle the figure of Ecclesia, represented as a crowned female, sheltering two tonsured males beneath her cloak while another two stand to the right, turning toward her; to

the left are several caricatured Jews, one of whom carries a moneybag (sign of usury and avarice). The visual parallels between the biblical and moralization scenes here are very striking: the Jews, turned to the left, parallel Orpha; Ecclesia, dressed in white, parallels Naomi (or "Boaz," as the text has it); and the tonsured figures are the visual counterparts to Ruth. For all the seeming inaccuracy of the biblical text when compared with the Vulgate, the composition of this pair of medallions otherwise produces remarkable coherence: text works with text, image with image, in ways that generate clear textual and visual analogies.

When we turn to the last of the seven principal *Bibles moralisées* to be made, a manuscript now in Paris, a very different picture emerges. Bibliothèque nationale de France, MS français 166 (hereafter BnF fr. 166), the illuminations of which were begun in the early fifteenth century by Paul and Jean de Limbourg under the patronage of Philip the Bold and later his brother Jean de Berry (as discussed in the introduction), contains texts in both Latin and French.[59] The texts in BnF fr. 166 could be judged a considerable improvement, from the point of view of accuracy, on the Vienna equivalents. For instance, in the French text illustrating this scene from the book of Ruth, readers are given the following:

> Naemi sapareilla pour sen retourner en son pais de Bethleem auec ses .ii. brus mais lune qui auoit non Orpha la baisa et la commanda a Dieu et ne retourna mie auec li, et lautre qui auoit non Ruth retorna auec li.

> [Naomi prepared herself to return to her country of Bethlehem with her two daughters-in-law, but the one named Orpha kissed her and commended her to God and did not return with her at all, and the other who was called Ruth returned with her.]

This correctly names the protagonists, and while it is certainly not a literal translation of the Vulgate (for example adding the reference to Bethlehem), it is a near enough rendition of events. When we look at the accompanying image, however, there is now a complete lack of fit (fig. 10). Two women are shown, to the left, embracing, but they appear to be Orpha (represented by the elaborate headdress) and Ruth (denoted by the more sober head scarf); their mother-in-law is shown walking off to the right, depicted as an older lady with a walking stick. Gone is the significance of Ruth clinging to Naomi and promising to remain with her. The moralization scene below compounds the confusion. The text tells how Orpha's departure "signifie ceulz que puis quil ont este netoiez de tout peche par baptesme ou par confession lessent leur dame Sainte Eglise et retournent a lordure de pechie" (signifies those who, after they have been cleansed of all sin by baptism or by confession, leave their lady, Holy Church,

Figure 10. Ruth 1:6,14; people who return to sin after baptism or persevere in virtue. Miniatures in *Bible moralisée*. Paris, fifteenth century. Paris, Bibliothèque nationale de France, MS français 166, fol. 63v (detail, lower left). Photo: Bibliothèque nationale de France.

and return to the filth of sin), whereas Ruth signifies those who remain in virtue. In the image itself we are shown an image of baptism to the right, and to the left a man with a moneybag and a man and woman embracing; the latter presumably represent those who, after baptism, return to sin. But taking both images together, the viewer is being asked to compare the embrace between Orpha and Ruth above with the lustful couple below. The visual structure of the biblical scene has been carried over into the accompanying moralization, with the sense of a division between left and right and the mirroring of the couples'

embraces. Yet the significance of the parallel ends there and makes little sense at all when the texts themselves are taken into consideration. The consequence, strange as it may seem, is that Orpha and Ruth's embrace is being presented, visually, as a parallel to those who, according to the text, "return to the filth of sin." It would be hard to describe this sort of outcome as a coherent text-image *relation*.

What is the significance of comparing an embrace between two women with an act of intimacy characterized, in the text, as sinful? We could simply attribute the change of emphasis to ignorance or error, and leave it there. After all, the idea that there is something suspicious about the relationship between Ruth and Orpha has no biblical basis. Elsewhere in the *Bibles moralisées* intimate relations between women are occasionally represented as sinful, as we have seen: the moralization of the fall in the two Vienna Bibles clearly depicts female homoeroticism and the usurpation of male power as a transgression of God's laws. However, in later Bibles this iconography shifts radically. In the Toledo Bible, produced in the 1230s, the Latin texts basically correspond to those in Vienna 1179, but the images themselves have been altered: the Serpent is no longer obviously gendered female and the commentary medallion below shows a cleric caressing a woman over a hell mouth alongside a male idolater.[60] The Bodley 270b volume of the Oxford-Paris-London Bible, which was modeled directly on the corresponding volume in the Toledo Bible, also adopts the new arrangement. While the biblical miniature retains the motif of a female, human-headed tempter, the creature, wearing a headdress, no longer mirrors Eve absolutely, which reduces the emphasis on sameness and self-loving (fig. 11). The last three *Bibles moralisées* to be produced—the mid-thirteenth-century London, British Library, Additional MS 18719; the mid-fourteenth-century Paris, Bibliothèque nationale de France, MS français 167; and BnF fr. 166—follow Bodley 270b visually, except that the male partner in the sinful, embracing couple is no longer identifiably a cleric.[61] So BnF fr. 166 does not feature an image of female homoeroticism in the context of the fall. Indeed, notwithstanding the fact that the image of Ruth and Orpha embracing is interpreted as corresponding to the "filth of sin" (a mode of sinfulness never clearly defined in the text), this manuscript contains no images of lustful behavior between women at all; the possibility of women's having sexual relations with one another has seemingly been effaced by the manuscript's makers.[62]

Another place where one might expect to find depictions of homoerotic behavior is the story of the destruction of Sodom in Genesis 19. The biblical story concludes with a description of the fate of Lot's wife when she fails to heed the angels' warning to "look not back"—an episode that, as we have seen in Peter the Chanter's commentary, provided a basis in the Middle Ages for associations between the sins of Sodom and invisibility. This motif of backward

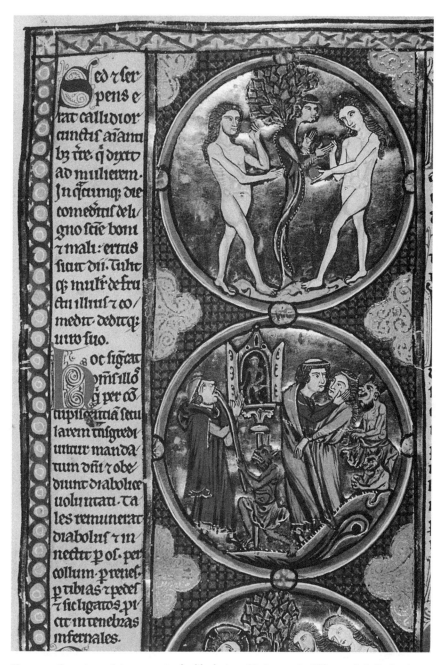

Figure 11. Genesis 3:1–6; transgressive bodily desires. Miniatures in *Bible moralisée*. Paris, circa 1230. Oxford, Bodleian Library, MS Bodley 270b, fol. 7v (detail, upper left). Photo: The Bodleian Libraries, the University of Oxford.

Figure 12. Abraham intercedes for Sodom (*right*); Lot greets angels (*center*); sins of Sodom (*left*). Lower register of page illustrating Genesis 18:22–19:2 in Bible picture book ("The Egerton Genesis"). England, possibly Norwich, third quarter of fourteenth century. London, British Library, Egerton MS 1894, fol. 11r (detail). © British Library Board.

looking, enacted by Lot's wife among others, will be discussed in more depth in chapter 3. Yet some medieval artists were not averse to looking back themselves when it came to representing the sins of Sodom. The Egerton Genesis, a picture Bible from the third quarter of the fourteenth century, includes an unusually explicit depiction of the sins of Sodom. Folio 11v of the manuscript is devoted to the events of Genesis 18:22–30, in which Abraham intercedes with the Lord on Sodom's behalf, and Genesis 19:1–2, in which Lot receives the angels sent to inspect the city (fig. 12). The drawing on the folio's bottom half, which has no accompanying caption, depicts Abraham conversing with the Lord and beseeching him to spare Sodom (right); Lot bowing before two winged angels who have arrived at the gates of the city (center); and a Sodomite in tight-fitting garments and pointed shoes violently attacking a pair of beggars (left). Another, similarly dressed figure faces the viewer, watching indifferently as his companion launches his uncharitable attack; he rests his right hand on the hilt of a sword, which projects suggestively from his waist. Above, on the rooftops, another Sodomite stuffs himself with food, while an enlarged male colleague seems to be lifting his lower garments as if he plans to touch himself or examine his genitals. The inclusion of masturbation in this catalogue of Sodomitic vices conforms to a tendency among medieval churchmen to lump together sexual practices with nonprocreative ends, including any activity that involved

the spilling of semen. In the *Verbum adbreviatum*, for example, Peter the Chanter suggests that, like Onan who "spilled his seed upon the ground" (Genesis 38:9) in an act of what would today be termed *coitus interruptus*, those guilty of *uicio sodomitico* waste seed.[63] Finally a pair of Sodomites, one of whom has his robe hitched up at the thigh, is depicted embracing and wrestling, presumably as a prelude to intercourse. This unique illustration, which was probably produced in England by a Flemish artist for a nonclerical, possibly middle-class patron, associates Sodom with a multitude of sinful practices: violence, inhospitality, luxury, greed, homoeroticism, masturbation, and self-indulgence. At some point in the manuscript's reception the groin areas of the embracing and masturbating Sodomites have been rubbed away, suggesting that at least one reader took offense upon being confronted with such a graphic depiction of Sodom's sins.[64]

Working more than a century earlier than the Egerton Genesis artist, and in a very different milieu, the artists of the *Bibles moralisées* associated Sodom with a narrower range of sinful behavior. In Vienna 2554 the inhabitants of Sodom are labeled *les sodomites*. However, as in the Judges 19 episode with which the Genesis story is linked by the book's makers, these "Sodomites" are visualized primarily as exponents of male violence, arriving with weapons at Lot's door. This arrangement is repeated in Vienna 1179, again with no effort to link Sodom's sins explicitly with homoeroticism (fig. 13). Moreover, in each of the Vienna Bibles the accompanying moralizations themselves fail to identify the sins as overtly sexual: Lot is identified in both manuscripts as a figure for Christ; the angels are viewed as figures for the virtues of virginity and humility (in Vienna 2554) or the "two orders" of clergy and laity (Vienna 1179); the Sodomites who wish to assault the angels are associated in each instance with devils; the destruction of the cities is interpreted as representing Christ's capacity to destroy vice (Vienna 2554); Lot's wife's backward glance is an allegory for the way in which some men of religion, like Lot, turn away from the world while others, like his wife, keep their heart fixed on earthly things (Vienna 2554, Vienna 1179).

The activities of the Genesis Sodomites are linked, for the first time, with homoerotic behavior in the corresponding Toledo volume. "Sodomites," as the moralization text declares, "signify all libidinous men and women who unite with one another against nature [*omnes homines et mulieres sibi inuicem libidinose contra naturam*], whom the devil abducts by all their members in order to drag them into hell to stay there forever"—a turn of phrase recalling the moralization of the fall in the Vienna Bibles, which likewise refer to how the sinners are dragged to hell by their body parts. The miniature accompanying this text (fig. 14) shows two couples embracing. To the left a monk in a cowl clasps a red-lipped youth of indeterminate gender, while to the right a woman hugs and holds the face of another woman (both identified as female by the long hair that falls down their backs). Thus although it no longer represents female

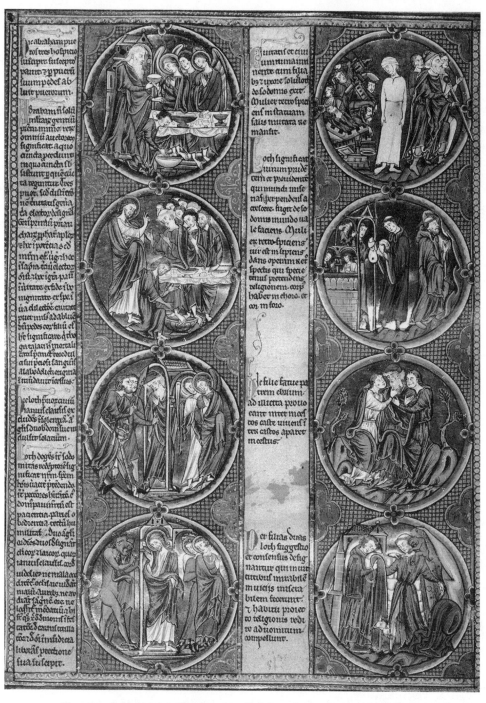

Figure 13. Genesis 18:6–8; Christ receives disciples at last supper (*a, upper left*). Genesis 19:1–11; Christ receives the two orders of clergy and laity and protects them from devils (*b, lower left*). Genesis 19:15–16, 26; men of religion turn away from or toward the world (*c, upper right*); Genesis 19:30–35; hermit deceived by the world, the flesh, and the devil (*d, lower right*). Miniatures in *Bible moralisée*. Paris, circa 1220–25. Vienna, Österreichische Nationalbibliothek, cod. 1179, fol. 9v. Photo: ÖNB Vienna.

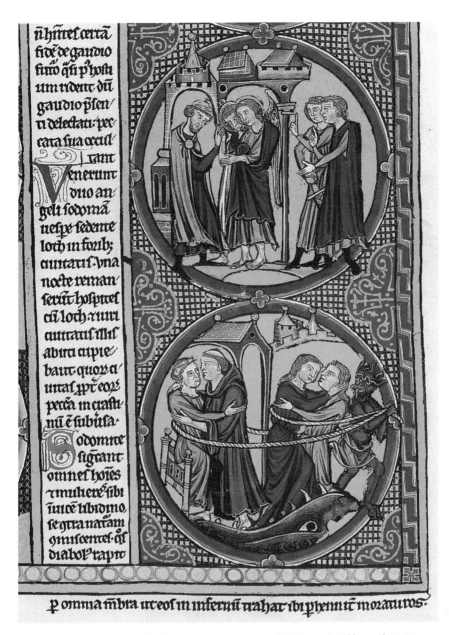

Figure 14. Genesis 19:1–11; sodomites unite against nature. Miniatures in *Bible moralisée*. Paris, circa 1230. Toledo, Tesoro de Catedral, MS 1, vol. 1, fol. 14r (detail, lower right). © M. Moleiro Editor, Bible of Saint Louis, vol. 1, f. 14r (www.moleiro.com).

homoeroticism in the context of the fall, the Toledo Bible finds room for such activity in connection with the Sodom narrative. However, in *Bibles moralisées* produced subsequently this arrangement is itself modified. In Bodley 270b, the first volume in the Oxford-Paris-London Bible, the moralization miniature shows a tonsured, hooded cleric with somewhat swollen lips kissing a bearded,

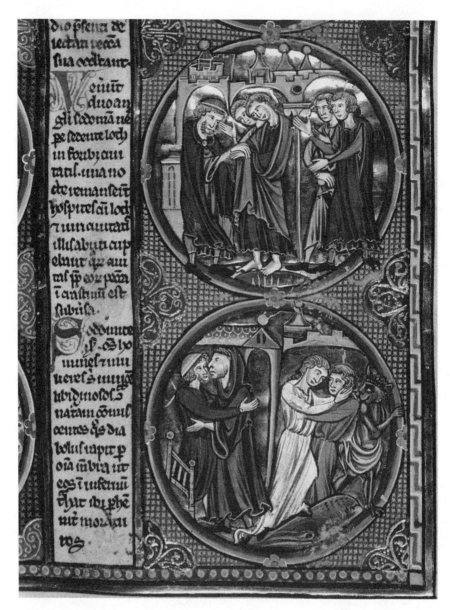

Figure 15. Genesis 19:1–11; sodomites unite against nature. Miniatures in *Bible moralisée*. Paris, circa 1230. Oxford, Bodleian Library, MS Bodley 270b, fol. 14r (detail, lower right). Photo: The Bodleian Libraries, the University of Oxford.

capped male to his side; to this couple's right, two more ambiguously gendered figures embrace over a hell mouth (fig. 15). This second couple corresponds to the female couple in the Toledo Bible, but here it is not immediately apparent that both participants are women: one has long hair, but it is unclear whether her partner does or not, since it could also be her hand clasping her lover's neck.[65] London, British Library, Additional MS 18719, a hastily prepared copy

of the Oxford-Paris-London Bible, follows the Bodley 270b artist in portraying an unambiguously male couple to the left, but again includes, to the right, two more ambiguously gendered figures embracing (fig. 16).[66] It is hard to decide whether this second couple represents male youths, a pair of women, or a male-female couple. When, in the early fifteenth century, the Limbourg brothers paint the same scene (fig. 1), as discussed in the introduction, the gender of

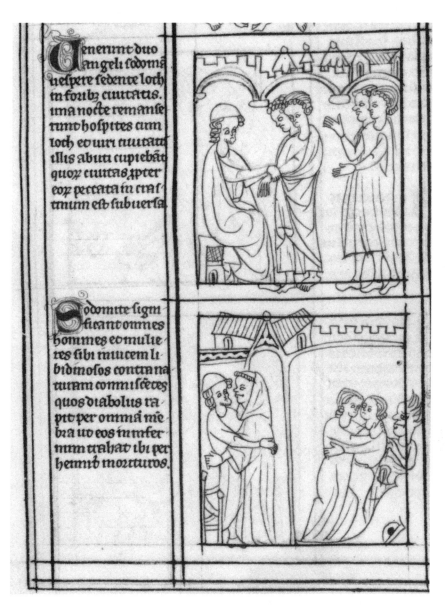

Figure 16. Genesis 19:1–11; Sodomites unite against nature. Miniatures in *Bible moralisée*. London or Westminster, circa 1260. London, British Library, Additional MS 18719, fol. 7v (detail, lower left). © British Library Board.

the participants in this second couple is finally clarified. In BnF fr. 166 a male cleric and layman are shown embracing to the left, while the couple on the right is male-female, dressed in fashionable courtly attire characteristic of noblemen and women elsewhere in the manuscript.[67]

This demonstrates the precariousness of interpretations of the Sodom story linking it with homoeroticism between men and between women. In the earliest Vienna Bibles, an overtly sexualized reading of the episode is not even attempted; in the Toledo Bible, female and probably male homoeroticism are juxtaposed; in all subsequent Bibles (except for BnF français 9561) only male versions of the sin against nature remain representable. Thus, in the course of the moralized Bibles' development, the possibility of women's having sexual relations with one another moves in and out of focus, the female couple in the Toledo volume finally morphing into a pair of conventional aristocratic lovers. It is unclear whether this is by chance or design; it could simply be a symptom of the process of transmission from one manuscript to the next. While, in the visual language of the artists, features such as beards and tonsures are unambiguously male, characteristics such as secular hairstyles and clothing are sometimes less easy to categorize as "male" or "female." For instance courtly male youths, with their beardless faces, long tunics, and headbands wrapped around wavy, shoulder-length hair, share many attributes also possessed by girls.[68] Whether or not the gender changes are deliberate, these examples reveal the recurrent instability of the Genesis 19 moralizations as they transfer from one manuscript to the next: from the perspective of a modern viewer seeking out homoerotic imagery in the Middle Ages, translations of Sodom in the *Bibles moralisées* fail to secure a fixed set of meanings. Within the logic of the books themselves, however, a different attitude holds sway: the "inconsistencies" I have been teasing out here illustrate a single entity, carnality, which readers are being urged to avoid through an assortment of distinctive and sometimes contradictory examples.

Sodomitry, Rats, and Hemorrhoids

Against the backdrop of all this apparent instability, even within interpretations of the Genesis story of Sodom, we are finally in a position to confront the rats and hemorrhoids to which I alluded earlier. They feature in a folio illustrating a bizarre episode in the first book of Kings, which tells the story of the Ark of the Covenant in the land of the Philistines. According to the scriptural account, which is one of the most baffling sections of the Hebrew Bible, the Israelites suffer a major defeat at the hands of the Philistines, who subsequently capture the ark and cart it off to the temple of their own god Dagon. The next day, however, the Philistines find Dagon destroyed, and this is followed by an

outbreak of some kind of pestilence among the Philistines, as well as by a plague of rodents. Unsure what to do, the Philistines transfer the ark from one city to another, but still the pestilence pursues them, until finally, once they restore the ark to the Israelites, the affliction abates. The pestilence is characterized in the Vulgate as some sort of swelling: we learn in 1 Kings 5:9 that the Philistines "conputrescebant prominentes extales eorum," a Latin phrase that has been variously interpreted by translators. Modern biblical and medical scholarship often construes the Philistines' misfortunes as references to an outbreak of bubonic plague, whereas the Douay-Rheims rendition of 1609 translates the relevant line as "they had emerods in their secret parts" ("emerods" is a variation on "hemorrhoids").[69] Some early Christian commentators also thought the Philistines were suffering from a very personal affliction: in his Latin rendition, which was the basis for the Vulgate, Jerome interprets the verse as referring to swellings "in secretiori parte natium" (in the more secret parts of their behinds).[70] Other mysteries abound. Douay-Rheims refers in 1 Kings 6.5 to offerings made to God by the Philistines in recompense as "quinque anos aureos . . . et quinque mures aureos" (five golden emerods . . . and five golden mice). However, the makers of the *Bibles moralisées* have proposed a somewhat different reading. In the Old French biblical paraphrases on fol. 36r of Vienna 2554 (fig. 17), the Philistines have been rendered *Sarrazin*—Saracens—who are depicted in the accompanying miniatures (a) setting up the ark before their god Dagon; (b) returning to find Dagon fallen to the ground; (c) being beset by rats who devour their genitals as a sign of God's anger; (d) repenting of their misdeeds and making offerings of gold pieces and "raz dor" (gold rats).[71]

The identification of the Philistines as Saracens translates the biblical narrative into the contemporary language of the Crusades.[72] The textual references to the religious practices of these men, referred to over the page as "mauveses genze Sarrazin" (the bad race of Saracens), reinforces this association: Dagon is described as a *mahomet* (literally a "Mohammed"), who inhabits a *mahommeri* or mosque; together, these references perpetuate medieval Christian myths of Muslim idolatry. Additionally the moralization miniatures generate another unusual gloss on the biblical episode: the genital affliction of the "Saracens" is likened to the sexual activities of clerics and prelates, who are depicted embracing and stroking the chins of youths while spurning Ecclesia. Significantly, the text gives these activities a name:

> Ce qe li sarrazin tindrent larche a force, et dex se corroca a els et lor envoia uns raz qi lor maingerent les antrailles, senefie les mauves prelaz et les mauves evesques qi tienent les rentes et les provendes par achatement et par symoniez et dex se corroce a els et il sunt feru de sodomitirie qi lor mainiuent et les rains et les antrailles.

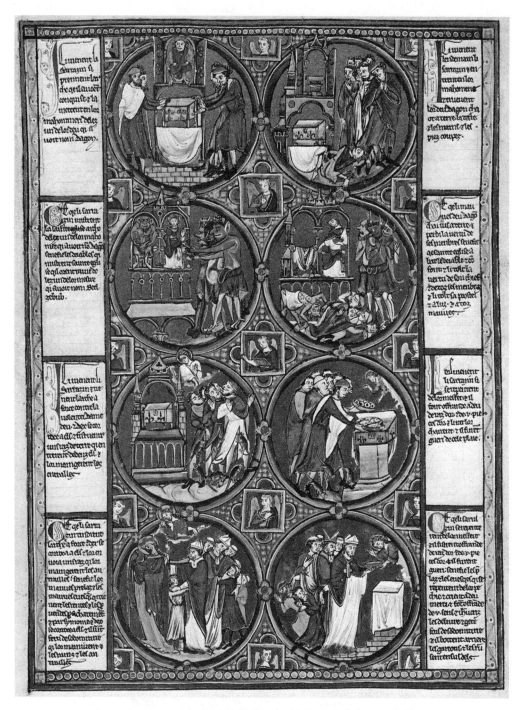

Figure 17. 1 Kings 5:2; devils place Ecclesia beside Beelzebub (*a, upper left*); 1 Kings 5:3–4; Ecclesia knocks down devil (*b, upper right*). 1 Kings 5:6; wicked prelates punished with "sodomitry" (*c, lower left*). 1 Kings 6:5; repentant prelates delivered from "sodomitry" (*d, lower right*). Miniatures in *Bible moralisée*. Paris, circa 1220–25. Vienna, Österreichische Nationalbibliothek, cod. 2554, fol. 36r. Photo: ÖNB Vienna.

[That the Saracens took the ark by force, and God was angered by them and sent them rats that ate their entrails, signifies the wicked prelates and the wicked bishops who hold rents and prebends through purchase and through simony, and God is angered with them and they are struck by sodomitry, which eats them and their loins and their entrails.]

In the Latin *Bibles moralisées* the relevant word is *sodomitico*, but Vienna 2554 refers to *sodomitirie*, a rare French term from which the sixteenth-century English word *sodomitry* is derived.[73] What this designates, according to the text, is a horrible, flesh-consuming virus, which infects the clerical hierarchy with its evil; it is represented as a punishment for the dubious economic practices—specifically, simony—that likewise devour the church from within. Visually, however, the makers of the Bibles have conflated sodomitry with age-differentiated eroticism between males: the youths whom the bishops fondle, some of whom are themselves tonsured, present a direct parallel to the rats who gnaw at the genitals of the so-called Saracens (figs. 17 and 18). The adjacent scene, mirroring the gold offerings made by the "Saracens," shows the prelates setting aside their boys and repenting. Just as the biblical rodents are sublimated by the "Saracens"—turned into golden rats—the bishops treat their boys like vermin, while transforming their fleshly "sens" (sense) into something holy and sublime. Again, in this example, we see how biblical text gets put in the service of a moral argument, which fixes the sinful behavior visually as a particular variety of homoeroticism.[74]

The sexual desire of older and more powerful males for younger males is also a feature of other scenes in later *Bibles moralisées* that have no equivalent in the Vienna volumes. In the London volume of the Oxford-Paris-London set, for example, there is a biblical image representing Paul's prohibition of uncleanness, covetousness, and fornication in Ephesians 5:3, which shows a bearded, hooded figure embracing an unbearded, short-haired male, who is presumably meant to be the younger of the pair (fig. 19).[75] The biblical text announces, of each of the sins, "nec nominetur in vobis" (and it should not be named among you), and the illuminator has interpreted this reference to unspeakability as an allusion to male sodomy. But the brand of fornication condemned also appears to be characterized by a distinction between youth and age. Similarly, in a scene in both Toledo MS 1 and Bodley 270b moralizing Deuteronomy 25.11–12, a tonsured male to the left offers an object (possibly the Eucharist) to a smaller tonsured male, while to the right the cleric draws the boy's head toward his own and stares into his eyes (fig. 20). The Deuteronomy text rules that if two men quarrel and the wife of the weaker man delivers him from the stronger by taking the latter by the secret parts (*verenda*), the wife should lose her hand; the commentary text interprets the quarreling men as Catholic and heretic,

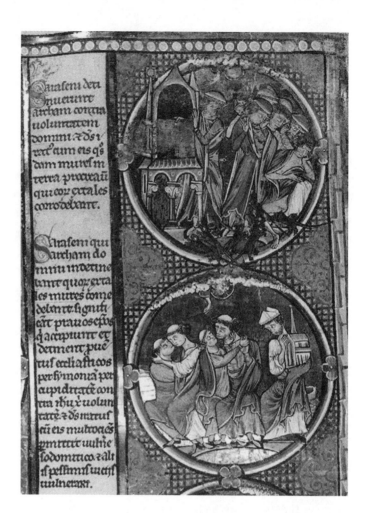

Figure 18. 1 Kings 5:6; wicked prelates afflicted with sodomy. Miniatures in *Bible moralisée*. Paris, circa 1220–25. Vienna, Österreichische National-bibliothek, cod. 1179, fol. 87v (detail, upper right). Photo: ÖNB Vienna.

the wife as the heretic's perversion (*heretica pravita*), the secret parts as weak Catholics (*catholici infirmi*), and the hand as that which must be cut off from the church through excommunication. But in the accompanying miniature it is the coupling of an older and younger cleric that stands in for all this heretical depravity.[76]

If age differentials are emphasized visually through contrasts between the size and sometimes facial hair of the sinners, one scene featured in the Toledo and Oxford-Paris-London Bibles also draws attention to the sexual exploitation of younger by older males via the text itself. The scene in question illustrates Lamentations 5:13, in which the narrator, Jeremiah, laments the mistreatment of young men and children: the Vulgate describes how, abusing young men (*adulescentibus*), the boys (*pueri*) "fell under the wood."[77] This text is reproduced very closely on the relevant folio of the second volume of the Toledo Bible. In fact, the Latin of this verse, with its reference to the abuse of "adulescentes" (young men), appears to be a misreading of the Hebrew and Greek versions

of Jeremiah's words, which probably refer to forced labor rather than sexual abuse.[78] However, as we saw at the beginning of this chapter, this same passage was linked by Peter the Chanter, in his chapter on sodomitic vice, to the sins of Sodom, a connection made more pertinent still by the fact that Jeremiah had referred earlier, in Lamentations 4.6, to his people's chastisement for sin as being greater than the punishment of the sin of Sodom (*peccato Sodomorum*). The corresponding image in the Toledo Bible follows the Chanter in identifying age-differentiated desire with sodomitic vice: a king is shown embracing and fondling the chin of an unbearded male, while another bearded male does the same thing to another "adolescent." This scene is also reprised in one of the later Bibles, Paris, Bibliothèque nationale de France, MS français 167 (fig. 21).[79]

These depictions in the later *Bibles moralisées* apparently represent a mode of sodomy with distinct, identifying features. Depicted as taking place between two males of unequal age and status, it is not exactly *utterly* confused. Another way in which homoeroticism is rendered coherent for the viewer, at least temporarily, is via concepts of religious difference. We have already seen how in the Vienna 2554 fall moralization (fig. 3), one of the partners in the male couple is a

Figure 19. Ephesians 5:3. Miniature in *Bible moralisée*. Paris, circa 1230. London, British Library, Harley MS 1527, fol. 107r (detail, upper right). © British Library Board.

Figure 20. Deuteronomy 25:11–12; heretic's perversion. Miniatures in *Bible moralisée*. Paris, circa 1230. Oxford, Bodleian Library, MS Bodley 270b, fol. 90r (detail, upper left). Photo: The Bodleian Libraries, the University of Oxford.

cleric while the other wears a hat that, in other miniatures in the manuscript, is associated with heretics and Jews. Sara Lipton has convincingly argued for the existence of a strong anti-Jewish subtext in the Vienna Bibles, with representations of sodomy occasionally contributing to this process of visual stereotyping.[80] In the Toledo and Oxford-Paris-London Bibles, moreover, homoeroticism is identified explicitly as a symptom of heresy, as in the medallion in Bodley 270b (fig. 22) illustrating the passage in Judges 20 when the Benjaminites flee

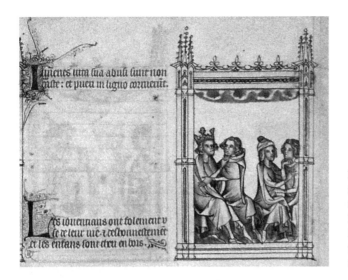

Figure 21. Lamentations 5:13. Miniature in *Bible moralisée*. Paris, mid-fourteenth century. Paris, Bibliothèque nationale de France, MS français 167, fol. 203v (detail, upper right). Photo: Bibliothèque nationale de France.

into the wilderness. The miniature depicts various embracing couples, including a male-male pair left of center, whom the text itself refers to as "Bulgars and Albigensians [*bugaros et albigenses*], who . . . adore and believe in the devil."[81] Heresy and sodomy had been associated with one another in medieval theology since at least the eleventh century, based on the assumption that religious and sexual modes of nonconformity were comparably sacrilegious; reinforcing the link was the accusation that certain heretical sects sanctioned hedonistic sexual activity. The theology of the Cathars, or "Albigensians" as they were known, was believed to originate with the "Bulgars" of Bulgaria; by the thirteenth century the French words *bougre* and *erite* could be used interchangeably to refer to heretics and sodomites.[82] Scenes such as this, which link heretical activity with illicit eroticism, translate this climate of overlapping categories into a visual register.

Like these images in the later *Bibles moralisées*, which appropriate homoerotic activity as a signifier of sacrilegious behavior, the Vienna Bibles' commentaries on the first book of Kings identify erotic relations between males as a manifestation of false or corrupted religion: *sodomitirie* is associated specifically with clerics, and compared with "Saracen" genital sufferings. The visual analogy between practitioners of *sodomitirie* and "Saracens" draws on a commonplace in Christian crusading polemic linking Saracens, Turks, and other Muslim-identified groups with sodomitical practices. In his history of the First Crusade (ca. 1106-9), Guibert of Nogent cites a letter from Robert I, Count of Flanders (1071-93), which describes how Islamic "Turks" not only turned Christians into prostitutes and raped women (which at least might be excused as being "in accord with nature"), but even went as far as sodomizing men, a mode of

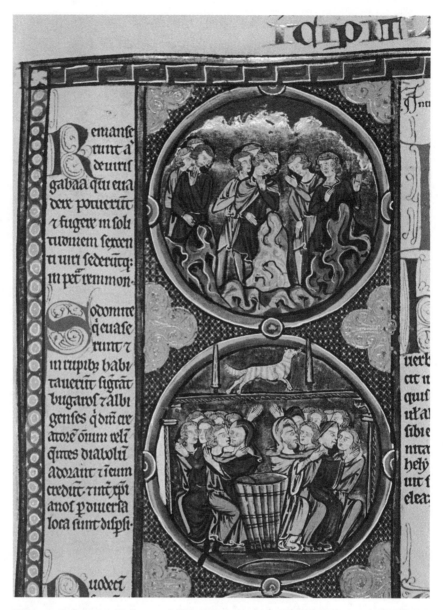

Figure 22. Judges 20:47; Bulgars and Albigensians worshiping the devil. Miniatures in *Bible moralisée*. Paris, circa 1230. Oxford, Bodleian Library, MS Bodley 270b, fol. 123v (detail, upper left). Photo: The Bodleian Libraries, the University of Oxford.

coupling that, the letter writer submits, is unheard of even among animals.[83] As with Peter the Chanter's allusion to pharaoh and to the Assyrian ruler Sardanapalus in his attack on *uicio sodomitico*, sodomitic practices are also associated here with a foreign "other." The Vienna 2554 miniatures echo these associations by turning biblical Philistines into Saracens and further comparing them to clerical abusers. Again the vision of sodomy generated here, multilayered as

it is, does not seem to be characterized by total confusion. We are afforded a glimpse of the kinds of social circumstances—encounters between churchmen and their younger charges, for example—that potentially give rise to sodomitic encounters, at least in the imagination of the Bibles' makers. Sodomy is linked, by a series of associations, with idolatry, religious difference, and possibly even ethnicity, as well as with clerical corruption. The sequence of images also lays out other identifying features in its definition of sodomitic behavior: sodomitry is age-structured, defined as taking place between adult males and boys; it is linked, via the textual caption and the corresponding biblical scenes, with genital contact, specifically the "loins"; and it is a punishment from God, eating the sinner up from the inside.

How we get from a plague of rodents and an ill-defined pestilence to a situation in which rats, metaphorically, convey the genital afflictions of Saracens is symptomatic of the ways in which translation in the *Bibles moralisées* potentially displaces its authoritative "source" through acts of intermedial, as well as interlingual, transfer. The procedure works to smother over the gaps and insufficiencies in the Bible itself, which is not, of course, an "it" at all but a complex and densely woven sequence of texts, variously organized, that change over time, from one religious tradition to another, and shift incessantly between languages, cultures, media, and forms. And the Genesis story of the destruction of Sodom itself is hardly conducive to stable interpretation. It is precisely from these untranslatable excesses that biblical translation acquires much of its energy, ideological force, and afterlife.

Erich Auerbach makes some pertinent remarks in this context. Discussing Augustine's biblical commentaries in *De civitate Dei* (City of God), he notes how, in the exegete's work,

> there is visible a constant endeavour to fill in the lacunae of the Biblical account, to supplement it by other passages from the Bible and by original considerations to establish a continuous connection of events. And in general to give the highest measure of rational plausibility to an intrinsically irrational interpretation.[84]

Jager, quoting these remarks in the introduction to his study of medieval treatments of Genesis 3, observes that biblical commentary in the Middle Ages is similarly never without a "quantum of irrationality," however logical it may seem in tone or method.[85] Jager's and Auerbach's comments are equally applicable to translations of the Sodom story in Genesis 19 and its analogues. In such phenomena as the translation of Philistines into Saracens, Benjaminites into Sodomites, rats into hemorrhoids, and all the other semantic maneuvers undertaken by the makers of the *Bibles moralisées*, it is possible to discover those

same qualities of supplementation, illogicality, and lacunae-filling effort that also characterize Augustinian exegesis. Just as the ambiguities at the heart of Genesis 19 have provided exegetes with no end of interpretive possibility (at least if that medieval coinage *sodomia* is anything to go by), attempts to decipher the cryptic account of the plague of the Philistines in the biblical book of Kings have generated plenty of hot air from the Middle Ages to the present. It is not possible to *know* whether the Bible text is referring to a precise disease or bodily affliction in 1 Kings 5:9; similarly it is not possible to know what the Sodomites in Genesis 19:5 want to "know" when they decide to pay Lot's angelic guests a visit. The Philistines' plagues are didactic details, rather than historical events, incorporated to underwrite a message about God's awesome rage. Duplicating this moralizing ethos, albeit within a medieval register, the *Bibles moralisées* thus have no difficulty radically playing with the biblical story. It is precisely the untranslatable qualities of the Philistine's afflictions that provide the point of departure for the lessons that these volumes impart, veiling over the obscure surplus of meaning in order to produce a newly authoritative but discontinuous *translatio*.

For Your Eyes Only: Reception, Audience, Impact

In conclusion, we need to ask why sodomy entered the field of vision at this particular juncture. What was it about the *Bibles moralisées* that made them such a fertile ground for representations of behavior defined, in some instances, as "sodomitic"? How, in turn, were these representations received by their audiences and patrons? What influence did these images have on the books' owners, and what do they say about medieval understandings of sodomy more generally?

The first thing to note is the significance of the location in which the *Bibles moralisées* were assembled: all but one of the Bibles was devised in Paris. There are hints that at least some contemporaries thought Paris was a location where sodomy was especially prevalent. A series of anonymous verses written in a twelfth- or thirteenth-century hand identify the inhabitants of the city as being especially prone to the practice: Paris, along with other French cities such as Chartres, Sens, and Orléans, is accused of having "reveled in the vice of Sodom."[86] Although we cannot know whether the craftspeople who made the books were familiar with such accusations, the imagery they produced has a distinct urban flavor; the makers of the *Bibles moralisées* translate their biblical "source" into a specifically Parisian moralizing register. Agricultural and rural scenes are missing from the moralization miniatures; contemporary society is predominantly a world of taverns, dining chambers, brothels, counting houses, churches, and courts.[87]

In itself this would not have provided an impetus for condemning sodom-itic practices visually. Although by the fifteenth century, in certain regions of Europe such as Italy, southern Germany, and the Low Countries, sodomy was being policed by urban authorities with increased vigor, John Boswell's hypoth-esis that the reemergence of a "distinct gay subculture" in the twelfth and thir-teenth centuries in certain regions was coterminous with urban renewal has been treated with skepticism by reviewers.[88] What the Parisian setting did pro-vide was an intellectual and moral environment in which an antisodomy rhet-oric might develop. The makers of the *Bibles moralisées* were working within a climate of intense debate about sodomy and its signs in thirteenth-century France. On the one hand, they followed the line of thinking dictated by peniten-tial guidance literature, which imagined sodomy as a variety of bodily disorder to which any fallen human is potentially susceptible. This universalizing ten-dency worked to cloak the category with an aura of confusion: the moment of unveiling, translating the sin of Sodom from a place of obscurity into a place of sense, simultaneously pushes other possible interpretations—such as explic-itly sexualized ones—into the background. On the other hand, the manuscripts also echo the particularizing attitude betrayed by scholars such as Peter the Chanter, which associates sodomy with specific characteristics such as homo-eroticism, age difference, gender transgression, and sacrilegious behavior. This endows the behaviors in question with a degree of visual coherence, at least with respect to individual depictions in isolation. Sex acts are still depicted somewhat elliptically of course. Genital contact itself is alluded to only very oc-casionally, in the earliest, Vienna manuscripts, via linguistic wordplay or visual analogy—a coyness corresponding to the recommendations of confessors such as Robert of Flamborough regarding the management of sins against nature. Nonetheless audiences are afforded a glimpse of the kinds of people involved (mainly males, often clerics, often heretics or Jews), the kinds of partners they pursue (younger or older, "active" or "passive," of the same sex), and the kinds of activities at issue (kissing, embracing, fleshly exposure, sexual violence). Sodomy is not so confused that it cannot be seen via these other signs.

The Parisian provenance does not necessarily explain why there are few other manuscripts from the period that condemn homoeroticism visually in this way. Why are the *Bibles moralisées* the only books surviving from this pe-riod to bring such behavior into view regularly, and in a range of contexts? To answer this question we need to consider the audience for which the books were originally commissioned. The royal setting for the Bibles has already been noted. The craftsmen who made the books were likely working in a royal orbit (perhaps even the royal palace itself) rather than monastic scriptoria; the only hands likely to have touched the pages of the *Bibles moralisées* in the decades after they had been completed were royal patrons and their families,

possibly under the instruction of spiritual advisers. The Toledo and Oxford-Paris-London manuscripts did eventually leave Paris a few decades after their completion but remained in royal circles: the Toledo set came into the hands of Alfonso X of Castile, Blanche of Castile's great-nephew, on the occasion of the marriage of Alfonso's eldest son to Louis IX's daughter Blanche of France in 1269; the Oxford-Paris-London volumes probably reached England around 1255 or later, possibly as a gift from Marguerite of Provence to her sister Eleanor and her husband Henry II.[89] The consequences of this containment within a royal setting are twofold. First, the intended audiences of the books were severely restricted; second, the individuals for whom the books were commissioned were educated and had access to supervision in the guise of royal chaplains and confessors. Even when there are documented references to encounters with the Bibles in later sources, as is the case with Toledo MS 1, the descriptions are superficial, suggesting that nonroyal observers did not have the opportunity to study the manuscripts closely. Indeed some volumes show signs of having been virtually untouched, suggesting that they were barely "read" at all; publicly they probably functioned more as symbols of the power, interest, and prestige of their owners.[90] Until the publication of facsimile editions in the twentieth and twenty-first centuries (a project that is still ongoing), only a very select group of individuals had the opportunity to see the *Bibles moralisées* at all.[91]

Although few medieval manuscripts could really be described as "public" documents, the fact that these books were designed with such a restricted audience in mind is potentially significant, since it may explain why images of dangerous corporeal practices such as homoeroticism feature uniquely among their pages. If, as Lowden believes, the *Bibles moralisées* were designed to function as luxury pedagogic devices, providing exempla for discussion between a member of the royal family and his or her chaplain,[92] then there was presumably less risk that the material contained within would get into the wrong hands. Of course, kings themselves were not immune from accusations of sodomy: scenes in several of the *Bibles moralisées* implicate crowned figures in homoerotic couplings.[93] While the idea that the moralized Bible was designed to operate systematically as *speculum principum* or "mirror of princes" may be far-fetched, collectively the critiques of contemporary society contained in the moralization scenes would have provided much food for thought for an aspiring royal looking to develop his or her conduct as a ruler.[94] A focus on issues of audience and patronage may also help explain why some volumes place emphasis on particular manifestations of the sin against nature: the early thirteenth-century Bibles pay more attention to female homoeroticism than the later examples, which may be connected to the fact that a female patron, Blanche of Castile, was probably the intended recipient of the first Vienna volume, as well as having a hand in the next three in the series.

Figure 23. Psalm 52. Illuminated initial in Cuerden Psalter. Oxford, circa 1270. New York, Pierpont Morgan Library, MS M.756, fol. 79r (detail). Purchased in 1929. Photo: The Pierpont Morgan Library, New York.

Of course the audiences for the *Bibles moralisées* also included the makers themselves, but we can only guess as to their own impression of the books. One thing is sure: because of the restrictions on viewing and the narrowly circumscribed audience, the *Bibles moralisées* had little discernible "influence" on medieval art as a whole.[95] Very occasionally other manuscripts containing biblical texts are illustrated with analogous scenes. For instance the Cuerden Psalter, made in England a few decades after the Vienna Bibles, includes an initial to Psalm 52 illustrating, and possibly acting as an aide-mémoire, to the first three verses (fig. 23).[96] Verse 2, "They are corrupted, and become abominable in iniquities: there is none that doth good," is represented as a male couple, lying together one behind the other. But although the unusual scene of a same-sex couple lying together recalls the fall commentary miniatures in the *Bibles moralisées*, here the positioning may also be alluding to anal or femoral intercourse from behind. Another marginal scene in a fourteenth-century book of hours, positioned at the bottom of a page containing the end of Psalm 120 and beginning of Psalm 121, shows a tonsured male playing a musical instrument while another, hunchbacked male crouches down and reaches beneath his partner's semitransparent garment as if to fondle his genitals (fig. 24). To the left, within and emerging from the initial to Psalm 121, the heads of a dog and a man watch events unfold.[97] In contrast to the Cuerden Psalter, however, there seems to be

Figure 24. Male reaching beneath clothes of musician. Marginal scene in Book of Hours. French Flanders, possibly Cambrai, first quarter of fourteenth century. Baltimore, The Walters Art Museum, MS W.88, fol. 80r. Photo: The Walters Art Museum, Baltimore.

no obvious connection between the text of the psalms and the marginal image. Moreover the conventions for depicting homoerotic activity are very different from those found in the *Bibles moralisées*, which contain no equivalent scenes of genital touching.

Elsewhere in this book we will encounter several images in which a visual language is deployed that is comparable, at least in some respects, to the *Bibles moralisées'* depictions of "Sodomites," sins against nature, and disorderly desire. In illustrated manuscripts moralizing Ovid's *Metamorphoses*, reference is occasionally made to homoeroticism (even between women) and to age-differentiated desire between males: here kissing and embracing are the main erotic signifiers, as will be demonstrated in chapters 2 to 4. As discussed in chapter 5, sinners being punished for sodomitic crimes in hell or purgatory are likewise depicted embracing improperly in a very small number of images. But there is no discernible or direct connection between these other scenes and the *Bibles moralisées*; no other class of medieval manuscript brings "sodomitic" behavior into view in such a varied manner.

What, though, of the social and political impact of the books? While we cannot know for certain how the Bibles were taken up by their individual royal owners, two events are worth noting in this context. First, it was in the reign of Alfonso X, the eventual owner of the Toledo Bible, that death was first prescribed as a penalty for sodomy in Castile: Alfonso's *Siete partidas* (Seven-Part Code), completed around 1265 under the king's personal direction, refers specifically to the biblical narrative of the destruction of Sodom as a justification for the severity of the penalty, defining sodomy as "a sin of which men are guilty by having intercourse with one another contrary to nature."[98] Second, Louis IX's reign saw the collation of a series of customary laws called the *Etablissements de Saint Louis*, written by an unknown author but claiming to have been instigated by the king himself. Book 2 of the *Etablissements* comprises a customary compilation from the Anjou-Touraine region of France, southwest of Paris, and includes among its rulings the penalty of burning and confiscation of property for those convicted of "bougrerie." Adding that this is also how "herite" should be dealt with, the implication is that two distinct categories are being targeted.[99] Given that the *Bibles moralisées* often conflate homoeroticism with heresy, it is plausible that the author of the *Etablissements* had in mind sodomy as well as heterodoxy in the reference to "bougrerie."[100] It would be pushing the point too far to suggest that the *Bibles moralisées* actually gave rise to such legislation. After all, Alfonso's *Siete partidas* probably predates his reception of the Toledo Bible, and Louis IX may have had little direct involvement with the *Etablissements* with which his name was linked. But these connections are significant all the same. Just as the thirteenth century bore witness to some critical moments in the history of Jews and heretics, it gave rise to some particularly violent

denunciations of sodomy in secular settings. The *Bibles moralisées* add one more voice to this chorus of condemnations.

This chapter has shown how a team of people—scribes, illuminators, patrons, advisers—working within a very specific environment negotiated a fine line between rendering sodomy visually coherent and keeping viewers in the dark. This process was not simply a mode of transfer, a *translatio* of biblical stories such as the destruction of Sodom, into a visual and verbal language that thirteenth-century viewers could understand; it also had the capacity to transform the Bible by projecting later conceptions of Sodomitic behavior into a biblical past. The *Bibles moralisées* cleared a space in which images could displace texts as an authoritative medium; the principal source for information about sodomy is not the Bible itself (insofar as the scriptural canon could ever be characterized as a singular "it") so much as the contemporary, moralizing discourse through which that text is read, imagined, and ultimately visualized. The next chapter similarly sets its sights on ideas of translation as transformation. The moralized Ovids, like the moralized Bibles, render their so-called source unstable by displacing it as the locus of authority and meaning. Again it is a biblical narrative—specifically the narrative of the virgin birth and Christ's incarnation—that provides the overriding moral compass. In what follows, moreover, we will confront another issue that has been implicit in my analysis of the *Bibles moralisées*: "sexuality," insofar as it is at issue in the manuscripts, can be approached only obliquely, via other categories; even the "eroticism" of homoeroticism represents a somewhat hazy mode of physicality, based on gestures such as kissing and embracing that also have perfectly legitimate associations in the context of medieval friendship discourse. Gender nonconformity pushes at the edges of sodomy's definition in the *Bibles moralisées*, but it provides the dominant interpretive framework only in a handful of cases; more significant than gender and sexuality are other dimensions such as religion, age, and material excess. In contrast, the moralized Ovids bring questions about the lines dividing what we call "gender" and "sexuality" firmly to the fore.

2

Transgender Time

It is only rarely that scholars of the Middle Ages deploy transgender as a category of analysis, and in this chapter I want to ask why. After all, medieval European clerical culture appears to have had somewhat clearer ideas about gender transformation than it did about the practices that today cluster under the heading of "sexuality." Sodomy itself could be a profoundly gendered concept, as William Burgwinkle, Ruth Mazo Karras, Karma Lochrie, and others have demonstrated.[1] What most worried the churchmen who composed diatribes against sodomy was not the sex acts with which it was sometimes associated; they tended to say relatively little about these, circumscribing their comments with qualifications to the effect that the acts in question were "unmentionable" or "unspeakable." What really turned their stomachs was the insurrection of gender that took place when men assumed what was perceived to be a "passive" role sexually and women an "active" one. Discussions of sodomy by the likes of Alan of Lille, Peter the Chanter, and Peter Damian are a case in point: particular attention is paid to the gendered ramifications of sex acts between males. In *De planctu Naturae*, Nature complains that mankind inverts the rules of Venus by introducing "in constructione generum barbarizans" (8.55–56) (barbarisms in its construction of gender); elsewhere in the text this defect of "inverted order" is linked to hermaphrodites (1.18), people of "neuter" gender (10.46), the mythical Narcissus (8.76–78), and the hammering of an anvil "que semina nulla

monetat" (1.27) (which coins no seeds). Peter the Chanter reminds readers of his *Verbum adbreviatum* that the church allows *homini androgeos* (androgynous people) to have sexual relations as long as they consistently behave as male or female during sex; if they cannot comply, the only solution is to remain celibate. Conversely the problem with sodomites is that they switch from one gender to another during sexual performance: practitioners of sodomitic vice are implicated in *alternitatis*—inversions or role reversals—which are dangerously unstable.[2] Peter Damian calls the sodomite a *homo effeminate*, while Odo of Cluny castigates the inhabitants of Sodom for experiencing intercourse like a woman (*Mascula femineum patitur caro . . . usum*) and becoming depraved softies (*mollem*).[3]

Similarly when, in the decades after the Norman Conquest, clerics wanted to criticize the new courtly fashions being worn in certain regions of France, they sometimes associated gender nonconformity with sodomy. The Norman monk Orderic Vitalis protested in his *Ecclesiastical History* against the introduction of a newfangled shoe, with pointy toes, by Fulk le Rechin, count of Anjou (d. 1109), whose bunions warranted the strange-shaped footwear. A man called Robert at the court of William II of England, William the Conqueror's successor, introduced an additional novelty to the design: the long "pulley-toes," first developed to hide Fulk's deformity, were stuffed and bent into the shape of a ram's horn, for which Robert earned the nickname *Cornardus* (literally "horny"). Soon this fashion for curly-toed shoes at William II's court spread like wildfire among the nobility, and effeminates (*effeminati*) began setting the trend in many parts of the world:

> foul catamites [*foedi catamitae*], doomed to eternal fire, unrestrainedly pursued their revels, and shamelessly gave themselves up to sodomitic filth [*sodomiti-cisque spurciciis*]. They rejected the traditions of great and illustrious men, ridiculed the counsels of priests and persisted in their barbarous way of life [*morem . . . vita*] and style of dress. They parted their hair from the crown of the head to the forehead, grew long and luxurious locks like women, and loved to deck themselves in long, over-tight shirts and tunics.[4]

Sex acts are not explicitly at issue in such denouncements. In his attack on the court's fashions, Orderic presents sodomitic practices as a symptom of the luxury and materialism he associates with courtly culture more generally, a foreign import signaling, in the minds of himself and other chroniclers, a direct affront to monastic ideals emphasizing austerity. Effeminacy, represented as a mode of aesthetic as well as social transgression, is characterized as a sodomitic "way of life," yet this is not linked definitively with homoerotic pursuits. Indeed the discussion of Fulk's pointy shoes makes clear that one of the reasons

courtiers adopted this fashion was so that they could "seek the favors of women with every kind of lewdness."[5]

Another document from the same period paints a comparably gendered picture, but this time associates male-male intercourse explicitly with motifs of gender inversion, which are conceived as a kind of bodily metamorphosis. Hugh of Flavigny, a French abbot writing at the end of the eleventh century, records some of the "marvels" preceding William II's death, including the case of one Peter, a royal chaplain, who confesses to being impregnated by another man (*masculum a masculis impregnatum*), after which he subsequently conceives a monstrous child. This tale of priestly parturition encodes the belief that a receptive male acts so like a woman that he becomes pregnant, but it also renders the idea of male femininity impossible: dying of the abominable growth, the chaplain is refused Christian burial and laid to rest beyond the cemetery walls like an ass.[6]

When we switch from clerical hysteria to legal practice, there are indications that homoerotic practices could also be viewed as resulting in cross-gendered performance. The well-known testimony of one John Rykener, "calling himself Eleanor," who, dressed in women's clothing, was hauled up before the authorities in fourteenth-century London for engaging in the unmentionable vice (*vitium nephandum*) with a man for money, records how he subsequently confessed to having sexual relations with a large number of people; whenever the partners were male, Rykener is said to have performed "as a woman."[7] Reports such as this in England are extremely rare: surviving church court records from fifteenth-century London document only two other cases that could conceivably come under the heading of sodomy, one concerning a man accused of being a "woman" who was accustomed to "grab" priests between the legs.[8] In fifteenth-century Florence, where considerably more documentation survives, only the receptive participants in male penetrative acts were associated with what were considered to be feminine activities and attitudes; "active" sodomites were thought to conform to the virile models of masculinity dominant in Florentine society at the time.[9] Although relations between women failed to attract the attention of authorities in Florence, when female homoeroticism intermittently became legible in courtrooms elsewhere in Europe, it often did so insofar as one of the participants had cross-dressed or used a dildo and was thus seen as having appropriated masculine prerogatives.[10]

Of course, as explored in the introduction, there is a risk in overstating the correlations between gender presentation and sodomitic behavior or sin identity. The example of Jerome's cross-dressing demonstrates how male performances of femininity could also be interpreted in very different ways, notably as a marker of the consequences of desire directed at women. Likewise, female masculinity also had the capacity to produce a wider set of meanings,

at least in theory. Lochrie has coined the term "heterosyncrasies" as a means of bypassing the presumption of heterosexual normativity in modern scholarship as well as accounting for medieval expressions of desire that fail to live up to the period's procreative ideals.[11] Prominent in this mapping of medieval heterosyncrasies are literary representations of masculine women, such as the mythic figure of the Amazon and Chaucer's fictional Wife of Bath, whose aberrant sexual practices fail to conform to dominant cultural ideals of gender. Manifestations of female self-governance and sovereignty get filtered through a sodomitic grid by Lochrie as a means of highlighting alternatives to a heteronormative framework: the Wife of Bath becomes, for her, "a kind of sodomite," to the extent that she turns female sexual passivity into active sexual agency; to put it more poetically (following Alan of Lille), the Wife effectively converts "anvils into hammers."[12] But a specifically "medieval" vocabulary is not always sufficient to capture the gender configurations to which these representations give rise; sometimes a contemporary queer lexicon may help to differentiate various modes of masculinized womanhood. Middle English incarnations of the figure of the Amazon, for instance, fail to conform to the fantasies of a heteronormative culture. Initiating sexual encounters with men for the purpose of producing female children, while finding her principal fulfillment in a female homosocial community, the Amazon is, in Lochrie's words, "more stone butch than she is either desexualized saint or heterosexual woman."[13]

Taking my cue from this potentially enabling (and knowingly anachronistic) multiplication of terminology, here I would like to mobilize transgender as a framework for interpreting certain medieval responses to the idea of unnatural sex. What might the term's deployment as an interpretive prism add to or take away from analyses of premodern sources? My argument is that thinking through the lens of transgender—and related categories such as female masculinity, butch, and femme—brings into sharper focus the significance of gender crossing and transformation in medieval visualizations of behavior deemed "sodomitic." One advantage of transgender is that, at least when it is deployed adjectivally, it covers a broad range of cross-gendered behaviors and experience, on a spectrum from androgynous dress and gesture to bodily transformation; according to Judith Halberstam "all kinds of people who challenge, deliberately or accidentally, gender normativity" can potentially be included under the heading.[14] In this sense it is arguably preferable to other terms such as "transvestite," which have also been applied quite frequently in medieval settings (for instance, with reference to cross-dressing saints and romance heroes).[15] Another advantage is that transgender transcends some of the other dichotomies, such as homosexuality/heterosexuality, through which sexual desire tends to be articulated in the present: it refers to modes of identification where sexual object choice is not the predominant factor.

At the same time, even as the postmodern category of transgender has the potential to be useful as a way of understanding medieval manifestations of cross-identification, it is important to appreciate the specific meanings that transgender carries in contemporary settings. As a term that has developed, for the most part, within trans communities in certain metropolitan locations especially since the 1990s, transgender is necessarily provisional in its application, even in those contexts where it has acquired a certain amount of social and institutional currency. Transgender's progressive institutionalization in certain geographic locations (especially the United States) has raised it to the status of an interpretive prism that is in some ways analogous to, if fundamentally distinct from, homosexuality.[16] The inception of transgender studies as a separate field of academic inquiry has also given a new impetus to the writing of particular transgender histories.[17] But the term's relative utility and sociopolitical appeal hinge on the ways in which it gets taken up in quotidian experience; there is a fair chance that, say, twenty years down the line, "transgender" itself may sound antiquated or old hat. Certainly, insofar as transgender gives rise to particular modes of identity politics (as in the currently fashionable LGBT or LGBTQ acronyms), it may be inadequate to the task of capturing the restrictions placed on sex and gender transformation in premodern cultures.[18] In Halberstam's definition, transgender also accounts for the cross-identification experiences of people who, as she puts it, "pick and choose among the options of body modification, social presentation, and legal recognition available to them."[19] But such voluntarist frameworks meet a challenge in the Middle Ages, when the possibilities of radically changing sex and gender were technically far more limited, both in terms of available medical technologies and in light of the relative paucity of social situations in which gender transformation could realistically be fostered and sustained. As such, there were not groupings precisely equivalent to modern trans communities in the Middle Ages. Sexual subcultures explicitly organized around gender crossing, such as the mollies of eighteenth-century London, do not come into view in medieval sources; surviving legal records tend to focus on the behaviors of particular individuals.[20]

One way of emphasizing the ongoing provisionality of transgender—its status as a discursive effect or rhetorical device, or even as a deliberate misnomer— would be to place it in quotation marks or italics, akin to the way Traub italicizes *lesbian* in her book *The Renaissance of Lesbianism in Early Modern England* as a means of highlighting its deployment as a "strategic anachronism and ongoing question."[21] Just as lesbian, enmeshed within the epistemology of the closet and ideas of a sexual minority, risks fulfilling the role of a confining category of erotic identity, transgender potentially carries with it its own normalizing charge.[22] However, the alleged anachronism of finding transgender in the Middle Ages can also draw attention to another issue I wish to address in this

chapter, the role played by temporal disjunction in contemporary transgender lives. The adoption of circumlocutions such as transgender-like, akin to Judith Bennett's influential "lesbian-like" formulation, would be another way of indicating transgender's inadequacy and contingency as a historical category.[23] Yet this runs the risk of implying that premodern versions of transgender simply represent half-baked or "early" precursors to a phenomenon that finds its fullest accomplishment in modernity. If, in what follows, I have resisted the tendency to bracket this and other categories off typographically, it is partly because the sense of temporal disjuncture evoked by transgender in medieval contexts productively focuses attention on the politics of time that inflects the category.

The first part of this chapter engages with the idea of transgender time as it has been conceived within recent historiography. This offers a vantage point from which to assess the temporal politics of the division between gender and sexuality in modern cultures. In the section that follows, I consider how theological definitions of sodomy, conceived as a strongly gendered category of perversion, are embedded in the sequential paradigms discussed in chapter 1. Hildegard of Bingen's analysis of cross-gendered performance, which is closely tied to condemnations of improper sexual activity, makes it clear that the relative visibility of experiences within the sex-gender-sexuality nexus is itself governed by a politics of time, and of translation. Turning, in the third and fourth sections, to the Ovidian myth of Iphis and Ianthe, a sex change narrative mediated in the Middle Ages via moralized retellings of Ovid's *Metamorphoses*, I demonstrate how a contemporary, periodizing rhetoric potentially resonates—sometimes problematically—with premodern efforts both to confront and to suppress the story's homoerotic implications. Finally, in the concluding sections, I explore other, alternative responses to Ovid. In one retelling of the Iphis narrative, by the fifteenth-century poet and intellectual Christine de Pizan (1363–ca. 1430), the transgender implications are highlighted—and indeed become a model for the author him/herself—seemingly at the expense of homoeroticism. Another, by the twenty-first-century novelist Ali Smith, renders homoerotic possibilities intelligible, even as the gender trouble that sets those possibilities in motion remains in play. This recent retelling of the Iphis story, Smith's 2007 novel *Girl Meets Boy*, brings to light configurations also envisioned by some of the medieval artists and writers introduced earlier in the chapter. Transgender potentially challenges the vocabularies commonly used by historians of sexuality to discuss medieval sex transformation narratives (as, for example, manifestations of early efforts to come to terms with, and render visible, "same-sex" or homoerotic bonds). But transgender also produces its own conceptual blind spots, as the critical fate of the feminine-performing

protagonist Ianthe shows. In other words transgender can be a potentially enabling, even transformative category when applied to medieval texts; but as with lesbian, queer, and other categories of identity and desire, the vision it affords is necessarily partial and provisional.

How to Do the History of Transgender

In his 2002 polemic *How to Do the History of Homosexuality*, David Halperin produces a genealogy of homosexuality that treats gender transitivity as a largely superseded model. Halperin's analysis of the ancient Greek category of *kinaidos*, defined as a gender-deviant male, characterizes it as a "pre-homosexual" type, which only partially overlaps with modern categories of deviance, if at all; defined not by his "sexuality" but by a spectacular betrayal of his masculine gender identity, one inscribed "all over his face and body," the ancient *kinaidos* is thoroughly "[u]nlike the modern homosexual."[24] In an earlier incarnation of this argument, his "Forgetting Foucault" essay, the analysis even went so far as to imply that such gender-deviant males are the dodos of premodern sexuality. *Kinaidos* represents, Halperin writes, "an extinct category of social, sexual, and gender deviance," obsolete and alien for the vast majority of his readers.[25] Modernity, in this analysis, is cast as conceptually coherent—the temporal zone in which homosexual identity becomes thinkable—and premodernity is the time of transgender. This inversion model is, in turn, differentiated from two other means of classifying male-male relations in premodern settings, pederasty and friendship, both of which traditionally do not compromise the masculinity of their subjects. The term "pederasty" is often applied somewhat loosely to any sexual relationship between older and younger males. Strictly speaking, however, it defined in ancient Greek tradition a publicly acknowledged relationship in which an adult male citizen educated and formed a younger freeborn male in the context of an erotic bond. Within this pattern boys may be sexually penetrated by their older male partners, whose own virility is never questioned; but the younger males' passivity, temporary and "unengaged," does not entail effeminacy as such. The tradition of male friendship provided an outlet for socially empowered men to express sentiments of love for one another, again without affecting perceptions of either participant's gender.

Here is what Halperin says specifically on this point:

> If anything, paederasty and friendship are both traditionally *masculinizing*, insofar as they express the male subject's virility and imply a thoroughgoing rejection of everything that is feminine. Both can therefore be seen as consolidating male gender identity (although not, of course, in every instance). As

such, they belong to a different conceptual, moral, and social universe from what the Greeks called *kinaidia*, the Romans *mollitia*, and the nineteenth-century sexologists "contrary sexual feeling" or "sexual inversion." All these terms refer to the male "inversion" or reversal of masculine gender identity, a wholesale surrender of masculinity in favor of femininity, a transgendered condition expressed in everything from personal comportment and style to physical appearance, manner of feeling, sexual attraction to "normal" men, and preference for a receptive or "passive" role in sexual intercourse with such men.

This "transgendered" model Halperin contrasts with what he calls "the modern homosexual." While Halperin insists that "what we now call homosexuality" incorporates elements of premodern patterns (notably friendship's focus on passionate, mutual love), ultimately it is part of a "new system of sexuality, which . . . assigns to each individual a sexual orientation and a sexual identity"; "under the aegis of homosexuality, the significance of gender and of gender roles for categorizing sexual acts and sexual actors fades."[26] For sure, says Halperin, this transformation has not been "total or absolute"; despite the dominance of the hetero/homo binary, masculine women and effeminate men are still considered "somehow *more homosexual* than other, less flamboyantly deviant, persons" who desire same-sex partners.[27] This represents, to his mind, the intransigence of certain earlier, "pre-homosexual" categories in the face of "our" modern sexual identities.

These arguments are immensely valuable in many ways. The idea that medieval friendship discourse might differ structurally from pederasty; that each might be distinct in turn from gender-variant behavior, morphology, or selfhood; that sodomy potentially encompasses or lingers at the edges of all these different ways of classifying same-sex relations—such a multiplication of what might go under the sign of sodomy was a crucial component in my analysis of the *Bibles moralisées* in the previous chapter. Yet there is also something potentially troubling about the language in which these arguments are couched. First, I am not certain that we know, or can ever fully apprehend, what "our" categories of sexuality and sexual subjectivity mean in the present. For all the cultural dominance of the heterosexual-homosexual binary, there is a fair amount of imprecision in the application of these terms, both globally and locally. Taxonomic projects aimed at drawing the lines between gender and sexuality, or among a series of "pre-homosexual" types, have a certain historicizing value; but they render invisible the ways in which these categories might overlap or blur in practice. Further, by inscribing the divisions too neatly, they cannot capture how some of these supposedly superseded frameworks actually

persist or assume different guises: the insistence that, with the rise of homosexuality, gender transitivity "fades"—or even that certain manifestations of deviant gender identity are "extinct"—fails to take account of gender transgression's continuing significance as a means of encoding homoerotic desire in the popular imagination, or to comprehend contemporary subcultures organized around gender identity, morphology, and embodiment.

Also, Halperin's overriding focus on male histories of homosexuality means that he has perhaps not taken sufficient account of the relevance of these pronouncements for women. By "modern," Halperin means the urban West; this "modern" male homosexual identity, attributed with conceptual coherence and assumed to be relatively self-evident, then becomes the global standard against which other sexual expressions are measured. One point to make, notes Carla Freccero in a recent evaluation of Halperin's rhetoric, is that "for women at least, then and now, gender and sexuality are inextricable and coextensively constituted"; another is that the consequence of making these distinctions between gender and sexuality is potentially disabling for those "queer sexual communities that centrally concern gender, such as movements for intersex, transgender, and transsexual rights and recognition."[28] One of the unintended consequences of this categorical division between (premodern) gender and (modern) sexuality, in other words, is the perception that expressions of gender transformation in the present, whether in the West or elsewhere in the world, are anachronistic throwbacks to the past. Not only do such analyses attribute to modernity a temporal unity that it may not possess; they also make the struggles of contemporary individuals for whom gender identity is a key concern seem somehow behind the curve of history.[29]

The production of gender inversion as a practice whose time is past also manifests itself in the emphasis within some modern sexual subcultures on flexibility. One landmark in the promotion of this climate of flexibility was Butler's 1990 book *Gender Trouble*, which described gender as a practice of reiterating or repeating the norms through which one is constituted, a practice she terms "performativity."[30] Although Butler's aim here was not, as she has pointed out in subsequent reflections on the book's reception, to suggest that individuals necessarily have the capacity to perform their way out of gender as willful agents or by engaging in self-conscious acts of gender nonconformity, readings of *Gender Trouble* nonetheless emerged, in a popularizing vein, that treated gender as a choice that could be radically subverted through modes of radical, improvisational theater.[31] Such an argument could potentially be taken to imply that conformity to gender binaries is a dispensable mode of artifice; in a post-Butlerian world of gender versatility and subversion, cross-identifying individuals who passionately inhabit more "rigid" gender roles may themselves

seem stuck in time. Those whose primary sense of themselves is still firmly grounded in strong gendered attachments risk being marginalized in such a climate, cast as "stereotypical" throwbacks to a kind of antiquated essentialism.

That these assumptions also condition some of the narratives that get written in the name of queer history should give the historian of sexuality pause for thought. Sexuality itself has a temporal politics that demands to be unpacked; the insertion of transgender into this political scenario, as the "pre-homosexual" invert dragging at the heels of a self-evident, homosexual present, contributes to the separation of "sex," "gender," and "sexuality" as analytic categories, but at what cost to individuals living within and between those categories? A history of homosexuality as a series of temporal ruptures and displacements, which implies that inversion begins to evaporate as soon as the "modern homosexual" takes center stage, risks treating transgender as a tired or outmoded antecedent. Instead it may be worth articulating alternative histories, which, rather that treating gender and sexuality as distinctive moments in a chronological sequence, focus on their ability to register temporal heterogeneity.[32]

Consequently it is worth emphasizing the contradictory status of what I am terming, in this chapter, "transgender time." My point is not only that transgender sometimes ends up representing—as an "earlier" model of gay or lesbian identity imagined as inversion—a body behind the times. Within contemporary queer subcultures, transgender also conveys the promise of a more flexible, multiply gendered future. Halberstam puts it thus: "as a model of gender inversion recedes into anachronism, the transgender body has emerged as futurity itself, a kind of heroic fulfillment of postmodern promises of gender flexibility."[33] Halberstam's point here is not simply to celebrate that flexibility as a sign of progress and liberation; nor is the aim, conversely, to rehabilitate the sites where transgender remains committed, in practice, to rigidity rather than flexibility. Rather, we need to move "beyond the binary division of flexibility or rigidity"—beyond the line separating future and past—in order to confront situations where transgender might mean both, or more.[34]

"A Strange and Perverse Adultery": Sequence and Imitation in Hildegard's *Scivias*

Returning, in light of this discussion, to medieval theological discussions of homoeroticism, we should recall that the relative priority of gender over sexuality in these texts is an effect of the secondary status generally attributed to sexual misdemeanors. Fallen sex is always imagined as a derivative and belated activity; sexual sinners mimic an original, divinely created source, but imperfectly. Embedded in this sequential time line, sodomy itself operates as a "bad" copy, one that fails to keep faith with the meanings of its putative source. Sodomy,

like other condemned practices such as masturbation and bestiality, is not so much a *conversion* of one bodily practice into another as a *perversion*, which turns away from the "original" meanings and follows an improper and shameful path.

The logics of sexual sequence are pursued with particular vigor in a treatise composed by the abbess and visionary Hildegard of Bingen (d. 1179). Although she does not use the term "sodomy" specifically in this context, Hildegard is forthright in condemning erotic relations between women as well as between men. Other commentators before and after Hildegard included women in their discussions of sins against nature, though the term *sodomia* was not explicitly applied to women until the 1200s or later.[35] Early medieval penitentials sometimes specify the penance due to women who have sex with women, referring to the acts in which they engage as "fornication."[36] They also occasionally allude to stimulation by means of artificial engines or *machina*, as discussed later in this chapter. In the later Middle Ages, writers took as a common point of departure Paul's statement in his epistle to the Romans concerning women who "have changed the natural use into that use which is against nature," in the same way that men also, "leaving the natural use of the women, have burned in their lusts one towards another, men with men working that which is filthy" (Romans 1:26–27).[37] Peter Damian quotes these verses in his attack on clerical sodomy; but since his letter is concerned only with the purity of male religious, the implications for women fail to register.[38] Nevertheless when Hildegard's contemporary Peter the Chanter cites the same verses in his meditation on sodomitic vice, as discussed in chapter 1, he supplements the citation with another from the epistle of Jude, which describes the cities of Sodom and Gomorrah as having "given themselves to fornication" (Jude 1:7), and adds an explanatory note to the effect that the shameful acts in question involve "males with males . . . women with women."[39] The fact that he repeats the point made by Paul in Romans suggests that he clearly interpreted the sins of Sodom as encompassing women.

Hildegard's reflections on fornication and homoeroticism are in keeping with Peter the Chanter's: her discussion of sexual incontinence pays close attention to its gendered implications. The abbess's meditation on Christ's sacrifice in book 2 of the *Scivias*, completed between 1141 and 1151, concludes with a discussion of the priesthood, the importance of clerical celibacy, and the sinfulness of clerical marriage. This final discussion catalogues prohibitions against a number of sexual practices. Although acknowledging that women can aspire to the office of priesthood vicariously, by joining with the heavenly bridegroom Christ "for love of chastity," Hildegard's text has already defined women as "infirm and weak" (*infirmum et debile*) individuals, appointed to give birth to children, who are not, as such, eligible for priestly office.[40] This statement, which is placed in the mouth of God, is followed by a chapter specifically targeting

cross-dressing, which underpins the preceding discussion of women's unsuitability for the priesthood:

> A man should never put on a feminine dress or a woman use male attire, so that their roles may remain distinct [*utraque persona discernatur*], the man displaying manly strength [*uirilem fortitudinem*] and the woman womanly weakness [*femineam infirmitatem*]; for this was so ordered by Me when the human race began [*ab initio*]. Unless a man's life or a woman's chastity is in danger; in such an hour a man may change his dress for a woman's or a woman for a man's, if they do it humbly in fear of death. And when they seek My mercy for this deed they shall find it, because they did it not in boldness [*temeritate*] but in danger of their safety. But as a woman should not wear a man's clothes, she should also not approach the office of My altar, for she should not take on a masculine role [*uirilem personam*] either in her hair or in her attire. (278)

In this Hildegard's text follows the proscription against cross-dressing in Deuteronomy 22:5, which rules that "a woman shall not be clothed with man's apparel, neither shall a man use woman's apparel: for he that doeth these things is abominable before God." At the same time, the passage makes certain concessions: cross-dressing is permitted out of necessity and "fear of death." These concessions acknowledge the fact that since the early centuries of Christianity stories had been told of women saints who disguised themselves in male garb, entered male religious houses to escape marriage and to protect their chastity, and engaged in acts of extreme asceticism or were martyred for their faith.[41] In chapter 4 we will encounter a visual image, almost contemporary with Hildegard's *Scivias*, which represents one such figure, Saint Eugenia, in a moment of gender transition that potentially disrupts the binaries Hildegard's speaker is so keen to enforce. However, Hildegard is quick to follow this acknowledgment of the circumstances in which cross-dressing is acceptable with a reinforcement of the overall message: any other performance of female masculinity, such as that which comes from "boldness" or from assuming the guise of a priest, is unacceptable.

The ensuing discussion reinforces this commitment to a binary model, in which bodily sex and sexual personae line up neatly with one another. First, in a discussion of erotic relations between men, the speaker condemns individuals who veer from the "proper" gendered course, characterizing their transgression as a perversion that turns them away from God:

> A man who sins with another man as if with a woman sins bitterly against God and against the union with which God united male and female. Hence both in God's sight are polluted, black and wanton, horrible and harmful [*polluti, nigri*

atque luxuriosi, horribiles ac molesti] to God and humanity, and guilty of death; for they go against their Creator and His creature, which is in them. How? God united man and woman, thus joining the strong to the weak, that each might sustain the other. But these perverted adulterers [*contrarii adulteri*] change [*transferunt*] their virile strength into perverse weakness, rejecting the proper male and female roles [*rectam institutionem maris et feminae abicientes*], and in their wickedness they shamefully follow Satan, who in his pride sought to split and divide Him Who is indivisible. They create in themselves by their wicked deeds a strange and perverse adultery [*alienum et contrarium adulterium*], and so appear polluted and shameful [*polluti et contumeliosi*] in My sight. (279)

Hildegard deploys a distinctive vocabulary in this passage, describing the deeds in question as a "strange and perverse adultery." Whereas a century earlier Peter Damian made use of a novel term, *sodomia*, to discuss sexual practices among male clerics, Hildegard makes no reference here to Sodom or the Genesis 19 story, emphasizing instead the consequences of following Satan and turning away from the "proper" gender roles instituted by God. This contrariwise practice is likened to another sin, adultery, but characterized as an alien form of it. As is apparent throughout this book, homoerotic practices are conveyed to the reader via a string of different categories and attributes—adultery, strangeness, perversion, gender switching, pollution, and shame—that capture the depths of sinfulness to which humans will stoop while avoiding directing attention to the associated sex acts. Hildegard's vision is not concerned with articulating a coherent position on what might be interpreted, from a modern perspective, as "homosexual" or "same-sex" relations; rather God's various references to gender and sexual dissidence serve a theological goal, namely, to underscore the importance of Christ's sacrifice for human salvation. Priests who commit fornication or other fleshly acts are unworthy to administer sacraments such as the Eucharist; members of their congregations who have participated in these acts are likewise unworthy to receive those sacraments and to reap the benefit of that sacrifice.

Hildegard follows her lengthy denunciation of gender-bending homoeroticism with an attack on the man "who sins with a woman by this same method of perverted fornication," whose behavior is similarly improper. Here she employs a semantic field that obliquely sheds light on the specific deeds that produce these "strange" effects:

A person would seem perverted [*contrarius*] and harmful to other people if he threw the beautiful clean food and ate the ordure [*stercus*] that comes out of the body in digestion; and these are in My sight equally unworthy and unclean,

since they forsake the proper way [*rectam institutionem*] of uniting with a woman and seek in her an alien [*alienam*] sin. (279)

The comparison between people who eat shit and men who have sex with women, who employ, in turn, the same variety of fornication as men who have sex with men, alludes to the practice's anal associations. But immediately following this is a passage elevating gender nonconformity, once again, to a central position in the definition of homoerotic practices, this time in relation to sex between women:

> And a woman who takes up devilish ways [*diabolicas artes*] and plays a male role [*uirili officio*] in coupling with another woman is most vile in My sight [*uilissima in conspectu meo*], and so is she who subjects herself [*illa quae se subicit*] to such a one in this evil deed. For they should have been ashamed of their passion, and instead they impudently usurped a right [*ius*] that was not theirs. And, having put themselves [*se transmutauerunt*] into alien ways, they are to Me transformed [*transpositae*] and contemptible. (279)[42]

Here the implication is that both participants, whether or not they turn away from their rightful roles, are blameworthy: the woman "who subjects herself" to a male-performing woman is characterized as being as perverted as her masculinized partner, despite not challenging gender roles. So much for the positive associations female masculinity acquires in certain medieval discourses of chastity, as discussed in chapter 5—and as implied by Hildegard's own concessions to chaste individuals who cross-dress "in danger of their safety." When gender nonconformity inflects earthly modes of coupling, as in situations where women have sex with other women, you're damned if you do and damned if you don't.

Of course Hildegard's principal aim in this text is to convey to her readers humanity's desperate need for salvation and the solution to that need, Christological sacrifice. Thus we cannot expect her to maintain a consistent position on female masculinity and homoeroticism. Nonetheless the abbess's intervention in debates concerning sexual wrongdoing is significant. Whereas Hildegard's own passionate attachments to other women (notably a fellow nun called Richardis of Stade) led her to develop alternatives to a gender-inverted or "tribadic" model of female homoeroticism,[43] the *Scivias* presents what, along with Alan of Lille's *De planctu Naturae*, is one of the most developed statements in medieval theology on the gendered causes and effects of homoerotic sex acts. As her discussion of the woman who "plays the male role" shows, those who perform such deeds are transmuted and transposed into a spectacle of wickedness. My vocabulary of cause and effect here also serves to highlight the sequential logic

embedded in Hildegard's rhetoric. What renders those sins shameful—what makes that shamefulness visible in the "sight" of God—is the fact that, at the moment when they engage in their shameful passions, male sinners are *seen* to enter the feminine and females are *seen* to enter the masculine. Accordingly the sinners are rooted in a chronological structure. The primary model—the source for the corrupt translation—is "the union with which God united male and female," a union conjoining "the strong to the weak" and thus exemplifying "the proper male and female roles"; those roles, which include dress and hair, were instituted *ab initio*, from the beginning. Adulterous perverts consciously take up this model; willful agents, they knowingly perform their way out of their assigned positions in the God-given male-female hierarchy. Men who have sex with men, "rejecting" their assigned position, "change their virile strength into perverse weakness"; men who have sex with women in "alien" ways "forsake the proper way of uniting with a woman"; women playing the male role "usurped a right that was not theirs."

The effect of these pronouncements is not only to depict sinful sexual practices as imitative practices; it also secures the originality of the mode of sexual union from which those aberrant practices derive. As well as reifying visibility as an explanatory framework within which to condemn sinful erotic activity, Hildegard's language foregrounds the fact that the terms within which sexual perversion is articulated have been decided in advance: what they translate—but badly, in the sense of "usurping" and transforming it—is a divinely instituted framework of sex roles that is always imagined coming first. To the extent that the identities associated with that bond can be impersonated, however, they also potentially take on qualities associated with gender: God created male and female in this manner, "that each might sustain the other," but this order of creation is also presented through a vocabulary of *iura* (rights) and *personae* (roles), qualities that can be taken up and discarded, which embeds them in a pattern of citation. The double of the man-loving male is the woman whose sex role he mimics; the double of the woman-loving woman is the man whose "right" she usurps. Transformed through the performance of wicked deeds, masculinity and femininity are the definitional ambits in which sinful sexual practices become spectacularly visible to Hildegard and her readers. In Hildegard's mind the acts in question are rooted in human will and a postlapsarian propensity for sin. Thus she does not have in mind the citational structures outlined by Butler in her analysis of gender trouble, which, as already discussed, are not necessarily the product of willful agents. The abbess's narrator targets volitional acts specifically, taking to task for turning away from God's laws men and women who knowingly fail to perform their proper roles.

To push this analysis further, it is also worth considering the order in which the various sins are targeted. Priority in the chain of sinfulness is assigned to

behavior that might conceivably fall under headings such as butch or possibly transgender—as in the woman who takes on "a masculine role either in her hair or in her attire," or who assumes the priestly office from which she is barred. Next comes the "man who sins with another man," who himself rejects divinely instituted sex roles; after him we encounter the man who has sex with women in a way that aligns him with those who trade "clean food" for "ordure"; finally readers are afforded a vision of the woman "coupling with another woman."[44]

Additionally, embedded within this discussion, is "she who subjects herself to such a one in this evil deed." This individual, who, coupling with the performer of the "male role," manifests the feminine "weakness" that is rightly hers, is assigned an equal share of the blame for submitting to a partner who "plays" the male role, despite not herself challenging the gender codes on which the speaker places so much emphasis. Effectively the visibility of female homoerotic behavior is dependent on additional layers of derivation: it operates in the shadows of what has gone before—men having improper sex with each other, or with women—and via a refusal of the shame that should otherwise follow. Additionally female homoeroticism is itself subject to division along temporal lines: the feminine partner lingers in the shadows of the masculine-performing woman who first comes into view. At the risk of distorting matters by deploying a modern and historically contingent language, we can say that the femme comes into visibility only insofar as she partners with a butch.

Of course, as already discussed, we need to be careful about applying terminology such as butch or femme or any other postmedieval vocabulary to medieval sources; but, like some other historians of sexuality, I also think analogies—even patently anachronistic ones—can be powerful tools when mobilized strategically. "Butch" and "femme" are categories with specific histories. In the middle of the twentieth century these terms assumed prominence within some working-class subcultures, notably in large cities in North America and Britain, but the significance of these terms has shifted profoundly even in a matter of decades. While today butch and femme might be used to describe personal codes of behavior, style, or eroticism, in earlier incarnations they facilitated the formation of communities. Women who identified as butch in the 1940s and 1950s were generally not trying to "pass" as men, meaning that butch does not possess precisely the same semantic range as transsexuality or transgender. Rather, self-identifying as butch provided a means for some women, whether individually or in groups, to establish viable and visible alternatives to heterosexual dominance. Femme identity differed from butch identity to the extent that it was less obviously grounded in visible acts of gender crossing. But the assumption that femmes in this period simply "conformed" to models of femininity developed within heterosexuality misses the extent to which femmes themselves participated in oppositional structures, notably by

sidestepping the imperatives of a culture organized around women's dependence on and desire for men. That said, historically the term "lesbian" has tended to be conflated with butchness, while feminine expressions of homoeroticism teeter on the edges of obscurity. This is because, except in certain well-defined circumstances (one of which, female chastity, is discussed in chapter 5), relations between women were not viewed as socially threatening when they did not appear to trouble prevailing gender codes or power dynamics.[45] Each category has a potentially different relationship to visibility, in other words; the coinage "butch/femme," which presumes that these roles can only be understood relationally, leaves out alternative permutations of desire and gender (femme-femme, for instance) as well as forms of intimacy structured around other categories such as friendship or chastity.[46] The challenge in deploying terms such as these historically, then, is not to lose sight of their particularities and nuances over time; medieval terminology such as sodomy is equally complex and shifting in its definition. Butch and femme can helpfully focus attention on the gender-differentiated dimensions of homoeroticism in different times and places, and women's relative intelligibility and visibility in those contexts; but inevitably these words retain the traces of their complex histories.

The same goes for lesbian and transgender when applied to medieval sources. Recognizing Hildegard's sinners through the word "lesbian," as a contemporary reader might be tempted to do, mobilizes that category's associations in the present with a politics of outing and visibility: naming them as lesbian strategically disrupts the logic of sequence within the text itself, by prioritizing the "same sex" components of the sinful interactions. Filtering our perspective through the lens of transgender acknowledges, conversely, the priority of gender transgression and transformation in Hildegard's account of sexual sequence: what is "same sex" turns out also to be "trans sex." Yet both modes of recognition (which we can apply only in retrospect) contain perspectival blind spots. Lesbian potentially renders invisible the priority of transgender in medieval depictions of sodomy by overwriting the cross-identifying woman's masculinity with a specifically female category of desire, one foregrounding its same-sex structure; transgender potentially relegates the masculine-performing woman's partner to the sidelines—and also, lest we forget, the anus-penetrating males to whom the abbess alludes in her other references to gender-deforming sex acts. What is visualized in this context is not so much lesbian or trans (in)visibility, but the role of spectacle itself in assigning priority to certain dimensions of experience over others: Hildegard's pronouncements principally seize on gender performance—which is characterized as a misperformance or transformation of the original model—as a means of bringing human sinfulness into the field of vision and thereby illuminating the mystery of Christ's sacrifice.

Analogously, the chronological sequence associated with certain versions of the history of sexuality, which present the category of sexuality—defined as a "new system," in which notions of orientation, identity, psychology, desire, and normalization work to render that category visible—as the more "modern" dimension of human experience, constructs gendered models such as inversion as manifestations of a time "before": expressions of inversion in the present are viewed as echoes of a "prehomosexual" past that has essentially passed. Transgender usefully foregrounds features of that past that might otherwise be assimilated into the history of homosexuality, by bringing into focus the relative priority afforded to gender over sexuality in the register of visibility. Deploying terms such as transgender in medieval settings also potentially disrupts the idea of a past whose time is over: it brings past and present into a mutually informing dialogue with one another. But as the product of a particular postmedieval, postmodern, even "posthomosexual" moment in history, transgender is also a clarification that obscures: inevitably, as with any of the other categories taken up in this book, it cannot precipitate total translation. So the goal in utilizing transgender as an interpretive prism is not to suggest that Hildegard's lesbians turn out, in the last analysis, to be trans, or that naming them as lesbian or transgender will securely situate them within the sphere of cultural intelligibility (as if what is at stake is simply an either/or). I am not saying that, if only we view things from the right angle, we will find the lesbian or transgender experiences that have been sitting there, waiting to be discovered, all along. Rather, the operation by which these terms lend themselves, retrospectively, to filling in the gaps and insufficiencies in Hildegard's text coincides with the critical challenges faced by queer and feminist scholarship more generally, in trying to negotiate the relationships among sex, gender, and sexuality historically.

Ovid in Other Words: Iphis and Ianthe, and Their Transformations

In order to comprehend how these temporal and sequential paradigms play out in contexts besides contemporary historiography and medieval theology, I now turn to a literary case study: the story of Iphis and Ianthe, told in Ovid's *Metamorphoses*, as mediated in a range of premodern settings.[47] In recent decades this story and its analogues have often been interpreted as bringing into view "lesbian" or "same-sex" passions, albeit namelessly, via the motif of gender crossing. What might transgender contribute to these discussions?

Ovid's own version of the legend runs as follows. Desperate for a male heir, Iphis's father, Ligdus, makes a vow to her mother, Telethusa, that, if the infant she is carrying turns out to be a girl, he will have the infant slaughtered. To protect her from this fate, the mother decides to bring the girl Iphis up as a

boy, after having a vision in which the goddess Isis orders her to disobey her husband's wishes. Some years later Iphis is betrothed to Ianthe, the daughter of a powerful duke, and the pair fall in love. But when the couple's wedding day approaches, Iphis is concerned that she will not be able to perform in the bedroom, laments the fact at length, and resolves her crisis only when Isis intervenes and, using her divine powers, magically transforms Iphis into a man. Before this happily-ever-after ending, however, Iphis expends a considerable amount of energy contemplating the unintelligibility of her desires. Just as no one has ever before been captured by a love as "prodigiosa novaeque" (9.727) (monstrous and strange/new) as this, nature itself has never encountered such passion:

> nec vaccam vaccae, nec equas amor urit equarum:
> urit oves aries, sequitur sua femina cervum.
> sic et aves coeunt, interque animalia cuncta
> femina femineo conrepta cupidine nulla est.
> vellem nulla forem! (9.731–35)

[Cows don't fall in love with cows, nor mares with mares. A ram wants a ewe; a doe belongs to her stag. Birds mate the same way, and in the entire animal kingdom no female has ever been seized by desire for another female. Oh how I wish I weren't a girl / didn't exist!]

This is followed by a reference to the sexual relationship between Pasiphaë and a bull, a story also mentioned briefly by Ovid in the previous book of *Metamorphoses*, which features the Minotaur, who was the monstrous offspring of that union (8.122–37). As Iphis acknowledges, though, even on that occasion it was still a case of "femina nempe marem" (a female loving a male), whereas the passion she is experiencing is "furiosor" (9.737) (more insane). Reminding herself that she needs to accept what she was born as and "ama quod femina debes" (9.748) (love as a female ought to love), Iphis has a second outburst in which she meditates on what is preventing her from expressing her desires: her own father, Ianthe's father, and Ianthe herself all want it to happen, she says, but nature, "potentior omnibus istis" (9.758) (more powerful than all those put together), is against her.[48]

Ovid's story of sexual metamorphosis underwent several metamorphoses of its own in the Middle Ages. Notable among these is the tale of Yde and Olive, a closely related story of sex transformation that circulated in French verse, prose, and drama from the thirteenth century, as well as in English prose from the 1530s, which has been analyzed in detail by Sahar Amer and Diane Watt, among others.[49] But it is the versions of *Metamorphoses* circulating in French

and English in the fourteenth and fifteenth centuries, under the sign of what modern scholars generally term the *Ovide moralisé*, which will concern me here.

Ovide moralisé is possibly a misleading label for what was, after all, a rather diffuse textual situation. What most commentators mean when they refer to the *Ovide moralisé* is the massive 72,000-line poem compiled before 1328—probably by a cleric, probably for Joan of Burgundy, wife of Philip VI of France—that presents a complete translation of *Metamorphoses* into French octosyllabic verse along with a series of allegorical interpretations or "moralizations" that seek to discover within Ovid's paganism echoes of the central tenets of Christian revelation.[50] But this anonymous poem also circulated in two independent fifteenth-century prose abridgments, the second of which—to date unedited—essentially secularized the verse *Ovide moralisé* by discarding many of the Christian allegorical expositions. To avoid confusion I will refer to this second prose version henceforth as the *Ovide moralisé en prose II*.[51] To complicate the picture further, the *Ovidius moralizatus*, another Latin prose text independent of the verse *Ovide moralisé* (though drawing on it in a later redaction), was composed by the Parisian monk Pierre Bersuire (Petrus Berchorius, d. 1362).[52] A further prose text, published by Colard Mansion in Bruges in 1484 and illustrated with woodcuts, works with the *Ovide moralisé en prose II* but effectively re-Christianizes the text by combining it with a blend of interpretations from several allegorical traditions.[53] Also working with the *Ovide moralisé en prose II* was Mansion's contemporary and one-time collaborator William Caxton, who in 1480 produced the earliest complete translation of *Metamorphoses* into English.[54]

This is not the place to get into all the finer details of these textual relationships. My brief overview of the complex interactions among the different texts simply serves to indicate that moralizing Ovid in the Middle Ages entailed making certain choices, about what version to translate and which interpretations to prioritize within that version. While the tradition's various strands were tied together by a single unifying purpose—to make Ovid into a harbinger of Christian truth—individual redactors might favor one interpretation over another, or juxtapose competing interpretations, some of which seemingly exceed the genre's Christianizing ethos. Caxton's Englishing of Ovid offers a particularly good case study for exploring these moments of excess: comparisons between the *Ovide moralisé en prose II* version of the Iphis story and the other moralized Ovids circulating in French and Latin between the thirteenth and fifteenth centuries demonstrate that this text, more than other translations, registers discomfort with the myth's potential to offer a positive Christian message to readers. As with the moralized Bibles discussed in chapter 1, the moralized Ovids were inherently translatable; but dissemination generated some widely divergent possibilities for reception and interpretation.

Although some attempts to allegorize *Metamorphoses*, such as the first re-daction of the *Ovidius moralizatus*, simply present abridged summaries of certain episodes along with the commentaries, the verse *Ovide moralisé* was the first also to incorporate a complete or expanded version of the narratives themselves. Later vernacular prose texts also included fairly close renditions of particular Ovidian episodes. Revisiting the story of Iphis and Ianthe, this time through Caxton's translation, we note some crucial differences between this text and other versions. The first has to do with the name attributed to the main protagonist: in both classical and medieval versions of the narrative, Iphis is said to share her name with her grandfather, thus reinforcing Ligdus's invest-ment in patrilineage.[55] In book 9, however, Ovid's narrator records the mother's delight with the name, for "gavisa est nomine mater, / quod commune foret, nec quemquam falleret illo" (9.709–10) (it was common to both sexes and she wouldn't deceive anyone with it); the name springs, we are told, from an act of "pia mendacia" (9.711) (honest deception) that went undetected. The androgy-nous potential of the name matches up with the androgynous potential of the child's body: as well as cross-dressing, the narrator confirms that the infant is already marked out as corporeally ambiguous, with a face that, "quam sive puellae, / sive dares puero, fuerat formosus uterque" (9.712–13) (whether you gave it to a girl or a boy, would have been attractive in either sex). Thus there seems to be some equivocation from the start, in Ovid's text, about whether cul-tural performance or sexual embodiment is the defining factor. Although, as we shall see, moralizations of *Metamorphoses* retained and indeed in some ways developed these ambiguous possibilities, the English text presents a very differ-ent spin on the question of the name: whereas Mansion's prose text, following the verse *Ovide moralisé* (*OM* 9.2879–80), acknowledges that "tel nom appart-enoit à masle et à femelle" (such a name appertains to male and to female), the English translation notes that Telethusa is pleased with the name "for suche a name apperteyneth to a man and not to a woman. And so myght by hys name he be apperceyved withoute sayeng the trouth. And thus was the lesynge hyde" (9.975–78).[56] Transforming "Iphis" into a fixed category of sexual difference, this statement effectively closes down the name's unisex potential.

The modification also reinforces notions of female masculinity as deceit. As Halberstam notes in her analysis of contemporary transgender biography, motifs of deception and fraud are all too familiar: transgender lives are typi-cally reduced to a form of counterfeiting.[57] Similarly, in Caxton's Ovid, naming is presented as a cultural activity that provides a cover for the real "truth." This emphasis on deceit tends to reinforce the division between cultural surface and biological depth, between Iphis's masculine performance and her sexed body.

Notwithstanding the alteration to the significance of the name, though, Caxton's text ultimately ends up undercutting distinctions between sex and gender by deploying a grammatical and bodily vocabulary of maleness to describe Iphis prior to the transformation. Although, as we have seen, Ovid's own version alludes to dimensions of gendered experience and behavior on a spectrum from naming and cross-dressing to the signs of bodily attractiveness that girls and boys are said to share, the poet's economic Latin verse avoids gendered pronouns for the most part: Iphis is described as a "girl" (*femina*) pretransformation and as a "boy" (*puer*) at the moment of the sex change. Retellings of the tale in the Middle Ages tend to be marked by a greater degree of linguistic fluidity. For example, discussing Telethusa's attitude to the name, the English text tells us that "she" was named thus; but a sentence later the narrator makes reference to "hys" name, which is the lens through which "he" is perceived. Moreover, taking their cue from Ovid's own reference to the androgynous facial appearance of the child, medieval translators make it clear that, even before Iphis's coupling with Ianthe, her body already exudes visible signs of maleness: in Caxton's text, for example, we are told that "Yphis had th'abyte of a *man* chylde whyche becam *hym* moche wel, and also *she* hade such a vysage that who sawe *her* myght indefferently saye *it* is a sone or a doughter" (9.978–80).[58] Even within this single sentence, Iphis's gender shifts grammatically between masculine, feminine, and neuter.

My point in directing attention to the changes made by Caxton and others to Ovid's discussion of the infant Iphis's name and facial appearance is not to contrast classical attempts to register transgender with medieval attempts to shut it down. Rather it demonstrates how the gap between the name "Iphis" (which in Caxton's Ovid is manifestly *not* unisex) and the embodied subject (who possesses features that visibly mark the body as androgynous or even mannish from the start) ends up being more significant in the fifteenth-century translations. The protagonist's gendered performance thus straddles the line between maleness and masculinity: if, even before her sexual awakening, Iphis looks like a man child, her *hym*ness is already presented as potentially embodied. The issue is not that Iphis's masculinity fails to convince, in other words, or to produce signs of maleness performatively on her body. It is that this process meets its limits in the bedroom.

In Ovid's own account the issue of what two women do in bed together is dealt with somewhat allusively. As already mentioned, Iphis makes reference to Pasiphaë's sexual relationship with a bull, which at least, she submits, was motivated by the possibility of sexual intercourse; crucial to Pasiphaë's ability to engineer the situation to her advantage is what Ovid describes as "dolis et imagine vaccae" (9.739) (a substitute for and likeness of a cow), with which she offered herself to the bull. Although Pasiphaë was reliant on a go-between—a

lifeless *imago*—the implication is that Pasiphaë's partner had the necessary quality (implicitly a phallus) to consummate her desires.[59] This reference in *Metamorphoses* to a woman's effort to transform herself into what she is not—a cow—by artificial means has crucial implications for the ways in which the Iphis story was taken up by allegorists in their moralizing commentaries, as we shall see. At the same time, it serves to reinforce Iphis's sense that appearance and dress alone are not a substitute for the morphology shared by animal and human males. Ovid makes clear that Iphis's desire for Ianthe is never in question: she "amat, qua posse frui desperat, et auget / hoc ipsum flammas, ardetque in virgine virgo" (9.724-25) (loved a girl she could never hope to possess, and this itself fanned the flames of her desire, a girl who burned with love for another girl). The poet then concludes Iphis's soliloquy on unfulfilled desire circumspectly, with an evocation of reasons why Iphis will not be able to quench her thirst:

> venit ecce optabile tempus,
> luxque iugalis adest, et iam mea fiet Ianthe—
> nec mihi continget: mediis sitiemus in undis. (9.759-61)

[And now the wished-for time approaches, the wedding torches are here, and Ianthe will soon be mine—but I won't have her. With water all around me, I'll be dying of thirst.]

Again, the implication is that Iphis's aspirations to "have" Ianthe and to obtain sexual pleasure from her body—or, as the image in this passage has it, literally to drink her in—are reliant on a faculty she does not possess. Iphis's resort to a liquid metaphor suggests that she does not envisage sexual consummation simply in penetrative or penile terms: sexual fluids are also crucial in enabling Iphis to fulfill her passion.[60]

The accounts of Iphis's dilemma in the moralized Ovids repeat these details but incorporate certain adjustments and additions. In Caxton's version, for example, the narrator's response to Iphis's passion is filtered through a language of shame: the more the pair embrace, the more "abasshed" Iphis becomes, which represents a change in direction from other texts.[61] This sense of shame is also bound up with a rhetoric of female irrationality: following the Pasiphaë reference, Caxton's Iphis tells herself to "Requyre thynge that is covenable [appropriate] and that thou maist by raison have and forgete thy folysshe love, for paraventure [by chance] thou art not worthy to be joyned to suche a creature" (9.1009-11).[62] Ovid's Latin also incorporates a distinctive diction at this point in the story—his Iphis describes her passion as "new," "monstrous," and "insane." These references to the passion's novelty are mirrored in the very vocabulary

Ovid attributes to the protagonist in her speech: *prodigiosa*, translated here as monstrous, is the first recorded appearance of the term in written Latin.[63] But medieval moralizers, building on this language, incorporate additional layers of moral (and implicitly misogynistic) judgment, even prior to the elaboration of moral and allegorical interpretations at the end of the story. Finally, while, as we have seen, Iphis in *Metamorphoses* has recourse to animal sex to articulate her dilemma, the moralized Ovids reiterate these references to the natural world but include an expanded meditation on the correct sexual configurations. Caxton's Iphis puts it thus:

> Alas, they dystroye me by this fowle amerous rage, which is not covenable to me nomore than one kowe to desyre another. A shep female desyreth the masle and engendre togeder, and a kowe assembleth her to a bulle. Every femele by ryght requyreth [requests] his masle. Ther is no femele that desireth to acowple her to another femele. And I, a femele, requyre as mayle agaynst raison. I hade lever [I would prefer] not to be born than to have so folisshe hope. (9.995–1000)[64]

The statement that every female needs "*his* masle" reproduces literally the grammatical gender of the phrase "son masle" in the French prose. But the possibility of erotic desire between women is also being evoked here via a familiar rhetorical strategy. It is the female demanding "as mayle" who goes against reason and animal nature, and whose birth should have been prevented. Her existence is plain illogical.

One answer to the dilemma Iphis poses in her soliloquy, acknowledged by Ovid in the tale's conclusion, is that one of the partners in the relationship experiences a full-fledged bodily sex change. This, like the consummation of love between one female and another, is treated as an impossibility that skilled artificers from all over the world cannot resolve; surely even the master craftsman Daedalus, with his "artibus" (arts) and waxen wings, is unable to turn her into a boy from a girl; nor can he change Ianthe, Iphis declares (9.744). Notwithstanding these statements, however, sexual transformation is the fabulous destination to which Iphis retrospectively appears to be heading from the start. Thus what in Hildegard of Bingen's condemnations of sexual vice was seen as the overriding problem arising from erotic relations between women—since it means that one of the participants, "playing a male role," will be "transformed"—becomes, in Ovid's own Iphis narrative, the solution, albeit an initially foreclosed one. Ovid's account of Iphis's eventual metamorphosis is clearly designed to emphasize its status as a miraculous rather than a natural scenario: step by step, the narrator outlines the process by which *femina* converts into *puer*—taking longer strides, possessing sharper facial features, having shorter, uncombed hair, displaying

more manly vigor (9.787–90)—which impresses on readers the marvelous qualities of the transformation.[65] Indeed preceding the narrative of Iphis's sex change the narrator refers to how the story just told, of Byblis's incestuous passion for her twin brother Caunus, would have filled a hundred Cretan cities if Crete had not recently produced "miracula" (9.667) (marvels) of its own, namely, Iphis's transformation.

Another tale of sexual metamorphosis in *Metamorphoses*, similarly filtered through the language of miracle, concerns the clairvoyant Tiresias (3.316–38). However, in this instance the change is not permanent: first Tiresias turns from a man into a woman, and then, after a period of female embodiment, the seer's male form is restored. The Tiresias myth is embedded in Ovid's account of a debate between Jupiter and Juno about the nature of love. Jupiter maintains that when a man has sexual intercourse with a woman, she takes more delight than he does; Juno argues the opposite. Tiresias, because he has experienced love as both a man and a woman, is called on to adjudicate. The impermanence of Tiresias's sex change, and the fact that it provides the backdrop to a discussion of sexual pleasure between men and women, highlight the difference between male-to-female (MTF) transition and Iphis's transformation: becoming a woman is just a phase, and MTF narratives are not generally presented as entailing homoerotic possibilities. Indeed, while *Metamorphoses* is completely silent about Tiresias's sexual desires following his embodiment as a woman, his verdict in the debate suggests that following the initial metamorphosis into a woman, Tiresias experiences sex with men, whereas before and after, as a man, he is sexually active with women. This is perhaps the implication of the reference in Caxton's Ovid to how Tiresias possesses everything women ought to have "by nature" (3.328): this extends also to desire, as a woman, for men, which is classed as a manifestation of "lecherye" (3.339).[66]

When, in the Middle Ages, stories were told about cross-dressing men, they tended, as in the Tiresias story, to present the transitions as temporary phases, rather than permanent resolutions—rites of passage marking a shift from one state of being to another. One example is the anecdote about the English hermit Richard Rolle discussed in the introduction; another is the case of John/Eleanor Rykener. While records of the latter use language evocative of sodomy— Rykener is discovered by city officials in the act of committing "illud vitium detestabile, nephandum, et ignominiosum" (that detestable, unmentionable, and ignominious vice)—what seems to have made the authorities especially anxious is Rykener's switching of roles: she/he shifts between letting men have sex with him/her "ut cum muliere" (as with a woman) and having sex with women "modo virili" (in a manly way).[67] What cannot figure, either in the Ovidian narrative or in these later references to MTF transition, is the possibility of a permanent sex change from male to female.

Ovid's *Metamorphoses* characterizes sex change, whether from male to female or from female to male, as a wonder—it is "mirabile" (3.326) or constitutes a "miraculum" (9.667). All the same, *pace* Ovid, female-to-male (FTM) transitions were sometimes viewed in antiquity as historically verifiable—if rare—events. Influenced by Aristotelian-Galenic ideas of anatomical symmetry between male and female, as well as mythological and scientific references to sexual transformation, accounts of sex changes of this kind, even surgically effected ones, were occasionally incorporated into works of natural history and philosophy, travelers' tales, and anecdotes in chronicles and histories about miraculous occurrences and prodigies. Pliny the Elder (d. 79 CE), writing a few decades after Ovid, catalogues in his *Natural History* several girls who became boys, changed names, married women, and grew beards as instances of the fact that sex changes were not entirely mythical.[68] Moreover although, as Pliny acknowledges, Aristotle disputes the evidence, sexual metamorphosis can also be attested in the animal kingdom, in the body of the hyena, which apparently switches between male and female from one year to the next; this example was subsequently redeployed in the medieval Christian bestiary tradition, where it became a figure for Jewish duplicity.[69] Finally, in a passage in the *Natural History* just preceding the one about human FTM transitions, Pliny refers to a people "born with both sexes" called *hermaphroditos*—an idea again attested in classical mythology.[70] Book 4 of *Metamorphoses* includes the story of Hermaphroditus, the son of Mercury and Venus, who is pursued by the nymph Salmacis; trapped by her in a fountain; and, when she embraces him in the water, turned into a sexual hybrid (4.285-388). Henceforth Hermaphroditus could not be called either *femina* or *puer* and seemed to be "neutrumque et utrumque" (4.378-79) (neither and both).[71]

Substantial scholarship has been devoted to exploring the medical, philosophical, and literary uses to which the figure of the hermaphrodite was put in the period 1500-1800, but there was also a thriving conversation on intersex embodiment in medieval theology, natural philosophy, and law.[72] Sometimes these discussions were purely theoretical in tone. Alchemical treatises, which drew parallels between the body of Christ and the philosopher's stone, rested on the assumption that Jesus himself, by combining divinity (male) with fleshly humanity (female), was the ultimate hermaphrodite.[73] This argument, which tended to highlight the bothness of Ovid's hermaphrodite at the expense of its hybrid neitherness, also resonates with medieval interpretations of the Ovidian myth: Bersuire's *Ovidius moralizatus* similarly connected the merger of Salmacis and Hermaphroditus with Christ's "double nature," which was the result of the union of the Virgin Mary with God.[74] Other discussions, assuming a more practical guise, adopted a more negative approach by comparing hermaphroditism to sodomitic behavior. Even then, though, the intersex body was

not necessarily subjected to the same level of opprobrium as sodomites themselves. Occasionally twelfth-century writers entertained the possibility that hermaphrodites constituted a third or neuter sex.[75] Even Peter the Chanter, in his discussion of sodomitic vice in his *Verbum adbreviatum*, regards sodomites and hermaphrodites as distinct categories, the latter more acceptable than the former. Although he cannot accept the Ovidian sense of the hermaphrodite as "neither and both," Peter is keen to stress that individuals who do possess male and female *instrumenta* or "organs" have a place within the church, so long as they consistently conform to one side of the dichotomy when it comes to sex roles.[76] Such viewpoints provided grounds for devising medical procedures aimed at regulating the bodies of persons of mixed or indeterminate sex, with a view to reinscribing binary difference.[77]

This brief detour through premodern discourses of hermaphroditism, intersexuality, and sex transformation highlights the gap between what Ovid's Iphis assumes is a physiological impossibility and accounts emphasizing the rare occasions when human beings really were believed to change sex, whether through miracle, natural causes, or surgical intervention. Against this backdrop Iphis's transformation appears to be one of the more mundane instances of metamorphosis in *Metamorphoses*. Moreover in the interpretations appended to some medieval moralized versions, this idea that sex changes really happen, albeit rarely, becomes the starting point for a meditation on how what appears to be a divinely or scientifically sanctioned bodily process is actually simply an effect of gendered performance. Caxton and others imply that what *seems* to be a thoroughgoing change of sex can in actual fact be effected, more mundanely, by unqualified human agents, who rely not on magical or surgical procedures but on artifice and deceit. This characterization of sex change as a hoax, which goes hand in hand with the presentation of homoeroticism as a derivative activity, rendered visible through acts of gendered performance, relies on evocations of what might be called the queer life of things. Crucially the "thing" provided a means for medieval audiences to fit sex change and gender nonconformity into the grid of verifiable history. As with Hildegard's discussion of cross-dressing and sexual perversion, it endows both dimensions of experience with a secondary status.

How to Do Queer with Things

Before turning to the interpretive passages appended to the Iphis narrative in the moralized Ovids, let us first consider a relatively innocuous reference to "things" in another retelling of the story. While John Gower's *Confessio Amantis* (1390) is not often considered in the same context as the other moralized Ovids discussed in this chapter, it participates in the same basic project of finding

Christian value in ancient stories.[78] Indeed, although Caxton's translation of *Metamorphoses* may never have made it into print form—our only witness to it is a handwritten manuscript—he published an edition of *Confessio Amantis* just three years after completing the Ovid translation.[79] In book 4 of Gower's poem the priest Genius recounts to the penitent Amans the tale of Iphis and Ianthe in such a way that, as several scholars have pointed out, sex between girls is treated with ambivalence, rather than downright condemnation, with the implication that even before the transformation the protagonists consummate their love sexually:

> These children leien, sche and sche,
> Which of on age bothe be.
> So that withinne time of yeeres,
> Togedre as thei ben pleiefieres
> Liggende abedde upon a nyht,
> Nature, which doth every with
> Upon hire lawe for to muse,
> Constreigneth hem, so that thei use
> Thing which to hem was al unknowe.[80]

[These children, who are both the same age, lie, she and she. So that within a period of years, lying in bed together one night, as they are playmates, Nature, who causes every person to muse upon her law, constrains them, so that they use a thing which was completely unknown to them.]

This "thing," in Gower's formulation, designates some appendage, accouterment, or body part for which even the users themselves have no name; all the same it is, despite that unknowability, evocative of a sphere of possibility. The implication is that something between two women—whatever it is—can be shared when they lie in bed at night, even if it goes against the laws of nature. Mediating between what is known and what is unknowable, in other words, the girls' thing is a potentially enabling enigma. Gower puts his readers in touch, in so doing, with the ways in which erotic life is never simply a matter of bodies in "nature"; it is also fundamentally a matter of things.

In this particular passage from *Confessio Amantis* the word "thing" designates that which is unspecified, ambiguous, irresolvable—a stand-in for what cannot, in the moment of enunciation, be named by a more specific word or phrase. The queer of queer theory, analogous to this "thing," hovers at the threshold between the namable and the unnamable. Though potentially reducible to a single, sexual thing—homosexuality—it also has the capacity to signify the profound complexity, temporality, and irreducibility of erotic life.

When, in a 2001 special issue of *Critical Inquiry*, Bill Brown made the case for a set of theoretical reflections gathered together under the heading of "thing theory," he argued for the excessive temporality of things—their status as "the before and after of the object." Thingness amounts, Brown writes, to an encounter with latency, "the not yet formed or the not yet formable"; it denotes the excess that "remains physically or metaphysically irreducible to objects."[81] Queerness similarly embodies a confrontation with latency and excess. Comparable to the term "thing" itself, which works, in everyday speech, to "overcome the loss of other words or as a place holder for some future specifying operation,"[82] queer likewise designates something amorphous, irresolvable, uncanny, incomplete—that which could be said to exist, in its effects, but which refuses to be assimilated as a stable presence. "I always thought there was something queer about her . . . something queer is going on here . . . the queer thing is . . ."

Moralized versions of Ovid, I suggest, capture this capacity of things to upset the definitional lines among sex, gender, and sexuality. Things may have queer effects when conjoined with bodies; bodies themselves can be imagined as swapping places with things, or being supplanted by them in order to produce new configurations of gender and sexuality. Itself a placeholder for something unnamable and unknown, the "thing" deployed by Gower's Iphis and Ianthe as they lie in bed together is figured as a kind of afterthought, a response to the constraints that nature—figured as primary—imposes. Thinking the thing, Brown has argued, "feels like an exercise in belatedness," a feeling "provoked by our very capacity to imagine that thinking and thingness are distinct."[83] Gower's girls likewise come up with an alternative to Nature's "law" by harnessing the "beforeness" and unknowability of the thing. But what happens when thinking and thingness coincide? What is it that Iphis and Ianthe belatedly come to know? Gower keeps his readers guessing: this is the point of using a word like "thing." But the reference arouses speculation all the same.

One possibility is that Iphis and Ianthe's thing is an inanimate object, a dildo of some kind. The oldest extant medieval European inquest into sex between women concerns one Bertolina, nicknamed Guercia, who in 1295 was accused in the Bolognese civic court of using devices made from silk to facilitate sexual relations with other women. The initial charge states that Guercia, a "publica et famosa sodomita" (public and well-known sodomite), conducted herself lustfully by using a certain "mancipium cum duobus testicullis de siricho" (*mancipium* with two silk testicles). Furthermore a male witness subsequently testified to an encounter with Guercia in which she showed him a number of silk "virilia," although, when questioned, he confessed that he had not actually seen her use such an "instrumenta" (instrument).[84] In the fifteenth century several more inquests into what has retrospectively been called "female sodomy" were recorded, including the case of one Katherina Hetzeldorfer, who

was drowned by the authorities from the Rhineland city of Speyer in 1477 for the crime of living as the "husband" of another woman. Hetzeldorfer's crime remains nameless in the relevant documents: unlike Guercia, she is not labeled as the German equivalent of a sodomite. But the legal record includes a detailed description of the tool that enabled Hetzeldorfer to achieve what Iphis can only dream about prior to her transformation: having first started out by using her fingers, we are told, she made "an instrument [*eyn instrument*] with a red piece of leather, at the front filled with cotton, and a wooden stick stuck into it, and made a hole through the wooden stick, put a string through, and tied it round"; one of the women with whom Katherina had her "manly will" (*manlichkeit*) also describes how she grabbed the device "and felt that it was a huge thing [*eynn vngefug dinck*], as big as half an arm."[85]

As things go, the device used by Iphis and Ianthe in Gower's retelling is more hazily defined. Their "thing" could conceivably be a dildo, but it could also be something else entirely: a nameless female body part, for example, or perhaps even the clitoris. Gower's contemporary, Geoffrey Chaucer, assigns to the Wife of Bath in the *Canterbury Tales* a language for discussing female sexuality that harnesses this potential interchangeability between body parts and things. The Wife refers to human genitalia as "thynges smale" (3.127), which enable bodies not only to be differentiated as male and female and to urinate but also to bring pleasure to their users; in addition she calls her own genitalia "myn instrument" (3.149)—echoing the terminology used to describe Guercia's and Hetzeldorfer's dildos—as well as her "bele chose" (3.453, 516), and of course her "queynte" (3.338, 450). The latter is a term that plays on cunt, but it also overlaps with quaint, a word derived from the Old French *cointe* (which could mean clever or knowing) and ultimately from the Latin *cognitus* (known). As that which is known and knowing, but also constituting one of the Wife's "thynges," Chaucer's "queynte" arguably presents a counterpart to Gower's thing "unknowe." The Wife's description of her genitals as an "instrument" and "chose" also draws on its irreducibility to a particular object or body: it is inherently deployable. Likewise the "maistrie" and "soveraynetee" (3.818) she seeks to assert over her husbands, which are traditionally viewed as male prerogatives, can be attached to other body parts than the penis: these are mobile qualities. Indeed the Wife's language possibly registers an awareness of the role of the clitoris in women's pleasure, thereby problematizing historical claims that the clitoris is a Renaissance "discovery."[86] Medical writings sometimes even assumed that women with an enlarged or hypertrophied clitoris were susceptible to homoerotic cravings: William of Saliceto, a thirteenth-century surgeon based in Bologna, describes in his *Summa conservationis et curationis* (1285) how sometimes a "thing" (*res*) appears on a woman that is "just like a penis" (*sicut virga*), and "sometimes it occurs to her to do what men do with women, that is, have coitus

with women; and sometimes there is a great *bothor* [Arabic for clitoris] or protuberance."[87] Could this be the same "thing" Gower has in mind when he imagines what Iphis and Ianthe get up to when they lie in bed together as playmates?

Whether or not there is a link between the reference to the thing "unknowe" in *Confessio Amantis* and the Wife of Bath's "bele chose," the imaginations of some of Ovid's other moralizers were also exercised by the capacity of things to render intelligible the otherwise unintelligible and unknown possibilities for sex between women. The majority of the moralized Ovids conclude the tale with an overtly Christianized moral, interpreting Ligdus as God the Father (who is determined to punish unrepentant sinners), Telethusa as Holy Church (who intercedes on behalf of humanity), and the sex transformation itself as an act of divine grace (which converts the sinner's bad life into good works and in so doing makes possible marriage to Christ).[88] These expositions map sinfulness onto Iphis's femaleness and virtue onto virility, thereby remolding the text into an allegory of the soul's journey to God.

In the verse *Ovide moralisé*, however, this interpretation is preceded by another in which Iphis is portrayed as a depraved female seducer who uses an add-on instrument—a "membre apostis" (*OM* 9.3149) (artificial member), which she deploys on the advice of a vile "maquerele" (*OM* 9.3143) (procuress)—to have her wicked way with her female lover. The narrator's view of such a story is unequivocal: it is "contre droit et contre nature" (*OM* 9.3133) (against law and against nature). This initial interpretation, described as the shocking "historial sentence" (*OM* 9.3115) of the story, is opposed to the "meillour sentence" (*OM* 9.3158) (better sense) of the spiritual interpretations that follow, which equate the gender metamorphosis first with Christ's Incarnation (*OM* 9.3162–89) and then with the transformation of the sinful soul through grace (*OM* 9.3190–3398)—this last interpretation being described as the "verité" (*OM* 3.3190) (truth) of the fable. The reason for needing the device of the "membre apostis," the commentary argues, is that the masculine-performing woman does not possess a "point de vit" (*OM* 9.3130), which is a euphemistic reference to the penis. The object, also named in the moralization as a "chose" (*OM* 9.3151), which is a manifestation of the procuress's "art" (*OM* 9.3141), allows her to render her "devoir" (*OM* 9.3148), which is to say her marital debt, as well as being the means by which her lover is "deçut" (*OM* 9.3149) (deceived).[89]

This language of things in the *Ovide moralisé* borrows from the same semantic field deployed by the Wife of Bath in her meditations on the "queynte." But unlike the Wife, who views the privileges associated with the phallus as mobile qualities that can legitimately be transferred among bodies, genitalia, and genders, the French allegorist apparently conveys a conventionally phallocentric and penetrative view of sexuality: the appropriation by women of a "membre" is dramatized as an act of usurpation; female homoeroticism is rendered

visible, but secondary, via the mediation of the thing. As in the Bologna and Speyer cases, it is not so much the assumption of male dress that causes concern as use of an inanimate object in bed.

Additionally the word "apostit" associates the sinful individual's use of a fake member with spiritual modes of apostasy, characterizing it as a literal rejection of God's laws. And the "chose" recalls a device also mentioned in texts directed at religious subjects centuries earlier. Hincmar of Reims, in his treatise on the divorce of Lothair from Theutberga, objected to women who "do not put flesh to flesh as in the fleshly genital member of one into the body of the other" but instead use "instruments of diabolical operations" (machinas diabolicae operationis) to excite desire and who thus sin by "fornicating in their own bodies" (fornicantes in corpus suum).[90] Early medieval confession manuals followed suit: a Latin penitential attributed to the Anglo-Saxon cleric Bede (but not written by him) prescribes penance for nuns who fornicate with other nuns by means of a machina.[91] This is a ruling repeated almost verbatim in the Decretum of Burchard, bishop of Worms (ca. 965–1025).[92] Burchard further expands on the idea in the influential nineteenth book of the Decretum, called by him the "Corrector," which was designed to aid priests in the administration of penance to lay people. In a lengthy chapter outlining the kinds of questions that might be asked of penitents, the bishop devotes a section specifically to women, suggesting that they might be asked, among other things, whether they have used "a device in the form of a virile member," according to the measure of their will.[93] The verse Ovide moralisé repeats this obsession with women's use of an artificial phallus. What in Metamorphoses is characterized as a full-blown sex change—a marvel that only the gods can effect—gets reduced in the French commentary to an event on a very human scale: a female homosocial world in which women plot with one another to deceive other women and God, substituting their prosthetically enhanced bodies for the bodies of the men who come before them.

Haunting this discourse of sequence, derivation, and bodily substitution is the specter of that other manifestation of thing-sex in Ovid's Metamorphoses: Pasiphaë's deployment of an artificial cow to precipitate her relationship with a bull. In the verse Ovide moralisé, the poet dramatically amplifies the brief reference to Pasiphaë in book 8 of Metamorphoses, so that the story of her bestiality now occupies 370 lines (OM 8.617–986).[94] This includes a histrionic aside from the narrator on the utterly distasteful implications of the queen's desire for the bull (OM 8.676–723), which he characterizes as "contre nature" (OM 8.718). The deployment of the phrase "contre nature" in the Pasiphaë narrative echoes the poet's characterization of dildo-facilitated desire in the "historial sentence" appended to the Iphis story, as well as deployments of the phrase elsewhere in the Ovide moralisé.[95]

Part of what goes against nature in each instance is that the desires that result are not, initially at least, wholly corporeal; rather they are facilitated by inanimate, humanly crafted objects—wooden heifers, dildos, and the like. The verse *Ovide moralisé* devotes considerable space to describing how it was via a material go-between, constructed by Daedalus, that Pasiphaë was first able to attract the bull's attention (*OM* 8.908–30). The desperate lover is described as making use of "enging" (*OM* 8.910), a word that could variously translate as "trick," "engine," or "thing," to complete her lechery; it is Daedalus's "art" that enables Pasiphaë to achieve "sa dyablie et sa pechié" (her devilry and her sin) (*OM* 8.918, 920).[96] And this allusion to prosthetic sex is deployed once more in the poet's retelling of the Iphis story and in one of the morals appended to it. As Iphis herself announces, when she reflects on the implications of Pasiphaë's bestial passion:

> Au malle se joint la femele,
> Si le deçut soutivement
> Par fraude et par engignement. (*OM* 9.2956–58)

[The female joined herself to the male, thus deceiving him cunningly, by fraud and by deceit.]

This reference to Pasiphaë's fakery and her efforts to engineer the situation to her advantage directly parallels the procuress's "chose" and the language of deceit and craft in the historical reading of Iphis's sex transformation. In both instances it is a question of an orientation toward things.[97]

Finally, there is an important back history to the goddess Isis, who according to Ovid oversees Iphis's sex change, which implicates the deity herself in an episode of phallic substitution. According to ancient Egyptian religion, the deity Osiris was brought back to life by his sister-consort Isis after he had been killed by his rival Seth, who dismembered his body into fourteen pieces. Isis finds thirteen of Osiris's body parts but is unable to locate the fourteenth—his penis—since it has been eaten by fishes. So she fashions an artificial phallus for her husband (which, depending on which account you read, is made from clay, wood, or gold), recites magical spells, and brings Osiris back to life; afterward the pair conceive a son, Horus, before Osiris passes into the next world. Isis, whose cult spread throughout the Greco-Roman world following the conquest of Egypt in the fourth century BCE, provides another context for Ovidian sex change by promoting the idea of the phallus as an incorporeal device, which nonetheless possesses generative powers.[98] Thus, although they are not explicitly acknowledged by medieval moralizers of the story, Ovid's Iphis narrative is

underpinned by a corpus of images of sorcery and phallic transfer that extends from Isis's resexing and revitalizing of her husband's body to Pasiphaë's utilization of artifice to effect her own quest for a bovine phallus.

Although the first prose abridgment of the *Ovide moralisé* eliminates the poet's fantasy of gender-usurping thing-sex, preferring only the spiritual exegesis,[99] other moralizations of Ovid repeat the anecdote but provide a different gloss on its relative significance. In Mansion's printed prose edition, both historical and spiritual interpretations are offered. Now, though, Mansion presents them as competing alternatives, rather than assigning one interpretation priority over the other. The legal records of late medieval Bruges, where Mansion's Ovid was printed, record several condemnations of women for unnatural sex in the course of the fifteenth century. In the period 1482–83, a year or so before the text was published, a group of six women were burned at the stake for the "pechié de zodomie," and in 1483 a widow was burned for the same crime; several cases are also recorded between 1490 and 1515 of women being subjected to corporeal punishment and exile for "zekere specyen van der onnatuerlike zonde van zodomye" (a certain species of the unnatural sin of sodomy).[100] Against this backdrop Mansion's decision to give the "sens historial" equal weight in his contextualization of the Iphis legend makes perfect sense. In Mansion's Bruges, moreover, the word "sodomy" is applied in the context of judicial proceedings against women, though it is unclear whether the "species" of unnatural sin in question involved expressions of female masculinity.

In Mansion's day, the standard treatise of criminal law and procedure in Burgundian Flanders was the *Practijke Criminele* of Philippe Wielant (1441–1520). This defined sodomy as a sin against nature, punishable by death by burning; such a severe penalty was warranted because by this period sodomy was characterized as a crime of *lèse-majesté*—an offense against both the divine and the social order. Those executed were condemned for the "très fort, villain et detestable criesme et pechié de zodomie."[101] The conclusion of Mansion's rendition of the anecdote about the dildo-deploying woman, which prays that no one henceforth have "envie" of "ceste euvre" (this work), ends with the statement that "trop est vilaine et vituperable et vers dieu et le monde" (it is too evil and disgraceful and against God and the world). Therefore although the word sodomy itself is never used, Mansion's language conjures up the very vocabulary used to condemn it in legal practice: the "euvre" of these imaginary women is also characterized as a crime of *lèse-majesté*. Moreover the flight of the cross-dressing woman's partner "du pays" (from the country) echoes the fate of those women who were exiled from Flanders at the end of the fifteenth century for a "zekere specyen" of sodomitic vice.

Caxton, a one-time collaborator with Mansion, also lived in Bruges during the third quarter of the fifteenth century, and he would surely have been

familiar with the repression of sodomy in this period: several cases of sodomy involved high-ranking male officials and were very well publicized.[102] Indeed, the commentary in Caxton's translation of the Iphis narrative shifts the emphasis more radically still, by eliminating the spiritual interpretation altogether; as in the *Ovide moralisé en prose II* that served as Caxton's source, only the historical sense remains. Rather than interpreting the story of Iphis as a Christian allegory, in other words, the narrator meditates on the practical realities of a woman's performing as a man in the bedroom.[103] This meditation provides an excuse for an outburst of flagrant misogyny—one of those moments that exceed the Christianizing logic that is the ostensible aim of Ovid's moralizers. The relevant passage in the manuscript reads as follows:

> It may wel be that in ancyent tyme was a woman that ware the habyte of a man whych semed a man. And they that saw her had supposed wel that she so had be. And the moder made the people also to byleve it. And it myght hapen that som fair mayde sawe her, faire, gente and plaisant, in th'abyte [habit] of a man and byleved that she was a man and desired to have her in maryage. And she, whych was folyssh and nyce, fyanced and espoused her, how wel she hade not th'ynstrumentes of nature, but, agenst the right of her, desyred to complaire [please] her lechery in her, how be it that she had such empesshement as afore is sayd, the whych wyf and very love knewe it not. So moche complayned she that the folysshe love tempted her that, by th'arte and craft of an old and evyl bawde achievyd her fowl desyre by a membre apostat and decyved this wif, whiche by lawe of mariage ought not to have her. And whan she apperceyvyd it, she hydd it no, but shewd and told it, wherof she had ever aftir all her lyf shame and vylonye and was sore blamed. And that other fledd and absented her fro the contrey. Now ther be none that have to doo with such werk, for it is over moch vylanous and domageable [harmful]. (9.1063–78)

What the narrator hypothesizes in this passage is a situation in which female seduction of another woman can be "achievyd." Caxton's prosification favors the interpretation that originally circulated in the verse *Ovide moralisé* as the initial, but ultimately inferior, exposition, which contemplates the very possibility that Iphis dismissed as thoroughly impossible in her speech: the marriage and sexual fulfillment of two women. The cross-dresser's masculinity in this moralizing aside is confined wholly to her performance, right down to the use of a "membre apostat" in place of "th'ynstrumentes of nature"; her enduring female nature is underscored by her inordinate desires, characterized as "folysshe," "fowl," and "vylanous." What the narrator effectively does, in other words, is to imagine how, through "art and crafte," female masculinity produces the corporeal effects of maleness—an outcome characterized unequivocally as morally suspect.

The cross-gender content of the story is by no means erased in this scenario, but it has been overwritten with an additional script that the Ovidian narrative itself tries hard to contain: the prospect of a sexual encounter between women. Yet at the end of the day, the moralization operates here at the level of a determined temporal displacement. The narrator's point is not that female homoeroticism cannot exist, but that it does not and should not exist in the present and future. It is in "ancyent tyme" ("ancienement" in the French analogues) that the narrator discovers a masculine-performing woman using an artificial phallus to bed a "fair mayde," and "now ther be none that have to doo with such werk"; furthermore the villainous cross-dresser's flight—her self-imposed exile "fro the contrey"—spatializes this act of displacement.[104] Caxton's text does something else here in articulating the fact that "now ther be none that have to doo with such werk." The verse *Ovide moralisé* simply urges readers not to have "envie" of this "oeuvre," which is too "dampnable" and sinful (*OM* 9.3156–57); Mansion's prose text follows suit, as we have seen, by praying that all who have read the story will not be persuaded to pursue the practice. Caxton's "now ther be none" adds a further dimension to the moral. If, in the other texts, anxiety is expressed for readers in the present and future, who may be tempted by the procedure just outlined, in Caxton's version transgender is cast as an anachronism while female homoeroticism itself is presented as a thing of the past. There is simply no room in the present to allow either possibility to be entertained.

Imag(in)ing Transgender: Illustrated *Ovide moralisé* Manuscripts

Early in its circulation the versified *Ovide moralisé* was illustrated with pictures, which provide an additional vantage from which to view the Iphis story's dissemination in the Middle Ages.[105] One of these illuminated manuscripts prioritizes the motif of sex transformation over homoerotic possibilities, but another does not. The oldest surviving copy of the *Ovide moralisé*, which dates to the first quarter of the fourteenth century, is Rouen, Bibliothèque municipale MS O.4 (1044) (hereafter Rouen O.4).[106] This deluxe manuscript, which incorporates the largest cycle of images of all the illuminated *Ovides moralisés*, was owned by Clemence of Hungary, widow of Louis X of France.[107] It contains three illustrations of the story of Iphis itself, followed by two scenes corresponding to the historical sense and the "better" allegorical gloss. The images accompanying Ovid's story begin with a scene showing Telethusa lying in bed, turning away from the baby to whom she has just given birth (presumably depressed that the child is a girl). A miniature on the next folio shows Telethusa and Iphis, both dressed as women, praying to the goddess Isis (fig. 25). This miniature does not match up to the text immediately beneath, which describes how "fille" (daughter) has transformed into "filz" (son). In the adjacent column,

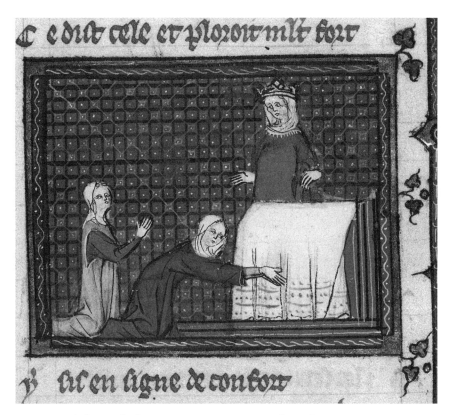

Figure 25. Telethusa and Iphis pray to Isis. Miniature in *Ovide moralisé*. Paris, circa 1315–28. Rouen, Bibliothèque municipale, MS O.4 (1044), fol. 244v (detail). Collections de la Bibliothèque municipale de Rouen. Photography C. Lancien; Y. Communeau.

however, we encounter an image of a soberly dressed male taking the hands of a woman wearing a skirt and raising it slightly with her hand (fig. 26). This is followed immediately by the text of the "historial sentence" and appears to be designed to correspond to it. Thus the male in the image stands in for the metamorphosed Iphis (as depicted in Ovid's text), a female impersonator (as the moralizer would have it), or the trans person (as we might wish to understand it), but at the expense of visualizing any "same-sex" implications. Finally, on the facing page, the alternative moralization shows a penitent sinner knelt before a male religious who holds a switch in one hand and blesses the devotee on the head with the other (fig. 27): the sinner presumably corresponds to Iphis, who, in the moral interpretation, denotes the sinful soul transformed by grace.

Strikingly, a second illustrated copy of the *Ovide moralisé*, Paris, Bibliothèque de l'Arsenal MS 5069 (hereafter Arsenal 5069), probably made just a few years later, produces a very different interpretation of events. Although the illuminators may have known Rouen O.4, to which some images correspond very closely, Arsenal 5069 has generally been interpreted as being freer and more

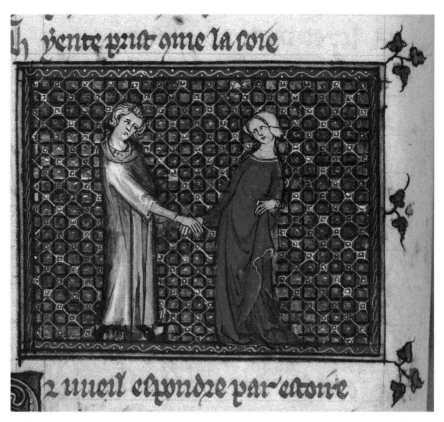

Figure 26. Iphis, metamorphosed, with Ianthe. Miniature in *Ovide moralisé*. Paris, circa 1315–28. Rouen, Bibliothèque municipale, MS O.4 (1044), fol. 244v (detail). Collections de la Bibliothèque municipale de Rouen. Photography C. Lancien; Y. Communeau.

creative than its counterpart, as well as being less courtly in expression; artists in Arsenal 5069 often make distinct iconographic choices.[108] This is certainly in evidence in the Iphis sequence. As in Rouen O.4, the manuscript contains a scene showing Telethusa in bed attended by two other women, one of whom holds the child: this is the only image corresponding directly to Ovid's story. On the following page, however, beneath a rubric announcing that this is the "moralité" of the story, which concerns a woman "qui se fut homme pour avoir une pucelle pour faire en sa volente" (who became man to have a girl in order to accomplish her desire), a miniature has been inserted, which depicts two individuals, dressed as women, embracing (fig. 28). Taking literally the "historial sentence," the Arsenal 5069 illustrator thus envisions a moment whose time never comes to pass in Ovid's tale itself: marriage without men. What is represented here is by no means an egalitarian, "same sex" utopia: as if to indicate an element of gendered hierarchy in the relationship, one woman draws the other into her arms by reaching forward. The scene partially resonates with another,

earlier in the manuscript, representing a male, possibly a cleric, forcing himself on a woman as a representative of the "mondains" (worldly) (fig. 29).[109]

Of course, staying with the allegorical, one might argue that the miniature of embracing women in Arsenal 5069 functions to illustrate the spiritual interpretation that follows immediately after: rolling the two interpretations into one, the image could also conjure up the salvation of the human soul (conventionally gendered female in medieval grammar and psychology) by the church (likewise gendered female). It could be viewed, from this allegorical perspective, as an image of Ecclesia enveloping Anima in her arms. Reliteralizing the scene, however, say as an image of erotic female coupling, is not simply the privilege of a modern audience, as moralized versions ranging from the verse *Ovide moralisé* to Caxton's English translation show. The narrator of the *Ovide moralisé en prose II*, which Caxton is translating, can fantasize about what an erotic relationship between women might entail, so long as it conforms to his phallocentric view of

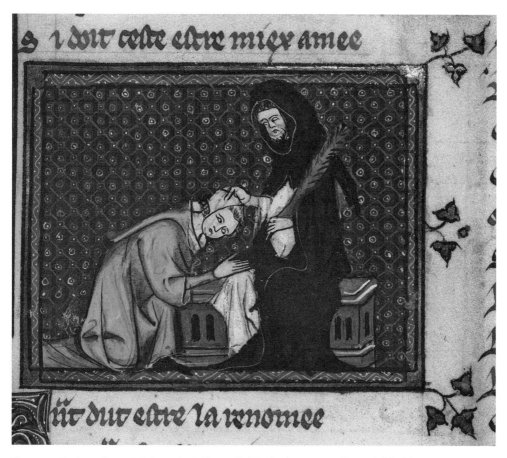

Figure 27. Penitent sinner. Miniature in *Ovide moralisé*. Paris, circa 1315–28. Rouen, Bibliothèque municipale, MS O.4 (1044), fol. 245r (detail). Collections de la Bibliothèque municipale de Rouen. Photography C. Lancien; Y. Communeau.

female sexuality. But he can do this only if it is additionally cast as a throwback to a dead and buried past. What he cannot do is to imagine transgender as anything other than a deceitful performance: against the testimony of ancient historians, natural philosophers, and mythographers, who at least recognize sex change as a possibility, corporeal transformation of the kind Iphis undergoes is figured as being impossible in reality. Sexual metamorphosis, reconfigured as a deceitful lie, is characterized as morally troubling and temporally contained.

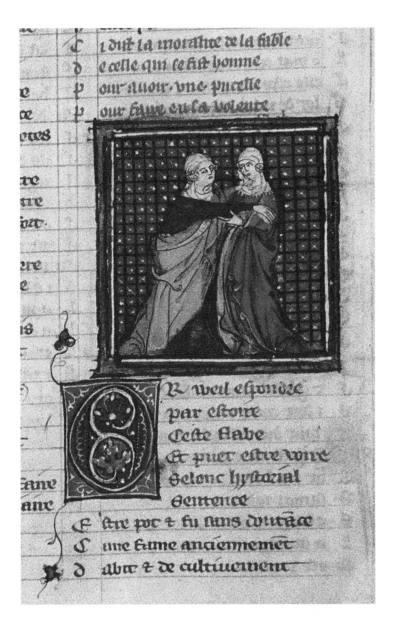

Figure 28. Iphis and Ianthe. Miniature in *Ovide moralisé*. Paris, 1325–35. Paris, Bibliothèque de l'Arsenal, MS 5069, fol. 131r (detail). Photo: Bibliothèque nationale de France.

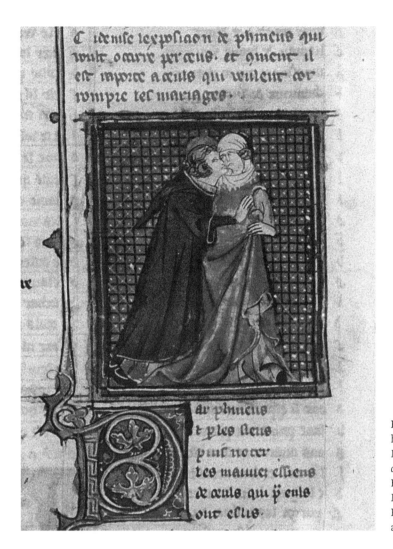

C idenise lexposiaon de phineus qui
vult ocurre per ceus. et coment il
est importe a ceus qui vuleur cor
rompre tes mariages.

ar phineus
t ples ficus
puis nocer
tes maintes essiens
de ceus qui ꝑ culs
out ellis.

Figure 29. Cleric forces himself upon a woman. Miniature in *Ovide moralisé*. Paris, 1325–35. Paris, Bibliothèque de l'Arsenal, MS 5069, fol. 64v (detail). Photo: Bibliothèque nationale de France.

Presenting Transgender: Christine de Pizan's *Le livre de la mutacion de Fortune*

The strategy of moralization deployed in Caxton's Ovid resonates surprisingly well with those strands within contemporary gay liberation politics that cast gender inversion as unfashionably retro; it also bears an uncomfortable resemblance to some of the assumptions in recent scholarship about the ostensible pastness of the inversion model. In my two concluding examples, I want to consider ways of reading gender and sexual dissidence that do not separate out past, present, and future quite so neatly. For perhaps it is by inhabiting the asynchronous relationship with time that Caxton's version of the moralized Ovid seems so intent on resolving—by identifying *with* such moments of time

out of joint—that supposedly anachronistic categories and experiences can be recuperated and remade.

One medieval appropriation of the story that saw in Iphis's mythic gender transformation a model for the present is contained in Christine de Pizan's *Le livre de la mutacion de Fortune* (The Book of Fortune's Transformation), completed in 1403. Although this lengthy allegorical poem comprises a comprehensive survey of the effects of fortune on the whole of human history, the opening section is presented in an autobiographical mode: Christine's narrator aims, in part 1, to trace his [*sic*] own development as author of the present book, following the death of his husband. What happens to the newly widowed Christine is characterized as nothing short of a sex change miracle.[110] To understand the goals of this project, the narrator writes,

> Vous diray qui je suis, qui parle,
> Qui de femelle devins masle
> Par Fortune, qu'ainsy le voult;
> Si me mua et corps et voult
> En homme naturel parfaict;
> Et jadis fus femme, de fait
> Homme suis, je ne ment pas,
> Assez le demonstrent mes pas,
> Et, si fus je femme jadis,
> Verité est ce que je dis;
> Mais, je diray, par ficcion,
> Le fait de la mutacion
> Comment de femme devins homme,
> Et ce dictié vueil que l'en nomme,
> Quant l'istoire sera commune:
> "La mutacion de Fortune."[111]

[I will tell you who I am, I who am speaking, I who was transformed from a woman into a man by Fortune who wanted it that way. Thus she transformed me, my body and my face, completely into those of a natural man. And I who was formerly a woman, am now in fact a man (I am not lying, as my story will amply demonstrate), and, if I was formerly a woman, my current self-description is the truth. But I shall describe by means of fiction the fact of my transformation, how from being a woman I became a man, and I want people to name this poem, once the story becomes known, *Fortune's Transformation*.]

This initial statement is followed by others that build to a discussion of the Iphis legend. The narrator spends several hundred lines describing his parents, and

emphasizes, in the course of this discussion, his father's formative role in what he perceives as a complete, corporeal transformation later in life. Christine's father, like Ligdus, had a strong desire for a male heir, whereas Christine's mother wanted a child who resembled her, so he ended up being born a girl. But, as the narrator puts it, Christine resembled his father in all things,

> Fors du sexe tant seulement
> Mais des façons, de corps, de vis,
> Si bien que il vous fust avis,
> Meismement es condicions,
> Que tous semblables les eussions. (396–400)

[only excepting my gender: in manner, body, face, we so resembled each other that you would have thought that we had them in common.]

Following this reference to Christine's masculinized persona even before the transformation, which extends, as in Ovid's Iphis, to androgynous appearance, the narrator describes the marriage—portrayed allegorically as a decade in the court of Hymenaeus—before going on to recount examples from Ovid that provide analogues to the wondrous miracles that Fortune every day effects. Fortune's power, the narrator writes, is even greater than that of the two serpents who, when Tiresias strikes them with his staff, turn Tiresias from man to woman and back again (1059–93). This discussion is followed immediately by a version of the Iphis story.

Christine's reworking of Iphis begins by evoking an ancient king of Lydia, who "tant ot femme en haÿne" (1095) (hated women so much) that he ordered any girl child to be killed. This blunt reference to the king's misogyny contrasts starkly with his wife's "nature de mere" (1108) (maternal nature), which causes her to protect her newly born daughter. The mother, indeed, becomes the main protagonist in this retelling of the story: Iphis's dilemma is consistently presented from the mother's perspective, so that, when the time comes for Iphis's marriage, it is the mother rather than the daughter who undergoes an existential crisis:

> Or est la royne esbahie,
> Or a ale sa vie enhaÿe,
> Car plus ne scet ne tour, ne voye,
> Comment a la celer pourvoye.
> Or cuide bien estre honnie,
> Ne scet comment le fait plus nye,
> Si pleure bas, en recelee. (1125–31)

[Then the queen was dumbfounded; then her life was hateful to her, for she no longer saw any means, any strategy for hiding her daughter's gender. Then she felt sure to be shamed, she did not know how she could deny the facts, and she wept softly, in private.]

No mention is made here of Iphis's burning passion for a woman, or of the absence of the phallus that, according to some versions of the story, prevents that passion from being fulfilled: this is a reading in which any hint of homoerotic possibility or sexual activity has seemingly been effaced. In keeping with Christine's interest in other mother figures in the *Mutacion*, notably mother Nature (whom the narrator views as creating his original female nature) and Fortune (who, by reforming Nature's work, effectively becomes a second mother to Christine), Iphis's mother thus eclipses Iphis herself as the focus of the story.[112] Finally, as Christine tells it, the mother visits the temple of Vesta (whose temple in Rome was ministered by unmarried women committed to chastity) rather than that of Isis; prays; and the goddess effects Iphis's transformation from daughter into son.

These retellings of Ovidian myth precede what is the ultimate goal in this opening section of the *Mutacion de Fortune*: to demonstrate how the narrator has undergone his own miraculous *mutacion* following the bereavement, which he narrates through an allegorical story about a storm at sea. The specific terms in which the poetic persona recounts his transformation generate further parallels to the Iphis narrative. First, Christine says that it was his maternal duties during the period of grieving following the husband's death that saved him from suicide and led to the transformation—a reference that resonates with the emphasis on Iphis's mother's own maternal instinct as the catalyst for her daughter's salvation. Second, although Iphis's own bodily transformation is not described following the events in the temple—Vesta simply "deffit / Son corps de femme et filz le fit" (1157–58) (undid her woman's body and made her a son)— Christine himself, awakening from her grief, describes how

> Tel qu'incontinent et sanz doubte
> Transmuee me senti toute.
> Mes membres senti trop plus fors
> Qu'ainçois et cil grant desconfors
> Et le plour, ou adés estoie,
> Auques remis; si me tastoie
> Moy meismes com toute esbahie.
> . . .
> Estoit muee et enforcie

Et ma voix formet engrossie
Et corps plus dur et plus isnel. (1335–41, 1349–51)

[immediately and with certainty, I felt myself completely transformed. I felt
my limbs to be stronger than before, and the great pain and lamentation which
had earlier dominated me, I felt to be somewhat lessened. Then I touched my-
self all over my body, like one completely bewildered . . . I felt that my flesh was
changed and strengthened, and my voice much lowered, and my body harder
and faster.]

The corporeal changes enumerated here, while not identical to the changes
listed by Ovid, are presented as stylistically analogous. Step by step, the nar-
rator lists his perception of greater strength, manifested in such qualities as
a deepened voice and a hardened body; these are what, in the eyes of Chris-
tine, make him a man. Bodily strength combines with a newfound authority
and boldness which enables him, continuing the sea metaphor, to become "vray
homs, n'est pas fable, / De nefs mener entremettable" (1391–92) [a true man (this
is no fable), capable of taking charge of the ship].

Christine's own take on the Iphis myth thus identifies with what might be
called its transgender content at the expense of its homoerotic implications. In
his summary of the Tiresias myth, the narrator has already eliminated the sex-
ual implications of the Ovidian analogue.[113] Although readers are informed that
Tiresias was a woman "en tous les cas, ou s'esprouva" (1076) (in every situation
which (s)he experienced), the narrator supports this observation with a refer-
ence to how Tiresias, during seven years of womanhood, sewed and labored in
women's tasks (1080–81). Likewise any reference to Iphis's erotic life is erased
in Christine's appropriation of the story. This is achieved in several ways. First,
as already mentioned, the mother becomes the chief site of feeling and instiga-
tor of events; gone is Iphis's lengthy soliloquy on the impossibility of her desire
for another woman, and only the mother's shame and weeping remain on show.
Second, Vesta replaces Isis as the divine architect of the miracle: a goddess of
the hearth and home, whose cult was bound up with the twin ideals of chastity
and fertility, replaces a goddess whose links to the Osiris myth identified her
with sorcery and phallic substitution. Finally, the prospective partner Ianthe
is never named, nor does she even figure as a nameless presence in Christine's
text: the narrator devotes no space at all to imagining a feminine partner for the
protagonist whose metamorphosis mirrors his own.

There are several consequences to Christine's radical revision of the Iphis
story in the *Mutacion de Fortune*. Explicitly resisting the discourse initiated
in the verse *Ovide moralisé* of the dildo-wearing woman, whose attempts at

emulating male anatomy constitute yet another instance of feminine perversity "contre nature," Christine exposes male phallic privilege as itself a simulacrum by suggesting that he himself—a new man who has undergone FTM transition—can embody the powers conventionally attributed to the phallus. In so doing the narrator consigns to oblivion the interpretation promoted by several of Ovid's medieval moralizers—that in assuming roles conventionally assigned to men within patriarchy, women who play an "active" role in sexual acts with other women constitute failed men or frauds—by repeatedly emphasizing instead the veracity and completeness of his own transformation. Additionally Christine's Iphis, prior to transformation, possesses no erotic inclinations. Since she lacks a soliloquy in which to express her desires, Iphis's "sexuality" fails to register. Whereas the anxieties expressed by Caxton and others regarding phallic substitution afford an opportunity to glimpse, from sideways on, the possibility that some women, whether "now" or in "ancyent tyme," might possess resources for expressing erotic autonomy without men, the vision projected by Christine's *Mutacion de Fortune*—which stridently rejects aspects of that misogyny—discovers in Iphis's story an account of sexual metamorphosis without the sex. Effecting a distinction between categories that, in Ovid and his other moralizers, has a tendency to be more blurred, Christine's narrator appears to want (trans)gender without the (homo)sexuality.

Furthermore Christine's relegation of Ianthe not just to the textual margins but to a nameless existence beyond the text participates in the structures of femme (in)visibility discussed earlier in this chapter. Feminine participants in homoerotic acts were not always completely unthinkable or insignificant in medieval cultures, for example, "she who subjects herself" to a woman in Hildegard of Bingen's *Scivias*. In legal contexts they were occasionally punished if and when their partner was a woman who cross-dressed or used prosthetic devices, albeit usually less severely than those perceived as usurping men.[114] In cultural representation, as the Iphis and Ianthe narrative demonstrates, these women were sometimes also assigned roles themselves as desiring agents. Thus in Caxton's retelling, following Ovid's own references to the fires of passion raging in the "altera virgo" (9.764–65) (other girl), space is also devoted to describing Ianthe's love for Iphis. So long as the narrator emphasizes Ianthe's ignorance of Iphis's "true" identity—that "he had ben a man"—and so long as the couple's desires are filtered through a conventional language of egalitarian same-sex friendship, which echoes comments made by Ovid on the equal age, beauty, and learning of the two (9.718–21), ideas of a woman-loving woman can be entertained. Moreover after Iphis has made her complaint about the impossibility of female homoeroticism, Ianthe's own desires are acknowledged, even if they are not expressed in direct speech. Says Caxton's narrator:

And Yente was not in lasse desir of love. She bewaylled moch the tyme that over longe taryed as she that wend not to see the hour that the maryage shold be made. She praid ofte to the goddes that the day myght soone come that she myght be wedded to Yphys. (9.1023-27)

The femme is assigned an even more tangible persona in versions of the Yde and Olive romance disseminated in the later Middle Ages, where the Emperor of Rome's daughter Olive—whose role is equivalent to Ianthe's in the Ovidian analogue—is married off to the cross-identifying Yde prior to the divinely instituted sex change. Olive, following the wedding, expresses a fervent desire to consummate her union sexually, at which point Yde reveals herself as another woman. But Olive does not appear to be especially shocked by the revelation. She is assigned dialogue, continuing to call Yde her "lover" and promising to keep the affair secret from her father. And when the Emperor gets wind of the fact that his daughter's husband is a woman, he labels it "buggery"—a vernacular term that, in the later Middle Ages, became interchangeable with sodomy—and threatens to burn the pair.[115] In these ways Olive's desire is rendered intelligible, even as it is located in a time before her companion's sex change. As in Caxton's Ovid, femme lovers are relegated to the past, but they are not, by that same token, wholly unthinkable: the women's passion is given a label, after all.[116] Conversely, Christine de Pizan's efforts to imagine a social and corporeal version of gender transition without any necessary erotic consequence mean that the author's appropriation of the Iphis story cannot countenance the body of the femme.

One other effect of desexualizing the Iphis narrative is to eliminate the capacity of the transformed body to be a sexed body. Although Christine is clear that he has been completely and entirely transformed, no mention is made of acquiring a penis in the moment of sex transformation; the definition of male embodiment does not—in either Christine's or Iphis's case—extend specifically to a new sex organ.[117] While Ovid's own description of Iphis's transformation also fails to visualize the acquisition of a penis, preferring to foreground other markers of corporeal change, its absence prior to the sex change is dimly evoked during the protagonist's prenuptial crisis. Conversely Christine's own experience of becoming man is ultimately a mode of spiritual rather than sexual metamorphosis: just as Christine's own name is a feminine form of "Christ" (371-78), s/he becomes a new man in Christ following the bereavement.[118] Christine's vision arguably evokes a sex change without the sex. This is not necessarily out of any "homophobia" on Christine's part; rather, as Kevin Brownlee has argued, it is part of a general tendency in Christine's literary output following the death of her husband to distance herself and her literary protagonists

from their traditional positioning as sex objects and sexually desiring subjects. Christine's strategies for neutralizing this discourse of female sexuality include inhabiting the position of virtuous widow and foregrounding the maternal consistently at the expense of the sexual.[119]

Ostensibly Christine's *Mutacion de Fortune* thus manages to purify transgender of its erotic repercussions: it foregrounds gender at the expense of sex and sexuality. Even in this retelling of the Iphis story, however, homoeroticism arguably continues to inflect the narrative from the sidelines. Christine's narrator imagines his own transformation, after all, in terms that conjure up the image of the female allegorical figure of Fortune touching the body of Christine's poetic persona: "my mistress" Fortune, he reminisces, came over to the sleeping Christine and

> Si me toucha par tout le corps;
> Chacun membre, bien m'en recors,
> Manÿa et tint a ses mains. (1327–29)

[she touched me all over my body; she palpated and took in her hands each bodily part.]

Unlike that of the usurper in the moralization, the transformation is not mediated by a transferable body part. It is fantasized as being effected not by a phallic substitute, as in the verse *Ovide moralisé*, but by the ministrations of a woman whose magic touch extends across Christine's entire body. We should remember, though, that this body is a trans body. While, in the persona of the narrator, it is unequivocally male, what Fortune touches at the moment of transformation was also born a *pucelle*. This nonphallic image of (fe)male-female association, constituted here through a language of touch, potentially hints at another dimension to Christine's reworking of the Iphis myth. Even as the homoerotic implications of a partnership between a feminine woman and her cross-identifying partner are suppressed, the moment of gender transformation generates alternatives to the phallocentric tone of Ovid's other moralizers.

Lesbian Futures: Ali Smith's *Girl Meets Boy*

In closing, I wish to consider one last response to the Iphis and Ianthe story, written some six centuries after Christine's *Mutacion de Fortune*. In 2005, the Edinburgh publisher Canongate launched "The Myths" series, a string of contemporary takes on classic tales by well-known authors; each book in the series contains a preface defining myths as "universal and timeless stories that reflect

and shape our lives." It is easy enough to see how, in the hands of some of Ovid's medieval redactors, the myth of Iphis becomes the very opposite of timeless, by conforming so closely to the moral structures in which they were embedded. It is by promoting the purity of this (medieval) Christian present over the impoverishment of that (ancient) pagan past that translators such as Caxton hope to keep the concept of "maryage without a man" in check. The response of one of the authors enlisted to "The Myths" series—the British writer Ali Smith—equally remakes the myth of Iphis as anything but timeless. Smith's novel *Girl Meets Boy* achieves this temporal anchoring by situating the story—or as the blurb on the back of the Canongate paperback edition declares, "re-mixing" it—in a resolutely culture-bound, time-specific mode: a world of Facebook and MySpace, of corporate-speak and British popular culture, all against the backdrop of Smith's hometown of Inverness in Scotland.[120] This is a response to Ovid's tale so located that it is hard to imagine precisely how the book could travel, and be comprehended fully, in times and places other than early twenty-first-century Britain. Yet Smith's own political commitments transform Ovid's tale into a narrative that puts lesbian desire at its very center, and advances the thesis that all gender binaries are temporal and therefore malleable. In so doing, she is responding to Butler's dictum that "gender is an identity tenuously constituted in time"—it is this very phrase that Smith quotes in one of the epigraphs in the novel's preface (ix). But she is also making the point that stories—myths—are themselves constituted in time, and subject to misappropriation and misquotation. It is this that enables her to transcend the limitations of Ovid's original text, expose its weaknesses, and set it on a different path. Ovid, in all his Roman specificity, obsesses about "what it is that girls don't have under their togas, and . . . can't imagine what girls would ever do without one" (97). Conversely the novelist's own aim is to foreground the messy implications of a world in which gender relations remain in play and in which marriage without men is a possibility.

Girl Meets Boy tells the story of Robin, a girl-cum-boy who scrawls political graffiti around Inverness under the moniker "Iphis," as seen through the eyes of Anthea (stand-in for Ianthe) and her straitlaced sister Imogen, nicknamed "Midge." In Smith's myth it is Midge herself, rather than Iphis-identified Robin, who undergoes the central transformation in the narrative: she shifts from naivety and narrow-minded homophobia to political conscience by the novel's end. Thus, Smith discards the Ovidian motif of divine sex change in favor of recurrent images of gender fluidity and fusion. The opening line of the novel is "Let me tell you about when I was a girl, our grandfather says" (3), an expression that disrupts notions of patrilineal transfer along a male line. The book's gendered wordplay culminates in a description of Robin herself, who, according her lover Anthea, embodies a surplus of inverted expectations:

She had the swagger of a girl. She blushed like a boy. She had a girl's tough-
ness . . . a boy's gentleness. She was as meaty as a girl . . . as graceful as a boy.
She was as brave and handsome and rough as a girl . . . as pretty and delicate
and dainty as a boy. (84)

Smith's remixing resists the ascription of timelessness to myth by situating her
novel in a setting that is conducive to sociopolitical transformation; the novel-
ist's celebrations of gender versatility and fluidity, much as they contrast mark-
edly with the medieval moralizers' dreams of lesbian impossibility, arguably
sideline precisely the aspect of Ovid's story that contemporary readers with
continuing attachments to gender binaries may find meaningful in the present:
the dream of sex transformation itself as a corporeal possibility. Discarding this
as the anachronism at the heart of Ovid's tale—and conversely promoting the
fact that, even in Inverness, genders need not simply be male or female—Smith's
vision of transgender generates its own temporal displacement. As Anthea de-
clares, when discussing with Robin the nuances of Ovid's myth, "Thank God
we're modern" (91).

I would like to make clear, then, that my point in invoking Smith's *Girl Meets
Boy* as a counterpoint to medieval transformations of Ovid such as Caxton's is
not simply to reinforce well-worn dichotomies between an intransigent, dark,
and ethically dubious past (Caxton) and an exhilarating, joyful, and right-on
present (Smith). The contemporary novel favors mutability over rigidity, move-
ment over constancy. But it shares with Caxton's narrator, and with the illus-
trator of Arsenal 5069, an interest in fantasizing the possibility of marriage
between women, albeit from a very different perspective. What Smith con-
sciously discards, in her appropriation of the Iphis myth, is the motif of sex
change itself as a mode of sequential FTM transfer. Rather than marking the
union of a (femme) woman and a (trans) man, the novelist thus promotes an
ideal of perpetual translation and transformation. "Reader, I married him/her,"
Anthea announces, in a parody of a line from Charlotte Brontë's *Jane Eyre*; this
wedding, like sex change in the Ovidian narrative, is depicted as the dreamlike
embodiment of "what's still impossible after all these centuries" (149). At the
same time this focus on the motif of marriage without men directs attention
away from that other motif of impossible embodiment in the Iphis myth, which
is brought to the fore in Christine de Pizan's *Mutacion de Fortune*: the idea of an
individual who really and truly does change sex. *Girl Meets Boy* attempts instead
what in Christine's account is only hinted out: it imagines a field of erotic pos-
sibilities for women that bypasses the phallic obsessions of Ovid's moralizers.

Thus what in Christine's retelling is relegated to the background of the
narrative—homoerotic experience and desire—becomes, in Smith's rework-
ing, the starting point for a meditation on the relationships between lesbian

identity, gender stereotyping, and sexual terminology in modern Britain. Following an account of Midge's reflections on her realization that her sister is, as she puts it, "A GAY" (49), for example, Midge goes to meet two male friends in a pub, who proceed, in a clichéd outpouring of misogyny and homophobia, to use disparaging coded language to refer to what they perceive as "unfeminine" (67) women and define lesbian sex as "pointless" and a "state of lack" (69). Such passages highlight the persistence of Ovidian blind spots about sex and gender, while also reflecting on the broader politics of gender and sexuality in contemporary British culture. Here, then, there is no room for a vision of gender transformation in which erotic implications are suppressed or sidelined: gender and sexuality are presented as mutually informing categories. Gender variance also fails to conform to a sequential logic that sees it as a cloak for some deeper, homoerotic truth; transgender is not simply presented as a movement from a to b, but, like water (a persistent metaphor in the novel), signals the fluidity and malleability of time and of human experience.

The idea of "transgender time," the expression I have adopted in this chapter's title, gets at the potential for differently gendered bodies to be imagined as temporally distinct—inhabiting alternative timescales with respect to the one inhabited by Halperin's "modern homosexuals." But pushing at the edges of this "pre-homosexual" timeline is the possibility of sexual expression between women that is just that. It is these Middle Ages of coexisting possibilities, situated somewhere between "lesbian" and "transgender," that Ovid's translators negotiate in different ways. Gender variance provides a foil against which sexual dissidence can be defined and visualized, but this is not inevitable. Christine's *Mutacion de Fortune* shows how what might be called a trans identity, rooted in a concrete experience of FTM transition, can become isolated from erotic meanings, just as today—in some contemporary political and institutional contexts—the deployment of "transgender" has worked to remove from categories such as "gay" and "lesbian" visible associations with gender-variant behavior. Conversely, other reworkings of Ovid, even into the twenty-first century, treat gender crossing as a defining feature of homoerotic behavior. Caxton's narrator can stomach such a scenario only if it takes place in a location that is temporally curtailed; he also follows other moralizers in reimagining insurrections of gender as modes of human artifice rather than natural or miraculous occurrences. The areas of overlap between what has been defined, in some branches of contemporary scholarship, as clear distinctions among biological sex, social gender, and sexual desire, mean that individuals who are perceived as being more conventionally "feminine" in this scenario appear to have less purchase on visibility than their gender-inverted partners. Yet, as one of the illustrated *Ovide moralisé* manuscripts demonstrates, the femme is not *utterly* insignificant, just as sodomy is not always utterly confused. She may often

depend for her intelligibility on the implied presence of the butch, but she does not fail to signify altogether. Conversely what most insistently comes into view in some of these interpretations of Ovid's story—that gender insurrection relies on various forms of bodily prosthesis and anatomical reinvention—generates a potentially troubled vision. The image afforded of the "instruments" and "members" taken up by masculine or tribadic women is sometimes quite precise (as the Hetzeldorfer record shows), but often it also harnesses the ambiguity and heterogeneity of things.

Throughout this chapter I have been arguing for the potential utility of transgender as a prism for understanding medieval encounters with sex change and other modes of gender variance, as well as interrogating the category's associations (or not) with homoerotic behavior. For all the temptation to read the legend of Iphis and Ianthe as a story that renders visible, via gender, a field of sexual possibility that would otherwise remain invisible and impossible, Iphis "is not only or easily a lesbian."[121] At the same time I remain wary of efforts to reify transgender as the preferred lens through which any subsequent interpretations should be filtered—what might be called, following the *Ovide moralisé*, the "meillour sentence" of sex transformation narratives. What appears from one angle to be transgender might, with a subtle shift of perspective, come into view as a form of homosexuality; distinctions among "sex," "gender," and "sexuality" are embedded in a logic of sequence that prioritizes certain terms over others in the realm of visibility.[122] In the next chapter, when I turn to medieval responses to the myth of Orpheus, I want to consider a different dimension to this sequential structure. As we shall see, the look of the sodomite—even the "first" sodomite—is consistently figured as a backward glance.

The First Sodomite

The myth of Orpheus features, as its protagonist, a man who is iden-
tified with beginnings, with coming first. But he is also embedded in
structures of imitation and retrospection. When, in his 1494 drawing of
Orpheus's death (fig. 30), Albrecht Dürer (1471–1528) included a bande-
role above the scene of the hero's murder labeling him "orfeuß der Erst
puseran"—Orpheus the first sodomite or "bugger"—he was playing on a
whole series of associations between Orpheus and origination. Orpheus
has always been a model from which other traditions are derived. He
is characterized as being first among artists, poets, or musicians, who
charmed nature with his creative powers.[1] He is credited with invent-
ing writing.[2] He is the archetypal lover, whose devotion to Eurydice has
provided countless poets, philosophers, and critics with material for
meditating on sexual difference, the myth of heterosexuality, and the
relationship between love and death.[3] He is even associated with found-
ing a religious cult that provided a monotheistic alternative to ancient
pantheism.[4]

Numerous competitors for Orpheus's privileged status as a founder
figure have also circulated in Western cultures. Throughout the Mid-
dle Ages the biblical book of Genesis provided a source for meditating
on many aspects of the originary thinking also associated with Orphic
legend. Genesis itself offers a sustained meditation on sexual differ-
ence and the union of male and female. As we saw in chapter 1, Eve was

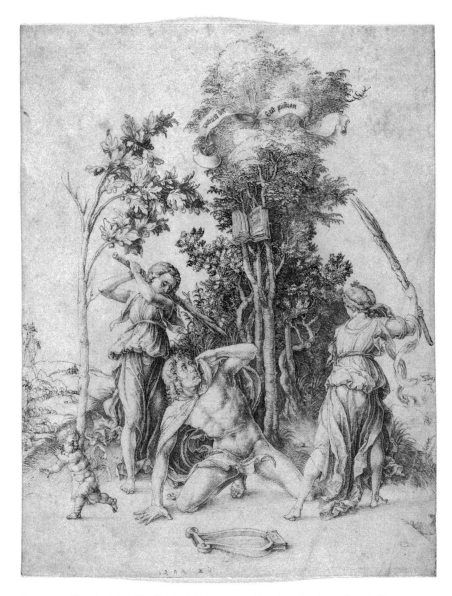

Figure 30. Albrecht Dürer, *The Death of Orpheus*, 1494. Drawing. Hamburg, Kunsthalle, inv. 23006. Photo: bpk/Hamburger Kunsthalle/Christoph Irrgang.

characterized in the story of the fall as having a predisposition to specifically feminine modes of sinful fleshliness, embodied in the figure of a female serpent. Thus Eve herself could—very occasionally—be construed as a kind of "first sodomite," to the extent that her feminine perversity was viewed as a point of departure for all subsequent orientations away from the spirit and toward the flesh: the earliest of the *Bibles moralisées* (fig. 3) articulates precisely this possibility.

Also located in Genesis are several other foundation myths that compete with Orphic claims to origination and sexual outlawry. These include Abraham, that other founder of monotheistic tradition; Abraham's nephew Lot, whose sexual relations with his daughters, following his escape from the city of Sodom, are the first acts of father-daughter incest recorded in the Bible; and of course those other "first" Sodomites, inhabitants of Sodom, whose iconic punishment became a model for subsequent condemnations of fleshly vice. Yet the figure of Orpheus as originator has persisted, through the Middle Ages and beyond.

This chapter interrogates medieval interpretations of the Orpheus legend as an originary story, obsessed with the problem of beginnings, as a means of confronting from a different angle the sequential logic that conditions the way sodomy is visualized and becomes intelligible in the period. One of the motifs this story shares with the biblical narrative of Sodom is that Orpheus's failure is precipitated by an act of looking. Not only is the sense of sight crucial to the denouement of the narrative—Orpheus's inability to rescue Eurydice in Hades is associated, in the most influential accounts, with a forbidden look—but what is punished specifically is a backward glance, an act of retro-vision, that instantiates the hero's turn from his beloved wife to young males as a response to loss. Also punished for the crime of looking back, in Genesis 19, is Lot's wife, whose scopophilic tendencies echo those of her forerunner Eve. As with Lot's wife and Orpheus, so with Eve: medieval art and literature, from at least the thirteenth century, presented the first woman's fall from grace in emphatically visual terms. Paradoxically, though, these acts of erroneous looking, which construct the bearer of the look as an initiator or founder figure, also work to foreground the secondary status of those initiating moments. Orpheus's love for males follows after his love for Eurydice; his polygamous attachment to lover boys is presented as a fundamental departure from, and poor substitute for, the celebrated union he previously sustained with a single woman. What is at stake in constructing this tale of the beginnings of male pederasty simultaneously as a tale of endings, and of coming second? When and how was this story of the "first sodomite" told in medieval art and literature, and why has it fallen by the wayside in subsequent centuries?

Several distinct accounts of the Orpheus story circulated in ancient cultures, which became the starting point for medieval retellings.[5] It is pointless to try to discover in these classical traditions a primary or *ur*-Orpheus. As a myth of origins, the Orpheus legend cannot be traced back to a discernible beginning or point in time; there is no "original" Orpheus. All we can say with certainty is that some of the earliest recorded mentions of Orpheus, in writing and in art, constructed him as both a founder and a celebrated artist. The oldest literary reference to Orpheus appears in a fragment from the Greek poet Ibykos (sixth

century BCE), describing him as "onomaklyton Orphēn" (famous Orpheus).[6] The source of that fame, as depicted also in early vase paintings and mosaics, was most likely Orpheus's supreme musical ability.[7] Alternatively Orpheus's celebrity can be attributed to his success in bringing back his wife Eurydice from the land of the dead. In this, as in stories of Orpheus's ability to tame animals with his music, Orpheus was held to transcend the laws of nature. With the Romans, thanks to Virgil and Ovid, the tradition of Orpheus's loss of Eurydice became one of the legend's other defining motifs. He who overcame or civilized nature was also defeated by nature's most basic necessity, death, which is the fate that every living being shares.[8]

Virgil's story of Orpheus and Eurydice appears in book 4 of his *Georgics* (29 BCE), where it is framed by another tale of loss, that of the beekeeper Aristaeus, who confronts the imminent demise of his cherished colony of bees. As the bees begin to sicken and die, Aristaeus consults the seer Proteus with a view to discovering which of the gods he has angered to warrant such a loss. Proteus announces that Orpheus is the source of punishment: it is because Eurydice ran away from Aristaeus, who was trying to rape her, that she failed to see a serpent in the grass, was fatally bitten, and ended up in hell. Virgil then recounts the tale of Orpheus's descent to the underworld to win her back. Orpheus's strategy is to bewitch the inhabitants of hell with his music. The phantoms of the dead lie spellbound; three-headed Cerberus, guardian of the gates of hell, forgets to bark; even the fiery wheel to which kin-slayer Ixion is eternally bound ceases to spin as a result of Orpheus's song. Moved, the Fates allow Orpheus to return with Eurydice, on condition that he resists the temptation to look at her on the homeward journey. But look back he does, and in that moment the pact is broken: Eurydice laments, vanishes from sight, and Orpheus is left hopelessly snatching at shadows. Robbed a second time of his beloved, he spends seven months wandering the frozen north in grief, until the Ciconian women, resenting such extremes of devotion, tear the youth limb from limb. Virgil's tale concludes with the eerie image of Orpheus's severed head floating down the river Hebrus, the banks of which echo with the cry of "Eurydice" as it issues from his dying breath.[9]

Ovid's reworking of the legend, written a few decades after Virgil and incorporated into *Metamorphoses* (10.1–85), presents a very different spin on the principal events. Although the poet retains the motif of Orpheus's backward glance, which appears for the first time in Virgil's retelling, *Metamorphoses* also incorporates a redemptive coda: following his death at the hands of the Ciconian women, Orpheus is reunited with Eurydice in hell (11.1–66). At the end of book 9 of *Metamorphoses*, readers have just witnessed the happy marriage of Iphis and Ianthe, following Iphis's miraculous transformation into a man, as

discussed in chapter 2. Hymenaeus, god of marriage ceremonies, was in attendance at this wedding. Now, in a seemingly casual transition at the beginning of book 10, Hymenaeus is summoned by the voice of Orpheus, who requests his presence at the young man's own wedding. But in contrast with the joyous occasion just encountered in Crete, the omens for this marriage are not good. The wedding torch held by Hymenaeus hisses and fails to ignite. And then, while the new bride Eurydice is out walking with her fellow nymphs, she is bitten on the ankle by a serpent and falls dead. The great "vates" (10.12) (poet) descends to the underworld, stands before Pluto and Proserpina, and sings a song. As a result of his exertions, Eurydice is reunited with her husband and allowed to return to the upper world as long as he does not turn his eyes behind him on the homeward journey. But worried that Eurydice will not make it up the steep road back to earth, Orpheus turns around to look, and immediately she falls away. Stunned, he sits grieving on the bank of the river Styx for seven days. Then, after describing in detail the lengthy song that Orpheus sings following the second loss of Eurydice, which takes up the remainder of book 10, Ovid recounts how, after Orpheus has been killed by the Ciconian women, his shade descends into the underworld a second time, finds Eurydice, and the pair are happily reunited. Henceforth Orpheus and Eurydice walk together side by side, she sometimes leading the way, sometimes he. And now Orpheus can look back—*respicit* (11.66)—unfailingly at his beloved.[10]

Some scholars have seen in Ovid's reworking of the story a parodic commentary on the overblown rhetoric of Virgil's *Georgics*. The argument goes that Orpheus's lament in Hades, in which he claims to speak the truth and to be laying aside stock poetic phrases (10.19–20), actually consists of a series of platitudes and literary commonplaces on the universality of death. "We all die," Ovid's Orpheus exclaims, so just give Eurydice back to me awhile! The seven days of grieving (compared with Virgil's seven months) also suggest insincerity on Orpheus's part. The hero seems to be more intent on overcoming death than on rescuing his beloved, and Eurydice's own role in the tragedy is consequently reduced. Ovid never assigns Eurydice any dialogue, and the cause of her initial death is completely arbitrary: gone is the frame narrative of Aristaeus the would-be rapist.[11] Others have claimed that Ovid's aim here is to humanize Orpheus, taking him down from the tragic pedestal on which Virgil has placed him and situating him in a world of realistic and comprehensible human emotions.[12]

Whether the changes wrought by Ovid in *Metamorphoses* were designed to humanize or to satirize, the description of Orpheus's love life following his second loss of Eurydice contributes further to a shift of emphasis. Henceforth Orpheus turns away from the love of women, and the narrator reflects on why this might be the case:

> refugerat Orpheus
>
> femineam Venerem, seu quod male cesserat illi,
> sive fidem dederat; multas tamen ardor habebat
> iungere se vati, multae doluere repulsae.
> Ille etiam Thracum populis fuit auctor amorem
> in teneros transferre mares citraque iuventam
> aetatis breve ver et primos carpere flores. (10.79–85)

[And now because it had ended sadly for him, or because he had vowed to be faithful, Orpheus fled the love of females. Yet many women longed for unions with the bard, and many grieved when he rejected them. He was also the first among the people of Thrace to transfer love to tender males and so to pluck the first blossoms boys offer in that brief springtime before they become young men.]

Ovid's rhetoric in this passage is striking. Orpheus is presented as an *auctor* among the men of Thrace, an initiator or originator of love for males. This draws on allusions elsewhere to Orpheus as an inventor and promoter of pederasty.[13] In these references Orpheus's pederastic transfer (*transferre*) is intimately connected with his shunning of women, and punished by those same women. Ovid's statement regarding Orphic pederasty is slightly ambiguous: the word *auctor* could possibly be taken to refer to Orpheus's role as a teacher rather than practitioner of desire for "tender males." However some Ovidian interpreters clearly viewed Orpheus as participating personally in this mode of love (*amorem*). The man who came to be characterized by Dürer, all those centuries later, as "der Erst puseran" was thus typecast, from the beginning, as an archetypal misogynist; taking up the role of first sodomite and exemplary woman hater, he was also effectively sodomy's first victim.[14]

What follows in this chapter is an interrogation of the various responses to Orpheus's sexual history in the Middle Ages. Orpheus's turn to males provided some medieval writers and artists with opportunities to envision, via interpretation and translation, erotic possibilities that would otherwise remain unspeakable or visually incoherent. At the same time, the sequential logic in which Orpheus is embedded—which presents sex between older and younger males as a derivative phenomenon, secondary to the union between male and female, which is always posited as coming first—marks him out for a life of retrospection. What is visualized in this context is not so much sodomy as a sex act—which, like Eurydice herself, will always escape our grasp—but sodomy's shadows: the secondary characteristics, such as age difference, gender, and sexual role, that bring sodomy into the field of vision. But Orpheus's gaze at Eurydice is also, like that of Lot's wife before him (or after, depending on which

tradition one sees as coming "first"), interpreted as reflecting badly on his attachments to the world. This is a narrative that could be viewed in strongly gendered terms. Medieval moralists figured Orpheus's backward glance as a perverted male investment in female fleshliness, whose loss precipitated a (sometimes salutary) turn to males. Compared with the discourses of homoeroticism and gender transformation discussed in the previous chapter, which linked sodomitic or otherwise nameless homoerotic practices indissolubly with shifts of gender, certain medieval discussions of Orpheus treat a devotion to homoerotic behavior—reconfigured as a homosocial rejection of the company of women—as gender inversion's redress.

Orpheus's look thus follows a distinctive path. Lot's wife looks back illegally at Sodom and is turned, as a result of her transgression, into a static, incorporeal entity—a statue of salt. This transforms the subject of the gaze into an object, just at the very moment when sodomitic practices (whatever those might be) are being consigned to the garbage can of history. Orpheus steals a forbidden glance at Eurydice and becomes only temporarily transfixed by loss, before embarking, in Ovid's version of the story, on a journey that sees him ultimately reunited with the object of that loss. While Lot's wife has *no* future, in other words, Ovid's Orpheus emerges as the once and future lover of Eurydice. His career as a pederast is just a phase. And perhaps because it is a temporary transgression, the motif of Orpheus the pederast has become, in modernity, one of the least acknowledged aspects of the myth. As discussed in this chapter's conclusion, scholars such as Heather Love and Kaja Silverman have recently seen in the rehabilitation of figures such as Orpheus a possible model for the practice of history (a history that may even be perceived as "queer"). Yet Orpheus since the Middle Ages has mainly fascinated commentators insofar as he is associated with Eurydice, not with boys; today Orpheus the first sodomite is remembered only intermittently.

Sidestepping Orphic Pederasty in the Middle Ages

Which aspects of the Orpheus legend medieval commentators prioritized was dependent on the pre- or early Christian sources they appropriated.[15] One of the most influential retellings of the narrative of Orpheus's descent to hell, which also became a crucial source for moralized interpretations in the later Middle Ages, was *Consolatio Philosophiae* (The Consolation of Philosophy) by Boethius (ca. 480–524). Boethius's retelling, which was principally filtered through a Virgilian prism, stimulated numerous later accounts, but crucially, as in Virgil, the Boethian Orpheus was wholly identified with loss. The twelfth poem in book 3 of *Consolatio* (which alternates between poetry and prose dialogues) is placed in the mouth of Lady Philosophy, who describes there Orpheus's powerless grief,

how he moves the inhabitants of hell to pity, and how he is allowed to return with his wife on condition that he resist the temptation of a backward glance. "But who," Lady Philosophy asks, "can give lovers a law? Love is a stronger law unto itself." And so Orpheus casts his forbidden look and loses Eurydice forever. The ensuing interpretation views the episode as a meditation on the difficulties of breaking free from earthly ties. When humans try to raise their minds upward, to the life of the spirit, too often they are drawn back to worldly things.[16] Eurydice herself disappears almost completely: hell in general, rather than Eurydice specifically, becomes a metaphor for the chains of earthly existence. Compared with Virgil's own account, which assigns Eurydice a modicum of dialogue and agency, Boethius's story is all about Orpheus, who is employed as an everyman figure. Later commentaries on Boethius's interpretation also see in the story a judgment on Eurydice herself. The twelfth-century Platonist William of Conches, for instance, identified her with the "natural concupiscence" in every one of us.[17] But absent from these interpretations is any mention of Orpheus after Eurydice: it is only when commentators turned to Ovid's *Metamorphoses* that they found reason to explore the afterlives of the legend's protagonists.

Turning to the Ovidian retellings, we see that different elements in the legend are being emphasized. These include the aftermath of Orpheus's descent to hell, when he begins desiring "tender males." Although, as John Block Friedman contends, this particular dimension to Ovid's narrative "raised problems many medieval commentators preferred not to deal with," a conversation on Orpheus the pederast nonetheless took place within certain well-defined parameters.[18] Why did some clerics, intellectuals, and artists in the later Middle Ages see fit to interrogate, and even to devise iconography for, the twists in Orpheus's love life? How and why did Orpheus the first sodomite come into view, given the strength elsewhere of the taboo against sodomy's speakability and visibility? To answer these questions we need to turn our attention first to another tradition that held sway in the Middle Ages: the trope of Orpheus-Christus.

The idea of Orpheus as a figure for Christ emerged early in the history of Christianity. Initially it was insofar as Orpheus was a civilizing influence—a musician whose playing could tame even animals—that he was aligned with the Savior: represented playing on his lyre and surrounded by wildlife, he stood in early artistic depictions in catacombs and mosaics for Christ the Good Shepherd.[19] Clement of Alexandria (ca. 150–ca. 215) expands on this reading by connecting the motif of Orpheus's song, which has the power to transform hearts and minds, to the "new song" of Christ, which Clement views as being more powerful still.[20] Although Clement's own aim was to distinguish Orpheus and Christ from one another morally, what he sets up as an opposition also served to identify the two in early Christian art: image makers blended together Orpheus,

Christ, and also that other biblical musician David, to produce a fundamentally hybrid figure.

Many centuries later the idea of Christ as a vanquisher of death, who descended into hell to save souls, also began taking shape as a parallel to the Orpheus legend: Christ, like Orpheus, harrowed hell. This idea drew attention to Orpheus's success in bringing Eurydice back from the dead; the motif of the backward glance and Eurydice's second death consequently receded into the background. Influenced by the notion of Eurydice's return, transformations of the story into romance in the later Middle Ages, such as the English poem *Sir Orfeo*, established Orpheus as a model courtly lover, whose victory over death and powers of persuasion as a musician were emphasized over his failure to deliver Eurydice from the underworld.[21] Finally, more than a millennium after Clement compared Orpheus explicitly to Christ, but also influenced by the harrowing of hell connection, Pierre Bersuire's *Ovidius moralizatus* interprets the story allegorically as being about the marriage of Christ to the human soul, who, analogous to Eurydice's death by snake bite, is killed by the devil with the poison of sin. "Orpheus Christus"—this is the very phrase Bersuire deploys— descends into hell to save humanity, singing a verse from the Song of Songs as he goes.[22] The citation of this verse, "Arise, make haste, my love . . . and come" (Canticles 2.10), resonates with Clement of Alexandria's reference to the parallels between Orpheus's song and the "new song" of Christ, but also now draws on an additional allegorical tradition. The twelfth century had witnessed a revival of interpretations treating the Song as an erotic love poem, the ultimate aim of which was to represent the relationship between Christ and the human soul.[23] Orpheus-Christus was thus now also an archetypal lover and bridegroom.

Of course what this interpretation leaves out is the motif of Orpheus's backward glance, which is why Bersuire hurriedly follows his moralization with another emphasizing the idea of Orpheus as a representative sinner, who loses his soul to the devil through temptation. The soul (like Eurydice) is regained through grace, when the sinner repents; but those who "look back [*respiciunt*] out of love of temporal goods and like a dog mentally turn back to their own vomit [*tanquam canis ad vomitum mentaliter reuertuntur*]" will lose their soul a second time.[24] This image, which oddly equates the recaptured soul/Eurydice to a dog eating the contents of its own stomach, despite the fact that union with the soul was previously identified as the ultimate goal of repentance, resonates with a series of further interpretations focusing on other aspects of the story. Jumping forward to Orpheus's song following the second loss of Eurydice and his death by stoning at the hands of the Ciconian women, Bersuire interprets Orpheus as a preacher, who, in an echo of Orpheus's refusal to associate with women, flees the "evils" of women and the "embrace of the flesh," but is wounded by the stones—that is to say, infamy—of those sinners. Finally

Orpheus is said to signify a learned man of the early church subjected to martyrdom, while the Ciconian women stand for persecuting tyrants.[25] What comes across very strongly in each of these interpretations is the misogyny of the author, who sees in Orpheus's hatred of women a model for all his Christian readers (who are assumed to be male). Women are variously identified with vomit, fleshliness, and tyranny, which prove fatal to Orpheus the penitent-preacher-martyr. What Bersuire leaves aside in all these readings is the phenomenon highlighted by Ovid as the upshot of Orpheus's hatred of women: despite devoting attention to many other details in the *Metamorphoses* narrative, including an extended discussion of the hellhound Cerberus, the moralizer fails to make any mention of Orpheus's role as an initiator of Thracian men into the pleasures of pederasty.

In the *Ovidius moralizatus* Orpheus's status as a "sodomite" thus remains unspeakable. This repeats a dynamic also found in certain vernacular discussions of Orpheus, which filtered analysis of his change of sexual tastes through the lens of unmentionability. For instance, in his *Confort d'ami* (1357), a compilation of classical and biblical examples of fortitude, the lyricist Guillaume de Machaut (ca. 1300–1377) describes Orpheus as having become

> homs de tel affaire
> Que ne le vueil mie retraire,
> Car li airs corront et empire
> De parler de si vil matyre.
> Mais onques puis ne volt clamer
> Dame amie, ne femme amer.

[a man of such condition I haven't the will to speak of, for it would corrupt and pollute the very air to bring up such a disgusting story. Now afterward he would never call any woman beloved, nor would he love a lady.][26]

Likewise Christine de Pizan, in her *Epistre Othea* (ca. 1400), written in the form of a letter from Othea (who represents prudence) to the Trojan hero Hector, cites Orpheus as an example of someone Hector should refuse to imitate. But it is inasmuch as he is a courtly lover, who vainly tries to win back Eurydice from the underworld with his "harping," that he functions as this antimodel. Christine thus discards the Ovidian conclusion about Orpheus's rejection of women, his pederastic teachings, and his eventual reunion with Eurydice: Othea's advice to Hector consists of a vague comment on how "il n'affiere aux filz de chevalerie eulx amuser en instrumens ne autres oysivetez" (it does not suit the sons of knighthood to amuse themselves either with instruments or in

other idle activities).[27] As we saw in the previous chapter, Christine also presented a reworking of Ovid's Iphis story in which she discarded the homoerotic possibilities. Since Christine's aim in her discussion of Orpheus in *Epistre Othea* was to critique the gender structures of courtly love and to emphasize the inevitability of Orpheus's failure, she had no interest in relaying the details of his conversion to misogyny and to the promotion of pederasty.

Unnatural Unions and "Masculine" Love in the *Ovide moralisé*

While Guillaume and Christine here participate in a process characterized by Marilynn Desmond and Pamela Sheingorn as "textual closeting,"[28] other vernacular references to the Orpheus story confront the homoerotic element in a less cryptic manner. Indeed in the verse *Ovide moralisé* and subsequent prosifications, Orpheus the sodomite becomes a major focal point for discussion. As Renate Blumenfeld-Kosinski has remarked, the *Ovide moralisé* poet's interpretation of Orpheus and his song is probably the "most excessive" in the entire poem.[29] As well as devoting much attention to the significance of the song, which, as identified by Clement of Alexandria centuries earlier, mirrors the "new song" of Christ in the New Testament, the allegorist even goes so far as to develop detailed explanations for each string and tuning peg on Orpheus's harp (*OM* 10.2578–2906).[30] Moreover he devotes several passages to what is described as Orpheus's retreat from women and his initiation of the men of Thrace in a new kind of pleasure. After the announcement that

> Ce fu cil qui premierement
> Aprist ceulz de Trace à retraire
> D'amour femeline et à faire
> Des joennes malles lor deduit
> Dont or sont cil de Trace duit (*OM* 10.191–95)

> [It was he who first taught the men of Thrace to abandon feminine love and to take their pleasure with young males, by which example those of Thrace are now guided]

a "historial" interpretation immediately ensues, which, it turns out, is simply a literal synopsis of events (*OM* 10.196–219). Eurydice is killed by a serpent and Orpheus grieves for her "outre mesure" (*OM* 10.204) (excessively), but in search of comfort he wishes to take his pleasure with males ("aus malles deporter"), whom he "usoit en leu de fame" (*OM* 10.209–10) (uses instead of women). This the poet finds thoroughly deplorable:

> Trop est crueulz à desmesure
>
> Teulz amours où contre nature
>
> Fet l'en dou malle femelin,
>
> Sans nulle esperance de lin.
>
> Mar fet tele amour maintenir,
>
> Dont l'en puet à mal fin venir. (*OM* 10.214-19)

[Such a love is too excessively wicked, where, against nature, feminine is made from the male without any hope of lineage. It is disastrous to persist in such a love, from which one can come to a bad end.]

Here, in keeping with earlier diatribes against sodomy such as *De planctu Naturae*, the poem characterizes Orpheus's new brand of "amour" as an affront to nature, a threat to gender hierarchies, and a nonreproductive sex act. It can only end badly for the participants.

Further interpretations then follow, the first of which resonates with Bersuire's interpretation of Eurydice as a misguided soul: Orpheus signifies "regnable entendement" (*OM* 10.221) (reasonable understanding) while Eurydice represents the soul's sensuality. Reason tries to keep sensuality under its yoke, but the latter goes running through the "malices" (*OM* 10.238) (evils) of earthly delights and is wounded by the serpent of sin. Then there ensues an additional allegorical reading (*OM* 10.444-577), in which Orpheus, in the guise of correct understanding, shuns corrupt "amour femeline" entirely and sets his sights on "la masculine," which is aligned with virtue; his flight from women is interpreted as the disgust felt by God toward femininity.

> Or het femeline nature,
>
> C'est tous ceulz qui metent lor cure
>
> En vaines cogitacions
>
> Et aus vilz delectacions
>
> . . .
>
> Mes les malles de jone aé,
>
> Ceulz qui gardent lor noceé,
>
> Qui sont pur et plain d'ignorence
>
> Et se prennent dès lor enfance
>
> A vivre vertueusement
>
> Et s'offrent agreablement
>
> De cuer, de cors et de desir
>
> A fere le devin plesir,
>
> Ceulz aime il, à ceulz se deduit.

> Cil sont sa joie et si deduit
> Qui à lui servir se presentent
> Tant dis com jone et fort se sentent. (*OM* 10.558-61, 566-77)

[Now this feminine nature, it is all those who place their trust in vain thoughts and in lowly pleasures. . . . But the males of young age, those who keep their vows, who are pure and lacking in awareness and try from their infancy to live virtuously and give themselves pleasingly with heart, with body, and with desire to enacting divine pleasure, he (God) loves them, he takes pleasure in them. Those who come forward to serve him are his joy and pleasure, as long as they feel young and strong.]

Orpheus's desire for tender males has thus been subsumed into the poet's overall Christianizing ethos: what was literally "contre nature" becomes, in the allegorical gloss, an embodiment of virtuous living, for which God himself has a taste; the reference to how God "à ceulz se deduit" deploys a phrase that could be applied to an act of lovemaking, which links the pleasures introduced by Orpheus to the men of Thrace directly to God's own "joie."

Finally, after Orpheus has sung the song that takes up the remainder of book 10 of *Metamorphoses*, in which he tells of "Les amours des grans dieux des cieulz / Qui amerent les jovencieulz" (*OM* 10.720-21) (the loves of the great gods of the heavens who loved youths), further interpretations follow. Now, readers are informed,

> Cil fist par sa male douctrine
> Mains folz atraire et alechier
> Primes à mortelment pechier
> Contre nature et contre loi (*OM* 10.2521-24)

[he set out, through his evil teaching, to attract and seduce many fools to sin mortally, for the first time, against nature and against the law],

as well as testifying that "l'amour masculine" (masculine love) is worth more than love for women (*OM* 10.2533-34). Moreover,

> Sa male douctrine plesoit
> Aus folz qui o lui s'amusoient
> Et de valetons abusoient,
> Cil qui furent de dure orine
> Plus que arbre ne sauvecine. (*OM* 10.2535-39)

[his evil teaching pleased the fools who amused themselves with him and abused young boys, those who were of a stronger stock than tree or wild beast.]

The word "male" potentially has a double meaning in this context: Orpheus's teaching is evil, but it is also oriented toward males. What constitutes this "male douctrine" are Orpheus's tales of gods who love young males, which delight the base "folz" who not only commit the sin with Orpheus himself but also perform it with "valetons." Yet the "autre sentence" follows immediately after, identifying Orpheus with Christ, who also harrowed hell (*OM* 10.2540-55), and his songs of love with the New Testament. Piling one interpretation on top of another, the verse *Ovide moralisé* ultimately prioritizes the reading that is, as in Bersuire's *Ovidius moralizatus*, a version of the Orpheus-Christus analogy.[31] Paradoxically, though, the "loves" featured by Orpheus in his song fit somewhat uneasily into a medieval moral outlook: they have to be viewed sideways on, as a Godlike devotion to virtuous males, in order to cohere with this perspective.

As discussed in the previous chapter, the phrase "contre nature" crops up repeatedly in the verse *Ovide moralisé*. As well as being applied to Iphis, as a figure for the cross-dressing woman who appropriates the male phallus, Salmacis, who represents women who use cosmetics, and Pasiphaë, who harbors a bestial passion for a bull, these words turn up again in several other places in the poem. In chapter 4 we will encounter the story of Jupiter's love for the youth Ganymede, one of the pederastic *exempla* embedded in Orpheus's song, which is also defined as going against nature. And bookending these tales of sex with improper objects are two tales of incest, which again get characterized as an affront to nature's laws. Immediately preceding the tale of Iphis in book 9 is the book's major story, that of Byblis, who harbors a secret passion for her twin brother Caunus. The *Ovide moralisé* poet first describes Byblis, who is transformed into a fountain, as a woman whose "putage" (*OM* 9.2544) (whoredom) is, somewhat counterintuitively, like Christian charity: the rationale is that, like Christ, she offers herself to all men. A second interpretation then follows, in which "Cadmus" (the poet's name for Caunus) represents humanity and Byblis stands for divine wisdom: Byblis's love for her brother corresponds to divinity's desire to unite "contre nature / Charnelment" (*OM* 9.2608-9) (carnally against nature) with humankind. Also Myrrha, whose incestuous liaison with her father Cinyras counts among Orpheus's examples of illicit passion in book 10, is equated by the *Ovide moralisé* poet variously with the Virgin Mary, who conceives Christ with God the Father, just as Adonis was born from Myrrha's union with Cinyras (*OM* 10.3748-3809); with an unconfessed sinner, who consumes the host on Easter Sunday and thus receives God wrongly (*OM* 10.3810-77); and with a sinner who loves her father "par puterie" (*OM* 10.3883) (whorishly) but

can still be saved, like Mary Magdalene, through contrition and repentance (*OM* 10.3878–3904). Again Myrrha's passion is characterized as an abomination: the narrator announces that he is telling this "cruel" story only because it belongs to his "matire" (subject matter), and reminds any "filletes" (young girls) listening to remember that it is not true (*OM* 10.1096–1101).[32] But because it is part of his "matire," the poet is still able to derive a spiritual meaning from an act of sexual transgression: even an incestuous coupling between daughter and father is salvageable when viewed through the twin lenses of redemption and the incarnation.

These analogies between unnatural or unspeakable sexual sins, the marriage of human and divine in Christ, and redemption explain why a spiritual meaning can also be derived from Orphic pederasty. Both the incarnation and Orpheus's love for "joennes malles" are modes of union that, while defying natural law, are purified of the corruption that is an ingredient of other modes of fusion. Thus in his "autre sentence," when the poet meditates on Orpheus's shunning of "amour femeline" (viewed as a manifestation of correct understanding), he uses the word "jointure" as shorthand for describing different kinds of union. God, he says, "ot nostre humanité / Mariee à la deïté" (*OM* 10.446–47) (married our humanity to the deity) and ascended from earth to heaven. But this model of perfect union, instituted by God, has become debased as a result of the fall:

> Cil crierres de tout le monde
> Fist jointure dou cors à l'ame
> Et mariage d'ome à fame,
> Mes l'une ne l'autre jointure
> N'est ne si fine ne si pure
> Que maint n'en soit puis mescheü
> Qui puis ont maint encombre eü. (*OM* 10.457–63)[33]

[This maker of the whole world created the union of body to soul and the marriage of man to woman, but neither union is so fine or so pure that many have not since come to grief from it, who have since had many mishaps.]

Following this statement with an evocation of Eve, "la premiere mere" (*OM* 10.468) (the first mother), who corrupts man with "la dampnable pome" (*OM* 10.472) (the damnable apple), the narrator thus underwrites his antifeminist message with a reference to the "first" in a long line of feminine mischief makers. Eve's union with Adam is an example of a "jointure" that deviates, as a result of temptation, from the divinely inspired model of redemption.

This, then, is the bizarre conclusion pursued by the *Ovide moralisé* poet as

a result of his meditations on unnatural sex. Though problematic from the point of view of natural law and Christian morality, since it is deemed incapable of continuing the "lin" (lineage), sodomy also provides an interpretive framework for explaining the most central "jointure" of all, the incarnation. This is in keeping with the poet's overall aim to impose unity on the diversity of Ovid's text: everything in *Metamorphoses* can ultimately be viewed through the prism of the incarnation and associated doctrines.[34] Other forms of union, including the marriage of man to woman and body to soul, are susceptible to corruption as a result of humanity's fallen status, whereas the incarnation, instituted by God, is "pur." Against this backdrop the allegorist also comes up with another rather startling interpretation: pederasty, defined as the joining of an older or more powerful male with a younger male for educational as well as erotic ends, can also become a metaphor for spiritual ascent: a love cleansed of dangerous femininity. Here, as David Hult has pointed out, the poet's working distinction between "femeline" nature, which is a question of generalized essence, and "malles," that is to say individuals who are male, is significant: femininity is consistently devalued as a quality to which humans in general are susceptible, while the attraction of a male God for male youths (as evidenced, for example, in Jupiter's love for Ganymede) endows pederasty with spiritual significance when viewed allegorically.[35] The *Ovide moralisé* poet's misogyny, which reiterates the misogynous attitude attributed to Orpheus himself, thus provides a means of reconfiguring what, according to the gender-inversion model of sodomy, tended to be presented as a dangerous turn *toward* the feminine. In line with Halperin's argument concerning the "masculinizing" potential of pederasty and friendship, which, as discussed in the previous chapter, were distinguished conceptually from gender inversion in the ancient world, Orphic pederasty has been transposed into a vision of all-male piety. The "historial" interpretation, which berated Orpheus's love for creating "femelin" from "malle" (*OM* 10.216), is completely incompatible with this "autre" interpretation.

Other Medieval Responses to Orpheus: Gender Inversion and "Un-love"

The transformation of Orphic pederasty into a metaphor for divinely inspired "jointure" diverges significantly from other discussions of Orpheus's sexual tastes in medieval literature. One lesser-known example of a text that translates Orpheus into an overtly sodomitical register is a Middle High German lyric signed off by a writer labeling himself "Der Tugentschrîber" (literally "the virtue-scribe"). This cutting little tirade against unnatural sex, datable to the thirteenth century, is worth quoting in its entirety:

Ein ander minne mac unminne heizen wol,
verwâzen ketzerîe und aller schaden vol!
obe aller missetât daz hoest unbilde!

die ervant ein wîser meister, Orpheus genant.
des harphen was den wilden tieren sô bekant,
daz sie dâ bî vergâzen gar ir wilde.

der kêrte an schône iunge man
der wîbe minne. owê, daz sich noch ieman kan
verschamter lîp, vor got geunêrte schône!

owê, daz er mannes bilde hât,
der alsô harphet únde an im harphen lât!
nâturen vîant—daz in der tiuvel hône!

Amen. Der Tugentschrîber.[36]

[A different kind of love can be rightly called un-love. Cursed heresy, filled
with all evil! Above all crimes the highest monstrosity! A wise master called
Orpheus invented it. His harp playing was so well known to the wild animals
that they completely forgot about their ferocity. He directed the love that one
has for women toward beautiful young men. Alas that anybody still knows it!
Shameless body, dishonored beauty before God! Alas that he who plays the
harp thus and lets himself be harped upon has a man's appearance! Enemy of
nature—may the devil revile him! Amen. The virtue-scribe.]

Although we are initially vague as to the identity of this strange "unminne,"
by the end, as Thomas Bein has argued, we are in no doubt at all.[37] "Unminne"
is named as "ketzerie," a word that by the end of the Middle Ages in German
legal settings generally denoted same-sex behavior.[38] Viewed as an aesthetic
insult—an "unbilde" or monstrosity—the practice is then attributed with an
inventor, Orpheus, who, in a possible transfiguration of Ovid's *auctor* refer-
ence, is said to have directed it to "schône iunge man." It is characterized as an
affront to nature, punishable by the devil. But perhaps most striking of all are
the repeated references to Orpheus's "harphen." Cited in the second stanza as
the instrument through which Orpheus tames wild beasts (itself perhaps an
oblique reference to associations between sodomy and bestiality), by the fourth
stanza it has become a metaphor for the sexual act itself, and implicitly for the
gender inversion sodomy produces. Harpist has become "harphet" (harped);

active has been turned into passive.[39] Orphic "unminne" is thus mediated to the reader, via a dense network of metaphoric substitutions, as a thoroughly negative practice.

Similarly negative in tone (at least on an initial reading) are two highly influential responses to Orphic artistry, which likewise translate the hero's gender identity and sexual history into a sodomitical register. The first appears in Alan of Lille's *De planctu Naturae*, which is framed as a somewhat gloomy response to Boethius's *Consolatio Philosophiae*. In place of the solace afforded by Lady Philosophy, Alan confronts readers with the musings of Lady Nature, who, having delegated some of her powers to Venus, laments the proclivity of humankind to act against her laws.[40] Despite possessing the capacity for free will, she says, men have embraced unnatural practices enthusiastically; male homoeroticism—the activity by which Venus, with her magic arts, robs men of their manhood (1.6)—is Alan's paradigmatic example of this trend. The term *sodomia* itself never appears in *De planctu Naturae*, but medieval readers would have been in no doubt that this practice, or a species of it, is being targeted in Nature's discourse. Manuscripts and the reception history support this view: the Dominican scholar Robert Holcot (d. 1349) praised the text's effectiveness in extirpating sodomy, and some French manuscripts of *De planctu* contain a colophon exclaiming, "Let the profane sodomite perish."[41]

Before turning to Alan's allusions to Orpheus it is worth considering his references to other mythical figures. The following passage from *De planctu*'s opening meter is representative of Alan's strategy for translating the unspeakable into speech:

> Non modo Tindaridem Frigius uenatur adulter,
> Sed Paris in Paridem monstra nefanda parit.
> Non modo per rimas rimatur basia Thisbes
> Piramus, huic Veneris rimula nulla placet.
> Non modo Pelides mentitur uirginis actus
> Vt sic uirginibus se probet esse uirum. (1.51–56)

> [No longer does the Phrygian adulterer (Paris) chase the daughter of Tyndareus (Helen), but Paris with Paris performs unmentionable and monstrous deeds. No longer does Pyramus search out Thisbe's kiss through the cracks, but the little crack of Venus no longer pleases him. No longer does Pelides (Achilles, son of Peleus) belie the actions of a girl in order to prove to girls that he is a man.]

This passage is packed with euphemism, paradox, and linguistic play. What Nature characterizes as unspeakable (*nefanda*) with one breath she also makes

perfectly clear with another. The practice is homoerotic and potentially nar-
cissistic: the reference to Paris with Paris anticipates Nature's later evocation
of Narcissus as a man who incurred the danger of self-love (8.76–78). Addi-
tionally, it is oriented toward the anus: the "rima" or crack through which the
Ovidian figure of Pyramus in *Metamorphoses* 4.65 manages to plant kisses on his
lover Thisbe is compared to the "rimula" of Venus, that is to say female genita-
lia, which evokes, as an absent presence, the other "rima" for which the new
Pyramus has a preference.[42] Finally, it is gender-inverting: Nature's reference
to Pelides's proving his manhood alludes to a legend recorded by Statius in the
Achilleid (ca. 95 CE) that Achilles, disguised as a girl during a spell at Lycome-
des's court in order to avoid going to war, fell for a trick in which wily Ulysses,
masquerading as a peddler of gifts and women's garments, placed among the
unwarlike (*imbelles*) objects he was selling a shield and spear that attracted
the warrior's attention, and revealed, in so doing, Achilles's "true" sex.[43] And
later Nature enlists other mythical figures in support of her condemnation of
a gender-inverted order, some of which also crop up in *Metamorphoses*. These
include Jupiter, who made Ganymede his wine master by day and his subject
(*suppositum*) in bed by night, and Bacchus and Apollo, who likewise, through
their lying, converted boys into women (*uerterunt in feminas pueros inuertendo*)
(8.119–22).

Fueling Nature's arguments throughout is a language of imitation, artifice,
and deceit: as well as the references to Venus's witchcraft and the inversion of
boys into women by mendacious gods, the text posits an analogy between verbal
expression and forging (1.27). It is against this backdrop that Alan's references
to Orpheus need to be understood. Orpheus is mentioned twice in *De planctu
Naturae*, each time in the context of his musical instrument: it is the lyre of Or-
pheus (*Orphei lira*) rather than Orpheus himself that Nature has in her sights,
a representative of the artistry that she sees as troubling. This is ironic, given
that her own playful language relies on comparable modes of artifice, devia-
tion, retrospection, and translation; she herself, by assuming the role normally
assigned to male preachers and clerics, could be said to turn from a "she" into a
"he" by virtue of her rhetorical performances.[44] The first reference to Orpheus
is just one more manifestation of the imitative, gender-inverting effects of sod-
omy that Nature sees everywhere around her:

> Solus homo, mee modulationis citharam aspernatus, sub delirantis Orphei lira
> delirat. Humanum namque genus, a sua generositate degenerans, in construc-
> tione generum barbarizans, Venereas regulas inuertendo nimis irregulari
> utitur metaplasmo. Sic homo, Venere tiresiatus anomala, directam predica-
> tionem per compositionem inordinate conuertit. A Veneris ergo orthographia
> deuiando recedens sophista falisgraphus inuenitur. (8.54–59)

[Man alone, shunning the modulated strains of my cithern, runs delirious to the sound of mad Orpheus's lyre. For the human race, degenerating from its noble state, makes a highly irregular use of metaplasm when it inverts the rules of Venus. Thus man, changed Tiresias-style by venereal anomalies, inordinately alters in his composition that which has been decreed as straight. Retreating in his deviance from the correct orthography of Venus, he shows himself to be a sophistic falsigrapher.]

The specific phrase used to describe the transformation that takes place when a man is lured (or literally "lyred") by Orphic artistry is *tiresiatus*, a word deliberately invoking that other Ovidian figure, Tiresias (discussed in chapter 2), who problematically switches between male and female. Presumably what connects Tiresias with Orpheus in this context is that, in each instance, the sexual history of the protagonist is unstable: Tiresias's gender identity, like Orpheus's sexual tastes, is changeable. So this first reference to Orpheus in *De planctu Naturae* is firmly linked, by association, with the examples of grammatical and sexual inversion that Nature diagnoses as being at the heart of intellectual and moral corruption. Imitating "mad" Orpheus has profound consequences for gender identity and sexual roles.[45]

The second mention of Orphic artistry occurs in a section of *De planctu* where Nature outlines the differences among vices. In her discussion of Avarice, she refers to the music of Orpheus's lyre, along with Amphion's song and Virgil's muse, as being stifled by humanity's worship of money (12.102). This evokes the tradition of Orpheus as supreme artist rather than pederast, but the use of an identical phrase in both—*Orphei lira*—serves to connect one mode of artifice with the other. As in Ovid's *Metamorphoses*, which characterizes Orpheus both as an archetypal *vates* and as the *auctor* of a newfound passion, Alan's Orpheus is situated at a crossroads between poetry and pederasty.

Famously taking up Alan's references to unnatural sex in *De planctu Naturae*, Jean de Meun (ca. 1240–ca. 1305), in his continuation of the *Roman de la Rose*, also cites Orpheus but to different ends. Alan's text condemned those who hammer on an anvil "quae semina nulla monetat" (1.27) (which coins no seeds) and who use a plowshare that "in sterili littore . . . arat" (1.30) (scores a barren strand).[46] But Jean's allegorical figure of Genius also berates individuals who, presumably dedicated to the pursuit of chastity rather than sodomy, "san cop de martel ferir / lessent les anclumes perir" (let the anvils perish without striking a blow with the hammer). Following this with a reference to how "Les jaschieres, qui n'i refiche / le soc, redemourront an friche" (If no one thrusts the ploughshare into the fallow fields, they will remain fallow),[47] Genius has this to say about individuals who imitate Orpheus's efforts to "plow" and "forge":

cil que si leur pechiez anfume
par leur orgueill qui les desraie
qu'il despisent la droite raie
du champ bel et planteüreus,
et vont comme maleüreus
arer en la terre deserte
ou leur semance vet a perte,
ne ja n'i tandront droite rue,
ainz vont bestournant la charrue,
et conferment leur regles males
par excepcions anormales,
quant Orpheüs veulent ansivre,
qui ne sot arer ne escrivre
ne forgier en la droite forge
(panduz soit il par mi la gorge!
quant tex regles leur controva,
ver Nature mau se prova),

. . .

Perte leur viegne des pandanz
a quoi l'aumosniere est pandanz!
Les marteaus dedanz estachiez
puissent il avoir arrachiez!

. . .

Li leur pechiez orz et horribles
leur soit doulereus et penibles,
qui par touz leus fuster les face,
si que l'an les voie en la face!

[Those who are so blinded by their sins, by the pride that takes them off their road, so that they despise the straight furrow of the beautiful, fecund field and like unhappy creatures go off to plow in desert land where their seedling goes to waste; those who will never keep to the straight track, but instead go overturning the plow, who confirm their evil rules by abnormal exceptions when they want to follow Orpheus (he did not know how to plow or write or forge in the true forge—may he be hanged by the throat!—when he showed himself so evil toward Nature by contriving such rules for them). . . . May they lose the pendants on which the purse hangs! May they have the hammers that are attached within torn out! . . . May their dirty horrible sin be sorrowful and painful to them; may it cause them to be beaten with sticks everywhere, so that one sees them as they are.][48]

Jean also revisited the Orpheus story toward the end of his life, when he translated Boethius into French.[49] There it was the Virgilian version that dominated, but in the *Rose* continuation the poet draws on the Ovidian account: the fate prescribed for Orpheus's followers—beating and dismemberment—mirrors that of Orpheus himself in *Metamorphoses*. Jean's catalogue of punishments is also reminiscent of the penalties listed in a law code devised ca. 1260 in Orléans, which recommended punishment by castration for a first offense of sodomy and dismemberment for a second.[50] But unlike Alan's Orpheus, who causes men to turn into women when they follow his sodomitic lead, the *Rose*, in a seemingly playful distortion of *De planctu*'s message, also numbers the chaste among those who "follow Orpheus."[51]

The author of the *Ovide moralisé* was surely familiar with Jean de Meun's reflections on Orphic imitation.[52] Alan of Lille, whose discussions of forging and plowing were subsequently taken up by Jean, established a connection between Orpheus and sodomy that associated this "deranged" musician's artistic output with outbreaks of Tiresias-style gender switching. And yet the *Ovide moralisé* poet was content to allow the comparison between Orpheus's distaste for "amour femeline" and God's antipathy toward "femeline nature" to stand. He did this by effectively evacuating from Orphic pederasty any sense of it as a sexual or gender-inverting activity. Acts that in the literal reading of the Orpheus myth could be perceived as dangerously sodomitical—a transformation of the "malle" into something "femeline"—become transfigured, in the allegorical interpretation, into something virtuously homosocial: relations between God and other "malles" that remain thoroughly oriented toward the "masculine." What, on the surface reading, is indicative of gender inversion becomes transformed, in this "autre sentence," into a celebration of (male) sameness and celibacy, which is deemed more "fine" and "pure" than the conjunction of males with femininity in other forms of union such as earthly marriage. Echoing the Boethian interpretation, which sees in the story a metaphor for human preoccupation with earthliness, as well as subsequent readings, which accept the familiar binary calculus by which the feminine is aligned with the lowly, physical, and worldly and the masculine with the lofty, intellectual, and spiritual, the *Ovide moralisé* thus finds a language for transforming male homoeroticism into a virtuously virilizing pursuit—just so long as the misogyny motivating this rejection of the feminine continues to keep gender dichotomies in place. A masculine Orpheus, turning to males, pursues a spiritual path that can and should be the model for every Christian reader. Implicitly his masculine allegiances are also associated with the purity that a celibate religious lifestyle offers.

In other moralizations of *Metamorphoses*, aspects of the interpretations presented in the verse *Ovide moralisé* are replicated in abbreviated form. But

generally speaking Orpheus's status as a sodomite is assigned only a negative value. The first fifteenth-century prose abridgment of the *Ovide moralisé* takes Orpheus to task for his pederastic turn even before the passages of allegorical reflection. Immediately after the narrator has announced that Orpheus took flight to Thrace for three years without wife or concubine, after which he "first" taught the men of Thrace to withdraw from feminine love, a name is assigned to the practice in which Thracian males are initiated: Orpheus encourages them "amuser follement à pecher par sodomye, contre nature. Dont il fist mal" (to amuse themselves foolishly by sinning through sodomy, against nature. Thus he did wrong].[53] This assessment, which is, to my knowledge, the first time that the word "sodomye" itself is applied to Orpheus in French literature, is unequivocal: his behavior was bad and deserving of censure. The moral expositions subsequently appended to the story focus first, in book 10, on the meanings of the different rivers of hell, as elucidated by the fifth-century philosopher Macrobius, which replicates the discussion of the rivers in the verse *Ovide moralisé* (*OM* 10.255–91). Then, in book 11, following the account of Orpheus's death and reunification with Eurydice, Orpheus is treated as a figure for Christ, while the Ciconian women are recruited as stand-ins for the evil, persecuting Jews.[54] This reading, which generates a heady mix of misogyny and anti-Jewish sentiment, also repeats one of the interpretations appended to the verse *Ovide moralisé*, where "li fel Juïf plain d'envie" (*OM* 11.184) (the wicked Jews full of envy) are similarly aligned with femininity. At the very moment when femininity is getting its own back, by rising up to confront Orpheus's masculinist bias, it becomes further abjected by association with other kinds of difference.

Mansion's printed text of 1484 no longer includes the anti-Jewish exposition, but it does incorporate a narrator's aside on Orpheus's turn to young males, which is said, in the "Sens historial," to be "oultre mesure cruel et contre nature" (immeasurably cruel and against nature); allegorically Eurydice is once again interpreted as the soul's sensuality and Orpheus as "raisonnable entendement" (reasonable understanding), though the account of Orpheus's death stresses that the Thracian women were motivated by his "doctrine," which is identified, in no uncertain terms, as "le mauvais traistre que les hommes & les jouvenceaulx attrait a lui" (the evil trait that attracts men and youths to him).[55]

Caxton's text, drawing like Mansion on the *Ovide moralisé en prose II*, likewise sets aside the anti-Jewish interpretation but includes a strident rejection of Orpheus's love for boys among the "hystoryal" interpretations:

This Poete by hys evyll doctryne drew many a personne to synne agaynst nature, for he endoctrined and taught folysshe peple, whyche held hym for a god, that masculyne love was better than femenyn. Unto foles that with hym abused hys evyl doctrine plesed and lovyd yonge boyes as they that were harded and

abstynat [obstinate] in this detestable and inhumayne synne more than the trees or the stones. (10.913–18)

The language in this passage adds a new element to the condemnation. Now Orpheus is characterized as the promoter of a vice that is not only "evyl" but also "inhumayne"; this rejection of humanity also extends to the obstinacy with which "yonge boyes" are "harded"—literally hardened—toward the vice. This description resonates with the verse *Ovide moralisé* reference to the fact that the followers of Orpheus are more "dure" (*OM* 10.2538) (hard/rough) than trees and wild animals. But the connection made by the narrator of the *Ovide moralisé en prose II* with trees and stones also draws on the opening lines of book 11 of *Metamorphoses*, where Orpheus is said to have lured with his music animals, trees, and even rocks (11.1–2). Sodomy, by comparison, is deemed to have taken root in these "foles" even more than the trees in the ground; the practice is attributed with a rigidity that transcends even that of the rocks he charms and is killed by. As in depictions of the punishment of sodomy in hell (discussed in chapter 5), which present the sodomite's orientation toward improper objects as an enduring and thoroughly dehumanizing state of affairs, what is threatening about Orpheus in the fifteenth-century prosifications is his ability to attract boys permanently to his "doctryne." Here, in contrast to earlier discussions, sodomy is not simply associated with the dangers of temporary role switching. Those who find out about it will also potentially become obstinate in their imitation.

Absent from these prosifications is any sense that Orpheus's turn to males— reconfigured in the verse *Ovide moralisé* as a virtuously homosocial change of tack—could be the basis for a positive Christian message. The reason that the *Ovide moralisé* poet connects Orpheus's rejection of femininity with virtue and virility has to do not only with his misogyny, which, as we have seen, inflects most medieval interpretations of the Orpheus story to a lesser or greater extent. Presumably it also stems from the poet's own background as a cleric or monk (probably a Franciscan friar), working within a scholarly milieu.[56] After all, the author of the *Ovide moralisé* himself, familiar with the all-male environs of the university or monastic institution, would surely have seen parallels between Orpheus's turn to males—viewed allegorically as a turn to "devin plesir," which is "pur"—and the settings in which he lived, wrote, and taught. Although ultimately the poem may well have been directed toward lay as well as religious readers, the poet's clerical vocation explains why he can extract from Orpheus the pederast a message about the spiritual benefits of all-male interactions, especially when those interactions were structured by hierarchical and age-related differences.

There are precedents for this interpretation in other commentaries on Ovid. The cleric Arnulf of Orléans, in his exposition of *Metamorphoses* (ca. 1170),

made the familiar connection between Orpheus's shunning of women, that is, those living in a sinful and womanlike (*muliebriter*) manner, and the translation (*transtulit*) of his affections to men, that is, to those acting manfully (*viriliter*); women, he remarks, are indeed "more prone to lust and vice than men."[57] The Bolognese scholar Giovanni del Virgilio, in his own commentary on Ovid (ca. 1322–23), also explained Orpheus's newfound love for men (*cepit amare viros*) as an example of how he acted manfully (*viriliter*) by transferring his soul's allegiances from the world (Eurydice) to God.[58] And during the eleventh century, shaped by the values of cathedral schools, poets had reflected in general on Orpheus's civilizing powers as a teacher and promoter of peace, love, and friendship.[59] This could explain why in subsequent centuries his role as a (pederastic) educator of other males came to be viewed positively in certain circles. The double move by which the *Ovide moralisé* poet condemns sodomy with one stroke and recuperates it with another finds support in these efforts to reimagine Orpheus as the ultimate teacher, woman hater, and man's man.

What, though, do readers "see" as a result of this transfiguration? What happens when Orpheus's homoerotic interests get transmuted into an image of clerical masculinity? Next I consider visualizations of Orpheus-as-pederast in the illustrations appended to some moralized interpretations of the story. While his sexual relations with male youths were sometimes pushed through the grid of unspeakability, they were not, for that matter, utterly confused.

Orpheus, "First Sodomite," in Art

The iconography of Orpheus's turn to males was not a medieval invention. Ancient Greek vase paintings, dating back to the fifth century BCE, had sometimes paired a depiction of Orpheus's murder at the hands of the Ciconian women with a scene showing him charming Thracian warriors with his lyre.[60] Almost two millennia later Orpheus's pederasty was still sometimes visualized in the context of his death. A decade before Dürer produced his death of Orpheus drawing, an anonymous artist designed a woodcut as the frontispiece to book 11 of Mansion's printed edition, which depicts Orpheus with a male youth in his arms juxtaposed with a scene of him lying dead (fig. 31).[61] In the left foreground, Orpheus, dressed in the fashionable attire of a Burgundian townsman, wraps one arm around the boy (who is shown with smaller proportions than Orpheus, presumably to highlight the age difference), while he places his other hand on the boy's chest. Orpheus also steps out with his left leg in front of the youth, who leans back slightly, which conveys both the musician's erotic motives and the power he has over his partner. Orpheus's harp, half covered in a protective sheath, rests against a rock, which is likely making a genital reference: playing the harp could be a metaphor for fingering the penis or sexual stimulation more

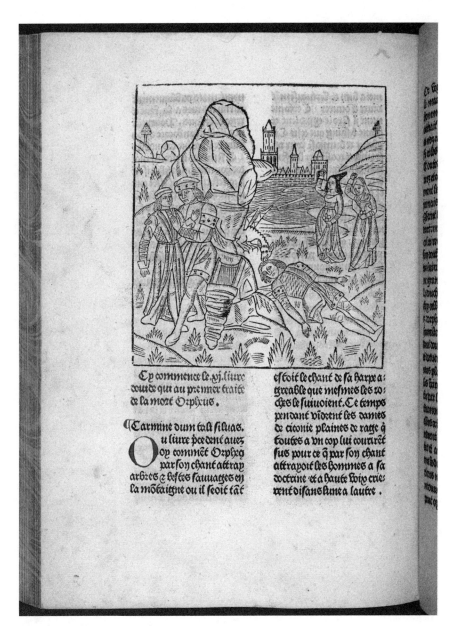

Figure 31. Death of Orpheus. Frontispiece to book 11 of *Bible des poëtes* (Bruges: Colard Mansion, 1484). Woodcut. London, British Library, IB.49428. © British Library Board.

generally, as already seen in the poem ascribed to "Der Tugentschríber."[62] To the right Orpheus is laid out, eyes closed, while two women in the background, gathering missiles in their skirts, hurl rocks at their victim's corpse. To the women's right the discarded harp floats in the river Hebrus; positioned almost in the exact center a little dragon, reminiscent of the winged creature that bites Eurydice's ankle in the frontispiece to Mansion's book 10, nibbles at Orpheus's

head. The last of these motifs conflates the death itself with Orpheus's eventual dismemberment: Ovid records how, following the poet's murder, his head found itself washed up on the shores of the isle of Lesbos and was attacked by a savage serpent, only to be rescued from this fate by the god Phoebus (Apollo) (11.54–60).

Although, as already noted, Mansion's text did not include a moralization of Orpheus's death, the narrator had reflected earlier, in book 10, on the excessively "cruel" and unnatural consequences of his turn to males. In keeping with that judgment, the woodcut inserted at the beginning of book 11 represents Orpheus's assassination not simply as an act of vengeance inflicted by the women he has rejected but also as a punishment specifically for sodomy: the dragon not only evokes the fate of Orpheus's disembodied head but also alludes to his ultimate destination, hell; the scene of pederasty to the dragon's left makes a clear connection between this "vice" and the death that follows. Sodomy, this woodcut announces, is a crime with deadly consequences. This chimes with the legal status of sodomy in fifteenth-century Bruges, where Mansion's volume was first published. As discussed in chapter 2, sodomy was connected in fifteenth-century Flanders with the crime of *lèse-majesté*, an offense against both the divine and the social order; it was this, as well as associations with heresy, that warranted the punishment of death by burning. Condemnations for sodomy, including female sodomy, hit an all-time high in the decades immediately before Mansion's Ovid was published in 1484, with thirty-two executions recorded in the bailiffs' accounts of Bruges for the years 1451–75 alone—an exceptionally high figure.[63] The Orpheus woodcut, which visually yokes together crime and punishment, participates in the hysteria and heightened visibility accorded to sodomy in this particular period of Burgundian history.

The most extended cycle of Orpheus images in medieval art appears in Rouen O.4, the earliest extant manuscript of the verse *Ovide moralisé*, which, as discussed in the previous chapter, imagines Iphis's relationship with Ianthe only as a cross-sex encounter. The illustrators found two opportunities to visualize same-sex relations in the Orpheus cycle that follows; but these images generate more ambivalence than the woodcut produced for Mansion's Ovid a century and a half later. The Rouen sequence, which consists of no less than fourteen miniatures representing or commenting on the story of Orpheus and Eurydice, begins with a scene showing Eurydice running away from Aristaeus as her ankle is bitten by a demon (fol. 246v); continues with an image showing Orpheus pursuing Eurydice to hell (fol. 247r); includes a miniature showing the resurrected Christ emerging from his tomb (fol. 249r), presumably about to harrow hell; and concludes with miniatures depicting Orpheus being attacked by women as he plays his harp (fig. 32) and his dismembered head, beached on the Lesbian coastline, being rescued from a demon by Phoebus (fol. 272r).[64] This

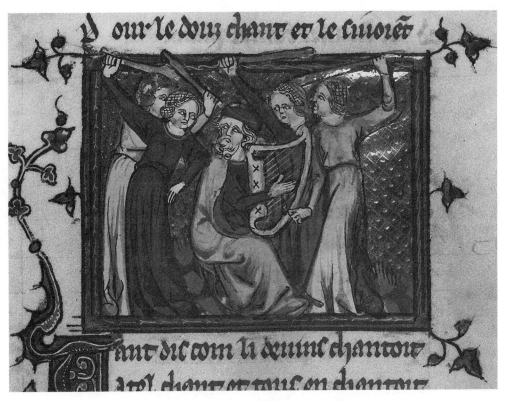

Figure 32. Death of Orpheus. Miniature in *Ovide moralisé*. Paris, circa 1315–28. Rouen, Bibliothèque municipale MS O.4 (1044), fol. 271r (detail). Collections de la Bibliothèque municipale de Rouen. Photography C. Lancien; Y. Communeau.

manuscript thus separates out events that, in the woodcuts inserted in Mansion's printed edition, came to be visually conflated. The blending together of Orpheus's death with his sexual behavior allowed the woodcut artist to send a clear moral message about the activity being depicted. Conversely in Rouen O.4 the representations of pederasty potentially have the capacity to be viewed on more than one level, in keeping with the *Ovide moralisé* poet's dual strategy of condemning sodomy and allegorizing it as a figure for male virtue. The first such image shows a taller male to the left leaning in to embrace and kiss a more diminutive male to the right (plate 6a).[65] The youth clearly reciprocates this gesture: his left hand is shown touching the waist of his partner. The iconography is reminiscent of imagery in the *Bibles moralisées*, discussed in chapter 1, which includes several scenes condemning age-differentiated eroticism between males (figs 17–21).[66] Although the *Ovide moralisé* miniature appears just above the passage of text describing the "historial sens" (*OM* 10.196–219), which condemns Orpheus's desire for males as "contre nature," the scene also

coheres with the "autre sentence" identifying Orpheus's aversion to "amour fe-
meline" with God's allegiances to virtuous males.

While the Rouen artist has not presented a utopian vision of friendship
among equals, since age and power differentials are clearly in evidence, there is
nothing especially pejorative about the iconography. The gesture represented
could simply be a kiss of peace or friendship, akin to images of ritual kissing
in certain contemporary chronicles. Or it could, as in the *Bibles moralisées* im-
ages of same-sex kissing discussed in chapter 1, denote something sinful and
sodomitic. To become another man's man in rituals of homage, the vassal swore
an oath on some sacred text or relic with one hand, while simultaneously seal-
ing the mutual *fidelitas* with a mouth-to-mouth kiss. Scenes depicting a kiss of
homage between lord and vassal are common in manuscript illuminations illus-
trating French fourteenth-century chronicles. The participants in these rituals
usually embrace and look into one another's eyes, which expresses a relation-
ship of mutuality and equality, but there is also a clear element of inequality in
the relationship: the figure to whom homage is being done is consistently taller
than the figure performing the homage, who in contrast is usually portrayed in
a bent-over, stooping stance, or kneeling on one leg.[67]

Mouth-to-mouth kissing and embracing between men was an act that, in
the Middle Ages, was culturally sanctioned across a variety of spheres. For the
English monk Aelred of Rievaulx (1110–67), a fleshly kiss between friends is an
act that, done for the right reasons, anticipates more spiritual modes of com-
munion with Christ. Quoting the first verse of the Song of Songs, "Let him kiss
me with the kiss of his mouth," Aelred devotes space in his treatise *De spirituali
amicitia* (On Spiritual Friendship) to considering the propriety of such forms of
interaction. Distinguishing between physical kisses, spiritual kisses, and intel-
lectual kisses, he concludes that kissing on the lips is a sign instituted by "natu-
ral law" that is nonetheless open to corruption and perversion by the wicked.[68]
Context is everything, and Thomas Aquinas mirrors Aelred in taking the view
that kisses do not necessarily step beyond the range of the lawful. Answering
the question "May there be mortal sin in caresses and kisses?" in his *Summa
theologiae*, Aquinas is perfectly clear on the point: kisses and embraces, un-
like fornication, do not affect the physical intactness of an unborn child, and
therefore mortal sin is not inevitably present. Moreover, he writes, "kissing
and embracing can be innocent. Therefore in themselves they are not mortally
wrong." Kisses "can be done without libidinousness according to the custom of
the country or from some fair need or reasonable causes"; it is only when they
are done "for the sake of pleasure" that they are to be treated as gravely sinful.[69]

Another set of images that bear comparison with the Rouen miniature of
same-sex kissing can be found in certain illuminated manuscripts of the *Roman*

de la Rose. These, as Simon Gaunt has demonstrated, frequently depict the lover-protagonist Amant and his guide Bel Acueil (who is ostensibly masculine) in erotically charged situations with one another, occasionally juxtaposed with scenes of copulation between men and women. Sometimes, however, Bel Acueil is visually or even textually feminized in these manuscripts or switches between male and female within a single volume. Gaunt's argument is that Bel Acueil's sex changes demonstrate awareness of the homoerotic possibilities generated by the narrative: sometimes scribes and illuminators found those possibilities disturbing and sought to "normalize" the allegory by modifying Bel Acueil's gender; sometimes they viewed them as a source of amusement.[70] A particularly striking image appears in London, British Library, Egerton 881 (ca. 1380), where the artist has envisaged the climactic moment in Guillaume de Lorris's portion of the poem, in which Amant is granted the gift of a kiss, as two men kissing (fig. 33).[71] The rubric beneath the miniature makes it clear that the kissing couple are Bel Acueil and Amant: in so doing the makers consciously underscore the homoerotic possibilities of the narrative. The encounter between Orpheus and his beloved in Rouen O.4 is portrayed in a less egalitarian fashion than this. Although they are depicted as "same-sex" lovers, their relationship is clearly inflected by pederastic power play. But in both instances artists have confronted head on the homoerotic dimensions of the respective texts they are illustrating. The *Ovide moralisé* illustrator fails to represent the relationship between an older and younger male in a fashion that demands instant censure.

Rouen O.4 features a second rendition of Orpheus's liaisons with male youths among the moralizations appended to the end of book 10 (plate 6b). This constructs an alternative vision of life after Eurydice. Now it is no longer a kiss—which, as Aquinas notes, could be variously interpreted as innocent or sinful—but music and teaching that define Orpheus's relationships with males. Three miniatures appear on this folio. In the left-hand column, Orpheus is first shown enticing animals, birds, and trees with his music, and then playing his harp again to attract male youths. Two beardless males, one of whom is dressed in the same blue tunic as the boy kissing Orpheus in the earlier miniature, stand to the left and gesture with their hands, as if they are conversing with their teacher; the hips of the lad closest to Orpheus sway slightly toward him, as if corporeally aroused by his harping. The image illustrates the text in the right-hand column emphasizing that these practices, a manifestation of Orpheus's "male" (evil) doctrine, are "contre nature et contre loi" (*OM* 10.2524), which coheres with the visual depiction of musical seduction. Orphic harping could sometimes function as a code word for sexual inversion, as we saw in the lyric signed off by "Der Tugentschrîber."[72] Here the Rouen illustrator depicts Orpheus as a pederastic teacher, whose behavior becomes a foundational model for others to imitate: the gesture of raising one hand upward, which one boy

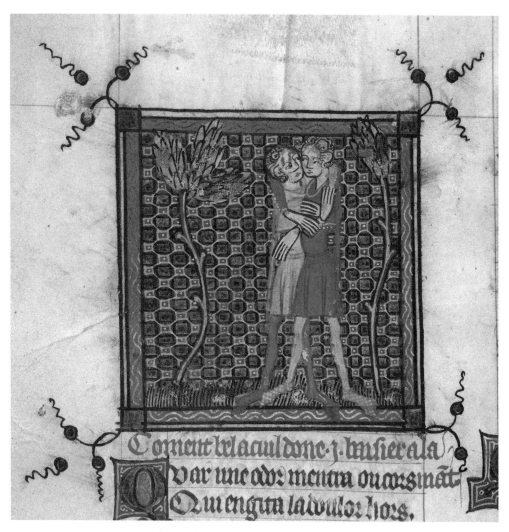

Figure 33. Bel Acueil kisses Amant. Miniature in *Roman de la Rose*. Central France, possibly Paris, circa 1380. London, British Library, Egerton MS 881, fol. 23v (detail). © British Library Board.

copies, reinforces this emphasis on imitation. And yet, at the foot of the page, the "autre sentence" appears, which interprets Orpheus as a figure for Christ who harrowed hell. This allegorization is preceded by an image of the crucifixion (fig. 34). The reader's eye is thus now afforded an opportunity to meditate on a naked male body (Christ's) as an alternative to the alluring charms of Orphic pederasty. But the ostensible opposition between these different modes of desiring males also reveals areas of overlap: placing both miniatures almost parallel to one another, toward the bottom of the page, encourages viewers to draw comparisons. A (presumed) male reader can legitimately desire a male body if that body is the Savior's; Christ's own desire for "masculine" virtue, which

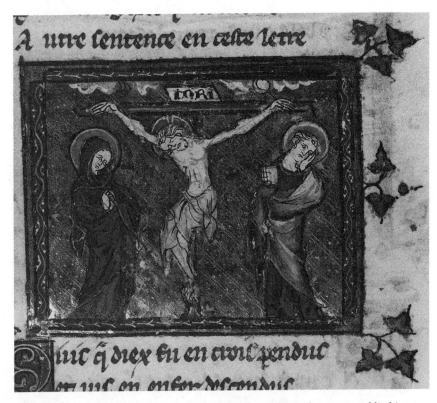

Figure 34. Crucifixion. Paris, circa 1315–28. Miniature in *Ovide moralisé*. Rouen, Bibliothèque municipale MS O.4 (1044), fol. 261v (detail). Collections de la Bibliothèque municipale de Rouen. Photography C. Lancien; Y. Communeau.

reverberates with Orpheus's misogyny in the poet's mind, provides a model for the Christian reader. The miniaturist, depicting Orpheus in the role of teacher as well as seducer, similarly emphasizes the protagonist's status as an initiator and role model for males. But here he could be taking up the role of a clerical or monastic educator as well as that of "first" sodomite of Thrace. Again the Rouen artist's depiction of Orphic pederasty reproduces some of the ambivalence also generated in the text being illustrated, where the poet combines multiple and sometimes contradictory readings of a single narrative.

In illuminated *Ovide moralisé* manuscripts produced after Rouen O.4 there is a steady reduction in the number of illuminations, and fewer images correspond to the spiritual level of meaning: artists focus their energies more and more on illustrating the stories themselves.[73] The Orpheus sequence in Arsenal 5069 participates in this trend. Although the illuminators appear to have known Rouen O.4, or a manuscript like it, only five images now illustrate the legend of Orpheus and Eurydice, and only one—a crucifixion (fol. 156v)—links to the moralizations. Orpheus is shown playing his harp, but not to attract young men. In one scene he plays outside the gaping jaws of hell to a cluster of

grimacing souls (fig. 35), and in another he sits playing as the Ciconian women stone him and wound him with a spear (fig. 36). Although these miniatures tend to follow the basic structure of the Rouen images (if sometimes "quoting" in reverse), there is one miniature, on the same folio as the one showing Orpheus harping to the underworld's inhabitants, that has no precedent in Rouen O.4.

Figure 35. Orpheus with Eurydice; Orpheus plays harp to inhabitants of hell. Miniatures in *Ovide moralisé*. Paris, 1325–35. Paris, Bibliothèque de l'Arsenal, MS 5069, fol. 132v. Photo: Bibliothèque nationale de France.

This depicts, according to the accompanying rubric, how he arrived in hell and attempted "par son harper enchanter les diables tant qu'il reust l'amie" (to enchant the devils with his harp until he rescued the beloved). The image itself shows what looks like marital union: Orpheus and Eurydice stand to either side holding hands, while a bearded old man in the center mediates (fig. 35). The identity of this man, playing the role usually assigned to an officiating priest in marriage, is unclear. Could it be Pluto, who as king of the underworld has the power to bring Orpheus and Eurydice back together? Or does the image correspond instead to the text appearing immediately below the miniature, which describes the ill-fated marriage of Orpheus and Eurydice—in which case the old man may represent Hymenaeus? This idealized scene may also be designed to act as a foil to the miniature on the previous folio, which shows Iphis and Ianthe (or their allegorical equivalents) embracing (fig. 28). The marriage of Orpheus and Eurydice, which includes a third, legitimating figure, contrasts markedly with the unequal encounter in the preceding image between a woman and the "pucelle" she corrupts. While the Arsenal illuminator visualizes an erotic encounter between women, the same artist has pushed Orpheus the pederast into the shadows.

Another later fourteenth-century illuminated *Ovide moralisé*, Lyon, Bibliothèque municipale, MS 742 (hereafter Lyon 742), which was in the possession

of Jean de Berry, reduces the image corpus further still. Five scenes correspond to the Orpheus story, none of which represent Orpheus's sodomitic phase. Because the allegorical interpretations have been eliminated in this manuscript, this change of emphasis is perhaps to be expected. The Lyon 742 artist now assigns a central role to Eurydice. The couple's marriage feast, attended by Hymenaeus, is depicted first (fol. 165v): Eurydice appears in the middle of the table, though it is unclear which of the three males also seated at the table is Orpheus. This is followed by scenes showing Eurydice's death (fol. 166r) and her rescue from the underworld by Orpheus, who plays on a fiddle-like instrument outside the entrance to hell as two devils reunite him with his bride (fig. 37).[74] Here the emphasis has shifted to Orpheus *with* Eurydice. Orpheus's ability to rescue his wife eclipses the moment of her loss, a motif influenced by romance conventions representing the pair as model courtly lovers. This resonates with other, fifteenth-century renditions of the Orpheus myth, in illustrated copies of texts such as Christine de Pizan's *Epistre Othea* and John Lydgate's *Fall of Princes* (ca. 1431–39), which likewise visualize the "happy" conclusion: Orpheus and Eurydice are shown reunited.[75]

An additional illustrated Ovid, Paris, Bibliothèque nationale de France, MS français 871 (ca. 1400), builds on the arrangements in Lyon 742 but clarifies things for the viewer by assigning labels to some of the protagonists. A folio illustrated on each side with large-scale drawings shows on the recto Eurydice's marriage to Orpheus (who is now identified by a label and by his harp), her death, and her rescue (fig. 38), and on the verso Orpheus charming nature (fol. 196v). This is also the only illumination I am aware of that shows Eurydice being led from hell, on the far left, prior to the moment of Orpheus's backward glance: he leads and she follows. But in all these later illuminated copies of the *Ovide moralisé* the emphasis is on Orpheus's union and postmortem reunion with Eurydice. Orpheus the first sodomite has retreated into the shadows, eclipsed by visions of Orpheus with Eurydice. This chimes with the secondary status attributed to Orphic pederasty in *Metamorphoses*. Whereas the makers of Rouen O.4 were content to treat Orpheus's turn to males more ambivalently, reflecting the exemplary status accorded to it by the *Ovide moralisé* poet, these later illustrations establish the primacy of Orpheus's relationship with Eurydice, and consequently the perceived primacy of the bond between male and female.

Why, then, did Orpheus-as-pederast reemerge with such force in Dürer's drawing? Helmut Puff has proposed a reading of this image that interprets it as being grounded in ambivalence.[76] Debates in early twentieth-century art history tended to focus on whether Dürer's message was serious or parodic. Erwin Panofsky sees in the work an example of the process by which, after centuries of Christianizing exegesis, the Ovidian Orpheus has returned to his classical roots—a manifestation of what Panofsky views as Dürer's appreciation

Figure 37. Orpheus rescues Eurydice from hell. Miniature in *Ovide moralisé*. Paris, circa 1385–90. Lyon, Bibliothèque municipale, MS 742, fol. 166v (detail). Photo: Bibliothèque municipale de Lyon, Didier Nicole.

of "Renaissance" sensibility. Compared with the Mansion woodcut published just ten years earlier—which, with its attribution of modish dress codes to the protagonists, close alignment between sin and punishment, and almost "comical" expression, corresponds to what Panofsky perceives as a thoroughly medieval aesthetic—Dürer's drawing "has the force of a classic tragedy."[77] In this, Panofsky follows Aby Warburg, who, in a 1905 lecture, similarly interprets the

Figure 38. Marriage of Orpheus and Eurydice (*top left*); death of Eurydice (*top right*); Orpheus plays to inhabitants of hell (*bottom right*) and rescues Eurydice (*bottom left*). Drawings in *Ovide moralisé*. France, circa 1400. Paris, Bibliothèque nationale de France, MS français 871, fol. 196r. Photo: Bibliothèque nationale de France.

composition as possessing "an entirely authentic, antique spirit," one of "intensified physical or psychic expression"—which comes into focus, Warburg maintains, when the drawing is juxtaposed with analogous scenes on ancient Greek vase paintings.[78] Conversely, Edgar Wind thinks that the drawing is intended to mock Orpheus's lofty status within Renaissance humanism. Focusing also on a later engraving by Dürer that borrows elements from the Orpheus composition, which depicts Hercules defending Virtue from Vice (1498), Wind argues that both Hercules and Orpheus are being subjected to ridicule as pederasts and victims of female violence—an "obvious" insult to humanist aspirations.[79] Mediating between these different positions, Puff contends that Dürer approaches his theme with a degree of equivocation. The fleeing *putto* infantilizes Orpheus's sexual partners; not simply a lover of male youths (an age group that could sometimes be quite broadly defined in classical and medieval sources), Orpheus is effectively presented as a child abuser, an adult male whose "tender" companions are completely incompatible as sexual partners. This coheres with medieval interpretations of the Ganymede story, which, as we shall see in the next chapter, sometimes narrowed the age range of Jupiter's beloved/victim. Additionally sodomy is associated with barrenness and sterility: compared with the lush foliage of the tree above, the left foreground of the image, into which the *putto* flees, is completely devoid of vegetation. And yet features such as the musical score floating beneath the explanatory scroll and the harp discarded at his feet continue to highlight his status as an exemplary artist. The scroll itself, which moves, as Puff puts it, "from the honorific priority of rank expressed in the word *first* . . . to the abyss of insult," also encourages multiple readings.[80]

This analysis, which I find convincing, coheres with one of this book's central claims, which is that sodomy's intelligibility and visibility—like those of all sexual categories in fact—is dependent on a sequential logic; consequently what "it" represents has a tendency to move. Embedded in imitative structures, which produce it as inferior to the divinely inspired ideal, sodomy is invariably constructed as secondary, artificial, unnatural, or backward looking. But this also potentially generates areas of ambivalence and ambiguity—moments when the notion of an "original" or founding moment is thrown into doubt. Dürer may well be reflecting in his drawing on his own status as a follower of Orpheus—somebody who, as another artist and *auctor*, also necessarily inhabits the roles of imitator and translator.[81] As Panofsky and others have argued, Dürer's Orpheus enters into a visual conversation with classical antecedents via the art and literature of Italy, thereby "translating" the ideals of the Italian Renaissance into German. But in this particular instance the contrast between this manifestation of a "Renaissance" spirit and its "medieval" predecessors may not be quite so stark. Just as in chapter 4 I question interpretations of visual encounters with antiquity that draw a sharp line between medieval

and Renaissance, here I submit that claims for the artist's originality, uniqueness, and modernity have possibly been overstated.[82] After all Dürer, like the *Ovide moralisé* poet before him, harnesses Orpheus's ability to function both as an originary, exemplary figure and as a sinner who suffers punishment for his moral backsliding. Famous Orpheus is simultaneously infamous; and yet, when viewed from a certain angle, his pederastic turn can nonetheless be a sign of Christian virtue, his unnatural practices a figure for the incarnation.

No wonder Dürer felt able to recycle the attitude first devised for Orpheus in a woodcut of Christ carrying the cross, executed 1498–99, in his *Large Passion* cycle: Christ mirrors in reverse the suffering pose of his mythic counterpart.[83] And the German artist's Orpheus is embedded in an iterative sequence that looks backward as well as forward. Panofsky, Warburg, and others postulate that Dürer based his composition on an earlier mythological image (now lost) by the Italian artist Andrea Mantegna (1431–1506). The existence of this scene by Mantegna is hypothesized principally on the basis of another, north Italian engraving from ca. 1480 (fig. 39), which adopts a strikingly similar arrangement to Dürer's drawing.[84] Also Mantegna's paintings on the ceiling of the Camera degli Sposi in the Palazzo Ducale, Mantua (1465–74), feature, in the side vaults, simulated reliefs depicting scenes from the myth of Orpheus, including the hero's death; the attitudes of his attackers in the death relief are reminiscent of the Italian engraving, though other aspects of the surviving painting are very different.[85] It has often been assumed that Dürer encountered Mantegna's work, or the print possibly based on it, on a trip to Italy in 1494–95. Persistent doubts remain, however, concerning the particulars of this journey or whether the artist ever made it across the Alps at this specific juncture.[86] Even if it cannot be proved that Dürer traveled to Italy physically in 1494, his Orpheus drawing clearly enters into a dialogue with a number of possible Italian antecedents. Another drawing, by Mantegna's contemporary Marco Zoppo (1433–78), which has sometimes been identified as depicting the Theban king Pentheus, whose death at the hands of female followers of Bacchus is described in *Metamorphoses* (3.708–33), shows the protagonist being attacked by the *putto* as well as women (fig. 40).[87] If, as some scholars now believe, Zoppo's image represents the death of Orpheus rather than of Pentheus, Dürer's drawing may well be reflecting— through his own composition produced twenty to thirty years later—on the citational structures in which he himself, as an artist, is embedded. Dürer's depiction of Orpheus, "first sodomite," is certainly not the first; like Orpheus himself, the artist is necessarily invested in acts of retro-vision, imitation, and transformation. Indeed Dürer's own *putto* could be interpreted as performing a transfiguration of Orphic looking. In a visual nod to Orpheus himself, who looks back at Eurydice and loses, the child turns around to face his teacher, role model, and abuser, just as the artist himself looks back at a series of artistic

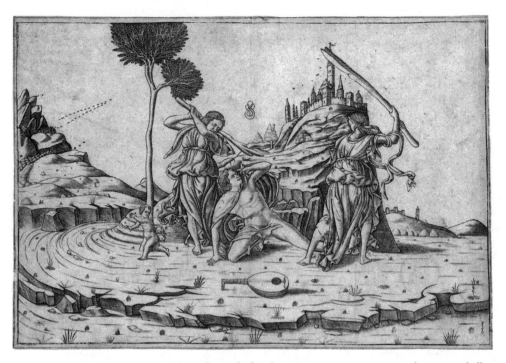

Figure 39. Ferrarese Master, *The Death of Orpheus*, circa 1480. Engraving. Hamburg, Kunsthalle, inv. 22. Photo: bpk/Hamburger Kunsthalle/Elke Walford/Christoph Irrgang.

forebears. In the process of looking backward, however, Dürer also strives to compete with and supplant these models, participating in the substitutive dynamics of *translatio*.[88]

Moreover the banderole, which identifies Orpheus as "der Erst puseran," links the hero with a specific geographic location: *puseran* is a corrupted version of the pejorative Venetian slang word *buzerar*, which denoted an active sodomite or "buggerer."[89] If, as some scholars think, Dürer wintered in Venice in 1494, he may have learnt the term there. Alternatively, given the strong cultural and trading associations between the artist's native Nuremberg and northern Italy, he may simply have encountered it closer to home. As Puff suggests, the point of citing the word *puseran* on the banderole is presumably to highlight the perceived "foreignness" of the practice, echoing the Ovidian Orpheus's own identity as an inhabitant of barbaric Thrace rather than civilized Greece.[90] Orphic sodomy, in keeping with a general tendency to identify sodomy with the Italian south, is always already perceived as secondary: it comes from somewhere else. But so, Dürer might be arguing, does his art. The "origins" of art, like those of sodomy, are inevitably located some place else—whether in a city such as Venice or in the iconographic models on which artists inevitably draw.

A year or two after Dürer composed his death of Orpheus drawing, he produced two other works that, as studies of single-sex groups of men and women in bathhouses, have sometimes been interpreted as conveying homoerotic themes. *Women's Bath*, dated 1496, is often viewed as a preliminary sketch for an unrealized print, while its counterpart *Men's Bath* (fig. 41) circulated as a popular and much-imitated woodcut. *Women's Bath* shows six women of various ages and physical builds cleansing themselves inside a steam room, while a man peers through a crack in the door in the background; two of the bathers look directly into the eyes of the beholder, who is made conscious of his or her participation—like that of the male onlooker within the drawing—in a voyeuristic scenario.[91] *Men's Bath* echoes the basic six-figure arrangement of the female group but underplays the viewer's status as voyeur by locating the action in a

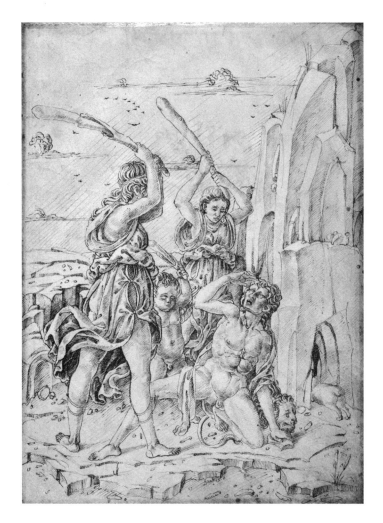

Figure 40. Marco Zoppo, *Death of Orpheus* (or *Death of Pentheus*). Drawing from Lord Rosebery album. North Italy, circa 1465–74. London, British Museum. © Trustees of the British Museum.

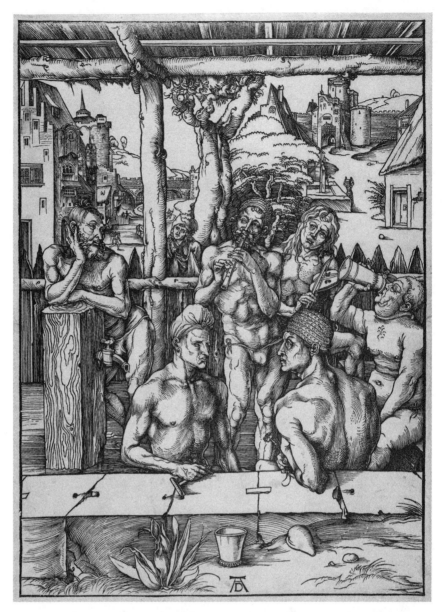

Figure 41. Albrecht Dürer, *Men's Bath*. Germany, circa 1496. Woodcut. London, British Museum. © Trustees of the British Museum.

public, open-air setting and doing away with the conceit of figures looking directly outward toward the beholder. Instead two of the pairs exchange mutual looks as they bathe. The man playing a recorder ogles a man of similar appearance to his right, while a cock-topped waterspout suggestively half-conceals the latter's groin, introducing an unambiguously erotic element; one of the men in the foreground, who has his back turned to the viewer, holds a flower, which

could be construed as a sign of courtship. Interpretations have proliferated of the possible allegorical, historical, or biographical significance of this composition, with arguments sometimes being made that the figure behind the tap—or occasionally the musician who catches his eye—represents the artist himself in a moment of self-portraiture.[92] It is beyond the scope of this chapter to make a detailed intervention in such debates, but they are cited to highlight how Dürer's encounter with Orpheus in 1494 was participating in a larger conversation concerning the erotics of looking, artistic identity, and same-sex relations in fifteenth-century Europe.[93]

Orpheus with Lot's Wife: Retro-vision and Gender

In this penultimate section I wish to return to one of the points raised at the outset of this chapter concerning links between the myth of Orpheus and Eurydice and that other prominent narrative of lethal retro-vision in medieval culture: Lot's wife and the destruction of Sodom. Of course the Bible contains plenty of other tales of dangerous looking. Among the scriptural stories enlisted in support of an argument against the dangers of looking in the thirteenth-century English anchoritic guide *Ancrene Wisse* (discussed further in chapter 5) are the stories of Eve, whose sin is said to have "earst" (first) entered into her through her "ehsiðe" (eyesight); Dinah, daughter of Jacob, who, according to the author's paraphrase of Genesis 34:1, "eode ut to bihalden uncuðe wummen" (went out to behold unknown women) and was punished by losing her virginity and being "imaket hore" (made a whore); and Bathsheba who, by uncovering herself in David's sight, caused him to sin with her (2 Kings 11:1–5). Female readers are advised, on the basis of these stories, to take steps not to allow men to see them in their anchoritic cells; but the narrator also makes reference here, more ambiguously, to the fact that "Of hire ahne suster haueð sum ibeon itemptet" (By her own sister some have been tempted).[94] The dangerous looks of women thus become conflated with women's role in leading men (and implicitly one another) to visual modes of sinning. Whether the anchorite tempted by her "own" sister was being condemned for a specifically homoerotic manifestation of fleshly looking is a question for chapter 5. But strikingly absent from *Ancrene Wisse*'s catalogue of biblical stories of dangerous looks is the story of Lot's wife's own problematic gaze in Genesis 19. In the latter, ignoring the advice of the angels to Lot and his family to "Save thy life: look not back [*noli respicere*]" (19:17) by "looking behind her [*respiciens*]," the nameless woman is transformed into a "statue [*statuam*] of salt" (19:26). Looking back, in other words, is the last thing Lot's wife ever does.

Presumably because the anchoritic discussion of looking ultimately focuses on women's agency in transforming themselves into sexual objects, the author

of *Ancrene Wisse* did not see fit to include a story where a woman, inhabiting the role of willful visual agent, finds herself unwillingly turned into an object (though in this respect Lot's wife surely possesses an affinity with Dinah). But steps were taken to confront the proscription against backward looking in Genesis 19 elsewhere in medieval culture. These representations sometimes contain visual and verbal echoes of Orphic retrospection, but the narratives conclude in distinctly gendered ways. Lot's wife, stealing a nostalgic glance toward the sins of Sodom, is stopped in her tracks and petrified: like sodomitic sinners in hell, discussed in chapter 5, she is effectively essentialized by her transgression, transformed into the very embodiment of the backward glance that kills her.[95] Conversely Ovid's Orpheus, for all his own "sodomitic" leanings, is afforded the prospect of transformative action and redemption. Orpheus himself gets transfixed by his look: Ovid describes how he is "stupuit" (10:64) (stunned), just like the man who, when he saw three-headed Cerberus, "was turned to stone." But unlike Lot's wife Orpheus continues in his journey, a journey taking in pederasty along the way. Orpheus is not completely immobilized in his grief; he learns to see the world and to love in other ways. While his death, like hers, was occasionally connected with sodomitic acts of retrospection, the imaginations of writers and artists seem to have found Ovid's redemptive coda more interesting than the moment of backward looking itself. The ending to the Orpheus legend is envisioned by Ovid as an exercise in movement rather than stasis: the couple are portrayed eternally strolling through hell with one another; as they continually switch roles in the procession, Orpheus can safely now "respicit" (11:66) (look back) at Eurydice.

One immediately striking parallel between Ovid's Orpheus and Lot's wife is the term used to describe their respective forbidden looks: in both *Metamorphoses* and the Vulgate the verb used is *respicere.* Moreover medieval commentators treated both episodes similarly, as a warning against moral backsliding. The *Ovidius moralizatus* allegorized Orpheus's backward glance as an instance of the penitent sinner who regains his soul through grace but looks back "out of love of temporal goods." Likewise interpretations of the Genesis story treated Lot's wife as a figure for those who, despite being filled with grace, continue to reminisce about their former lives. From around 1140 books of the Bible were produced and distributed through Europe that contained the entire biblical text along with a series of marginal and interlinear comments and explanations, largely drawn from patristic texts. The gloss in these Bibles, known as the *Glossa ordinaria* (Ordinary Gloss), was seen in the Middle Ages as giving the scripture its voice; in some senses it *was* the Bible. In a section of the Gloss devoted to Genesis 19, Lot's wife's transgression is compared to that of people who, "gratia vocati, retro aspiciunt" (called to grace, look back). Additionally the Gloss's reflection on the dangers of hindsight, which is literally identified as

"retro," is supported by two New Testament quotations: first Christ's warning against looking back ("aspiciens retro") in Luke 9.62, which, he says, bars entry to the kingdom of heaven, and then his call in Luke 17.33 to "remember Lot's wife."[96]

The makers of the *Bibles moralisées*, whose commentaries were sometimes informed by the *Glossa ordinaria*, followed suit.[97] Lot is likened to the worthy who leave the world and forget about it, while his wife is said to signify clerics who, despite taking up a religious life, continue to yearn in their hearts for worldly pleasures. In the Vienna Bibles these interpretations are illustrated with a scene showing Lot's wife, stripped of her clothes and completely white, looking back toward the collapsing city and its inhabitants. Lot escapes with his daughters to the right, while the accompanying moralization underneath shows a tonsured male engaged in a financial transaction with people who display various forms of worldly behavior, while another cleric retreats to the right (fig. 42).[98] The equivalent scenes in subsequent Bibles, including Bodley 270b, represent the worldly recidivists as males engaged in additional forms of ludic activity.[99] An illustration of Lot's departure from Sodom with his family and the angels is the first in the sequence (fig. 43). The accompanying commentary miniature shows two young beardless males seated to the left, their heads facing one another, while a pair of tonsured males enters a building (presumably a cloister) to the right. The sinful duo is seated before a chessboard, which doubles as an apparatus for counting money; one of the companions also carries a falcon in his hand. Below this there is a miniature representing Lot's wife's fatal stare (fig. 44), which triggers her transformation into a naked statue. Although she still wears a headdress, she uses her hands to cover her groin, which presents her metamorphosis as a moment of shame. The corresponding moralization shows a tonsured male seated before the chessboard with another male, while a cleric sits to the right in a building. Chess could be an erotic signifier in late medieval art and literature. Allegorical texts treated chess pieces as symbols for the emotions of a lady and her male suitor, while the game itself could be viewed as a signifier of sexual as well as civic order.[100] Although at least one pair in the Bodley 270b miniatures appears to be using the board for money-counting purposes, it would be entirely in keeping with depictions of homoeroticism elsewhere in this volume if the makers also had in mind here a coded reference to erotic power play. The falcon carried by one of the young men in the upper moralization possibly supports this reading. Falcons, like chess games, could sometimes have sexual connotations, even in the context of male same-sex encounters.[101] In light of these connections the makers of the *Bibles moralisées* might be communicating a comparable message: the pursuits of these "worldly" individuals correspond to the sins of Sodom for which Lot's wife also has a retrospective yearning.

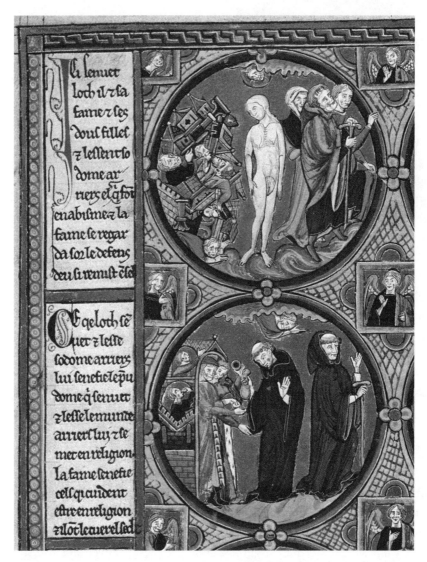

Figure 42. Genesis 19:15–16, 26; men who leave or remain in the world when they enter religion. Miniatures in *Bible moralisée*. Paris, 1220–25. Vienna, Österreichische Nationalbibliothek, cod. 2554, fol. 5r (detail, upper left). Photo: ÖNB Vienna.

But what did Lot's wife actually see when she looked behind her? Although the Genesis narrative itself provides no clear answer to this question, medieval illuminators sometimes speculated. In the *Bibles moralisées*, she is shown staring at a collapsing heap of buildings, and in some manuscripts the rubble is interspersed with Sodomites. Depicted as dead or dying, these unlucky individuals are invariably male. This coheres with visualizations of other aspects of the narrative. Although, as discussed in chapter 1, *Bible moralisée* artists identified those labeled "Sodomites" in the biblical paraphrase of Judges 19 as men

who abuse and rape women, treatments of the Genesis Sodom narrative tended to imagine the city's inhabitants as men and the objects of their desire as beardless, short-haired angels. It is not possible to extrapolate from this the conclusion that Sodomites were necessarily being presented as sexual abusers of male youths. In the *Bibles moralisées* beardless individuals count among the men of Sodom who desire to "know" the angels in Genesis 19, and Lot and Abraham are the only figures who are consistently endowed with facial hair. Angels were conventionally represented as beardless in medieval art, so a lack of sexual characteristics such as facial hair may be designed to connote angelic purity rather than age difference specifically.[102]

Whether Sodomitic desire was perceived as being structured by age or not, one thing is clear: the sinners in question were invariably gendered male. For instance the Egerton Genesis, which, as discussed in chapter 1, envisages Sodom as a location for multiple sins from masturbation to inhospitality, shows only male Sodomites in action (fig. 12). Other illustrated Bible manuscripts paint a different picture: very occasionally medieval artists included women among

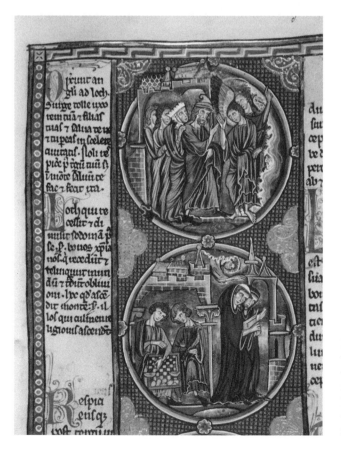

Figure 43. Genesis 19:1–11; Christians who leave or remain in the world. Miniatures in *Bible moralisée*. Paris, circa 1230. Oxford, Bodleian Library, MS Bodley 270b, fol. 15v (detail, upper left). Photo: The Bodleian Libraries, the University of Oxford.

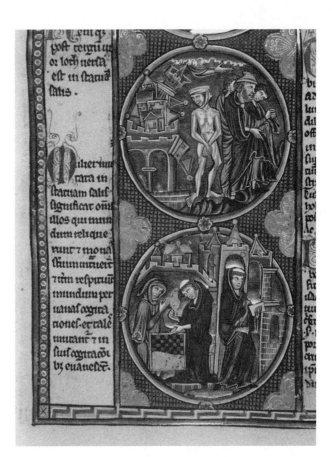

Figure 44. Genesis 19:15–16, 26; men of religion who leave or remain in the world. Miniatures in *Bible moralisée*. Paris, circa 1230. Oxford, Bodleian Library, MS Bodley 270b, fol. 15v (detail, lower left). Photo: The Bodleian Libraries, the University of Oxford.

the inhabitants of Sodom. A pair of miniatures almost contemporary with the thirteenth-century *Bibles moralisées* seems to entertain precisely this possibility (fig. 45). These scenes, which appear in a picture Bible illuminated in northeast France (Manchester, John Rylands Library, MS French 5), include among the dead and dying a pair of female Sodomites, identifiable by their wimples, one of whom apparently returns the gaze of Lot's wife on the adjacent page.[103] Hands stretched outward and upward, the woman's gestures are almost identical to those of the wife, who holds her hands in a similar outstretched position. Unlike her double's, however, Lot's wife's own eyes are closed. This could simply be indicative of the fact that her transformation into a statue is the death of her, but another interpretation is also possible. According to Genesis 19:11 the men pressing to enter Lot's house were "struck with blindness from the least to the greatest"; thus Lot's wife's sightlessness potentially mirrors that of the Sodomites themselves.[104] The female Sodomite has appropriated the male prerogative to stare; the wife, reciprocating this Medusa-like look, is punished for her transgression. Fueling Lot's wife's identification with Sodom's inhabitants

is the gendered nature of her backward glance: she appropriates a mode of active looking that was stereotypically reserved for male spectators. Lot's wife is effectively comparable to the women who, in Hildegard of Bingen's terms, have "usurped a right that was not theirs" when they assume the priesthood or sleep with other women. Like Katherina Hetzeldorfer, drowned for the crime of posing as a man, she possesses a "manly will," which undermines Lot's own status as husband and patriarch. The wife thus becomes a kind of sodomite herself, to the extent that she steps outside of her prescribed gender role with her backward glance. As Alan of Lille might say, her look "inverts the rules of Venus."[105]

As perpetrators of the crime of looking back, Orpheus and Lot's wife both function as figures for loss in medieval culture. But Orpheus's loss—reconfigured as the loss of the feminine and the world—is also Orpheus's gain: it allows him to ascend to previously unknown heights of artistry. Singing his song of love and lust, which could even, when viewed from a certain angle, be a symbol for Christ's redemptive message, Orpheus thus manages to break free from the past that threatens to stop him in his tracks. A future is mapped out

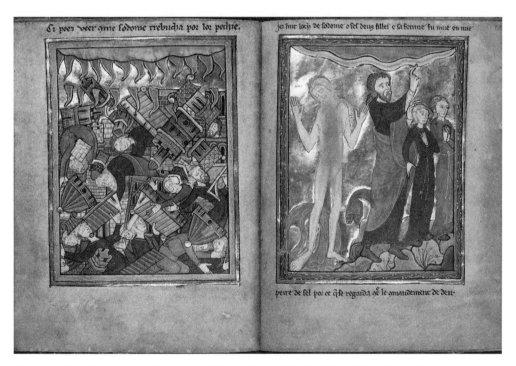

Figure 45. Genesis 19:15–16, 26: destruction of Sodom; Lot and his family flee Sodom; Lot's wife turned into pillar of salt. Miniatures in Bible Picture Book. Northeast France, early thirteenth century. Manchester, John Rylands Library, MS French 5, fols 19v, 20r. Reproduced by courtesy of the University Librarian and Director, The John Rylands Library, The University of Manchester.

for Orpheus that continues even after death. The motif of the poet's severed head, washing up felicitously on the shores of Lesbos, captures the ability of Orphic poetry to transcend the limits of biological existence and the flesh. Eurydice herself fails to reciprocate: she is never more than the object of Orpheus's backward glance. Although Ovid's redemptive conclusion endows her with a modicum of agency (now, Ovid says, Eurydice herself sometimes leads the way during the couple's wanderings in hell), Orpheus remains the subject of the gaze throughout; he is the one who, in the end, can safely look back at "his" Eurydice. Medieval image makers occasionally endowed Eurydice with a greater element of reciprocity than the Ovidian narrative. Artists visualized the moment when the pair was first reunited in the underworld as an exercise in mutual looking, as in the miniatures in Arsenal 5069 (fig. 35) and Lyon 742 (fig. 37). But what remains invisible in these contexts is the backward glance itself. Orpheus after Eurydice is imagined predominantly as Orpheus with Eurydice; Orpheus the backslider and sodomite is a relatively minor theme in comparison.[106] When Orpheus is represented looking back in manuscript illuminations, it is usually in the context of his death: Rouen O.4 (fig. 32) and Arsenal 5069 (fig. 36) both include scenes of his stoning in which he turns around to face his persecutors. This shifts the scene of backward looking to a moment in the narrative when crime and punishment can be conflated. As in the Mansion woodcut, Orpheus's transgression is represented as deadly, but it is the backward glance rather than pederasty that generates this outcome.

While Orpheus was associated only intermittently with the backward glance in medieval art, Lot's wife is consistently identified as a sinful scopophile. She is the very embodiment of eternal regret, a loser who is lost. Unlike Orpheus she has no future. This comparison between Lot's wife and Orpheus serves to underscore, once again, the patriarchal and misogynous structures that tend to shape depictions of retrospection in the Middle Ages. Men and women who look back suffer different fates in the hands of artists: Lot's wife's Sodomitical leanings are stopped in their tracks; Orphic pederasty might be glossed as being dangerously sodomitical or as a virtuous retreat from femininity, but either way it can also be conveniently forgotten in the end, overshadowed by Ovid's "happy" postmortem ending. Each story is shaped by a common gendered structure; each thrives on the age-old equation of femininity with fleshly desire, sin, silence, and death, and masculinity with wisdom, redemption, eloquence, and beginnings. But Orpheus's and Lot's wife's respective scopic passions—for Eurydice, for Sodom—also position them at different ends of the gender spectrum, organized according to a distinction between movement and stasis. Although Lot's wife momentarily acts like a man by appropriating the power to look, henceforth she is not afforded the luxury of being an active presence in

the world. Only Orpheus has that privilege. Only Orpheus rides off into the sunset of eternal movement and transformation.

Looking/Feeling Backward

In conclusion it is worth contemplating two recent reflections on the myths of retrospection that have been this chapter's focus. These generate what might be called a queer-feminist rehabilitation of backward looking. The first is Kaja Silverman's 2009 book *Flesh of My Flesh*, which discovers in Orpheus's story a message about the power of analogy. What we, as vital subjects, share is the fact that we will one day die; this embodied finitude is what connects us to every other being. More often than not, though, we refuse to acknowledge those limits. This, says Silverman, is the lesson that Ovid's Orpheus imparts: devastated by losing Eurydice a second time, Orpheus attempts to rid himself of mortality by feminizing it. This projection of death onto Eurydice—a projection grounded in the myth of difference between the sexes—is what fuels Orpheus's misogyny, his subsequent turn to pederasty, and his efforts to stave off death with song. Orpheus's inability to grasp the fact of death is exemplary of the ways in which death becomes othered in Western cultures—something that, as Silverman puts it, "happens elsewhere, and only to those who are not fully human."[107] Yet Orpheus's backward glance at Eurydice is ultimately transformative; it sets in motion a chain of events that returns the couple to a mode of relationality before the binary of gender. Thus in Ovid's redemptive coda Orpheus sees Eurydice again, but differently; clasping her in his arms he finally acknowledges her equality.[108]

Silverman's argument also takes shape against the backdrop of biblical concepts of a common flesh. Eve may be characterized in the creation story as a derivative, subordinate entity: she is, from Adam's perspective, "flesh of my flesh [*caro de carne mea*]; she shall be called woman, because she was taken out of man" (Genesis 2:23). But this image contains within it a kernel of analogic thinking: every living being is derived from a common flesh.[109] Metaphoric thinking and a logic of sequence clearly inform Adam's words. Guiding his statement is a notion of hierarchy and nonreciprocity, a sense that Eve is this, not that. Conversely, analogy springs out of a perception of resemblance and commonality. This perception is inevitably partial, rooted in contingency and embodied life. But from it comes a sense of relationality, of this *and* that. Orpheus's transformation through death and his eventual acknowledgment of Eurydice as a subject convey the power of analogy to generate relationality. Finitude is perhaps the most enabling analogy of all.

Heather Love also takes up Orpheus, and Lot's wife too, in her meditations

[handwritten margin note: Analogy: Adam, Eve, + derivatives]

on queer history and loss in *Feeling Backward* (2007).[110] These figures encapsulate, for Love, a tradition of backwardness in queer representation and experience. Love's book engages in a wider set of conversations in recent scholarship concerning the "positive" affects associated with doing queer work, especially queer historical work. Love responds, for instance, to Carolyn Dinshaw's efforts in her 1999 book *Getting Medieval* to interrogate the self- and community-building impulses that motivate what Dinshaw defines as the "touch of the past." What is it, Dinshaw asks, that draws some contemporary individuals in the present toward experiences of marginalization and exclusion in the past, even the distant medieval past? What possibilities do these "partial connections," "strange fellowships," and "good vibrations" create for building selves and communities in the present?[111] In the fifteen years or so since *Getting Medieval* was published there has been a perceptible shift toward a different set of questions in queer-oriented criticism. Untouchability not touch, unintelligibility not recognition, regression not succession, backwardness not futurity, failure not success—these are the new buzzwords in the so-called "antisocial turn" in queer theory.[112]

Love's turn to Orpheus participates in this shift. Like Halberstam, who has recently explored the politics of failure in contemporary cultures and queer efforts to inhabit the category of failure, Love identifies the art of losing as a "particularly queer art," one that serves to expose regions of overlap between the exclusions of the past and experiences in the present, which show up, for her, the "inadequacies of queer narratives of progress." While acknowledging Dinshaw's refusal to enlist the medieval past unproblematically within such narratives (say, as a manifestation of nostalgic longing for a time before sexual identity), Love also questions the idea that community is the destination to which a cross-temporal encounter inevitably leads. Untouchability also runs deep in queer experience, she argues, and works against the kinds of community and affiliation that have been seen as the primary motive for "touching" the past.[113] We contemporary queers, Love acknowledges, may find ourselves in the odd situation of hanging back and clinging to the past, while simultaneously looking forward. Such contradictory impulses work "to keep our gaze directed toward the past, toward the bad old days before Stonewall"—even if that means opening ourselves up to things that we would rather forget.[114]

It is clear why Orpheus might be a peculiarly apt figure for queer scholars working in the antisocial mode. Orpheus, and Lot's wife too, count among the "icons" of backwardness and backward looking enlisted in Love's analysis, as allegories of what she sees as the pull of backwardness in queer historical experience. (Among the other backsliders and backward lookers populating *Feeling Backward* are a number of other well-worn figures, including Odysseus, who casts his eyes back toward the Sirens as his boat pulls away, and Walter

Benjamin's angel of History, which turns from the future to face the ruined landscape of the past.) Love sets out, in so doing, to critique modernity's reliance on defining itself through the exclusion, denigration, or supersession of those it regards as backward and backward looking—a group that includes sexual and gender deviants.[115] Narratives of gay and lesbian progress, recognition, and pride obviously generate compelling counterarguments to these allegations of backwardness; yet many queer subjects continue, as she puts it, to "feel backward"—holding on, doggedly, to the shame, retrospection, and sense of loss with which queerness has been associated historically. Moreover it is precisely these "bad attachments," these allegiances to loss and relentless back turning, that contemporary queers might discover in the myth of Orpheus.

Historically speaking, retro-vision is an affective structure: looking backward and feeling bad constitute the "dark, retrograde aspects of queer experience."[116] But backwardness can also be a model for queer historiography. When Lot's wife looks back at Sodom, she confronts a "scene in which all her past attachments have been destroyed. In doing so, she refuses the imperative of the law and responds instead to the call of what the law has destroyed."[117] In this outpouring of grief, though, it is possible to discern a possible politics, albeit one that is grounded in ambivalence and melancholy. On the one hand, the losses of history instill in the beholder the desire for change, for moving forward; on the other, the danger of looking back at past losses is that it may leave us rooted to the spot. Orpheus similarly functions as an emblem for the challenges of queer history: "The failed attempt to rescue Eurydice is a sign of the impossibility of the historical project per se: the dead do not come back from beyond the grave. . . . But we might also read the Orphic lament as an effect of the particular losses suffered by queer historical subjects."[118] Any effort to save such subjects from the past is a recuperation necessarily doomed to failure; the dead will always remain dead, after all. Yet a refusal to look back, to catch a glimpse of Eurydice at the instant she returns to darkness, also constitutes a betrayal of that past.[119] Looking back in love is inevitably accompanied by the shadow of such losses; one of the motivating impulses within queer history and politics is the desire to follow the "trace" of experiences of violence and marginalization from past to present. Orpheus and Lot's wife both offer lessons in how to imagine this "backward future."[120]

Neither Love's nor Silverman's responses to Orpheus's backward glance explore in any depth the motif of Orpheus the "first sodomite." As a mode of relationality structured by hierarchy and subordination, and underpinned by a profound misogyny, it is hardly surprising that Orphic pederasty has been consigned to oblivion in modernity, even within queerly situated analyses. The idea that age-structured relations in which Orpheus engages are potentially abusive was not a feature of Ovid's own description of Orphic pederasty. But

clearly it sometimes featured in medieval interpretations, as discussed also in chapter 4. Today perceptions of pederasty as a form of sexual abuse, combined with a strong taboo against pedophilia more generally, make Orpheus's turn to "tender males" ethically troubling from almost every perspective. Also potentially problematic from the vantage of contemporary sexual ethics is Orpheus's sexual versatility—what might be seen as his bisexuality. Given the requirements sometimes placed on queer subjects to "convert" (notably in the context of the "ex-gay" movements, with their fantasies of mutable sexualities), the idea of an Orpheus who appears to change, from heterosexual to homosexual and back again, is politically unappealing. A growing consensus within the scientific community that sexual orientation is a largely fixed phenomenon, with efforts made to prove a biological or other basis for this "fact," also militates against the idea of an Orpheus who changes sexual taste as a response to loss. Finally the cultural ambivalence surrounding bisexual identity and desire more generally (not least within mainstream gay culture and politics) means that the story of a man who switches from female to male partners may have less currency at the present time.[121]

Yet insofar as the act of turning around is attributed with a redemptive value, analyses such as Love's and Silverman's also throw into relief some of the issues raised in this chapter concerning the ethics and politics of retrospection in the Middle Ages. The real blind spot in medieval visualizations of the Orpheus story, as we have seen, was not Orphic pederasty per se. Although the motif of Orpheus as sodomite was subject to various modes of displacement or even "closeting," it was not entirely absent from the field of vision. What worried medieval commentators most of all was the backward glance itself, which was allegorized as a return to worldly corruptibility and (feminine) fleshliness. In visual depictions this look is encountered only very rarely, and then generally via acts of metaphoric substitution. Dürer's fleeing *putto* displaces the motif of Orphic backward looking from the onlooker to his victim; medieval manuscript illuminations likewise sometimes depicted the motif of retrospection in the context of *his* death, not Eurydice's. When Orpheus looks at Eurydice, as he does in numerous illustrations of the story in medieval manuscripts, he neither looks behind him nor loses what he sees. Compared with visual depictions of Lot's wife, which essentialize her as a scopophile, Orphic retro-vision is not a common iconographic subject. His experience of love is not bound up with loss.

As such, medieval treatments of Orpheus do not work precisely in the ways Love envisages in her allegorization of Orpheus as a figure for queer history.[122] His look is sometimes one of failure (notably in images where he looks behind him as he dies), but it also witnesses the triumph of Eurydice's return. Nor do

medieval moralizers generally partake of the analogical thinking Silverman views as being at the heart of Ovid's story. Casting a backward glance at Ovid's Latin text, the *Ovide moralisé* poet perceives, in Orpheus, the possibility of a structural equivalence between such things as unnatural sex and the union of human and divine. But this ultimately works in the service of a thoroughgoing substitution: the subjugation of Ovid's morally dubious stories within a framework compatible with Christianity. Eurydice's reunion with Orpheus, which is the most common medieval iconographic type, is manifestly also an act of translation and transformation. Orphic pederasty is rendered invisible, while Orpheus *with* Eurydice takes center stage.[123]

In closing, then, it is worth reflecting on Orpheus's potential as a contemporary queer theoretical icon—a representative of the queer arts of failure, loss, and backward looking. Even in his most ostensibly "queer" moments, Orpheus was *not* primarily a figure for failure in the Middle Ages. His medieval representation arguably corresponds more readily to precisely the kinds of affirmative or assimilationist agendas that theorists working in the antisocial mode seek to counter. Gender variance, for instance, continues to be a site today for intense debates about the political significance of certain sexual identities and desires. The masculinist homosocial structures sometimes promoted within a more assimilationist or "homonormative" vein, which cast feminine identification as a source of inferiority, resonate surprisingly well with the aims of the *Ovide moralisé* poet, who likewise wants to imagine Orphic pederasty without the gender variance that would make it sodomitical.[124] So when Orpheus is appropriated as a model of queer historical affect and of "feeling backward," it is worth remembering that this is only half the story. Orpheus is also susceptible to being recruited in the service of what, from a modern perspective, would constitute some very normative and normalizing agendas.

Throughout this chapter we have encountered Orpheus insofar as he is translated, transfigured, and transformed. The great irony is that, as a story of firsts—first artist, first bugger—the legend is never anything other than secondary itself. A copy of a copy, it always comes from someplace else. There is no original Orpheus to which beholders can return their gaze. Paradoxical too (and this is where Dürer's drawing derives its meaning) is the fact that medieval writers and artists were implicated in the very acts of looking that their translations simultaneously seek to problematize. Commentators cannot help but cast their eyes back toward a series of literary and visual predecessors; their status as *auctores* is dependent on inhabiting the Orphic spirit within every one of them. If, as Nature puts it in *De planctu Naturae*, she herself possesses a "lira poetica" (8.133) (poetic lyre) with which to reveal the truth of the Christian message, this pointedly recalls Orpheus's own instrument—the *Orphei lira*—which

is invoked on two occasions in the text. Nature's promise of a single Christian truth thus depends on summoning up a plurality of other texts and signs; she herself necessarily inhabits the role of imitator and translator, piling one pagan figure on top of another to convey the message of the One True God. In a sense she too is the flesh of his flesh.[125]

The moralized Ovids similarly strive to discover the One within the many.[126] Finding in Orpheus's sexual adventures a recuperative message, the verse *Ovide moralisé* even perceives in sodomitic Orpheus a figure for God himself—once, that is, his sexual desires have morphed into a figure for divine love. Visualizations of Orpheus's sexual behavior in illustrated Ovids similarly convey some of the ambivalence that comes from attempting to glimpse unity within the diversity and fluidity of Ovid's poem. While most images of Orpheus do not participate in this trend—in the Mansion woodcut, his pederasty is literally presented as deadly; in other image cycles its ability to be seen is eliminated altogether—the entry of Orphic sodomy into the field of vision, when it does occur, produces confusion as well as clarity. Much as it holds out the promise of explaining what this unmentionable vice really is—how one might identify it, how it might appear to those who dare to cast a backward glance—the arts of Orpheus never allow us to confront his sexual history in an unmediated or stable fashion. Visibility is not simply invisibility's redress. Seeing sodomy is prone to generating further ambiguities.

While sexuality is a phenomenon that medieval commentators on Orpheus confronted only intermittently, his gender—and that of his followers and imitators—comes insistently into view. The *Ovide moralisé* poet's reflections on the story seem positively obsessed with the need to articulate a maleness from which any trace of femininity has been eliminated. One brief reference is made to the fact that the sin against nature has gender-inverting consequences for its participants (*OM* 10.216), but elsewhere in the text and in the images it inspires, Orpheus's gender identity is never questioned. Compared with the Iphis story, where transgender was such a driving force, the Orpheus of the moralized Ovids is generally a "manly" kind of man; his misogyny is the basis for that recuperation.

In the next chapter I turn to one of the central representatives of pederastic behavior in Orpheus's song, Ganymede, and put his own gender and sexuality under the spotlight. Considering also the relationships among age, power, sexual roles, and gender identity in medieval clerical culture, we will see how another set of viewers—monks in the abbey church of Vézelay—experienced Ovid in translation. In the examples cited, from the church's well-known series of twelfth-century sculpted capitals, the line dividing Christian stories from their pagan analogues is often blurred. Saints can, like Ganymede, become objects of desire for God and his earthly devotees; or, as with Ovid's Iphis, they

may be invested in gender transformation as a strategy for loving and living in the world. But interpretations of these Christian and pagan role models do not take shape within a wholly repressive or anti-erotic climate; nor, compared with treatments of the Orpheus legend itself, are representations of gender and sexuality in the Vézelay sculptures simply misogynous in outlook or effect. The epistemology of the cloister generates ambivalent kinds of knowledge.

4

The Sex Lives of Monks

This chapter's title is, of course, mildly tongue-in-cheek. On the face of it, the cloister is not the kind of place one associates with having sex. Surely the one thing monks cannot be said to possess—at least, if they are good monks—is a "sex life"; indeed, to the extent that they aspire to be dead to the world, they cannot be said to have a *life* at all. The assumption that monastic living and erotic expression are polar opposites conditions much historical writing on the subject. Historians of friendship have tended to produce defensively asexual interpretations of the passionate language deployed by medieval writers, especially religious writers, to convey the strength of those friendship bonds. Commonly the strategy is to desexualize what on the literal level seems to be erotically charged. Scholars demonstrate how what might sound sexual to modern ears is based on a fundamental misunderstanding of medieval literary convention. Understanding literature of the period "on its own terms" reveals how even physical gestures such as mouth-to-mouth kissing have no necessary erotic significance when read in context.

Jean Leclercq's 1979 study *Monks and Love in Twelfth-Century France* is a locus classicus for this argument. "In such matters," cautions Leclercq, "we must be careful not to project on to a less erotically preoccupied society the artificially stimulated and commercially exploited eroticism of our own sex-ridden age."[1] Leclercq was himself a monk, at a Cistercian house in Luxemburg, and his statement tends to get wheeled out

by scholars wishing to interpret the language of passionate friendship as an effect of genre and convention, dissociated from any "real" underlying feeling.[2] In fact, if we read his own statement in context, Leclercq is making a slightly different point than this. Reflecting on the writings of Bernard of Clairvaux (1090–1152), particularly his sermons on the Song of Songs, Leclercq follows this sentence with the words: "But neither should we be afraid to face the facts and take the texts as Bernard wrote them." He then goes on to discuss how Bernard himself does not shy away from deploying "strong sexual imagery" in his writings—language that those living in other, more "sexually self-conscious periods" would consider to have overstepped the mark.[3] So it is not that the language is "not erotic." Rather, the abbot deploys the language of human love to develop the theme of the loving relationship between Christ and Church, in ways that are not conditioned by modern notions of decorum, sexual psychology, or repression. Leaving aside this potential misappropriation of Leclercq's argument, we will easily find other scholars claiming to follow suit in arguing for a desexualized reading of passionate language in monastic settings. Discussing medieval literature on male monastic friendship, for example, religious historian Brian Patrick McGuire asks whether the intense feelings his materials evoke ever manifested themselves physically: it is "simply out of the question," he argues, to discuss the relevance of heterosexuality, let alone homosexuality, in this context.[4]

Of course McGuire is right here, up to a point. Medieval monks were not working with the epistemology of the closet that Eve Kosofsky Sedgwick has identified as one of the defining structures of sexual expression and oppression in modernity.[5] That a heterosexual/homosexual binary, differentiating the genital activities of people from one another according to the gender of object choice, was not the dominant paradigm for twelfth-century monks such as Bernard is, to my mind, indisputable. But this does not mean that the line dividing erotic activity from its verbal articulation was always maintained in practice. Nor should we simply privilege genitally organized activity as the only form of erotic desire that counts as sexuality. Clearly members of religious orders were attributed with sex lives by some medieval commentators: anticlerical satire is a case in point.[6] Likewise the authorities in the later Middle Ages who conducted visitations—inspections focusing on the moral upkeep of religious houses—discovered within the cloister a variety of misdemeanors including, very occasionally, practices that came under the heading of sodomy.[7] In the Middle Ages themselves it was not out of the question to confront the possibility that the passionate feelings articulated in religious writings of the period did sometimes find physical expression.

In the eleventh century the Roman Church had undergone a program of moral and religious revitalization, during which the papacy strengthened its

authority. Connected with this period of "Gregorian Reform," concerted efforts were made to restore the ideal of clerical celibacy to its original purity, which also led to rulings specifically against clerical sodomy in certain regions. The Council of London, instigated by Anselm in 1102 when he was archbishop of Canterbury, passed a statute condemning all those who indulge in unnatural sex acts, especially those "who of their own free will take pleasure in doing so"; clerics found guilty of the vice were to be deposed, lay folk deprived of legal status.[8] Such ideals were also reaffirmed several times during the twelfth century. The First Lateran Council, an ecumenical meeting of Christian bishops held in 1123 at the Lateran in Rome, ruled against marriage and concubinage among priests, nuns, and monks. These canons were repeated in the second council in 1139; Lateran III, in 1179, set sodomy in its sights, imposing sanctions against both clerics and lay people who were found "to have committed incontinence which is against nature, on account of which the wrath of God came upon the sons of perdition and consumed five cities with fire."[9]

Monastic writers periodically worried that close friendships forged within the cloister might slip into debased forms of eroticism. Aelred of Rievaulx, inspired by the classical ideal of friendship developed by Cicero, drew a clear line in *De spiritali amicitia* between carnal modes of relation and what he called "sublime" love, a love that transcends social and fleshly bonds.[10] But several decades earlier the Benedictine Guibert of Nogent (ca. 1055–1124) had written a treatise on virginity for cloistered males in which he warns against the "fatal love" that friendship might precipitate and concludes that the practice is best avoided.[11] In the tenth century Odo, abbot of Cluny from 927 until his death in 942, composed his massive Latin poem, the *Occupatio*, which devotes substantial space to denouncing sodomitic acts in the confines of the monastery.[12] And sexual practices within religious houses had long been regulated in handbooks on penance. First compiled for the use of confessors in Irish and Anglo-Saxon monasteries, these penitentials counted among the possible practices deserving censure fornication *in sodomitico more*.[13] Burchard of Worms, who also paid attention to the sexual incontinence of religious women, incorporated similar rulings directed against both clerics and lay people in his eleventh-century *Decretum*.[14] Collectively these various regulations suggest a more coordinated response after the eleventh century. This was clearly a period when claustral sexuality was generating anxiety within the church, perhaps provoked in part by the fact that some churchmen and women really did have sex lives.

But I would like to get beyond the assumption that eroticism simply entails bodily intimacy with another person, or that it needs to be expressed physically to count as eroticism. For what might be termed the "epistemology of the cloister" is, I want to argue, structured principally as a choice between maintaining and not maintaining chastity—and chastity itself participates in erotic

structures.[15] In this, my point is not simply that monastic culture used sensual imagery in the service of worship: clearly it did, as commentaries on the Song of Songs surely testify. Rather I want to include in my understanding of the sexual what, following Virginia Burrus (and before her, Karmen MacKendrick), might be termed the "countererotic" pleasures of enclosure. Burrus deploys the term "countererotic" as an alternative to the theories of repression and sublimation that tend to shape writing about Christian sexuality. Her book *The Sex Lives of Saints* asks what happens when, far from viewing sexuality and sanctity in opposition to one another, we read the ancient legends of ascetics and martyrs precisely for their "exuberant eroticism."[16] How do the saints themselves bear witness, in their biographies, to the power of eros? How might a perspective on the sexuality of saints teach us to read hagiography differently, as a body of texts concerned with positioning saints as desiring subjects? This countererotic (as opposed to nonerotic) impulse works by producing an intensification of desire through restraint; Burrus considers the ways in which saints prolong their desires through such counterpleasurable experiences as pain, discipline, and temptation.

Though developed specifically as a framework for reading early Christian hagiography, this idea of countererotics might usefully be transferred to medieval monastic cultures. Monks, like their saintly role models, were invested in the pursuit of modes of pleasure that consist in or come through frustration, refusal, or even pain. Variants on the asceticism that is a defining feature of monastic life, these counterpleasures are, in MacKendrick's words, "so absurdly difficult in attainment that we must sometimes suspect that the pleasure comes in the intensity of the challenge itself . . . pleasures that refuse the sturdy subjective center . . . pleasures that don't come within the economy of gratification."[17] Not all monks participated in this countererotic structure, or at least not all of the time. It was, like all erotic structures, an ideal that inspired various levels of conformity. The subjects of anticlerical satire seek sexual gratification in this life, as surely did many of their nonfictional peers. It is precisely their lack of enthusiasm for asceticism that provides the starting point for the satire. But a model of countererotics nonetheless helps delineate the subjects' transgressions of monastic discipline. Precisely to the extent that fictional monks suffer from an aversion to the cloister—what might accurately be called their "claustrophobia"—they transgress the codes of claustrophilia (love of confinement) to which an enclosed individual should ideally aspire.

This erotics of enclosure—memorably described by Cary Howie as "thinking inside the box"—is always bound up with the risk of sex.[18] Stories of wayward monks beating themselves up, mentally and physically, for their fleshly imaginings, or desperately trying to control their nocturnal emissions, represented

one response to these corrupting impulses. In the lives of early desert fathers such as Saint Anthony, sexual temptation had been characterized as a mode of demonic possession; demonology, in turn, provided a fertile ground for the cultivation of clerical misogyny by aligning sexual pollution specifically with women.[19] One manifestation of this idea in medieval art, as discussed later in this chapter, was the personification of *luxuria* as an explicitly feminized figure: depicted with such gendered signs as breasts, long hair, or immodest dress, Luxury is simultaneously tempted and punished by demonic creatures such as snakes or toads. Or she might be represented in the guise of a demonic predator, lusting after and sexually dominating men. The *Belles Heures of Jean de Berry* contains a particularly striking instance of what might be called the "dominatrix" model of sexual temptation (fig. 46). Between the Jerome sequence discussed in the introduction and a sequence containing scenes from the lives of Anthony and another hermit called Paul, the Limbourgs have painted a miniature that depicts Paul and another pious male (probably Anthony) looking on in horror as a young man, arms bound behind his back, is molested by a female temptress. The woman pins the youth down with her knee as she runs her hand up his leg; named as a Christian in the accompanying text, he takes the extreme step of biting out his tongue and spitting it at his abuser in order to resist the woman's advances.[20] Typically the image promotes carnal renunciation as the solution to fleshly temptation, which is cast as a sexually voracious female.

While the *Belles Heures* miniature is unquestionably powerful, it is important not to assume that such scenes represent the *only* response to the problem of maintaining chastity in medieval culture. In male monasteries, specifically, other strategies were sometimes adopted; my aim, in what follows, is to consider some of the alternatives that developed in particular times and places. First there is the fact that within a single-sex environment such as an all-male monastery, the sources of sexual temptation were not inevitably gendered female: demonically inspired lust could assume different guises. Second, monks were not inevitably faced with making a stark choice between desire and its renunciation in these settings: the spiritual love to which they should all, ideally, aspire was itself sometimes conceived as an experience in translation.

I have been using this initial overview to set up one of the arguments I will be putting forward in this chapter: that Western monasticism's efforts to contain eroticism are not simply repressive, and that there is something potentially erotic—or more specifically countererotic—about the way medieval monks handled their desires. Here I concur with Leclercq's arguments concerning Bernard's sermons on the Song of Songs. Since, in the twelfth century, recruits to new monastic orders such as the Cistercians were mainly adults, commonly drawn from noble or knightly stock, they had experienced the world in a way

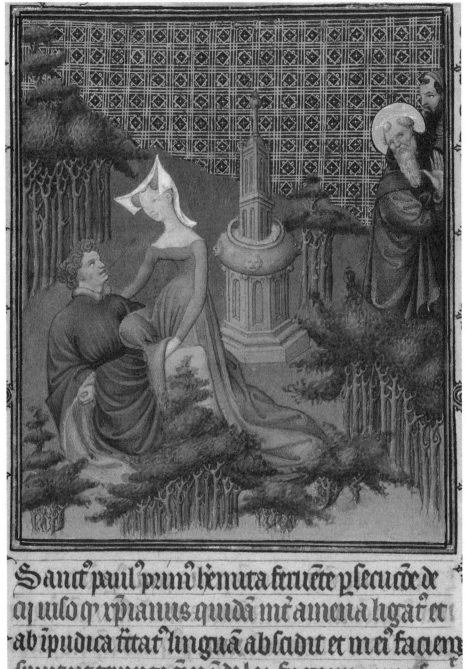

Sanctus paul' primi hemita feruere psecucoe de
aj uiso cp xpianus quida mr amena ligat et
ab ipudica fitat' linguam abscidit et in ei faciem
spuit ut temptacoie dolor fugaret. roma fug.

Figure 46. Saint Paul the Hermit sees a Christian tempted. Miniature by Herman, Paul, and Jean de Limbourg in *The Belles Heures of Jean de France, Duc de Berry*. Paris, circa 1405–1408/9. New York, Metropolitan Museum of Art, The Cloisters Collection, 1954 (54.1.1a, b), fol. 191r. © Photo SCALA, Florence 2013. Image copyright The Metropolitan Museum of Art / Art Resource / Scala, Florence.

that those recruited as children, through the practice known as oblation, had not. These individuals would likely enter the cloister having experienced personally the pleasures and pains of sexual love, as well as the perils of knightly violence; but rather than seeking to repress those potentially risky secular experiences, Bernard sought to exploit them with a view to transforming them. Writes Leclercq:

> Monastic love and other forms of Christian love have a different quality, but the latter can and ought to be integrated into this love for God. And monastic love for God can and must be expressed in terms of human love; it can assume, retrieve, and integrate images, representations of human love, and even memories of its accomplishment, as seems to have been the case with some young men who had become monks.[21]

Talal Asad, developing and nuancing this argument, points to the dual significance of the term *libido* in early Christian thought. It refers to the drives, deriving from concupiscence, that have to be restrained because they transgress God's Law (as in references to the devil's "enticements" and libidinal corruption in the *Bibles moralisées*). But it can also denote "eagerness for eloquence and glory," that is to say, desire for excellence and virtue. In this other sense libidinal experience is defined

> not as something to be repressed, but as the essential means for achievement of excellence, as a precondition for training the virtuous self. . . . Bernard set before his novices an authoritative model of virtue towards which they were led to aspire, but he also sought to use concupiscence itself as the material for exercising virtue.[22]

Though this procedure clearly courted danger—as Leclercq puts it, "We may wonder whether Bernard's pedagogy was always free from such risks and from all ambiguity"[23]—it dealt with that danger through a program of redirection and transformation rather than simple rejection.

To this contention, I wish to add a second: that monastic counterpleasures were construed as experiences in translation. Translation has long provided a productive set of questions for historians of sexuality, as discussed in the introduction. More than three decades ago Boswell drew attention to the appropriation of classical models by twelfth-century clerics as a means of negotiating love, gender, and sexuality in their own time. As Boswell points out, the invocation of literary analogues, whether from ancient Greece and Rome or from erotic poetry circulating on the Iberian peninsula, gave clerics a language for talking about same-sex desire that bypassed some of the moralizing stigma

associated with sodomy.[24] Translation was also crucial to the development of monastic traditions of love more generally, as articulated by figures such as Bernard: speaking of the "transforming work of Bernard's sermons," Asad argues that the abbot's exegeses of the Song of Songs offer a "new vocabulary by which the monks themselves can re-describe, and therefore in effect construct, their memories in relation to the demands of a new way of life."[25] Turning to the nave capitals of Vézelay, the principal case study in this chapter, I want to consider how depictions of sex in medieval monasticism might themselves participate in this work of translation and transformation; how translation functions in this context not simply as a site of openness for the representation of sex, but also as a mode of clarification that obscures; and how, in so doing, these depictions potentially generate a surplus of meaning for the medieval viewer.

Vézelay, Mary Magdalene, and *Translatio*

The monastic church of Vézelay provides an excellent case study for exploring these questions. The church's nave was rebuilt in the 1120s and early 1130s, following a disastrous fire in 1120, but several decades earlier one of the community's abbots, a man called Geoffrey, had begun spreading a rumor that the remains of Mary Magdalene lay buried within their church. Magdalene's own story is one of moral translation—from a life of sinful sexuality to one of pious sanctity. Hers is a composite narrative, pieced together from references to several biblical women. Magdalene was the devoted disciple of Jesus who, according to John's gospel, was the first person to witness Christ resurrected and to bring news of it to the apostles (John 20.11–18), and from whom Christ cast out seven devils (Mark 16.9; Luke 8.2). Early Christians also associated Mary Magdalene with the woman sinner who anointed Christ's feet in the gospels (Luke 7.36–50; John 12.1–5); in turn she was identified as Mary of Bethany, sister of Martha and Lazarus (Luke 10.38–42; John 11.1–2). A year into his papacy, in 591, Gregory the Great (ca. 540–604) chose to highlight connections between Mary Magdalene and these other gospel women in a sermon, as well as fleshing out certain details about her life prior to meeting Christ. Identifying the seven demons cast out from Magdalene by Christ as the seven deadly sins, the pope also clarified the nature of the sins committed by the woman who anoints Christ in Luke 7.38: this nameless "sinner" (identified as Magdalene) applies an ointment to the Savior's feet that was previously used to perfume her flesh with what Gregory calls "illicitis actibus" (unlawful acts). Finally, though, Magdalene "convertit ad virtutum numerum criminum" (turned the mass of her crimes to virtues) by devoting herself to a life of penance.[26] In subsequent centuries, influenced by Gregory's sermon, Magdalene acquired a reputation as a former prostitute, who repented of her ways and devoted herself to a life of chastity

and meditation. She therefore acted as a role model for any individuals wishing to change their sinful behavior and devote themselves to penitence, as well as those wishing to pursue chastity after a period of sexual activity.[27]

It takes considerable ingenuity to explain why a woman from Judea came to be interred on top of a hill in Burgundy, and inevitably questions were raised about the plausibility of Abbot Geoffrey's story. One miracle collection suggested that he responded, somewhat enigmatically, with the statement "All things are possible with God, and He did whatever He liked."[28] Other events in subsequent decades helped bolster the church's claim, in particular the miracles that began occurring at the site of Magdalene's supposed tomb. And at around the time that the present church was built, a Latin legend began being circulated, known as the *translatio posterior*, which claimed that the saint had miraculously sailed in a leaky vessel all the way from the Holy Land to Provence, where she died and was buried; that Magdalene's relics, interred in the city of Aix-en-Provence, had been stolen by a Burgundian nobleman, Count Girart, in the late ninth century, supposedly to protect them from Saracen invaders; and that Girart had subsequently returned to Burgundy with the sacred booty, which he duly installed in the church he founded at Vézelay. Welcoming Magdalene's bones into the church with a lavish ceremony, the community henceforth celebrated the saint's translation annually in March.[29]

The most common explanation for the Vézelay community's enthusiastic reception of this holy harlot's relics is that the claim allowed the monks to lure in pilgrims en route to the shrine of St. James of Compostela. By the twelfth century Vézelay had become one of the starting points for these "chemins de Saint-Jacques," conveniently located as it was for pilgrims setting out from Germany to Santiago in Galicia. The community thus had a stake in playing up its own connections with a prominent saint: the claim helped secure its place at the head of one of the most important pilgrim roads in Europe.[30] But other reasons can also be identified for investing so much energy in the promotion of Mary Magdalene's cult at this particular juncture. Several manuscripts from around 1100, which record miracle stories, suggest that at one time the monks of Vézelay had been less than virtuous: relaxing the rules, they had indulged in "lascivious" behavior and thereby tarnished the house's reputation; abbot Geoffrey is said to have turned the community around, after which Magdalene-related miracles began taking place.[31] What is more, the massive rebuilding of the church's nave was overseen by a man called Renaud, who became abbot in 1128; the rebuilt nave contains the famous sequence of carved capitals that are this chapter's focus. Abbot Renaud was recorded on the epitaph—now lost—on his tomb at Cluny as having been a *reparator*, that is to say, a "repairer" or "reformer" of the house of Vézelay.[32] This *reparator* epithet may simply refer to Renaud's status as refurbisher of the building's fabric; additionally, though, it

could allude to his role as the promoter of moral as well as material regeneration.[33] In general terms, then, it is possible to imagine a line of identification that extends from the reformed, formerly lascivious monastic community to a repentant prostitute saint. The rumors circulating about Mary's sinful sexuality make her an unlikely role model for monks, yet here was a woman who ultimately repented and was redeemed, functioning as a powerful illustration of God's forgiveness and a model of the possibilities of reform. Those in need of such a message, I am suggesting, may have included the monks of Vézelay themselves.

Perhaps surprisingly, given the importance of Mary Magdalene to the church's financial and moral welfare, the sculptures of Vézelay do not make much direct reference to her presence. There are a couple of relatively minor depictions representing Mary in the church, and originally there may have been more. But the saint is generally conspicuous by her absence, and there is not a single depiction of her in the nave capitals.[34] This absence has prompted recent commentators to question the dominance of interpretations of the nave capitals that focus on their significance for pilgrim audiences.[35] Rather than seeing the building as an index to the saint's cult, for instance, Kirk Ambrose has foregrounded monastic spectatorship as the most significant context for comprehending the sculptures.[36] I agree with Ambrose: it is important to consider the meanings of the capitals for monks. But it is also worth drawing attention to the monks' interest in Mary Magdalene's cult as a map for their own spiritual journeys. The saint's status as a repentant sinner may not have been conducive to representations of her as a frequent physical presence in the church; yet some of the nave capitals themselves, which ostensibly represent other subjects, nonetheless help bring into focus Mary Magdalene's own potential as an exemplary model of monastic life. Translating the lesson imparted by her legend, these capitals are centrally concerned with eroticism and its management, and the manifold forms it takes in a community such as Vézelay. In what follows I concentrate on three examples that resonate strongly with the themes of sexuality and redemption in Magdalene's legend. Though not generally considered together, these sculptures also bring into focus translation's role in monastic confrontations with sex.

Eugenia, Temptation, and Transformation

The only woman saint to be represented on the Vézelay nave capitals is Eugenia, whose "femaleness" is hardly stable. A summary of Eugenia's legend shows why the abbey's monks may have found this story especially inspiring.

According to hagiographers, Eugenia's story is set in Alexandria in the reign of Emperor Commodus (180–92 CE). Eugenia is the young daughter of a Roman

patrician called Philip who has been appointed prefect in the city. Through her reading she discovers Christian teachings and decides to devote herself to a life of chastity. On a trip away from home with her two eunuch slaves, Protus and Hyacinthus, Eugenia determines to join a community of Christians. To avoid being separated from her traveling companions, she asks the eunuchs to cut her hair short and proceeds to wear male garb. The three enter a nearby monastery, which is governed by a saintly bishop, Helenus, who sees through Eugenia's disguise but agrees to admit them anyway. Personally overseeing their baptism, Helenus keeps Eugenia's gender secret from the monastery's inhabitants. A few years later Eugenia, who has renamed herself Eugenius, becomes leader of the house following the death of her mentor; but still no one guesses that the new abbot entered the monastery as a girl. However, Eugenius soon attracts the attentions of a wealthy widow, Melantia, who comes to him to be healed of a terrible fever. Falling in love with him, Melantia tries to woo Eugenius with thoughts of worldly pleasures and marriage. Frustrated that she cannot have her wicked way with the abbot, Melantia claims that Eugenius has attempted to rape her and a case is brought before the abbot's own father, Philip, who does not realize that the accused, dressed in male clothing, is his daughter. As a last resort, during the trial (which takes place in public), Eugenius rips off his/her clothing as proof of innocence. Everyone, seeing that s/he has breasts, recognizes Eugenia as the prefect's daughter, praises God, and converts. Eventually the saint and her eunuch companions are martyred.[37]

Varzy (Nièvre), around two days' walk from Vézelay along the road to Santiago, was reputedly in possession of Eugenia's relics from the tenth century.[38] So the martyr's cult would have been familiar both to the monks of Vézelay and to its pilgrim visitors. Moreover the story repeats a narrative structure—flight, disguise, seclusion, discovery, recognition—also found in several other tales of cross-dressing or "transvestite" saints.[39] The protagonists of these legends confront precisely the situations in which Hildegard of Bingen, writing two decades or so after the rebuilding of the nave at Vézelay, concedes that women might legitimately cross-dress. As discussed in chapter 2, the *Scivias* allows for situations in which a "woman's chastity is in danger," which may necessitate the adoption of male attire, while going on to condemn all other manifestations of female masculinity, including women who couple with other women erotically. The point is that cross-dressing saints have chastity as their goal. The moment of miraculous revelation, when the protagonist's "true" gender identity is discovered, serves to demonstrate the enduring threat posed to a woman's chastity by femininity; often it is only after death that the saint's female embodiment is discovered.

Eugenia, unusually, is exposed as female prior to death. Yet visual depictions of the saint rarely focus on the scene of revelation itself, preferring to fix

her in her postmartyrdom state as securely female. Surviving images produced prior to the twelfth century represent Eugenia as a nimbed, standing saint, while depictions of Eugenia in fourteenth- and fifteenth-century illuminated manuscripts underplay the saint's cross-dressing or render it invisible.[40] Surviving artworks in Varzy associated with Eugenia's cult are in keeping with this trend. A late fifteenth- or early sixteenth-century statue, now in the church of Saint-Pierre in Varzy and formerly in a church in the town dedicated to Eugenia, represents the saint wearing the crown of martyrdom, carrying a book (possibly a sign of her dedication from an early age to philosophy and Christian teachings), and dressed in the garments of a late medieval noblewoman (fig. 47).[41] A sixteenth-century painted panel also now in the church of Saint-Pierre, part of a triptych dedicated to the saint, shows a short-haired and tonsured figure dramatically stepping forward to bare a breast while Melantia stands accusingly pointing a finger, but during the Middle Ages scenes showing Eugenia cross-dressed or in a moment of transition were exceptional.[42]

The depiction of the Eugenia legend at Vézelay represents one such exception. On a capital in the nave's north aisle, the sculptors chose to represent Eugenius's trial, rather than the saint's subsequent martyrdom, in a manner that plays up the ambiguities in the narrative at this juncture (fig. 48).[43] A short-haired, tonsured figure is shown in the center, looking toward the father/judge (right) as s/he rends the habit by hand as if about to display his/her chest; the abbot's accuser, Melantia (left), points to Eugenius with one hand as she holds her own, long tresses with the other; the widow's tight-fitting clothing and wide sleeves further accentuate her femininity and sensuality.[44] The carving balances strongly gendered figures to the left and right, with an ambivalently gendered image in the middle.

Breasts are represented elsewhere in the nave sculptures. Two piers along from the Eugenia capital is a depiction of Eve taking fruit from the tree of knowledge as she faces the Serpent: naked from the waist up, she covers her groin with a leaf.[45] High up in the north clerestory (though still visible to the naked eye) another capital also represents the fall: Eve, naked and full frontal, is depicted taking fruit from the tree of knowledge and passing it to Adam (fig. 49). But, as suggested by Ambrose, Adam's unusual gesture of touching his upper body as he receives the fruit also possibly plays on the similarity between the words for chest (*pectum*) and sin (*peccatum*) in Latin.[46] Eve's act of displaying her breast may well reinforce this vision of corporeal sinfulness.[47] A capital on the south side of the nave, closer to ground level, shows a bloated demon caressing a naked woman, while a serpent gnaws at a musician's genitals—presumably an evocation of punishments for *luxuria* and worldly pleasure.[48] Walking further along the south aisle brings visitors to a capital depicting Despair and Lust, which represents the lecherous sinner as a woman with a

Figure 47. Saint Eugenia. Polychromed statue, late fifteenth or early sixteenth century. Choir of Saint-Pierre, Varzy (Nièvre). Photo: Robert Mills.

somewhat riotous hairdo nursing a snake with a downward pull of her breast (fig. 50).[49] Contemporary sculptures in other monastic churches in France, such as the porch of the abbey church at Moissac (ca. 1125), likewise personify *luxuria* as a naked female, with serpents hanging from her nipples and a toad from her groin. These scenes seem to participate unambiguously in the demonization of female sexuality, though arguments have been made for gender instability here too. After all, the toad dangling from Luxuria's genitals in the Moissac scene can also be interpreted as a "hellish parody of male genitalia," a sign that it is "more than just Luxuria's femaleness that matters."[50]

The Eugenia capital likewise inverts the viewer's expectations of breasts

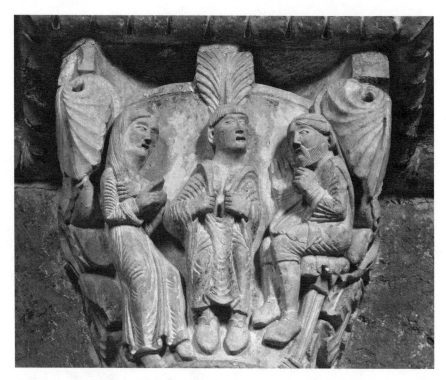

Figure 48. Saint Eugenia's trial. Carved capital, circa 1120–40. North aisle of nave, La Madeleine, Vézelay. Photo: Robert Mills.

as a sign of disorderly, feminine desire: simultaneously male and female, Eugenius/Eugenia is depicted precisely at the moment *before* the breasts are fully displayed. This temporal suspension is crucial to the sculpture's meaning. Although, from one perspective, the saint's stance serves to display an overriding femaleness—the "bared breasts" are, writes Ambrose, an "unmistakable synecdoche for a female body"—I see the scene evoking instead a moment of crossing or transition, which is queerly multivalent in its meanings.[51] Not only does the abbot's body partake in what might be defined, broadly, as a trans experience, but the gap between the saint's tonsure and his/her anatomy also potentially opens the image up to monastic viewers. They would be able to see, in Eugenia's act of resistance to the offer of sex and to its subsequent redeployment as an accusation, a model for their own clerical vocation. Monks, like Eugenia, were required to transcend their identities as earthly men by preserving their celibacy in the face of possible sexual temptation. The mismatch between their religious identities and their bodies generated similar and ongoing tensions. To paraphrase the language sometimes used to describe experiences of gender variance, the monk was encouraged to imagine himself as a spiritual being trapped in a (worldly) man's body.[52]

There is also another sense in which Eugenia's gender identity, as expressed on the Vézelay carving, maps onto the ideals of celibacy promoted by the church. As discussed in the introduction, effeminacy or devirilization among males could be viewed as a manifestation of a general orientation toward carnality, as well as connoting sodomitic inversion specifically; this stemmed from the widespread devaluation of the feminine as a site of fleshly disorder. Against this backdrop some early church fathers explicitly characterized spiritual ascent as a variety of FTM transition. Jerome, for example, reflects in a biblical commentary on the transgender possibilities afforded to religious women. Citing a passage in Ephesians where men are encouraged to "love their wives as their own bodies" (Ephesians 5.28), as well as Adam's reference to Eve as "flesh

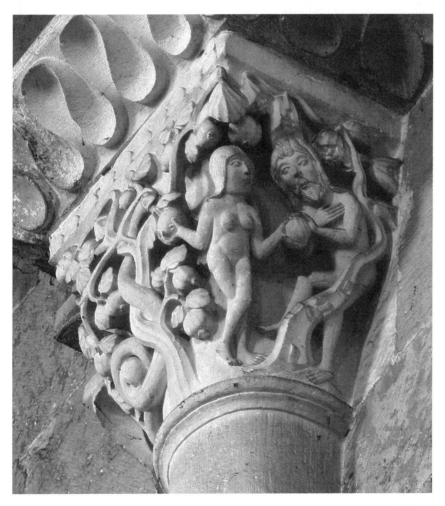

Figure 49. The fall. Carved capital, circa 1120–40. North side of nave, upper level. La Madeleine, Vézelay. Photo: Robert Mills.

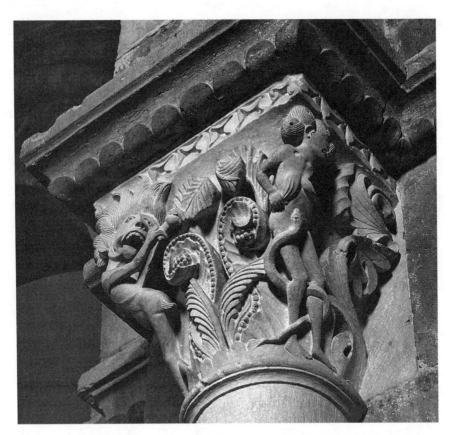

Figure 50. Despair and Luxury. Carved capital, circa 1120–40. South aisle of nave, La Madeleine, Vézelay. Photo: Robert Mills.

of my flesh" (Genesis 2:23) and Christ's reiteration of this idea in the gospels (Mark 10:6), Jerome expresses the view that

> quamdiu mulier partui servit et liberis, hanc habet ad virum differentiam, quam corpus ad animam. Sin autem Christo magis voluerit servire quam saeculo, mulier esse cessabit, et dicetur vir, quia omnes in perfectum virum cupimus occurrere.[53]

> [so long as woman serves for birth and children, she is as different from man as body is from soul. If, however, she wishes to serve Christ more than the world, then she will cease to be a woman and will be called man, because we all wish to attain the perfect man.]

Little wonder that the man depicted wearing a dress in the *Belles Heures of Jean de Berry* was reputed to have run away following his own experience of forced feminization. Viewing chastity and devotion to Christ as a means for women

to transform themselves into men, Jerome's statement promotes the pursuit of spiritual virility—modeled on Christ's own manhood—as the aspiration "we all" should share.[54]

Jerome's contemporary Saint Ambrose (d. 397) conveys a similar message in a gospel commentary. Reflecting on the moment in John 20:15 when the resurrected Jesus encounters Mary Magdalene in the garden and asks, "Woman, why weepest thou?," the saint asserts:

> Quae non credit, mulier est, et adhuc corporei sexus appellatione signatur: nam quae credit, occurrit in virum perfectum, in mensuram aetatis plenitudinis Christi, carens jam nomine saeculi, corporis sexu, lubrico juventutis, multiloquio senectutis.[55]

> [The one who does not believe is woman and still designated by the name of the sex of the body, whereas the one who believes progresses to the perfect man, to the measure of Christ's adulthood, now lacking the name of the world, the sex of the body, the seductiveness of youth, the talkativeness of old age.]

But the point is that male monks, too, needed to focus on progressing to a greater state of perfection along these lines. Ambrose's and Jerome's words are as applicable to men as they are to women. The representation of cross-dressing in the Vézelay capital, which positions Eugenia/Eugenius visually as a monk (even at the instant when s/he is being exposed as female), conveys the enduring virility of his/her faith and resistance to sexual temptation. This echoes one of the Latin versions of the legend, which characterizes the saint as acting manfully (*viriliter*) by bravely embracing the virginity that is in Christ (*virginitatem quae in Christo est fortiter amplectendo*).[56] Moreover another Latin *passio* attributes to Eugenia a speech prior to her disrobing in which she describes having performed the perfect man (*virum gessi perfectum*) by preserving her virginity for Christ.[57] Significantly the close identification between saint and Christ is cemented further by the fact that the saint's feast day, which marks the date of her martyrdom, falls on Christmas Day. The abbey's inhabitants, like Eugenia, needed to learn to become men in Christ rather than in the world. They too needed to direct their desires toward the *virum perfectum*.

Equally the Eugenia capital also articulates another element in the saint's experience: the lecherous desires that Eugenius rejects in his/her encounter with Melantia are multifaceted. On one level Melantia thinks that she is seducing a male person, but on another level she is expressing desire for another woman. As David Clark has argued of the Old English translation by the tenth-century hagiographer Ælfric, written lives of Eugenia use language to describe the widow's lust that shares a semantic field with condemnations of

sodomy.[58] For instance Ælfric describes the widow's overtures to the abbot as follows:

> Ða gewænde seo wydewe ham to hyre agenum
> and com siððan gelome mid leasum mode
> to þam wlytegan mædene wende þæt heo cniht wære.

> [she often came to the beautiful maiden, whom she believed was a young man, with deceptive intentions. . . . Pretending she was ill for a shameful purpose, she asked Eugenia to visit her, and tried to tell her black thoughts to her.][59]

These dark thoughts include the revelation that while her husband was alive she never had sex with him. It is clear from Eugenius's response to this "flattery" that the abbot interprets the widow's advances as sexual and violently rebuffs her in these terms. The Vézelay capital retains these possibilities. Fleetingly, in the moment when Eugenia's own femininity is revealed, the sculptors conjure up the possibility that Melantia herself—strongly feminine as a result of her hair and clothing—is directing her desires at another woman.

That the widow thinks that she is a *cniht* or "boy" in the Ælfric passage also raises another possibility too. Not only is eroticism between women potentially being evoked; so too is the idea that other monks—young novices, for example—might elicit desire in monastic settings. As Eugenius puts it, the widow is, to her shame,

> galynysse ontendnyss and gramena mæge
> þeostra gefæra and mid sweartnysse afylled,
> Deaðes dohtor and deofles fætels.

> [truly an inferno of lust and kinswoman of demons, a companion of darkness and filled with blackness, a daughter of Death and vessel for a Devil!][60]

On one level, then, monks might identify with Eugenia/Eugenius on account of her asexuality: s/he, like them, occupies a male identity, which demands a life of absolute continence. Likewise the abbot's maleness in the capital—evoked by the tonsure, habit, and short hair—is clearly a significant and enduring element. *She* has effectively turned into *he*, even at the moment when "she" is on the verge of being exposed. Melantia thus also lusts after what she thinks is a boy, which could in turn stimulate a reflection on the part of monastic spectators on their own desire for male youths. The eroticism condemned with one stroke is simultaneously aroused with another. A boyish monk is cast, temporarily at least, as an erotic object, even as "her" shameful femininity is disavowed.[61]

Ganymede in Hell

One possibility, then, is that the Eugenia capital functioned as a warning to the Vézelay monks about the different embodied forms sexual temptation takes. This leads me to another, much better-known capital located at the western end of the nave's south aisle, on a pier just inside the entrance. It is a scene that most critics, since the 1930s, have identified as depicting the rape of Ganymede.[62] Although there are counterarguments, to which I shall return, I accept this identification, albeit with certain qualifications about its meaning. The issue that concerns me here is the significance of representing Ganymede's ordeal in this particular location. Was it designed with a distinct audience in mind? To what extent does it represent a specifically "medieval" *translatio* of the classical sources from which the legend was derived?

Ganymede was a common subject in the art of ancient Greece and Rome, where he is generally shown being abducted by an eagle representing the god Zeus or Jupiter. Legend has it that Jupiter snatched the youthful male beauty Ganymede from the clutches of his earthly guardians; that Jupiter enlisted the boy as his attendant and beloved; and that eventually—by way of thanks for his service—the god spared Ganymede old age and death by transforming him into the constellation Aquarius. Ganymede's story is picked up by Virgil, in the *Aeneid*, and Ovid, in *Metamorphoses*, the texts through which it was transmitted to medieval culture; Ovid's is the account that endows Jupiter with the form of an eagle, rather than simply having the bird act on the god's behalf.

The Ovidian Ganymede is incorporated into Orpheus's song, where it is one of three tales he tells of gods who burned with love for male youths. Immediately preceding the Ganymede anecdote, Ovid describes the trees that gather round Orpheus as he sings his song. These include the cypress, a transmutation of the boy Cyparissus, who loved a stag so greatly that, having accidentally killed the beloved beast while out hunting, he begged the gods to be allowed to weep for it eternally.[63] Transformed into the tree, Cyparissus is mourned in turn by Phoebus (Apollo), who announces that he will grieve for the boy just as the boy grieves for others. Next in Orpheus's litany of divine pederasts is Jupiter, king of the gods, who

> Phrygii quondam Ganymedis amore
> arsit, et inventum est aliquid, quod Iuppiter esse,
> quam quod erat, mallet. nulla tamen alite verti
> dignatur, nisi quae posset sua fulmina ferre.
> nec mora, percusso mendacibus aere pennis
> abripit Iliaden; qui nunc quoque pocula miscet
> invitaque Iovi nectar Iunone ministrat. (10.155–61)

[once burned with love for Phrygian Ganymede and Jupiter cast about for a form to take that he preferred to his own. The only bird it wasn't beneath his dignity to become was one that could carry his lightning bolts (i.e., an eagle). And instantly, beating the air with a pair of wings he'd put on, he carried off the shepherd of Ilium, who still today mixes nectar for Jove and serves it to him, under the hostile eye of Juno.]

A discussion of Phoebus's tragic passion for Hyacinthus (who dies when the god accidentally strikes him during a game of discus throwing) follows immediately after (10.162–219). Though much longer than Ganymede's story in Ovid's text, the Hyacinthus story was far less influential as a literary and artistic motif.[64]

Virgil's references to Ganymede are equally brief but add a visual dimension to the episode: Ganymede's rape is mediated through a description of a fabulous image, a cloak of braided gold with, woven into its weft, a scene in which "Ganymede, prince of woody Ida, spins his javelins, wearing out the racing stags—he's breathless, hot in the hunt, so true to life as the eagle that bears Jove's lightning sweeps him up from Ida into the heavens, pinned in its talons while old guardsmen reach for the stars in vain and the watchdogs' savage howling fills the air."[65] Virgil's reworking of the legend is less obviously sexualized than Ovid's: Jupiter's deployment of an avian go-between arguably diminishes the scene's capacity to register homoeroticism. That said, Ganymede's breathless panting and the lushness of Virgil's visual description retain a sensual dimension.

In ancient Greece and Rome visual representations of the rape of Ganymede tended to idealize the narrative. As in the sculpture now in the Vatican museum, a second-century Roman copy reputedly based on a bronze by the Greek sculptor Leochares (working ca. 370–320 BCE), Ganymede was cast as a scantily clad adolescent, who put up little resistance to his capture. Renaissance revisions of the motif, such as the famous drawings by Michelangelo, similarly presented an ambivalent attitude to the rape component: Michelangelo strikes a balance between the menace of the eagle's claws as they clutch Ganymede's limbs, and the bird's tender, supportive embrace.[66] Although the rape scene itself was not represented very often in medieval art, one object roughly contemporary with the Vézelay capitals, the Scylla bowl, now in the British Museum, includes a scene of Ganymede's rape juxtaposed with a scene showing him performing his role as Jupiter's cupbearer (figs. 51 and 52). In all these examples Jupiter himself is represented symbolically as a bird, but on the medieval bowl his proportions are especially menacing; the boy himself is represented fully clothed, and turning his head toward the god, he does not seem to be too pleased about his abduction.[67] Depictions such as the latter seemingly convey a view peddled by Augustine several centuries before, in *De civitate Dei*, that the "raptus" (rape/abduction) of the beautiful boy Ganymede was actually a "nefas"

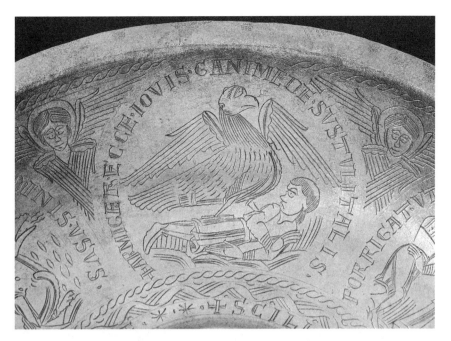

Figure 51. Ganymede's abduction. Scene on Scylla bowl. Germany, twelfth century. Bronze. London, British Museum. © Trustees of the British Museum.

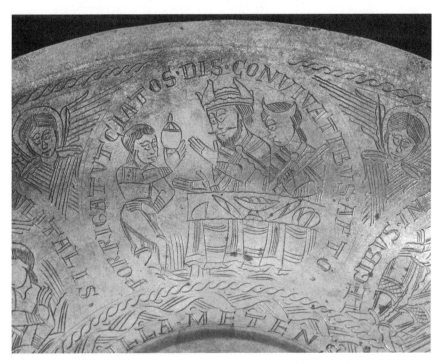

Figure 52. Ganymede serving the gods. Scene on Scylla bowl. Germany, twelfth century. Bronze. London, British Museum. © Trustees of the British Museum.

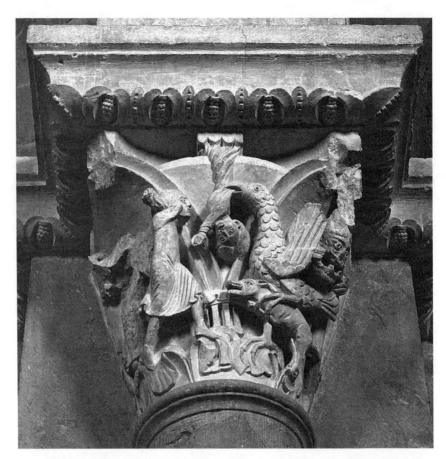

Figure 53. Rape of Ganymede. Carved capital, circa 1120–40. South aisle of nave, La Madeleine, Vézelay. Photo: Robert Mills.

(shame/wickedness), which historically had been committed by the earthly king Tantalus rather than the god Jupiter.[68] Augustine's attribution of the crime to Tantalus, who reputedly also chopped his son Pelos's body into bits and fed it to the gods (Ovid, *Metamorphoses* 6.401–11), serves to denounce the practice unequivocally. Condemning ethereal readings, which transform the perpetrator of the rape into a god, Augustine also implicitly critiques efforts by storytellers to reinvent sexual violence as an act of love.

These negative assessments also apparently conditioned the treatment of the subject at Vézelay (fig. 53). Refusing to sublimate the power imbalance between the king of the gods and a vulnerable young male by transforming the narrative into an image of unambiguous erotic bliss, the Vézelay sculptors have depicted Ganymede turned upside down, in a pose reminiscent of sinners falling into hell or possibly the fall of Lucifer and the rebel angels.[69] No longer a naked ephebe passively accepting his fate, the boy has a facial expression that

apparently conveys his terror. The capital also introduces other new elements into the iconography: to the left, the boy's guardians frantically plead on his behalf (a detail carried over from Virgil), while to the right a gleeful devil snarls at the viewer (fig. 54), as the eagle snatches Ganymede's canine companion in its claws.

Doubts have occasionally been raised about the identification of the capital as a Ganymede image. Some scholars see it as conveying a general scene of demonic assault rather than representing an explicit allusion to the Ganymede myth.[70] Also, since it is one of only two or three capitals in the church that seem to draw inspiration from classical sources, there is the question of whether Ganymede would be a likely subject in an ensemble dominated by Christian themes.[71] Although around one-fifth of the capitals in Vézelay's nave depict unknown or uncertain subjects, the historiated capitals are generally biblical

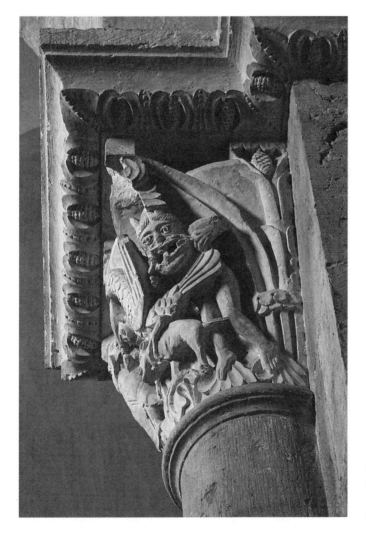

Figure 54. Devil. Detail from Ganymede capital, circa 1120–40. South aisle of nave, La Madeleine, Vézelay. Photo: Robert Mills.

or hagiographic in tone. These are occasionally interspersed with images inspired by the medieval bestiary tradition, while the other dominant subject is foliage.[72]

Despite these possible objections, there are several compelling reasons why Ganymede would have been a likely subject in this context. Certainly, in view of other references to the myth in twelfth-century France (culminating in Alan of Lille's *De planctu Naturae*), the theme was not a particularly unusual subject for discussion within clerical or monastic circles, nor were the sexual ramifications of the story entirely overlooked by medieval commentators, as we shall see. Additionally the image resonates with the themes of sexuality and redemption that, I am arguing, also inform other capitals in the nave. Although I would not want to impose too much unity and coherence on these images, the Ganymede thesis, which has dominated scholarship for more than eighty years, has not been seriously challenged. My contribution to this scholarship is to place it alongside some of the other sculptures with sexual themes in Vézelay's nave: viewed in context, additional elements in the capital's meanings emerge.

Benedictine Regulations of Sex

First, there are clear indications that a Benedictine religious house in the twelfth century would have seen, in Ganymede's ordeal, a means of confronting anxieties about monastic sex more generally. In the decades around 1100 a vigorous debate had developed about the legend's significance. This interest, which discovered in the conventions of antiquity a means of commenting on contemporary sexual ethics, was part of an emergent Ovidian literary subculture, characterized by Boswell as a flowering of "gay" subculture, in the period.[73] During his time as the abbot of a Benedictine house in west-central France, Baudri of Bourgeuil (1046–1130) composed numerous erotic verses, at least eighteen of which were addressed to *pueri* or "boys." These include a poem in which the poet praises the beloved for becoming another Orpheus (*Orpheus alter*), imagined here as possessing an eternally youthful singing voice. Lines later, though, Baudri also congratulates the boy for "refusing to be Jove's Ganymede," a phrase signaling Ganymede's role as a point of disidentification: countereroticism is a central theme in Baudri's poetry.[74] Ganymede was also the subject of anonymous debate poems, circulating widely in Europe from the twelfth century, which compared the relative merits of male and female love objects. The most significant of these, the *Altercatio Ganimedis et Helene* (Debate between Ganymede and Helen), opens with a scene in which Helen, inflamed with desire for Ganymede, offers herself up to him only to find that he does not know how to perform the expected role. Helen proceeds to present a series of arguments promoting women as lovers, including routine jibes against

the sterility, gender nonconformity, and unnaturalness of this "unmentionable crime"; her interlocutor interjects with counterarguments. Finally, horrified by Helen's description of how, in coupling with another male, he loses "the tear of Venus" (i.e., semen) between his thighs, Ganymede requests Helen's hand in marriage; the debate is won, and the narrator prays for God's mercy should he ever commit the dirty deed himself. "Let the Sodomites blush, the Gomorrhans weep," he declares. "Let everyone guilty of this deed repent."[75] V. A. Kolve has also highlighted intertextual resonances between Ganymede's story and a twelfth-century St. Nicholas play, *Filius Getronis* (Son of Getron), which was likely composed for performance at the Benedictine house of Fleury in Saint-Benoît-sur-Loire (Nièvre). Kolve's argument is that cloistered monks might have discovered in the play a covert meditation on the dangers of erotic attraction to younger members of the community; additionally, though, the dramatization of the pagan king's love for his beautiful cupbearer betrays a degree of sympathy or melancholia for those proscribed desires.[76]

As with the rendition of Eugenia's trial, it is thus possible to see the representation of the boy's abduction on the Vézelay capital as expressing a theme with direct relevance to the lives of the abbey's monks. Kolve's reading of *Filius Getronis* demonstrates a connection between the theme of the Fleury play and the almost-contemporary sculpture, even if the sculpture ultimately seems to express a "more fierce and uncompromising message."[77] Glenn Olsen draws attention to other sculptures in Romanesque churches where Ganymede's abduction is a likely subject, some of which may have a didactic purpose.[78] He also discusses churches attached to several houses in the Auvergne region in south-central France, which contain a high proportion of images apparently dedicated to "pederastic" or "epheban" themes.[79] Although the precise purpose of these sculptures is unknown, the fact that some buildings contemporary with the church at Vézelay represented Ganymede or related subjects suggests that the artists employed in the rebuilding of the nave were drawing on a wider vocabulary. Just as the Eugenia scene urges monks to maintain their own spiritual purity by resisting the temptations of the world, the Ganymede scene argues that they protect the spiritual welfare of the younger monks within their midst, precisely by refusing *them* as objects of sexual temptation. As in Baudri's poem, the image also potentially works to highlight the risks to boys if they themselves become Jove's Ganymede.

In the early Middle Ages, the practice known as child oblation had been common in Benedictine monasteries in western Europe. Children as young as five would be placed in cloistered communities, brought up in a life of prayer until they reached an age at which they were ready to commit independently to a religious vocation. But by the twelfth century, when the nave of Vézelay was being rebuilt, the tide was turning, and the practice of oblation became much

less common.[80] Part of the problem may have been that sexual relations were taking place between boys and monks, or at least that was the fear. In England the *Regularis concordia*, a code of monastic observance approved by the Synod of Winchester ca. 970–73, had ruled against physical contact between older and younger monks, a statement echoing earlier warnings against the temptations of young males in monastic environments.[81] The Rule of Saint Benedict (ca. 530–40) had paid attention to the sleeping arrangements of monks, stipulating that they sleep clothed with their garments girded; that a lamp be kept burning in the dormitory during the night; and that senior monks supervise the juniors by sleeping between them.[82] The latter arrangement would obviously not, in itself, have prevented physical interaction, which may explain why special plans were drawn up to keep the two groups spatially segregated in certain institutions. At Vézelay itself there would have been a separate cloister for novices, located southeast from the church's east end.[83] It was in Vézelay's nave that adult monks and novices would have come together most frequently, at times of prayer. The Ganymede capital, located in the nave's southwest corner, would thus have functioned both as a spectacular sign to the outside world that the inhabitants of Vézelay condemned sexual relations between monks and boys, and as a warning to the monks themselves of the dangers that potentially came from within.[84]

In so doing, the capital translates the classical myth of Ganymede into a form that resonates with contemporary moral teachings. In the middle of the eleventh century, Peter Damian, himself a member of the Benedictine order, had publicly denounced the sexual misbehavior of monks and clerics in his letter to Pope Leo IX. Sexual relationships between adult men and male youths do not appear to have been the major or only concern for Peter. After all in his eyes even solitary masturbation comes under the heading of *sodomia*. But in one section of the letter he characterizes clerical sodomites as father figures who, committing a sacrilege with their "spiritual children," are guilty of the crime of incest; for this reason it would be preferable, in his view, to "fall into shameful lust with an animal than with a male," for at least bestiality drags only one human being into the mire of disastrous ruin.[85] Later in the letter Peter also cites a passage from a monastic rule, which he attributes to Basil the Great (ca. 330–79) and which also turns up in a rule devised by the Visigothic saint Fructuosus of Braga (d. 665) for the monastery of Compludo in Spain, that recommends that clerics and monks found seducing young boys or youths (*parvulorum aut adolescentium*), or even so much as kissing them, be publicly flogged, lose their tonsures, be bound in chains for six months in prison-like confinement, and spend another six months under the close supervision of a spiritual elder. If even a kiss deserves such punishment, Peter submits, then how can a cleric who has polluted himself with another male carry out ecclesiastical duties?[86]

Compared with his more general comments on male-male copulation and masturbation, Peter Damian's remarks specifically about age-differentiated or "pederastic" relations seem somewhat muted. An anecdote from the following century paints a different picture. Not long after the nave sculptures of Vézelay were completed, Peter the Venerable (ca. 1092–1156), abbot of the great Benedictine house of Cluny and a former resident of Vézelay himself, collated a series of visions and miracles that he had encountered at Cluny. In one of these stories, he tells how a certain monk spends the night in the dormitory, a little apart from the other monks, and has a vision of a monstrous vulture, which arrives and stands beside his bed. While the stupefied brother stares at the creature, two other demons arrive there in the guise of men and enter into a dialogue with the vulture: "What are you doing here?" they ask, to which the vulture replies that he is not able to do anything at all, because everyone repels him with prayers and the sign of the cross. Other demons subsequently confess that they have had better luck:

> "Nos," aiunt, "de Cabilone uenimus, ubi militem quendam Gaufredi de Donziaco cum uxore hospitis sui in adulterium labi compulimus. Item per quoddam monasterium transeuntes, magistrum scole cum uno puerorum fornicari fecimus."[87]

> ["We," they say, "have come from Cabilon (Chalon-sur-Saône, another monastic house in Burgundy), where we have caused adultery to be committed between a certain knight of Geoffrey de Donzy and the wife of his host. Moreover, passing through a certain monastery, we have made the schoolmaster fornicate with one of the boys."]

Peter's story contains some familiar elements: a threatening bird, ready to pounce on a sleeping monk, and the tale of a sexual encounter between an adult cleric—characterized here as a *magistrum*—and one of his young male charges. But the moral of the tale is that those who resist temptation, sexual or otherwise, will be able to withstand the assaults of the devil. This surely reverberates with the scene depicted on the Vézelay capital.[88]

The possibility is strengthened when this capital is considered alongside others that likewise center on sexual themes. Taken together, these images highlight the potential for dialogue and thematic overlap. This capacity for intervisual conversation generates a network of overlapping and interlocking interpretations that expose the sculptures as a site of perpetual translation—comparable, in their capacity to generate multiple meanings, to the *Bibles moralisées* discussed in chapter 1. This is not to say that the capitals necessarily compose a fully unified or coherent iconographic "program," or that themes are

guided by a single overriding principle: analogous to the first Vienna Bible, the sculptures at Vézelay spin a complex web of viewing possibilities. Nor am I fully convinced by recent attempts to group the sculptures spatially into distinct thematic sequences or "zones."[89] At the same time, it is worth countenancing the possibility that the capitals were designed to converge in certain ways, particularly when viewed from the perspective of their monastic patrons. Attempts in the later Middle Ages to discover the One within the many (notably manifested in the moralized Ovids) exemplify precisely such modes of thinking.

Viviane Huys-Clavel has suggested that the overriding message of the Vézelay nave capitals is one of conversion, which can be perceived by walking through the church from north to south and south to north; in the capitals, linked spatially according to certain thematic groupings, which the foliate capitals serve to punctuate, she discovers a network of visual echoes, inversions, resemblances, and repetitions that convey this sense of unity within variety.[90] The interpretations advanced in the present analysis are not so strongly invested in the idea of discovering a single dominant message, but I do not think that the capitals simply present a series of disconnected and disparate images either. As with the *Bibles moralisées*, it is possible to perceive certain structural parallels and thematic echoes among the capitals; pursuing links between Romanesque sculpture and cenobitic culture—or what might be called, following Émile Mâle, the sculptures' "monastic imprint"—is a potentially productive line of inquiry, as Ambrose's recent study of the capitals has shown.[91] My suggestion here is that Magdalene's message of redemption after a life of fleshliness provided an additional lens through which the sculptures could have been viewed by monks—an interpretive prism that complements others, such as conversion, sin, temptation, and embodiment, through which those patterns and homologies might be perceived.

The identification of the Ganymede capital makes further sense in light of possible resonances between this scene and a capital depicting events from the life of Saint Benedict (ca. 480–547), further along the south aisle of the nave. Benedict, the founder of western monasticism and author of the eponymous Benedictine Rule, was an obvious figure to represent in this context. Among the events from his life recorded in the church is an episode, appearing twice in the church, which depicts his temptation by a woman. This visualizes in each instance an anecdote first recorded by Gregory the Great in the second of his *Dialogues*. This text is an account of the life of this saint and founder of western monasticism, which Gregory tells through a series of miracles and anecdotes. Early on in the collection, Gregory records an episode in which Benedict, pursuing a life of holiness in the wilderness, is harassed by a little black bird, named as a "merle" (a word for the common blackbird). The bird disappears when Benedict blesses himself with the sign of the cross, but immediately

afterward he is tormented by a terrible, fleshly temptation. The memory of a woman he once saw incites him to lustful thoughts, so that, seeing a thick patch of nettles and briars nearby, he throws off his clothes and flings himself into the bushes until his whole body is wounded. "Yet," Gregory remarks, "once he had conquered pleasure through suffering, his torn and bleeding skin served to drain the poison of temptation from his body. Before long, the pain that was burning his whole body had put out the fires of evil in his heart."[92] Of course it was also the very same Gregory who delivered the sermon on Mary Magdalene that led to her identification as a penitent prostitute. The susceptibility of both Benedict and Magdalene to fleshly temptation, and their use of asceticism as a means of controlling it, would have provided the monks of Vézelay with two potentially complementary narratives about eroticism and its regulation. On the surface the Benedict story is inflected with a strong antisomatic tone, as well as being implicitly misogynistic; but we might also see, in this story, aspects of the counterpleasurable ethos identified by Burrus and MacKendrick. Benedict disciplines the flesh, translating pleasure into pain. But the gesture also raises the specter of eroticism at the moment when it is spectacularly overcome. Where would Benedictine discipline be without the memory of such moments of temptation?

The first sculpture at Vézelay to represent this episode in Benedict's life appears in the narthex, just before the south entrance to the nave (fig. 55). Many of the capitals probably originally possessed painted *tituli* identifying scenes.[93] But here, rarely, Latin inscriptions have actually been carved into the stone: Benedict is identified to the right, while a woman and a devil are both labeled DIABOLVS, thus implying—in a typically misogynistic maneuver—that the two are virtually interchangeable. The blackbird of the story is represented to the left of the woman, visible fully when approaching the capital sideways on, thus echoing the bird-devil pairing in the Ganymede capital just beyond in the nave. The second time Benedict's temptation is represented, in the south aisle of the nave (fig. 56), there are clear structural parallels with the Eugenia capital (fig. 48).[94] In the center of the carving stands the woman, as the source of temptation; to her left (occupying the same position as Eugenia's father) Benedict gestures with the sign of the cross. To the woman's right stands a winged demon, whose avian features clearly conjure up the blackbird in Gregory's anecdote; structurally, though, he also parallels the widow who lusts after Eugenia in the other capital. Both widow and demon are represented as sources of fleshly temptation, which Benedict is shown rejecting on the right-hand side of the capital, where he throws himself into the thorn bushes. The female tempter herself remains fully clothed in the Benedict capital, like Eugenia, but she herself seems to be about to reveal her upper body. Whereas a palm leaf—conventional symbol of martyrdom—is depicted above Eugenia's head, in the Benedict capital this has

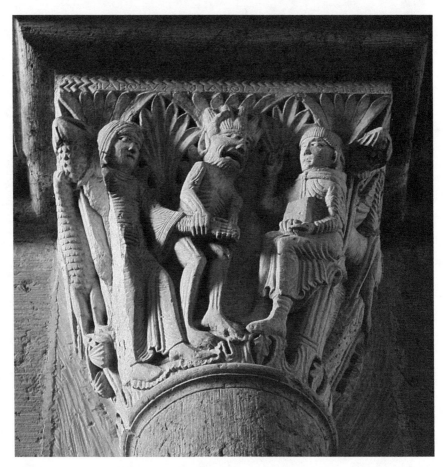

Figure 55. Temptation of Saint Benedict. Carved capital, circa 1150. Narthex, La Madeleine, Vézelay. Photo: Robert Mills.

transmuted into the female tempter's hair (or at least that is the implication of the demon's gesture, as he clutches a bunch of it with his hand—though it also resembles foliage). The uncanny resemblances in the structure of these capitals, situated on opposite sides of the nave, encourage viewers to read one image in terms of the other.⁹⁵ Eugenia's body, though it has been withheld from view, also inhabits the position of Benedict's tempter, drawing attention to his/her own erotic potential as a woman who is also desirably male.

The Benedict nave capital echoes the Eugenia scene aesthetically and thematically. Additionally, though, it is worth pursuing possible connections between this sculpture and the image identified as a scene of Ganymede's rape. The latter is situated in a different part of the church, so the resonances are not as meaningful from the perspective of location. But it is possible to observe a number of thematic and iconographic overlaps. Both the Ganymede capital and the Benedict capital feature demons; the latter represents this demon as a

winged creature—a transfiguration of the blackbird in Gregory's *Dialogues*—which resonates with the close alignment between the avian abductor and the devil in the Ganymede sculpture; both scenes contain images of bird-devil hybridity or collaboration. Also the objects of sexual temptation—a boy, a woman—take center stage on the capitals, paralleling the central positioning of the object of desire in the Eugenia capital: Eugenia is depicted as a boy-girl whose erotic potential is signaled at the very moment when it is being undermined.[96] This triangulated interpretation, which sees each capital as contributing to a wider dialogue about clerical sexuality, is not necessarily a product of fully conscious design or artistic intention. I am not suggesting the existence of a coherent iconographic program concerned with eroticism and its control. At the same time these images betray some common assumptions about sexual

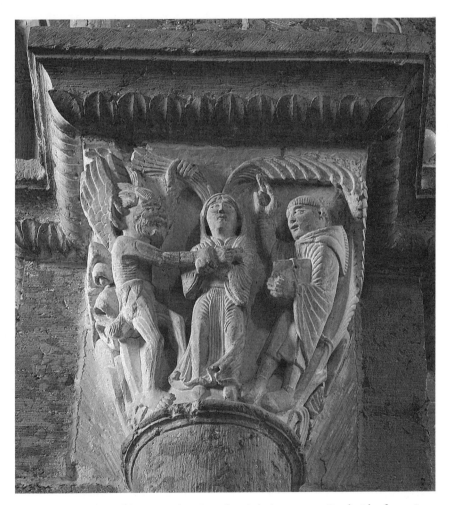

Figure 56. Temptation of Saint Benedict. Carved capital, circa 1120–40. South aisle of nave, La Madeleine, Vézelay. Photo: Robert Mills.

regulation and reform. Monks can avoid the perils of the flesh by participating in ascesis (modeled by Benedict or Eugenia), or by contemplating the terrifying consequences of demonic assault (as experienced by Benedict and Ganymede) and temptation (which all three capitals confront). Moreover each capital has something to say to viewers wishing to restructure their lives along the lines also exemplified by Magdalene. Disciplining desire in the cloister means postponing rather than simply repressing it. It is an erotics of deferred but repeatedly tested possibilities.

Reading the Eugenia and Benedict capitals alongside the Ganymede capital, then, we can see how each targets monastic eroticism in comparable ways. Both the Eugenia and Benedict sculptures highlight the dangers of female temptation—a motif that presumably struck a chord with the monks at Vézelay. After all, pilgrim visitors to Mary Magdalene's shrine would have included precisely the figures—women—from whom monks had originally withdrawn to live a life of sexual purity. However, the two scenes also articulate the possibility that temptation can come in other guises (a boy, a demon), even when monks think they are safely enclosed. Eugenia's experience is construed partly as a mode of counterpleasure. Defying the pleasures of sexual gratification associated with the widow, the sculpture promotes instead monastic ascesis, symbolized by the covering of the saint's body beneath his/her habit. Benedict's gesture of making the sign of the cross, and the devil's arm laid across the female tempter's chest, similarly work to counteract the possibility of erotic satisfaction. These acts of artistic containment function repressively: viewers are being refused a vision of naked female flesh. But Eugenia's sartorial enclosure also serves to accentuate her simultaneous maleness, a reminder that it is a beautiful man—or boy—that the widow lusts after, as well as a desirable woman. This in turn resonates with the themes of the Ganymede capital. Monks need to beware of corrupting boys, and boys need to keep their distance from predatory monks; but an alignment with enclosure—represented here by Eugenia's tonsure and monastic dress—enjoins the monk to suspend those fleshly desires indefinitely, in favor of the countererotic pleasures of deferral. Freezing Eugenia's trial scene to the moment just before sexual revelation, the image courts temptation even as it dispels it: the monk's asceticism is visualized as an erotics of perpetual waiting.

Ganymede Revisited: Ambivalence, *Translatio*, Divine Love

When viewed alongside the Eugenia capital, the Ganymede capital appears to be more conventionally repressive in its message. What could be more unambiguous than the presence of that grimacing demon? Compared with the ambivalent classical and Renaissance analogues, the Vézelay scene seems designed to

function only as a work of moral censure—an embodiment of the repressive ethos that is supposedly the very hallmark of Christian attitudes to sex. This mirrors attitudes commonly conveyed in some strands of medieval translation theory. Copeland's survey of vernacular commentaries on Latin texts such as Ovid has demonstrated that medieval exegetes set out not simply to repeat and reproduce their primary texts but also to contest them. Classical ideas of translation as displacement and substitution, radically refashioning texts in ways appropriate to new conditions of understanding, thus gained new impetus in the later Middle Ages with the *translatio* of authority from Latin to vernacular culture.[97] The Ganymede capital at Vézelay itself arguably participates in this disjunctive process. Refusing simply to "quote" the Ganymede myth verbatim, it challenges the notion of any clear-cut continuity between pagan attitudes to sex and their Christian counterparts, foregrounding instead an interpretation of the myth that is morally compatible with a medieval monastic setting.

That the Vézelay carving presents a direct challenge to its classical sources is seemingly strengthened by a comparison with other capital sculptures in French churches representing birds attacking animals, or abducting humans. One example, from the collegiate church of Saint-Pierre, Chauvigny, in western central France, is almost exactly contemporary with the Vézelay capitals. It depicts, on two faces, a pair of rather menacing birds, each of which carries a naked humanoid figure in its elongated, oversized beak (fig. 57). Usually interpreted as images of the condemnation of sinners to hell, these scenes seem to represent birds as the very essence of demonic assault.[98] The Chauvigny capital itself may also have apocalyptic undertones. Facing the birds is a scene on an adjacent capital representing the whore of Babylon, as well as another featuring the archangel Michael carrying the scales of judgment.[99] In light of these references the birds possibly allude to the book of Revelation, in which John the Divine warns of the judgment that will be imposed on sinners: "And I beheld, and heard the voice of one eagle flying through the midst of heaven, saying with a loud voice: Woe, woe, woe to the inhabitants of the earth" (Apocalypse 8.13). Yet this biblical passage fails to conform fully to the negative interpretation. After all, it refers to an eagle that flies through heaven, not hell. The words of warning are conveyed not by a demonic creature but by a bird voicing the word of God. This being could even be a stand-in for the man behind the book of Revelation himself. From the sixth century, John was symbolized as an eagle, typically on the portals of Romanesque and Gothic churches.[100] The convention is deployed on the tympanum above the central western portal of Chartres (the so-called Royal Portal); the bird, with its prominent claws and exaggerated plumage, itself bears comparison with the Vézelay bird (fig. 58).[101] Is it possible that the Chauvigny capital represents not a bird of damnation but one of

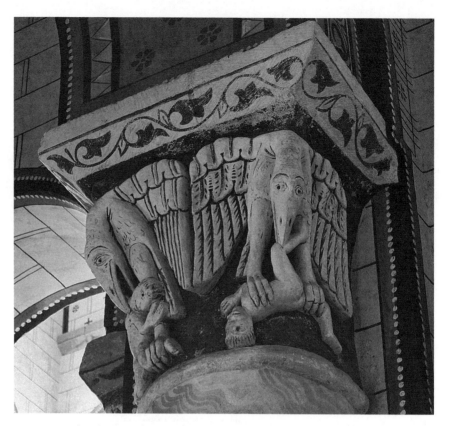

Figure 57. Birds carrying souls. Carved capital, first half of twelfth century. Choir of Saint-Pierre, Chauvigny (Vienne). Photo: Robert Mills.

salvation? Could the bird's act of abduction at Vézelay, clearly sinful on a literal level, equally be read allegorically as a salutary gesture? Could the eagle representing the pagan god Jupiter, in other words, also simultaneously epitomize Christian redemption, or at least reference it obliquely?

I would not be tempted to raise this possibility, were it not for the fact that medieval thinkers got there first. The early fourteenth century represents a particular milestone in the development of this interpretation. Famously, in canto 9 of his *Purgatorio*, Dante (ca. 1265–1321) has a dream in which Ganymede's ordeal is imagined as a symbol of the human soul lifted heavenward by grace:

> in sogno mi parea veder sospesa
> un'aguglia nel ciel con penne d'oro,
> con l'ali aperte e a calare intesa,
> ed esser mi parea là dove fuoro
> abbandonati i suoi da Ganimede,
> quando fu ratto al sommo consistoro. (9.19–24)

[as in some dream, there hovering, it seemed
I saw an eagle in the sky, with plumes of gold,
its wings wide spread, its purpose soon to swoop.

And I, it seemed to me, was where the kin
of Ganymede, when he was seized—swept up
towards the highest court—remained abandoned.][102]

Dante's identification with Ganymede in this passage stems from the vision he has following his departure from hell, in which he dreams of an eagle carrying him to the steps of purgatory. By yielding to the rapture of divine love, he gives himself over—like Ganymede—to movement and translation. When he awakes from his dream, his guide Virgil informs the dreamer that he has been carried up to purgatory by Lucia (Saint Lucy), which purportedly displaces the homoerotics of Ganymedean rapture. Yet Dante's subsequent identification with Achilles (9.34-42), who, as noted in chapter 3, was persuaded to cross-dress in order to avoid going to war, does not necessarily secure his wholesale remasculinization. Statius's *Achilleid* recalls how, dressed in women's clothing, Achilles sexually assaults one of King Lycomedes's daughters, Deidamia, which enables him to reassert his manhood; but before this moment, as Susan

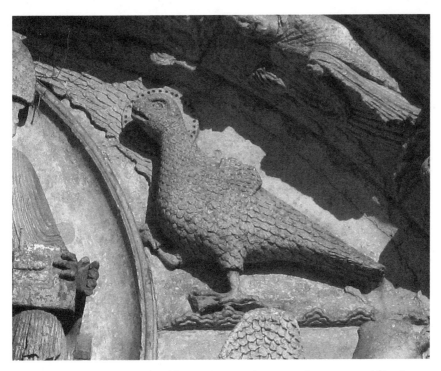

Figure 58. Evangelist symbol. Detail from tympanum above central western portal (Royal Portal) at Chartres Cathedral, circa 1145-55. Photo: Robert Mills.

Schibanoff has pointed out, Achilles himself was feminized—indeed even partially transsexualized—through his enthrallment with Deidamia and his donning of female garb.[103] Thus Dante's alignment with both Ganymede and Achilles arguably queers his poetic identity. Rather than simply imagining it as a shift from passivity and feminization to active masculinity, Dante records how, like Achilles when he is carried off by Odysseus to the male world of war, he grows "ismorto" (deathly pale), like a man who has been turned to ice (9.41–42).[104]

Chaucer also makes reference to the Ganymede legend in his *House of Fame* (ca. 1380), which is knowingly conceived against the backdrop of Dante's *Commedia*.[105] The poem opens with the narrator "Geffrey" (729) dreaming that he has found himself roaming about a glass temple, filled with images of figures from ancient mythology. Finding there a brass tablet inscribed with the first lines of Virgil's *Aeneid*, he proceeds to recount the adventures of Aeneas, Aeneas's love affair with Dido, and the hero's eventual arrival on the shores of Italy. Looking up, Geffrey then notices an eagle soaring in the sky, who proceeds, in book 2 of the poem, to carry him upward to Fame's palace. Feeling the eagle's "grim pawes stronge" (541) around his body, the narrator responds with "drede" (551); "I am," the eagle reassuringly asserts, "thy frend" (582). Perhaps, Geffrey wonders, Jupiter intends to "stellyfye" (586) him, a reference to the tradition in Greek mythology that, as a reward for his services to the gods, Ganymede was granted immortality by being transformed into the constellation Aquarius.[106] And yet he is, Geffrey explains to his abductor,

> ". . . ne Ganymede,
> That was ybore up, as men rede,
> To hevene with daun Jupiter,
> And mad the goddys botiller [god's cupbearer]."
> Loo, this was thoo my fantasye. (589–93)

The eagle sets the speaker right on this score: Jupiter is not intending to make a star of him just yet. Nor is Geffrey about to experience physical assault of the kind Ganymede undergoes, "For Joves ys not," the bird confirms, "thereaboute" (597).

Geffrey's "fantasye" here is double-edged. Implicitly he interprets the eagle's offer of friendship as sodomitically motivated, playing on the ambiguity of signs of friendship in medieval culture. As we have seen elsewhere in this book, gestures such as kissing and embracing had the capacity to connote both *sodomia* and *amicitia*, depending on the context; indeed it is this semantic fluidity that enabled the *Ovide moralisé* poet (as discussed in chapter 3) to reinvent Orphic pederasty itself as a figure for divine love. Also, however, Geffrey fantasizes spiritual or intellectual motives for his ravishment. Could stellification be

the ultimate goal?, he muses. Chaucer plays here on the obscurities in Dante's own appropriation of the Ganymede legend. Using Ganymede to forge a queer poetics of his own, the poet also underpins this identification with a fleeting reference to Orpheus himself, when Geffrey finally reaches Fame's palace in book 3: playing a harp "ful craftely" (1203), Orpheus is enlisted as the first in a long line of harpers and other musicians whose "craft countrefeteth kynde" (1213) (artistry counterfeits nature).[107]

Roughly contemporary with Dante's vision and preceding Chaucer's by several decades were the moralized Ovids that circulated in the fourteenth century, already encountered in chapters 2 and 3, which similarly interpreted the Ganymede myth as Christian allegory. Although there are differences of opinion across the various texts, the verse *Ovide moralisé* is among the texts promoting a spiritualized reading. The poet offers his readers three different interpretations of Orpheus's song of Ganymede (*OM* 10.3362–3425). First, there is the historical explanation: Jupiter was a king of Crete who, "selonc la paiene geste" (*OM* 10.3369) (according to pagan tales), was worshiped as king of the gods. Declaring war against the Phrygians, in the period when Tros reigned in Troy, Jupiter defeated them in battle and proceeded to take a "joenne enfant" (*OM* 10.3378) (young child)—Tros's son—captive:

> En sa contree l'emporta
> Et mainte fois se deporta
> Avuec lui par non de luxure,
> Contre droit et contre nature,
> Si le fist malgré sa mouillier
> De sa cort mestre et bouteillier. (*OM* 10.3382–87)

[He carried him off into his country and many times he enjoyed himself with him in the name of luxury, against law and against nature, so that he made him, despite his wife, master and cupbearer of his court.]

The phrase "contre droit et contre nature" in these lines recalls the words used to describe Orphic pederasty, which had been characterized by the poet as "contre nature et contre loi" (*OM* 10.2524). It also chimes with a chorus of other condemnations of unnatural sin elsewhere in this poem. The *Ovide moralisé* poet's historicizing interpretation draws on a tradition of rationalization that reaches as far back as antiquity. The view that Ganymede was raped by a mortal king, not a god, was promoted by the Roman historian Eusebius (ca. 263–339), among others, and cited approvingly by Augustine, as we have already seen.[108] The idea that Ganymede's abduction was a historical event provided early Christian commentators such as Augustine with a means of highlighting the scandal of pagan

religion and the lack of divinity in its gods. The notion that Jupiter himself was the king in question circulated in writings by the fourth-century Christian apologist Lactantius and the fifth-century mythographer Fulgentius; in the twelfth or thirteenth centuries, it was also the subject of a medieval commentary on Martianus Capella's fifth-century *De nuptiis Philologiae et Mercurii*.[109] The *Ovide moralisé* poet cites this interpretation initially as a means of stressing the base physicality of Jupiter's actions. As well as stressing the victim's youth (he is an *enfant*), he also characterizes the mortal king's crime as one of *luxure*, thereby securing its status as a mortal sin.

Yet the poet follows the historicized reading with an alternative explanation, the "autre sens," which reads Jupiter as an astrological "element" whose heat is tempered by "l'umoistour dou jovenciel" (*OM* 10.3394) (the moisture of the youngling). Both this and the historical interpretation are also cited in the fifteenth-century prosification translated by Caxton.[110] Finally a third, allegorical reading, which is absent from the prosified renditions, likens the pairing of Jupiter and Ganymede to the incarnation. Jupiter stands in for God the Father, whose "amour d'umaine nature" (*OM* 10.3411) (love for human nature) made him want to climb down from the sky and become human himself, while Ganymede, joined to the eagle just as flesh combines with spirit, implicitly becomes a representative of Christ. This other figure, the poet surmises, is "vrais diex et vrais homs tout ensamble" (*OM* 10.3421) (true God and true man all together); he sits like Ganymede in heaven, performing the role of cupbearer for God's overflowing grace.[111] This rather daring analogy, which transforms an act of sexual violence into an expression of "amour," is perfectly in keeping with other allegorizations in this text, which, as we have already seen, repeatedly translate Ovid's paganism into a source of Christian revelation. That which goes against nature may be sodomitical from the vantage point of human history, but it also helps explain the mystery of incarnation.

Bersuire's *Ovidius moralizatus* presents a slightly different spin on the episode. In his discussion of book 10 of *Metamorphoses* Ganymede is identified specifically as John the Evangelist, "a beloved young man," while the eagle represents wisdom and clarity; alternatively the eagle signifies Christ, who "loved the boy and elevated him to celestial secrets."[112] In the first book of his commentary, conceived as a preface to the exposition of Ovid, Bersuire also turned his attention to another transfiguration of the story. Francesco Petrarch (1304–74) had included a reference to Ganymede's abduction in book 3 of his epic poem *Africa*. Recounting the interior of the ancient king Syphax's palace, Petrarch evokes a fabulous ceiling adorned with signs of the Zodiac and depictions of Olympian deities, which allows the poet to flaunt his mythological learning.[113] Drawing on Petrarch's description in his opening meditation on the "forms and figures of the gods," Bersuire contemplates a scene in which Jupiter is depicted

sitting in majesty, casting down thunderbolts and crushing giants, while nearby an eagle carries Ganymede, "a very handsome boy," between its feet. The moralist links Jupiter in this guise variously with God, master of heaven; good prelates; oppressive tyrants; and preachers who "raise boys—that is, filthy sinners, to heaven by word and example and carry them to God"; he cites, in conjunction with the latter, Christ's words in Matthew 19.14 to allow children to join him in heaven.[114] Thus although he pursues a different path from that of the *Ovide moralisé* poet, Bersuire ends up producing a similarly redemptive spin on the story: in each instance Ganymedean sex acts enable the respective writers to confront the paradoxes of divine intimacy and spiritual rapture.

Turning to images in illuminated copies of the moralized Ovids, we see considerable variation in the attitudes displayed toward Ganymede's abduction. Everything depends on the boy's position in relation to the bird, and their relative proportions. In Rouen O.4 (plate 7a) the eagle dominates the miniature, snatching Ganymede by the waist from behind; the youth's hands are stretched out before him, his eyes are closed, and his face is streaked with tiny strokes of red, which indicate bloodshed. The action takes place against a backdrop of gold leaf and billowing clouds, features that identify Ganymede's destination as celestial. But it is difficult to ignore the fact that we are witnessing an act of violence. This is further emphasized by the resonance of the Ganymede scene with the miniature on the facing page, depicting Phoebus grieving for Hyacinthus after he has accidentally killed him with a discus (plate 7b). Phoebus, lips downturned, carries the dead boy in his arms; Hyacinthus's pose is identical to that of Ganymede on the adjacent folio, and again blood spews from the youth's head. Clearly, then, readers' eyes are being directed to the parallels between the two episodes and the potentially deadly consequences of pederastic passion.[115] A similar tone is imparted in the roughly contemporary Arsenal 5069 volume, where the artists chose to represent one of the moral interpretations—the literal, historical reading, in which Jupiter is said to represent an actual king of Crete—rather than the Ovidian story itself. Again, though, the god's actions are figured as oppressive, and there is little room for ambiguity. On fol. 142r "Jupiter" is depicted enthroned, gesturing toward a group of males, one of whom kneels before him, while another—presumably the youth who has been taken captive—is thrust into his presence, hands raised in defense or horror. The accompanying rubric does not mince words: a Cretan king, conquering the Trojans, found a "petit enfant trop bel" (little child too beautiful) and wished to join with him "par bougrerie" (through buggery).

Yet despite the persistence of these negative attitudes, the images accompanying moralized Ovid texts occasionally seem to partake in the more upbeat readings also promoted by the *Ovide moralisé* poet and Bersuire. One striking example is a scene in a manuscript of the verse *Ovide moralisé*, Paris,

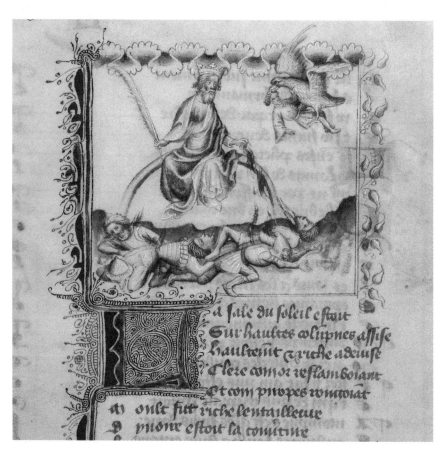

Figure 59. Jupiter seated in majesty, hurling thunderbolts at giants; rape of Ganymede. Miniature in *Ovide moralisé*. France, circa 1380. Paris, Bibliothèque nationale de France, MS français 373, fol. 24r (detail). Photo: Bibliothèque nationale de France.

Bibliothèque nationale de France, MS français 373, which appears as the frontispiece to book 2. Unlike illustrations in Rouen O.4, Arsenal 5069, and Lyon 742, which generally correspond to the Ovidian episodes themselves or to aspects of the accompanying moralizations, this manuscript—which dates to the late fourteenth century—participates in a separate iconographic tradition whereby each of the fifteen books of the poem is preceded by an illustration representing one or more pagan gods, often with no immediately obvious link to the text that follows.[116] Book 2 opens with an image (fig. 59) showing a crowned and bearded Jupiter seated in majesty on a rainbow, raining down thunder and lightning on giants below; in the top right corner flies an eagle carrying a youth of matching proportions between its legs. Though Ovid himself refers in book 2 to Jupiter as an almighty, thunderbolt-wielding ruler (2.60–62), a reference repeated in the *Ovide moralisé* poet's translation (*OM* 2.113–15), the artists have in mind here the image evoked by Bersuire in his opening chapter (and before him by Petrarch),

in which Jupiter's omnipotence and majesty are represented alongside Ganymede's abduction. As in Rouen O.4 (plate 7a), the youth in the miniature is depicted fully clothed, his hair grasped in the eagle's beak. Now, however, he is turned toward his abductor rather than being seized from behind; crucially, moreover, the bodies of boy and bird touch in several places, which serves to accentuate the erotic dimension.[117] The eagle's claws straddle Ganymede's waist, while the boy's left hand grasps the bird's neck. Ganymede's gesture could denote resistance on his part, but his right hand also hangs downward, a sign of helplessness or passivity. While the image still clearly conveys the violence of Ganymedean ravishment, it also potentially coheres with moralizations of the episode elsewhere in the poem as a figure for God's "amour" for humanity. Further underscoring this interpretation is the appearance of Jupiter himself. Bearded, like the Christian God, Jupiter holds a palm branch in his right hand (a detail, carried over from Bersuire, that exemplifies the victory of spirit over flesh); looking toward Ganymede in the eagle's clutches, he thus embodies Bersuire's vision of God as a simultaneously benign and all-powerful being who punishes the wicked and saves the good.[118]

Besides being represented in the moment of his ravishment, Ganymede also turns up in medieval art as cupbearer to the gods, as we have already seen on the Scylla bowl, and more frequently still in the guise of Aquarius.[119] In the fifteenth century these two roles were combined in the January page of the *Très Riches Heures*, painted by Paul de Limbourg for Jean de Berry (fig. 60), which depicts Aquarius as a naked water bearer in the zodiacal frame, while the scene below shows a feast in which the duke himself sits at table. The feasting scene features, to the left, a young man whose drinking vessel is filled with wine by another youth, the latter sporting a phallic object that protrudes from the purse he wears around his waist. Clearly presenting an allusion to Ganymede, the scene is cited by Camille as evidence of Jean de Berry's rapacious sexual and artistic appetites.[120] Ganymede functions playfully in the January page, to render the duke godlike: waited on by a series of beautiful young men, Jean effectively becomes a second Jupiter.

Obviously the various renditions of Ganymede's abduction I have been discussing thus far only appear two centuries or more after the Vézelay capital was carved. We cannot simply assume that because writers and artists in the fourteenth and fifteenth centuries found ways to exploit the story for Christian or earthly ends or at least to confront its ambiguities, sculptors in the twelfth century—or their monastic patrons—consciously set out to do the same. Yet in earlier periods, too, some writers encountered the story of Ganymede's ordeal and found in it redemptive possibilities. Three anonymous writers known as the Vatican Mythographers—so-called because of a manuscript in the Vatican library collating all three works—included the story in their handbooks

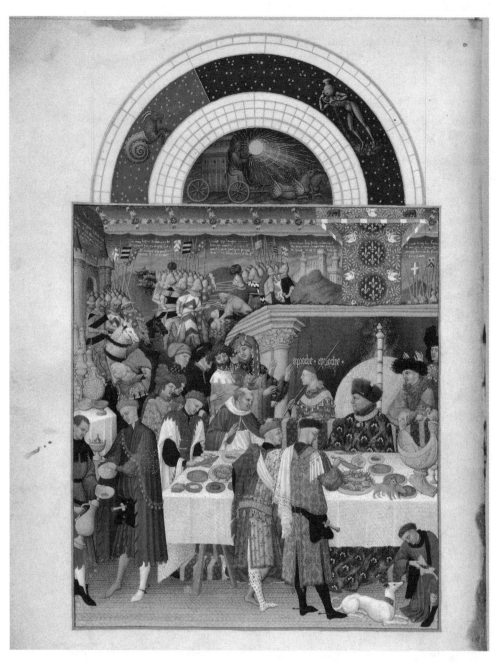

Figure 60. Attendants at a feast. Detail from January page by Paul de Limbourg in *Très Riches Heures de Jean de France, Duc de Berry*. France, 1412–16. Chantilly, Musée Condé, MS 65, fol. 1v. © RMN-Grand Palais (domaine de Chantilly) / René-Gabriel Ojéda.

of mythological stories. The aim of these collections, the first of which may have been written as early as the ninth century, was to facilitate the reading of classical poetry as part of the grammar curriculum in schools.[121] This meant sometimes reworking aspects of the stories so that they would cohere with a Christian outlook—a project clearly consonant with later medieval efforts to extract spiritual meaning from stories such as Ovid's.[122] The First Vatican Mythographer, whose work survives uniquely in the twelfth-century manuscript from which the writers take their names, recounts how Jupiter changed into an eagle in order to avoid "the disgrace of sexual union with a youth, that is, a male."[123] Acknowledging the distasteful implications of the episode, in other words, the mythographer simultaneously displaces those implications by refiguring Jupiter's transformation as a means of circumventing homoerotic union. The Second Vatican Mythographer, whose collection is attested in at least eleven surviving manuscripts, expresses similar discomfort, but figures the boy's kidnap as an act that protects the victim as well as the perpetrator from disgrace: "So that he might not suffer the shame of male intercourse because of the beauty of his body, an eagle snatched him up to the sky while he was hunting in the forest on Mount Ida."[124] Here, then, the implication is that avian abduction facilitates salvation rather than degradation. Becoming a cupbearer in heaven, the mythographer implies, is infinitely preferable to being subjected to the "shame of male intercourse" on earth.

Another response to Ganymede's story, composed a few decades after the rebuilding of the nave at Vézelay, similarly attempts to contain the homoerotic dimension of Jupiter's desire for Ganymede. In what is among the most complex—and in the view of some commentators least "translatable"—of passages in *De planctu Naturae*, Alan of Lille's narrator questions why Nature focuses on the sexual activities of men alone, when gods, too, engage in such deeds:

> Iupiter enim, adolescentem Frigium transferens ad superna, relatiuam Venerem transtulit in translatum. Et quem in mensa per diem propinandi sibi prefecit propositum, in thoro per noctem sibi fecit suppositum. (8.117–20)

> [Jupiter, for instance, translating the Phrygian adolescent to the heavens, transferred there a proportionate love for him on his transference. And the one he had set above him to wait at his table by day, he made his subject in bed by night.]

Ganymede had also been evoked by Alan in an earlier passage, appearing as a sculpted image in one of the gems that adorns Nature's crown. From the sculpture, readers are informed, flows a stream of tears—an evocation of the youth's

sadness at the way his reputation has been tarnished by poets (2.67–71). Alan's second reference demonstrates how this poetic transfiguration plays out in practice. The narrator, reeling off a series of words related to the concept of *translatio* in quick succession ("transferens," "transtulit," "translatum"), demonstrates the potential for language to be corrupted or misunderstood, and for those absorbing classical poetry to get thoroughly "carried away" by what they are reading. It is precisely the message that Jupiter's actions might be sinful that gets lost in this act of semantic transfer, and Nature's response is swift. Denouncing misreadings of the notes sounded by the "lira poetica" (8.133) (poetic lyre), which focus only on their surface meaning at the expense of their deeper significance, she tries to connect linguistic *translatio* by poets with the carrying away of Ganymede himself. Nature thus desperately attempts to protect Ganymede from the corruption associated with that other *lira poetica*, the lyre of Orpheus, but in the end Ganymedean rapture can only end in trouble: what Nature tries to extirpate, through language, only draws attention to the potential for her own rhetorical strategy to become corrupted.[125]

My point is that the Ganymede capital at Vézelay may not completely eliminate the ambivalence also expressed in these later moralizations. Raising a challenge to the sexual ethics of the classical sources, it nonetheless reproduces those sources' own ambiguities regarding the significance of Ganymede's ordeal.[126] According to some versions of medieval translation theory *translatio* involves a thoroughgoing substitution of the vernacular exegesis for its Latin counterpart, but this is an idealized scenario: the gaps and insufficiencies in the primary text will potentially continue to exert pressure on subsequent renditions. Just as Ganymede's experience may well have been regarded as morally ambiguous even in Ovid's Rome, it is worth entertaining the possibility that rape's potential as a figure for divine rapture influenced the audiences and makers of the Vézelay scene. The boy's posture is upside down, but he apparently holds his hands together in a gesture of prayer. His costume, emerging from a stylized opening at the top of the capital (itself possibly cloud-like), is twisted tightly round and round, as if he has been caught up in a swirling tornado. In the Old Testament, whirlwinds often signal moral turpitude, but they also mark entry into paradise, as in the fourth book of Kings, where the prophet Elijah "went up by a whirlwind into heaven" (4 Kings 2.11).[127] Thus what operates as a harsh warning to monks not to indulge in predatory desire is not completely emptied of the capacity to inspire thoughts of union with the divine. The desire Jupiter shows for Ganymede potentially transmutes into a metaphor of redemption; the monks' own desires—for others within the monastery or for those who, inspired by Mary Magdalene's own redemptive story, streamed through Vézelay on pilgrimage—get channeled toward a different kind of inti-

macy, that which transpires between human and divine. What is promoted via this other reading is a desire for union, a union that translates a scene of rape into an amorous act. As in the Eugenia capital, there is no place here for the reinscription of "heterosexuality" as a viable alternative: chastity is the ideal inspiring imitation in the cloister. Yet chastity requires not the elimination of desire but its reorganization—a desire for desire that is never simply repressive. It is the allure of this countererotic ethos, I am suggesting, that structures the sex lives of monks. Enclosure is a discipline one learns to love.

If we wish to engage fully with the range of meanings potentially generated by the nave capitals of Vézelay, therefore, we need to imagine a world in which sex is not simply a dark, unmentionable horror. The sculptures addressing sexual themes enter into a spirit of repression and regulation, for sure. But they also potentially facilitate the displacement of pleasure into a spiritual realm—a substitution or *translatio* that contributes not so much to desire's elimination as to its intensification. This process of translation works to clarify the ambiguity of its sources, but in so doing it potentially generates new layers of obscurity and obfuscation. The carrying over of interpretation from one language, medium, or culture to another, or even within the same cultural setting, produces further layers of meaning; the art of enclosure fails to inspire interpretive closure. Sex, itself notoriously resistant to translation, is never simply "represented" in the nave capitals of Vézelay; indeed in some of its manifestations (notably sodomy) sex is by definition a site of untranslatable excess. Paradoxically, though, the makers of the Ganymede capital confront the possibility of rendering that excess intelligible through translation; the Christian moralizing response is offered up as an alternative to a pagan allusion notable for its ambivalence and ambiguity. But the desire to displace competes with the compulsion to repeat: *translatio*, transformational to the last, cannot shake off fully the consequences of its investment in this more circular variety of transfer.

The Sex Crimes of Priests

In closing it is worth reflecting momentarily on a dimension that makes the images discussed in this chapter and the last highly problematic from the perspective of contemporary sexual ethics. This concerns the role played by age hierarchy in the erotic scenarios that were ostensibly rejected, but also subtly reconfigured as spiritually meaningful, by monastic audiences reflecting on the arts of Orphic love. These issues are especially contentious at the time of writing. Since the mid-1980s allegations of acts of sexual abuse by members of the clergy have surfaced repeatedly in North America and Ireland, as well as receiving media attention (and sometimes state intervention) in other parts

of the world from Austria to Australia. In the opening decade of the twenty-first century there has also been intense cultural interest in the phenomenon of clerical abuse, especially the sexual molestation of boys or male adolescents by Roman Catholic priests. Films such as Pedro Almodóvar's *Bad Education* (2004) and John Patrick Shanley's *Doubt* (2008), as well as a host of documentaries and docudramas, written testimonies, popular music lyrics, cartoons, and jokes, have all contributed to constructions of the "pedophile priest" as a figure of fascination, censure, and social satire.[128] These notions also take shape against the backdrop of the huge amounts of attention devoted more generally to "child porn" and child sex abuse in Western cultures since the late 1970s. If, as Gayle Rubin remarked in 1984, there has been no strategy for stirring up erotic hysteria in the last century "as reliable as the appeal to protect children," her prediction that "in twenty years or so, when some of the smoke has cleared, it will be much easier to show that these men [who love underaged youth] have been the victims of a savage and undeserved witch hunt" has proved, in the event, to be highly inaccurate.[129]

The intense media scrutiny devoted to clerical and other sexual abuse scandals has been accompanied, in recent years, by a proliferation of academic or popular writings on the subject. It is common, in this context, to cite historical precedents for the current crisis. Mark Jordan's observation that the highly publicized 2002 *Boston Globe* coverage concerning charges of abuse by priests in the Boston area seems "like one more chapter in a chronicle that began in the Middle Ages" sounds a note that reverberates in many other analyses, scholarly or otherwise.[130] While Jordan's own comments are based on rigorous primary research and directed at continuities in the Catholic Church's responses to allegations of abuse throughout its history, for the most part efforts to historicize the abuse scandal rely heavily on secondhand readings of a small number of early Christian and medieval treatises concerning the sexual incontinence of clerics. Peter Damian's so-called *Book of Gomorrah* looms especially large as a point of reference in these studies: the account of sodomy in Peter's letter is assumed to be fundamentally coterminous with modern constructions of clerical sexual misconduct, even though, for him, eroticism between men and boys is by no means the only practice deserving censure.[131] Such claims to historical continuity notwithstanding, commentators often also make strident efforts to loosen the ties connecting pedophilia with homosexuality, responding critically to the church's tendency to deal with charges of sexual abuse within its ranks by condemning clerical homosexuality in general rather than abusive structures specifically. Taxonomic distinctions between adult sexual attraction for prepubescent children (which constitutes "pedophilia" in the most narrowly defined sense) and other forms of intergenerational desire such as relations between adult men and adolescent males (which may be distinguished from pedophilia

using labels such as "ephebophilia" or "pederasty") frequently shape these efforts to determine the relative extent and moral standing of erotic encounters in which age and status differentiation play a role.[132] If, as Rubin notes, contemporary discourses on sex have tended to be framed by debates over where to draw the "line" between sexual behaviors that are acceptable, contested, and immoral, contemporary discourse on pedophile priests continues to engage in this ongoing struggle concerning the place of homosexuality to one side or the other of this imaginary moral border.[133]

Just as pedophilia has been a cornerstone of antigay rhetoric in modern societies, the evidence assembled in this and other chapters suggests that references to age difference also contributed significantly to medieval efforts to render sodomy intelligible. When Ganymede is described in *Ovide moralisé* manuscripts as a young or little "enfant" whom Jupiter enjoys in the name of "luxure" or "bougrerie"—and when, as is the case in some of the illustrated manuscripts and on the Vézelay capital, he is visualized as such—these depictions may well be participating in a vigorous process of construction in which the age gap between participants is being accentuated, both as a way of upping the moral stakes and as a means of visibly delineating sodomy's unethical dimensions. Pederasty conventionally allows the "active" subject in the relationship to maintain his status as a man: his penetration of a subordinate male might be deemed ethically troubling as a sex act, but it does not usually impugn his masculinity.[134] However, representing him as a man who plays the insertive role with infants, rather than with men of lesser status or older youths, exposes the pederast's vocation as essentially abusive, akin to the men who hanker after Lot's guests in Sodom. Rather than simply acting out the conventional male role, which demands that his partner be subordinate in some way (whether through age, social class, gender, and/or sexual role and style), the older male seeks to gratify his sexual desire with another male so junior to himself that the boy takes on the characteristics of a victim rather than a receptive but complicit lover. Ganymede's depiction as a young child effectively renders Jupiter's transgression more abominable, reprehensible, and "sodomitical" than if he had been presented simply as an ephebe or older youth. Similarly Dürer's Orpheus drawing (fig. 30), which partly alludes to the hero's pederasty by means of a fleeing putto, hyperbolizes the distinction between maturity and youth to the point of being ridiculous: Orpheus, himself depicted in the drawing as a beardless youth submitting to violent punishment, is effectively accused of terrorizing a chubby toddler. The prelates who perform acts of *sodomitirie* in the scenes moralizing the first book of Kings in the Vienna Bibles (figs. 17 and 18) fondle diminutive boys rather than one another; it is not simply the "same-sex" component of the relations that is being condemned (although that is doubtless also at issue) but the fact that the clerics in question are sodomizing children.[135]

Cumulatively, such depictions can give the impression that the homoerotic attractions condemned in medieval monasteries (but presumably also sometimes felt, expressed, or even acted upon) reflect lived experience—that *all* sexual interactions between males in cloistered settings were necessarily hierarchical and age defined. Assumptions of this sort also guide discussion of other accounts of clerical incontinence such as concubinage or adultery with married women, which have sometimes been treated as symptomatic of social realities. James Brundage observes, for instance, how documentary evidence of visitations, court records, and papal petitions "bears out the impression that clerical incontinence was an open scandal in many parts of western Christendom."[136] Yet the texts and images encountered in the present book, prone as they are to embellishment and exaggeration, are hardly reliable sources of lived experience. Just as there has been a tendency in modern cultures to yoke together homosexuality and child abuse—at least until the mid-1980s when AIDS began to eclipse pedophilia as the homophobic slur of choice—the discursive role of age hierarchy in rendering visible otherwise unmentionable activities needs to be acknowledged. Age differentiation was politically useful because, as with the narratives of gender transformation and inversion encountered in this and other chapters, it helped throw the cloak of suspicion over forms of same-sex intimacy that might otherwise be sanctioned publicly—namely, bonds of male friendship structured by such ideals as fraternity, reciprocity, equality, and enduring peace. Drawing attention to significant age gaps (and therefore power differentials) could be a means of highlighting the abusiveness, violence, and lack of consent associated with *amicitia*'s obverse *sodomia*—a configuration tracing a line of descent back to Genesis 19, with its themes of inhospitality and rape.

Conversely idealizations of pederastic love, as mediated in classical poetry, may also have provided a means for monks to reimagine their desires in terms that distanced them from the charge of sodomy by conforming instead to a thoroughly conventional model of Christian virtue. Celebrating the Ganymede myth as an allegory of divine rapture restores to pederasty precisely the ennobling qualities that the language of sodomy seeks to undermine. Such narratives provided a means of articulating the hierarchy that pertains between God and male religious, as discussed also in chapter 3: the *Ovide moralisé* poet's references to "les malles de jone aé" (males of young age) who submit to "devin plesir" (divine pleasure) (*OM* 10.566, 573) in one of the Orpheus moralizations transforms pederasty into a medium for expressing the virtues of divine authority over submissive subjects. In this, the hierarchical pattern of Orphic sodomy simply represents an extension of the demand placed on all Christian subjects to comply with God's laws by cultivating obedience and humility. For, as Asad notes in his analysis of monastic discipline,

the programme which aims to transform sensual desire (the desire of one human being for another) into "the desire for God" requires at the same time a change in the status of the monks as lovers. From being masters or equals of human lovers (male or female), they must now learn to become humble subjects of a heavenly Lover.[137]

One strategy developed by twelfth-century monks as a means of effecting this transition was an identification with the feminine, as documented by Caroline Walker Bynum in *Jesus as Mother*. But Bynum's much-cited claim that "religious males had a problem" when they wished to use the metaphor of sexual union to explore union with God requires qualification: as she acknowledges, monks sometimes imagined being loved, penetrated, and aroused by a male or ambiguously gendered God without being explicitly feminized in the process.[138] Even pederasty could occasionally be taken up as a model for contemplating mystical eros, one that, through the transformative work of enclosure and disciplinary practice, taught religious subjects to accept their submission willfully by pleasuring God just as Ganymede "serves" his Jupiter.

It would be risky, then, to draw conclusions about the prevalence of age-structured desire in clerical and monastic cultures in the Middle Ages simply on the basis of texts and images surveyed in this chapter. These depictions were directed both at censuring the physical expression of such erotic feelings and also sometimes at partially transforming them into more spiritually ennobling modes of intimacy. Certainly pederasty could be sublimated in religious environments into forms such as spiritual friendship or divine rapture. But this is not to say that it always ended up assuming such idealized characteristics in actuality, or that there were not also relations that followed a less obviously hierarchical or age-differentiated pattern. If amorous or sexual relationships were forged in cloistered settings in the Middle Ages, there is usually no way of knowing precisely the age gap between the partners, whether those relationships were abusive, or how often or not the younger participants in the relationships consented. It is simply not possible to cut through the hysteria of sodomy accusations or anticlerical satire in order to access the objective "truths" of clerical or monastic sex lives.[139]

In parts of Europe where the survival of legal records permits statistical analysis, it is clear that age differentiation could indeed play a significant role. In late medieval Florence, quantitative analysis of court documents suggests that most adult males engaged in sexual relations with younger, adolescent males as well as with women; those males deemed "passive" tended to be eighteen or younger, for the most part, while those playing the insertive role in sexual encounters with other males were usually older.[140] Idealizations of pederasty also featured heavily in the literary output of the Muslim-Arab world,

both in the Middle Ages and beyond, despite the existence of religious prohibitions strongly condemning sodomy's Islamic equivalent, *liwat* (a term derived from the Koranic version of the Sodom story). Numerous poems survive from the Arab East celebrating the beardless chins and downy cheeks of adolescent boys, often comparable in tone to evocations of female beauty, which reveal the strong premium placed on both age and gender hierarchy in these cultures; the Iberian peninsula, dominated for half a millennium by Muslim rulers, developed its own tradition of poetry celebrating the sensuality of male adolescent beauty.[141] But there is no conclusive evidence that these patterns held for the whole of medieval Europe, or that they were universal. We cannot assume that the monks of twelfth-century Vézelay participated in a value system identical to that of the males of Renaissance Florence or the Arab-Islamic world, even if—as the Ganymede capital suggests—they sometimes engaged with analogous motifs in literature and art.[142]

Certainly the scenes discussed in this chapter suggest that monks were concerned about their susceptibility to desire in all its guises: desire for boys and for women provoked comparable strategies of containment and sublimation. All the same I would be wary of assuming, as some historians have for later centuries, that age differentiation is the preeminent organizing prism through which homoeroticism was filtered in this period.[143] It is important to remember that age is also being deployed rhetorically, constructing the desires it purportedly describes in order to render them ethically unsound compared with other manifestations of male intimacy such as friendship and sworn brotherhood. This is certainly not to deny that sexual abuse occurred in medieval religious cultures, or to argue that modern accounts of clerical pedophilia are similarly fictitious. There is likely to be a kernel of truth in depictions of Orphic pederasts and boy-loving monks, just as some priests today undoubtedly do abuse children.[144] But there is no clear route back from centuries-old representations of mythical, imaginary, or perceived pederasty to the "facts" of monastic sexualities.

Moreover despite ostensible similarities between medieval religious encounters with pederasty and modern constructions of pedophile priests, medieval ideas of childhood and youth may well have differed significantly from the paradigms that predominate today. If modern manifestations of pedophilia trade on the presumed innocence and sexlessness of children, such ideas cannot be taken for granted in a period when ideas of original sin made even newborn babies prone to the perils of the flesh. Augustine, in his *Confessions*, notoriously attributes to infants such sins as jealousy and anger, and laments the constant struggle he experienced in his own youth to negotiate the "shadowy jungle of erotic adventures."[145] Monastic penitentials acknowledged different levels of culpability depending on the age of the participants in sexual activities, but in

some early examples of the genre even boys who unintentionally got drawn into erotic encounters with older males were liable for penance.[146] Philippe Ariès's claim that "in medieval society, the idea of childhood did not exist" has been much contested, with references to clerical pederasty lending further support to those critiques.[147] The fact that some of the Ovid moralizations discussed here trade on the idea that Jupiter had sex with an infant rather than an adolescent on the verge of sexual maturity suggests that concepts of childhood as a distinctive phase were operating by the later Middle Ages in certain quarters. Peter the Venerable, the source of the anecdote about a monastic schoolmaster fornicating with one of his boys, viewed children as morally less culpable than adults: although the abbot accepted the orthodox Augustinian view that infants were corrupt owing to original sin, he judged children below the age of discretion to be incapable of performing actual sinful deeds.[148] Moreover, according to William F. MacLehose, a wide variety of sources in the twelfth and thirteenth centuries attest to a heightened social anxiety about children's vulnerability and susceptibility to external threats, which again points to the existence of a distinct concept of childhood.[149] That said, there is no evidence that the kinds of moral panic that have erupted periodically in twentieth- and twenty-first-century societies concerning the danger posed to children specifically from sexual abuse and molestation were ever as deep-rooted or widespread in the Middle Ages. Sex crime panic did surface in certain times and places—notably in some late medieval Italian city-states—but clerical pederasty itself provoked relatively little discussion compared with other misdemeanors such as monks copulating with nuns or priests with married women. The Jew was more likely to be cast as a child abuser than the Christian cleric, who was usually, as in the genre of fabliau, presented lusting after, wooing, and bedding women rather than prepubescent boys.[150] Beginning in the 1140s in Norwich following the death of a boy called William, male Jews were periodically accused of participating in ritualistic acts of child slaying, an allegation that emerged with particular vigor in thirteenth-century collections of Marian miracles. However, while it may be possible to perceive in these stories sublimated sexual references, eroticism is never explicitly depicted as a motive for Jewish savagery.[151]

For a late medieval audience, therefore, the image of Jupiter buggering "little" Ganymede may not have possessed quite the same shock value as, say, images of child pornography circulating on the internet today do for us, even though readers and viewers of these scenes were clearly being asked to reject physical relations between men and boys as gravely sinful. This explains, in turn, why age-structured pederasty—so troublesome from the perspective of modern sensibilities—could occasionally play a symbolic role within medieval Christianity, insofar as it cohered with the demands placed on monks to translate their bodily experiences into something spiritually meaningful. In the

final chapter, I consider the extent to which such processes of affective transfer hinge on motifs of directionality and turning, and whether, in so doing, they might justifiably be viewed as manifestations of "sexual orientation." I also return to issues raised in earlier chapters concerning the relevance of the sodomy paradigm to depictions of female homoeroticism.

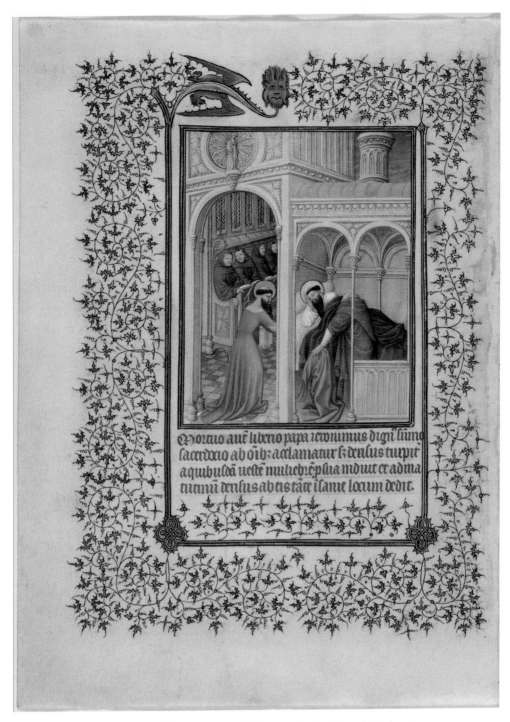

Plate 1. Saint Jerome in a woman's dress. Miniature by Herman, Paul, and Jean de Limbourg in *The Belles Heures of Jean de France, Duc de Berry*. Paris, circa 1405–1408/9. New York, Metropolitan Museum of Art, The Cloisters Collection, 1954 (54.1.1a, b), fol. 184v. © Photo SCALA, Florence 2013. Image copyright The Metropolitan Museum of Art / Art Resource / Scala, Florence.

Quondiclaamie quondiegemmus et fi qñdo
irpugnari fompn opfiff; bnimo uir offa beie
aa collidebanreraifenpionüntñ focaus fepe cho
ris puellarü inïeffe ꝫ fola libidmü morndia

Plate 2. Saint Jerome tempted by dancing girls. Miniature by Herman, Paul, and Jean de Limbourg in *The Belles Heures of Jean de France, Duc de Berry*. Paris, circa 1405–1408/9. New York, Metropolitan Museum of Art, The Cloisters Collection, 1954 (54.1.1a, b), fol. 186r. © Photo SCALA, Florence 2013. Image copyright The Metropolitan Museum of Art / Art Resource / Scala, Florence.

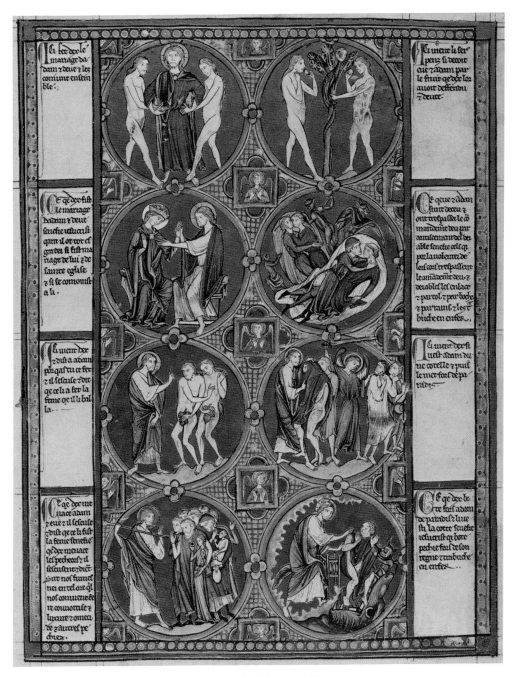

Plate 3. Genesis 2:22–24; marriage of Christ and Ecclesia (*a, upper left*). Genesis 3.1–6; transgressive bodily desires (*b, upper right*). Genesis 3:9–12; sinners excuse themselves (*c, lower left*). Genesis 3:21, 23–24; Christ pushes sinners into hell (*d, lower right*). Miniatures in *Bible moralisée*. Paris, circa 1220–25. Vienna, Österreichische Nationalbibliothek, cod. 2554, fol. 2r. Photo: ÖNB Vienna.

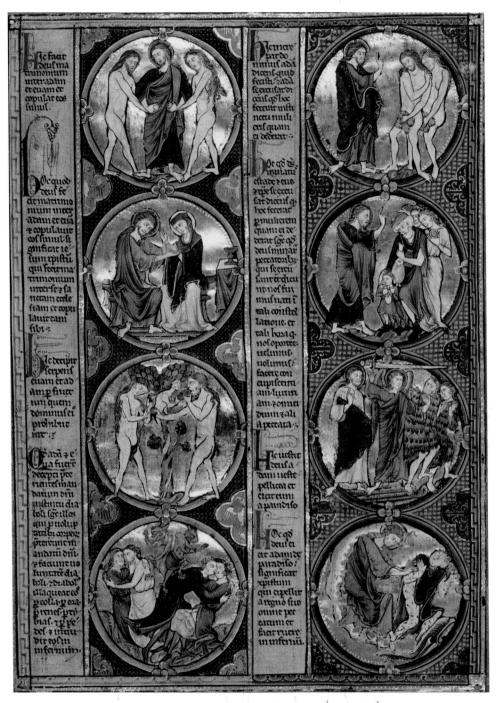

Plate 4. Genesis 2:22–24; marriage of Christ and Ecclesia (*a, upper left*). Genesis 3:1–6; transgressive bodily desires (*b, lower left*). Genesis 3:9–12; sinners excuse themselves (*c, upper right*). Genesis 3:21, 23–24; Christ pushes sinners into hell (*d, lower right*). Miniatures in *Bible moralisée*. Paris, circa 1220–25. Vienna, Österreichische Nationalbibliothek, cod. 1179, fol. 4r. Photo: ÖNB Vienna.

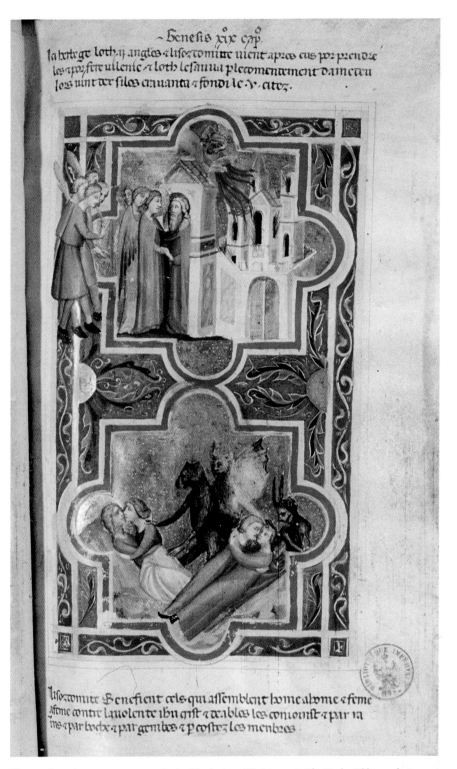

Plate 5. Genesis 19.1–14; transgressive bodily desires. Miniatures in *The Naples Bible moralisée*. Naples, 1350 or later. Paris, Bibliothèque nationale de France, MS français 9561, fol. 8v. Photo: Bibliothèque nationale de France.

Plate 6a. Orphic pederasty. Miniature in *Ovide moralisé*. Paris, circa 1315–28. Rouen, Bibliothèque municipale MS O.4 (1044), fol. 247v (detail). Collections de la Bibliothèque municipale de Rouen. Photography C. Lancien; Y. Communeau.

Plate 6b. Orpheus plays music to youths. Paris, circa 1315–28. Miniature in *Ovide moralisé*. Rouen, Bibliothèque municipale MS O.4 (1044), fol. 261v (detail). Collections de la Bibliothèque municipale de Rouen. Photography C. Lancien; Y. Communeau.

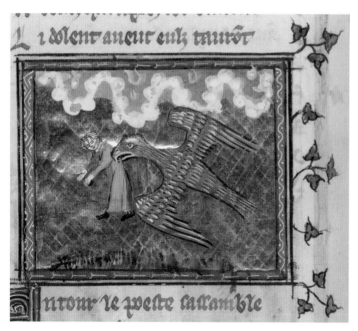

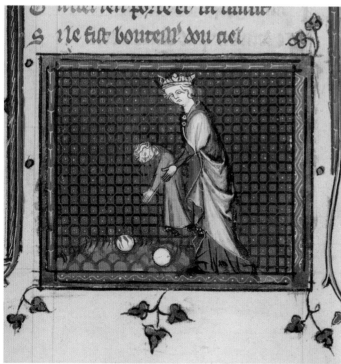

Plate 7a. Rape of Ganymede. Miniature in *Ovide moralisé*. Paris, circa 1315–28. Rouen, Bibliothèque municipale, MS O.4 (1044), fol. 250v (detail). Collections de la Bibliothèque municipale de Rouen. Photography C. Lancien; Y. Communeau.

Plate 7b. Death of Hyacinthus. Miniature in *Ovide moralisé*. Paris, circa 1315–28. Rouen, Bibliothèque municipale, MS O.4 (1044), fol. 251r (detail). Collections de la Bibliothèque municipale de Rouen. Photography C. Lancien; Y. Communeau.

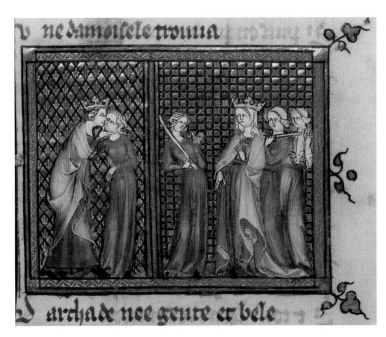

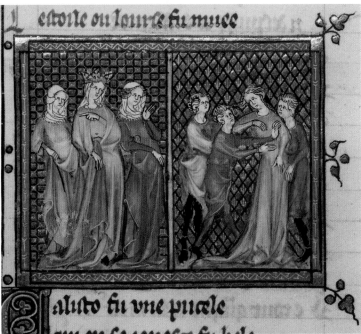

Plate 8a. Jupiter as Diana kisses Callisto (*left*); Callisto rejoins the real Diana and her company (*right*). Miniature in *Ovide moralisé*. Paris, circa 1315–28. Rouen, Bibliothèque municipale, MS O.4 (1044), fol. 50r (detail). Collections de la Bibliothèque municipale de Rouen. Photography C. Lancien; Y. Communeau.

Plate 8b. Callisto inspected by her companions for pregnancy, as Diana looks on. Miniature in *Ovide moralisé*. Paris, circa 1315–28. Rouen, Bibliothèque municipale, MS O.4 (1044), fol. 52r (detail). Collections de la Bibliothèque municipale de Rouen. Photography C. Lancien; Y. Communeau.

5

Orientations

Throughout this book we have encountered individuals who are implicated in acts of turning and being turned. Just as Adam and Eve stray from God's commandment and orient their bodies toward sin, as embodied physically in the fruit of the tree of knowledge, their latter-day equivalents in the *Bibles moralisées* transgress God's law only to be dragged into hell via the body parts they have wrongly directed toward one another. Gower's Iphis and Ianthe play with an unknown "thing" as they lie together "sche and sche," constrained by Nature, while their historical counterparts in the moral interpretations appended to Caxton's Ovid and the verse *Ovide moralisé* turn away from the laws of marriage and toward a particular object, an apostate "membre," through which they discover a means of fulfilling their unspeakable desires. Lot's wife's transgression is represented as an act of perverted optics, as she turns her gaze toward Sodom and implicitly toward the world; Orpheus's turn to males and away from Eurydice is similarly figured as a backward glance toward earthly pleasure. In each instance, sexual practices that would otherwise remain hazy and indistinct are rendered intelligible by bringing into view a field of improper objects; individual actors are imagined directing themselves toward or organizing their desires around these illicit bodies, body parts, devices, activities, and erotic pathways, while ignoring or deviating from others.

Some of the most influential treatises on sodomy also draw attention to its disorienting effects and employ a directional rhetoric to do so. Peter Damian's letter on the subject reflects on how sodomites (biblical or otherwise) are not only struck blind by their activities but, prevented from crossing the "threshold of the proper entrance"—which in context refers to the entrance to sacred office—grope vainly at the impenetrable barrier of a wall. Citing verses from the Psalms in which the wicked are described being turned into wheels or walking in circles, Peter outlines how those who try to go into the sanctuary via this improper route are "turned about, wandering in a circle in whirling madness."[1] Alan of Lille's *De planctu Naturae* is also littered with imagery of twisting, turning, wandering, and diversion: the text opens by lamenting the transposition (*translatio*) and conversion (*conuersio*) of subject into predicate (1.23, 1.25); later, complaining of those who reject the sounds of her instrument in favor of the notes of Orpheus's lyre, Nature berates the man who changes his composition inordinately (*per compositionem inordinate conuertit*) by distorting that which has been decreed straight (*directam*), and in his deviance (*deuiando*) retreating from the correct penmanship (*orthographia*) of Venus (8.57–59); later still, he is anxious not to allow hammers to stray (*peregrinare*) from their anvils in any form of deviation (*exorbitatione*), or to permit Venus to allow the writing pen with which she has been bestowed to do her work to wander (*deuagari*) from the proper path (*semita*) of her orthography into the turning (*deuia*) of false writing (*falsigraphie*) (10.33–34).[2]

In the wake of Foucault's influential argument in *The History of Sexuality*, volume 1, that something new happens to sex between the end of the seventeenth and the beginning of the twentieth century, which endows it with an individuating, normalizing function—a phenomenon exemplified especially by the emergence of the category of "homosexuality" in the late nineteenth century—it has become customary to declare the expression "sexual orientation" more or less irrelevant to any period before modernity. Whereas in the civil and canonical codes of premodernity, Foucault submits, "sodomy" was typically defined as a "category of forbidden acts," the nineteenth-century scientific construct of homosexuality, which treats deviant sexual acts as symptomatic of a type of personality and a "mysterious morphology," belongs to a fundamentally different conceptual universe.[3]

Inspired by this line of thinking, a consensus has emerged among historians: before these new discursive practices emerged in modernity, the idea that humans "have" a distinct "sexuality" or "sexual orientation" (where "having" translates into a mode of being) would have been unthinkable or at most inconsequential. Although there have been some dissenters to this viewpoint—notably Bernadette Brooten, who discovers in the Roman world analogues

to "what we might call *sexual orientation*," and Rictor Norton, who argues for the existence of a transcultural and transhistorical "core" of queer desire, one to which directional metaphors have always been applied—most historians of sexuality remain reticent about applying the phrase to periods prior to the advent of modern sexology, psychology, and the science of physiology.[4] Halperin, responding to Brooten, notes that scholars have sometimes mistakenly conflated notions of lifelong erotic orientation (as mediated by modern psychosexual discourse) with ideas of a distinct category of person (which do sometimes show up in ancient sources). Citing a review of Brooten's study by Traub, he concludes: "Pre-modern societies may well have had a number of categories of social actor to which sexual characteristics were attached without those categories necessarily approximating to sexual orientations—in the sense of particular configurations of erotic desire—let alone to modern homo- and heterosexual ones."[5] Turning to the Arab-Islamic world in the period 1500–1800, Khaled El-Rouayheb periodically finds evidence, in literary disputations comparing the relative attractiveness of boys and women, for a concept of sexual or aesthetic "preference," but he is not convinced that "we are dealing with expressions of sexual orientation in the modern sense."[6] Kim M. Phillips and Barry Reay, building on such arguments, find "sex but no sexuality" in the period 1100–1800; rejecting "modern notions of stable sexual orientation," they prefer to speak of historically specific "dispositions."[7] And Schultz, warning medievalists of the danger posed by "heterosexuality" to their field, is unequivocal in his dismissal of the concept: "The Middle Ages had no notion of sexual orientation."[8]

In lots of respects I find these arguments very persuasive. You could say that, over time, I have developed a "disposition" toward the Foucauldian way of thinking—and it has by no means been a passing phase. Indeed I have come to adopt the view that ideas of an enduring sexual selfhood, which the concept of "sexual orientation" is generally taken to represent, fail fully to describe even some aspects of modern erotic life, let alone those conveyed in premodern texts and images. I have therefore found myself observing, in the context of the age-differentiated or pederastic structures inflecting some medieval love poetry, that the idea of sexual orientation "may well distort the place assigned to role differentiation in these literary encounters"; that, while early medieval penitentials sometimes make reference to outbreaks of habitual sodomy, which possibly even convey a sense of personhood, "there were also clearly males who had sex with other males outside these parameters, groups for whom the notion of modern gay identity, in the sense of sexual orientation, would not make immediate sense"; and that, while "sexual object choice, in the sense of orientation, appears to have been a much less powerful interpretive force" in

the Middle Ages compared with today, even in contemporary cultures we need to account for "those who experience queer desires but who are less willing or able to identify as gay in the sense of an enduring or pre-eminent orientation."[9]

In what follows, I do not wish to renounce my earlier skepticism completely: I continue to see the value in questioning the assumption that medieval concepts of sexuality were the same as ours. Yet I also want to consider whether anything is to be gained from viewing medieval sexualities precisely through the prism of "orientations." What does it mean for sexuality to be lived as orientated? How does "who" or "what" people are orientated toward matter in medieval texts and images? What happens when we pose the question of "the orientation" of "sexual orientation" as a historical question?

These questions replicate or lightly revise questions put forward by Sara Ahmed in the opening pages of her book *Queer Phenomenology*, where she asks what it would mean "to pose the question of 'the orientation' of 'sexual orientation' as a phenomenological question."[10] This recourse to phenomenology helpfully brings into focus a dimension that has largely been missing from the warnings customarily issued by historians of sexuality, myself included, concerning the deployment of "sexual orientation" as an interpretive grid for comprehending premodern sexualities. Whereas the "orientation" of sexual orientation is usually taken to refer, as Halperin explains, to "a psychiatric notion of perverted or pathological *orientation* . . . which is an essentially psychological concept that applies to the inner life of the individual,"[11] Ahmed points instead to the spatial and directional dimensions of the word. Taking her cue from Maurice Merleau-Ponty's observation in *Phenomenology of Perception* that sexuality is a mode of bodily projection, a "manner of being toward the world, that is, toward time and other men," she proposes an analysis that "queers" this sense of bodily projection by considering how desires go off line, are deemed to wander or deviate from the designated path, or get (mis)read in ways that strive to bring them back into line.[12] While, as Ahmed acknowledges, the spatiality of other terms such as "queer" has been subject to a certain amount of discussion in sexuality studies, the directionality of sexual orientation itself has tended to escape notice.[13] If phenomenology entails coming to terms with how bodies inhabit spaces with others, and if a specifically *queer* phenomenology might offer, as she puts it, "a different 'slant' to the concept of orientation itself,"[14] how might these methodologies be harnessed as a means of exploring, in different historical contexts, the eroticization and gendering of bodies as modes of inhabiting space and being with others?

In this concluding chapter I turn first to virginity as a form of being in the world, one that seems analogous, in certain respects, to sexual orientation. My aim here is not to flatten out the distinctions that obviously exist between twelfth- and thirteenth-century discourses of virginity and nineteenth-century

psychiatric conceptualizations of heterosexuality and homosexuality, or to encourage an uncritical acceptance of sexual orientation as an instrument for interpreting erotic life across vastly different times and spaces. Rather, by risking the anachronism that inevitably accompanies such maneuvers, I hope it will be possible to direct attention toward the directional imagery in which medieval encounters with sex are sometimes couched. In so doing, I aim also to trouble certain modern assumptions concerning the reducibility of sexual orientation to two orientations in particular, homo- and heterosexuality, which occlude all the other possibilities for directing or redirecting desires in human experience.

In this context, I focus especially on the vocation of the female anchorite, whose spatial orientation occasionally even conjures up the language of sodomy. Anchorites were women or men who attempted to mimic the eremitic lifestyle of the desert fathers by dedicating themselves to a life of solitary confinement in a cell or "anchorhold," usually under the spiritual direction of a bishop. While the reclusive life was adopted by individuals from the early Middle Ages until well into the sixteenth century, statistical surveys demonstrate that in England anchoritism reached its apogee in the thirteenth century, a period when women adopting the lifestyle outnumbered men by a ratio of roughly four to one.[15] Why, I ask, does the rhetoric of sodomy occasionally end up attaching—like virtually nowhere else in medieval culture—to this particular category of woman? Conceptions of virginity as a distinct identity and orientation, a manner of being toward God—that is, toward a field of otherworldly spaces, objects, and time frames—help explain why female solitaries could sometimes be deemed at risk of succumbing to unnatural desires. Anchoritic identity was also subjected to the kinds of public scrutiny that made it especially vulnerable to such accusations.

Finally, I investigate a location in medieval art where sodomy consistently congeals into an identity formation—albeit an identity bound up with religious concepts of sin rather than with the psychiatric, sexological conceptions of personhood formulated in the second half of the nineteenth century. Depictions of hell and purgatory, which sowed the seeds for perhaps the most persistent definition of sodomy to have survived into the modern period, narrow the sodomite's vocation down to one sex act especially—anal penetration of a male by another male—and harness the spatial and directional dimensions of infernal punishment to do so. Here again we shall encounter some of the codes deployed in images discussed elsewhere in this book to convey sodomitical proclivities, a vocabulary of touch and disorderly affect in which women are occasionally implicated. But the sodomites of hell are often directed exclusively toward a specific object, the anus, which sustains a substantially narrowed definition of sodomy.

Holding it Straight: Virginity as a Sexual Orientation

Around the year 1112, Christina, the daughter of rich merchants from the town of Huntingdon in East Anglia, took a vow of virginity. Eventually she became prioress of Markyate, near St. Albans in Hertfordshire. The story of Christina's path to holiness was recorded by an anonymous biographer, a monk from St. Albans Abbey, who knew her and her family. According to the *Life* of Christina of Markyate (ca. 1096–after 1155), a hagiography commissioned before her death, the virgin's vocation had already been mapped out from an early age. Even before Christina was aware of the difference between right and wrong, readers are informed, "she used to beat her tender flesh with whips whenever she thought she had done something forbidden."[16] She spoke with Christ "at night and on her bed as if he were a man whom she could see," desisting only when people started teasing her about it (4). When Christina's parents took their daughter to St. Albans Abbey during her childhood, the girl reportedly scratched the sign of the cross onto the door with one of her fingernails (5). Arriving in a nearby village, Christina spent her time meditating, "as if it were already the future," contemplating her death and resolving to recoil from earthly things. Turning (*conversa*) to God with all her heart, the narrator declares, Christina expressed a desire to draw near (*adhere*) to him by dedicating herself to inviolable virginity (*integritatem virginitatis*) (5–6). Returning to Huntingdon, she revealed to her spiritual mentor at the time, a canon called Sueno, that she had promised herself to God, setting in motion a train of events that culminated in her seeking refuge with a series of religious solitaries in the St. Albans area. On one occasion the bishop of Durham, Ranulf Flambard, paid a visit to Christina's father, Auti, and unsuccessfully tried to deflower the girl (6–8), before setting her up with another young nobleman called Beorhtred, to whom she was eventually betrothed with her parents' approval (9). Various efforts were made by Auti and his wife Beatrix to break their daughter's resolve, including persuading Melisen, one of her female friends and peers, to whisper "incessant blandishments in her ears" (9); forcing her to act as a cupbearer at an important merchants' gathering, dressed seductively so as to arouse the desires of onlookers (10–11);[17] arranging for Beorhtred to enter the maiden's bedchamber at night by force and act the man (*esse virum*) (12); hiring a series of old crones to corrupt Christina with love potions (24); and consulting with the prior of Huntingdon, Fredebert, to try to persuade her to consummate the marriage. Fredebert eventually conceded to Auti that he had failed in his efforts: "We have tried our best to bend [*inclinare*] your daughter to your will but we have made no headway. . . . We respect the resolution of this virgin, since it is based on steadfast virtue [*virtute stabilitam*]" (19).

As this brief summary of the early part of the *Life* demonstrates, Christina's virginal vocation and attempts to counter it are steeped in directional metaphors. Directionality and willful acts of turning are constitutive of her identity as a virgin, and of her positioning in space and time: Christina's transformation into a bride of Christ involves the translation of direction into identity, orientation into a way of life. She turns (*conversa*), draws near (*adhere*), and surrenders herself to God, remaining steadfast (*virtute stabilitam*) and recoiling from the insistent haranguing of friends and family. She fixes in her mind an alternative set of desired objects, manifested as visions of Christ and the Virgin Mary, and also given material form through the hermits and anchorites with whom she lives. Chastity is, Christina says, a vocation she has chosen from infancy, one "I showed by my actions [*operibus ostendi*]" (18), which include asceticism and self-punishment as well as the verbal and physical stratagems she adopts to outwit her parents. If some people are apparently born with virginal aspirations, others achieve it through willpower, discipline, and effort. Christina's identity as a virgin is doubtless an accomplishment "tenuously constituted in time," to take up Butler's analysis of gender performativity, and "needs to be made visible as a form of work," to quote Ahmed's analysis of the labor of orientation and lesbian becoming; but there is also a sense in which, even in infancy, Christina possesses an inbuilt orientation toward chastity.[18] As her biographer explains, citing the auspicious appearance of a white dove in the presence of Christina's pregnant mother, who sees it fly from a local religious house dedicated to the Virgin Mary, "even before she was born she had already been singled out by God" (3). Subsequently Christina carves out a relationship to space (the graffiti on the abbey door; the hermitages in which she eventually seeks refuge) and to time (the meditation on her future death) that further separates her from the world of earthly marriage into which she finds herself coerced. It is also partly via the spaces of her earthly existence—the hall, the bedroom—that Christina's parents try to bend (*inclinare*) their daughter's will and to correct (in their eyes) the wayward direction of her desire. But the climactic point in Christina's turn to God is literally figured in terms of direction and movement, as a running away (*fugisse, fugitivis*) (36) from her father and earthly husband; it is subsequently represented as a mode of dwelling together (*commorandum simul*), as when Christina spends four years living chastely with a hermit of Markyate called Roger (40).

As discussed in the previous chapter, the pursuit of chastity by monks entailed the transformation of sensual desire (manifested as the desire of humans for one another, or for other carnal pleasures) into desire for God. This did not simply require saying "no" to eroticism; it involved redirecting desire toward a distinct field of objects, specifically heavenly bodies, and thereby translating

it into a means of exercising virtue. In keeping with this structure, Christina's *Life* records several moments when she encounters Christ in his humanity, passages that position him as a wealthy lover (18) and jealous husband (23); as a small child, whom she holds to her breast "with immeasurable delight" (48); and finally as a mysterious pilgrim, whose attractive features, handsome beard, and refined conversation inspire Christina and her sister Margaret to "yearn for the man" repeatedly (84). Obedience and humility were vital ingredients in this process of transformation: the monastic program was, as Asad puts it, "directed at forming/re-forming Christian dispositions."[19] In keeping with this disciplinary ethos, Christina's virginal identity is cultivated progressively through ascetic practices. Even from a young age, she willingly beat herself with whips. Later on, the extreme lengths to which Christina goes as a recluse to resist concupiscence are amply documented by the author of her *Life*: "By long fasting, little food and only raw herbs at that, a ration of drink, sleepless nights, and harsh scourgings she vehemently resisted the desires of her own flesh, lest her own members become the agents of wickedness against her" (46–47). But the antidote to this "warfare" against her lustful urges is redirection, not repression: a vision of the Christ child, granted by Christ himself, who not only graces his "handmaid" with his presence as a child whom she can hold to her breast but also fills her "in her innermost being" (48). It is passages such as this, I want to suggest, that construct Christina's virginity *as* a sexuality—an orientation toward a specific set of objects, conceived as an expression of will and intentionality, which conditions her inner life and erotic sensibility. The medieval virgin is indeed (like Foucault's homosexual) "a personage"—one possessing "a past, a case history and a childhood. . . . Nothing that went into [her] total composition was unaffected by [her] sexuality. It was everywhere present in [her]: at the root of all [her] actions."[20]

Foucault's statement on the emergence of homosexuality in the nineteenth century, which I have just been quoting, also includes a reference to the homosexual's "indiscreet anatomy" and "mysterious physiology," one "written immodestly on his face and body because it was a secret that always gave itself away." Virginity is likewise often construed in anatomical terms: defined as a physical state, mysteriously written on the body, it is accompanied by a complex mythology, which assumes that it can be tested or proved through physical examination (as evidenced by the fiction of the intact hymen). In the Middle Ages ideas of this sort were bolstered by architectural metaphors for bodily intactness: the virgin might be visualized as a besieged tower or citadel, an impregnable fortress, or even a sealed tomb. Even so, these images often also worked in tandem with ideas of virginity as a spiritual state, rooted in the soul and inner life. In keeping with Christian concepts of selfhood, which tended to make no clear separation between body and soul, medieval virginity discourse

produces a varied response to the question of whether the virgin's orientation was "written immodestly" on her face and body or whether it was an effect of willpower and the inclinations of the inner self.[21]

Christina's *Life* begins with the statement that she is a "maiden of extraordinary sanctity and beauty," which aligns her with other female virgin saints such as Saint Cecilia and Saint Margaret, both of whom are evoked in the text. But these references are not supplemented by any discussion of Christina's physiology as a manifestation of her sexual purity: you would not know that she was a virgin just by looking at her. On the contrary, the *Life* draws attention to moments when anatomy threatens to hold her back. When a woman's chastity is endangered, rules Hildegard of Bingen, women may legitimately change into men's dress—an argument that assumes that what is at issue for women protecting their virginal status is precisely their feminine "weakness," which occasionally needs the remedy of masculine disguise. As in stories of cross-identifying saints such as Eugenia, the truth will out eventually; but the woman's body—associated by Hildegard with infirmity (*infirmitatem*), by Jerome with "birth and children," and by Ambrose with "the name of the world, the sex of the body, the seductiveness of youth, the talkativeness of old age"—can also be transcended and transformed through virginal performance. This is a possibility explicitly pursued by Christina, according to her biographer. Echoing the recommendations of early virginity theorists such as Jerome and Ambrose that Christians, whether men or women, need to man up in order to progress to the *virum perfectum* in Christ, the *Life* describes how, during her escape to a hermitage in Flamstead, Christina dresses in male garb before hesitating, with embarrassment, just as she is about to take flight. "Why delay, oh fugitive?" declares the narrator, "Why respect your feminine sex [*sexum feminei*]? Put on manly courage [*virile animum*] and mount the horse like a man [*in more viri*]" (34). When Christina is described as plucking up the courage to jump onto the horse "manfully" (*viriliter*), her biographer evokes the situational gender-crossing that Hildegard says is licit for the purposes of protecting chastity.

Christina's biographer takes up the virile virginity topos a second time in a later passage, describing how, following the death of her beloved Roger, she is confronted with the "shocking" lustful behavior of a nameless cleric under whose protection she has been placed. Though Christina is described as "struggling with her desires," she manages to resist the cleric's advances, "whence he sometimes said that she was more like a man than a woman [*virum illam non feminam*], where the virago with her masculine qualities [*virago virtute virili*] might more justifiably have called him effeminate [*effeminatum*]"; the ascetic practices she adopts again exemplify her ability to act *viriliter* (46). Clearly the rhetoric in these passages is misogynistic: it equates masculinity with self-control and femininity with unruly lust. Peter Damian repeats these

associations in his reflections on clerical sodomy: male monks and priests are similarly encouraged to act *viriliter* by taming their lusts, so avoiding the fate of the sodomitical *homo effeminate*; the hand of the spirit is likewise described as rescuing the penitent sinner "manfully."[22] But from the perspective of Christina's biographer, this language of virile discipline and unmanly deviation is designed to pay her the greatest compliment: she is such a brilliant master of her desires that she outmans the man with whom she has been living.[23] Orientation is the crucial ingredient in determining whether the performance of female masculinity is deemed praiseworthy or repugnant. Because, in Katherina Hetzeldorfer's case (as discussed in chapter 2), the cross-identifying woman's appropriation of the male role was directed only at carnal ends, at least in the eyes of her prosecutors, she was put to death. Conversely Christina, several centuries earlier, had acted *viriliter* as a means of directing her desires away from carnality and toward God. Because she combines *virgo* and *virago* in the same person, gender switching is detached from the stigma accompanying manifestations of sodomy.

One question this raises is whether Christina's experience of gender aligns her with the physiological and psychological theories in which modern concepts of homosexuality are steeped, transposed as it was from the practice of sodomy onto "a kind of interior androgyny, a hermaphroditism of the soul." Foucault's statement here draws attention to the models of gender identity, sexual embodiment, and interiority that continued to attach to some nineteenth- and early twentieth-century scientific models of homosexuality, as exemplified by the sexological category of "inversion."[24] As discussed in earlier chapters, related ideas also sometimes surface in medieval diatribes concerning the gender-switching effects of sodomy. While the clerics and theologians who produced these tirades were not working with modern ideas of a sexual psyche (which, in the case of "inverts," was thought to be at odds with the sex of the body), they would have been conversant with notions of the soul as a gendered entity—one that, in its idealized, perfected state, could connote masculinity or a mode of internalized androgyny. Concepts of the *virgo* as *virago* persisted throughout the Middle Ages, coexisting with ostensibly more "feminized" models representing the virgin as *sponsa Christi* or identifying her with the mother of God.[25] Christina herself switches between these roles depending on circumstance. She acts as a *virago* only in times of dire need; more frequently she inhabits the bridal position, which is sometimes conceived in very literal terms as a marriage to a real husband.[26] Occasionally, as in the image of her suckling the Christ child, she also imitates the Virgin Mary. Christina's gender effectively shifts from she to he and back again only when her situation demands it, in a fashion that would presumably make Nature's stomach turn in Alan of Lille's *De planctu Naturae*.

In light of these different possibilities, arguments have been put forward for treating virginity as a distinct gender identity: Sarah Salih suggests it afforded a minority of medieval women "the option not to do womanliness."[27] These modes of doing gender were manifestly willful, shaped by the discipline-bound activities of enclosure. In some respects Christina takes up the reclusive lifestyle reluctantly, pushed into the practice by her overbearing family; but the *Life* also repeatedly characterizes the subject's virginity as an expression of her unyielding will. To the extent that Christina is an aspiring bride of Christ trapped in a fleshly wife's body, she could herself be said to manifest a kind of hermaphroditism or interior androgyny—although in her case the social performances of androgyny this necessitates are always temporary. The work of reorienting desire away from the carnal and toward the spiritual requires a constant effort to inscribe the practice of discipline onto the virgin's soul; this requires that Christina internalize her virginal status, which (as the cross-dressing incident reveals) conflicts with her social embodiment as a woman.

This work is also, in a sense, phenomenological. That is to say, insofar as it registers what Edmund Husserl has called "intentionality," the directedness of experience toward or around some things and away from others, virginity is the product of repeated and habitual performance, one that consciously directs the self "toward" specific objects.[28] When, as a child, Christina scratches the cross into the entrance of St. Albans Abbey, it marks the fact that "in that monastery in particular she had stowed away her heart's desire" (5). When, later in life, she escapes from home dressed as a man, she sets aside her "feminine" weakness, rides her horse to Flamstead, and, finding there joy in Christ, recites verses from Psalm 37 including the line "Lord, all my desire is before thee" (35). Once Christina is under the tutelage of Roger the hermit, she is stricken by physical afflictions of various kinds, which she bears calmly, and she is rewarded for her steadfastness with a vision of Christ offering his cross and instructing her always to hold it in a straight line (*tene simper recta linea*) (42). Ahmed speaks of the ways in which "spaces and bodies become straight as an effect of repetition," citing heteronormativity as a prime instance of what she terms "straightening devices."[29] Ahmed's dependence here on modern concepts of normativity meets a challenge in premodern contexts, where ideas of a social or sexual "norm" were arguably less prevalent. In Christina's vision it is virginity, not compulsory heterosexuality, that functions as the ideological straitjacket. Christ presents devotion to his cross as a straightening device, one that will, through repetitive action, correct the deviant pathways pursued by fallen humanity.

So there are ways in which Christina of Markyate's virginal positioning could, in the senses outlined above, be said to possess qualities analogous to sexual orientation, at least in its directional aspect. As Halperin reminds us,

there exists between sex and identity a "multiplicity" of possible historical permutations; modern conceptions of sexuality or sexual orientation should not necessarily be treated as identical to ancient or medieval constructions of sexual morphology or sexual subjectivity, even if they bear superficial resemblance to one another or share some common features.[30] Yet to the extent that Christina's virginity is a spatial formation, construed through a particular mode of inhabiting space, and insofar as it is a fundamental part of her identity, one constitutive of how she understands herself and her relationship to others, I think she is being represented, and represents herself, as a distinct type of person, one who tends toward a particular field of objects and others. There is also a mismatch between Christina's morphology, rooted in her woman's body, and the "manly courage" she discovers in her soul by virtue of her virginal vocation, suggesting a coincidence between her religious identity and an androgynous persona.

It remains to be seen how and when this idea of virginal orientation overlaps with sodomitical frameworks. In the next part of this chapter I turn to anchoritic guidance literature produced in England in the later Middle Ages, where specters of Sodom do occasionally put in an appearance.

"Sodom Thy Sister": Friendship, Sodomy, and the Anchorhold

Whether they lived together in communities or lived alone, religious women were not generally susceptible to the accusations of sodomy that periodically troubled male religious in premodernity. When women's kisses and embraces were afforded prominence in medieval culture, there is not usually any suggestion that such relations might spill over into carnality. Nor did women's assumption of male dress and deportment provoke the kinds of outrage reserved for men's effeminate behavior or dress codes. It is Christina's clerical companion who is berated for being *effeminatus*.

A telling example is Alan of Lille's *De planctu Naturae*. We might expect this particular text to be especially attentive to the possibility that kisses and embraces between women could be a prelude to unnatural sex. This is a prospect confronted head on by some of the *Bibles moralisées* artists, after all; but Alan makes no such effort to trouble acts of female intimacy. On the contrary, exchanges of affection between female allegorical figures are consistently idealized. Nature, personified as a beautiful maiden and queen, uses passionate corporeal gestures to receive a series of female virtues. After the arrival of Humility, the narrator tells us, Nature sweetens the feast of her greeting with the sauce of kisses (*osculorum . . . condimento*), exhibiting a face that betokens a love (*dilectionis*) in the marrow of her bones (*medullatae*) (16.152–53); Generosity announces to Nature that they are joined by a golden chain of love (*aurea*

dilectionis catena) (18.47–48); even Chastity is welcomed by Nature with a prefatory kiss (*osculi preludio*) and a nuptial embrace (*conplexus connubio*) (16.74). The apparent contradiction between the text's allegorical celebration of intense female fellowship and its condemnation of male-male relations elsewhere may thus be symptomatic of the difference gender makes to the interpretation of same-sex bonds. It could also, of course, be symptomatic of Alan's assumptions concerning his audience, which he presumes to be male.[31]

One location in medieval culture where female fellowship was given visual prominence was the iconography of the visitation, which depicts Mary's "salutation" to her cousin Elizabeth, as described in Luke 1.40, prior to the birth of Jesus and John the Baptist. The St. Albans Psalter, a manuscript probably adapted for Christina of Markyate's own use, contains a striking full-page miniature of the visitation (fig. 61), which depicts Mary and Elizabeth embracing, touching their heads together, and looking into one another's eyes. Two female maidservants are depicted, left and right, drawing back curtains to reveal the intimate scene beyond. A sense of symmetry pervades the image, subtly disrupted by the fact that one of the embracing figures (presumably Mary) is slightly taller than the other. The episode takes place in an architectural setting, a church-like structure with a nave flanked by aisles; but it also resonates with the enclosed spaces in which Christina herself holed up with holy men and women during her flight from Huntingdon.[32] As with Alan of Lille's celebrations of intense female bonding, these scenes were presumably encouraged precisely because they were thought not to pose a threat to the devotee's chastity.

Another place where female fellowship was depicted visually was the motif of the "Four Daughters of God," which again gave rise to images of women kissing, embracing, and holding hands. This allegorical reading of Psalm 85, popularized by Christian commentators between the twelfth and seventeenth centuries, takes up the reference in verse 11 to four virtues—Mercy, Truth, Justice, and Peace—who are said by the psalmist to have met together and kissed.[33] Given the religious provenance of these motifs, we would not necessarily expect to find references to sexual possibilities beneath the allegory. Representations of kisses and embraces between women were customarily intended to convey female virtue; only very rarely, as in the *Bibles moralisées* scenes discussed in chapter 1, did such gestures conjure up proscribed forms of eroticism. And yet, as Traub has observed, the homoerotic potential of some early modern depictions of the virtues' interactions has been overlooked by scholars, explained away as only signifying allegorically or ignored on account of the protagonists' femininity. What she playfully terms "chaste femme love" is assumed to be free of the homoerotic affects sometimes evoked in the context of tales of FTM cross-dressing, which present a more explicit challenge to gender imperatives and reproductive codes.[34]

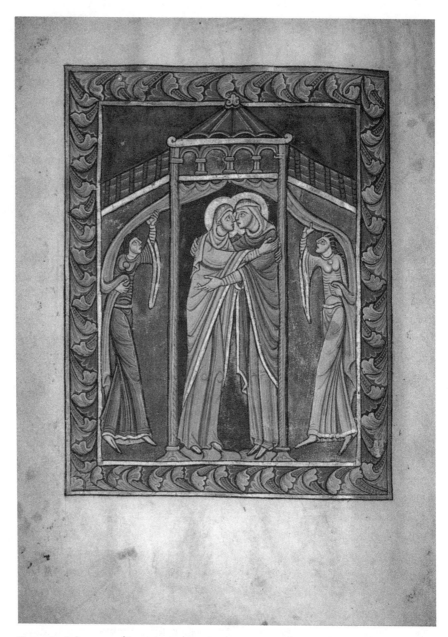

Figure 61. Luke 1:39–56 (the visitation) by Alexis Master. St. Albans Psalter. St. Albans, second quarter of twelfth century. Dombibliothek Hildesheim, MS St Godehard 1, p. 20. © Bildarchiv Foto Marburg / Dom-Museum Hildesheim / Photographer: Ulrich Knapp.

An additional context in which we might expect to discover expressions of female homoeroticism in premodern settings is the story of Diana and Callisto from Ovid's *Metamorphoses* (2.405–531). According to the Ovidian narrative, Jupiter catches sight of Callisto, one of the goddess Diana's warrior virgins, and decides to seduce her. Assuming the dress and appearance of Diana, the god

enters into a conversation with Callisto, before kissing the girl in a wild and un-chaste fashion (2.431) and finally betraying his true identity by committing with her a "crimen" (2.433) (crime/outrage). Nine moons later the real Diana invites Callisto and her companions to bathe in a brook, but Callisto hesitates to get undressed. When the nymphs pull off the girl's clothes, they see the signs of the *crimen* on her body (i.e., the fact she is pregnant) and promptly expel her from the company of maidens; seeking revenge, Jupiter's wife, Juno, subsequently turns Callisto into a hairy bear after she has given birth to her son Arcas. Objects such as wedding chests from fourteenth- and fifteenth-century Italy sometimes incorporated sensual scenes from the story such as panels showing the nymphs examining one another while bathing. Other Italian paintings of this period depict Jupiter disguised as Diana, sometimes kissing and embracing Callisto, thereby obliquely referencing the story's homoerotic potential.[35] Particularly striking in this regard is a woodcut published for the first time in Venice in 1497, which illustrates a fourteenth-century vernacular translation of Giovanni del Virgilio's commentary on Ovid by Giovanni dei Bonsignori. The woodcut por-trays, to the left of a scene depicting Callisto's poolside examination and expul-sion, two barely indistinguishable figures, dressed as women, hugging tightly and pressing their faces together (fig. 62).[36]

Illustrated manuscripts of the *Ovide moralisé* generally focus on the scene of Callisto's expulsion. In Lyon 742 Callisto is depicted outside the pool with a visibly enlarged stomach, while three women with identical hairdos stand in the water gesticulating and looking at her disparagingly (they appear to be smiling) (fig. 63). One of the miniatures in Rouen O.4 likewise illustrates the expulsion scene (plate 8b), but the same manuscript also includes a two-part miniature depicting, to the left, Callisto's encounter with Jupiter and, to the right, Callisto rejoining Diana and company (plate 8a).[37] Jupiter is depicted chin-chucking the maiden and kissing her on the lips, which echoes the *Ovide mor-alisé* poet's description of how the god kisses her "saffrement . . . en la bouche / Plus que vierge ne deüst faire" (*OM* 2.1476–77) (voluptuously . . . on the mouth, more than a virgin should). But rather than depicting a "same-sex" female kiss and embrace, as in the Venetian woodcut, the artist has taken steps to differ-entiate the god's appearance from that of Diana in the adjacent scene. While Diana and Jupiter both wear crowns and identically colored outfits, Jupiter's dress comes above his ankles, suggesting that he is too big for his costume; the god's unwieldy proportions are further emphasized by his stooping posture as he bends over to plant the kiss. Additionally, whereas Diana wears a white headscarf, a sign of chastity, Jupiter's hair is left uncovered, which accentuates his base intentions. This image could be interpreted as an allegory of the fate of female homoeroticism in medieval culture: in order to register as sexual, one of the partners needs to be rendered butch. Or, read another way, Jupiter's

Figure 62. Jupiter as Diana embraces Callisto (*left*); Callisto's examination and expulsion (*center*); Callisto gives birth to Arcas and is transformed into a bear (*right*). Woodcut in Giovanni dei Bonsignori, *Ovidio Metamorphoseos vulgare* (Venice: Zoane Rosso, 1497). London, British Library, IB.23185. © British Library Board.

MTF transition fails to take—which places the blame squarely on Callisto, who should have spotted the threat to her chastity from this most mannish of "virgins."

The difference between Christina of Markyate's (successful) masculine performance and Jupiter's (unsuccessful) feminine performance again comes down to a question of orientation: is desire directed toward a carnal or a spiritual purpose? Significantly, while the Lyon miniature depicts virgins bathing naked together, the Rouen miniaturist has reduced the erotic potential by depicting the nymphs and Callisto fully clothed (plate 8a). Furthermore, in the investigation scene to the right, three individuals, tunics hitched up at the knees, run their hands intrusively across the maiden's upper body. The androgynous appearance of these figures—whose hairstyles, plain clothing, and breeches contrast markedly with those of the watching Diana and her companions to the left—again suggests an effort on the part of the artist to regender the scenario: a visual image of female virgins touching up another woman is apparently too hot to handle, so steps have been taken to contain the (homoerotic) potential of (virginal) women's interactions. Indeed there are hints that the artist has

also gone further still: the victimized woman's hair is lifted away from her face to the viewer's left, as if one of the investigating agents is pulling at it, a sign commonly connoting rape.[38] The scenario resonates with images in the Vienna *Bibles moralisées* representing sexual abuse in Judges 19 (fig. 7); any "feminine" homoerotic potential has been thoroughly eliminated.

Figure 63. Diana expels Callisto. Miniature in *Ovide moralisé*. Paris, circa 1385–90. Lyon, Bibliothèque municipale, MS 742, fol. 30r (detail). Photo: Bibliothèque municipale de Lyon, Didier Nicole.

My question is whether textual reflections on virginity in the Middle Ages similarly confront female homoeroticism within a governing logic that attempts to contain it or render it invisible. I think that they do, but paradoxically by bringing those female (homo)sexualities intermittently into view. Early modernists have tended to date the eroticization of same-sex friendship to their own period of study. Alan Bray's analysis of friendship prior to 1500 focuses predominantly on fictional narratives of sworn brotherhood and examples from material culture such as shared tombs, where sodomy is ostensibly not at issue, while Traub dates the collapse of distinctions between female friends and "tribades" to the seventeenth century.[39] Where men are concerned, medievalists have sometimes found evidence for the sodomy-friendship dyad in earlier periods. Mathew Kuefler, for instance, draws attention to an explosion of narratives casting suspicion on male friendships as breeding grounds for sodomitical liaisons in twelfth-century French romances and Anglo-Norman chronicles.[40] While attention has also been paid to the possibilities for love, friendship, and eroticism among nuns and other religious women in the Middle Ages, however, the sodomy-friendship opposition has not generally emerged as a relevant interpretive prism.[41]

The arguments commonly put forward to explain the relative paucity of medieval texts condemning female homoeroticism are twofold: first, sources such as chronicles and documentary records are primarily concerned with men and reflect the near-universal dominance of men over women's sexual and social lives; second, women's same-sex friendships did not have the same public significance as those of men and therefore fail to register in those sources.[42] Partnerships between men were sometimes recognized as having an erotic component, albeit via the "confused" category of sodomy, because those partnerships were publicly sanctioned and socially significant. Conversely women's relationships were not politically resonant enough to warrant the erection of a fully fledged regulatory divide separating female fellowship from female homoeroticism. Furthermore, as Traub has argued of the early modern period, where she discovers a "renaissance" of lesbianism, if we fail to find erotic significance in scenes such as those depicting the Four Daughters of God embracing, it is because of the palpable femininity of the motif's protagonists, which blinds us—and probably also blinded early modern people too—to the homoeroticism of such scenes. This is not to say that some women did not participate in more conventionally feminine modes of homoerotic intimacy, but they appear not to have aroused much social anxiety.[43]

Medieval anchoritism represents a situation where women did possess a role that was culturally and socially significant, and where they also—theoretically at least—represented a threat to male dominance. Because of this, I suggest, efforts were sometimes made to police the relations they formed with

one another, or with their own bodies, in terms that implicated the erotic. Added to this was the fact that the erotic life in which they *were* expected to participate, that is to say, devotion to chastity and the love of God, was a mode of orientation constructed through directional and spatial metaphors. The word "anchorite" comes from the Greek verb ἀναχορέο (*anachōreō*), which means "to retire" or "to withdraw"; anchoritism was styled as a form of desert withdrawal, as modeled first by John the Baptist and Christ in the Bible, and later by early Christian desert hermits.[44] Since the transactions of the anchorhold were bracketed off, physically and symbolically, from other modes of social existence, they were subjected to a degree of scrutiny not encountered in other spheres. These various factors intermittently brought female intimacies into contact with sodomitical frameworks.

In chapter 4, we encountered regulations concerning sexual misdemeanors in Benedictine religious houses, especially those thought to be taking place between older monks and novices. Guidance literature written for religious solitaries took similar steps to regulate the sex lives of anchorites and hermits. This included targeting such expressions of lust as masturbation and nocturnal emission, as well as other sins such as gluttony and sloth, which were thought to be especially conducive to sexual temptation. In the early 1160s Aelred of Rievaulx wrote a treatise, *De institutione inclusarum*, which, styled as a letter to his sister, was designed to regulate the life of a recluse. This included a warning, in Latin versions of the text, that the addressee should not assume that fellowship with a man constitutes the only danger to her chastity. Quoting a verse from the book of Revelation, which declares, "These are they who were not defiled with women: for they are virgins," Aelred counsels: "Do not think this means that a man cannot be defiled without a woman or a woman without a man, since that abominable sin [*detestandum illud scelus*] which inflames a man with passion for a man or a woman with passion for a woman meets with more relentless condemnation than any other crime."[45] The same passage is rendered somewhat more circumspectly in an English translation of Aelred's treatise included in the vast late fourteenth-century collection known as the Vernon manuscript (ca. 1390–1400), which was possibly compiled for an audience of women: "Bote I say not this that thu shuldest wene [think] that a man may not be defoyled [polluted] wit-owte a wymman, ne a wumman wit-oute a man; for in other wyse [ways], moor cursed and abhominable, which schal not be sayd now ne ynemned [named], bothe in man and womman often chastete is lost."[46] Whereas Latin versions of the text clearly condemn homoeroticism between men or between women, the English translation could simply be interpreted as an attack on masturbation, which, like sodomy, was commonly conveyed via motifs of unspeakability. One of the surviving miniatures in the Vernon manuscript, illustrating another text called the *Estorie del Evangelie* (Story of

the Gospel), depicts a visitation scene in which Mary and Elizabeth face one another and embrace, above the words "Then þer was a swete metynge, swete clyppinge [embracing] and swete cussynge [kissing]."[47] Here, then, physical relations between women are representable only if they have spiritual significance; anything else cannot be named or visualized.

A reference to unnatural vice also turns up in the fourteenth-century Latin *Speculum inclusorum,* translated into Middle English in the fifteenth-century *Myrour of Recluses.* The Latin version, apparently directed at a male monastic audience, refers to the sin of "mollicies," or self-touching. This is defined as an abominable activity that could be a prelude to the practices of "masculorum concubitores" (those who lie with males), a phrase clearly alluding to 1 Corinthians 6.10, which rules that "neque molles, neque masculorum concubitores" (neither the soft/effeminate nor those who lie with males) will inherit God's kingdom. But the Middle English translation, possibly adapted for a female audience, simply glosses the sin by quoting the word *molles* from the Corinthians passage but omitting the reference to "masculorum concubitores"—so once again in context the sin in question is probably masturbation. In both Latin and Middle English, the reference is followed by an anecdote about a solitary hermit who is deeply troubled by this sin of "mollicies."[48]

At the close of the fourteenth century in England, however, the celibate lifestyles of enclosed men and women were explicitly accused of encouraging lewd behavior in another context besides monastic or eremitic rulebooks and their vernacular counterparts. The eleventh of the heretical Lollards' Twelve Conclusions, posted anonymously on the doors of Westminster Hall in 1395, attacked the continence of religious women for precipitating the "most horrible synne possible to mankynde," that is to say, "knowing with hemself or irresonable beste or creature þat beris no lyf."[49] "Knowing with hemself" is ambiguously phrased, since it could refer to carnal knowledge of an autoerotic or homoerotic nature, while the second item in the series is clearly bestiality. Sex with a creature that bears "no lyf" is the least translatable of the activities listed. While it may refer simply to the masturbatory use of inanimate objects such as dildos, it more likely alludes to the sexual use of dead things in general—a kind of sexualized idolatry in which desire is directed at images and false gods as well as sex toys.[50] Countering the convention, evoked in Christina of Markyate's crossdressing episode, that virginity is a virilizing pursuit that enables women to transcend the supposed limitations of their gender, the Lollards' eleventh conclusion sees vows of continence laying the groundwork for a whole spectrum of sexual activities, presented here as extensions of the "fekil" (fickle), imperfect nature of womankind in general. In the sixteenth century, chastity aroused similar anxieties among Protestant reformers: for the historian and bibliographer John Bale (1495–1563) it constitutes a "filthy Sodome."[51]

Resting behind all these concerns surrounding the pursuit of chastity by religious women and men was the assumption, as expressed in the *Bibles moralisées*, that sexual practices are relational and cannot be separated from other manifestations of carnal desire. The Lollards' eleventh conclusion ends by expressing a wish that widows, and those who "han takin þe mantil and þe ryng deliciousliche fed" (have taken the mantle and the ring deliciously fed), should marry, for they cannot be excused from "priue synnis" (secret sins).[52] The secrets taking place behind the doors of the convent, or the anchoritic cell, are various, as the list of possible sex acts demonstrates, but women's appetite for taking the veil is also connected with excessive feeding.[53] Aelred's rulebook for recluses likewise presents overindulgence in food and drink as a threat to chastity: one of the Middle English versions warns the addressee not to receive visits "by way of hospitalite anempst [among] women of deuocyon, religious or other," for they may give rise to talk of "worldly daliaunce" and "fleshly loue."[54] Lochrie discusses how, in the letters exchanged between Heloise and Abelard, Heloise alludes to the convent as a place where chastity and female homoeroticism may collide, complaining that the Benedictine Rule was "clearly written for men alone." Quoting a statement in Ovid's *Ars amatoria* on how banquets give rise to lascivious behavior, Heloise questions the wisdom not only of allowing male visitors to join the abbess at table but also of inviting female visitors to enjoy the nuns' hospitality: "Surely nothing is so conducive to a woman's seduction as woman's flattery," she gasps; "nor does a woman pass on the foulness of a corrupted mind so readily to any but another woman."[55] Idleness is also another problem, as identified in Aelred's rule. It is, the narrator says in one of the English translations, "moder [mother] of all vices, wurcher [creator] of alle lustes, norsher [nourisher] of veyn thoughts, former of vnclene affeccions, sturer of vnclene desires."[56] The *Myrour of Recluses* refers to "voluptuus sleuthe" (voluptuous sloth) and "sleuthi fleschly lust" (slovenly fleshly lust), as if the two sins are interchangeable.[57]

These connections between eating, drinking, idleness, and other modes of carnal pleasure conform to prevailing medical theories linking culinary excess to lust.[58] But they also repeat long-standing connections between idleness, gluttony, and the sins of Sodom in biblical exegesis and patristic commentary. Following its first appearance in Genesis 19, references to Sodom's sin in subsequent books of the Bible did not associate it specifically with sex. In a chapter berating Jerusalem's disloyalty to God, which takes the form of a husband's upbraiding of his unfaithful wife, Ezekiel defines the sin of Sodom in terms of excessive bodily consumption. Sodom is cast in the role of Jerusalem's "younger sister," and God accuses Jerusalem of doing "more wicked things" than her sister: "Behold this was the iniquity of Sodom thy sister, pride, fullness of bread, and abundance, and the idleness of her, and of her daughters. . . . And they

were lifted up, and committed abominations before me" (Ezekiel 16:49-50). Early Christian commentators followed suit: Jerome associated the sin of Sodom with pride, excessive eating, and *luxuria* (a mode of disorderly desire that, in the Bible, variously connoted drunkenness, gluttony, and sexual excess).[59] In later centuries, theologians continued to connect sodomy to excessive bodily pleasures and consumption. Peter the Chanter opens his meditation on *uicio sodomitico* with a reference to Ezekiel 16, while the Dominican moralist Paul of Hungary likewise quotes the passage in his *Summa de poenitentia* (ca. 1219-21) to support his argument that the "Sodomitic sin" or "sin against nature" is caused by too much material comfort.[60]

Written shortly after Paul of Hungary compiled his confession manual, the thirteenth-century English anchoritic text *Ancrene Wisse*—which may itself have been written by a Dominican cleric—incorporates the same citation from Ezekiel.[61] Quoting a condensed version of the biblical verse, the text's narrator declares: "Of idelnesse awakeneð muchel flesches fondunge. *Iniquitas Sodome: saturitas panis et ocium*—þet is, Sodomes cwedschipe com of idelnesse ant of ful wombe" (160) (Much temptation of the flesh stems from idleness. "The crime of Sodom was a surfeit of bread and idleness"—that is, Sodom's wickedness came from idleness and from a full belly).[62] The excerpt appears within the section of *Ancrene Wisse* known as the "Outer Rule," which was designed to control the anchorite's daily life and interactions with the outside world. Earlier in the Outer Rule the author has already contemplated the scandals that may arise if anchorites mix with male visitors, or have meals with guests outside their quarters: "Þet," says the narrator, "is to muche freondshipe; for of alle ordres, þenne is hit uncundelukest ant meast aȝein ancre ordre þe is al dead to þe world" (156) (That is too much friendship; for in all orders then it is unnatural, and most of all against the order of the recluse, who is utterly dead to the world). Although the reference to "unnatural" desires here is directed at necrophilial relations between living and dead (as in the Lollard conclusion's reference to sex with lifeless creatures), the assumption is that chastity is endangered by such acts of hospitality. While the narrator subsequently directs recluses to host "wummen ant children, ant nomeliche ancre meidnes, þe cumeð iswenchet for ow . . . makieth ham to eotene wið cheartitable chere and leaðieð to herbarhin" (157) (women and children, and especially the recluses' maidservants, who visit having taken trouble for you . . . have them eat with loving hospitality and invite them to stay over), he has earlier declared, somewhat ambiguously, that "Of hire ahne suster haueð sum ibeon itemptet" (26) (By her own sister some (anchorites) have been tempted).

Whether the line just quoted refers to sexual temptation, or to other activities such as exchanging gossip (162) or playing games of "ticki" (164) (touch/tickling) with her maidservant (to name just two of the other activities the

author later warns against), part 4, a section on temptations that contributes to the anchorite's "Inner Rule," issues a stark warning against lustful behaviors to which female solitaries are particularly susceptible:

> Ich ne dear nempnin þe uncundeliche cundles of þis deofles scorpiun, attri iteilet; ah sari mei ha beon þe, bute fere oðer wið, haueð swa ifed cundel of hire galnesse, þet Ich ne mei speoken of for scheome, ne ne dear for drede, leste sum leorni mare uuel þen ha con ant beo þrof itemptet. Ah þenche on hire ahne aweariede fundles in hire galnesse. . . . I ȝuheðe me deð wundres. . . . ȝe þe of swucches nute nawt, ne þurue ȝe nawt wundrin ow ne þenchen hwet Ich meane, ah ȝeldeth graces Godd thet ȝe swuch uncleannesse nabbeð ifondet, ant habbeð reowðe of ham þe i swuch beoð ifallen. (79)

> [I dare not name the unnatural offspring of this devil's scorpion [lechery], venomously tailed. But sorry she may be who, without a friend or with, has fed the offspring of her lustfulness thus, which I may not speak about for shame, nor dare not for fear, lest someone learns more evil than she knows and is tempted by it. But let her consider her own accursed inventions in her lustfulness. . . . In youth people do wonders. . . . You who know nothing about such things, you need not wonder at or ponder what I mean, but give thanks to God that you have never come across such uncleanness, and have pity on them that have fallen into such things.]

This passage condemns multiple sexual practices. It is directed against acts performed with a friend (whose gender is ambiguous) and those performed individually; but, in an outpouring of clerical misogyny, women are additionally characterized as the epitome of inordinate desire, pregnant with the spiraling *fundles* (inventions) of female lust. Significantly the scorpion is explicitly feminized in the text—described as a snake with a face "sumdeal ilich wummon" (79) (rather like a woman's), which seems designed to link lechery with the fall. As we saw in the Vienna *Bibles moralisées*, roughly contemporary with *Ancrene Wisse*, the fall commentary miniatures play on the consequences of a female Serpent tempting a female Eve by linking the biblical narrative to women's homoerotic activity (plates 3 and 4). Against this backdrop, in light of the passage's efforts to identify women as the source of unmentionable activity, and in view of the fact that Aelred's *De institutione inclusarum*, which warns the recluse against the passion of a "woman for a woman," was a source for *Ancrene Wisse*, I think it highly likely that readers of *Ancrene Wisse* are also being told—in a very roundabout way—to avoid homoerotic sex acts as well as masturbation.[63] Typically, the narrator's circumspection regarding the precise nature of the sin calls sodomy into being in the context of a refusal to incite it. The additional

recommendation that those anchorites who do not know what he is on about should not "wundrin ow ne þenchen" (wonder at or ponder) what he means adds an additional layer to the unspeakability.

The version of _Ancrene Wisse_ I have been quoting here was aimed at a readership of twenty or more recluses, geographically dispersed but united under a single rule. This revised and expanded text, the most complete copy of which is contained in Cambridge, Corpus Christi College, MS 402, adapts an earlier version directed at an audience of three female anchorites. Significantly a passage inserted in part 4 of the Corpus text, announcing this enlarged readership, characterizes anchoritism not simply as an individual journey to God, but as a collective orientation and identity:

> Ȝe beoð þe ancren of Englond, swa feole togederes (twenti nuðe oðer ma—Godd i god ow mutli), þet meast grið is among, meast annesse ant anrednesse ant sometreadnesse of anred lif efter a riwle, swa þet alle teoð an, alle iturnt anesweis, ant nan frommard oðer, efter þet word is. For-þi, ȝe gað wel forð ant spedeð in ower wei; for euch is wiðward oþer in an manere of liflade. (96)

> [You are the anchorites of England, so many together (twenty now or more—may God increase you in virtue), among whom there is most peace, most unity and unanimity, and concord in your common life according to one rule, so that all pull as one, all turned one way, and none away from the other, according to what I have heard. For this reason, you are advancing well and are prospering on your path; for each is turned toward the other in one way of living.]

Pulling, turning, and facing in one direction, the anchorites follow the road to virtue and to God, thereby ascending, in unison, to another world. The course they follow provides a context for the condemnations of unspeakable lustfulness earlier in this section of the text. Just as the "ancren of Englond" need to pull together as a single body, they need to ensure that their desires consistently follow a single, unswerving path.

Other versions of _Ancrene Wisse_ were produced, in abridged or altered form, for mixed lay or religious audiences or even adapted specifically for male readers, as signaled by the modification of gendered pronouns or the inclusion of direct addresses to "men of religiun" or "brethren"; sections of the text were also translated from English into Latin and French, and repurposed as penitentials or meditative treatises.[64] Texts of _Ancrene Wisse_ adapted for a mixed or male audience were less likely, for the most part, to include references to unmentionable activities such as masturbation and sex with (same-sex) friends. One fourteenth-century manuscript, designed for a mixed audience of men and women, is particularly telling in this regard. Cambridge, Magdalene College,

MS Pepys 2498 includes a version of *Ancrene Wisse* that radically modifies the passage about the scorpion's "unnatural offspring": discarding the discussion of unmentionable activities performed with or without a friend, the narrator directs attention instead to the sex organ, the "entrance" that lets lechery enter the body, as the locus of unspeakability—unless, that is, the sin in question is performed within marriage. The relevant passage puts it thus:

> Þat ingonge þat leteþ in synne I ne dar nouȝth, for drede, speke þere of ne writen, lest oþer ben ytempted þere of. . . . For hou so it euer is yqueynt it is dedlich synne ȝif it be wakeand and willes wiþ fleshlich likyng, bot ȝif it be in wedlok.⁶⁵

> [I dare not, for fear, speak or write about that entrance that lets in sin, lest others be tempted by it. . . . For however it is satisfied it is a deadly sin if it is stirred up and consented to with fleshly desire, except if it is in wedlock.]

This revision of *Ancrene Wisse* carries the text over into new conditions of understanding, performing, in so doing, the work of transposition, rupture, and appropriation that is the task of the translator. But what are not transported—what remain more or less untranslatable—are illicit acts performed within the anchoritic cell. They have become, in this different context and milieu, nameless orifices, loosely identified as the beginning and end of sin. Unspeakable (female) sex acts metamorphose into unmentionable (female) body parts, while the focus of the reviser's concern becomes any sexual activity performed outside marriage, irrespective of the participants' gender.

If the Corpus 402 revisions to *Ancrene Wisse* do confront, albeit obliquely, the various erotic possibilities to which enclosure gives rise, it may seem rather odd to encounter such imaginings in the context of a text aimed at readers dedicated to a solitary lifestyle. It is worth recalling that Christina's own experiences as a recluse involved residing with various spiritual partners, male and female. And while most anchoritic cells were designed for lone recluses, there is evidence that occasionally anchorites or hermits did live in same-sex pairs.⁶⁶ Moreover, the Corpus 402 text of *Ancrene Wisse*, like other versions, makes reference to the anchorite's need for maidservants, and includes recommendations designed specifically with these women in mind.⁶⁷ Partly for this reason, Michelle Sauer has speculated that the lifestyle promoted by *Ancrene Wisse* may have created a "lesbian void" in medieval culture—a space where anchorites could explore woman-woman erotic possibilities without fear of censure.⁶⁸ This is not to say that the anchorhold necessarily constituted some kind of queer utopia: *Ancrene Wisse*'s allusions to specifically female modes of (homo)eroticism imply a more tightly regulated regime. However, it is worth entertaining the possibility that

chastity fostered a mode of "queer space" in the Middle Ages—one in which, as Lochrie puts it, "female chastity becomes not so much a sexual condition defined by restraint and the antithesis of carnality or marital eroticism as a sexuality that exists alongside those formations."[69] Or if, put differently, queerness is defined as an "outcome of strange temporalities," "imaginative life schedules," and "willfully eccentric modes of being"—uses of time and space developed "in opposition to the institutions of family, heterosexuality, and reproduction"[70]— then the life of a medieval female solitary itself is potentially queer.

Obviously medieval chastity was defined not simply in opposition to family, heterosexuality, and reproduction, but as a turning away from *all* expressions of worldly carnality—and this has been my point. Halberstam's *In a Queer Time and Place*, phrases from which have just been quoted, is directed at capturing post/modern experiences of queerness, where notions of sexual normativity and the binarism of the hetero-homo dyad strongly shape perceptions of what signifies as strange or oppositional. While Christina of Markyate's turn to God is clearly represented as a flight from family and from marriage to earthly men, the eroticism she evades is positioned not in opposition to homosexuality so much as continuous with it, and with every other fleshly practice to which humans tend. And, as my analysis of *Ancrene Wisse* and other anchoritic guidance literature has shown, even when women and men are safely stowed away in cells and other enclosed spaces, the prospect of an eruption of disorderly perversion never entirely disappears.

The remedy, as defined by virginity discourse, is to engage in a program of reorientation and willful self-fashioning. To quote Christ's words to Christina, it is a case of holding the cross—and implicitly oneself—firmly, slanting it neither to the right nor to the left (*firmiter non inclines eam ad dexteram neque ad sinistram*) and always keeping it in a straight line, pointing upward (*recta linea sursum versus*) (42). Holding it "straight" for an audience of aspiring virgins entails pursuing not asexuality but a sexuality the contours of which become visible in opposition to and conjunction with all the other bodily possibilities to which humans are inclined. Virginity is a place where "queer" moments happen—where deviations from the straight line are repeatedly imagined, occasionally even via the circuitous route of sodomy. But equipped only with concepts of a heterosexual/homosexual divide and the presumption that female same-sex interactions are inevitably protected from erotic meanings, we fail to do some of those moments justice. My argument here is that anchoritic identity, conceived as a mode of positioning that sets the virgin straight, gives rise to an effort to channel the obliqueness of *all* human desire along a different path.

Yet there exists here a fundamental contradiction. While medieval anchoritism inspired a series of texts that encourage absolute withdrawal from the world—something that requires, from the perspective of the anchorite's inner

life, following a line direct to God—the recluse also paradoxically remained rooted in that world, reliant as she was upon her maidservants, upon her confessor or spiritual guide, and upon the socioreligious networks of support required to sustain her. The idea of the anchorite literally being "walled up" and isolated from the world around her, which many scholars now dispute, probably takes the prescriptions of texts such as *Ancrene Wisse* too much at face value. In reality anchorites required financial sponsorship, ecclesiastical approval, and the endorsement of the community; the guidance literature they used was embedded in a concrete world of textual circulation, collaborative authorship, and revision.[71] These women were effectively situated on a frontier between the world to which they remained attached, practically speaking, and the otherworld they continually aspired to enter. But because their vocation was ultimately, in these ways, a "borderland" phenomenon, positioned in the ambiguous zone between world and otherworld, life and death, it is perhaps unsurprising that traces of a fault line separating sodomy from friendship sometimes surfaced in this context.[72]

Finally, it is worth returning to an argument also presented in the course of analyzing monastic encounters with sex in Chapter 4, concerning enclosure as a space of proliferating sexualities. In the context of anchoritism, too, it is possible to see this phenomenon at work. Anchoritic enclosure embodied the paradox that the cell was a private space, ostensibly operating outside the conventions of friendship and intimacy that characterize earthly social relations; and yet it was also simultaneously a public space, one that—as episcopal legislation in England attests—was subjected to increasing levels of regulation from the twelfth century.[73] By physically bracketing off the transactions of the anchorhold—closeting them, as it were—relations between women were spatialized and subjected to a level of visibility not encountered in other spheres. This may well explain the references to homoerotic and other erotic possibilities in this context.

My reasoning here derives from an analogy between the anchorhold and the premodern closet. By the latter, I do not necessarily have in mind the figurative closet that Sedgwick suggests has been so "inexhaustibly productive of modern Western culture and history at large" and that is identified, for the most part, with solitary experience.[74] Rather, I refer to Alan Stewart's argument in his book *Close Readers* about the physical closets and private chapels of early modern households, which, designated as rooms for private devotion and study, nonetheless fostered transactions between different classes in socially resonant ways, demarcating the relations forged behind closed doors spatially as well as politically. Moreover, as a space beyond the household, the locked closet could itself sometimes be susceptible to the accusation that it was a site for unsavory or even sexually suspect relations (for instance, between a servant and master

or mistress). Closet transactions were deemed to take place beyond the codes of social determination such as friendship that commonly regulated the relations forged in other spheres.[75]

Clearly there are major differences between the private studies and chapels of early modern houses within which male masters and secretaries temporarily withdrew and the cells at the sides of medieval churches in which female recluses permanently holed up. Each space differed with respect to the amount of time that a person was expected to remain there: in the anchorite's case it was until death. But the spatialization of anchoritic relations potentially created the conditions for an analogous structure.[76] Combined with virginity's status as a straightening device, an orientation replete with identity-conferring and group-defining characteristics, this gave rise to situations in which even religious women living in isolation could find their sex lives intermittently subjected to management or regulation. In 1444, ecclesiastical authorities in the town of Rottweil in southwest Germany investigated a recluse for the "vice against nature which is called sodomy" with a nameless laywoman, suggesting that female solitaries were, very occasionally, accused of precisely the practices dreamed up in texts such as *Ancrene Wisse*.[77] For some women, this was not simply a theoretical problem.

Two points emerge from my analysis of virginity in this chapter. The first is that the Middle Ages did (*pace* Schultz) have an understanding of sexual desire rooted in notions of orientation. Nonetheless the activities and identities with which this concept was associated—chastity and its others—followed different trajectories from the norm-bound, heterosexual/homosexual pathways of modernity. The second is that female homoeroticism is not consistently consigned to the black hole of invisibility in the period. Sometimes it matters because the bodies of the women who were occasionally implicated in it mattered too. It is now time to turn our attention to a very different context in which concepts of orientation play a role: visions of hell, which locate sodomitic bodies within a distinctive configuration of space and time.

Phenomenology of the Anus

In the anchoritic texts just discussed, female homoeroticism registers obliquely with reference to bodily practices such as masturbation, as well as to more general outbreaks of carnality such as greed and laziness. Since, in the case of *Ancrene Wisse*, these discussions were part of a text devoted to outlining the temptations that may beset the anchorite and their remedy in confession, the authors do not mention genitalia or other body parts directly. As in confession manuals such as Robert of Flamborough's *Liber poenitentialis* (discussed in chapter 1), the narrator does not want to feed the anchorite's spiraling "fundles"

(inventions) by providing a "how to" guide on what is involved. The Pepys manuscript of *Ancrene Wisse*, with its euphemistic reference to the "ingonge" or entrance that lets in sin, is unusual in this regard; for the most part anchoritic sexualities are rendered intelligible via a meandering and allusive vocabulary of shameful and forbidden pleasures. In this final section, I wish to focus on a contrasting situation, one in which sodomy was not (with apologies to Foucault) "utterly confused." Whereas, give or take a few brief glimpses, female homoeroticism is barely imaginable in hell or purgatory, male sodomites turn up repeatedly in the context of their punishment. Moreover the penalties infernal sodomites receive often draw attention to the sex acts for which they are being punished: more often than not male sodomy involves penetration of the anus.

Sodomy's connections with anal penetration are deep-seated. Burchard of Worms, in the series of canons in his *Decretum* devoted to fornication, catalogues the various penances due to the man—cleric or lay—who has sinned like Sodomites (*peccaverit sicut Sodomitae*), including bestiality, sex between the thighs (*inter femora*), and sex in the rear (*in terga*). In the book of the *Decretum* entitled the *Corrector*, designed as a penitential for use by parish priests, Burchard further advises confessors what questions they should ask a male sinner concerning fornication: these include enquiring whether he has inserted his rod (*virgam*) into the backside of a male (*in masculi terga et in posteriora*) in the Sodomitic manner (*more Sodomitico*); whether he has put his penis between the hips (*intra coxas*); whether he and another male have moved each other's shameful part (*veretrum*) with the hands; and whether he has made fornication with himself alone (*solus tecum fornicationem*).[78] Attacking the tradition represented by Burchard for being too lenient, but retaining his fourfold classification, Peter Damian, in his letter to Pope Leo IX, confirms fornication in the rear (*in terga*) as the most serious of the practices deserving censure.[79] By the end of the Middle Ages some secular legal authorities drew similar conclusions: prosecutors in fifteenth-century Venice generally defined sodomy as acts of anal intercourse between males.[80] Between the late thirteenth and fifteenth centuries medical theorists and natural philosophers likewise pondered the causes of anal sexual pleasure among males and some men's preference for the receptive role in coitus. Although these thinkers were concerned as much with perianal stimulation between the thighs as with anal penetration, the susceptibility of some men to anal pleasure and to sexual "passivity" was a recurring issue in late medieval commentaries on an Aristotelian work known as the *Problemata* (Problems).[81] In the Arab-Islamic world, the term *liwat*, which, like sodomy, is etymologically linked to the Sodom story, was used by Islamic jurists to refer specifically to acts of male anal penetration.[82]

Literary texts reproduce these associations. A short satirical text called the *Testamentum Porcelli* (Will of the Little Pig), which can be traced back to the late

antique period but circulated in manuscripts between the ninth and twelfth centuries, describes how a cook grants a pig the opportunity to write a will before the animal is slaughtered; the pig counts among his legacies "cinaedus musculos," which could mean he bequeaths either his muscles or his anus to the unmanly.[83] Jean de Meun's continuation of the *Roman de la Rose* describes how Amant gains access to the castle in which his guide Bel Acueil has been imprisoned by entering "par l'uis darriere" (through the back door)—an image echoing the earlier account by the old woman La Vieille of the "ever-open door" by which she made herself sexually available in her youth.[84] The fourteenth-century English poem *Cleanness* includes a section devoted to the sin of Sodom in which males are berated for taking "a man as hymselven / And fylter folyly in fere on femmales wyse" (a man like himself, and they join together wantonly in female fashion), but the poet also later puns on the vice's anal associations: the city's inhabitants are linked to Sodom's "asyse" (assize/asses), to "spitous fylthe" (spiteful filth), and to the stinking "brych" (opening/breeches) from which they pour forth venomous words.[85]

Numerous scenes of rectal incursion, or the threat of it, turn up in manuscript marginalia. The marginal scene discussed in chapter 1, which shows a male thrusting his hand beneath the garments of another male and apparently caressing his genitals (fig. 24), is found in a book of hours that also contains an image of a male, naked except for his shoes, plunging a pole or spear into the animal-headed rump of a male hybrid, who turns round to face his attacker wielding a shield and club (fig. 64). The drawing appears immediately below the first verse of Psalm 2, though there is no discernible connection between the biblical text and the act depicted.[86] Imagery of anal exposure or incursion features especially prominently in the repertoire of some illuminators. Camille draws attention to the anal obsessions of one of the artists in the Rutland Psalter (London, British Library, Additional 62925), working in England ca. 1260, who incorporates within the text's margins a number of depictions of animals or humanoid creatures exposing their rumps to arrows or to the tail ends of the script itself. One of these scenes even shows a figure with more than a passing resemblance to Christ preparing to take it in the butt, bending over to bare his backside to a spear-wielding, ostrich-riding monkey on the facing page (fig. 65).[87]

The significance of these images is contested but participates in a wider vocabulary of profanity and defamation: the ass-baring figure could be deploying a gesture of defiance against his simian attacker, or his impending penetration might be a sign of vulnerability and victimhood. Either way, depictions of bottoms being bared (sometimes with accompanying genitals) also turn up in other settings, such as misericords, or carvings on the interior or exterior of buildings. Such depictions do not necessarily have sexual significance. Camille

Figure 64. Male penetrating armed hybrid with pole or spear. Marginal scene in book of hours. French Flanders, possibly Cambrai, first quarter of fourteenth century. Baltimore, The Walters Art Museum, MS W.88, fol. 72v. Photo: The Walters Art Museum, Baltimore.

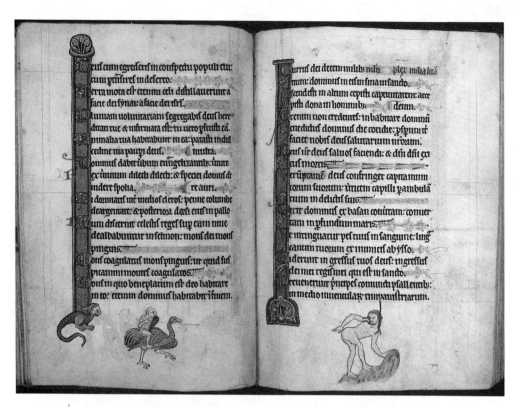

Figure 65. Man prepares to take it in butt. Marginal scenes in Rutland Psalter. England, circa 1260. London, British Library, Additional MS 62925, fols 66v–67r. © British Library Board.

quotes an interpretation by the physician and iconographer G. J. A. Witkowski (1844–1923) of a thirteenth-century bottom sculpture decorating the staircase that descends into the crypt of Bourges Cathedral, which the doctor characterized as belonging either to a "big-bummed Venus or a big-bummed German homosexual"; but he shows how Witkowski was deploying the new late nineteenth-century vocabulary of sexology and physiological science, whereas a medieval audience would not think to differentiate anuses physically in this way. In the Middle Ages, the sign of the anus functioned variously—depending on context and location—as an apotropaic device, as a motif of carnivalesque role reversal and the world upside down, or as a defamatory insult (as in the practice of "mooning"). But it operates in such settings primarily as a sign of power rather than vulnerability—an extension of the phallus sometimes seen extending from the bum-bearer's body.[88]

Sometimes illuminators depicted acts of kissing or worshiping the anus. Again, these acts do not necessarily have sexual significance, though sometimes allusions to illicit erotic practices are likely being made. A mid-fourteenth-century manuscript of the *Voeux du paon* (Vows of the Peacock), a poem about the Nine Worthies composed by Jacques de Longuyon around 1312, includes

among its sequence of marginalia a drawing of a tonsured male, all legs and no torso, baring his naked bottom to a man who kneels and prays at the altar of his partner's anal cleft (fig. 66). The worshiping figure sports a tall cross-inscribed hat or helmet; lying abandoned at his feet is a scourge similar to those used in religious acts of self-punishment. Marginal images elsewhere in the manuscript also depict individuals wearing similar headgear, engaged in acts such as raising a sword over the head of a kneeling monk, and holding or dropping a scourge; in some instances the helmeted figure is an animal or animal hybrid.[89] The cross-inscribed helmets worn by some of these figures may be a reference to headgear worn by the Knights Templar, a military order founded in Palestine around 1119 for the purpose of defending the newly created Latin kingdom of Jerusalem in the aftermath of the First Crusade. In 1307 the Templars in France were arrested by Philip IV and charged with heresy. Among other things they were accused of indulging in an illicit kiss (*osculum infame*) "on the mouth, on the navel or on the bare stomach and on the buttocks or the base of the spine," as well as permitting new brothers to have "carnal relations together" and saying that it was "licit" to do so. When similar charges were brought against the

Figure 66. Male (Templar?) worshiping at and kissing anus. Marginal image in manuscript of Jacques de Longuyon's *Voeux du paon*. Northern France or Belgium, possibly Tournai, circa 1350. New York, Pierpont Morgan Library, MS G.24, fol. 70r (detail). Gift of the Trustees of the William S. Glazier Collection, 1984. Photo: The Pierpont Morgan Library, New York.

Templars in England, one of the witness statements describes how, twenty-five years earlier, the man had overheard a member of the Hospitallers (another military order) calling the Templars "anus kissers," while another said the Master of the Templars in England "wished to seize him for sodomy."[90] In light of these accusations, the scene in the margins of the *Voeux du paon* manuscript showing the behelmeted male kissing and worshiping the hybrid monk's naked butt cheeks can plausibly be interpreted as a satirical comment on the sodomitical charges brought against the Templars.[91]

Almost a century beforehand heretics and unbelievers had similarly been depicted as anus kissers in the thirteenth-century *Bibles moralisées*: several commentary miniatures in Vienna 2554 and Vienna 1179 depict bearded males worshiping at or kissing a cat's mouth or anus.[92] One of these scenes, in Vienna 1179, comments on a miniature in the Judges 19 sequence in which the Levite's wife is raped by Benjaminite "Sodomites" (fig. 67): the medallion shows one of the men described in the accompanying text as "publicani" (publicans) kissing a cat on the buttocks, while he and his colleagues club to death a woman allegorically representing Philosophy, whose experience mirrors that of the raped woman in the biblical scene above. These depictions echo contemporary anti-heretical slanders describing heretics as cat or toad worshipers. In his treatise *Contra haereticos* (Against Heretics) Alan of Lille went as far as linking these stories to the etymology of the term "Cathar," which was applied to the heretical movements that sprang up in twelfth- and thirteenth-century Languedoc. Cathars are named after the cat, he cheekily observes, "because they kiss the posterior of a cat in whose shape, it is said, Lucifer appears to them."[93]

The motif of kissing ass—including animal ass—produces slander against both sexual and religious dissidents. The people doing the kissing become bestial, like the creatures they worship; or, as in the case of the anus-worshiping "Templar" in the margin of the *Voeux du paon* manuscript, they abandon the ascetic lifestyle they should be following in favor of lewd corporeal behavior. Anal penetration tends to humiliate those involved in different ways: whereas ass kissers willingly turn toward their improper objects, the possibility that penetrated males will be victimized, and thus rendered "passive" against their will, is always on the horizon in scenarios where individuals risk being poked in the behind. When the penetration is shown taking place rather than simply (as in the Rutland Psalter page opening) being threatened, it is more likely still to convey this element of victimhood. A singular scene illustrating the fabliau "Trubert," also cited by Camille, visualizes the moment when a swindler exacts a bizarre payment from the duke of Burgundy in exchange for a multicolored goat: the trickster demands four of the duke's anus hairs, which he proceeds to extract publicly from the payee's exposed rump. The accompanying miniature, which appears in a unique thirteenth-century manuscript of the story, shows

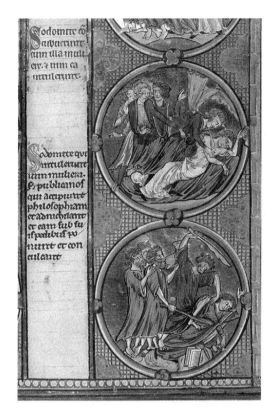

odomite co
arbuerunt
cum illa inult
cie. 7 uim ca
intuilerunt.

odomite qui
intuilerunt
cum muliea.
s. publicanos
qui accipiunt
philosophiam
eradnichilant
er eam sub su
is pedibus po
nuntt er con
culcant.

Figure 67. Judges 19.25; publicans abuse and kill Philosophy. Miniatures in *Bible moralisée*. Paris, circa 1220–25. Vienna, Österreichische National-bibliothek, cod. 1179, fol. 79v (detail, lower right). Photo: ÖNB Vienna.

the swindler preparing to insert a knife into the duke's anal cleft, thereby meta-phorically fucking him over (fig. 68).[94]

Other comic tales also drew on a comparable range of meanings. Chau-cer's *Miller's Tale* memorably climaxes with an episode in which the clerk and adulterer Nicholas sticks his "ers" out of the window and farts in an effort to humiliate his love rival Absolon. Seeking revenge on their mutual love inter-est Alisoun, who is spending the night with Nicholas rather than her husband John and who has previously offered her own naked "ers" to Absolon's kissing lips, Absolon requisitions a red-hot coulter (the blade of a plowshare), which he proceeds to plant on Nicholas's buttocks. In this particular scene, however, the humiliation is multilayered. Nicholas gets figuratively fucked by Absolon's fiery weapon, but Absolon himself mistakenly directs his tool at the wrong object (Nicholas, not Alisoun); or, as Genius in the *Roman de la Rose* would put it, he plows the wrong furrow, which effectively reorients his performance in a sod-omitical direction.[95] Additionally, of course, the violence of Absolon's actions (which entail a kind of pseudo-rape) conjures up the threats made by the bibli-cal men of Sodom against Lot's guests.

Edward II's murder following his imprisonment in Berkeley Castle, Glouces-tershire, in 1326 was reputedly accomplished by an act of anal penetration.

Figure 68. Swindler extracts hairs from anus of duke of Burgundy. Decorated initial illustrating *Roman de Trubert*. Third quarter of thirteenth century. Paris, Bibliothèque nationale de France, MS français 2188, fol. 5v (detail). Photo: Bibliothèque nationale de France.

Fourteenth-century chronicles describe how Edward's captors "passed a red-hot soldering iron through a trumpet-like instrument . . . into his anus, through the intestines and into his wind-pipe," or how he was "slain with a hot broche [spit] put through the secret place posterielle [posterior]."[96] Although his relations with male companions such as Piers Gaveston were idealized during the king's reign as bonds of intense friendship, ritually sealed with a covenant of brotherhood, chroniclers looking back on the king's reign suspected that this language was simply a cover for sodomy.[97] So the idea that he died as a result of anal impalement may be designed to imprint the sovereign's perceived sodomitical status onto his body.[98] For a poet such as Chaucer, writing several decades after the king's death, an allusion to the fate of England's most notorious high-ranking "sodomite" would surely have added an irresistible extra layer of meaning to the story of Nicholas's and Absolon's comeuppance.

Chroniclers of Edward II's reign and Chaucer could tap into a rich vein of iconography depicting sinners in hell or purgatory being penetrated or impaled, sometimes in sexually explicit ways. But writers and artists did not always single out sexual sinners for chastisement in infernal contexts; and when

they did the motif of impalement was by no means universal. The *Hortus deli-ciarum* (Garden of Delights), an encyclopedic manuscript completed in 1185 by Herrad of Landsberg, the abbess of Hohenburg Abbey in Alsace, and intended for the use of the convent's novices, included within its prolific cycle of min-iatures a Last Judgment sequence featuring a full-page depiction of hell. This includes, toward the left side of the uppermost register, two male sinners, en-tangled with serpents, one of whom is depicted touching his companion's chest with the palm of his right hand. Although the manuscript was destroyed dur-ing the Siege of Strasbourg in 1870, copies of this and other miniatures were made a few decades earlier, allowing us to appreciate the illuminator's vision (fig. 69).[99] The inscription above the sinners' heads quotes Isaiah 66.24, which warns that "their worm will not die, nor will their fire be quenched."[100] The same-sex couple appears between a man stabbing himself in the stomach, to the viewer's left, and a woman stroking her hair seductively, to the viewer's right; the latter, breastfeeding a snake, seems to be engaged in a futile attempt to seduce the same-sex lovers canoodling right in front of her.[101] Significantly these two sins, despair and lust, also appear together on the capital adjacent to the Ganymede capital at Vézelay (fig. 50), a scene sculpted a few decades before Herrad compiled her manuscript.

While the makers of the *Hortus deliciarum* deployed a visual language remi-niscent of the *Bibles moralisées*, which generally render same-sex eroticism intelligible through gestures such as caressing, kissing, and embracing, other artists focused on the pose and differentiated embodiment of the sinners. De-pictions of sodomites in manuscripts of Dante's *Inferno* tend to conform to this model, as discussed in detail by Camille.[102] Conversely, in Romanesque sculp-ture artists sometimes combined imagery of homosocial affect with scenes that possibly resonate in more sexually explicit ways. A capital in a gloomy area to the right of the altar of Saint-Genès, Châteaumeillant (Cher), which is part of a group of carvings in the church depicting virtues and vices, shows two bearded males who are apparently locked in an intimate embrace (fig. 70); the carving is captioned with the phrase HAC RUSTICANI MIXTI, which could translate as "Look, peasants mingling." In light of features such as the phallus-like object being grasped by one of the men at groin height and the menacing serpent to the right, Olsen and others have suggested that the pair represent male *luxuria* fig-ures, though the significance of the reference to *rusticani* is unclear.[103] My own examination of the carving confirms that the object identified by Olsen as an erect penis emerging from one of the men's tunics is actually a sickle-like im-plement, identical to the tool being wielded by the other man in his right hand, which implies that the pair may simply be engaged in a violent struggle, per-haps brought on by the sin of Anger. This does not entirely rule out a sexualized

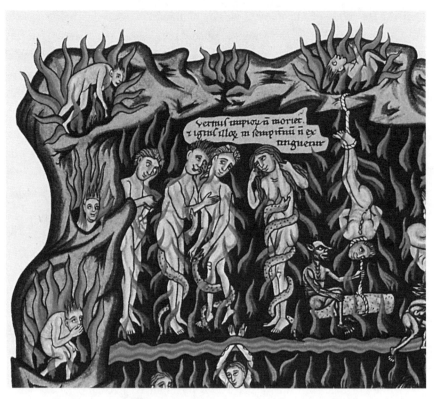

Figure 69. Punishments for despair and lust in hell. Detail from full-page depiction of hell in Herrad of Landsburg, *Hortus deliciarum*. Hohenburg Abbey, Alsace, circa 1176–96. From copy by Christian Moritz Engelhardt circa 1812. Photo: Bibliothèque nationale de France.

interpretation. Like Vézelay as discussed in chapter 4, Châteaumeillant was located on a pilgrimage route to Santiago. Carvings showing sexual exhibitionists or other scenes with a sexual significance seem to have been especially popular along these routes.[104] Moreover the tools or weapons carried by the fighting/embracing pair could be designed to make an allusion, obliquely, to the violence of sodomitic encounters, as conveyed in the story of Sodom in Genesis 19. It should be recalled that the Egerton Genesis, discussed in chapter 1, features a drawing (fig. 12) in which Sodomites appear to wrestle with one another prior to intercourse or attack beggars with sticks.

Whether or not the Châteaumeillant capital was intended to condemn sexual intimacy between males, other writers and artists drew attention explicitly to the violent and boundary-defying features of sodomy. These particular representations were also among the most obviously sexualized. The *Visio Monachi de Eynsham* (Revelation of the Monk of Eynsham), a text recounting a vision of paradise and purgatory experienced by a young novice called Edmund at the Benedictine house of Eynsham in 1196, describes several zones of purgatorial

torment including a place deliberately segregated from the others so that the only sinners who can access it are the ones already being punished or deserving punishment there. In the English translation published ca. 1483, this place is described as being unimaginably cruel: in a field shrouded in thick cloud, worms, with "onspekable" devouring, tear the sinners to pieces, after which they are liquefied in flames by devils, before being reconstituted and tormented again, in an interminable cycle of violence. The rhetoric of unspeakability bespeaks the nature of the sin being chastised: the punishment is directed at the "vnclene and foule vyce and synne of sodemytys."[105] Furthermore one torment the sodomites are forced to undergo is described as being more awful and humiliating than all the others. Edmund explains how certain great monsters, "onnaturally shapyne," violently set upon them and, "in a fowle damnable abusion," compel them to "medylle" with them against their will.[106] The English word "medylle," which translates the Latin *permisceri* (to be intermingled, thrown into confusion), is a form of the verb *medlen*, meaning "to blend, mix together,

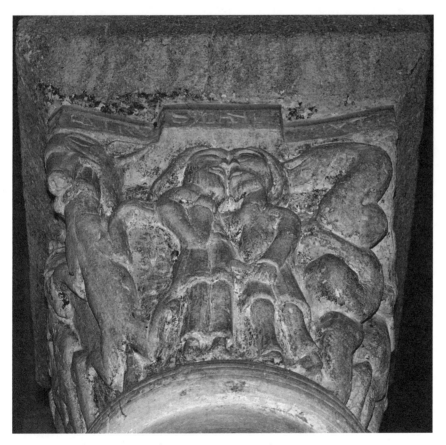

Figure 70. "Hac rusticani mixti" (Look, peasants mingling). Carved capital, twelfth century. Saint-Genès, Châteaumeillant (Cher, Centre). Photo: Robert Mills.

mingle, become confused with," but it can also be used explicitly in the sense of sexual mingling.[107] In several manuscripts of Alan of Lille's *De planctu Naturae* sodomites are described as people "qui . . . inuicem se commiscent" (who mingle with one another), which echoes the *Visio's* imagery of mixing and miscegenation.[108] The monk's *Visio*, then, visualizes sodomy as a blurring or "meddling" of the boundaries differentiating monster and sinner as well as evoking the exchange of sexual fluids associated with sodomitic acts. The violence deployed by the monstrous meddlers also conforms to the mob violence of biblical Sodomites, so that sodomy is presented as an act of rape.

Although the motif of monstrous meddling was not an especially common theme in medieval art, there is a scene on the carved frieze of Lincoln Cathedral (fig. 71), roughly contemporary with the monk of Eynsham's twelfth-century vision, which shows two naked figures, positioned so that one faces the other's backside in a parody of anal or interfemoral intercourse. A large horned or big-eared demon perches on the victims' backs and pulls at their hair as he wraps his legs around their groins, while serpents coil around the sinners' limbs to the left and right. A replacement panel carved as part of the recent restoration brings out these details very clearly (fig. 72). The scene is juxtaposed with another to the left representing a more standard depiction of *luxuria*: a man and woman are shown being separated from one another by monsters, two of which chomp on their genitals; the pair are likely being punished for adultery. To the right a man is chastised for avarice, as indicated by the moneybag around his neck, while a monstrous creature also attacks his groin. George Zarnecki has identified the sinners whose hair is pulled as a pair of males, who "presumably thus suffer punishment for sodomy."[109] Also contemporary with the Latin *Visio* is a sculpture in the cathedral cloister of Girona (Catalonia), which depicts three men in an infernal cauldron, flanked by a pair of devils who sodomize two men *in terga*, who are bordered in turn by *luxuria* figures to the left and right. Olsen has made a case for viewing the Girona sculpture as drawing on a comparable image bank to the monk's vision of sodomy-performing monsters.[110]

Echoing these ideas, William Dunbar's "The Dance of the Seven Deadly Sins," a Middle Scots poem probably dating to the opening decades of the sixteenth century, imagines embodiments of the sins dancing together in a sexualized fashion for Mahoun (the Muslim prophet Mohammed and here a synonym for Satan). Lechery, who enters the scene like a "bagit hors" (pregnant horse), leads along "Lythenes" or Wantonness with him, and the pair are described as conjoining "tersis" (penises) with "ersis" (asses), which they proceed to "fycket" (fuck/fidget with) like red-faced "turkas" (Turks/red-hot tongs). The word *fycket* is a variation on *fukkit*, meaning "fucked," which appears elsewhere in Dunbar's poetry and is one of the earliest written records of the word.[111] Lechery's depiction

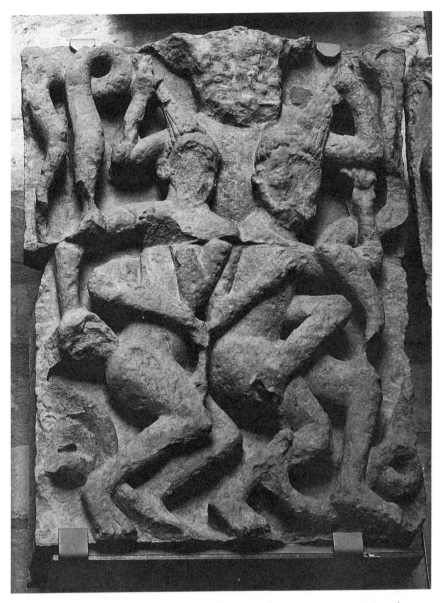

Figure 71. Punishments for sodomy. Panel from limestone frieze, circa 1145–55. St. James's Chapel, Lincoln Cathedral (formerly on west front). Photo: Robert Mills.

as an expectant horse, fertile with lust, plays on the feminization of desire encountered elsewhere in texts such as *Ancrene Wisse*, but it also conveys sodomy's feminine and feminizing characteristics; the reference to the sinners going at it like "turkas" is a pun conveying their foreign, Turk-like countenances as well as their twisted, red-hot passion. Meanwhile the poem's evocations of ass fucking betray a more narrowly circumscribed range of meanings.

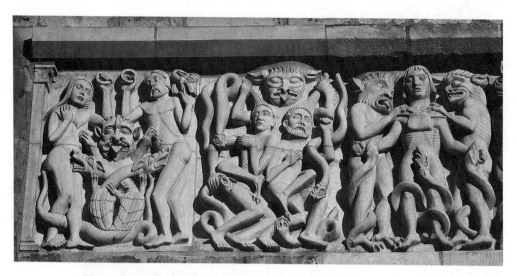

Figure 72. Punishments for adultery, sodomy, and avarice. Panels from the restored limestone frieze, installed 2001. Sculpted by John Roberts and Alan Mickelthwaite. West front, Lincoln Cathedral. Photo: Robert Mills.

In Last Judgment tympana above the doorways of medieval churches, sodomitical allusions are fairly uncommon, but the west façade of Bourges Cathedral—site also of the bottom sculpture in the crypt—features, among the sinners being pushed into the infernal cauldron, a reference to anal touching or penetration (fig. 73). A naked, mitered male is laid out on his back, while a figure behind him appears to be placing a hand between the bishop's buttocks; Camille cites the carving as one of the earliest recorded images of "fist-fucking," though the wrist is still clearly visible. Meanwhile at the far right of the scene the sculptors have endowed a demon operating a pair of bellows with oversized genitalia and a grinning face instead of an anus.[112] Bourges was also the capital of Jean de Berry's territories in Burgundy: the anonymous Parisian poem cited in the introduction, which imagines Jean being eternally fucked in hell by a thousand demons, in recompense for the duke's penchant for luxury in life, prescribes for the duke a penetrative penalty not dissimilar from that of the damned bishop on the tympanum.[113] Sharing the bishop's horizontal positioning, but taking his humiliation to a new level, numerous other infernal sinners are roasted on spits, penetrated from the anus to the mouth. These scenes turn up quite frequently in Italian Last Judgment paintings and mosaics, but also feature in manuscript illuminations depicting hell.[114]

Before we analyze one of these scenes in depth, it is worth considering the gender of the individuals thus punished: although the act of penetration arguably genders them differently in the context of their torment, the sinners in

question are invariably male. Very occasionally women accused of unnatural passions do turn up in visionary texts. In his discussion of the "synne of sodemytys," the narrator of the *Revelation of the Monk of Eynsham* expresses complete surprise when confronted with the possibility that women, too, might engage in the practice. Confessing that he had forgotten Paul's words in Romans 1.26–27 concerning the "synne agaynest nature bothe of men and wemen," the visionary states: "I neuyr herde before nether hadde any suspycyon hethirto that the kynde of wemen hadde be deprauyd and defoyled by such a foule synne." Echoing the lesson in Caxton's almost contemporary moralized Ovid, which, as we saw in chapter 2, displaces gender-disruptive sex acts between women onto "ancyent tyme," the narrator also makes a concerted effort to project female sodomy onto a distant past. If, in biblical times, the apostle found it necessary to condemn the vice, "nowe in tyme of Crystendame" he could not "in any wyse haue be-leuyd that suche a foule synne and vyse myght haue be presumed and done, specyally of wemen, the whyche naturelly schuld be more schamfull thenne other."[115] The expression of incredulity in these lines performs a rhetorical function. Expanding the original monastic vision, which makes only

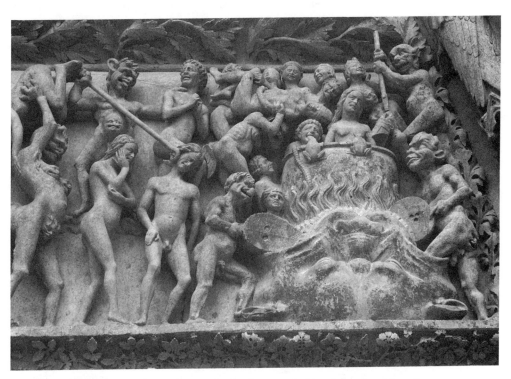

Figure 73. Torments in hell, including mitered bishop being pushed into infernal cauldron. Detail from Last Judgment tympanum, circa 1270. West façade, central portal, Bourges Cathedral. Photo: Robert Mills.

passing reference to female sodomy, the English translator makes a concession to the mixed audience of the fifteenth-century printed edition, which would have included lay people, by supplementing the text with a lengthier statement directed specifically at women.[116] No precise punishments are dreamed up for these women who sin against nature, though the narrator goes on to say that he does indeed find a large "company of suche" in the same location as the male sodomites. This belies his previous statement regarding the difference between then and "nowe," thereby further enhancing the shock value of this particular "revelation."

The Sodomites of San Gimignano

Scenes showing male sinners being impaled through their anuses potentially bestow some specificity onto the proceedings by alluding to sexual intercourse through motifs of cooking and penetration. While these depictions may not always have been designed to represent punishments for sodomy, occasionally we have incontrovertible evidence that they were. I will turn my attention, in this concluding section, to one such image, probably the best known, which appears in the *Last Judgment* fresco (ca. 1393–1413) by the Sienese painter Taddeo di Bartolo in the Collegiata, San Gimignano. The scene depicts, among a group of sinners who are guilty of lust (under the heading LA LUSSURIA), a male couple who possess labels identifying their sins (figs. 74 and 75). One of the sinners is seated with his legs crossed, as flames lick his exposed genitals. A serpent coils around the lad's upper torso, and an inscription to the left of his head designates him CATIVO.[117] In Italian this word shares the same semantic range as the English term "caitiff," which originally denoted a captive but later came to signify someone deemed vile, base, or wretched.[118] Significantly Boccaccio's tale of Pietro di Vinciolo of Perugia, the tenth story of the fifth day of the *Decameron*, which describes Pietro's sexual indifference to women and his erotic preference for young men, refers to Pietro as "il cattivo uomo" (the caitiff man/husband); here Boccaccio is clearly applying the term to a man possessing sodomitical leanings.[119] The mouth of the sinner in the painting is penetrated by a rod, which emerges from the mouth of the male to the right. This second sinner is laid out on his back; the rod that exits the second sinner's mouth enters his body via the anus, and it is inserted by a bearded, blue-colored demon, who holds the other end at groin height. Meanwhile a second devil applies pincers to the skewered victim's feet, which are bound together by some kind of cord; a third, winged demon stoops down to apply another instrument of torture (perhaps oil or hot wax) to the belly of the sinner, who responds by rolling back his eyes. This gesture draws attention to the label on the victim's head: a miter bearing the legend SOTOMITTO, which presumably refers to his status as a sodomite.

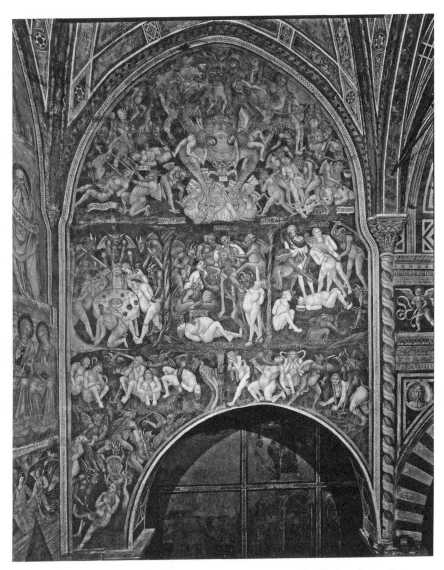

Figure 74. Taddeo di Bartolo, *Hell*, circa 1393–1413. Fresco in nave of Collegiata di San Gimignano. Photo: Duccio Nacci, © Parrocchia di Santa Maria Assunta di San Gimignano.

The skewering motif in the San Gimignano fresco clearly alludes to anal penetration, while the reception of the rod by the sodomite's blond-haired companion surely makes an analogy with fellatio. However it is not simply a case of one-to-one correspondence between text and image. *Sotomitto* conflates two other words, *sodomito* (meaning "sodomite") and *sottometto* (meaning "I submit"), underscoring the punished sinner's status as a person who submits, while the term *sotto* (below) is also a euphemism for anus.[120] The motif of sexualized penetration also appears elsewhere in the painting, in a scene in the bottom left-hand corner: this features a grimacing demon thrusting a stake

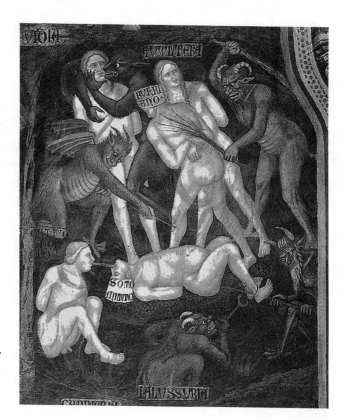

Figure 75. Punishments for lust, including sodomy, adultery, and seduction. Detail from Taddeo di Bartolo, *Hell*, circa 1393–1413. Fresco in nave of Collegiata di San Gimignano. Photo: Duccio Nacci, © Parrocchia di Santa Maria Assunta di San Gimignano.

menacingly into the pubic region of a long-haired woman, who faces her assailant with a look of horror (fig. 76). The sodomite, thus participating in the sexually submissive scenario assigned elsewhere in the painting to women, is also feminized by his very posture: he gets flipped on his back, just like the sinful bishop of Bourges, and eternally "fucked" by the demon's hot rod.

As in other texts and images discussed in this book, gender and age are important factors in rendering sodomy intelligible to the viewer. Michael Rocke's statistical analysis of sodomy prosecution records in fifteenth-century Florence, where a special judicial commission called the Ufficiali di Notte was set up specifically to root out and punish sodomites, has demonstrated that male same-sex encounters in this region were predominantly structured by age and sexual role; moreover adult men who assumed insertive roles in acts of anal or intercrural copulation with younger, sexually receptive males often also engaged in penetrative sex with women. In fact in Florentine legal contexts the epithet "sodomite" was normally reserved only for those males who adopted the position of phallic inserter; the receptive partner (whether female or adolescent male) was almost never referred to in this fashion. Moreover those who performed fellatio on a subordinate male retained their "active" status despite

being the insertee rather than the inserter; the younger male's perceived receptivity was ultimately what counted here.[121] Given San Gimignano's geographical proximity to Florence, these models may have exerted an influence on the painting in the Collegiata: in a manifestation of *contrapasso*-style justice, the artist depicts a wholesale reversal of the scenario conventionally assigned to sodomitical relations in life. Active has been turned into passive; it is the figure labeled "sodomite" who undergoes the humiliation of demonic anal rape (underscored by the pun with the verb *sottometto*). Meanwhile the youth named as a CATIVO now assumes what was perceived to be the more "active" role in the performance of oral sex, by taking the devil's penal instrument into his mouth and thereby becoming the fellator.

Another element reinforces this dimension of role reversal: it seems likely that the figure labeled SOTOMITTO is being equated with cooked meat, slow-roasted for eternity on a spit. The culinary significance of the motif comes across especially clearly in the two images that present the closest analogues to this painting: the mid-fourteenth-century *Last Judgment* on the south wall

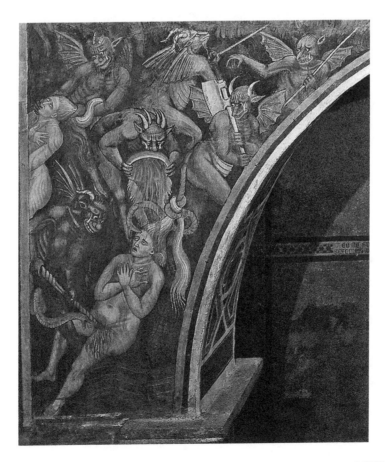

Figure 76. Infernal punishments, including female penetration. Detail from Taddeo di Bartolo, *Hell*, circa 1393–1413. Fresco in nave of Collegiata di San Gimignano. Photo: Duccio Nacci, © Parrocchia di Santa Maria Assunta di San Gimignano.

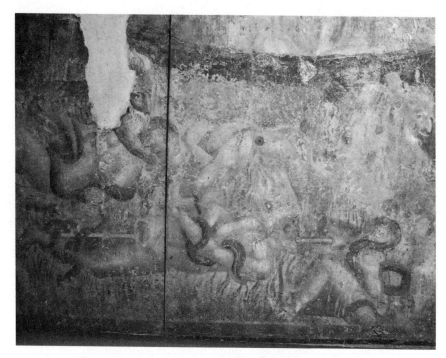

Figure 77. Punishments for lust. Detail from Buonamico Buffalmacco (?), *Last Judgment*, circa 1332–42. Fresco on south wall of Camposanto, Pisa. Photo: Robert Mills.

of the Camposanto, Pisa (fig. 77), usually attributed to Buonamico Buffalmacco, and Giovanni da Modena's fifteenth-century inferno in the Bolognini Chapel of San Petronio, Bologna. Both paintings depict naked male sinners being turned by a devil on implements that resemble the equipment traditionally used to cook animal carcasses over a fire; although one end of the spit enters the mouth of another male sinner, it also rests on an upright support, a mechanism that recalls medieval rotisseries.[122] Depictions of lone figures being cooked on spits by demons also feature in the thirteenth-century *Last Judgment* mosaic in the Baptistery, Florence, and in Giotto's fresco of the same subject in the Scrovegni Chapel, Padua (ca. 1303–5).[123] Although none of these depictions feature labels identifying the impaled figures as sodomites, a spit-roasted male exhibiting close parallels to Giotto's rendition of the motif features in a late fourteenth- or early fifteenth-century *Inferno* in the crypt of the church of San Francesco, Leonessa (Lazio), revealed during a recent restoration, which includes the legend "Sodomito" in a sign above the sinner's head.[124] Thus Taddeo di Bartolo's painting is not the only surviving example to identify the sodomite verbally.[125]

Further elements in the San Gimignano scene contribute to the culinary symbolism: the winged devil pouring a substance onto the sinner's belly may well be seasoning the roast or giving it a good basting, implicitly prior to serving

it up as a tasty morsel for Satan, who is depicted stuffing sinners into his mouth in the top register of the fresco (fig. 74). What is more, a dramatic *lauda*, written in Perugia around the time that the Pisa fresco was painted, makes explicit reference to the culinary processes that the sodomite undergoes, even specifying the kind of meat with which he is being compared. In the poem's final verse, the culmination of a Last Judgment sequence in which the punishments inflicted by Satan and other devils are described, a demon named Zabrin is called upon to follow a recipe for roast piglet. The relevant lines read as follows:

> Sodemite maledette
> che pecchevate contra natura.
> rostite a guisa de porchette!
> Zabrin, si aggie quista cura,
> fa encender bien lo forno
> e volta bien l'arosto atorno.[126]

[You cursed sodomites, who have sinned against nature, roast like suckling pigs! Zabrin, let this remedy be followed, fire up the furnace well and give the roast a good turning.]

Significantly the plural form *sodemite* in this verse possesses a feminine ending, which seems designed deliberately to place emphasis on the sodomite's perceived gender disposition during his transformation into cooked meat. The word *arrosto* also had particular associations with sodomy, stemming from a symbolic opposition between boiling and roasting, wet and dry; roasted meats sometimes figured in Italian erotic verse as a signifier for anal intercourse.[127] Moreover the allusion to pork presumably draws some of its significance from long-standing associations between pigs and sensual excess, a resonance that would be especially pertinent in this context. William of Auvergne, in his penitential, explicitly compares practitioners of unnatural lust to pigs; Bernardino of Siena—who publicly preached against sodomy on numerous occasions—makes an analogy in one of his sermons between three varieties of swine and what he perceives as three different varieties of sodomy.[128] Here, surely, Foucault's distinction between the sodomite as a "temporary aberration" and homosexuality as a "species" loses some of its salience.[129]

To my knowledge there is just one reference in Italian sources to spit-roasting as a punishment outside the realm of infernal fantasy: a report in a late thirteenth-century Florentine chronicle, which describes how Charles of Anjou (Charles II of Naples), on the way to the papal court in Rome with his son Charles Martel in 1293, arrested a certain "count of Acerra" (Adenolfo IV d'Aquino) "per certa malivolglenza che lli portava sacretamente" (through a

certain animosity which he secretly bore against him) and accused him of being a "soddomito" (sodomite). The source of the king's secret hostility against the count is unclear, but the punishment to which he is subjected is described matter-of-factly: "uno palo li fece ficcare per la natura disotto, ed ispicciolli per la bocca, e come un pollo il fece arostire" (a stake was thrust through his lower nature [i.e., anus], and out through the mouth, and he was roasted like a chicken).[130] While corporal punishments including death by burning were imposed by a number of secular judiciaries in medieval and Renaissance Italy, in Florence itself the penalty was often simply a fine—a pattern that led to a much higher conviction rate—and there is no evidence that officials systematically punished sodomites in the guise of chickens or pigs.[131]

The penalty inflicted on the pair of sinners in the San Gimignano fresco, which bears witness, through a process of dramatic reversal, to the illicit sex acts being chastised, also characterizes sodomy as a vice in which the participants assume clearly delineated roles. On the one hand is the "active" sodomite, who, for the crime of fucking boys on earth, gets figuratively fucked over and feminized in hell; on the other hand is the naughty "passive" blond, whose penalty puts him in a more instrumental position (at least, to the extent that he takes the spit in his mouth; the apparent binding of the youth's hands continues to emphasize his submissiveness). Crucially, because the scenario takes place in hell—a space where the damned will suffer torment without end—the sinners are confined to these roles eternally. Their very beings are inscribed by the acts they suffer or perform, by virtue both of the infernal punishments themselves and of the sex acts to which the torments parodically refer. Peter Damian and Paul of Hungary describe how the inhabitants of Sodom were not only burned alive in this life, with fire from heaven, but also cast into the flames of hell to be perpetually punished.[132] They repeat here an idea found in the biblical epistle of Jude, cited also by Peter the Chanter in his *Verbum adbreviatum*, which describes how inhabitants of Sodom and Gomorrah suffered the punishment of eternal fire for giving themselves over to "fornication" and "going after other flesh" (Jude 1.7). The Perugian *lauda* in which sodomites are compared to roast piglet emphasizes this dimension of endless temporality by including the motif of turning on the spit ("volta bien l'arosto atorno"). The topos of the sodomite being penetrated for eternity in hell, in a kind of perpetual action-replay of his sin, also finds a parallel in the *Songe véritable*, which expresses a desire to see Jean de Berry have his backside scorched endlessly in hell. Sodomy in these texts becomes a practice for which individuals have an enduring taste or proclivity, a vice localized in certain parts of the body and entailing particular gendered and corporeal consequences; it is precisely this dimension of suspended temporality that potentially endows the Collegiata fresco with a performative dimension, the effect of which is to construct the sodomite as a preestablished

social type. Caught in the act, as it were, the sinner labeled sotomitto becomes fixed in his sexual role for all eternity, defined—in reverse—by the very sexual practice for which he has been condemned.

In what sense, though, could it be argued that the activity represented constitutes an orientation? As discussed at the beginning of this chapter, modern, Western understandings of "sexual orientation" have been rejected by many historians of sexuality as too time-bound to accommodate the diverse and often contradictory frameworks through which same-sex relations come into view in premodern Europe—frameworks variously inflected by gender, age, race, religion, social status, and style. It is true that the San Gimignano fresco's depiction of the sodomite does not map neatly onto the idea of homosexual orientation as mode of being defined primarily by same-sex desire; if there is a sense in which orientation is something that the sodomite can be said to "have," it is not the sex of his chosen object so much as the sexual activity with which he is associated (and which he suffers in reverse, as a mode of gendered role inversion) that orients the viewer's understanding of his sinful essence. Moreover post-nineteenth-century concepts of homosexual orientation are also sometimes combined with notions of a distinct appearance or physiology, which draw, in turn, on a tradition going back to ancient times in which effeminacy is marked on the body or treated as a medical condition.[133] In 1908 the German sexologist Iwan Bloch (1872–1922), who among other things is credited with discovering the manuscript of the Marquis de Sade's *The 120 Days of Sodom*, attributed to homosexual men a "considerable deposit of fat, by which the resemblance to the feminine type is produced, the contours of the body being more rounded than in the case of the normal male."[134] This trope of ambiguously gendered physiognomy and corporeal norms does not seem to have strongly shaped the depiction of the sodomite in the San Gimignano *Last Judgment* scene. Although the figure labeled cativo has a distinctive hairstyle, possibly intended to convey effeminacy as well as youth, other visible marks of corporeal difference are absent: the pair's curvaceous figures mirror the plump bodies of many of the other sinners in this depiction of hell, and they are not really set apart aesthetically. If, by "homosexual," we have in mind a variety of identity defined by an overriding preference for same-sex objects, and conditioned by certain modes of dress, deportment, gesture, or corporeal style, it may well be misleading to regard the San Gimignano scene as depicting the "punishment of homosexuals," even though superficially the sinners in question are two males.

As the continuing importance of the inversion topos in modern experience demonstrates, however, sexual orientation may also be said to encompass much more than the direction of one's sexual object choice toward one sex or the other. As Ahmed has cogently argued, sexual orientation can also be viewed as a metaphor for how, in contemporary contexts, people get directed toward and

"face" the world they inhabit. While Ahmed's definition of what she calls "queer orientation" relies on modern ideas of normativity and "straightness," I'd like to twist her questions in the direction of the spit-roasted sodomite. By positing orientation as a process of "arrival"—a process in which one is to various degrees "in line" or "out of line"—Ahmed bends the category in the direction of an understanding that views sexuality not simply as a field of love objects, but also as a network connecting bodies, objects, and spaces.[135]

So how are the sodomites in medieval Last Judgment scenes oriented? In a very basic sense, the object toward which they are oriented—and that fundamentally orients them—is the spit. On the one hand, the spit itself functions as an orienting instrument: the sodomitical body, gendered slantwise, is also compartmentalized, stuck in a particular temporal and spatial moment. On the other hand, the sodomite faces his world upside down and out of line; his horizontal alignment also stands in contrast to the alignment of many other sinners in the painting. Thus the penetrated victim's orientation—a facing-the-world that is at once both forced (the demon rapes him with the rod) and chosen (his transgression is a question of will rooted in the soul's responsibility)—has the effect of reclassifying him as a particular variety of sin identity. The man is positioned as an inverted, feminized piece of meat, his regendered status conceived in terms of its alignment and its directional capacity. The arrangement cements the sinner's identity as a sodomite, thereby keeping in check some of the wonkiness that his body threatens to expose. If this does not make him sexually oriented in the narrow sense of same-sex object choice, motifs of orientation and disorientation nonetheless frame the painter's vision. Ahmed takes inspiration in her argument from theorists such as Butler and Pierre Bourdieu, who highlight the extent to which bodies take the shape of repeated actions and gestures, which imperceptibly, over time, *become* the identities from which those enactments appear to spring.[136] Rather more obviously, sinners in hell are shaped and positioned by their actions, which double as their punishments, taking the shape of objects around which they tend. The man named SOTOMITTO is reduced to a single essence, sodomy, which points back to his unitary identity as a sodomite.

The concept of orientation can also bring into focus the sodomite's twisted relationship with other objects and bodies. In the zone to the left, among the avaricious, another male sinner has been laid on his back in an almost identical pose to that of the sodomite. This time, however, instead of inflicting anal penetration, a devil excretes gold coins into his mouth—a punishment for the crime of usury (fig. 78). Monetary imagery also turns up in other contexts as a metaphor for sterile sexual activity. In *De planctu Naturae* Alan of Lille compares sexual intercourse to the minting of coins (1.27), characterizes Nature as the mistress of God's mint (8.225), and presents deviations from the natural order

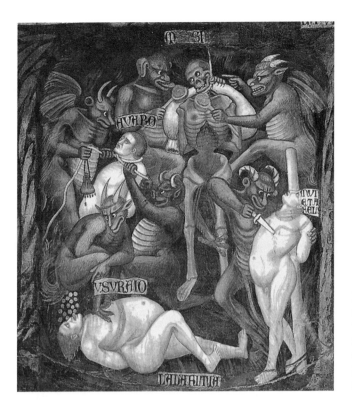

Figure 78. Punishments for avarice, including usury. Detail from Taddeo di Bartolo, *Hell*, circa 1393–1413. Fresco in nave of Collegiata di San Gimignano. Photo: Duccio Nacci, © Parrocchia di Santa Maria Assunta di San Gimignano.

as an act of fraudulent counterfeiting (8.227–28).[137] The Lincoln frieze puts punishments for sodomy side by side with those for avarice, and the San Gimignano arrangement also echoes Dante's *Inferno* (11.46–51), which juxtaposes sodomy and usury as crimes that together scorn nature—possibly a source of inspiration for the San Gimignano painter. Additionally, the association finds legal justification in Alfonso X of Castile's *Siete partidas*, which singles out usurers and those who commit the "sin against nature" as being comparably infamous.[138] These analogies hinge on the fact that both categories of sin involve illicit forms of consumption: while usurers engage in unnatural economic consumption, sodomites and their partners ingest semen unnaturally with their bodily orifices. According to the inverted logic of the fresco, however, the orientations of usurer and sodomite are also fundamentally opposed. Whereas the usurer is oriented toward a sterile object (money), which he attempts to render nourishing through loans at interest, the sodomite is oriented toward a productive substance (semen), which he renders sterile through its reception in the anus or the mouth. In both cases, the orientations are "failed," in the sense that they lead precisely nowhere. Bodies deploy objects that do not extend their ability for reproduction or action in the world, except as containers for shit.[139]

This vision of sodomy as a failed orientation—a tendency that projects sexual activity back onto the sodomitical body as a form of sinful, unreproductive essence—was symptomatic of a general tendency in late medieval theology and pastoral care to imagine sodomites as a separate people or race.[140] Rocke's analysis of legal records in Florence demonstrates that in everyday judicial practice a minoritarian understanding of sexual identity did not predominate for the most part. Although those convicted of sodomy sometimes earned the label "sodomite," the tendency to fine rather than to maim or execute enabled the perpetrators to be reintegrated tacitly into Florentine society; sodomy was normally viewed as a temporary transgression to which all males were potentially prone, rather than as a life-defining trait, an understanding that tended to work against minoritarian, identitarian conceptions. Yet in some respects the pragmatic, universalizing viewpoint adopted by legal bodies was in tension with moral, church perspectives, which also sought to make an identity of the sodomite—to orient him as a sinful subject—by characterizing sodomy as a more enduring kind of practice, a vice for which a person has a particular disposition, tendency, or taste.[141] Such perspectives developed unevenly, over long periods of time, and sodomy was troubled from the moment of its inception by fundamental inconsistencies and confusions. Nonetheless there are signs that some medieval thinkers, especially after the eleventh century, wished to pin the sin down to particular bodies and selves. It is precisely this sense of sodomy as a form of moral orientation and "turning toward" that structures the San Gimignano fresco's vision of sodomitic being.

In this particular context the sodomite's appetite for unnatural sex cannot be said to stem from pathology or psychological aberration. Rather, it concerns his tendency toward sin, which is an orientation every fallen human can be said to share. Although medical considerations could sometimes be attached to sodomy in natural philosophy, for the most part theologians blamed practices of this sort on the sinner's weak will, which put him or her on the wrong moral course.[142] In the Christian Bible the Greek word most frequently used to denote sin is ἁμαρτία (hamartia), a noun derived from the verb ἁμαρτάνειν (hamartanein), meaning "to miss the mark" (as in a spear failing to hit its target). This ambiguous term, used by ancient philosophers such as Aristotle to refer to wrong actions committed in ignorance or error, is taken up in the New Testament, especially by Paul in his letters to the Romans, as a means of describing those who have wandered in error from God's laws.[143] Sin is thus, at base, an essentially spatial concept, rooted in notions of deviation and disorientation. The sin identities that medieval artists and writers imagined taking shape in hell, which represent sin as a permanent aspect of personhood, enacted repeatedly for all time, are presented as permanently disoriented modes of being. They

reveal the twisted, slantwise directions humans will inevitably take if they fail to channel their desires along a more virtuous path.

So we need to be wary of collapsing theological notions of sodomitic sin identity into late nineteenth-century ideas of the homosexual. My argument is not that the San Gimignano sodomite possesses an orientation that is "homosexual" or even "protohomosexual" in the senses in which those terms are often used today. Twentieth- and twenty-first-century identities organized around protest and pride, which emerged partly in response to these pathologizing, minoritizing perspectives, contrast with premodern notions of sodomy as a fluid and disorderly category of carnality. Yet the concept of orientation, redefined as the process by which bodies and objects are shaped by repeated and habitual actions, and in so doing assume particular directions toward one another and away from others, may help articulate dimensions of this painting that cannot simply be understood with recourse to fantasies of premodern Europe as an identity-less utopia—an era in which acts alone defined one's sexual status. Illicit sex acts are the target of this infernal scene, but they also coalesce into a particular vision of sodomitical being. The male sodomite is presented as someone whose desires are directed toward a particular orifice (the anus) and sex object (the young "cattivo"), in a precise direction (horizontal and upside down), around a specific device (the spit), and in accordance with a designated role (feminized passivity). In these senses, I am suggesting, the San Gimignano sodomite is sexually oriented, which is to say he is spiritually disoriented: his actions shape his body and his world.

CONCLUSIONS

The last chapter brought together two very different conceptions of directional desire in medieval Christianity. At one end of the spectrum was the enclosed virgin, hidden within her cell and consciously striving not to stray from the straight and narrow; at the other was the equally constricted sodomite, forced to turn perpetually on his spit in an extravagant display of disoriented movement that confirms his willful departure from natural law. In each instance, the orientations in question construct a space for action, which places some objects and not others within reach. For the female anchorite, that space becomes an internal battleground for the virgin's will, as she fights it out against the temptations constantly threatening to drive her off course. But her desires can always be channeled toward a different object, the heavenly lover, to whom we all, in fact, should tend. For the male sodomite, this space is one of external punishment and humiliation, which imprints his unspeakable desires spectacularly on his body. His desires, stimulated only by the wretched lover-boy with whom he has been paired, follow a path we should be aiming constantly to avoid. The spit extending from the sodomite's anus to the mouth of his lover maps this line and makes it into a permanent mark of identity. These two figures—anchorite and sodomite—are thus literally "poles" apart. One is directed toward an upright cross; the other spins on a horizontal spit. And yet, as anchoritic guidance texts reveal, sometimes even these positions can become

confused. Even the female solitary might find herself straying into the disordered universe of sins against nature if she fails to hold the line.

The foregoing analysis also highlights the potential benefits of comparing male and female sexualities, and the languages used to describe them, rather than treating them each simply as representative of separate spheres. Gender and sexuality were mutually constitutive concepts in the Middle Ages—an obvious enough point, I think, but perhaps not one that has been given sufficient weight in research organized along more gender-segregated lines. Projects such as Lochrie's, which aim to rescue female sexualities from the Middle Ages as well as from the heteronormative presumption of modern culture, helpfully draw attention to discourses where sex acts and desire were clearly gendered and gendering, while not assuming that these modes of doing gender correspond to "heteronormativity." My argument, too, has been that *sodomia*, the *crimen nefandum*, sins *contra naturam*, and other related concepts are not opposed to heterosexuality in medieval texts and images, or at least not a heterosexuality that conforms fully to modern understandings; other binaries—notably the division between chastity and its others—are much more readily discernible in the period's encounters with sex.

This book has also kept in focus those moments when gender deviance does or does not play a part in sodomy's entry into the field of vision. In order not to flatten out the gender dynamics of medieval sexuality—suggesting that, for example, every expression of deviation from the "straight" path registers something that could be called homosexuality—I opened my analysis with an image of cross-dressing that feminizes its subject, Jerome, and temporarily humiliates him in the process; but the effeminacy the saint is forced to endure registers the essential femininity of *all* sensual experience following the fall. Ideas of effeminacy were not necessarily or only applicable to a particular sexual minority, in other words. According to theologians any experience that did not lead to God potentially put people on the road to hell; the devil was, in medieval Christian terms, the ultimate sexual predator, constantly seeking out opportunities to drive humans off the proper course. This is why in some medieval texts and images devils even act like Sodomites, variously raping, sodomizing, or "meddling" with their victims.

Lochrie is also right that we sometimes need to look "beyond sodomy" if we want to discover permutations of sexual desire, embodiment, and eroticism that transcend the invisibility supposedly accorded to female sexualities in the Middle Ages.[1] "Sodomy" is a handy coin for communicating the subject matter of this book, a term with a discernible pattern of deployment in the period; but the word is simultaneously too narrow and too imprecise to capture the full range of phenomena discussed. Some of the *Bibles moralisées* refer to Sodomites, the practice of sodomitry, or the sins of Sodom by name; but they

may also visualize sexual practices such as homoeroticism, sexual violence, or age-differentiated desire without any specific textual label identifying them as such. Sodomy in these manuscripts, and in other texts and images explored in this book, is always encountered as an experience in translation, whether between media, languages, cultures, or time frames.

Another, thoroughly *un*medieval term that can, I think, be broad enough in its range to be usefully—if cautiously—applied to medieval examples is transgender. This and associated vocabularies can help bring into focus dimensions of premodern experience governed neither by heteronormativity nor by a framework in which sodomy—viewed narrowly as a byword for "same-sex" activity and power play—is applicable only or predominantly to a male sexual minority. Scholars working in other periods, too, have warned against the dangers of what the classicist James Davidson terms "sodomania"—an obsession that, in Davidson's estimation, stresses the physical aspects and power dynamics of "Greek love" at the expense of its emotional and reciprocal dimensions.[2] There is obviously no value in looking at the world only through male, sodomy-tinted glasses, or focusing only on female sexualities or affects insofar as they intersect with words and concepts originally developed by and for men. That said, it is still important to keep in view locations where sodomitical frameworks were applied to Christians regardless of their social gender. Virginity is a place where, in the Middle Ages, these anxieties sometimes coalesced. Desire that does not lead to God always has the potential to be feminizing, whether the subject is male or female, which is why even Orpheus, lover of boys, had to be allegorized as acting *viriliter* in certain Christianized appropriations of his legend. Because his turn to male youths is ultimately viewed as a figure for the turn to God, the gendered consequences of pederasty fail to register.

So how do you know a sodomite when you see one? It should be clear by now that this question, posed at the outset, delivers no easy answers. Bringing objects and texts about sodomy and other associated behaviors to visibility often makes manifest instead their ambiguity, illegibility, or unreadability, at least when viewed from certain angles. Foucault's much-debated statement concerning sodomy's utterly confused status describes what happens when sodomy is filtered through some modern ways of seeing (the hetero/homo binary, for example). At the same time Foucault himself would probably agree that sodomy did not give rise to confusion in each and every premodern source. In the Middle Ages sodomy's focus could be substantially narrowed, its legibility dependent on references to specific bodily practices such as coitus *in terga* or masturbation. Fields such as gender, religion, ethnicity, age, or social status also enabled an entity that might otherwise be troubled by vagueness or ambiguity to be visually or verbally deciphered by medieval audiences. Possibilities such as female homoeroticism were sometimes subject to greater levels of

circumspection or imprecision in the period; but acknowledging the role played by processes such as translation and the "logics of sequence" in communicating those possibilities allows further subtleties to emerge, for instance concerning the relative contribution gender roles such as butch and femme make to lesbian (in)visibility.

While modern efforts to distinguish "gender" and "sexuality" strive repeatedly—but not always successfully—to draw some kind of line (as witnessed in the emergence of transgender as a separate category from homosexuality), I would also like to think that this book has played a bit more fast and loose with such conceptual borders. Heterosexuality has a history, but so too does the separation of gender and sexuality into distinct analytic categories. It is not simply that the gender/sexuality distinction or categories such as heterosexuality or transgender were not recognized concepts in the Middle Ages. I am yet to be persuaded of the benefits of developing a "new philology" in the history of sexuality, one that strives relentlessly to tie analysis to the vocabulary of the texts under discussion rather than deploying a terminology derived from some later period. There is much to be gained from approaches that sidestep the homogenizing tendencies to which some histories of sexuality are prone— analyses that would, for example, seek to identify a unitary "medieval" attitude, one distinct, in every sense, from "our modern" understanding. Indeed scholarship cast in the philological mold can sometimes end up producing wildly anachronistic projections of its own. Olsen's recent (and otherwise very useful) effort to flesh out the contexts for Peter Damian's attack on sodomy is an example of the problems with this approach. After attempting to establish Peter's own sexual orientation as a chaste but essentially heterosexual-leaning male, Olsen concludes that Peter, in his attack on sodomy, held to a thoroughly "hetero-normative idea" of proper sex, defined as sex that leads to procreation.[3] What are the criteria by which Peter's thought registers as heterosexual or normalizing in Olsen's analysis? "Natural" sex acts between men and women are so narrowly circumscribed—and, in the context of the clerical culture Peter is addressing, so thoroughly delimited—that I would personally hesitate to describe the letter as a propaganda weapon in the onward march of "heterosexual" history, much as, superficially, this is what it appears to represent. We need to be careful about assuming the inevitability and universal applicability of one category, heterosexuality, while insisting that other categories such as homosexuality or lesbian be discarded.

This is not the place to police every instance of anachronism in the history of sexuality. It is easy enough to discover such effects in the work of even the most philologically driven scholars. Whether scholars deploy a willfully anachronistic terminology, or actively seek to root out anachrony wherever it appears, anyone engaged in historical work has to negotiate a pathway between these

different possibilities. What I have been advocating is a flexible and fluid approach to questions of terminology—one in which "faithfulness" to an authentically "medieval" lexis does not constitute the only properly ethical relation to the genders and sexualities of the past. In contemporary translation studies ideas of fidelity have given way to work seeking to exploit translation's polysemic potential. Rather than trying to pin meanings or interpretations down to some first principal, point of origin, or source, translation seeks instead to confront the necessity and impossibility of communication across borders, media, or time frames. This is a project in which every historian, art historian, and literary critic is engaged. Translating the past into the language of the present means not simply treating the past as a linguistic or moral master, but releasing its potential. And that potential often resides in what resists translation, which is why, when we apply "our" own vocabularies to past cultures, we are never going to generate a total understanding of the past or of texts and images we are striving to translate. But the languages of the present do not fully describe contemporary cultures either. These are the plural, conflicted worlds toward which I have been orienting myself in this book: seeing sodomy generates multiple lines of sight.

NOTES

Introduction

1. For an overview and further reproductions, see Husband, *Art of Illumination;* König, *Les Belles Heures*. On Jean de Berry as patron to the Limbourgs, see also Nash, *Northern Renaissance Art*, 115–19.

2. The scene is discussed briefly in Easton, "Uncovering the Meanings of Nudity," 161.

3. Husband, *Art of Illumination*, 220.

4. Payer, *Sex and the Penitentials*, 40–43, 135–37.

5. Hincmar of Reims, *De divortio Lotharii et Tetbergae*, in Migne PL 125:689a–695b; the phrases quoted are at 693c. Discussion in Boswell, *Christianity, Social Tolerance, and Homosexuality*, 203–4; Olsen, *Of Sodomites*, 33–41, 197–200. Olsen, critiquing Jordan's argument in *Invention of Sodomy* that Peter Damian "invented" the term in the eleventh century, identifies Hincmar's treatise as an early witness to the use of the word *sodomia* in a citation from a letter of Gregory the Great in which Gregory's original word *sodomitae* has become, whether by error or design, *sodomiae*.

6. Chiffoleau, "Dire l'indicible"; Hergemöller, *Sodom and Gomorrah*, esp. 86–126.

7. More than 160 manuscripts containing the letter survive in European archives. For a general introduction see Olsen, *Of Sodomites*, esp. 203–419.

8. Peter Damian, "Letter 31," ed. Reindel, 287; Peter Damian, *Book of Gomorrah*, trans. Payer, 29. See Olsen, *Of Sodomites*, 263–72.

9. Olsen, *Of Sodomites*, 271–89.

10. Peter Damian, "Letter 31," ed. Reindel, 313; Peter Damian, *Book of Gomorrah*, trans. Payer, 68. See Olsen, *Of Sodomites*, 389–405.

11. Peter Damian, "Letter 31," ed. Reindel, 310; Peter Damian, *Book of Gomorrah*, trans. Payer, 64. On gender imagery in this passage, see also Burgwinkle, *Sodomy, Masculinity, and Law*, 57–58.

12. Alan of Lille, *De planctu Naturae*, ed. Häring, 1.5–6. Subsequent references are provided in parentheses, by section and line number. Translations are my own but make used of Alan of Lille, *Plaint of Nature*, trans. Sheridan; and Rollo, *Kiss My Relics*, which quotes many of the relevant passages.

13. Jacobus de Voragine, *Legenda aurea*, ed. Maggioni, 2:653–58; Jacobus de Voragine, *Golden Legend*, trans. Ryan, 2:211–16.

14. John Beleth, *Summa de ecclesiasticis officiis*, in Migne *PL* 202:9–166. Beleth was a secular clergyman writing in Paris in the mid-twelfth century, whose main work, a manual of Christian liturgy, is one of the most frequently cited texts in the *Legenda aurea*. In fact the earliest reference to Jerome's cross-dressing is probably contained in a slightly earlier twelfth-century work by Nicholas Maniacoria, the *Vita sancti hieronimi*, which likewise describes the incident as a malicious attempt by clerics to discredit Jerome, in return for his accusations of fleshly vice on their part. See Migne *PL* 22:186.

15. *Legenda aurea*, ed. Maggione, 2:654; *Golden Legend*, trans. Ryan, 2:212.

16. See, e.g., Simon Winter, *Life of St. Jerome*, ca. 1430, which recalls how Jerome's enemies had laid a "wommanys cloth" beside his bedside "to make folk wene [think] that he hadde hade a womman in hys chambere and so to scorne hym." Winter, *Life of St. Jerome*, ed. Whatley, lines 116–26.

17. P. Brown, *Body and Society*, 366–72.

18. *Legenda aurea*, ed. Maggioni, 2:655; *Golden Legend*, trans. Ryan, 2:213.

19. Boyd and Karras, "Interrogation of a Male Transvestite Prostitute"; Ruggiero, *Boundaries of Eros*, 136; Puff, *Sodomy in Reformation Germany*, 31–32; Benkov, "Erased Lesbian."

20. Cadden, *Meanings of Sex Difference*, 214–16; Cadden, *Nothing Natural Is Shameful*, 106–38; Lochrie, *Heterosyncrasies*, 76–89.

21. Jaeger, *Origins of Courtliness*, 176–89; Goldberg, *Sodometries*, 111.

22. For an overview, see Hotchkiss, *Clothes Make the Man*.

23. Schultz, *Courtly Love*, 46.

24. *Legenda* included in Office for Rolle's canonization, in Richard Rolle, *Fire of Love*, ed. Comper, xlvi.

25. Astell, *Song of Songs*, 9–15, 105–18 (discussing Rolle specifically); Bynum, *Jesus as Mother*, 135–46; Mills, *Suspended Animation*, 180–85; S. D. Moore, *God's Beauty Parlor*, 21–89.

26. Moranvillé, *Le songe véritable*, vv. 1650–72, 3075–76, cited in Camille, "For Our Devotion," 183.

27. Jean Froissart, *Oeuvres*, ed. Lettenhove, 13:312–14, cited in Camille, "For Our Devotion," 171–72. Camille also finds examples in works of art commissioned by the duke of an interest in the bodies of lower-class males, and in sexual acts between older and younger men, but interprets such images as part of a self-conscious attempt on the duke's part to construct himself as a man of power.

28. Lowden, *Making of the "Bibles moralisées*,*"* 1:274.

29. Book-length treatments include Boswell, *Christianity, Social Tolerance, and Homosexuality*; Burgwinkle, *Sodomy, Masculinity, and Law*; D. Clark, *Between Medieval Men*; Goodich, *Unmentionable Vice*; Hergemöller, *Sodom and Gomorrah*; Jordan, *Invention of Sodomy*; Olsen, *Of Sodomites*; Puff, *Sodomy in Reformation Germany*; Rocke, *Forbidden Friendships*; and most recently Cadden, *Nothing Natural Is Shameful*.

30. See Saslow, *Pictures and Passions*, 55–78, for a useful preliminary survey. Other studies that examine the visual history of medieval sexuality, and include references to homoerotic themes, include Camille, *Medieval Art of Love*; Olsen, *Of Sodomites*, esp. 329–84; Wolfthal, *In and Out of the Marital Bed*.

31. Peter Damian, "Letter 31," ed. Reindel, 292–94; Peter Damian, *Book of Gomorrah*, trans. Payer, 37–39.

32. Peter Damian, "Letter 31," ed. Reindel, 313; Peter Damian, *Book of Gomorrah*, trans. Payer, 68. For visualizations of the Sodomites' gaze and Sodomitical blindness in images depicting the Genesis 19 story, see Caviness, *Visualizing Women*, 69–73 and fig. 30.

33. Peter Damian, "Letter 31," ed. Reindel, 298; Peter Damian, *Book of Gomorrah*, trans. Payer, 45 (translation adjusted). Damian also repeats the *quisquis es* phrase toward the end of the letter, where he asks his brother, "whoever you are," to consider the example of virgins and to keep the flesh "immune from every lustful plague." See Peter Damian, "Letter 31," ed. Reindel, 325; Peter Damian, *Book of Gomorrah*, trans. Payer, 85. For further discussion of the letter's visual imagery, see Burgwinkle, "Visible and Invisible Bodies."

34. Foucault, *History of Sexuality*, vol. 1, trans. Hurley, 101.

35. For the Middle Ages see especially Burgwinkle, *Sodomy, Masculinity, and Law*; Jordan, *Invention of Sodomy*. For the early modern period see Bray, *Homosexuality in Renaissance England*; Goldberg, *Sodometries*; Stewart, *Close Readers*.

36. Lochrie, *Covert Operations*, 178–226; Lochrie, "Presumptive Sodomy."

37. On the difficulties of applying distinctions among "sex," "gender," and "sexuality" to the Middle Ages, see Karras, *Sexuality in Medieval Europe*, 6; for the early modern period, see Traub, *Renaissance of Lesbianism*, 46.

38. Doan, "Topsy-Turvydom"; Marshall, "Pansies, Perverts and Macho Men."

39. Valentine, *Imagining Transgender*; Sinfield, "Transgender and LesBiGay Identities."

40. Thus, while I am in broad agreement with Schultz's recent critique of the deployment of heterosexuality as a category in medieval scholarship, his recommendation that medievalists, following Gayle Rubin, separate out gender and sexuality analytically has not been followed here. The assumption that gender conformity always equates with "heteronormativity" would certainly benefit from being unpacked. Equally, though, there are dangers in placing too much faith in the transhistorical applicability and translatability of what is after all itself a very recent theoretical opposition—more recent, indeed, than the homosexual-heterosexual opposition Schultz recommends we dismantle. See Schultz, "Heterosexuality as a Threat," 15; Schultz, *Courtly Love*, 60. In a different vein, David Halperin makes a case for driving a firm wedge between gender and sexuality in historical research: effeminacy, as one of what he terms "pre-homosexual" categories of male sex and gender deviance, should be distinguished from other categories such as pederasty or active sodomy, same-sex friendship, and passivity or inversion. See Halperin, *How to Do*, 110–13.

41. Jagose, *Inconsequence*.

42. See especially Butler, *Gender Trouble*; Butler, "Imitation and Gender Insubordination."

43. Jagose, *Inconsequence*, ix.

44. Murray, "Twice Marginal." Sautman and Sheingorn follow suit in their introduction to *Same Sex Love and Desire among Women*, expressing a desire to "make same-sex love and desire among medieval women visible to our readers" (4).

45. On interpretations of Genesis 3 in patristic and medieval thought, see Jager, *Tempter's Voice*; on the theology of nature and the fall, see Lochrie, "Heterosexuality," 40–42; Lochrie, *Heterosyncrasies*, xxii–xxiii; Payer, *Bridling of Desire*, 19–20.

46. Peter Damian, "Letter 31," ed. Reindel, 298; Peter Damian, *Book of Gomorrah*, trans. Payer, 45. See Olsen, *Of Sodomites*, 304–5, 324–26, 401–2.

47. See, for instance, fols. 91v (showing the duke's second wife, Jeanne de Boulogne, in prayer), 181r (showing Saint Geneviève), 191r (showing a woman tempting a Christian youth), and 212v (showing Salome). One scene that does show men in tight, figure-hugging costumes appears on fol. 16v, showing servants pushing Saint Catherine into prison. For the most part, holy men and women are depicted clothed in baggy cloaks and overgarments that cover their bodies partially or completely.

48. Husband, *Art of Illumination*, 222.

49. The scene's homoerotic potential is also discussed briefly in Easton, "Uncovering the Meanings of Nudity," 161–63. Easton also discusses the role played by Jeanne de Boulogne in the manuscript's reception.

50. Jaeger, *Ennobling Love*.

51. Kuefler, "Male Friendship"; Burgwinkle, *Sodomy, Masculinity, and Law*, 47–52.

52. Traub, *Renaissance of Lesbianism*, 320–25; Gowing, "Politics of Women's Friendship."

53. Castle, *Apparitional Lesbian*, 2, 11.

54. Ibid., 2, 12. See also Traub, *Renaissance of Lesbianism*, 30–31.

55. For the early modern period see Gowing, "Politics of Women's Friendship."

56. Having contributed a section on medieval depictions of male same-sex intimacy to one such volume—*A Gay History of Britain* in 2007—I was disappointed to learn that the accompanying *A Lesbian History of Britain* began its analysis in the 1500s; but this is symptomatic of the practicalities of producing such histories over a *longue durée* (whereas *A Gay History* was co-authored by four specialists in different periods, *A Lesbian History* was single-authored), as well as the pressures that come from conceiving the analytic object in question, homoeroticism, according to other potentially problematic categories (notably "Britain") that considerably narrow the possibilities for collating relevant material. See Cook, with Mills, Trumbach, and Cocks, *Gay History of Britain*; Jennings, *Lesbian History of Britain*.

57. Traub, *Renaissance of Lesbianism*; Amer, *Crossing Borders*. On sodomy as metaphor, see also Morton, "Queer Metaphors and Queerer Reproduction"; on desire in general, see Berry and Hayton, *Translating Desire*.

58. On the turn to translation in art history, see Bal and Morra, *Acts of Translation*, esp. 5–11; Morra, "Translation into Art History." For an overview of the word/image dialectic in art history, see Mitchell, "Word and Image." On art history as ekphrasis/translation see Elsner, "Art History as Ekphrasis"; Carrier, *Principles of Art History Writing*. For "visual translation" in French illuminated history manuscripts, see Hedeman, *Translating the Past*; Hedeman, "Presenting the Past."

59. Venuti, *Translator's Invisibility*.

60. See Copeland, *Rhetoric, Hermeneutics, and Translation*, 45–51.

61. Husband, *Art of Illumination*, 226.

62. *Belles Heures*, fol. 186v; Jacobus de Voragine, *Golden Legend*, trans. Ryan, 2:213.

63. On the place of queer within medieval art history, see Whittington, "Queer."

Chapter 1

1. For evidence of a more celebratory attitude in the century before, see Holsinger and Townsend, "Ovidian Homoerotics." For orientation to Parisian intellectual life in this period, see Wei, *Intellectual Culture in Medieval Paris*.

2. Versions of the *Verbum adbreviatum* are found in almost one hundred manuscripts, the earliest dating to ca. 1190–92. The short *Textus prior* (which includes the chapter entitled "De uicio sodomitico") and *Textus alter* (which does not) were brought together, at a later stage, into the long *Textus conflatus*, which gives the title of the relevant chapter as "Contra sodomiticam turpitudinem" (On the Sodomite sin). For a translation of the short version see Boswell, *Christianity, Social Tolerance, and Homosexuality*, 375–78, drawing on Migne *PL* 205:333d–335d. My translation is based on Boswell's, but I have modified it slightly, to conform to the text in Peter Cantor, *Verbum adbreviatum: Textus prior*, ed. Boutry, 637–41. For the long version, see Peter Cantor, *Verbum adbreviatum: Textus conflatus*, ed. Boutry, 773–79; Baldwin, *Language of Sex*, 247–50. Baldwin's study also contains general background on the Chanter, his circle in Paris, and the *Verbum adbreviatum*.

3. Peter Cantor, *Verbum adbreviatum: Textus prior*, ed. Boutry, 638. On the significance of this passage for understanding attitudes to intersex persons, see Rubin, "Person in the Form,"

103-4. The long text also implicates those who adopt neither "active" nor "passive" roles in *uicio androgei* (hermaphroditic vice), a phrase that places androgynous behavior on a par with *uicio sodomitico*. See Peter Cantor, *Verbum adbreviatum: Textus conflatus*, ed. Boutry, 775; Baldwin, *Language of Sex*, 248.

4. Peter Cantor, *Verbum adbreviatum: Textus prior*, ed. Boutry, 640-41. The equivalent passage in the long text does not include the phrase "ut uidentes non uideant." See Peter Cantor, *Verbum adbreviatum: Textus conflatus*, ed. Boutry, 779; Baldwin, *Language of Sex*, 250.

5. Kuhrt, *The Persian Empire*, 42n1. Sardanapalus is a corruption of the name of the Babylonian ruler Ashurbanipal (669-630? BCE).

6. For an overview of antisodomy discourse emanating from Parisian schools, see Goodich, *Unmentionable Vice*, 55-63.

7. Peter of Roissy, *Manuale de mysteriis ecclesiae*, cited in Goodich, *Unmentionable Vice*, 56 and 136n13.

8. Robert of Flamborough, *Liber poenitentialis* 8, ed. Firth, 196; discussion and translation of the relevant passage in Goodich, *Unmentionable Vice*, 56-58; Goodich, *Other Middle Ages*, 112-15. Alan of Lille discusses fornication against nature in his *Liber poenitentialis* from the previous century, and similarly advises priests not to probe for details. See Alan of Lille, *Liber poenitentialis* 1.4 and 32, discussed in Jordan, *Invention of Sodomy*, 90, 92-93.

9. *De poenitentia* 19 and *De legibus* 13, in William of Auvergne, *Guilielmi Alverni . . . Opera omnia*, 2:232, 1:44, cited in Goodich, *Unmentionable Vice*, 61-62. To date, William of Auvergne's condemnations of sodomy have not been subjected to systematic analysis, but for further references see Puff, *Sodomy in Reformation Germany*, 54, 66. On the political ramifications of *nefandum* in discussions of sodomy, see also Chiffoleau, "Dire l'indicible."

10. Saslow, *Pictures and Passions*, 69 and fig. 2.4.

11. Hergemöller, "Middle Ages," 58.

12. Camille, *Gothic Idol*, 90-91; Camille, *Medieval Art of Love*, 138. The miniature is also discussed in Carré, *Le baiser sur la bouche*, 78; Guest, "'Darkness and the Obscurity of Sins,'" 79-83; Murray, "Twice Marginal," 208-9; Tammen, "Bilder der Sodomie," 34. One reason why this image has received so much attention is that it is accessible in two widely available facsimiles edited by Guest and Haussherr.

13. For a discussion linking William of Auvergne with the *Bibles moralisées*, see Tammen, "Bilder der Sodomie," 40.

14. For an overview of the manuscripts' interrelationships, dates, patrons, makers, and functions, see Lowden, *Making*. On the role of Blanche of Castile specifically, see Lowden, *Making*, 1:8, 52, 94, 132 and 2:200-202; Guest, "Picturing Women." The thirteenth-century manuscripts and associated scholarship are also summarized in Hellemans, *La Bible moralisée*, 201-21.

15. Foucault, *History of Sexuality*, vol. 1, 17-49.

16. On the arguments for this unusual production order, see Lowden, *Making*, 1:30. Thirteenth-century Bible picture books such as Manchester, John Rylands Library, French 5, discussed below 180 and fig. 45, also prioritize image over text, the written captions being designed to match the content of the images rather than a clearly identifiable textual "source." See Hull, "Rylands MS French 5."

17. The different permutations are set out in Lowden, *Making*, 1:27-28. On the limitations of a discrete, iconographic approach, which fails to consider relations across several layers of text and image, see also Heinlen, "Ideology of Reform"; Hellemans, *La Bible moralisée*, 93-121; Hughes, "Typology and Its Uses"; Lipton, *Images of Intolerance*, 4.

18. "Ici fet dex le mariage d'adam et d'eve et les coniunt ensemble" (Here God makes the marriage of Adam and Eve and joins them together). The texts in Vienna 2554 are transcribed in Stork, *Bible moralisée Codex Vindobonensis 2554*; translations in Guest, *Bible moralisée*.

19. Augustine, *De Genesi ad litteram* 8.17.36, in Migne *PL* 34:387. For discussion of this and other references to gendered hierarchies in patristic commentary, and an introduction to Paul's prohibition of women's teaching, see Jager, *Tempter's Voice*, 24–31. Eve's secondary status is also emphasized in images depicting her being created from Adam's side, which attribute to Adam himself the faculty of giving birth. The iconography, which started appearing from the eleventh century, features in *Bibles moralisées*, e.g., Paris, Bibliothèque nationale de France, MS latin 11560, fol. 186r. See Zapperi, *Pregnant Man*.

20. On Alan's grammatical metaphors, see Ziolkowski, *Alan of Lille's Grammar of Sex*.

21. Moore, *Formation of a Persecuting Society*, 62–65.

22. Peter Damian, "Letter 31," ed. Reindel, 307, 314–15, 325; Peter Damian, *Book of Gomorrah*, trans. Payer, 59, 70, 85. Peter's image of a "leprous soul" is inspired by a citation from 2 Kings 3.29, which describes David's curse on the house of Joab. In Peter's rendition of the verse, David condemns the house henceforth to producing men "suffering from a discharge of semen, or a leper, or one unmanly, one falling by the sword, or one in need of bread"; taking inspiration from these words, Peter goes on to associate the leper's outlaw status with waste of semen.

23. For an argument that conversely the exposed partner plays the "passive" role, see Camille, *Medieval Art of Love*, 139.

24. The Vienna 1179 medallion has not been discussed nearly as frequently as the Vienna 2554 equivalent, probably because the latter is more accessible to researchers as a result of widely available facsimile editions. Tammen, "Bilder der Sodomie," 36, 45n31, implies inaccurately that Vienna 2554 is the only manuscript to include an image of same-sex couples in the moralization of the fall. One study that does refer to the Vienna 1179 image is Heinlen, "Ideology of Reform," 70.

25. The book was possibly commissioned for Joan I of Naples (d. 1382). See Besseyre and Christe, *Bible moralisée de Naples*, 17, 49–54, 114, 130; Hausherr, *Bible moralisée: Prachthandschriften des Hohen Mittelalters*, 20.

26. Jews in the Vienna manuscripts are generally shown wearing various kinds of round hat including the conical or pointed *pileum*, as are heretics and pagans. See Lipton, *Images of Intolerance*, 16–19, 85.

27. Camille, *Medieval Art of Love*, 139. In fol. 4r of Vienna 1179, the males are almost identical, unbearded, and hatless: the distinction between cleric and lay/Jew is no longer maintained.

28. A further aspect of the iconography that may be significant is the fact that in both Vienna 2554 and Vienna 1179 the couples are probably lying outdoors; elsewhere in the manuscripts copulation, whether licit or illicit, usually takes place in beds. See Wolfthal, "Art Historical Response," 17; Mills, "Seeing Sodomy," 431–32. This could reflect practicalities: in 1323 Arnaud de Verniolle confessed to inquisitors to soliciting male youths in Pamiers in southern France and having sex with them in fields, gardens, and a cemetery, as well as in his own house. For a translation of Arnaud's trial records, see Goodich, *Other Middle Ages*, 118–43.

29. "diabolus illaqueat eos per colla per ora per renes per tibias et per pedes et intrudit eos in infernum."

30. See Godefroy, *Dictionnaire de l'ancienne langue française*, 6:561–62, for *rein/rains*; 8:347–48 for *boche/bouche*; 9:121–22 for *col*; 9:264–65 for *cul*.

31. Peter Damian, "Letter 31," ed. Reindel, 307; Peter Damian, *Book of Gomorrah*, trans. Payer, 59–60.

32. For an overview, see Olsen, *Of Sodomites*, 329–86.

33. Odo of Cluny, *Occupatio* 3.654–76, quoted in Jones, "Monastic Identity," 30. The poem cannot be securely dated, but the sole surviving manuscript witness was written ca. 1000. Jones's article provides a detailed treatment.

34. Peter Damian, "Letter 31," ed. Reindel, 307; Peter Damian, *Book of Gomorrah*, trans. Payer, 60.

35. Olsen also sees these ideas as contributing to a "situational" understanding of homosexual behavior in Peter Damian's letter. In Peter's case this means not only that sodomites have been possessed but also that such men will fornicate with other males only if women aren't available. See Olsen, *Of Sodomites*, 305–7, 323–25, 398–99, 418–19. For a challenge to the idea that concepts of "situational homosexuality" can easily be applied to periods besides our own, see Halperin, *How to Do*, 114–15.

36. Stahuljak, *Bloodless Genealogies*, 170.

37. Augustine, *Confessions* 11.20(26), ed. O'Donnell, 157; Augustine, *Confessions*, trans. Chadwick, 235. This passage is cited in Hedeman, *Translating the Past*, 207. On visual and verbal translation and the "presentness" of the past, see also Carruthers, "Meditations on the 'Historical Present'"; Hedeman, "Presenting the Past." On the moralized Bibles' efforts to modernize biblical history, see also Heinlen, "Ideology of Reform," 31–61.

38. For examples, see Bonnell, "Serpent with a Human Head"; and chapter 5, where I discuss an instance of the motif in *Ancrene Wisse*.

39. Jager, *Tempter's Voice*, 4, 111, 195.

40. Peter Comestor, *Historia Scholastica* 1.21, in Migne *PL* 198:1072. For an overview of the *Historia Scholastica* and its vernacular afterlives, see Morey, "Peter Comestor"; on Comestor's being the first writer to attribute to the Serpent a woman's face, see Jager, *Tempter's Voice*, 111. Camille quotes this passage in the context of the Vienna 2554 miniatures in *Gothic Idol*, 91, noting that Comestor may even see in the female-headed Serpent an embodiment of "lesbian love." Tammen also makes the connection between the woman-headed Serpent and the female couple in the commentary miniature in "Bilder der Sodomie," 34. The corresponding medallion in Vienna 1179, fol. 4r, alters the arrangement: now it is Adam who looks into the eyes of the female Serpent and who accepts the fruit. But later artists do occasionally draw attention in other contexts to the homoerotic potential of a female-bodied serpent. See, e.g., a late fifteenth-century print by Lucas Cranach the Elder, reproduced in Riches, *St George*, 157 fig. 5.10, which shows Eve facing an identical-looking Serpent, whose prominent round breasts—which are turned toward and almost touching Eve's own—visually resemble the apple Eve is handing to Adam.

41. "Ici fet dex le mariage d'adam et d'eve et les coniunt ensemble" (Here God makes the marriage of Adam and Eve and joins them together).

42. "Ici vindrent li trois cent sodomite qi estoient eschapei et senfuerent en roches et habiterent en diverses montaignes" (Here the 300 Sodomites who escaped and fled into the rocks come and live in different mountains).

43. Translations of the Vulgate and Latin glosses are from Edgar, *Vulgate Bible*.

44. Cited in Carden, *Sodomy*, 164–93. Carden notes "how little the story of Gibeah figures in the medieval imagination" (169). Vienna 2554, fol. 65v, and Vienna 1179, fol. 79v, both depict the behavior of "sodomites" in Gibeah as concerning sexual violence: viewers are confronted with horrifying scenes of the Levite's concubine being poked in the eye, grabbed by the arm, and raped. The corresponding commentaries suggest that the Levite signifies good philosophers, and the old man who accommodates him represents Christ, who gave philosophy a place in the church; the sodomites themselves represent "les populicanz et mescreanz" (publicans and miscreants) (or in Vienna 1179 *publicani* and *infideles*) who wish to destroy church sacraments by abusing philosophy. Although, as such, the activities of the biblical sinners and their miscreant counterparts do not include homoeroticism, the Vienna 1179 rape scene incorporates a potentially significant innovation in the commentary medallion: one of the "publicans" who abuses Philosophy is shown kissing a cat's anus, which may function as an oblique reference to the sexual activities of sodomites. For an analysis of depictions of Jews

in these scenes, see Lipton, *Images of Intolerance*, 101–6; on the representation of rape in the Judges 19 sequence, see Wolfthal, "'Hue and a Cry,'" 49–51.

45. "Concilium Pariense," canon 34, quoted in Crompton, *Homosexuality and Civilization*, 157–58.

46. Benedict the Deacon, *Capitularium collectio* 3.356 and *additio tertia* 160, in Migne *PL* 97:842d–843a, 909a–910a.

47. Benedict the Deacon, *Capitularium collectio, additio secunda* 21 in Migne *PL* 97:866c–866d. Discussion in Crompton, *Homosexuality and Civilization*, 159–61.

48. See Mills, "Seeing Sodomy," 435–36.

49. Lowden, *Making*, 2:73. See also Besseyre and Christe, *Bible moralisée de Naples*, 76 (discussing "errors" in BnF français 9561 as well as Vienna 2554 and Vienna 1179); Brugger, "Les 'Paraphrases bibliques' moralisées"; Heinlen, "Ideology of Reform," 60–61.

50. For further discussion of this scene, see Heinlen, "Ideology of Reform," 42–43; Lowden, "Inventing Biblical Narrative."

51. Copeland, *Rhetoric, Hermeneutics, and Translation*. See also Stahuljak, *Bloodless Genealogies*, 142–89.

52. Murdoch, *Medieval Popular Bible*, 20.

53. For examples see Jager, *Tempter's Voice*, 16; Lesley Smith, *Glossa ordinaria*, esp. 91–139.

54. Jager, *Tempter's Voice*, 2. On the variation and expansion of, and "deviation" from, the biblical Genesis in vernacular adaptations, see Murdoch, *Medieval Popular Bible*; and in visual depictions see Zapperi, *Pregnant Man*, 3–27.

55. Reinhardt, "Texts of the 'Bible of Saint Louis,'" 277.

56. The uncertainty that this arrangement lends to interpretation is discussed in Hughes, "Typology and Its Uses," 137; Lowden, "'Reading' Images and Texts," 506.

57. The implications of the change of layout for reading/viewing patterns are discussed in Lowden, *Making*, 1:66–67, 77; Lipton, *Images of Intolerance*, 12–13. Other limiting strategies are discussed in Hughes, "Typology and Its Uses."

58. Lowden, *Making*, 2:203–4.

59. The Limbourgs had a hand in images only in the first three quires of BnF fr. 166. The relevant folios are reproduced in their entirety in Meiss, *French Painting in the Time of Jean de Berry*, 2: *Plates*.

60. Toledo MS 1, vol. 1, fol. 7v.

61. London, British Library, Additional MS 18719, fol. 3v; BnF fr. 167, fol. 3v; BnF fr. 166, fol. 3v.

62. In later centuries there is evidence for a homoerotic interpretation of Ruth 1.14–17. For instance Ruth and Naomi's relationship is invoked in a sixteenth-century Scottish poem ("Poem XLIX"), in which a female speaker cites the women in conjunction with a number of classical and biblical male same-sex couples such as David and Jonathan and Achilles and Patroclus; expressing a desire to metamorphose into a man so she can wed her beloved (a likely allusion to the Ovidian tale of Iphis and Ianthe, discussed in chapter 2), she appears to be desiring sexual consummation of the relationship. See Farnsworth, "Voicing Female Desire," 63.

63. Peter Cantor, *Verbum abbreviatum: Textus prior*, ed. Boutry, 639; Peter Cantor, *Verbum adbreviatum: Textus conflatus*, ed. Boutry, 777; Baldwin, *Language of Sex*, 249. Peter Damian's "Letter 31" also makes reference to Onan, on which see Olsen, *Of Sodomites*, 276–79.

64. For a detailed introduction see Joslin and Watson, *Egerton Genesis*; discussion of folio 11r at 83–87 and 145–48. Joslin and Watson surmise that the artist was probably a Fleming, Michiel van der Borch, who was active in Norwich or its environs in the mid-1400s; speculate that the costumes of the Sodomites standing outside the city walls evoke the fools/vices of medieval drama; and conclude that the patron was neither very wealthy nor a cleric. In his facsimile M. R. James admits that the book is "the most puzzling" medieval picture book he

has ever encountered; notes the artist's "rather cynical pleasure" in illustrating incidents "on which it is customary not to lay stress"; and confesses that he has refrained "from describing in any detail the not infrequent coarseness which the artist has permitted himself." See James, *Illustrations of the Book of Genesis*, 2–4. The manuscript is also discussed briefly in Caviness, *Visualizing Women*, 71, though Caviness's focus is a drawing over the page (fol. 11v), showing Lot offering his daughters to the Sodomites, the Sodomites being struck blind, and the destruction of Sodom.

65. Camille and Carré assume the pair are a female couple. See Camille, "Gothic Signs," 166; Carré, *Le baiser sur la bouche*, 87. Tammen interprets the woman's partner as a "young person of indeterminate sex." See Tammen, "Bilder der Sodomie," 36.

66. BnF fr. 167, fol. 7r, follows its model, Additional 18719, in retaining this ambiguity.

67. In BnF fr. 167, fol. 7r, the gender of one partner is ambiguous. The scene in BnF fr. 166 is discussed briefly in Camille, "For Our Devotion," 21.

68. For other instances of gender transformation in individual scenes from the earliest to the latest *Bibles moralisées*, and for an argument that, after a proliferation of scenes in the Toledo and Oxford-Paris-London Bibles representing homoeroticism, there is a quantitative reduction in the fourteenth- and fifteenth-century copies, see Mills, "Seeing Sodomy," 454–62.

69. This translation is also followed exactly in the King James Bible of 1611.

70. Quoted in Conrad, "Biblical Tradition," 281. As Conrad points out, there is very little evidence to support the view that bubonic plague is at issue in the Hebrew account: the reference to pestilence is a rhetorical device, deployed to illustrate the theme of God's awesome wrath, rather than a reference to historical events.

71. In the Latin of Vienna 1179 the Philistines are similarly named as *saraseni*, as they are in the Toledo and Oxford-Paris-London Bibles. See Vienna 1179, fol. 87v; Toledo MS 1, vol. 1, fol. 101v; Bodley 270b, fol. 131v. BnF fr. 167, fol. 66r reverts to the label "Philistines."

72. The transmutation of Philistine into Saracen in the Toledo Bible is discussed in Reinhardt, "Texts of the 'Bible of Saint Louis,'" 286–88. For analysis of other scenes featuring crusading references, see Maier, "*Bible moralisée* and the Crusades."

73. Vienna 1179, fol. 87v, referring to "saraseni" wounded by "vulnere sodomitico et aliis pessimis viciis." On *sodomiterie* in Old French, see Godefroy, *Dictionnaire de l'ancienne langue française*, 7/2:436. On the uses of "sodomitry" in early modern English, see Goldberg, *Sodometries*, xv–xvi.

74. Heinlen, "Ideology of Reform," 70n15, argues that the biblical miniature illustrating the Philistines' affliction is typical of the makers' attitudes to biblical history: the motif of genital-eating rodents is devised purely in the service of the contemporary moral, which in this instance berates the sexual practices of prelates. See also Carré, *Le baiser sur la bouche*, 87; Guest, "'Darkness and the Obscurity of Sins,'" 95–97; Kolve, "Ganymede / Son of Getron," 1050; Tammen, "Bilder der Sodomie," 31–34. Folio 157v of Vienna 1179 also contains another image comparing the activities of "Sodomites" with disease: a depiction of two young males embracing corresponds to the scene above showing the prophet Job suffering, his skin riddled with worms. See Mills, "Seeing Sodomy," 440–42 and fig. 9.

75. There is no equivalent to this scene in Toledo MS 1, but in vol. 3, fol. 134r, there is a scene illustrating Ephesians 2.3, which addresses those who fulfill "the will of the flesh" and depicts various men and women kissing over a hell mouth, including what could be a male-male pair.

76. In the Toledo Bible, the two couples are not identical, whereas in Bodley 270b they appear to be alike. See Toledo MS 1, vol. 1, fol. 78r. Another image in both the Toledo Bible and Bodley 270b representing age differentials appears in a medallion moralizing Numbers 16.33, when as punishment for their revolt against Moses, the people of Dathan and Abiron are swallowed by the hell mouth. Here an older, hooded man embraces and kisses a short-haired

youth and, to the right, in a pointed "Jewish" hat, hands over money to the same boy; the text describes the figures as heretics and schismatics, who are dragged off to hell with their "discipulis" (pupils/followers). For discussion and a reproduction, see Mills, "Seeing Sodomy," 449–50 and fig. 17. The Dathan and Abiron narrative was associated with the destruction of Sodom and Gomorrah in other contexts. Hilary of Poitiers refers to it in a fourth-century commentary on Psalm 67, and the comparison also turns up in Old English homilies. See Clark, *Between Medieval Men*, 91–92 and 92n18.

77. Lamentations 5.13: "adulescentibus inpudice abusi sunt et pueri in ligno corruerunt."

78. Boswell, *Christianity, Social Tolerance, and Homosexuality*, 377n56; Olsen, *Of Sodomites*, 382.

79. There are possible precedents for depicting relations between adult males and adolescents visually in this context: a *trumeau* from around 1135 at the abbey of Sainte-Marie in Souillac (Lot) depicts several pairs of male youths and adults wrestling, a possible scene recalling the rape of Ganymede, and an image showing the sacrifice of Isaac, which could also be making reference Lamentations 5.13. See Olsen, *Of Sodomites*, 381–82, drawing on Wirth, *L'image à l'époque romane*, 282.

80. Lipton, *Images of Intolerance*, esp. 102–3, 109, discussing "Jewish" sexual perversions. See also Lipton, "Root of All Evil"; Lipton, "Un-moralized Bible."

81. "bulgaros et albigenses, qui . . . diabolum adorant et in eum credunt." The Bodley 270b scene is also discussed in Tammen, "Bilder der Sodomie," 36–38 ; Carré, *Le baiser sur la bouche*, 89. See also Toledo MS 1, vol. 1, fol. 93v, though here the text follows Vienna 1179 in referring to *infideles*. Sodomy also features among the fleshly vices associated with heretics in Vienna 1179, fol. 165v, which interprets Belshazzar's feast in Daniel 5.1–2 as signifying heretics (*heretici*) who pervert (*peruertunt*) the scriptures and explain them according to their pleasure (*libitum*). See Lipton, *Images of Intolerance*, 109; Mills, "Seeing Sodomy," 424 and fig. 3. Additionally Bodley 270b, fol. 11v, includes a miniature commenting on Genesis 12.11–20, where Abraham travels to Egypt with his wife Sarai, whereupon she is taken into the house of Pharaoh. The scene, for which there is no equivalent in the Vienna Bibles, depicts a king kissing and touching a bearded, hooded, and barefooted man; and a tonsured cleric and a capped male embracing. But the accompanying text announces that Pharaoh signifies the "principes huius mundi et hereticos" (princes of this world and heretics), who endeavor to infest the church with persecutions and corrupt it with "heresibus" (heresies). See Mills, "Seeing Sodomy," 445 and fig. 14.

82. Boswell, *Christianity, Social Tolerance, and Homosexuality*, 283–86; Goodich, *Unmentionable Vice*, 7–10.

83. Guibert of Nogent, *Gesta Dei per Francos* 1, quoted in Olsen, *Of Sodomites*, 298–99; Olsen cites the scenes on fol. 36r of Vienna 2554 at 299n36. See also Boswell, *Christianity, Social Tolerance, and Homosexuality*, 280–82.

84. Auerbach, *Mimesis*, 75.

85. Jager, *Tempter's Voice*, 12.

86. Manuscript formerly belonging to Peter Daniel of Orléans, quoted in Boswell, *Christianity, Social Tolerance, and Homosexuality*, 262–63.

87. Heinlen, "Ideology of Reform," 72–74.

88. Boswell, *Christianity, Social Tolerance, and Homosexuality*, 207–9. Reviews of and responses to Boswell's book that question the applicability of an urban/rural dichotomy include Jeremy Adams, in *Speculum*; Bonds, in *Journal of Homosexuality*; Greenberg and Bystryn, "Christian Intolerance of Homosexuality"; Patricca, in *American Journal of Sociology*. For fifteenth-century accusations of sodomy in urban settings, see Boone, "State Power"; Puff, *Sodomy in Renaissance Germany*; Rocke, *Forbidden Friendships*.

89. On Vienna 1179, see Lipton, *Images of Intolerance*, 6–8; Lowden, *Making*, 1:94. On the Toledo and Oxford-Paris-London Bibles, see Lowden, *Making*, 1:132, 216; and Hernández, "'Bible of Saint Louis,'" 19–22, 31–32.

90. Ruiz, "'Bible of Saint Louis'"; Lowden, "'Reading' Images and Texts," 513.

91. Access to the manuscripts continues to hamper scholarship. The excellent facsimiles of the Toledo Bible and the Naples Bible by M. Moleiro (Rodríguez, *Biblia de San Luis*; Bibliothèque nationale de France, *Bible moralisée de Naples*) are beyond the budgets of most research libraries in the UK; the Valencia-based publisher Patrimonio's 2010 facsimile of BnF fr. 166 (*Biblia moralizada de los Limbourg*, with accompanying commentary volume by König and Lowden) is listed in the Bibliothèque nationale de France's catalogue, but it was not accessible to researchers at the time of writing. A. de Laborde's black-and-white reproductions of the Oxford-Paris-London set, along with selected folios from other manuscripts, are a valuable resource, but the glimpse they provide is partial: see Laborde, *La Bible moralisée illustrée conservée a Oxford, Paris et Londres*. Vienna 2554 is the only manuscript available in affordable, full-color reproductions (Guest, *Bible moralisée*; Hausherr, *Bible moralisée*), though for qualifications about their value as witnesses to the original manuscript, see Lowden, *Making*, 1:11–12. High-quality digital reproductions of each folio in Vienna 2554 are now also available via the Österreichische Nationalbibliothek web pages. However, a large-scale, collaborative digitization project would facilitate comparisons across all the Bibles.

92. Lowden, *Making*, 2:209; Lowden, "'Reading' Images and Texts," 515.

93. See, e.g., fig. 21; and Bodley 270b, fol. 11v, discussed above, n79.

94. The "mirror for princes" theory was first advanced in Heinlen, "Ideology of Reform." For critiques see Lowden, *Making*, 2:208–9; Ruiz, "Codicological Study," 261–62.

95. Lowden, *Making*, 1:9.

96. For a discussion of the mnemonic functions of this and other illuminated initials in the Psalter, see Carruthers, *Book of Memory*, 228.

97. Walters W.88 also contains a number of other scenes with possible homoerotic connotations, including several of men wrestling, sometimes naked or partially clothed (e.g., fol. 171v); a pair of naked female bathers conversing (fol. 75v); a bishop blessing the exposed rump of a hybrid figure (fol. 106r); a man kneeling, naked butt exposed, while another, untonsured male hits it with a switch (fol. 163r); and a bald-headed male playing a wind instrument to another male, lying on his side, who wields an oversized sword at his waist in a gesture possibly designed to evoke phallic tumescence (fol. 164v). For a scene of anal penetration in the same manuscript, see fig. 64.

98. Burns, *Las siete partidas*, 5:1427 (title 21, laws 1–2), discussed in Boswell, *Christianity, Social Tolerance, and Homosexuality*, 289, and Goodich, *Unmentionable Vice*, 77. See also Alfonso's *Fuero real* 4.9.2, in *Los códigos españoles concordados y anotados*, 1:409, quoted in Boswell, *Christianity, Social Tolerance, and Homosexuality*, 288, which again prescribes castration and death.

99. Akehurst, *Etablissements de Saint Louis*, 59.

100. At the end of the thirteenth century, Philippe de Beaumanoir's *Coutumes de Beauvaisis*, a massive compilation of French customary law, also referred to heresy and sodomy in the same paragraph as two separate crimes deserving burning. See Akehurst, *Etablissements de Saint Louis*, 59n119; Boswell, *Christianity, Social Tolerance, and Homosexuality*, 290–91.

Chapter 2

1. Burgwinkle, *Sodomy, Masculinity, and Law*; Cadden, *Meanings of Sex Difference*, 214–25; Karras, *Sexuality in Medieval Europe*; Lochrie, *Covert Operations*, esp. 192–99; Lochrie, "Presumptive Sodomy."

2. Peter Cantor, *Verbum abbreviatum: Textus prior*, ed. Boutry, 638; Peter Cantor, *Verbum adbreviatum: Textus conflatus*, ed. Boutry, 775; Baldwin, *Language of Sex*, 248.

3. Peter Damian, "Letter 31," ed. Reindel, 313; Odo of Cluny, *Occupatio* 3.646–47, quoted in C. Jones, "Monastic Identity," 29. On Peter's references to effeminacy, see also Olsen, *Of Sodomites*, 389–405.

4. Orderic Vitalis, *Ecclesiastical History*, ed. and trans. Chibnall, 4:188–89 (translation adjusted slightly). "Catamitus" is a Roman form of the Greek name Ganymede, which could be used to refer to any beautiful young males who were the subordinate sexual partners of older men. See Williams, *Roman Homosexuality*, 60–61.

5. Orderic Vitalis, *Ecclesiastical History*, ed. and trans. Chibnall, 4:188–89. Later in his history (6:64–66), Orderic also reports an Easter sermon, delivered in 1105 in the court of Rufus's successor, Henry I, by Serlo, bishop of Séez, who berates the male courtiers, whose beards give them "the appearance of billy goats, whose filthy viciousness is shamefully imitated by the degradations of fornicators and sodomites," and whose long hair makes them "imitators of women." Likewise, in ancient Rome accusations of effeminacy did not automatically imply that the males in question were engaged in homoerotic acts. On the stereotype of the womanish womanizer in Roman texts, see Williams, *Roman Homosexuality*, 157–69.

6. Hugh of Flavigny, *Chronicon*, in Migne *PL* 154:390d–391a, discussed in Barlow, *William Rufus*, 409. The story is reminiscent of a legend widespread throughout the Middle Ages of the emperor Nero becoming pregnant and dying after giving birth to a frog, which in some accounts is viewed as divine punishment for having sex with a man. See Zapperi, *Pregnant Man*, 112–24. For other references to effeminacy, sartorial excess, and lewd mannerisms in the court of William II, see Orderic Vitalis, *Ecclesiastical History*, 5:286; William of Malmesbury, *Gesta regum anglorum*, ed. Stubbs, 2:370. For sodomy specifically, see Eadmer, *Historia Novorum in Anglia*, ed. Rule, 192.

7. Boyd and Karras, "Interrogation of a Male Transvestite Prostitute."

8. This case (Margaret Myler versus Agnes Andrew) and the other (Thomas Tunley versus William Smyth) are discussed in Wunderli, *London Church Courts*, 83–84.

9. Rocke, *Forbidden Friendships*, 106–10. The same distinction held in fifteenth-century Venice, though the "active" sodomite was held to be more culpable. See Ruggiero, *Boundaries of Eros*, 121–24.

10. Benkov, "Erased Lesbian"; Cadden, *Meanings of Sex Difference*, 224; Crompton, "Myth of Lesbian Impunity"; Lansing, "Donna con Donna?"; Simons, "Lesbian (In)Visibility," 86.

11. Lochrie, *Heterosyncrasies*, xix–xx.

12. Ibid., 95.

13. Ibid., 105. On twentieth-century definitions of stone butch, see Kennedy and Davis, *Boots of Leather*, 192, 204–8.

14. Halberstam, *In a Queer Time*, 55. For other articulations of this collective sense of transgender as including all kinds of gender variance, see Meyerowitz, *How Sex Changed*, 10; Stryker, *Transgender History*, 1–24; Valentine, *Imagining Transgender*, 32–40.

15. See, e.g., Anson, "Female Transvestite"; Bullough, "Transvestites in the Middle Ages"; Grayson, "Disruptive Disguises"; Hotchkiss, *Clothes Make the Man*; Perret, "Travesties et transsexuelles"; Szarmach, "St. Euphrosyne." "Transvestite" has also been taken up in discussions of medieval romance. See, e.g., Putter, "Transvestite Knights"; McCracken, "'Boy who was a Girl.'" Additionally it has occasionally been applied to legal cases, such as the John/Eleanor Rykener interrogation record; see Boyd and Karras, "Interrogation of a Male Transvestite Prostitute," and Boyd and Karras, "*Ut cum muliere*." On the preference for "cross-dresser" over "transvestite," see Stryker, *Transgender History*, 16.

16. Valentine, *Imagining Transgender*.

17. On transgender studies' inception as a field, see Stryker and Whittle, *Transgender Studies Reader*. For differing approaches to transgender history see Devor and Matte, "One Inc. and Reed Erickson"; Feinberg, *Transgender Warriors*; Halberstam, *In a Queer Time*. On the tensions between transgender history and the history of homosexuality, see Valentine, *Imagining Transgender*, 29–65.

18. For an interrogation of these challenges, which keeps in view also the opportunities, see Raskolnikov, "Transgendering Pride."

19. Halberstam, *In a Queer Time*, 53.

20. Richard of Devizes's late twelfth-century *Cronicon* counts among London's "grave obscenities" categories such as *molles* (effeminates) and *mascularii* (male-lovers), which have occasionally been read as indicating the existence of sexual subcultures in the medieval city. See Richard of Devizes, *Chronicle of Richard of Devizes*, ed. Appleby, 65–66. But the references occur within a satirical travel narrative, placed in the mouth of a French Jew, which ultimately takes aim at the fictive nature of Christian representations of Judaism; the discussion of urban obscenity is a literary pastiche, for the most part, that draws on scriptures and classical poetry. For a discussion that sees in the passage evidence for subterranean homosexual networking in medieval London, see Dynes and Johansson, "London's Medieval Sodomites"; Dynes, *Encyclopedia of Homosexuality*, 2:1259. On the difficulties posed by the chronicle as a document of social history, see Bale, "Richard of Devizes."

21. Traub, *Renaissance of Lesbianism*, 16. Lochrie is more skeptical about the benefits of strategic anachronism in "lesbian" history. See Lochrie, preface to Giffney, Sauer, and Watt, *Lesbian Premodern*, esp. xiv.

22. Halberstam, *In a Queer Time*, 54, points to how, even as it aims to supplant or provide an alternative to the medical-sexological language of "transsexuality," transgender continues to be haunted by that earlier term; and transsexuality itself has undergone reconstruction at the hands of those who identify as transsexual, so transsexuality itself cannot simply be aligned with a conservative, medicalized discourse. See also Stone, "*Empire* Strikes Back"; Meyerowitz, *How Sex Changed*; Valentine, *Imagining Transgender*.

23. Bennett, "Lesbian-like"; Bennett, *History Matters*, 108–27.

24. Halperin, *How to Do*, 38. For a different take on *kinaidos*, see Davidson, *Greeks and Greek Love*, 55–60.

25. Halperin, "Forgetting Foucault," 103.

26. Halperin, *How to Do*, 121, 132, 134.

27. Ibid., 132.

28. Freccero, *Queer/Early/Modern*, 41.

29. The tendency, since the 1970s and 1980s, to cast transsexuals, transgender, and other gender-variant people as conservative, old-fashioned, or irrelevant—and to displace gender transgression from gay liberation politics as a visible sign of difference—is documented in Meyerowitz, *How Sex Changed*, esp. 168–200, 258–59. See also H. Rubin, "Trans Studies"; Stryker, *Transgender History*, 94–98, 135–38; and Valentine, *Imagining Transgender*, 40–51, 157–66. On debates in feminism and queer studies regarding the analytic distinctness of "gender" and "sexuality," and the mismatch between these academic discussions and uses and understanding of these terms in practice, see also Butler, *Undoing Gender*, 181–88.

30. Butler, *Gender Trouble*.

31. For Butler's comments on "popular" readings of *Gender Trouble*, see Osborne and Segal, "Gender as Performance," 33.

32. For the affective dimensions to such experiences of temporal transitivity and heterogeneity, see Freeman, *Time Binds*.

33. Halberstam, *In a Queer Time*, 18.

34. Ibid., 21.

35. Olsen identifies Albert the Great (d. 1280) as the source for the idea that acts of *sodomia* can occur between one woman and another. See Olsen, *Of Sodomites*, 238, 424. Clearly before this time, though, Christian thinkers had concerned themselves with female same-sex practices. For women's inclusion in the category of sodomy, see also Lochrie, *Covert Operations*, 192–99; Lochrie, "Presumptive Sodomy."

36. Payer, *Sex and the Penitentials*, 43, 138.

37. For a detailed exegesis of this obscure passage, see Brooten, *Love between Women*, 195–302.

38. Peter Damian, "Letter 31," ed. Reindel, 292; Peter Damian, *Book of Gomorrah*, trans. Payer, 37. Elsewhere in his letters Damian does consider "shameful acts" between girls in an anecdote about a woman who witnesses her dead godmother in the grip of purgatorial torment. See his "Letter 168," partially translated in Le Goff, *Birth of Purgatory*, 178, cited in Olsen, *Of Sodomites*, 282, and Sobczyk, *L'érotisme des adolescents*, 22.

39. " 'Sodoma et Gomorrha et finitime ciuitates quia exfornicatae' sunt 'et abierunt post carnem alteram,' masculi cum masculis turpitudinem agentes, mulieres cum mulieribus"; *Verbum adbreviatum: Textus prior*, ed. Boutry, 639.

40. Hildegard of Bingen, *Scivias*, trans. Hart and Bishop, 278. Subsequent references to this edition are provided in the main body of the text by page number. Latin glosses are from Hildegardis, *Scivias*, ed. Führkötter and Carlevaris, 2.6.76–78. For an overview of Hildegard's references to sins against nature in her writings, see Limbeck, "Turpitudo antique passionis," 208–12.

41. For overviews of the tradition, see Anson, "Female Transvestite"; Patlagean, "L'histoire de la femme déguisée en moine."

42. Hildegard's rulings on cross-dressing and homosexuality are discussed briefly in Cadden, *Meanings of Sex Difference*, 213; Murray, "Twice Marginal," 199; Schibanoff, "Hildegard of Bingen," 59.

43. For a detailed discussion of the relationship with Richardis and its resistance to a phallocentric view of female homoeroticism, see Schibanoff, "Hildegard of Bingen." On Hildegard's friendships with women in general, see Wiethaus, "In Search of Medieval Women's Friendships."

44. It is also worth noting that, at the conclusion to this chapter on sinful sexual practices, Hildegard includes a condemnation of male and female masturbation, followed by a denunciation of bestiality (279–80).

45. For twentieth-century butch and femme roles, especially as they developed in working-class communities in North American cities, see Faderman, *Odd Girls*, 159–87; Kennedy and Davis, *Boots of Leather*, 151–230. For mobilizations in more recent settings, and theoretical reflections, see Munt, *Butch/Femme*. For applications of femme in early modern contexts, especially to describe what the author calls "chaste femme love," see Traub, *Renaissance of Lesbianism*, 230–70; for a playful application of the term to medieval sources, see Kłosowska, "Medieval Barbie Dolls." Another category of female masculinity, tomboyism, is productively applied to medieval sanctity in Kao, "Tomboyism of Faith."

46. Related vocabularies have also developed in contemporary gay male cultures, the word "fem" being used (often pejoratively) as shorthand for male effeminacy, while phrases such as "straight acting" evoke performances of masculinity that potentially stray into the territory also occupied by butch.

47. Ovid, *Metamorphoses*, ed. Miller, 9.666–797. Subsequent references to this edition are provided in the main body of the text by book and line number. Translations are based on Ovid, *Metamorphoses of Ovid*, trans. Simpson, with occasional modification where a more prosaic rendering is required.

48. On ancient contexts for Ovid's story see Pintabone, "Ovid's Iphis and Ianthe"; Walker, "Before the Name." On the ancient category of *tribas*, a Greek word borrowed by Romans and derived from the verb "to rub," as well as an overview of the "manly" practices of these tribadic women, see Brooten, *Love between Women*, esp. 14–26.

49. Sahar Amer argues that the French versions themselves bear comparison with cross-dressing and forced same-sex marriage narratives in the Arabic literary tradition: see Amer, *Crossing Borders*, 50–86. See also Archibald, "*Ide and Olive* Episode"; R. L. A. Clark, "Heroine's Sexual Itinerary"; De Weever, "Lady, the Knight, and the Lover"; Durling, "Rewriting Gender"; Watt, "Behaving like a Man?" Illustrations in Turin, Biblioteca Nationale Universitaria, MS L. II. 14—a fourteenth-century manuscript of the Old French *Yde and Olive*—are discussed in Kłosowska, *Queer Love in the Middle Ages*, 81–87. Another parallel story, the fourteenth-century *Tristan de Nanteuil*, is discussed in Sautman, "What Can They Possibly Do Together?" William Robins also adds the fourteenth-century Florentine *Cantari della Reina d'Oriente* to the list of analogues: Robins, "Three Tales."

50. Boer et al., *Ovide moralisé*. References to this edition are provided in the main body of the text, accompanied by the abbreviation *OM*, by book and line number. As Ralph Hexter reminds us, the twenty-three surviving manuscripts are subject to considerable variation, to the extent that it may be more helpful to think in terms of multiple *Ovides moralisés*: Hexter, "Ovid in Translation," 1314. For background on the poem, as well as other, earlier moralized interpretations of parts of *Metamorphoses* such as the twelfth-century glosses by Arnulf of Orléans and John of Garland's *Integumenta Ovidis* (ca. 1234), see Blumenfeld-Kosinski, *Reading Myth*, 90–94; Coulson, "Ovid's Transformations"; Possamaï-Pérez, *L'Ovide moralisé*; Caxton, *Book of Ovyde Named Methamorphose*, ed. Moll, 7–19. On the poem's identity as a translation, see Copeland, *Rhetoric, Hermeneutics, and Translation*, 107–26; Griffin, "Translation and Trans-formation"; Jung, "L'Ovide moralisé," 108–9.

51. For the first prose abridgment, written in Angers between 1466 and 1467 on the orders of René of Anjou, see Boer, *Ovide moralisé en prose*. The second prosification (*Ovide moralisé en prose II*), composed in Bruges shortly before 1480, appears in London, British Library, Royal MS 17.E.iv; Paris, Bibliothèque nationale de France, MS français 137; and St. Petersburg, Rossijskaja Nacional'naja Biblioteka, MS F.v.XIV.1. See Jung, "Ovide métamorphose en prose." For William Caxton's English translation of this prosification, see Caxton, *Booke of Ovyde Named Methamorphose*, ed. Moll; the *mise en prose* tradition is introduced at 19–25. Part of an ongoing project to edit Caxton's Ovid along with its French source, Caxton, *Middle English Text of "Caxton's Ovid*," ed. Rumrich, includes a transcription of the prologue, book 1, and the first few folios of book 2 in BnF français 137.

52. Pierre Bersuire's *Ovidius moralizatus* was originally book 15 of his *Reductorium morale*, a moralizing *summa* of human knowledge. Bersuire's text exists in two redactions, the second of which is influenced by the verse *Ovide moralisé*. There is no printed edition of the second redaction, but for the first, reprinted from the volume printed in Paris in 1509 (in which the moralizations were ascribed incorrectly to the English Dominican Thomas Waleys), see Berchorius, *Reductorium morale, Liber XV, cap. i*, ed. Engels; and Berchorius, *Reductorium morale, Liber XV, cap. ii–xv*, ed. Engels (hereafter Berchorius, *Reductorium morale ii–xv*). Berchorius, *Ovidius moralizatus*, trans. Reynolds, is a translation of the first redaction. Book 1 of the *Ovidius moralizatus* was translated into French prose in 1480 (Copenhagen, Royal Library, MS Thott 388).

53. Ovid, *Bible des poëtes* (Bruges: Colard Mansion, 1484). I consulted the British Library copy, which is unpaginated, so I have not provided further references in the notes. As in the 1509 edition of the first redaction of Bersuire's *Ovidius moralizatus*, Mansion incorrectly attributes the moralizations to Thomas Waleys in his opening rubric. For background see Moisan and Vervacke, "Les *Métamorphoses* d'Ovide."

54. Caxton's English translation precedes Mansion's edition, but is based on the second prose *Ovide moralisé* (see above, n51). Caxton's moralized Ovid is found in a two-volume manuscript: Cambridge, Magdalene College, Old Library MS F.4.34 (vol. 1) and Cambridge, Magdalene College, Pepys Library MS 2124 (vol. 2). For a critical edition of the entire work see Caxton, *Booke of Ovyde Named Methamorphose*, ed. Moll. When researching the present book I made use of Caxton, *Metamorphoses of Ovid* (1480), facsimile in 2 vols, 1:9.14, but line references in the main body of the text reproduce Moll's numbering. For an overview of Caxton's rendition, including the possibility that it was produced for Margaret of York or Elizabeth Woodville, see Oakley-Brown, *Ovid and the Cultural Politics of Translation*, 165–91 (discussion of Caxton's Iphis story at 174–76). See also Traub, *Renaissance of Lesbianism*, 283.

55. Additionally, in book 14 of *Metamorphoses* the name Iphis is attached to a male youth, who hangs himself when his love for the princess Anaxarete is unrequited (14.698–764). On the politics of naming and visibility in Ovid's text, see Walker, "Before the Name," 214–15. Etymologically, the name Iphis is connected to the Latin word *vis*, meaning "force," which reinforces these associations with masculine privilege. See also Wheeler, "Changing Names," 195.

56. Bersuire's *Ovidius moralizatus* does not discuss the name.

57. Halberstam, *In a Queer Time*, 47–75.

58. Emphasis mine. Caxton is translating here the basic structure of the French prose, but the reference to the "vysage" of someone who is perceived as a "she" by those who see "her" reflects a change of emphasis from Mansion's text, where the relevant sentence reads "Yphis avoit habit d'enfant masle qui lui plaisoit, et si avoit tel visage que qui le veoit indifferamment povoit dire cest filz ou fille." Mansion's prose repeats details also found in the verse *Ovide moralisé*, except that here we are told that the face is such that "qui la veoit" would be unable to say if it is "fille ou filz" (*OM* 9.2888–89).

59. On the Pasiphaë reference in Iphis's soliloquy, see Pintabone, "Ovid's Iphis and Ianthe," 268–69.

60. On the significance of sexual fluids in premodern culture, see Simons, *Sex of Men*.

61. In the verse *Ovide moralisé*, the pair are described embracing, but no reference is made to Iphis's shame, only to her crying (*OM* 9.2916–20). Mansion's text informs readers that prior to Iphis's lament, the pair kiss, but again refers only to her crying: "Moult ses bahissoit et piteu lement se complaindoit souvent en l'armoyant."

62. See also *OM* 9.2975–82.

63. Hallett, "Female Homoeroticism," 226n16; Walker, "Before the Name," 217.

64. The relevant passage in Mansion also includes a line absent from Caxton's translation, in which Iphis refers to how her and her lover are of "un sexe" and how "Toute femelle par droit naturel requiert son masle." See also *OM* 9.2928–45. The animal kingdom also sets the standard in texts condemning male sodomy: just before he labels the sodomite a *homo effeminate* Peter Damian characterizes homoerotic behavior as a form of "madness," because, he reasons, goats, stallions, bulls, rams, and mules never desire sex with their own kind. See Peter Damian, "Letter 31," ed. Reindel, 313; Peter Damian, *Book of Gomorrah*, trans. Payer, 68.

65. Galinsky, *Ovid's* Metamorphoses, 181–88.

66. Moralizations of the episode by Caxton and others include the idea that powerful women (represented by Juno) are dangerous and that just as Tiresias turns from masculine to feminine, so the seasons turn from hot to cold. The verse *Ovide moralisé* includes a series of typological explanations (*OM* 3.1189–1291), which connect his sex changes to the moral transformations of penitent sinner saints such as Mary Magdalene and Paul, and connect his answer to the question about sexual pleasure to the dedication of the holy women to the holy sepulcher following Christ's death. Bersuire interprets Tiresias as representing the Jews, who start out virtuous (like a man) but become imperfect and unstable (like a woman), but

when eventually the Jews learn to believe in Christ's "double nature" they will be turned into man (*virum*) again, become virtuous (*virtuosus*), and turn away from feminine evil (*malicia foemina*): see Berchorius, *Reductorium morale ii–xv*, 68–69; Berchorius, *Ovidius moralizatus*, trans. Reynolds, 190–91. For modern takes on the Tiresias story, which sometimes view the protagonist as a figure for variant sexualities, including homosexuality, see Madden, "Anus of Tiresias," 113–27. Another related story is included in Caxton's Ovid, following the tale of Salmacis and Hermaphroditus in book 4, which is placed in the mouth of Leucothoe, a young woman in *Metamorphoses* who has sex with the sun. Caxton's Leucothoe describes how the Hermaphroditus myth could be supplemented with the story of Gyton [Sithon], who "dvyversyfyed hym self agaynst nature in suche wyse that on houre he was a man and another he was a woman. This Gyton entremeted hym of grete fylthe, for he was one tyme actyf, and another tyme passyf." This passage, unlike the Tiresias legend, envisages the problematic sexual consequences of repeatedly changing sex, condemning it as emphatically unnatural and filthy. Caxton's narrator thus deploys an explicitly sodomitical script to condemn male switches of gender that have sexual consequences: despite the sex changes, Gyton is consistently referred to as a "he." See Oakley-Brown, *Ovid and the Cultural Politics of Translation*, 176–77. For a comparative analysis of gender transformation stories in *Metamorphoses*, see Ginsberg, "Ovid and the Problem of Gender."

67. Boyd and Karras, "Interrogation of a Male Transvestite Prostitute," 481–82.

68. Pliny's examples include an individual he himself encountered who "changed into a man on his wedding day" (*Natural History* 7.4, ed. Page et al., 2:530); this reference to prenuptial transformation, which sounds so close to the Ovidian myth of Iphis as to be influenced by it, was incorporated into lists of sex changes that began being documented in medical treatises from the end of the fifteenth century. On the incorporation of such anecdotes into late medieval and early modern medical writings, see Beecher, "Sex Changes."

69. Pliny, *Natural History* 8.44, ed. Page, 3:76. See Hassig, *Medieval Bestiaries*, 145–55. For a discussion of the sodomitical ramifications of the hyena's sexual metamorphoses, see Boswell, *Christianity, Social Tolerance, and Homosexuality*, 138–43.

70. Pliny, *Natural History* 7.3, ed. Page, 2:528. Elsewhere Pliny also compares hermaphrodites with women with a body part resembling the male organ and with a "third class" of men who, unlike hermaphrodites and eunuchs, lack testicles as a result of an accident or natural causes. See *Natural History* 11.109–10, ed. Page, 3:596–58.

71. A competing tradition, derived from a speech of Aristophanes in Plato's *Symposium*, referred to the idea of the androgyne, "a distinct kind, with a bodily shape and a name of its own, constituted by the union of the male and the female," which was the basis for notions of a third sex. See Plato, *Symposium* 18c, in *Collected Works of Plato*, trans. Jowett, 520. On deployments of the Ovidian myth, see esp. Silberman, "Mythographic Transformations."

72. For early modern culture, see Dreger, *Hermaphrodites*; Gilbert, *Early Modern Hermaphrodites*; Long, *Hermaphrodites in Renaissance Europe*; Park and Daston, "Hermaphrodite and the Orders of Nature"; Simons, *Sex of Men*, 25–39. For the modern taxonomic project of distinguishing "hermaphrodites" or intersex people from other categories of gender identity and sexual desire such as "transsexuals" and "homosexuals," see Meyerowitz, *How Sex Changed*, 5–10. For medical-theological and literary treatments of hermaphroditism in the Middle Ages, see Cadden, *Meanings of Sex Difference*, 201–12; McAlpine, "Pardoner's Homosexuality"; Rollo, *Kiss My Relics*; M. Rubin, "Person in the Form." Specific legal cases are discussed in Neal, *Masculine Self*, 142–50, and Ruggiero, *Boundaries of Eros*, 136. For the early Middle Ages, see Knüsel and Ripley, "*Berdache* or Man-Woman."

73. DeVun, "Jesus Hermaphrodite." For another abstract discussion of hermaphroditism, which appropriates it as a figure for grammar and logic, see the poem *De ermafrodito* by Hildebert of Lavardin (d. 1133), discussed in Otter, "Neither/Neuter."

74. Berchorius, *Reductorium morale ii–xv*, 79–81; Berchorius, *Ovidius moralizatus*, trans. Reynolds, 212–14. The verse *Ovide moralisé* piles up a number of competing interpretations, focusing especially on Salmacis, who figures first women who like wearing makeup and then, in the concluding interpretation, worldliness in general (which includes sins such as pride, lechery, and fake beauty); the fountain itself is interpreted in the opening moralization as a representation of the seven-chambered womb that, following medieval medical theory, is viewed as containing a middle chamber that, if entered by the sperm, will produce a hermaphrodite. See *OM* 4.2224–2389. Caxton's and Mansion's versions of the Hermaphroditus story reproduce these readings. For Christine de Pizan's take on the Hermaphroditus legend in her *Epistre Othea*, as well as illustrations of the episode in the *Ovide moralisé*, see Desmond and Sheingorn, *Myth, Montage and Visuality*, 148–50.

75. Nederman and True, "Third Sex."

76. Peter Cantor, *Verbum abbreviatum: Textus prior*, ed. Boutry, 638; Peter Cantor, *Verbum adbreviatum: Textus conflatus*, ed. Boutry, 775; Baldwin, *Language of Sex*, 248. Dante has Guido Guinicelli and his band in purgatory cry out, "Nostro peccato fu ermafrodito" (our sin was hermaphrodite), but goes on to say that they followed bestial appetites and announced their "obbrobrio" (opprobium), which may imply that they are also implicated in sodomy. See *Purgatorio* 26.82–84. For discussion of "hermaphrodite" as a category that could be applied to sodomites, see Boswell, "Dante and the Sodomites"; Cadden, *Meanings of Sex Difference*, 224–25.

77. M. Rubin, "Person in the Form," 101–3.

78. Ricks, "Metamorphosis in Other Words."

79. John Gower, *Confessio Amantis* (Westminster: William Caxton, 1483). On the possibility that the surviving manuscript of Caxton's Ovid was made from a printed source, see Caxton, *Book of Ovyde Named Metamorphose*, ed. Moll, 43–45.

80. Gower, *Confessio Amantis*, ed. Peck, 4.479–87. For discussions of Gower's version of the story, see Dinshaw, *Getting Medieval*, 10–11; Gallacher, *Love, the Word, and Mercury*, 67–68; Lochrie, *Covert Operations*, 213–16; Watt, *Amoral Gower*, 73–75; Woolf, "Moral Chaucer and Kindly Gower," 225.

81. B. Brown, "Thing Theory," 3–5. For intersections between thing theory, anthropology, and the medieval life of things, see Robertson, "Medieval Things."

82. B. Brown, "Thing Theory," 4.

83. Ibid., 16.

84. Guercia's fate was to be banished. Archivio di Stato di Bologna, Comune, Curia del Podestà, Accusationes 16 b, 20 (Liber bannitorum pro maleficia), 1r (notification and ban); Archivio di Stato di Bologna, Comune, Curia del Podestà, Libri inquisitionum et testium 33 I, 33r–35r (inquest). Transcription in Lansing, "Donna con Donna?" 117–19.

85. Stadtarchiv Speyer, 1 A 704/II, 12r–14r. Transcription and translation in Puff, "Female Sodomy," 57–61. It is worth stressing also the nonpenile aspects to Hetzeldorfer's masculine performance, on which see Simons, *Sex of Men*, 35, 217. Bennett catalogues fifteen known criminal accusations concerning sexual relations between women from before 1500, including the above-cited cases. See Bennett, *History Matters*, 191–92n11.

86. Lochrie, *Heterosyncrasies*, 72–99, responding to Traub, *Renaissance of Lesbianism*, 87–89, 190–226, and Park, "Rediscovery of the Clitoris," 171–93.

87. Guilielmus de Saliceto, *Summa conservationis et curationis* 168, quoted in Lochrie, *Heterosyncrasies*, 83–4.

88. *OM* 9.3190–396; Boer, *Ovide moralisé en prose*, 253. The *Ovidius moralizatus* also presents a comparable interpretation, treating the goddess Isis as a figure for the Virgin, who effects salvation by turning Telethusa's girl (who represents evil) into a boy (who represents good).

See Berchorius, *Reductorium morale ii–xv*, 146; Berchorius, *Ovidius moralizatus*, trans. Reynolds, 344.

89. For discussions of the verse *Ovide moralisé* moralizations, see Blumenfeld-Kosinski, *Reading Myth*, 121; Blumenfeld-Kosinski, "Scandal of Pasiphae," 318–19; Hult, "Allégories de la sexualité," paragraph 26; Leibacher-Ourard, "Divergences et *Queeriosités*," 16–17.

90. Hincmar of Reims, *De divortio Lotharii et Tetbergae*, in Migne *PL* 125:693a. See also Benkov, "Erased Lesbian," 104–5; Matter, "My Sister, My Spouse," 89; Murray, "Twice Marginal," 198. Boswell and Murray interpret Hincmar's statement, which occurs in a treatise on divorce, as a rare reference to "lesbianism," but in fact, as the reference to "fornication against their own bodies" implies, he could also be talking about masturbation.

91. "Si sanctaemoniales cum sanctaemoniale per machinam, annos vii"; *Penitential of "Bede"* 3.24, quoted in Payer, *Sex and the Penitentials*, 172n136, and discussed in Frantzen, *Before the Closet*, 177. See also the *Penitential of Theodore*, discussed in Murray, "Twice Marginal," 197–98.

92. Burchard of Worms, *Decretum* 17.28 in Migne *PL* 140:924c–924d. For background on the *Decretum*, see Payer, *Sex and the Penitentials*, 81–83. Peter Damian is not interested in targeting women in his letter to Pope Leo but reproduces some of Burchard's rhetoric regarding demonic artifice, describing the four species of sodomy as being a product of "artifex diaboli machinatio" (the devil's artful fraud). See Peter Damian, "Letter 31," ed. Reindel, 288; Peter Damian, *Book of Gomorrah*, trans. Payer, 29.

93. "Fecisti quod quaedam mulieres facere solent, ut faceres quoddam molimen aut machinamentum in modum virilis membri, ad mensuram tuae voluntatis"; Burchard of Worms, *Decretum* 19.5 in Migne *PL* 140:971d–972a. See Matter, "My Sister, My Spouse," 90. For another, much-discussed literary reference to female homoeroticism, which can imagine such relations only with reference to a spectral but absent phallus, see Etienne de Fougères's *Livre de manières* (ca. 1174). As discussed in Amer, *Crossing Borders*, 29–49, the poem draws on a corpus of imagery also found in Arabic erotic manuals. Blumenfeld-Kosinski links the "historial sentence" in the *Ovide moralisé* fable of Iphis to Etienne's *Livre*: see "Scandal of Pasiphae," 319. See also R. L. A. Clark, "Jousting without a Lance"; Karras, *Sexuality in Medieval Europe*, 110; Murray, "Twice Marginal," 205, 210. Dildo-like devices, often capable also of holding fluids, survive from the early sixteenth century and later: see Simons, *Sex of Men*, 214–18.

94. More details of Pasiphaë are provided in Ovid's *Ars amatoria* 1.295–326, which includes references to the queen's jealousy toward cows, whom she sees as love rivals, as well as her vain attempts to woo the bull with her appearance. See Ovid, *Art of Love*, trans. Mozley, 32–35. The amplified discussion in the verse *Ovide moralisé* draws on details in this and other accounts, including that of the first-century mythographer Hyginus, in *Fabulae* 40, and Apollodorus (or pseudo-Apollodorus), in *Bibliotheca* 3.1.4. Although Apollodorus was a Greek scholar of the second century BCE, the latter is a work that probably dates to the second century CE. See *Myths of Hyginus*, trans. and ed. Grant, 53; Apollodorus, *Library*, trans. Frazer, 1:304–5. Alan of Lille has Nature cite Pasiphaë's union with the bull as a "bestial parody of marriage" in *De planctu Naturae* 8.70–72.

95. For instance Salmacis, the nymph who pursues Hermaphroditus in the fountain, is interpreted first as a woman who adorns herself with makeup and traps men (*OM* 4.2250–81), and then as a figure of worldliness (*OM* 4.2282–2389), manifestations of which include "biautez fainte, contre nature" (fake beauty, against nature) (*OM* 4.2289).

96. Ovid's *Ars amatoria* 325 makes only brief reference to the use of a device. More details are found in Hyginus, *Fabulae* 40, and Apollodorus, *Bibliotheca* 3.1.4. For analysis of the *Ovide moralisé* poet's textual amplification of the Ovidian Pasiphaë, see Blumenfeld-Kosinski, "Scandal of Pasiphae"; Hult, "Allégories de la sexualité," paragraphs 35–36. Illustrated versions of

the versified *Ovide moralisé* depict Pasiphaë, at the moment she encounters the bull, as either an embodied woman or a woman in the process of metamorphosing physically into a cow, thus apparently eliminating any signs of artifice. But the Arsenal image, which represents Pasiphaë with a human upper torso but the body of a cow, could be depicting her *disguised* as a cow rather than metamorphosing corporeally into one, so it is possible that it acknowledges the presence of engineered sex. See Rouen, Bibliothèque municipale MS O.4 (1044), fol. 204v; Paris, Bibliothèque de l'Arsenal MS 5069, fol. 109r. For discussions of these and other illustrations of the Pasiphaë story, including an image of her in an illustrated manuscript of Christine de Pizan's *Othea*, see Desmond and Sheingorn, *Myth, Montage, and Visuality*, 137-42.

97. Iphis's reference in *Metamorphoses* 9.744 to how even Daedalus, with his "artibus," is unable to change her nonetheless raises the possibility that artifice might indeed enable a woman to penetrate her companion, as well as acknowledging the craftsman's ability to help Pasiphaë. See Leibacher-Ourard, "Divergences et *Queeriosités*," 16. In addition to this piling up of references to thing-oriented desire in the Iphis story, it is also worth remembering that book 10 of *Metamorphoses* includes what is surely the most influential discussion of objectification and bodily substitution in the Ovidian tradition: that of Pygmalion's love for a statue.

98. The myth is summarized in Mojsov, *Osiris*, xix-xx. See also Goux, "Phallus," 43. In *Metamorphoses* 9.693 Ovid mentions that Osiris is in Isis's company when she appears to Telethusa, describing him as the one for whom she endlessly searches ("numquamque satis quaesitus Osiris"). The Osiris myth was also transmitted to the Middle Ages via the fifth-century author Martianus Capella. See Martianus Capella, *De nuptiis Philologiae et Mercurii* 1.4, ed. Willis, 3.

99. Boer, *Ovide moralisé en prose*, 253.

100. Boone, "State Power," 142, 151n62.

101. Ibid., 138, 145.

102. Ibid., 149-50. On Caxton's three decades in the Low Countries, see Caxton, *Book of Ovyde Named Methamorphose*, ed. Moll, 4-5.

103. For an overview of what she terms the Iphis legend's "tribadic gloss," as well as what is interpreted as a mode of heteronormative fixing in postmedieval adaptations, see Leibacher-Ourard, "Divergences et *Queeriosités*." On early modern retellings, see also D. Robinson, "Metamorphosis of Sex(uality)." On Caxton's approach to translation, see Caxton, *Book of Ovyde Named Metamorphose*, ed. Moll, 27-36.

104. In this, the medieval moralized Ovids follow ancient Roman sources, which similarly locate female homoeroticism and gender variance outside of contemporary reality by rendering such possibilities Hellenistic and anachronistic. See Hallett, "Female Homoeroticism." On Caxton's own efforts to dispatch the sodomitical consequences of the tale to history, see also Oakley-Brown, *Ovid and the Cultural Politics of Translation*, 176.

105. For overviews of the illuminated *Ovide moralisé* manuscripts, see Lord, "Three Manuscripts"; Lord, "Survey of Imagery," 261-70; Rabel, "L'illustration de 'l'Ovide moralisé.'" For an analysis of the illustrations in the context of a general survey of *Ovide moralisé* manuscripts, see Jung, "Ovide, texte, translateur et gloses."

106. C. de Boer's edition of the verse *Ovide moralisé* is based on this manuscript.

107. Lord, "Marks of Ownership." The manuscript was subsequently inscribed with the arms of Aymar of Poitiers, who also came into possession of français 166, one of the *Bibles moralisées* discussed in chapter 1. See Dupic, "Ovide moralisé MS du XIVe siècle," 5.

108. Lord ("Three Manuscripts," 164) argues that the Arsenal Master is "more creative" and "freely invented the majority of scenes." See also Blumenfeld-Kosinski, "Illustrations et interprétations"; Lord, "Survey of Imagery," 270 and n18. On the differences and similarities between the miniatures in Arsenal 5069 and Rouen O.4, and the possibility of a lost archetype for both, see Lord, "Three Manuscripts," 163-68.

109. Although the male is not tonsured, Blumenfeld-Kosinski ("Illustrations et interprétations," paragraph 11 and n16) thinks his dress implies clerical status.

110. Christine de Pizan's husband was Etienne de Castel (d. 1390). In my discussion of *Le livre de la mutacion de Fortune*, I deploy male third-person pronouns when referring to the poetic persona Christine, in keeping with the narrator's self-presentation as a man. This follows the practice of some critics such as Thompson in "Medea in Christine de Pizan's *Mutacion de Fortune*." Other discussions include Blumenfeld-Kosinski, *Reading Myth*, 178–87; Brownlee, "Widowhood, Sexuality, and Gender"; L. J. Walters, "Fortune's Double Face."

111. Christine de Pizan, *Livre de la mutacion de Fortune*, ed. Solente, 1:141–56. Subsequent references to this edition are provided in the main body of the text by line number. Translations are from Christine de Pizan, *Book of Fortune's Transformation*, trans. Brownlee.

112. For Christine's representations of maternity elsewhere in the text, see Thompson, "Medea in Christine de Pizan's *Mutacion de Fortune*."

113. For discussions of Christine's "desexualization" of both the Iphis and Tiresias stories, see Blumenfeld-Kosinski, *Reading Myth*, 178–86; Leibacher-Ourard, "Divergences et *Queeriosités*," 18–19. As Blumenfeld-Kosinski points out, while Christine omits the negative moral interpretations of Iphis that first circulated in the verse *Ovide moralisé*, such readings are nonetheless present as an intertext.

114. In the Hetzeldorfer trial, two female witnesses, with whom Hetzeldorfer was said to have "had her ways," were subjected to the relatively mild punishment of banishment. See Puff, "Female Sodomy," 45. See also Benkov, "Erased Lesbian," 111–14; Cadden, *Meanings of Sex Difference*, 224; Traub, *Renaissance of Lesbianism*, 182.

115. Watt, "Behaving Like a Man?," 270–71, discusses the ramifications of this and another buggery reference earlier in the text, which contrasts it with the worse sin of incest. See also Amer, *Crossing Borders*, 56, 65–71.

116. Pucci's *Reina d'Oriente* devotes even more space to the union of the protagonists: the relationship between the female-born "King" of the Orient and the Princess of Rome to whom s/he is married endures for two more years, "amando l'una l'altra d'amor fino" (the one loving the other with courtly love), before the "King" changes sex. See Robins, "Three Tales," 54–57.

117. Brownlee, "Widowhood, Sexuality, and Gender," 341.

118. In the *envoi* at the conclusion of the poem, Christine thus makes reference to 2 Corinthians 12:2–12, where Paul refers to a certain "man in Christ" whose weaknesses are his strengths, and sees in this man a model for how he himself will glory in his infirmities, "that the power of Christ may dwell in me." See Thompson, "Medea in Christine de Pizan's *Mutacion de Fortune*," 165–67.

119. Brownlee, "Widowhood, Sexuality, and Gender."

120. Ali Smith, *Girl Meets Boy*. Subsequent references are provided in the main body of the text.

121. The phrase is Butler's. See Butler, *Undoing Gender*, 143, discussing Brandon Teena and the film *Boys Don't Cry* (1999).

122. This is not to deny the affective and political stakes in reclaiming FTM trans history as distinct from lesbian history—ably explored in Jason Cromwell, "Passing Women and Female-Bodied Men"—but simply to highlight how both modes of making history are inflected by a visibility politics that is situated on a fault line between "gender" and "sexuality."

Chapter 3

1. Segal, *Orpheus*, 1–10; Robbins, "Famous Orpheus."

2. Detienne, *Writing of Orpheus*, 152–64.

3. Segal, *Orpheus*, 118–98.

4. Guthrie, *Orpheus and Greek Religion*; J. B. Friedman, *Orpheus in the Middle Ages*, 13–37.

5. For an overview, see Semmelrath, *Der Orpheus-Mythos*, 4–14.

6. Guthrie, *Orpheus and Greek Religion*, 1; Lee, *Virgil as Orpheus*, 3–4; Robbins, "Famous Orpheus," 5.

7. Hyginus, *Fabulae* 14, in *Myths of Hyginus*, ed. Grant, 34, 37; Hyginus, *Poetica astronomica*, 2.7, in *Myths of Hyginus*, ed. Grant, 191.

8. Guthrie, *Orpheus and Greek Religion*, 39–40; Lee, *Virgil as Orpheus*, 1–8; Segal, *Orpheus*, 8–10.

9. Virgil, *Georgics* 4.453–527, in Virgil, *Eclogues, Georgics, Aeneid I–IV*, trans. Fairclough, 250–57. On the innovations introduced by Virgil to the legend, see Lee, *Virgil as Orpheus*, 9–13, 111–22; Segal, *Orpheus*, 20–24, 36–53.

10. Ovid also cites Orpheus in *Ars amatoria* 3.321–22, but as the exemplary artist who tames stones and animals with his lyre rather than as a lover. See *Art of Love*, trans. Mozley, 140–41.

11. Anderson, "Orpheus of Virgil and Ovid."

12. Segal, *Orpheus*, 54–94.

13. The earliest such reference appears in a fragment by the Alexandrian poet Phanocles (*Erotes e kaloi*, in *Collectanea Alexandrina*, ed. Powell, 107), which remembers Orpheus as the lover not of Eurydice but of a male youth and fellow Argonaut called Calais; the women of Thrace murdered Orpheus both because he was the "first" among the Thracian men to show male loves and because he failed to praise love for women. Hyginus, whose writings drew like *Metamorphoses* on Alexandrian sources, also attributes the reason for Orpheus's death to the fact that, as well as insulting women, he "first favored love for youths" in his *Poetica astronomica* 2.7 (*Myths of Hyginus*, ed. Grant, 192). The surviving texts of this and Hyginus's other mythological collection, the *Fabulae*, are much-abridged versions of Hyginus's original compositions. For overviews of these and other references to Orpheus's pederastic activities, see Bein, "Orpheus als Sodomit," 50–51; Bremmer, "Orpheus," 17–23; Makowski, "Bisexual Orpheus"; Ziogas, *Ovid and Hesiod*, 148–54.

14. I echo here a formulation in Puff, "Orpheus after Eurydice," 77.

15. Responses to the Orpheus myth in medieval mythography are summarized in J. B. Friedman, *Orpheus in the Middle Ages*, 86–145; Semmelrath, *Der Orpheus-Mythos*, 15–25.

16. Boethius, *Consolation of Philosophy* 3.12, ed. and trans. Stewart, Rand, and Tester, lines 47–48, 55–58. Translation in Boethius, *Consolation of Philosophy*, ed. Langston, 57.

17. Quoted in J. B. Friedman, *Orpheus in the Middle Ages*, 106.

18. J. B. Friedman, *Orpheus in the Middle Ages*, 117. For a counterargument, which characterizes Friedman's confidence in this statement as "very much misplaced," see Holsinger, *Music, Body, and Desire*, 295–343. For another summary of medieval and Renaissance responses, see Crawford, *Sexual Culture of the French Renaissance*, 23–66. Crawford contrasts the "hegemony of Medieval Christian ethics" (24) with efforts in the French Renaissance to elide Orpheus's "messy sexuality" (62) by excising all reference to sodomy and foregrounding his role only as a good husband. The various textual traditions are ably summarized, but I find Crawford's insistent periodizing, registered in such statements as that there was a "Medieval consensus on most things sexual" (24), a "Medieval Orpheus" (40), and a "Medieval Christian box" (42), unhelpful. There was no single "medieval" response to Orpheus; indeed some of the trends Crawford identifies as features of a sixteenth- and seventeenth-century "Renaissance"—notably efforts to expurgate references to Orpheus's pederastic turn and to emphasize instead his role as a lover and husband—were already present in fourteenth- and fifteenth-century treatments.

19. J. B. Friedman, *Orpheus in the Middle Ages*, 39–49; Guthrie, *Orpheus and Greek Religion*, 261–71. Orpheus as civilizer and tamer of animals was also usually the image of him projected

in public cathedral sculpture in the later Middle Ages. See Pressouyre, "St. Bernard to St. Francis," 82.

20. Jourdan, *Orphée et les chrétiens*. See also J. B. Friedman, *Orpheus in the Middle Ages*, 53–55; Irwin, "Songs of Orpheus."

21. Dronke, "Return of Eurydice"; J. B. Friedman, *Orpheus in the Middle Ages*, 146–210; Louis, "Robert Henryson's *Orpheus and Eurydice*"; Vicari, "*Sparagmos*."

22. Berchorius, *Reductorium morale ii–xv*, 147; Berchorius, *Ovidius moralizatus*, trans. Reynolds, 347.

23. Astell, *Song of Songs*; Matter, *Voice of My Beloved*.

24. Berchorius, *Reductorium morale ii–xv*, 147; Berchorius, *Ovidius moralizatus*, trans. Reynolds, 347.

25. Berchorius, *Reductorium morale ii–xv*, 148–49; Berchorius, *Ovidius moralizatus*, trans. Reynolds, 348–50.

26. Guillaume de Machaut, *Le confort d'ami*, ed. and trans. Palmer, lines 2585–90. For discussions of Machaut's references to Orpheus in this and other works, see Blumenfeld-Kosinski, *Reading Myth*, 143–48; Holsinger, *Music, Body, and Desire*, 321–26.

27. Christine de Pizan, *Epistre Othea* 67.17–18, quoted in Desmond and Sheingorn, *Myth, Montage, and Visuality*, 111. See also Semmelrath, *Der Orpheus-Mythos*, 34–36.

28. Desmond and Sheingorn, *Myth, Montage, and Visuality*, 111.

29. Blumenfeld-Kosinski, *Reading Myth*, 111.

30. See Holsinger, *Music, Body, and Desire*, 316–20.

31. For further discussion of the various moralizations of Orpheus in the *Ovide moralisé*, see Blumenfeld-Kosinski, *Reading Myth*, 94–96; Caxton, *Book of Ovyde Named Methamorphose*, ed. Moll, 17–19; Desmond and Sheingorn, *Myth, Montage, and Visuality*, 101–3; Holsinger, *Music, Body, and Desire*, 312–21; Kay, *Place of Thought*, 64–67; Possamaï-Pérez, *L'Ovide moralisé*, 337–41, 417–22, 451–53, 579–80; Semmelrath, *Der Orpheus-Mythos*, 26–30.

32. In this, the *Ovide moralisé* poet follows Ovid's warning in *Metamorphoses* 10.300–302 not to believe the story, except that Ovid targets fathers as well as daughters. On the various interpretations, see Blumenfeld-Kosinski, *Reading Myth*, 95–98; Possamaï-Pérez, *L'Ovide moralisé*, 419–20, 453. Myrrha is also cited by Nature as an example of Venus's *falsigraphia* in Alan of Lille's *De planctu Naturae* 8.72–74.

33. See also the reference to the incarnation as "jointure" in the interpretation of Orpheus's song: *OM* 10.2600–2605.

34. On the category of "jointure" in the text, see Hult, "Allégories de la sexualité," paragraphs 31–41. On the poet's unity-within-diversity approach to allegorization, see Kay, *Place of Thought*, 42–69.

35. Hult, "Allégories de la sexualité," paragraph 33. God's disdain for "femeline nature" is also emphasized in the "meillour sentence" attached to the Iphis legend: see *OM* 9.3202.

36. Quoted in Bein, "Orpheus als Sodomit," 34–35. See also Tervooren and Bein, "Ein neues Fragment."

37. Bein, "Orpheus als Sodomit," 35–37.

38. Puff, *Sodomy in Reformation Germany*, 23–30.

39. The metaphor of being "harped" may have persisted into the sixteenth century: the right-hand panel of Hieronymous Bosch's *Garden of Earthly Delights* (ca. 1490–1510) features, among the sinners in hell, a man being played like a harp, which could be an allusion to sodomy. For other possible sodomitical references in Bosch's painting, see Holsinger, *Music, Body, and Desire*, 253–55; Myers and Dynes, *Hieronymous Bosch*, esp. 42, 45, 48, 88, 90; Saslow, *Pictures and Passions*, 78.

40. For the Boethian connection, see Ziolkowski, *Alan of Lille's Grammar of Sex*, 9.

41. "Explicit Alanus pereat sodomita prophanus." The line is ambiguous. It could be referring to the sodomites who are the target of the preceding text, or to Alan himself as a *sodomita prophanus*, on which possibility see Rollo, *Kiss My Relics*, 216–17. For another discussion of the colophon see Guynn, *Allegory and Sexual Ethics*, 96–97; on Alan's text as an act of "writing the self," see Burgwinkle, *Sodomy, Masculinity, and Law*, 193. Even if, as Rollo and others have argued (convincingly in my view), *De planctu* is a profoundly ironic work, which ultimately aligns the author with the very deviance his creation decries, later medieval commentators viewed the text as a tool in campaigns against the practice, and this "homophobic" deployment is what concerns me here. Alan's text may even have influenced the ruling of the Third Lateran Council in 1179 (which Alan attended) against those who commit "that incontinence which is against nature," on which see Scanlon, "Unspeakable Pleasures," 217–18, 238. At the same time, as Häring points out in his edition of *De planctu*, the greatest number of extant manuscripts were produced in the fourteenth and fifteenth centuries, and it was initially "rather slow in winning publicity"; Holcot's appreciative comments are cited as an example of the text's belated afterlife. See Alan of Lille, *De planctu Naturae*, ed. Häring, 802.

42. This analogy is generated by virtue of a triple homophony, which also takes in the verb *rimatur*. For other examples of sexual wordplay in retellings of the Pyramus and Thisbe legend, see Delany, *Naked Text*, 127–32. Further wordplay is discussed in Rollo, *Kiss My Relics*, 99–100.

43. Statius, *Achilleid* 1.318–78, 718–884, in *Thebaid, Books 8–12, Achilleid*, ed. and trans. Bailey, 336–41, 366–79. For discussion of the "trans-sexualizing" effects of Achilles's cross-dressing, see Schibanoff, *Chaucer's Queer Poetics*, 128–29. Alan also invokes the cross-dressing Achilles again in his *Anticlaudianus*. See Alan of Lille, *Anticlaudianus* 8.5.56–60, ed. Wright, 421.

44. Much discussion has centered, in recent years, on the irony that Nature's moralizing language is itself permeated by deviance and desire, or even that she herself is an androgynous figure. See Burgwinkle, *Sodomy, Masculinity, and Law*, 170–199; Guynn, *Allegory and Sexual Ethics*, 93–135; Jordan, *Invention of Sodomy*, 70–72; Rollo, *Kiss My Relics*, 77–142; Scanlon, "Unspeakable Pleasures," 220–29; Schibanoff, "Sodomy's Mark," 28–56. Guynn and Rollo also discuss how even Alan's narrator-protagonist himself takes on female attributes, dreaming of being, in Rollo's words, "precisely the hermaphrodite he accuses others of becoming" (*Kiss My Relics*, 103). For interpretations of *De planctu* as more straightforwardly homophobic, see Boswell, *Christianity, Social Tolerance, and Homosexuality*, 310–12; Keiser, *Courtly Desire*, 71–92.

45. Discussions of this particular passage on Orpheus in *De planctu* include Guynn, *Allegory and Sexual Ethics*, 116–19; Rollo, *Kiss My Relics*, 80–81; Scanlon, "Unspeakable Pleasures," 225–26; Sturges, *Chaucer's Pardoner and Gender Theory*, 137.

46. On the grammatical dimensions to Alan's hammer-and-anvil imagery, see Ziolkowski, *Alan of Lille's Grammar of Sex*, 27–30. On the trope's contradictions, see Lochrie, "Heterosexuality," 44–45.

47. Guillaume de Lorris and Jean de Meun, *Roman de la Rose* 19539–40, 19543–44, ed. Lecoy, 3:87; Guillaume de Lorris and Jean de Meun, *Romance of the Rose*, trans. Dahlberg, 322, 323.

48. Guillaume de Lorris and Jean de Meun, *Roman de la Rose* 19610–26, 19639–42, 19653–56, ed. Lecoy, 3:89–91; Guillaume de Lorris and Jean de Meun, *Romance of the Rose*, trans. Dahlberg, 324. On the contradictions in Jean's metaphors of plowing and hammering, see Kay, "Sexual Knowledge," 74–75. On humor in the passage, see Huot, *Dreams of Lovers*, 76. On Jean's use of *De planctu Naturae*, see also Bein, "Orpheus als Sodomit," 54–55 (which discusses links between the German lyric ascribed to "Der Tugentschriber" and Orphic allusions in the *Rose*); Holsinger, *Music, Body, and Desire*, 300–301; Keiser, *Courtly Desire*, 113–33; Schibanoff, "Sodomy's Mark"; Wetherbee, "Literal and the Allegorical."

49. Jean de Meun, "Boethius' *De Consolatione*," ed. Dedeck-Héry, 232–33.

50. *Li livres de jostice et de plet* 18.24.22, cited in Boswell, *Christianity, Social Tolerance, and Homosexuality*, 290n58. As Boswell notes, this was a privately issued code and is not necessarily indicative of legal practice. On Jean's general preoccupation with dismemberment, see Hult, "Language and Dismemberment," 101–30.

51. On historical contexts for Guillaume de Lorris's and Jean de Meun's respective attitudes to sexual ethics, see Moran, "Literature and the Medieval Historian." On Jean's ironic distortion of Alan's language, see Kay, "Sexual Knowledge." On Jean's role as a translator of Alan's Genius, and the place of Orpheus within this act of creative transposition, see Morton, "Queer Metaphors and Queerer Reproduction." For a view that Bel Acueil is a personification of the *falsigraphia* condemned by *De planctu*, see Rollo, *Kiss My Relics*, 174–75, 201–13. For an argument that by suppressing Orpheus's identity in *Metamorphoses* as a *vates* and highlighting only his pederasty, Jean wishes to present himself as a new, vernacular Orpheus, see Brownlee, "Orpheus' Song Re-sung," 201–9. For an alternative view, which sees Orpheus's relevance to the *Rose* as extending beyond the specific reference to nonreproductive sexual behavior, since the poem is also haunted by allusions to the Boethian backward glance, see Huot, *Dreams of Lovers*, 55–82. Another significant transfiguration of Orpheus in medieval literature is Chaucer's Pardoner: as well as being renowned for his verbal eloquence and skills of manipulation, and associated with the promise of victory over death, he too is associated metaphorically with sodomy. On this and other Chaucerian allusions to Orpheus, which draw in turn on the depiction of him in the *Rose*, see Calabrese, "'Make a Mark That Shows'"; Rollo, *Kiss My Relics*, 226–34; Sturges, *Chaucer's Pardoner and Gender Theory*, 107–39.

52. For the question of Jean's influence on the verse *Ovide moralisé*, see Copeland, *Rhetoric, Hermeneutics, and Translation*, 119–22; Hult, "Allégories de la sexualité," paragraphs 2–5.

53. Boer, *Ovide moralisé en prose*, 257.

54. Ibid., 267–68.

55. Ovid, *Bible des poëtes* (Bruges: Colard Mansion, 1484), book 10. For the *Ovide moralisé en prose II*, see Jung, "Ovide métamorphose en prose," 106; Caxton, *Book of Ovyde Named Metamorphose*, ed. Moll, 565–68.

56. On the identity of the author, see Hult, "Allégories de la sexualité," paragraphs 2–3; Possamaï-Pérez, *L'Ovide moralisé*, 717–88. Possamaï-Pérez makes a lengthy case for the Franciscan connection. On links between interpretations of Orpheus's turn to males as a figure for celibacy and the all-male clerical circles in which Ovidian poetry thrived from the twelfth century, see Puff, "Orpheus after Eurydice," 77.

57. Arnulf of Orléans, *Allegoriae super Ovidii Metamorphosen* 10, quoted in J. B. Friedman, *Orpheus in the Middle Ages*, 120–21. See also Bein, "Orpheus als Sodomit," 51.

58. Giovanni del Virgilio, *Allegoriae librorum Ovidii Metamorphoseos* 11, quoted in J. B. Friedman, *Orpheus in the Middle Ages*, 123. See also Bein, "Orpheus als Sodomit," 52; Holsinger, *Music, Body, and Desire*, 310.

59. Jaeger, "Orpheus in the Eleventh Century."

60. Guthrie, *Orpheus and Greek Religion*, 33, 64–65n8.

61. A version of Mansion's text with revised spellings, the *Bible des poëtes* (Paris: Antoine Vérard, 1493), features a comparable scene. For further discussion of the Mansion woodcut, including its "almost comical" treatment of the subject, see Panofsky, *Life and Art of Albrecht Dürer*, 32.

62. On associations between the harp or lyre and sexual stimulation, see Simons, *Sex of Men*, 243.

63. Boone, "State Power," 145. As Boone notes, this represents a dramatic increase in convictions compared with previous decades.

64. For further discussion of the Orpheus miniatures in Rouen O.4 and other illuminated *Ovide moralisé* manuscripts, see Desmond and Sheingorn, *Myth, Montage, and Visuality*, 103–8;

Rabel, "L'illustration de 'l'Ovide Moralisé,'" 83–114. Orpheus-related illustrations in medieval manuscripts are catalogued in Semmelrath, *Der Orpheus-Mythos*, 184–87.

65. The scene is discussed in Rabel, "L'illustration de 'l'Ovide Moralisé,'" 103–4.

66. Lord, "Three Manuscripts," 162, suggests that the thirteenth-century *Bibles moralisées* influenced the *Ovide moralisé*. The general pattern of finding the New Testament and the doctrine of incarnation prefigured in Ovid's stories, which are bent into shape by the allegorical readings, has a counterpart in the *Bibles moralisées*, where, as discussed in chapter 1, the Bible—like *Metamorphoses*—is subjected to a substitutive procedure whereby the "source" text is displaced by the moralizing content. I have not found substantial evidence of direct iconographic borrowings from the *Bibles moralisées* in illustrated *Ovide moralisé* manuscripts, but the miniature of Orphic pederasty in Rouen O.4 bears comparison with *Bible moralisée* scenes of age-differentiated relations between males.

67. For visual images of the kiss of peace, see Carré, *Le baiser sur la bouche*, 153–215 and figs. 44–52. In general, see also Camille, *Medieval Art of Love*, 133–40; Camille, "Gothic Signs"; Harvey, *Kiss in History*; Perella, *Kiss Sacred and Profane*.

68. Aelred of Rievaulx, *De spiritali amicitia* 2.21–27, in *Opera omnia*, ed. Hoste and Talbot, 1:306–8; Aelred of Rievaulx, *Spiritual Friendship*, trans. Williams, 47.

69. Aquinas, *Summa theologiae* 2-2.154.4.

70. Gaunt, "Bel Acueil and the Improper Allegory." For another illuminating analysis of the sexual indeterminacies of the *Rose*, which draws on Gaunt's analysis, see Rollo, *Kiss My Relics*, 145–213.

71. For discussion of this miniature and the accompanying text, see Gaunt, "Bel Acueil and the Improper Allegory," 83–84. Camille, *Medieval Art of Love*, 139–40, also discusses another homoerotic scene in a *Rose* manuscript—Oxford, Bodleian Library, MS Douce 195, fol. 15v, reproduced as fig. 126—which depicts the God of Love Amor embracing Amant.

72. Bein, "Orpheus als Sodomit," 36. This second depiction of Orpheus as a seducer of males in Rouen O.4 is discussed in Desmond and Sheingorn, *Myth, Montage, and Visuality*, 105.

73. Blumenfeld-Kosinski, "Illustrations et interprétations," paragraph 3; Lord, "Three Manuscripts," 169.

74. The artist has been identified as the Master of the *Policratique*. See Drobinsky, "La narration iconographique."

75. For Lydgate's version of the Orpheus legend, see Holsinger, *Music, Body, and Desire*, 334–40. Illustrations in London, British Library, Harley MS 1766, a mid-fifteenth-century manuscript of Lydgate's text, show Orpheus happily playing his harp to Eurydice on one folio (76r), while over the page he is shown being attacked by three women with oversized spindles (76v); although, as Holsinger argues, Lydgate exploits the homosocial implications of Orpheus's return from hell for political reasons, no explicit mention is made in the poem or its accompanying illustrations of Orphic pederasty. See also the illuminated copy of Christine de Pizan's *Epistre Othea* in London, British Library, Harley MS 4431, fol. 126v (ca. 1410–15), which focuses on the happy ending. Both this and one of the *Fall of Princes* manuscripts are discussed in J. B. Friedman, *Orpheus in the Middle Ages*, 170, 175 and figs. 24, 29. One of the *Ovide moralisé en prose II* manuscripts, Royal MS 17.E.iv, fol. 155r, features a similar scene. For other images of Orpheus in illustrated *Epistre Othea* manuscripts, see Desmond and Sheingorn, *Myth, Montage, and Visuality*, 108–11; Semmelrath, *Der Orpheus-Mythos*, 35–36 and figs. 7–8.

76. Puff, "Orpheus after Eurydice."

77. Panofsky, *Life and Art of Albrecht Dürer*, 32.

78. Warburg, "Dürer and Italian Antiquity," 553, 555. See further Hurttig, *Antiquity Unleashed*.

79. Wind, "'Hercules' and 'Orpheus.'" Warburg thought that the so-called "Hercules" engraving had been "wrongly identified" as such ("Dürer and Italian Antiquity," 555), and interpreted it instead as an image of "Jealousy." Wind, identifying it as indeed showing Hercules,

but as a coward rather than a hero, argues that Hercules himself—in common with Orpheus in the earlier drawing, which also includes the motif of a little boy running away—is being depicted as a pederast: "The association of Hercules with the vice of pederasty had an even more impressive mythographical record than Orpheus himself could boast" (214). Italian humanist interest in Orpheus was especially sparked by Angelo Poliziano's play *Le favole d'Orfeo*, first staged in Mantua in 1480.

80. Puff, "Orpheus after Eurydice," 80. For an overview of the drawing's critical fortunes in twentieth-century scholarship, see also Rosasco, "Albrecht Dürer's 'Death of Orpheus.'"

81. On the drawing's "personal" significance to Dürer, in light of Orpheus's role as an exemplary victim-artist, see Puff, "Violence, Victimhood, Artistry." On issues of originality, imitation, and transformation, see Koerner, "Albrecht Dürer."

82. For a larger argument in this regard, see especially the reassessments in Hess and Eser, *Early Dürer*.

83. Panofsky, *Life and Art of Albrecht Dürer*, 61 and fig. 89; Puff, "Violence, Victimhood, Artistry," 67.

84. Panofsky, *Life and Art of Albrecht Dürer*, 31-32; Puff, "Orpheus after Eurydice," 73, 80; Puff, "Violence, Victimhood, Artistry," 64; Warburg, "Dürer and Italian Antiquity," 552. For an argument that the print is likely to have acted as Dürer's source, independent of any hypothesized "lost" original by Mantegna, see Alistair Smith, "'Germania' and 'Italia,'" 280.

85. Semmelrath, *Der Orpheus-Mythos*, 66-73 and figs. 19-23; Welles, "Orpheus and Arion."

86. On the details of Dürer's hypothesized first trip to Italy, see Hutchison, *Albrecht Dürer*, 40-47; Böckern, "Young Dürer and Italy." For counterarguments, reassessments, and revisions, see Eser, "Different Early Dürer," 24-28; Luber, *Albrecht Dürer*; Alistair Smith, "'Germania' and 'Italia'"; Robert Smith, "Dürer, Sexuality, Reformation"; Wolf, *Dürer*, 50-54.

87. For the Pentheus identification, see Armstrong, *Paintings and Drawings of Marco Zoppo*, 282-87; Tietze-Conrat, "Intorno ad un disegno." On the case for it as a depiction of the death of Orpheus, see Roesler-Friedenthal, "Ein Porträt Andrea Mantegnas," 178-79. On the similarities between the compositions see also Rosasco, "Albrecht Dürer's 'Death of Orpheus,'" 33-34. Zoppo also produced other images with sodomitical themes, including one showing *putti* playing in a fashion that alludes to anal penetration. See Wolfthal, *In and Out of the Marital Bed*, 172-73, 175-76, and figs. 126, 129.

88. It has even been suggested that the face of the man he looks at resembles that of Mantegna, which would make the *putto*'s backward glance a stand-in for Dürer's own: Mantegna himself is subjected, through this maneuver, to the dubious honor of being cast as an exemplary artist-sodomite. See Roesler-Friedenthal, "Ein Porträt Andrea Mantegnas," esp. 156-58. On Dürer's possible reasons for attributing to Mantegna an Orphic identification, see Puff, "Orpheus after Eurydice," 82-83. Puff's conclusion, that the drawing is "a work of translation, a translation that has not been completed and therefore brings to the fore the work of translation itself, a tension-prone process that arrests our gaze," is one with which I am in broad agreement. See also Puff, "Violence, Victimhood, Artistry," 64-65; and, on Dürer's participation in this period of his work in a mode of *aemulatio* (emulative competition) with other artists, see Porras, "Dürer's Copies."

89. Puff, "Orpheus after Eurydice," 73 and 86n8; Puff, "Violence, Victimhood, Artistry," 61, 71-72.

90. Puff, "Orpheus after Eurydice," 81.

91. Bremen, Kunsthalle. See Grosse, "The Nude"; Röver-Kann, *Albrecht Dürer, "Das Frauenbad"*; Smith, "Dürer, Sexuality, Reformation," 313-14.

92. See Grosse, "Nude"; Heard and Whitaker, *Northern Renaissance*, 81; Simons, *Sex of Men*, 272; Robert Smith, "Dürer, Sexuality, Reformation," 313; Wind, "Dürer's *Männerbad*"; Wolfthal, *In and Out of the Marital Bed*, 138; Woods, "Albrecht Dürer."

93. Another sketch sometimes included in discussions of Dürer's preoccupation with (homo)erotic themes depicts the artist's best friend, the humanist Willibald Pirckheimer of Nuremberg—who is often identified as the stout figure drinking from a tankard to the right in *Men's Bath*—accompanied by a snippet of ancient Greek, inscribed above the portrait using Dürer's own stylus but probably in Pirckheimer's hand, which can be translated as "with a cock in the ass." See *Portrait of Willibald Pirckheimer*, ca. 1503, Berlin, Staatliche Museen zu Berlin. For differing interpretations, see Gulden, "Nuremberg's Elites," 287; Woods, "Albrecht Dürer," 263.

94. Millett, *Ancrene Wisse*, 21, 22, 26. Subsequent references are to this edition, provided in the main body of the text by page number. Translations are my own but make use of the glosses in Hasenfratz, *Ancrene Wisse*.

95. For a feminist response to the story of Lot's wife, which I have found helpful in formulating these contrasts between her and Orpheus's acts of backward looking, see Haaken, *Pillar of Salt*, 1–7, 266–69.

96. Anselm of Laon et al., *Glossa ordinaria*, in Migne *PL* 113:132b. There is no standard critical edition of the Gloss, but while the textual tradition was fluid, it appears to stabilize around 1200. See Smith, *Glossa ordinaria*, 73–76.

97. For the influence of *Glossa ordinaria* interpretations on the *Bibles moralisées*, see Lowden, *Making*, 2. The influence varies between manuscripts, and between individual biblical books within those manuscripts. As Lowden points out in his analysis of the book of Ruth, the moralization texts represent a "complex of texts, sources, and piecemeal revisions" (*Making*, 2:8). The use of the Gloss in Toledo specifically is discussed in Reinhardt, "Texts of the 'Bible of Saint Louis,'" 289, 301.

98. Vienna 2554, fol. 5r; Vienna 1179, fol. 9v.

99. See also Toledo MS 1, vol. 1, fol. 15v; London, British Library, Additional MS 18719, fol. 7v; BnF français 167, fol. 7v; BnF français 166, fol. 7v.

100. On chess as an erotic signifier in medieval art, see Camille, *Medieval Art of Love*, 107, 124, and figs. 93, 110. See also Adams, *Power Play*, 57–94, discussing the allegory *Les échecs amoureux* (ca. 1400).

101. Males with falcons in two fifteenth-century artworks, Petrus Christus's *Couple in a Goldsmith's Shop* (1449) and a drypoint print by the Housebook Master (ca. 1485), have been interpreted by Diane Wolfthal as references to same-sex desire: Wolfthal, *In and Out of the Marital Bed*, 166–85, and figs. 123, 124, 131. On the falcon more generally as an erotic signifier, see Camille, *Medieval Art of Love*, 94–99; M. Friedman, "Falcon and the Hunt."

102. In Genesis 19.8, when Lot problematically offers his daughters up to the Sodomites as an alternative, he refers to his houseguests as "these men" (*viris istis*). So he clearly identifies them as male and sees his female offspring as a more suitable alternative. But there is no clear evidence that the makers of the *Bibles moralisées* also saw the angels as youths, and that they therefore viewed the sodomy of Sodom specifically as a mode of age-differentiated desire. One possible exception to the beardless angel rule is fol. 11r of the Egerton Genesis (fig. 12), which shows in the upper register Abraham receiving three heavenly visitors with beards but wingless, as described in Genesis 18.2. Although the Vulgate describes Abraham's guests as three men (*tres viri*), the Anglo-Norman caption accompanying the illustration refers to them as "treis damisels" (three young men), who are "treis angels" (three angels). Thus it seems that the makers of the Egerton Genesis could envisage bearded males as "angels," just so long as the beards were not combined with wings. In the lower register of the same folio Lot bows before more conventionally beardless angels with short curly hair and feathered wings.

103. For an overview of depictions of the Lot's wife episode and its aftermath, see Caviness, *Visualizing Women*, 45–81; Rylands MS French 5 is discussed at 63–64. For an overview of the Manchester picture Bible, see Hull, "Rylands MS French 5."

104. The Sodomites' blindness is also illustrated in the Egerton Genesis, fol. 11v.

105. The Manchester picture Bible potentially condemns an additional mode of looking too: the stultified object at which the female Sodomite stares implicates her in idolatry, which was also occasionally a feature of other illustrations of the Lot's wife story. One image, illustrating a typological sequence in Lilienfeld, Stiftsbibliothek, MS 151, fol. 38v, shows Lot's wife staring back at a bust of herself on a pedestal, in a gesture described by Caviness as one of "narcissistic or homoerotic fascination" (*Visualizing Women*, 64).

106. The twelfth-century Scylla bowl in the British Museum includes a pair of scenes depicting the story of Orpheus and Eurydice, one of which shows Orpheus looking back as he exits hell playing his harp. As discussed in chapter 4, the bowl also represents the Ganymede myth (figs. 51, 52), though Orpheus's own turn to males is not explicitly visualized. A late fourteenth-century copy of Bersuire's *Ovidius moralizatus* from Padua—Bergamo, Biblioteca Civica CF.3.4—features, in the lower register of a drawing on fol. 108v illustrating the myth, a depiction of Orpheus looking back, as Eurydice, back turned, is received into the arms of a devil. See Semmelrath, *Der Orpheus-Mythos*, 32 and fig. 5.

107. Silverman, *Flesh of My Flesh*, 185.

108. Ibid., 4–5, 49–51.

109. Ibid., 40.

110. Love, *Feeling Backward*, 49–51 (Orpheus), 127–28, 148–49 (Lot's wife).

111. Dinshaw, *Getting Medieval*, esp. 1–54.

112. See especially Lee Edelman's *No Future*, which yokes queerness indissolubly to the death drive; or, adopting a less psychoanalytic register, Halberstam's *Queer Art of Failure*.

113. For Love's response to *Getting Medieval*, see *Feeling Backward*, 37–40.

114. Ibid., 28.

115. Ibid., 5–8.

116. Ibid., 146.

117. Ibid., 128.

118. Ibid., 50.

119. Love's analysis of Orpheus is filtered through Foucault's discussion of the legend in a 1966 essay on Maurice Blanchot, which contemplates Blanchot's claim in "Gaze of Orpheus" that not to turn to Eurydice would be "no less untrue" than looking back. See Foucault, "Thought of the Outside."

120. Love, *Feeling Backward*, 147.

121. On the virtual absence of references to Orpheus the sodomite in contemporary culture, see also Puff, "Orpheus after Eurydice," 84–85. For a modern reworking that recuperates Orpheus's love for boys, reversing the sequential hierarchy by making his love for Eurydice come second, see "Orpheus," in Calimach, *Lovers' Legends*, 63–73.

122. As Love admits, in order to function in this fashion, she has often had to wrest the disparate figures populating her analysis from their original contexts. See Love, *Feeling Backward*, 5.

123. On the verse *Ovide moralisé* as a vernacularization that supplants the Latin text it serves, see also Copeland, *Rhetoric, Hermeneutics, and Translation*, 107–26.

124. On contemporary "homonormativity," see Duggan, *Twilight of Equality?*

125. Scanlon, "Unspeakable Pleasures," 223–25.

126. Kay, *Place of Thought*, 42–69.

Chapter 4

1. Leclercq, *Monks and Love*, 100.

2. See, e.g., Ailes, "Medieval Male Couple," 237. For an assessment of the remark's reception, see Salih, "When Is a Bosom Not a Bosom?" 19–20.

3. Leclercq, *Monks and Love*, 100–101.

4. McGuire, *Friendship and Community*, 409.

5. Sedgwick, *Epistemology of the Closet*.

6. See, e.g., Chaucer's portraits of lecherous clerics in the *Canterbury Tales*, including the protagonist of the Shipman's Tale.

7. For visitation records referring to same-sex practices, whether cast in sodomitical terms or not, see Thompson, *Records of Visitations*, part 1, 2:188, 191, 197, discussed in Salih, "Sexual Identities," 123–24.

8. Quoted in Bailey, *Homosexuality and the Western Christian Tradition*, 124.

9. Quoted in Boswell, *Christianity, Social Tolerance, and Homosexuality*, 277.

10. See Jaeger, *Ennobling Love*, 110–14; McGuire, *Brother and Lover*.

11. Guibert of Nogent, *De virginitate*, quoted in Newman, *From Virile Woman*, 39–40.

12. Comprehensively analyzed in C. Jones, "Monastic Identity."

13. Payer, *Sex and the Penitentials*, 40–43, 135–39; Jordan, *Invention of Sodomy*, 41–42.

14. Burchard of Worms, *Decretum* 17.56, 19.5, in Migne *PL* 140:931b–933d, 967c–68c.

15. The idea of an "epistemology of the cloister" has been taken up by several scholars in recent years as a means of confronting, more or less directly, the mediation of religious identities through texts in ways that both resonate with and diverge from the epistemology of the closet. See Campbell, "Epistemology of the Cloister"; O'Malley, "Epistemology of the Cloister." The phrase is also used as a section heading in Leyser, "Cities of the Plain," 202.

16. Burrus, *Sex Lives of Saints*, 1, drawing on MacKendrick, *Counterpleasures*. For a parallel argument, which engages with supposedly repressive Anglo-Saxon attitudes to sex in heroic and Christian writings from the early Middle Ages, and which, like the present analysis, reads the displacement of erotic pleasure into the spiritual realm as a process of metaphoric substitution or *translatio*, see Lees, "Engendering Religious Desire."

17. MacKendrick, *Counterpleasures*, 18.

18. Howie, *Claustrophilia*, 10.

19. For a detailed analysis of this conflation of the female and the demonic in the context of clerical sexuality, see Elliott, *Fallen Bodies*.

20. See Easton, "Uncovering the Meanings of Nudity," 163–64; Husband, *Art of Illumination*, 230–31; Phillips and Reay, *Sex before Sexuality*, 1–4.

21. Leclercq, *Monks and Love*, 23.

22. Asad, "On Ritual and Discipline," 173.

23. Leclercq, *Monks and Love*, 105.

24. Boswell, *Christianity, Social Tolerance, and Homosexuality*, 243–66. The significance of the language of mythology, especially Ovidian allusions, in twelfth-century erotic poetry is also emphasized in Stehling, *Medieval Latin Poems*; the point is repeated in Kolve, "Ganymede / Son of Getron," 1048.

25. Asad, "On Ritual and Discipline," 173, 174. For an overview, see also Karras, *Sexuality in Medieval Europe*, 37–43.

26. Gregory the Great, *Homiliarum in evangelia* 33, in Migne *PL* 76:1240a, 1240b.

27. Mary Magdalene's cult and role in the history of Christianity have been the subject of several recent studies. These include Griffith-Jones, *Mary Magdalene*; Haskins, *Mary Magdalen*; Jansen, *Making of the Magdalen*; Schaberg, *Resurrection of Mary Magdalene*.

28. "Sed paucis his respondendum, quoniam omnia possibilia sunt apud Deum, et quaecumque voluit fecit"; Paris, Bibliothèque nationale de France, MS latin 5296B, in Faillon, *Monuments inédits*, 2:739. See Ambrose, *Nave Sculpture*, 1.

29. For summaries of the development of Mary Magdalene's cult at Vézelay, and for general introductions to the nave capitals, see Ambrose, *Nave Sculpture*; Huys-Clavel, *Image et discours*.

30. Ashley and Deegan, *Being a Pilgrim*, 39–43.

31. Paris, Bibliothèque nationale de France, MS latin 5296B, in Faillon, *Monuments inédits*, 2:735–38. See Ambrose, *Nave Sculpture*, 2.

32. Ambrose, *Nave Sculpture*, 8–9.

33. Ambrose suggests that the epitaph may have been designed to pay tribute to Renaud's attempts to discipline monastic observances, though he does not link it specifically to Magdalene's story of sin and redemption. See ibid., 9.

34. The church's fabric was heavily damaged in the French Revolution, and it is possible that more images of Mary Magdalene once existed in the nave. For a discussion of surviving images of Magdalene from the church, including two scenes from the narthex (of which only one survives) and a capital from the gallery now in the Musée Lapidaire at Vézelay, see ibid., 13–16; Salet and Adhémar, *La Madeleine*, 198 (narthex 21). The choir of Auxerre Cathedral, around thirty miles away, contains a thirteenth-century window dedicated to Magdalene's life.

35. For interpretations of images in the church, which focus on its role as a pilgrimage site associated with Mary Magdalene's relics, see Mouilleron, *Vézelay*, 8–9.

36. Ambrose, *Nave Sculpture*, 1–16.

37. It is not known which version of Eugenia's legend the Vézelay sculptors were using. A unique Old French text is included in a thirteenth-century collection of miracles of the Virgin, saints' legends, and other devotional texts: see *De la passion sainte Eugene virge* in Paris, Bibliothèque nationale de France, MS français 818, fols 248r–255v. The best-known edition of the Latin *vita*, published by Heribert Rosweyde in 1615, is reprinted in Migne *PL* 21:1105–22 and Migne *PL* 73:605–24. This text, along with the oldest known form of the legend, dating to the late fifth century and published by Boninus Mombritius in 1477, survives in dozens of pre-1300 manuscripts. For discussion of the principal Latin versions, and their medieval circulation history, see Whatley, "Eugenia before Ælfric." Sources and analogues include the *Acts* of another cross-dressing saint, Thecla; the episode of Joseph and Potiphar's wife in Genesis 39, a legend also represented on both nave and narthex capitals at Vézelay, on which see Salet and Adhémar, *La Madeleine*, 113, 135, 158, 191 (nave 85), 196 (narthex 6); and a pre-Christian tale recorded by Hyginus (*Fabulae* 274, in *Myths of Hyginus*, ed. Grant, 176) about the first Athenian female physician, Agnodice, who cross-dresses in order to practice medicine. See Whatley, "More Than a Female Joseph." Whatley includes a detailed summary of the Mombritius version, on which the above synopsis is based, at 109–111. Eugenia's story is also included in the *Legenda aurea* under the heading "Saints Protus and Hyacinthus": see Jacobus de Voragine, *Golden Legend*, trans. Ryan, 2:165–67.

38. Ambrose, *Nave Sculpture*, 43–44; Loos-Noji, "Temptation and Redemption," 229n5. The church of Sainte-Eugénie in Varzy, which held Eugenia's relics, was damaged during the French Revolution and subsequently abandoned; the remains are now in private hands. The nearby village wash house still has a fountain named after the saint.

39. For overviews, see Anson, "Female Transvestite"; Hotchkiss, *Clothes Make the Man*.

40. Ambrose, "Two Cases," 8; Grayson, "Disruptive Disguises," 147–48, 151–52, 165–66, and figs. 3, 6, 15; Loos-Noji, "Temptation and Redemption," 230n13. For an argument that the oldest Latin version of the legend likewise ultimately returns Eugenia to fleshly femininity, thus questioning or even subverting the "virile woman" topos, see Whatley, "More Than a Female Joseph," 107–9.

41. A brief notice appears in Baudoin, *Grand livre des saints*, 205.

42. The triptych by the Master of the Dinteville Allegory (Netherlandish or French), bearing the date 1535, is discussed in Thuillier, "Études sur le cercle des Dinteville," 65–70. Other panels depict the saint's martyrdom and her tomb. The church also possesses several other Eugenia-related items, including a thirteenth-century arm reliquary and a modern stained

glass window, while Varzy's Musée Auguste Grasset has a late fifteenth-century glass roundel depicting the saint, probably again from the former church of Sainte-Eugénie, which shows her nimbed, clasping a book, and carrying a palm of martyrdom.

43. Other analyses include Ambrose, "Two Cases"; Ambrose, *Nave Sculpture*, 39–44, 104; Ambrose, "Male Nudes and Embodied Spirituality," 75–76; Despiney, *Guide-Album de Vézelay*, 126; Grayson, "Disruptive Disguises," 155–64; Huys-Clavel, *La Madeleine de Vézelay*, 141–43 (which argues that the scene contributes to a sequence of capitals concerned with the theme of imposture); Huys-Clavel, *Image et discours*, 223–25; Loos-Noji, "Temptation and Redemption"; Mouilleron, *Vézelay*, 127; Mâle, *L'art religieux du XIIᵉ siècle*, 242–43; Porée, *L'abbaye de Vézelay*, 60–61; Salet and Adhémar, *La Madeleine*, 120–21, 145, 157, 188 (nave 59). This is the earliest surviving depiction of Eugenia's trial. For discussion and reproductions of a comparable scene, one of eight from the *Life* of Eugenia featured on a late thirteenth-century altar frontal from the church of Santa Eugenia de Saga in Ger (Catalonia) and now in the Musée des Arts Decoratifs, Paris, see Ambrose, "Two Cases," 8 and fig. 2; Cook and Ricart, *Pictura e imaginería romanicas*, 257, 263 fig. 251; Grayson, "Disruptive Disguises," 164–65.

44. On Melantia's clothing and hair in the capital, see Loos-Noji, "Temptation and Redemption," 223–24.

45. Salet and Adhémar, *La Madeleine*, 113, 147, 189 (nave 65); Ambrose, *Nave Sculpture*, 106. This is older in appearance than the majority of the nave capitals, so may have been recycled during the twelfth-century rebuilding. The fruit Eve takes—a bunch of grapes—presumably reflects the fact that Burgundy is a wine-producing region, thereby imbuing the fall with a local flavor.

46. Ambrose, *Nave Sculpture*, 22.

47. As Ambrose points out, however, the gesture has several meanings, signaling also, among other things, confession. See ibid., 27. Perhaps the contrast between Eve's outstretched hands and Adam's more reserved gesture is also designed to highlight contrasting attitudes to sin.

48. Salet and Adhémar, *La Madeleine*, 155, 181–82 (nave 6); Ambrose, *Nave Sculpture*, 89.

49. Salet and Adhémar, *La Madeleine*, 122, 154, 183 (nave 15); Ambrose, *Nave Sculpture*, 42, 92.

50. Smartt, "Cruising Twelfth-Century Pilgrims," 50. For other *luxuria* figures in Romanesque sculpture, female and male, see Olsen, *Of Sodomites*, 339–47, 359–84.

51. Ambrose, *Nave Sculpture*, 40. Later, however, Ambrose also points out that the saint's clean-shaven appearance is not necessarily a marker of femininity, since other saints depicted in the nave are also without beards. Moreover the juxtaposition of tonsure and breasts emphasizes the "confusion of genders" also found in written versions of the legend. See Ambrose, *Nave Sculpture*, 42; Ambrose, "Two Cases," 8. For another analysis reflecting on the saint's status in the capital as "paradoxically both woman and monk," see Loos-Noji, "Temptation and Redemption," 220. For connections between the Eugenia sculpture and other exhibitionist figures in medieval sculpture such as the Sheela-na-gigs (naked women exposing exaggerated genitals), see Bonnet, *Voir, être vu*, 2:103–75; Grayson, "Disruptive Disguises," 160–64. Grayson emphasizes how unusual the Vézelay capital is compared with other representations in medieval art, which consistently return the cross-dressing FTM saint to femininity. Marina Warner advances the view that Eugenia is depicted displaying her "sex" not simply by revealing her breast: the sculptor has also carved "an extremely rare image in Christian art of a woman's vagina, encoded rather than described as a deep, lipped orifice, placed as high as her navel"; but this is based on a perception that the shadow cast by the open tunic on the saint's stomach is a deliberate sculptural detail rather than a play of the light. See Warner, *Monuments and Maidens*, 296 (caption to plate 86), 303.

52. Loos-Noji argues that the location of the Eugenia capital may be significant: a small door directly across from the sculpture, in the north wall of the church, could have been used

by monks wishing to travel between the choir and conventual buildings without having to encounter large numbers of pilgrims. A narrative about temptation and its aversion might have been especially relevant in this context. See Loos-Noji, "Temptation and Redemption," 223. On Eugenia as an exemplary model for monks, see Ambrose, "Two Cases," 10.

53. Jerome, *Commentariorum in Epistolam ad Ephesios* 3, in Migne *PL* 26:533b–533c.

54. Jerome did not mean these ideas to be applied literally. In a letter to Eustochium he strongly condemns those women who "change their garb and put on men's dress; they cut their hair short and lift up their chins in shameless fashion; they blush to be what they were born to be—women, and prefer to look like eunuchs." See "Ad Eustochium" (letter 22), 116–17, discussed in Weston, "Virgin Desires," 97.

55. Ambrose, *Expositio Evangelii secundum Lucam* 10.161, in Migne *PL* 15:1844c.

56. Migne *PL* 73:614d.

57. The relevant passage, from the Mombritius version, is quoted and discussed in Whatley, "More Than a Female Joseph,"107–8. For other commentaries on Eugenia's trial speech, which justifies her cross-dressing spiritually with reference to the "manliness" of loving God, see Gulley, "*Heo man ne wæs*"; Roy, "Virgin Acts Manfully"; Szarmach, "Ælfric's Women Saints."

58. D. Clark, *Between Medieval Men*, 193.

59. Ælfric, "Life of Eugenia," ed. Skeat, 32, lines 144–46; translation in Ælfric, "Life of Eugenia," trans. Donovan, 71. Donovan's edition also provides a brief overview of Eugenia's cult in Anglo-Saxon England and the circulation of Latin manuscripts of the saint's *vita*. Ælfric's text is based on a hybridized version of the two main Latin versions. On the hagiographer's Latin sources, see also Roy, "Virgin Acts Manfully"; Whatley, "Eugenia before Ælfric."

60. Ælfric, "Life of Eugenia," 34, lines 173–75; trans. Donovan, 71. In his discussions of the Latin texts, one of which similarly portrays Melantia as the very essence of darkness, E. Gordon Whatley points out that the Greek word *melania* means "blackness." See Whatley, "Eugenia before Ælfric," 351; Whatley, "More Than a Female Joseph," 111.

61. D. Clark, *Between Medieval Men*, 191–93. See also Gulley, "*Heo man ne wæs*"; Roy, "Virgin Acts Manfully"; Schecke, *Reform and Resistance*, 90–96; Szarmach, "Ælfric's Women Saints."

62. The capital was first identified as a depiction of the Ganymede myth in Adhémar, "L'enlèvement de Ganymède," 290–92. Adhémar refers somewhat allusively, in this discussion, to the fact that the sculptor was directed in his choice of subject by a "moral intention"; this interpretation is repeated, with the additional comment that the sculptor wished to stigmatize a "certain vice," in Adhémar, *Influences antiques*, 222–23. The hand behind the capital is named as the "Auteur du Ganymède" in Salet and Adhémar, *La Madeleine*, 154–55; see also 123, 182–83 (nave 12). Prior to Adhémar's identification, the subject matter had been the subject of speculation: Émile Mâle surmises that it represents a forgotten local legend, while Louise Lefrançois-Pillion reproduces the capital as a plate with the label "sujet inexpliqué" and refers to it in the text as an enigmatic example of the perpetual battle between human and nonhuman. See Mâle, *L'art religieux du XIIᵉ siècle*, 368; Lefrançois-Pillion, *Les sculpteurs français du XIIᵉ siècle*, 28, 43, 77, and plate 22. Adhémar's moral intention is the focus of a more sustained discussion in Forsyth, "Ganymede Capital," which has influenced most subsequent analyses. These include Ambrose, *Nave Sculpture*, 91; Ambrose, "Male Nudes and Embodied Spirituality," 77; Boswell, *Christianity, Social Tolerance, and Homosexuality*, 251–52; Flohic, *Le patrimoine de la Basilique*, 90; Huys-Clavel, *La Madeleine de Vézelay*, 90, 96; Huys-Clavel, *Image et discours*, 157–58; Kolve, "Ganymede / Son of Getron," 1021–27; Mouilleron, *Vézelay*, 114–15; Quinn, *Better Than the Sons of Kings*, 185–87; Saslow, *Pictures and Passions*, 64–65. Similar conclusions about the moral character of the scene are reached independently from Forsyth in Kempter, *Ganymed*, 22–27, which is also a useful source more generally for representations of the legend in medieval art.

63. The irony here, of course, is that Orpheus, the teller of this tale, spent only seven days grieving for his beloved Eurydice: this seems to be part of a general effort on Orpheus's part to shore up the profundity of pederastic passion.

64. On the myth of Apollo's love for Hyacinthus in ancient Greece, where it had cultic significance, see Davidson, *Greeks and Greek Love*, 234–51.

65. Virgil, *Aeneid* 5.329–39, trans. Fogles, 161. Virgil also makes reference, early in the poem, to Juno's anger toward Ganymede and to Trojans in general: see *Aeneid* 1.41–44.

66. For general surveys and reproductions of the images associated with Leochares and Michelangelo, see Davidson, *Greeks and Greek Love*, 169–200; Kempter, *Ganymed*; Saslow, *Ganymede in the Renaissance*; Barkan, *Transuming Passion*; Orgel, "Ganymede Agonistes." For the classic discussion of the Ganymede myth in Renaissance art, as a representation of "the ecstasy of Platonic love . . . freeing the soul from its physical bondage and carrying it to a sphere of Olympian bliss," see Panofsky, *Studies in Iconology*, 216. On the myth's popularity in the literature and art of ancient Rome, see Williams, *Roman Homosexuality*, 60–64.

67. One of two found in Hawbridge, Gloucestershire, and possibly made in Germany. Discussion in Kempter, *Ganymed*, 20–22; Parkinson, *Little Gay History*, 58–59; J. Robinson, *Masterpieces of Medieval Art*, 296–97. The scenes are accompanied by short inscriptions identifying the protagonists as Jupiter and Ganymede; the bowl also includes a pair of scenes showing the story of Orpheus and Eurydice.

68. "Porro autem quicumque finxerunt a Jove ad stuprum raptum pulcherrimum puerum Ganymedem, quod nefas rex Tantalus fecit, et Jovi fabula tribuit"; Augustine, *De civitate Dei* 18.13, in Migne *PL* 41:571.

69. In support of the "negative" medieval interpretation of the myth, it is common also to cite John of Salisbury's *Policraticus* 1.4, which refers to the "Dardanian hunter" as an example of the vices to which noblemen lay themselves open when they practice hunting; Ganymede was, John splutters, carried into the heavens to serve as a cupbearer, "from which to go on to illicit and unnatural embraces"; John of Salisbury, *Policraticus I–IV*, ed. Keats-Rohan, 29. This is the basis for Adhémar's ascription of a "moral intention" to the scene: see Adhémar, "L'enlèvement de Ganymède," 292, and Adhémar, *Influences antiques*, 223n2. See also Forsyth, "Ganymede Capital," 242; Kolve, "Ganymede / Son of Getron," 1022.

70. Adhémar's identification is disputed in Weisbach, *Religiöse Reform und mittelalterliche Kunst*, 145–47, which links the image instead to comparable scenes representing birds carrying stolen animals in their claws in Romanesque sculpture. The rapacity of the bird is strengthened by giving it a "double booty": the human in its beak and the dog in its claws. One scholar who takes this refutation seriously is Neil Stratford, who, citing Weisbach, laments that "this improbable reading of the capital's subject matter has refused to disappear. It is much more likely that this and other such Vézelay capitals are attempts to represent diabolical manifestations, the world of the strange, unnatural and fantastical." See Stratford, "Cluny Capital in Hartford (Connecticut)," 16 and 19n33; also Saulnier and Stratford, *La sculpture oubliée de Vézelay*, 114n29.

71. One of the other sculptures identified as depicting a classical theme, located a little further east along the south aisle, may show Achilles being instructed in the art of archery by the centaur Chiron—an association mentioned by Homer, Philostratus, and Plato among others. See Salet and Adhémar, *La Madeleine*, 123, 154, 181 (nave 3); Ambrose, *Nave Sculpture*, 87–88. Another capital containing a possible classical allusion, located in the narthex, just outside the south entrance to the nave (and thus again in the vicinity of the "Ganymede" capital) is less securely identified. It has been interpreted as depicting Ulysses being lured by a siren (though the "siren" in question is bearded, wears a moustache, and plays a hurdy-gurdy-style instrument). Alternatively, it has been suggested that the capital shows the prophet Jonah before he is swallowed by the whale: the man blocking his ears to the sound

of the bearded musician could be Jonah, who avoids hearing God's commandment that he preach to the city of Nineveh (Jonas 1.2–3). See Salet and Adhémar, *La Madeleine*, 152, 179 (nave facade VI); Ambrose, *Nave Sculpture*, 117.

72. Though nonnarrative in content, the foliate capitals have also been interpreted as having symbolic significance. On meanings attributed to the foliate capitals specifically, see Ambrose, *Nave Sculpture*, 59–72; Huys-Clavel, *La Madeleine de Vézelay*, 46–50; Huys-Clavel, *Image et discours*, 95–96.

73. Boswell, *Christianity, Social Tolerance, and Homosexuality*, 243–66. Boswell's thesis about the newly celebratory attitude toward same-sex love in the twelfth century is corroborated in Holsinger and Townsend, "Ovidian Homoerotics."

74. Bond, "'Iocus Amoris,'" 167; Kempter, *Ganymed*, 19. In addition, see Holsinger, *Music, Body, and Desire*, 306–8, discussing also Baudri's other references to Orphic song. For the flowering of Ovidian themes more generally in twelfth-century erotic poetry, see also Boswell, *Christianity, Social Tolerance, and Homosexuality*, 244–48; Curtius, *European Literature*; Kolve, "Ganymede / Son of Getron," 1048–49; Stehling, "To Love a Medieval Boy"; Stehling, *Medieval Latin Poems*.

75. *Altercatio Ganimedis et Helene*, quoted in Boswell, *Christianity, Social Tolerance, and Homosexuality*, 381–89; discussion at 255–61.

76. Kolve, "Ganymede / Son of Getron," esp. 1044–45, 1055–60.

77. Ibid., 1021–23, 1065.

78. Carvings from ca. 1100 possibly making reference to the Ganymede legend can be found at Monprimblanc (Gironde) and Notre-Dame-du-Port, Clermont-Ferrand (Auvergne); the Monprimblanc carving is associated with others probably evoking sodomy. See Olsen, *Of Sodomites*, 30 and fig. 7.

79. Olsen, *Of Sodomites*, 166–77, discussing capitals at the abbey of Saint-Pierre de Mozac (Auvergne), and related capitals at the priory of Saint Marcellinus, Chanteuges (Auvergne) and the collegiate church of Saint-Julien, Brioude (Auvergne). Olsen draws on Wirth, *L'image à l'époque romane*, 154–69, who likewise identifies pederastic themes in some of these sculptures.

80. For changing attitudes to oblation in the period, see Boswell, *Kindness of Strangers*; Quinn, *Better Than the Sons of Kings*; De Jong, *In Samuel's Image*. On the effects of adult recruitment on monastic literature, see Leclercq, *Monks and Love*, 8–26.

81. "In the monastery moreover let neither monks nor abbot embrace or kiss, as it were, youths or boys [*adolescents uel puerulos*]; let their affection for them be spiritual, let them keep from words of flattery, and let them love the children reverently and with the greatest circumspection. Not even on the excuse of some spiritual matter shall any monk presume to take with him a young boy alone for any private purpose but, as the Rule commands, let the boys always remain under the care of their master"; Symons, *Regularis concordia Anglicae nationis monachorum sanctimonialiumque*, 7–8. See also *De renuntiatione saeculi*, attributed to Basil the Great (ca. 330–79), and remarks by Pope Gregory III (690–731) on sodomitic practices among the ordained, discussed in Quinn, *Better Than the Sons of Kings*, 156–57. For discussion of these regulations in the context of the Vézelay capital specifically, see also Kolve, "Ganymede / Son of Getron," 1027–28. For monastic concerns about homosexuality among adolescents specifically, see Sobczyk, *L'érotisme des adolescents*, 12–14; for an overview of sexual regulation in monastic rulebooks, see Godfrey, "Rules and Regulations," 45–57.

82. Benedict, *The Rule of St Benedict in Latin and English* 22, ed. and trans. McCann, 70–71. Discussion in Kolve, "Ganymede / Son of Getron," 1040; Quinn, *Better Than the Sons of Kings*, 63, 165. Although Benedict himself doesn't explicitly target the Sodomite sin, a ninth-century commentary on the *Rule* by Hildemar of Corbie says this is because Benedict was trying to maintain some decorum: what is at issue here is indeed the Sodomitic crime (*sodomiticum*

scelus) or masturbation (*immunditiae*). For this and other comparable comments in monastic literature, see C. Jones, "Monastic Identity," 26–27.

83. The ninth-century St. Gall Plan, a product of the Benedictine reform movement, took various steps to segregate children from adults physically by means of spatial zoning. See Quinn, *Better Than the Sons of Kings*, 45–73, 186.

84. Discussions linking the changes in oblation practice directly to the theme of the Vézelay capital include Quinn, *Better Than the Sons of Kings*, 187–89; Kolve, "Ganymede / *Son of Getron*," 1023–28.

85. Peter Damian, "Letter 31," ed. Reindel, 296–97; Peter Damian, *Book of Gomorrah*, trans. Payer, 41–42.

86. Peter Damian, "Letter 31," ed. Reindel, 308; Peter Damian, *Book of Gomorrah*, trans. Payer, 61–62. The same passage appears in Fructuosus of Braga, *Regula monachorum Complutensis* 16 in Migne *PL* 87:1106d–1107b; Fructuosus of Braga, *Rule for the Monastery of Compludo*, trans. Barlow, 169. For discussion of Damian's comments specifically directed against relations between adult men and boys, see Quinn, *Better Than the Sons of Kings*, 182–84. In the previous century Odo of Cluny used the Greek loan word *ephebia* twice in a passage denouncing same-sex acts in his *Occupatio* (3.686, 693), but as Jones points out this section of the poem does not make any clear distinction between adult sodomy and pederasty. Later on, though, in the seventh book (*Occupatio* 7.140–58), Odo expresses concern at the nurture of a boy (*puer*) in what is meant to be the Lord's school (*scola*), suggesting that he is indeed concerned with the molestation of young males. See C. Jones, "Monastic Identity," 32–33, 36–37.

87. Peter the Venerable, *De miraculis* 1.14, ed. Bouthillier, 46; my translation, but for a modern French translation see Peter the Venerable, *Livre des merveilles de dieu*, trans. Torrell and Bouthillier, 122. See also Limbeck, "Turpitudo antique passionis," 204–5.

88. Forsyth, "Ganymede Capital," 244, makes the link with Peter the Venerable's story, and demonstrates that Peter knew Virgil's version of the myth. For links more generally between Peter's writings and the moral message ascribed to the capitals, see Huys-Clavel, *Image et discours*, 129–70; Salet and Adhémar, *La Madeleine*, 132–35.

89. Attempts to delineate thematic zones are made in Angheben, *Les chapiteaux romans de Bourgogne*, 13–18, 427–32; Huys-Clavel, *La Madeleine de Vézelay*; Huys-Clavel, *Image et discours*. For a critical analysis of these theories, which considers it unlikely that capitals were designed with specific locations in mind and recommends that we avoid applying the term "program," see Ambrose, *Nave Sculpture*, x–xii, 83–85. Ambrose nonetheless devotes attention to the visual resonances generated by repetition and semantic overlap, which lend the sculptures a certain "formal cohesion."

90. Huys-Clavel, *La Madeleine de Vézelay*; Huys-Clavel, *Image et discours*.

91. Ambrose, *Nave Sculpture*, xii, discussing Mâle, *L'art religieux du XIIe siècle*, 365–76. For studies of other ensembles of claustral sculpture, which take into account the viewing needs of monks and discern, in so doing, the existence of cohesive iconographic ensembles or programs, see Patton, *Pictorial Narrative*, 1–21; Pressouyre, "St. Bernard to St. Francis"; Rutchick, "Sculpture Programs." For the relationship between monastic beliefs and practices and the syntax of the portal at Moissac, see Forsyth, "Narrative at Moissac."

92. Gregory the Great, *Dialogorum libri* 2.2, in Migne *PL* 66:132a–132c; Gregory the Great, *Dialogues*, trans. Zimmerman, 59–60.

93. Ambrose, *Nave Sculpture*, xi; Salet and Adhémar, *La Madeleine*, 135–36.

94. Salet and Adhémar, *La Madeleine*, 137, 156, 185 (nave 31); Ambrose, *Nave Sculpture*, 97–98. Another capital, on an adjacent pier to the Eugenia capital, which may represent Saint Anthony's temptation by demons, was introduced during the church's restoration by Viollet-le-Duc in the nineteenth century. This copy, which was designed to replace a medieval fragment, has not been included in my analysis, but see Salet and Adhémar, *La Madeleine*, 122,

139, 156, 189 (nave 63); Ambrose, *Nave Sculpture*, 105–6. However, it is worth noting a potential resonance between a capital on the same pier as this and the Ganymede capital, which probably depicts the Fall of Simon Magus: the man plummeting to his death, surrounded by demons, with his head turned upside down, possesses an affinity with Ganymede's positioning. See Salet and Adhémar, *La Madeleine*, 122, 156, 189 (nave 62) and, for the Simon Magus identification, Ambrose, *Nave Sculpture*, 105.

95. Possible links between the Eugenia and Benedict capitals are briefly discussed in Ambrose, *Nave Sculpture*, 51. Thematic connections between the capitals are explored in Loos-Noji, "Temptation and Redemption," 223, but Loos-Noji does not contemplate the aesthetic links. Some scholars have also suggested thematic connections between the Eugenia capital and a capital immediately opposite depicting the mythical basilisk, which reputedly turned the onlooker to stone with its evil eye. See Salet and Adhémar, *La Madeleine*, 123, 145, 153, 190 (nave 74); Ambrose, *Nave Sculpture*, 107–8. The confrontation between Eugenia and her defamer echoes the encounter between the basilisk (represented as a bird-serpent hybrid) and a grasshopper-like creature, said to represent people who have converted but struggle against evil. See Huys-Clavel, *La Madeleine de Vézelay*, 49, citing Bonnet, *Voir, être vu*.

96. Although Ovid's *Metamorphoses* may have been known to some Anglo-Saxon writers—the Fontes Anglo-Saxonici database contains forty-seven Ovidian allusions, mainly in the writings of Aldhelm (ca. 639–709)—there is no evidence that Ælfric himself knew Ovid or the Ganymede legend. Striking, nonetheless, is the reference in his life of Eugenia to how, when the saint's family searched for her following her departure to the monastery, they were told that the gods had "gegripon" (snatched) her because of her goodness—a description of ravishment surely resonating with Ganymedean rapture. See Ælfric, "Life of Eugenia," 31, line 113; trans. Donovan, 70.

97. Copeland, *Rhetoric, Hermeneutics, and Translation*.

98. Hamann-MacLean, *Frühe Kunst im Westfränkischen Reich*, 17, links the Chauvigny capital with Ganymede and interprets the bird as an "infernal" creature carrying off human souls; Horvat and Pastoureau, *Figures romanes*, 28, cite the capital as an image of the "châtiment d'un damné," and suggest that the male figure may be a cleric. Olsen, *Of Sodomites*, 30–31, also wonders whether the capital has a Ganymede connection. Other depictions of eagles apparently attacking sinners include a carving on the pulpit in Salerno Cathedral, reproduced in Venturi, *Storia dell'arte italiana*, 598 fig. 558. Birds may sometimes be seen attacking other animals: at the abbey of Fleury in Saint-Bénoît-sur-Loire a capital shows birds taking lions in their beaks and claws, while Tarragona Cathedral features a stylized representation of an eagle stealing a hare, as does a capital in the Baptistery at Parma. See Bernheimer, *Romanische Tierplastik*, 132, figs. 129–31.

99. The other faces of the capital adjacent to the birds scene show a devil pulling on Michael's scales and the angel Gabriel announcing Christ's birth to the shepherds. Also potentially significant is the fact that the birds scene is located to Michael's right; the souls being carried by the birds are almost identical to the supplicant soul who kneels before Michael, also to his right.

100. Associations between the eagle, John, Christ, and the astral realm in early Christian thought are discussed in J. B. Friedman, *Orpheus in the Middle Ages*, 50–52.

101. See also the evangelists on the tympanum above the south porch at Moissac, carved 1125–30.

102. Dante, *Purgatorio*, ed. and trans. Kirkpatrick, 76–77. Subsequent quotations to this edition are made in the text by canto and line number. Dante's use of the episode is discussed in Holsinger, "Sodomy and Resurrection," 253–59; Saslow, *Ganymede in the Renaissance*, 6; Schibanoff, *Chaucer's Queer Poetics*, 126–31.

103. Schibanoff, *Chaucer's Queer Poetics*, 128–29, commenting on Holsinger, "Sodomy and

Resurrection," 257. Schibanoff points to Statius's reference to Achilles's sexual ambiguity—his "ambiguus . . . sexus"—in the relevant passages. See Statius, *Achilleid*, trans. Bailey, 535.

104. For discussion of Dante's queer or "hermaphroditic" poetics elsewhere in the *Commedia*, see also Schibanoff, *Chaucer's Queer Poetics*, 136–42. For Dante's allusions to Orpheus, Ganymede, and Achilles, see also Holsinger, *Music, Body, and Desire*, 326–330.

105. Chaucer, *House of Fame*, in *Riverside Chaucer*, ed. Benson, 347–73. References in the text by line number. On the interplay between the *House of Fame* and Dante's *Commedia*, and a summary of critical responses to Chaucer's Ganymede reference, see Schibanoff, *Chaucer's Queer Poetics*, 152–59. See also Chance, *Mythographic Chaucer*, 62–64.

106. See, e.g., Hyginus, *Poetica astronomica* 2.29, in *Myths of Hyginus*, ed. Grant, 218. An important source for the Aquarius connection in the Middle Ages was the Third Vatican Mythographer, whose work circulated in numerous manuscripts between the twelfth and fifteenth centuries. See Pepin, *Vatican Mythographers*, 221, 334.

107. On Chaucer's Orpheus reference, see Schibanoff, *Chaucer's Queer Poetics*, 186.

108. Eusebius, *Eusebii Pamphili Chronici Canones*, ed. Fotheringham, 79. Augustine's student Orosius (ca. 375–after 418) similarly characterized Tantalus as the perpetrator, though this time possibly acting as an agent on Jupiter's behalf. See Orosius, *Historiorum libri septem* 1.12, in Migne *PL* 31:721b–722a.

109. Fulgentius, *Mitologiarum Liber I.20*, ed. Helm, 31; Lactantius, *Divinarum institutionum* 1.20, in Migne *PL* 6:171a. For the commentary on Martianus Capella and an overview of the historicizing tradition, see Gastad, "Interpretation of Ganymede," 161–68. Another rationalization was provided in the work of the Second Vatican Mythographer (writing between the ninth and eleventh centuries): Jupiter's "eagle" is transformed into a symbolic ensign, like the insignia used by the Roman army, thus casting doubt on the god's ability to metamorphose into a bird. See Pepin, *Vatican Mythographers*, 187–88.

110. Caxton, *Booke of Ovyde Named Methamorphose*, ed. Moll, 10.919–34.

111. This interpretation is discussed in Blumenfeld-Kosinski, *Reading Myth*, 112. For general discussions of interpretations in the moralized Ovids, see Kempter, *Ganymed*, 27–33; Saslow, *Ganymede in the Renaissance*, 6.

112. Berchorius, *Reductorium morale ii–xv*, 147; Reynolds, *Ovidius moralizatus*, 353.

113. Petrarch, *Africa* 3.170–72, ed. and trans. Bergin and Wilson, 46.

114. Berchorius, *Reductorium morale, Liber XV, cap. i*, ed. Engels, 9–10; Reynolds, *Ovidius moralizatus*, 46–53. The scene of Jupiter hurling his thunderbolt and suppressing giants is evoked by Ovid in *Metamorphoses* 1.151–62. Petrarch's *Africa*, however, is the text in which the image of Jupiter sitting in majesty is juxtaposed with Ganymede's abduction, and it is Petrarch that Bersuire cites as his principal source at this juncture.

115. On this pairing in Rouen O.4, and its relationship to a scene in an illustrated manuscript of Christine de Pizan's *Epistre Othea*—London, British Library, Harley MS 4431, fol. 119v—which fuses the Ganymede and Hyacinth episodes into a single image, see also Desmond and Sheingorn, *Myth, Montage, and Visuality*, 113–18.

116. For a brief discussion of this second iconographic tradition, see Blumenfeld-Kosinski, "Illustrations et interprétations," paragraph 2 and n5.

117. The arrangement in BnF français 373 is somewhat reminiscent of another Ganymede image incorporated into the bronze doors of St. Peter's in Rome, by the Florentine sculptor Antonio Averlino "Il Filarete," which were completed in 1445, a few decades after the manuscript, though on the bronze the boy embraces the eagle's neck and is not held in the bird's beak. For a reproduction of the relevant detail, see Davidson, *Greeks and Greek Love*, 174 fig. 8.

118. This and other manuscript illustrations of this type, which juxtapose Ganymede's abduction with Jupiter's majesty, are discussed in Kempter, *Ganymed*, 31–33, 179. Although in some examples Ganymede is turned away from his abductor and the erotic implications

are less obvious (e.g., in Rome, Biblioteca Apostolica Vaticana, Cod. Reg. lat. 1290, fol. 1r the bird's claws sit on the boy's shoulders and Ganymede carries a chalice in his hand), in at least one other example—Rome, Biblioteca Vaticana, Cod. Reg. lat. 1480—a spiritual interpretation seems to hold sway: Ganymede holds his hands in a gesture of prayer and looks toward Jupiter, who, as in BnF français 373, wields a palm rather than the scepter wielded by earthly powers. See Kempter, *Ganymed*, plates 8–10.

119. Astrological manuscripts containing depictions of Ganymede as Aquarius are discussed in Kempter, *Ganymed*, 34–41, 178, plates 12–20.

120. Camille, "For Our Devotion," 15, 18.

121. For an introduction to the purpose of these works, and possible dates and identities of the writers, see Pepin, *Vatican Mythographers*, 1–11.

122. Bersuire and Petrarch knew the Third Vatican Mythographer's work. See ibid., 4.

123. Ibid., 78.

124. Ibid., 187. The Third Vatican Mythographer refers to the Ganymede legend twice (221, 334) but does not articulate the view that Jupiter, transforming himself into an eagle, thereby saves himself or his victim from shame. Rather, the Ganymede story is followed immediately by an account of another of Jupiter's avian transformations—his rape of Leda, disguised as a swan—which, the mythographer submits, reflects Jupiter's degeneration "from the dignity of his own character into bestial habits."

125. For discussions of the ambiguities of this passage, see Guynn, *Allegory and Sexual Ethics*, 119–20; Pittenger, "Explicit Ink," 226–27.

126. As such, my interpretation differs from most other discussions of the capital as a representation of Ganymede's ordeal, which tend to view it as a thoroughgoing medievalization/Christianization of a more ambivalently situated classical legend. Boswell is alone, I think, in questioning whether the sculpture communicates a thoroughly derogatory message (*Christianity, Social Tolerance, and Homosexuality*, 251–52). Kolve ("Ganymede / Son of Getron," 1065) contrasts the "more severe" and "uncompromising" tone of the Vézelay image with the dramatization of homoerotic love in *Filius Getron*, finding ambivalence only in the latter; but his impulse to ascribe to twelfth-century adaptations some of the complexity and subtlety also associated with classical and Renaissance renditions is one I share.

127. The whirlwind that carries Elijah up to heaven is referred to again in Ecclesiasticus 48.9, 13. Whirlwinds also indicate divine anger and destruction, as in Job 9.17; Isaiah 28.2, 29.6; Jeremiah 25.31, 30.23. They can be the place from which God speaks, as in Job 38.1, 40.1. So the whirlwind in the Ganymede capital also coheres with the negative moralization. But relevant to the alternative reading is the reference in Ezekiel 1.4 to a whirlwind, as well as a great cloud and fire, out of which emerge four creatures with the faces of a man, a lion, an ox, and an eagle. This prophecy is the source for medieval iconography representing signs of the evangelists, including John in the likeness of an eagle. Mouilleron, *Vézelay*, 145, pairs the Ganymede capital with a capital further along the south aisle depicting the death of Lazarus (which shows Lazarus's soul being carried to Abraham's bosom), arguing that both are "allegories of the destiny of the soul" but with contrasting significance.

128. For an overview, see Jenkins, *Pedophiles and Priests*. For more recent data and testimony, see also Frawley-O'Dea and Goldner, *Predatory Priests*; Frawley-O'Dea, *Perversion of Power*; Plante, *Sin against the Innocents*. For a cultural analysis, see Kincaid, *Erotic Innocence*.

129. G. S. Rubin, "Thinking Sex," 153, 154. See also Rubin's reflection on these issues, twenty-five years after the publication of "Thinking Sex," in "Blood under the Bridge," 37–39. On constructions of child abuse more generally, see Jenkins, *Moral Panic*.

130. Jordan, "Confusion of Priestly Secrets," 232.

131. See, e.g., Sipe, "Crisis of Sexual Abuse," 66–67, drawing on Doyle, "Roman Catholic Clericalism," which in turn relies heavily on Johannson and Percy's somewhat partisan

"Homosexuality"; Frawley-O'Dea, *Perversion of Power*, 117; and, in a less scholarly vein, Yallop, *Beyond Belief*, 9–13. In fact it is worth remembering that although, as discussed above, Peter Damian does refer in passing to age-differentiated structures—e.g., his reference to clerical sodomites as "fathers" corrupting spiritual "sons," and his citation of a monastic rule that recommends harsh punishment even when a cleric or monk is found just kissing a youth—the fourfold scheme of sodomitical behavior outlined in the letter makes no direct reference to the participants' age.

132. See, e.g., Jenkins, *Pedophiles and Priests*, 7, 77–83; Jenkins, *Moral Panic*, 7–8; Plante, *Sin against the Innocents*, xxi.

133. G. S. Rubin, "Thinking Sex," 152–54.

134. Halperin, *How to Do*, 113–17.

135. The age at which sexual experiences occur also plays a significant role in commentaries by late medieval natural philosophers on the problem of males who derive pleasure from "passive" sexual intercourse. See Cadden, *Nothing Natural Is Shameful*, 91–97.

136. Brundage, *Law, Sex, and Christian Society*, 536.

137. Asad, "On Ritual and Discipline," 175.

138. Bynum, *Jesus as Mother*, 161–62. Critiques include Lochrie, "Mystical Acts, Queer Tendencies"; Mills, "Ecce Homo"; Rambuss, *Closet Devotions*, 42–49.

139. Jordan, *Silence of Sodom*.

140. Rocke, *Forbidden Friendships*.

141. For medieval examples, see Wright and Rowson, *Homoeroticism in Classical Arabic Literature*; for the early modern period, see El-Rouayheb, *Before Homosexuality*. Jewish poets in Spain, influenced by this tradition, also sometimes wrote comparable verses addressed to young male beloveds. See Schirmann, "Ephebe in Medieval Hebrew Poetry"; Roth, "Deal Gently."

142. Owing to different marriage patterns in Italy, which meant that women married in their teens and men in their late twenties or thirties, men in regions such as Florence may have found different outlets for same-sex encounters than they did in other parts of Europe. See Karras, *Sexuality in Medieval Europe*, 141–42. Rocke occasionally discovers cases where the partners are young and close in age, and Dennis Romano has recently drawn attention to an image showing two male youths, roughly similar in age (though one is slightly taller), in Ambrogio Lorenzetti's *Effects of Bad Government* fresco painted in the Sala dei Nove of the Palazzo Pubblico, Siena, in the 1330s. See Romano, "Depiction of Male Same-Sex Seduction."

143. See, e.g., Trumbach, *Sex and Gender Revolution*, which argues for the existence of a sodomitically acting male majority in early modern England, who, like their Florentine counterparts, actively penetrated boys before going on to marry women. A condensed form of the argument appears in Cook, Mills, Trumbach, and Cocks, *Gay History of Britain*, 45–75. The latter includes discussion of visitations conducted in England during the Reformation, which uncovered several instances of sexual irregularity between monks and boys, but Trumbach treats the records as documents of social history that can be analyzed statistically and underplays their rhetorical significance.

144. Documented cases in which priests were indicted for sodomy with youths include that of Johannes Stocker, a curate of Basel Minster, convicted of raping a choirboy in 1475, discussed in Hergemöller, "Middle Ages," 74, and Puff, *Sodomy in Reformation Germany*, 38–40; and Arnaud de Verniolle, who confessed to inquisitors in 1323 to having sex with a number of students in their mid- to late teens while posing as a priest in the town of Pamiers in southern France, as recounted in documents translated in Goodich, *Other Middle Ages*, 118–43. The Lincoln visitation records, cited above, n7, include accusations of bed sharing between canons and choristers or secular youths. For differing estimates of the level of sexual abuse by priests in recent decades, see Frawley-O'Dea, *Perversion of Power*, 5–6; Jenkins, *Pedophiles and Priests*, 77–83.

145. Augustine, *Confessions* 1.7(11) and 2.1(1), ed. O'Donnell, 6–7, 16; Augustine, *Confessions*, trans. Chadwick, 9, 24.

146. Payer, *Sex and the Penitentials*, 42, quoting the seventh-century *Penitential of Cummean*. On attitudes to children's sexuality in medieval Christianity, see also Quinn, *Better Than the Sons of Kings*, 155–64; on literary depictions, see Sobczyk, *L'érotisme des adolescents*.

147. Ariès, *Centuries of Childhood*, 98–124. On reception of the Ariès thesis by medievalists, see MacLehose, "Tender Age," xii–xiii. While Karras (*Sexuality in Medieval Europe*, 154) concludes with an argument that our ideas of childhood innocence cannot be presumed for the Middle Ages, Boynton ("Liturgical Role of Children") documents references to pederasty in ninth- to twelfth-century monastic customaries as evidence for a distinct notion of childhood in the period. See also Kincaid, *Erotic Innocence*, 51–72.

148. Peter makes this argument in the course of explaining why unbaptized children have ameliorated punishments in the afterlife. See MacLehose, "Tender Age," 69.

149. Ibid.

150. Burrows, *Stereotype of the Priest*, 77–122. For an antifraternal poem from 1490 that briefly mentions the possibility that friars will seduce sons as well as wives and daughters, see Neal, *Masculine Self*, 114–15.

151. Bale, *Jew in the Medieval Book*, 131–34; Bale, *Feeling Persecuted*, 50–55; MacLehose, "Tender Age," 107–74.

Chapter 5

1. "Et quia recti aditus limen transcendere nequeunt, pererrando circuitum insania rotante volvuntur"; Peter Damian, "Letter 31," ed. Reindel, 294; Peter Damian, *Book of Gomorrah*, trans. Payer, 39. Peter cites Psalms 11.9 and 82.14 (Douay-Rheims numbering).

2. See Rollo, *Kiss My Relics*, 79–81.

3. Foucault, *History of Sexuality*, vol. 1, trans. Hurley, 43. For analysis of the passage's reception and misreadings it has inspired, see Halperin, *How to Do*, 24–47.

4. Brooten, *Love between Women*, 140 (original emphasis); Norton, *Myth of the Modern Homosexual*, esp. 45. Medievalists who take up the concept of orientation and its analogues include Matter, who refers to some religious women's possessing a "deep homoerotic orientation" ("My Sister, My Spouse," 84); Boswell, who defines gay sexuality as same-sex "eroticism associated with a conscious preference" (*Christianity, Social Tolerance, and Homosexuality*, 44); and Olsen, who finds in Peter Damian's "Letter 31" evidence of Peter's belief in a "natural heterosexual orientation" (*Of Sodomites*, 324; see also 290, 412). For an opposing view, which finds no coherent "heterosexual" standard in the Middle Ages against which other sex acts are measured, see Lochrie, "Heterosexuality." The word "sexuality" has provoked less resistance than "sexual orientation" in premodern scholarship, though Phillips and Reay, *Sex before Sexuality*, makes a strident case for rejecting it. For an argument defending the applicability of "sexuality" to the period, see Karras, *Sexuality in Medieval Europe*, esp. 5–9.

5. Halperin, *How to Do*, 67–8, citing Traub, "Rewards of Lesbian History," 369. Halperin also refers to sexual orientation as a "foreign" concept in classical antiquity (101) and discusses expressions of "sexual preference without sexual orientation" (116). For a parallel argument see Williams, *Roman Homosexuality*, 188–90.

6. El-Rouayheb, *Before Homosexuality*, 70.

7. Phillips and Reay, *Sex before Sexuality*, 13, 59, 69, 81–82, 88, 100,

8. Schultz, *Courtly Love*, 57; Schultz, "Heterosexuality as a Threat," 21.

9. Mills, "Homosexuality," 77; Cook, Mills, Trumbach, and Cocks, *Gay History of Britain*, 34; Mills, "Queer Is Here?" 257, 258.

10. Ahmed, *Queer Phenomenology*, 1.

11. Halperin, *How To Do*, 131.

12. Ahmed, *Queer Phenomenology*, 67–72, quoting Merleau-Ponty, *Phenomenology of Perception*, 183.

13. Ahmed, *Queer Phenomenology*, 67, 69. As Ahmed notes, Norton's *Myth of the Modern Homosexual* represents an exception to this general inattentiveness to the concept's directional aspect.

14. Ahmed, *Queer Phenomenology*, 4.

15. Warren, *Anchorites and Their Patrons*, 19–20, drawing on Clay, *Hermits and Anchorites*, 203–63.

16. Talbot, *Life of Christina of Markyate*, revised by Fanous and Leyser, 4. Subsequent references to this translation are provided in the main body of the text by page number; very occasionally translations have been modified slightly. Latin glosses are taken from Talbot, *Life of Christina of Markyate: A Twelfth Century Recluse*.

17. Although, in light of the previous chapter, it would be possible to pursue a Ganymede connection in this context, especially given the references to Christina's unwillingness to perform the role and its characterization as an attempt to "prepare her body for the deed of corruption" (11), as Stephanie Hollis and Jocelyn Wogan-Browne point out the cupbearer motif recalls a specifically Anglo-Saxon take on the role, which is traditionally inhabited by women in poems such as *Beowulf*. See Hollis and Wogan-Browne, "St. Albans and Women's Monasticism," 36.

18. For the classic Butlerian reading of medieval virginity, see Salih, *Versions of Virginity*. On chastity, male or female, as an "orientation" and "sexual identity," one "constitutive of how individuals would have understood themselves and their role in life," see Karras, *Sexuality in Medieval Europe*, 40, 45. On virginity as a willful practice, see R. Evans, "Virginity." On orientation as work, see Ahmed, *Queer Phenomenology*, 56, 100.

19. Asad, "On Ritual and Discipline," 165.

20. Foucault, *History of Sexuality*, vol. 1, trans. Hurley, 43.

21. For an overview of the relationship between physical and spiritual versions of virginity, see Salih, *Versions of Virginity*, esp. 9–13. On virginity tests and "hymenologies," see Kelly, *Performing Virginity*, 17–39. On architectural metaphors, see Whitehead, *Castles of the Mind*, 90–100. On tombs, see Barratt, "Context."

22. Peter Damian, "Letter 31," ed. Reindel, 320, 322; Peter Damian, *Book of Gomorrah*, trans. Payer, 79, 81. On contexts for Damian's gender stereotyping, see Olsen, *Of Sodomites*, 398–405.

23. On Christina's gender transitions, see Salih, *Versions of Virginity*, 131–32.

24. "Inversion," like Karl Heinrich Ulrichs's earlier coinage *Urning*, was used to describe individuals for whom the sex of the psyche does not correspond to that of the body. Used by Richard von Krafft-Ebbing and Havelock Ellis, it was popularized in Radclyffe Hall's 1928 novel *The Well of Loneliness*.

25. For other manifestations of the "virile" model of female spirituality, see Newman, *From Virile Woman*. Though Newman's main interest is in what she terms the feminized, "womanChrist" model, she finds the virile virginity topos "lingering throughout the middle ages" (3). For arguments that, especially in anchoritic texts, *sponsalia Christi* is not always conducive to gender stability, see Salih, "Queering *Sponsalia Christi*"; Salih, "Transvestism in the Anchorhold"; and Mills, *Suspended Animation*, 185–91.

26. On Christina as *sponsa Christi*, see Head, "Marriages of Christina of Markyate."

27. Salih, *Versions of Virginity*, 8. See also Jankowski, "'Virgins' and 'Not-Women.'"

28. For discussion of Husserl's intentionality thesis, see Ahmed, *Queer Phenomenology*, 27–37. On anchoritism as a phenomenological enterprise, see Cannon, "Enclosure." On early medieval virginity discourse performing the work of "reorientation," see Weston, "Virgin Desires."

29. Ahmed, *Queer Phenomenology*, 66–67, 72, 79–92.

30. Halperin, *How to Do*, 43.

31. As Rollo remarks, "the *De planctu* is outwardly the most virulently homophobic text of the Middle Ages, yet it does not a single time countenance (indeed, even intimate) the existence of same-sex relations between women"; Rollo, *Kiss My Relics*, 174n4.

32. The manuscript is available in facsimile: Bepler, Kidd, and Geddes, *St. Albans Psalter*. On Christina's connection to the Psalter, see Geddes, *St Albans Psalter*; Watt, *Medieval Women's Writing*, 19–38. Female anchorites in England were encouraged to meditate on comparable imagery: the squints through which they would have been able to view, from their cells, services in parish churches were sometimes trained onto scenes from the life of Christ and the Virgin Mary such as the visitation, as discussed in Sauer, "Architecture of Desire," 557. On visitation iconography and female same-sex kissing generally, see Carré, *Le baiser sur la bouche*, 106–7.

33. On iconography of the Four Daughters, see Carré, *Le baiser sur la bouche*, 16.

34. Traub, *Renaissance of Lesbianism*, 160–62 (on Four Daughters), 230–70 (on chaste femme love).

35. Simons, "Lesbian (In)Visibility," 97–101 and figs. 2–4, citing, e.g., a *cassone* panel from ca. 1420 now in the Muzeum Narodowe, Warsaw, in which one woman touches another's breasts.

36. Ibid., 106.

37. See Desmond and Sheingorn, *Myth, Montage, and Visuality*, 119–31. For the homoerotic possibilities in other images of Diana and company, see Simons, "Lesbian (In)Visibility."

38. Wolfthal, *Images of Rape*, 43.

39. Bray, *Friend*; Traub, *Renaissance of Lesbianism*.

40. Kuefler, "Male Friendship."

41. Other studies exploring possibilities for love, friendship, and eroticism among religious women include Matter, "My Sister, My Spouse"; Weston, "*Sanctimoniales cum Sanctimonilae*"; Wiethaus, "Female Homoerotic Discourse."

42. Bennett, "'Lesbian-like,'" 2; Halperin, *How to Do*, 78; Karras, *Sexuality in Medieval Europe*, 109; Traub, "Friendship's Loss," 350.

43. Traub, *Renaissance of Lesbianism*, 182–84. See also Gowing, "Politics of Women's Friendship."

44. McAvoy, *Medieval Anchoritisms*, 2.

45. Aelred of Rievaulx, *De institutione inclusarum* 15, in *Opera omnia*, ed. Hoste and Talbot, 1:651; Aelred of Rievaulx, "Rule of Life for a Recluse," trans. Macpherson, 64. Elsewhere Aelred warns his sister against familiarity with women and effeminates (*Opera omnia*, 1:656), and even girls under her tuition (*Opera omnia*, 1:640–41), who, he imagines, may end up being touched, embraced, and called daughter and friend by the recluse. On these other rulings, see Newman, *From Virile Woman*, 40–41; Sobczyk, *L'érotisme des adolescents*, 22.

46. Oxford, Bodleian Library, MS Eng. poet. a. 1, in Aelred of Rievaulx, *De institutione inclusarum*, ed. Ayto and Barratt, 27. Ayto and Barratt discuss the possibility of a female audience for the manuscript at xviii.

47. Oxford, Bodleian Library, MS Eng. poet. a. 1, fol. 105r, reproduced in Scase, *Vernon Manuscript*.

48. For the Latin *Speculum*, see Oliger, "*Speculum inclusorum* auctore anonymo anglico saeculi XIV," 79–80; for the English, see Powell Harley, *Myrour of Recluses*, xiv, 14. For evidence that the *Myrour* has female readers in mind, see E. A. Jones, "New Look into the *Speculum inclusorum*," 123–45; for a brief discussion of the texts' references to masturbation and sodomy, see McAvoy, *Medieval Anchoritisms*, 74. Further references to homoeroticism and masturbation in guidance texts aimed at hermits and anchorites are discussed in Sauer, "Uncovering Difference," esp. 143, where she examines the so-called *Rule of St. Celestine*. This anonymous English text, appearing in a late fifteenth- or early sixteenth-century manuscript,

recommends that male hermits seek companionship with another hermit or, failing that, a child or servant boy; but the recommendation is accompanied by a passage warning against the "temptacion of fleschly luste" this choice of companion might provoke should the hermit stray into the lad's "contre," which presumably refers to the boy's personal area within the living quarters. Peter Damian also regales readers of his letter to Pope Leo with a story of a masturbating hermit who has been told by a devil that whenever he feels sexually aroused, "he should release semen by rubbing his genitals, just as he blows mucus from his nose"; the hermit's friend subsequently looks on in horror as demons seize the hermit's soul when he dies. See Peter Damian, "Letter 31," ed. Reindel, 319; Peter Damian, *Book of Gomorrah*, trans. Payer, 76-77. A century before, Odo of Cluny told a similar story, on which see C. Jones, "Monastic Identity." For early medieval warnings about nuns sharing beds, see Olsen, *Of Sodomites*, 102-3.

49. Hudson, *Selections from English Wycliffite Writings*, 25.

50. For an overview of the Twelve Conclusions' attack on sodomy and other lascivious practices, see Dinshaw, *Getting Medieval*, 68-87; for a sensitive analysis of the eleventh conclusion, which interprets the third perversion in the Lollards' list as a mode of "inanimophilia," couched in terms of idolatrous devotion to "dead creatures," see Lochrie, *Heterosyncrasies*, 47-59.

51. Frantzen, *Before the Closet*, 270-78; Traub, *Renaissance of Lesbianism*, 63. The Lollards and Protestant reformers were saying nothing new here: the idea that celibacy generates threats of sexual incontinence had been in circulation for centuries, and it is a belief that persists into modern times, as evidenced by recent clerical abuse scandals. See Olsen, *Of Sodomites*, 306-8.

52. Hudson, *Selections from English Wycliffite Writings*, 25.

53. Lochrie evokes Chaucer's Prioress as a literary embodiment of associations between eating and sexual appetites, as expressed in the Lollard conclusions. See Lochrie, *Heterosyncrasies*, 60-61.

54. Oxford, Bodleian Library, MS Bodley 423 (fifteenth century), in Aelred, *De institutione inclusarum*, ed. Ayto and Barratt 3; discussion in Sauer, "Uncovering Difference," 145-47.

55. Lochrie, *Heterosyncrasies*, 26-46, quoting letter 3 in Abelard and Heloise, *Letters of Abelard and Heloise*, trans. Radice, 160-61. Lochrie also goes on to investigate the playfulness of Heloise's language in this passage and the letter more generally, showing how Heloise's aim is to convince Abelard that chastity is a way of life fraught with unruly desires, one that cannot simply be subjected to repressive regulation as promoted in the Benedictine Rule.

56. MS Bodley 423, in Aelred, *De institutione inclusarum*, ed. Ayto and Barratt, 6.

57. Powell Harley, *Myrour of Recluses*, 4. This, Aelred's, and other references to idleness are discussed in Sauer, "Uncovering Difference," 149-50.

58. Medical connections between sex and fine foods are discussed in Waldman, "Abbot Suger and the Nuns of Argenteuil," 247-49.

59. Jordan, *Invention of Sodomy*, 33, 37; Olsen, *Of Sodomites*, 335-38.

60. Peter Cantor, *Verbum adbreviatum: Textus prior*, ed. Boutry, 637; Paul of Hungary, *Summa de poenitentia*, 209. Although Paul's comments on the Sodomitic sin are mainly aimed at clerics, cloistered monks, and courtiers (*curiales*), he also quotes Romans 1.26-27 in this context. On Peter's citation of Ezekiel, see Carden, *Sodomy*, 180-81; on Paul of Hungary, see Jordan, *Invention of Sodomy*, 92-103. For an earlier example linking sodomy to fleshly appetite in general, see Odo of Cluny's *Occupatio*, discussed in C. Jones, "Monastic Identity," esp. 33-35.

61. On the Dominican connection, see Millett, "Origins of Ancrene Wisse."

62. *Ancrene Wisse* also contains other references to the Sodom narrative: part 5, on confession, refers to God sinking Sodom and Gomorrah to the bottom of hell (127); part 7, on love,

interprets God's warning to Lot to flee the city before it falls as an act of divine love (154). See Mills, "Gender, Sodomy, Friendship."

63. For readings that likewise identify a reference to homoerotic possibilities in the passage on lechery, see Bernau, "Virginal Effects," 41; Dinshaw, *Getting Medieval*, 88–89; Lochrie, "Between Women," 79; Salih, "Transvestism in the Anchorhold," 159. See also Farina, *Erotic Discourse*, 58, which analyzes the passage briefly in the context of a more general discussion of the anchorhold as a space producing sexual interiority; and Jager, *Tempter's Voice*, 214–15, which considers it in light of the author's awareness that to forbid is to tempt. Some scholars interpret the passage as referring only to masturbation. See Bullough, "Sin against Nature and Homosexuality," 68–69. The Vernon manuscript, which, as discussed above, contains a translation of Aelred's *De institutione inclusarum*, also includes a recension of *Ancrene Wisse*, but part 4 is much abridged and the passage on lechery has not been included. See Zettersten and Diensberg, *English Text of the Ancrene Riwle: The "Vernon" Text*.

64. For summaries of each version, see Millett, *Ancrene Wisse*, xi–xxvii. On modifications affecting the references to friendship and unnatural sex, see Mills, "Gender, Sodomy, Friendship" 18–21.

65. Zettersten, *English Text of the "Ancrene Riwle," Edited from Magdalene College, Cambridge MS. Pepys 2498*, 94–95. At one time Pepys 2498 was thought to be a Lollard-inspired compilation, but recent attempts to date the manuscript to ca. 1365–75 make this seem unlikely: see Hanna, "English Biblical Texts before Lollardy," 143.

66. Clay, *Hermits and Anchorites*, 130; Warren, *Anchorites and Their Patrons*, 33–36. Christina of Markyate seeks refuge for a time with the female anchorite Ælfwynn.

67. On the Outer Rule's references to maidservants, see Mills, "Gender, Sodomy, Friendship," 8–9.

68. Sauer, "Representing the Negative," drawing on Jankowski, ". . . In the Lesbian Void."

69. Lochrie, *Heterosyncrasies*, 29. Lochrie cites, in this context, Theodora Jankowski's argument that virginity in the early modern period "represented a queer space within the otherwise very restrictive and binary early modern sex/gender system." See Jankowski, *Pure Resistance*, 8.

70. Halberstam, *In a Queer Time*, 1.

71. On the socioreligious contexts, see esp. Warren, *Anchorites and Their Patrons*; on *Ancrene Wisse* as a collaborative enterprise, see Savage, "Communal Authorship of Ancrene Wisse"; for a review of the social thesis, see McAvoy, *Medieval Anchoritisms*, 3–4.

72. For concrete examples of anchoritism's "borderland" status, see McAvoy, *Medieval Anchoritisms*, 147–77.

73. On diocesan statutes aimed at preserving the sexual continence of anchorites, see Mills, "Gender, Sodomy, Friendship," 7.

74. Sedgwick, *Epistemology of the Closet*, 68. On the possibilities and limitations of the "closet" analogy, see also Frantzen, *Before the Closet*, esp. 3–4, 13–15; Burgwinkle, *Sodomy, Masculinity, and Law*, 9–10.

75. Stewart, *Close Readers*, 160–87.

76. The trope of the closet seems especially relevant to a passage in part 3 of *Ancrene Wisse* where the anchorhold is compared to the "hole" in which Saul did his "fulðe" (51) (filth) in 1 Kings 24: readers are informed that "false" anchorites exploit the privacy of the space in order to "bifule þet stude, ant don dearnluker þrin fleshliche fulðen" (52) (befoul that place, and to perform fleshly filths there more secretly) than if they remained in the world. But sexual transgressions are not specifically identified here: the point is that the "good" anchorite's hole allows her to hide from worldly vice (represented by Saul), not from God, and we can only guess at the specific sins her false counterpart secretly wishes to pursue. See Sauer, "Privacy, Exile and the Rhetoric of Solitude."

77. Puff, *Sodomy in Renaissance Germany*, 31–32.

78. Burchard of Worms, *Decretum* 17.39, 17.56, and 19.5, in Migne *PL* 140:926d–927a, 931d–933a, 967d. The relevant passage from book 19 of the Corrector is translated in Jordan, *Invention of Sodomy*, 52.

79. Peter Damian, "Letter 31," ed. Reindel, 287; Peter Damian, *Book of Gomorrah*, trans. Payer, 29. Peter's fourfold categorization is identical to Burchard's, but he lists the practices in reverse order. See Jordan, *Invention of Sodomy*, 51–54; Olsen, *Of Sodomites*, 263–70.

80. Simulation of anal intercourse between the thighs was also regularly prosecuted. Some Venetian men were accused of having anal intercourse with their wives or with prostitutes, but prosecutions were relatively uncommon. See Ruggiero, *Boundaries of Eros*, 118–21.

81. Cadden, *Nothing Natural Is Shameful*.

82. El-Rouayheb, *Before Homosexuality*, 124–27, 136–37.

83. See Steel, *How to Make a Human*, 203.

84. Guillaume de Lorris and Jean de Meun, *Roman de la Rose* 12803–11, 14676–81, ed. Lecoy 2:140, 196. See Gaunt, "Bel Acueil and the Improper Allegory," 72–73; Rollo, *Kiss My Relics*, 201–2.

85. *Cleanness*, lines 695–96, 841–48, in Anderson, *Sir Gawain and the Green Knight*, 81, 88–9. See Frantzen, "Disclosure of Sodomy in Cleanness"; Keiser, *Courtly Desire*.

86. The same manuscript also includes marginal scenes depicting a gender-ambiguous figure inserting a pair of bellows into the rump of a male crouched down ready to receive it (fol. 81v); and a long-beaked heron pecking the posterior of a hybrid figure (fol. 187r). For other scenes in Walters W.88 with possible homoerotic significance, see above, 77–79 and fig. 24.

87. Camille, *Image on the Edge*, 42–43. The arrow-in-the-hindquarters motif also appear at fols. 33v–34r, 87v, and 107v–108r.

88. Camille, "Dr. Witkowski's Anus." The bottom sculpture in question, in the first console of the staircase leading down to the crypt, is reproduced as fig. 2.1.

89. New York, Pierpont Morgan Library, MS G.24, fols. 67r, 70v, 95r, 140v.

90. Barber, *Trial of the Templars*, 221–23, 249. See also Crompton, *Homosexuality and Civilization*, 192–96; Gilmour-Bryson, "Sodomy and the Knights Templar."

91. The scene, captioned "Templar kissing cleric" or some variation on this, is discussed in Crompton, *Homosexuality and Civilization*, 193; Hergemöller, "Middle Ages," 65; Reed, *Art and Homosexuality*, 40; Saslow, *Pictures and Passions*, 75–76. The marginalia of Pierpont Morgan G.24 also feature disembodied anuses or half-length figures mooning, being worshiped or kissed, or defecating (fols. 33r, 34v, 44v, 45v, 54r, 79r, 81v, 82v, 123v, 139v), bagpipe- or trumpet-playing asses (fols. 1r, 65r, 82r, 136v), and figures pointing their fingers into their buttocks (fols. 25v, 30v).

92. Vienna 2554, fols. 41r, 50v; Vienna 1179, fols. 79v, 83v, 171v, 203v.

93. "Vel Cathari dicuntur a cato, quia, ut dicitur, osculantur posteriora catti, in cujus specie, ut dicunt, apparet eis Lucifer"; Alan of Lille, *Contra haereticos* 63, in Migne *PL* 210:366a. Alan cites the story of cat-kissing Cathars without necessarily believing it fully. This and other textual references linking heretics to cat worship and kissing are cited in Lipton, *Images of Intolerance*, 45, 88–91.

94. Camille, "Dr. Witkowski's Anus," 30–31. On representations of sodomy in the fabliaux, see Levy, "Le dernier tabou?" 117–19.

95. Analyses include Boyd, "Seeking 'Goddes Pryvetee'"; Burger, "Erotic Discipline." As Boyd discusses, here Chaucer is deliberately making an allusion to the *Rose*, a poem that takes up, in turn, Alan of Lille's reference in *De planctu Naturae* to a plowshare that "in sterili littore . . . arat" (1.30) (scores a barren strand).

96. Geoffrey the Baker, *Chronicon Galfridi le Baker*, ed. Thompson, 33–34; Ranulf Higden, *Polychronicon*, ed. Babington and Lumby, 8:235–37.

97. On Gaveston as an adoptive brother, see Chaplais, *Piers Gaveston*. Chronicles that characterize Edward as a sodomite include Luard, *Flores Historiarum*, 3:229; and Bond, *Chronica Monasterii de Melsa*, 2:355. That said, Michael Evans has suggested that the impalement motif may originally have been designed to defame the murderers rather than the victim, by aligning the perpetrators with tyranny and Edward himself with saintly martyrs. See M. Evans, *Death of Kings*, 124–34.

98. The injuries inflicted on the body of Richard III, which apparently included a post-mortem injury to the king's right buttock, suggest that butt stabbing or penetration also participated in a wider vocabulary of humiliation designed to denigrate deposed or defeated kings. See Buckley et al., "'King in the Car Park,'" 536.

99. See Herrad of Hohenbourg, *Hortus deliciarum*, ed. Green et al.; Griffiths, *Garden of Delights*.

100. "Vermis impiorum non morietur et ignis illorum in sempiternum non extinguetur."

101. The scene is discussed in Griffiths, *Garden of Delights*, 194, but she makes no mention of the male couple.

102. Camille, "Pose of the Queer."

103. Olsen, *Of Sodomites*, 377–79. The capital is also discussed briefly in Reed, *Art and Homosexuality*, 40; Saslow, *Pictures and Passions*, 65.

104. See Weir and Jerman, *Images of Lust*, esp. 85 (discussing the Châteaumeillant capital) and 153 (discussing a possible reference to sodomy at the collegiate church of San Pedro de Cervatos, Campoo de Enmedio, Spain).

105. Easting, *Revelation of the Monk of Eynsham*, 77–79. Easting's edition prints the English translation alongside the Latin *Visio*. For a survey of other visionary literature singling out sodomites, including the *Vision of Paul*, the *Vision of Ansellus Scholasticus*, and the *Vision of Tnugdal (Tundale)*, see Limbeck, "'Turpitudo antique passionis'"; the monk of Eynsham's *Visio* is discussed at 187–94. The account of sodomitic torment in the *Revelation* is followed by descriptions of encounters with a lawyer who, testifying that he practiced the sin in life, is now compelled to perform the "same foule passyon" in death (81–85), and with a recently deceased prior, who had closed his eyes to the "fowle abusyons" of his monastery's inmates (93–95). See Mills, "Queering the Un/Godly," 120–21.

106. Easting, *Revelation of the Monk of Eynsham*, 79.

107. Kurath et al., *Middle English Dictionary*; Simpson et al., *Oxford English Dictionary*. See Mills, "Queering the Un/Godly," 119–20; Simons, *Sex of Men*, 269.

108. Alan of Lille, *De planctu Naturae*, ed. Häring, 802. The word "mixti" in the Châteaumeillant inscription may also possess these connotations.

109. Zarnecki, *Romanesque Lincoln*, 68. See also Buckler et al., *Lincoln Cathedral*, 38–39. Traces remain on one of the victims of a beard, suggesting a possible effort on the sculptors' part to differentiate the couple by age; the bearded male is in the penetrated position, suggesting a reversal of his role as "active" sodomite in life. These scenes are part of a sequence representing Christ harrowing hell: to the right of avarice is an eighteenth-century replacement panel showing two other males being tormented, and to the right of that Christ tramples on the devil and releases suffering souls. Olsen discusses other scenes in Romanesque sculpture showing male pairs entwined with snakes or devoured by devils, which could conceivably be making reference to sodomy. These include carvings at the abbey of Saint-Amand de Coly (Dordogne); the Colegiata of San Martín de Elines (Cantabria); and the church of Saint-Vincent-de-Pertignas (Gironde). See Olsen, *Of Sodomites*, 371.

110. Olsen, *Of Sodomites*, 18, 364–65, and fig. 33.

111. "The Dance of the Seven Deadly Sins," lines 80-81, 87-89, in Dunbar, *Complete Works*, ed. Conlee. See Mills, "Queering the Un/Godly," 123-24.

112. Camille also points to associations between Bourges and sodomy more generally (e.g., the city's name recalls the term *bougre*, meaning heretic or bugger), as well as citing other representations of anal penetration and crotch grabbing on Last Judgment portals of Chartres, Reims (now effaced), and Notre-Dame in Paris. See Camille, "Dr. Witkowski's Anus," 31-38. The Bourges hell also features, to the left, a man with a moneybag tied around his neck being tormented by a demon, who pulls the man's hair while a serpent-headed tail, emerging from the demon's anus, bites the sinner's leg.

113. See above, 8. Camille also discusses another sculpted ass on the roof of a projecting chapel on the south side of Bourges Cathedral built with funds from Jean de Berry, which, he speculates, may be a joke designed to disparage Jean's alleged sodomitical tastes. See Camille, "Dr. Witkowski's Anus," 31-32.

114. For examples, see Baschet, *Les justices de l'au-delà*, 395, 502, and figs. 33, 43, 49, 87, 96, 123, 140, 143, 145; Mills, *Suspended Animation*, 83-105.

115. Easting, *Revelation of the Monk of Eynsham*, 81.

116. On the English text's expansion of the Latin *Visio's* reference to sodomy between women, see Easting, *Revelation of the Monk of Eynsham*, lxiii. In fact, female homoeroticism was condemned in early Christian visionary literature, as discussed in Brooten, *Love between Women*, 303-14.

117. Another word or phrase appears below, but I have not been able to decipher it. Other inscriptions on the fresco are transcribed in Baschet, *Les justices de l'au-delà*, 636-39. For a general introduction to the Bartolo hell, see Symeonides, *Taddeo di Bartolo*, 153-58.

118. Simpson et al., *Oxford English Dictionary*.

119. I am grateful to Barry Byrne for pointing out this connection. See Boccaccio, *Decameron*, ed. Branca, 693. For differing interpretations of the story's approach to matters of sexual subjectivity, see Freccero, *Queer/Early/Modern*, 41-48; Halperin, *How to Do*, 38-41; J. Walters, " 'No More Than a Boy.' " For more on *cattivo* as a euphemism for sodomy, see Toscan, *Le carnaval du langage*, 1:454-55.

120. On *sotto* see Toscan, *Le carnaval du langage*, 1:424.

121. Rocke, *Forbidden Friendships*, 14, 89-111. Florentine attitudes to fellatio contrast with those expressed in ancient Rome, on which see Williams, *Roman Homosexuality*, 218.

122. See Mills, *Suspended Animation*, 85-87 and figs. 42, 43, 70. Spit roasting is also deployed in other contexts as a sexual metaphor. See, e.g, the badge showing a phallus roasting on a spit over a vulva acting as a grease trap, discussed in Simons, *Sex of Men*, 84 and fig. 13.

123. Mills, *Suspended Animation*, 86 and figs. 44, 45, 47, 48.

124. This and other paintings showing heaven and scenes from the life of Christ were uncovered during the 1993 restoration. The frescoes have been attributed to the Maestro della *Dormitio Virginis* di Terni, who was active mainly in southern Umbria and Le Marche in the late 1300s and early 1400s. See Bliersbach, "I Bianchi nell'arte Umbro-Laziale," 398-99, 402-3, and figs. 41, 44. I am grateful to Andrew Chen for this reference.

125. Several of the Pisa sinners are labeled, and it is possible that the spit-roasted figure and his companion may originally have been identified with legends on their miters. See Baschet, *Les justices de l'au-delà*, 624-27.

126. Bartholomaeis, *Laude drammatiche e rappresentazioni sacre*, 1:52, lines 427-32.

127. Toscan, *Le carnaval du langage*, 1:543-46.

128. Goodich, *Unmentionable Vice*, 61; Mormando, *Preacher's Demons*, 119.

129. "The sodomite had been a temporary aberration; the homosexual was now a species"; Foucault, *History of Sexuality*, vol. 1, trans. Hurley, 43. On pig symbolism and sodomy, see Mills, *Suspended Animation*, 96-98; Toscan, *Le carnaval du langage*, 1:548-52.

130. Schiaffini, *Cronica fiorentina compilata nel secolo XIII*, 139.

131. The closest parallel to penetration by a spit in the Florentine records is the case of Giovanni di Giovanni, a fifteen-year-old boy who allowed himself to be sodomized by numerous men; convicted in 1365, he was castrated and branded between the thighs. See Rocke, *Forbidden Friendships*, 24. The Florentine situation is mirrored in the rest of Europe: while there are frequent examples of punitive anal penetration in premodern art and literature, there is no evidence that it was used systematically as a form of punishment or execution in actuality. See Pettitt, "Skreaming like a pigge halfe stickt," 89–90. That said, Florentine records document several cases of defamatory miters being worn by convicted sodomites, a motif paralleling the depiction of fool's caps in the Pisa and San Gimignano infernos. See Rocke, "Ambivalence of Policing Sexual Margins," 60–63. In fifteenth-century Venice males convicted of "active" sodomy were executed (often being subjected to death by burning), while receptive partners generally received a lighter penalty. See Ruggiero, *Boundaries of Eros*, 121–27.

132. Peter Damian, "Letter 31," ed. Reindel, 321, 323–24; Peter Damian, *Book of Gomorrah*, trans. Payer, 79–80, 83. Paul of Hungary, *Summa de poenitentia*, 209.

133. On ancient and medieval precedents for the medico-scientific treatment of homosexuality, see Cadden, *Meanings of Sex Difference*, 214–18; Cadden, *Nothing Natural Is Shameful*; Camille, "Pose of the Queer," 71, 83–84n36; Halperin, *How to Do*, 124–25; Jordan, *Invention of Sodomy*, 115–23; Olsen, *Of Sodomites*, 308–12.

134. Bloch, *Sexual Life of Our Time*, 498, quoted in Camille, "Dr. Witkowski's Anus," 22.

135. Ahmed, *Queer Phenomenology*, 49, 58–61, 67–70.

136. Ibid., 16, 41–44, 56–57.

137. See Jordan, *Invention of Sodomy*, 84.

138. Burns, *Las siete partidas*, 5:1334 (title 6, law 4).

139. For a more detailed analysis of links between sodomy and illicit economic activity, including the parallel between the usurer and the sodomite in the San Gimignano *Last Judgment*, see Fisher, "Queer Money." On coins, minting, and semen, see Simons, *Sex of Men*, 169–86. On failed orientation and tendencies/tending toward, see Ahmed, *Queer Phenomenology*, 47–51, 56–58.

140. Jordan, *Invention of Sodomy*, 163–65.

141. Rocke, "Ambivalence of Policing Sexual Margins," 56–57, 67–68.

142. Natural philosophers sometimes associated sodomy with certain kinds of bodily deficiency or physiology, but even then it tended to be seen as a perversion of the soul rather than simply as an accident of birth. See Cadden, *Meanings of Sex Difference*, 215–18; Cadden, *Nothing Natural Is Shameful*, 139–75; Jordan, *Invention of Sodomy*, 114–35.

143. Barclay, *New Testament Words*, 118–25. I am grateful to Barry Byrne for drawing my attention to these connections.

Conclusions

1. Lochrie, *Heterosyncrasies*, xxv.

2. Davidson, *Greeks and Greek Love*, 101–34.

3. Olsen, *Of Sodomites*, 290.

BIBLIOGRAPHY

Classical and Medieval Primary Sources

Abelard, Pierre, and Héloïse d'Argenteuil. *The Letters of Abelard and Heloise.* Translated by Betty Radice. New York: Penguin, 1974.

Ælfric. "Life of Eugenia." In *Ælfric's Lives of Saints, Being A Set of Sermons on Saints' Days Formerly Observed by the English Church*, edited by Walter W. Skeat. EETS o.s. 76 & 82. Oxford: Oxford University Press, 1966.

———. "Life of Eugenia." In *Women Saints' Lives in Old English Prose: Translated from Old English with Introduction, Notes and Interpretive Essay*, translated by Leslie A. Donovan, 67–77. Cambridge, UK: D. S. Brewer, 1999.

Aelred of Rievaulx. *De institutione inclusarum.* In *Opera omnia*, edited by A. Hoste and C. H. Talbot. Vol. 1: *Opera ascetica*, 635–82. Corpus christianorum: continuatio mediaevalis 1. Turnhout: Brepols, 1971

———. *De institutione inclusarum: Two English Versions.* Edited by John Ayto and Alexandra Barratt. EETS o.s. 287. London: Oxford University Press, 1984.

———. *De spirituali amicitia.* In *Opera omnia*, edited by A. Hoste and C. H. Talbot. Vol. 1: *Opera ascetica*, 279–350. Corpus christianorum: continuatio mediaevalis 1. Turnhout: Brepols, 1971.

———. "A Rule of Life for a Recluse." In *Aelred of Rievaulx: Treatises and Pastoral Prayer*, translated by Mary Paul Macpherson. 1971; repr., Kalamazoo, MI: Cistercian Publications, 1995.

———. *Spiritual Friendship.* Translated by Mark F. Williams. London: Associated University Presses, 1994.

Akehurst, F. R. P., trans. *The Etablissements de Saint Louis: Thirteenth-Century Law Texts from Tours, Orléans, and Paris.* Philadelphia: University of Pennsylvania Press, 1996.

Alan of Lille. *Anticlaudianus*. In *The Anglo-Latin Satirical Poets and Epigrammatists of the Twelfth Century*, edited by Thomas Wright, 268–426. 1872; repr. New York: Kraus, 1964.

———. *Contra haereticos*. In Migne *PL* 210:305–430.

———. *De planctu Naturae*. Edited by Nikolaus M. Häring. In "Alain of Lille, 'De Planctu naturae.'" *Stvdi medievali*, ser. 3, 19 (1978): 797–879.

———. *The Plaint of Nature*. Translated by James J. Sheridan. Mediaeval Sources in Translation, vol. 26. Toronto: Pontifical Institute of Mediaeval Studies, 1980.

Alfonso the Wise. *Fuero real*. In *Los códigos españoles concordados y anotados*. 12 vols. Madrid: Imprenta de La Publicidad, a cargo de M. Rivadeneyra, 1847–51.

Ambrose. *Expositio Evangelii secundum Lucam*. In Migne *PL* 15:1527–1850.

Anderson, J. J., ed. *Sir Gawain and the Green Knight, Pearl, Cleanness, Patience*. London: J. M. Dent, 1996.

Anselm of Laon et al. *Glossa ordinaria*. In Migne *PL* 113.

Apollodorus. *The Library*. 2 vols. Translated by James George Frazer. Loeb Classical Library 121–22. London: Heinemann, 1921.

Aquinas, Thomas. *Summa theologiae*. Edited and translated by the Dominican Fathers. 61 vols. London: Eyre and Spottiswoode, 1964–80.

Augustine. *Confessions*. Vol. 1: *Introduction and Text*. Edited by James J. O'Donnell. Oxford: Oxford University Press, 2012.

———. *Confessions*. Translated by Henry Chadwick. Oxford: Oxford University Press, 1991.

———. *De civitate Dei*. In Migne *PL* 41:13–804.

———. *De Genesi ad litteram*. In Migne, *PL* 34:245–486.

Bartholomaeis, Vincenzo de, ed. *Laude drammatiche e rappresentazioni sacre*. 3 vols. Florence: Felice le Monnier, 1943.

Beleth, John. *Summa de ecclesiasticis officiis*. In Migne *PL* 202:9–166.

Benedict, Saint. *The Rule of St Benedict in Latin and English*. Edited and translated by Justin McCann. London: Burns Oates, 1952.

Benedict the Deacon [Benedictus Levita]. *Capitularium collectio*. In Migne *PL* 97:697–912.

Bepler, Jochen, Peter Kidd, and Janes Geddes, eds. *The St. Albans Psalter (Albani Psalter)*. Simbach am Inn: Müller & Schindler, 2008.

Berchorius, Petrus [Pierre Bersuire]. *The Ovidius moralizatus of Petrus Berchorius: An Introduction and Translation*. Translated by William D. Reynolds. PhD diss., University of Illinois, 1971.

———. *Reductorium morale, Liber XV, cap. i. Ovidius moralizatus naar de Parijse druk van 1509*. Edited by Joseph Engels. Utrecht: Instituut voor Laat Latijn der Rijksuniversiteit, 1960.

———. *Reductorium morale, Liber XV, cap. ii–xv. Ovidius moralizatus naar de Parijse druk van 1509*. Edited by Joseph Engels. Utrecht: Instituut voor Laat Latijn der Rijksuniversiteit, 1962.

Bibliothèque nationale de France, Paris. *Bible moralisée de Naples* [facsimile]. Barcelona: M. Moleiro, 2009.

Boccaccio, Giovanni. *Decameron*. Edited by Vittore Branca. Turin: Einaudi, 1992.

Boer, C. de, ed. *Ovide moralisé en prose: Texte du quinzième siècle*. In *Verhandelingen der Koninklijke Akademie van Wetenschapaen te Amsterdam, Afdeeling Letterkunde, nieuwe reeks* 61 (1954).

Boer, C. de, et al., eds. *Ovide moralisé: Poème du commencement du quatorzième siècle publié d'après tous les manuscrits connus*. In *Verhandelingen der Koninklijke Akademie van Wetenschapaen te Amsterdam, Afdeeling Letterkunde, nieuwe reeks* 15 (1915) [books 1–3], 21 (1920) [books 4–6], 30 (1931) [books 7–9], 37 (1936) [books 10–13], 43 (1938) [books 14–15 and appendices].

Boethius. *Consolation of Philosophy*. Edited and translated by H. F. Stewart, E. K. Rand, and S. J. Tester. Loeb Classical Library 74. Cambridge, MA: Harvard University Press, 1973.

───. *The Consolation of Philosophy*. Edited by Douglas C. Langston. Translated by Richard H. Green. New York: Norton, 2010.

Bond, E. A., ed. *Chronica Monasterii de Melsa*. Rolls Series 43. London: Longman, 1866–88.

Bonsignori, Giovanni dei. *Ovidio Metamorphoseos vulgare*. Venice: Zoane Rosso, 1497.

Burchard of Worms. *Decretum*. In Migne *PL* 140:537–1057.

Burns, Robert I., ed. *Las siete partidas*. Translated by Samuel Parsons Scott. 5 vols. Philadelphia: University of Pennsylvania Press, 2001.

Caxton, William, trans. *The Booke of Ovyde Named Methamorphose*. Edited by Richard J. Moll. Studies and Texts 182. Toronto: Pontifical Institute of Mediaeval Studies, 2013.

───, trans. *The Metamorphoses of Ovid* (1480). Facsimile in 2 vols. New York: George Braziller, 1968.

───, trans. *The Middle English Text of "Caxton's Ovid," Book 1, Edited from Cambridge, Magdalene College, Old Library, MS F.4.34, with a Parallel Text of the "Ovide moralisé en prose II," Edited from Paris, Bibliothèque Nationale, MS fonds français 137*. Edited by Diana Rumrich. Middle English Texts 43. Heidelberg: Winter, 2011.

Chaucer, Geoffrey. *Riverside Chaucer*. Edited by David Benson. 3rd ed. Oxford: Oxford University Press, 1987.

Christine de Pizan. *The Book of Fortune's Transformation*. Translated by Kevin Brownlee. In *The Selected Writings of Christine de Pizan*, edited by Renate Blumenfeld-Kosinski, 88–109. Norton Critical Editions. New York: Norton, 1997.

───. *Le livre de la mutacion de Fortune*. Edited by Suzanne Solente. 4 vols. Paris: Picard, 1959–66.

Dante Alighieri. *Purgatorio*. Edited and translated by Robin Kirkpatrick. London: Penguin, 2007.

Dunbar, William. *William Dunbar: The Complete Works*. Edited by John Conlee. Kalamazoo, MI: Medieval Institute Publications, for TEAMS in association with the University of Rochester, 2004.

Eadmer. *Historia Novorum in Anglia*. Edited by Martin Rule. Rolls Series 81. London: Longman, 1884.

Easting, Robert, ed. *The Revelation of the Monk of Eynsham*. EETS o.s. 318. Oxford: Oxford University Press, 2002.

Edgar, Swift, ed. *The Vulgate Bible: Douay-Rheims Translation*. 4 vols. Cambridge, MA: Harvard University Press, 2010.

Eusebius. *Eusebii Pamphili Chronici Canones*. Edited by J. K. Fotheringham. London: Humphrey Milford, 1923.

Faillon, Étienne Michel, ed. *Monuments inédits sur l'apostolat de Sainte Marie-Madeleine en Provence et sur les autres apôtres de cette contrée, Saint Lazare, Saint Maximin, Sainte Marthe et les Saintes Maries, Jacobé et Salomé*. 2 vols. Paris: Migne, 1848.

Froissart, Jean. *Oeuvres de Froissart: Chroniques*. Edited by K. de Lettenhove. 25 vols. Brussels: V. Devaux, 1867–77.

Fructuosus of Braga. *Regula monachorum Complutensis*. In Migne *PL* 87:1097–1130.

───. *Rule for the Monastery of Compludo*. Translated by C. W. Barlow. The Fathers of the Church 63. Washington, DC: Catholic University of America Press, 1969.

Fulgentius. *Mitologiarum Liber I.20*. Edited by R. Helm. Stuttgart: Teubner, 1970.

Geoffrey the Baker. *Chronicon Galfridi le Baker de Swynebroke*. Edited by Edward Maunde Thompson. Oxford: Clarendon, 1889.

Goodich, Michael, ed. and trans. *Other Middle Ages: Witnesses at the Margins of Medieval Society*. Philadelphia: University of Pennsylvania Press, 1998.

Gower, John. *Confessio Amantis*. Westminster: William Caxton, 1483.

————. *Confessio Amantis*. Edited by Russell A. Peck. 2nd ed. Kalamazoo, MI: Medieval Institute for TEAMS in association with the University of Rochester, 2006.

Green, Rosalie, Michael Evans, Christine Bischoff, and Michael Curschmann, eds. *The Hortus deliciarum of Herrad of Hohenbourg (Landsberg, 1176-96): A Reconstruction*. London: Warburg Institute, 1979.

Gregory the Great. *Dialogorum libri 2*. In Migne *PL* 66:125-204.

————. *Dialogues*. Translated by Odo John Zimmerman. Washington, DC: Catholic University of America Press, 1959; repr. 1977.

————. *Homiliarum in evangelia*. In Migne *PL* 76:1238-46.

Guest, Gerald B., ed. *Bible moralisée: Codex Vindobonensis 2554, Vienna, Österreichische Nationalbibliothek*. London: Harvey Miller, 1995.

Guillaume de Lorris and Jean de Meun. *Le Roman de la Rose*. Edited by Félix Lecoy. 3 vols. Paris: Champion, 1965-70.

————. *The Romance of the Rose*. Translated by Charles Dahlberg. 3rd ed. Princeton, NJ: Princeton University Press, 1995.

Guillaume de Machaut. *Le confort d'ami (Comfort for a Friend)*. Edited and translated by R. Barton Palmer. New York: Garland, 1992.

Hasenfratz, Robert, ed. *Ancrene Wisse*. Kalamazoo, MI: Medieval Institute Publications, for TEAMS in association with the University of Rochester, 2000.

Hausherr, Reiner. *La Bible moralisée de la Bibliothèque Nationale d'Autriche Codex Vindobonensis 2554 reproduite en fac-similé intégral*. Translated by Elisabeth Wintzenrieth. Paris: Club du Livre-Philippe Lebaud, 1973.

Hildegard of Bingen. *Scivias*. Edited by Adelgundis Führkötter and Angela Carlevaris. Continuatio Mediaevalis 43. Turnhout: Brepols, 1978.

————. *Scivias*. Translated by Columba Hart and Jane Bishop. New York: Paulist Press, 1990.

Hincmar of Reims. *De divortio Lotharii et Tetbergae*. In Migne *PL* 125:619-772.

Hudson, Anne. *Selections from English Wycliffite Writings*. Cambridge: Cambridge University Press, 1978.

Hugh of Flavigny. *Chronicon*. In Migne *PL* 154:390d-391a.

Hyginus. *The Myths of Hyginus*. Translated and edited by Mary Grant. Lawrence: University of Kansas Press, 1960.

Jacobus de Voragine. *The Golden Legend: Readings on the Saints*. Translated by William Granger Ryan. 2 vols. Princeton, NJ: Princeton University Press, 1993.

————. *Legenda aurea: Edizione critica*. Edited by Giovanni Paolo Maggioni. Revised ed. 2 vols. Millennio Medievale 6; Testi 3. Florence: SISMEL, Edizioni del Galluzzo, 1998.

Jean de Meun. "Boethius' *De Consolatione* by Jean de Meun." Edited by V. L. Dedeck-Héry. *Mediaeval Studies* 14 (1952): 165-275.

Jerome. "Ad Eustochium" (Letter 22). In *Select Letters of St. Jerome*, edited and translated by F. A. Wright, 52-159. Loeb Classical Library 262. Cambridge, MA: Harvard University Press, 1933; repr. 1991.

————. *Commentariorum in Epistolam ad Ephesios*. In Migne *PL* 26:439-554.

John of Salisbury. *Policraticus I-IV*. Edited by K. S. B. Keats-Rohan. Turnhout: Brepols, 1993.

Laborde, A. de. *La Bible moralisée illustrée conservée à Oxford, Paris et Londres: Reproduction intégrale du manuscrit du XIIIᵉ siècle accompagnée de planches tirées de Bibles similaires et d'une notice*. 5 vols. Paris: Société française de reproductions de manuscrits à peintures, 1911-27.

Lactantius. *Divinarum institutionum*. In Migne *PL* 6:111-252.

Luard, H. R., ed. *Flores Historiarum*. 3 vols. Rolls Series 95. London: Eyre & Spottiswoode, 1890.

Maniacoria, Nicholas. *Vita sancti Hieronimi*. In Migne *PL* 22:183-202.

Martianus Capella. *De nuptiis Philologiae et Mercurii*. Edited by James Willis. Leipzig: Teubner, 1983.

Migne, Jacques-Paul, ed. *Patrologia Latina* [*Patrologia Cursus Completus: Series Latina*]. 217 vols. Paris: Migne, 1844–55.

Millett, Bella, ed. *Ancrene Wisse: A Corrected Edition of the Text in Cambridge Corpus Christi College, MS 402, with Variants from Other Manuscripts*. Vol. 1: text. EETS o.s. 325. Oxford: Oxford University Press, 2005.

Moranvillé, Henri, ed. *Le songe véritable: Pamphlet politique d'un Parisien du XVe siècle*. Paris: Société de l'Histoire de Paris, 1891.

Oliger, P. Livaro, ed. "*Speculum inclusorum* auctore anonymo anglico saeculi XIV." *Laternanum* n.s. 4 (1938): 1–148.

Orderic Vitalis. *Ecclesiastical History*. Edited and translated by Marjorie Chibnall. 6 vols. Oxford: Clarendon, 1968–80.

Orosius. *Historiorum libri septem*. In Migne *PL* 31:663–1174.

Ovid. *The Art of Love, and Other Poems*. Translated by J. H. Mozley. 2nd ed. revised by G. P. Goold. Loeb Classical Library 232. Cambridge, MA: Harvard University Press, 1986.

———. *Bible des poëtes*. Bruges: Colard Mansion, 1484.

———. *Bible des poëtes*. Paris: Antoine Vérard, 1493.

———. *Metamorphoses*. Edited and translated by Frank Justus Miller. 3rd ed. revised by G. P. Goold. 2 vols. Loeb Classical Library 42, 43. Cambridge, MA: Harvard University Press, 1977–84.

———. *The Metamorphoses of Ovid*. Translated by Michael Simpson. Amherst: University of Massachusetts Press, 2001.

Paul of Hungary. *Summa de poenitentia*. In *Bibliotheca Casinensis* 4 (1880): 191–215.

Pepin, Ronald E. *The Vatican Mythographers*. New York: Fordham University Press, 2008.

Peter Cantor [Peter the Chanter]. *Verbum abbreviatum*. In Migne *PL* 205:21–554.

———. *Verbum abbreviatum: Textus conflatus*. Corpus Christianorum Continuatio Mediaevalis 196. Edited by Monique Boutry. Turnhout: Brepols, 2004.

———. *Verbum abbreviatum: Textus prior*. Edited by Monique Boutry. Corpus Christianorum Continuatio Mediaevalis 196A. Turnhout: Brepols, 2012.

Peter Comestor. *Historia Scholastica*. In Migne *PL* 198:1049–1722.

Peter Damian. *Book of Gomorrah: An Eleventh-Century Treatise against Clerical Homosexual Practices*. Translated by Pierre J. Payer. Waterloo, Ontario: Wilfrid Laurier University Press, 1982.

———. "Letter 31" [*Liber Gomorrhianus*]. In *Die Briefe des Petrus Damiani*, edited by Kurt Reindel, 1:284–330. Monumenta Germaniae historica: Die Briefe der deutschen Kaiserzeit 4. Munich: MGH, 1983.

Peter the Venerable. *De miraculis*. In *Petri Cluniacensis Abbatis, De miraculis libri duo*, edited by Denise Bouthillier. Turnhout: Brepols, 1988.

———. *Livre des merveilles de dieu*. Translated by Jean-Pierre Torrell and Denise Bouthillier. Paris: Cerf, 1992.

Petrarch, Francesco. *Africa*. Edited and translated by Thomas G. Bergin and Alice S. Wilson. New Haven, CT: Yale University Press, 1977.

Phanocles. *Erotes e kaloi*. In *Collectanea Alexandrina: Reliquiae minores poetarum Graecorum aetatis Ptolemaic, 323–146 A.C.*, edited by John U. Powell, 106–7. Oxford: Clarendon, 1925.

Plato. *Symposium*. In *Collected Works of Plato*, translated by Benjamin Jowett. Oxford: Oxford University Press, 1953.

Pliny. *Natural History*. Edited by T. E. Page et al. Translated by H. Rackham. 10 vols. Loeb Classical Library. Cambridge, MA: Harvard University Press, 1961–69.

Powell Harley, Marta, ed. *The Myrour of Recluses: A Middle English Translation of "Speculum inclusorum."* London: Associated University Presses, 1995.

Ranulf Higden. *Polychronicon.* Edited by C. Babington and J. R. Lumby. 9 vols. Rolls Series 41. London: Longman, 1865–86.

Richard of Devizes. *The Chronicle of Richard of Devizes of the Time of King Richard the First.* Edited by John T. Appleby. London: Thomas Nelson, 1963.

Richard Rolle. *The Fire of Love, or, Melody of Love and the Mending of Life or Rule of Living.* Edited and translated by Frances M. M. Comper. London: Methuen, 1914.

Robert of Flamborough. *Liber poenitentialis.* Edited by J. J. Francis Firth. Toronto: University of Toronto Press, 1971.

Rodríguez, Manuel Moleiro, ed. *Biblia de San Luis.* 3 vols. Barcelona: M. Moleiro, 2001.

Scase, Wendy, ed. *The Vernon Manuscript: A Facsimile Edition of Oxford, Bodleian Library, MS Eng. Poet.a.1.* Bodleian Digital Texts 3. Oxford: Bodleian Library, 2011.

Schiaffini, Alfredo, ed. *Cronica fiorentina compilata nel secolo XIII.* In *Testi fiorentini del Dugento e dei primi del Trecento,* 82–150. Florence: Sansoni, 1926.

Statius. *Thebaid, Books 8–12, Achilleid.* Edited and translated by D. R. Shackleton Bailey. Loeb Classical Library 498. Cambridge, MA: Harvard University Press, 2003.

Stehling, Thomas, ed. *Medieval Latin Poems of Male Love and Friendship.* New York: Garland, 1984.

Symons, Thomas, ed. and trans. *Regularis concordia Anglicae nationis monachorum sanctimonialiumque.* London: Oxford University Press, 1953.

Talbot, C. H., trans. *The Life of Christina of Markyate.* Translation revised, with introduction and notes, by Samuel Fanous and Henrietta Leyser. Oxford: Oxford University Press, 2008.

———, ed. and trans. *The Life of Christina of Markyate: A Twelfth Century Recluse.* Oxford: Clarendon, 1959.

Thompson, A. Hamilton, ed. *Records of Visitations Held by William Alnwick, Bishop of Lincoln, 1436–1449,* part 1. In *Visitations of Religious Houses in the Diocese of Lincoln.* 3 vols. Horncastle: Morton & Sons, 1918–29.

Virgil. *Aeneid.* Translated by Robert Fogles. London: Penguin, 2006.

———. *Eclogues, Georgics, Aeneid I–IV.* Translated by H. Rushton Fairclough. Revised by G. P. Goold. Loeb Classical Library 63. Cambridge, MA: Harvard University Press, 1999.

William of Auvergne. *Guilielmi Alverni . . . opera omnia.* 2 vols. Paris: A. Pallard, 1674.

William of Malmesbury. *Gesta regum anglorum.* Edited by William Stubbs. 2 vols. Rolls Series 90. London: Eyre & Spottiswoode, 1887.

Winter, Simon. *Life of St. Jerome.* In *Saints' Lives in Middle English Collections,* edited by E. Gordon Whatley, with Anne B. Thompson and Robert K. Upchurch. Kalamazoo, MI: Medieval Institute, for TEAMS in association with the University of Rochester, 2004.

Zettersten, Arne, ed. *The English Text of the* Ancrene Riwle, *Edited from Magdalene College, Cambridge MS. Pepys 2498.* EETS o.s. 274. London: Oxford University Press, 1976.

Zettersten, Arne, and Bernhard Diensberg, eds. *The English Text of the* Ancrene Riwle: *The "Vernon" Text.* EETS o.s. 310. Oxford: Oxford University Press, 2000.

Secondary and Postmedieval Sources

Adams, Jenny. *Power Play: The Literature and Politics of Chess in the Late Middle Ages.* Philadelphia: University of Pennsylvania Press, 2006.

Adams, Jeremy. Review of John Boswell, *Christianity, Social Tolerance, and Homosexuality. Speculum* 56, no. 2 (1981): 350–55.

Adhémar, Jean. "L'enlèvement de Ganymède sur un chapiteau de Vézelay." *Bulletin Monumental* 91 (1932): 290–92.

———. *Influences antiques dans l'art du Moyen Age français: Recherches sur les sources et les thèmes d'inspiration.* London: Warburg Institute, 1939.

Ahmed, Sara. *Queer Phenomenology: Orientations, Objects, Others.* Durham, NC: Duke University Press, 2006.

Ailes, M. J. "The Medieval Male Couple and the Language of Homosociality." In *Masculinity in Medieval Europe*, edited by D. M. Hadley, 214–37. Harlow, UK: Longman, 1999.

Ambrose, Kirk. "Male Nudes and Embodied Spirituality in Romanesque Sculpture." In Lindquist, *Meanings of Nudity in Medieval Art*, 65–83.

———. *The Nave Sculpture of Vézelay: The Art of Monastic Viewing.* Toronto: Pontifical Institute of Mediaeval Studies, 2006.

———. "Two Cases of Female Cross-Undressing in Medieval Art and Literature." *Source: Notes in the History of Art* 23, no. 3 (2004): 7–14.

Amer, Sahar. *Crossing Borders: Love between Women in Medieval French and Arabic Literatures.* Philadelphia: University of Pennsylvania Press, 2008.

Anderson, W. S. "The Orpheus of Virgil and Ovid: *flebile nescio quid*." In Warden, *Orpheus*, 25–50.

Angheben, Marcello. *Les chapiteaux romans de Bourgogne. Thèmes et programmes.* Turnhout: Brepols, 2003.

Anson, John S. "The Female Transvestite in Early Monasticism: The Origin and Development of a Motif." *Viator* 5 (1974): 1–32.

Archibald, Elizabeth. "The *Ide and Olive* Episode in Lord Berner's *Huon of Burdeux*." In *Tradition and Transformation in Medieval Romance*, edited by Rosalind Field, 139–51. Cambridge, UK: D. S. Brewer, 1999.

Ariès, Philippe. *Centuries of Childhood: A Social History of Family Life.* Translated by Robert Baldrick. Harmondsworth: Penguin, 1962.

Armstrong, Lilian. *The Paintings and Drawings of Marco Zoppo.* New York: Garland, 1976.

Asad, Talal. "On Ritual and Discipline in Medieval Christian Monasticism." *Economy and Society* 16, no. 2 (1987): 159–203.

Ashley, Kathleen, and Marilyn Deegan. *Being a Pilgrim: Art and Ritual on the Medieval Routes to Santiago.* Farnham, UK: Lund Humphries, 2009.

Astell, Ann W. *The Song of Songs in the Middle Ages.* Ithaca, NY: Cornell University Press, 1990.

Auerbach, Erich. *Mimesis: The Representation of Reality in Western Literature.* Translated by Willard R. Trask. Princeton, NJ: Princeton University Press, 1953.

Bailey, Derrick Sherwin. *Homosexuality and the Western Christian Tradition.* London: Longmans, Green, 1955.

Bal, Mieke, and Joanne Morra, eds. *Acts of Translation.* Special issue of *Journal of Visual Culture* 6, no. 1 (2007).

Baldwin, John W. *The Language of Sex: Five Voices from Northern France around 1200.* Chicago: University of Chicago Press, 1994.

Bale, Anthony. *Feeling Persecuted: Christians, Jews and Images of Violence in the Middle Ages.* London: Reaktion, 2009.

———. *The Jew in the Medieval Book: English Antisemitisms, 1350–1500.* Cambridge: Cambridge University Press, 2006.

———. "Richard of Devizes and Fictions of Judaism." *Jewish Culture and History* 3, no. 2 (2000): 55–72.

Barber, Malcolm. *The Trial of the Templars.* Cambridge: Cambridge University Press, 1978.

Barclay, William. *New Testament Words.* Louisville, KY: Westminster John Knox Press, 1974.

Barkan, Leonard. *Transuming Passion: Ganymede and the Erotics of Humanism.* Stanford, CA: Stanford University Press, 1991.

Barlow, Frank. *William Rufus.* New Haven, CT: Yale University Press, 2000.

Barratt, Alexandra. "Context: Some Reflections on Wombs and Tombs and Inclusive Language." In *Anchorites, Wombs and Tombs: Intersections of Gender and Enclosure in the Middle Ages*, edited by Liz Herbert McAvoy and Mari Hughes-Edwards, 27–38. Cardiff: University of Wales Press, 2005.

Baschet, Jérome. *Les justices de l'au-delà: Les représentations de l'enfer en France et en Italie (XIIᵉ-XVᵉ siècle)*. Rome: École française de Rome, 1993.

Baudoin, Jacques. *Grand livre des saints: Culte et iconographie en Occident.* Nonette, France: Créer, 2006.

Beecher, Donald. "Sex Changes: The Cultural Significance of a Renaissance Medical Polemic." *Sixteenth Century Journal* 36, no. 4 (2005): 991–1016.

Bein, Thomas. "Orpheus als Sodomit: Beobachtungen zu einer mhd. Sangspruchstrophe mit (literar)historischen Exkursen zur Homosexualität im hohen Mittelalter." *Zeitschrift für deutsche Philologie* 109 (1990): 33–55.

Benkov, Edith. "The Erased Lesbian: Sodomy and the Legal Tradition in Medieval Europe." In Sautman and Sheingorn, *Same Sex Love and Desire among Women*, 101–22.

Bennett, Judith. *History Matters: Patriarchy and the Challenge of Feminism*. Philadelphia: University of Pennsylvania Press, 2007.

———. "'Lesbian-like' and the Social History of Lesbianisms." *Journal of the History of Sexuality* 9, nos. 1–2 (2000): 1–24.

Bernau, Anke. "Virginal Effects: Text and Identity in *Ancrene Wisse*." In *Gender and Holiness: Men, Women and Saints in Late Medieval Europe*, edited by Samantha J. E. Riches and Sarah Salih, 36–48. London: Routledge, 2002.

Bernheimer, Richard. *Romanische Tierplastik und die Ursprünge ihrer Motive*. Munich: Bruckmann, 1931.

Berry, Craig A., and Heather Richardson Hayton, eds. *Translating Desire in Medieval and Early Modern Literature*. Tempe: Arizona Center for Medieval and Renaissance Studies, 2005.

Besseyre, Marianne, and Yves Christe, eds. *Bible moralisée de Naples*. Barcelona: M. Moleiro, 2011.

Bliersbach, Elisabeth. "I Bianchi nell'arte Umbro-Laziale." In *Sulle Orme dei Bianchi (1399) dalla Liguria all'Italia Centrale: Atti del Convegno Storico Internazionale Assisi-Vallo di Nera-Terni-Rieti-Leonessa (18-19-20 giugno 1999)*, edited by Francesco Santucci, 363–440. Assisi: Accademia Properziana del Subasio, 2001.

Bloch, Iwan. *The Sexual Life of Our Time in Its Relations to Modern Civilization*. Translated by M. Eden Paul. New York: Allied Book Co., 1908.

Blumenfeld-Kosinski, Renate. "Illustrations et interprétations dans un manuscrit de l'*Ovide moralisé* (Arsenal 5069)." *Cahiers de recherches médiévales* 9 (2002). http://crm.revues.org//index56.html.

———. *Reading Myth: Classical Mythology and Its Interpretations in Medieval French Literature*. Stanford, CA: Stanford University Press, 1997.

———. "The Scandal of Pasiphae: Narration and Interpretation in the *Ovide moralisé*." *Modern Philology* 93, no. 3 (1996): 307–26.

Böckern, Beate. "The Young Dürer and Italy: Contact with Italy and the Mobility of Art and Artists around 1500." In Hess and Eser, *Early Dürer*, 52–64.

Bond, Gerald A. "'Iocus Amoris': The Poetry of Baudri of Bourgueil and the Formation of the Ovidian Subculture." *Traditio: Studies in Ancient and Medieval History, Thought, and Religion* 42 (1986): 143–93.

Bonds, William N. Review of John Boswell, *Christianity, Social Tolerance, and Homosexuality*. *Journal of Homosexuality* 7, no. 1 (1981): 94–102.

Bonnell, John K. "The Serpent with a Human Head in Art and in Mystery Play." *American Journal of Archaeology*, 2nd ser. 21 (1917): 255–91.

Bonnet, Gérard. *Voir, être vu: Figures de l'exhibitionnisme aujourd'hui.* 2 vols. Paris: Presses Universitaires de France, 1981; repr. 2005.

Boone, Marc. "State Power and Illicit Sexuality: The Persecution of Sodomy in Late Medieval Bruges." *Journal of Medieval History* 22, no. 2 (1996): 135–53.

Boswell, John. *Christianity, Social Tolerance, and Homosexuality: Gay People in Western Europe from the Beginning of the Christian Era to the Fourteenth Century.* Chicago: University of Chicago Press, 1980.

———. "Dante and the Sodomites." *Dante Studies* 112 (1994): 63–76.

———. *The Kindness of Strangers: The Abandonment of Children in Western Europe from Late Antiquity to the Renaissance.* New York: Pantheon, 1988.

Boyd, David Lorenzo. "Seeking 'Goddes Pryvetee': Sodomy, Quiting, and Desire in *The Miller's Tale.*" In *Words and Works: Studies in Medieval English Language and Literature in Honour of Fred C. Robinson,* edited by Peter S. Baker and Nicholas Howe, 243–60. Toronto: University of Toronto Press, 1998.

Boyd, David Lorenzo, and Ruth Mazo Karras. "The Interrogation of a Male Transvestite Prostitute in Fourteenth-Century London." *GLQ* 1, no. 4 (1995): 459–65.

———. "*Ut cum muliere*: A Male Transvestite Prostitute in Fourteenth-Century London." In Fradenburg and Freccero, *Premodern Sexualities,* 101–16.

Boynton, Susan. "The Liturgical Role of Children in Monastic Customaries from the Central Middle Ages." *Studia Liturgica* 28 (1998): 194–209.

Bray, Alan. *The Friend.* Chicago: University of Chicago Press, 2003.

———. *Homosexuality in Renaissance England.* London: Gay Men's Press, 1982.

Bremmer, Jan. "Orpheus: From Guru to Gay." In *Orphisme et Orphée en l'honneur de Jean Rudhardt,* edited by Philippe Borgeaud, 13–30. Geneva: Droz, 1991.

Brooten, Bernadette J. *Love between Women: Early Christian Responses to Female Homoeroticism.* Chicago: University of Chicago Press, 1996.

Brown, Bill. "Thing Theory." *Critical Inquiry* 28, no. 1 (2001): 1–22.

Brown, Peter. *The Body and Society: Men, Women and Sexual Renunciation in Early Christianity.* London: Faber & Faber, 1989.

Brownlee, Kevin. "Orpheus' Song Re-sung: Jean de Meun's Reworking of *Metamorphoses* X." *Romance Philology* 36 (1982): 201–9.

———. "Widowhood, Sexuality, and Gender in Christine de Pizan," *Romanic Review* 86, no. 2 (1995): 339–53.

Brugger, Laurence. "Les 'Paraphrases bibliques' moralisées: L'exemple du livre de Job." *Bibliothèque de l'École des chartes* 162 (2004): 75–96.

Brundage, James A. *Law, Sex, and Christian Society in Medieval Europe.* Chicago: University of Chicago Press, 1987.

Buckler, Philip, Gavin Kirk, Nicholas Bennett, Mary Lucas, and Anne Coltman. *Lincoln Cathedral: A Journey from Past to Present.* London: Third Millennium, 2010.

Buckley, Richard, Mathew Morris, Jo Appleby, Turi King, Deirdre O'Sullivan, and Lin Foxhall. "'The King in the Car Park': New Light on the Death and Burial of Richard III in the Grey Friars Church, Leicester, in 1485." *Antiquity* 87 (2013): 519–38.

Bullough, Vern L. "The Sin against Nature and Homosexuality." In *Sexual Practices and the Medieval Church,* edited by Vern L. Bullough and James Brundage, 55–71. Buffalo, NY: Prometheus, 1982.

———. "Transvestites in the Middle Ages." *American Journal of Sociology* 79, no. 6 (1974): 1381–94.

Bullough, Vern L., and James A. Brundage, eds. *Handbook of Sexuality.* Garland Reference Library in the Humanities 1696. New York: Garland, 1996.

Burger, Glenn. "Erotic Discipline . . . or 'Tee Hee, I Like My Boys to Be Girls': Inventing with

the Body in Chaucer's *Miller's Tale*." In *Becoming Male in the Middle Ages*, edited by Jeffrey Jerome Cohen and Bonnie Wheeler, 245–60. New York: Garland, 2000.

Burger, Glenn, and Steven F. Kruger, eds. *Queering the Middle Ages*. Minneapolis: University of Minnesota Press, 2001.

Burgwinkle, William E. *Sodomy, Masculinity, and Law in Medieval Literature: France and England, 1050–1230*. Cambridge: Cambridge University Press, 2004.

———. "Visible and Invisible Bodies and Subjects in Peter Damian." In *Troubled Vision: Gender, Sexuality, and Sight in Medieval Text and Image*, edited by Emma Campbell and Robert Mills, 47–62. New York: Palgrave, 2004.

Burrows, Daron. *The Stereotype of the Priest in the Old French Fabliaux: Anticlerical Satire and Lay Identity*. Bern: Peter Lang, 2005.

Burrus, Virginia. *The Sex Lives of Saints: An Erotics of Ancient Hagiography*. Philadelphia: University of Pennsylvania Press, 2004.

Butler, Judith. *Bodies That Matter: On the Discursive Limits of "Sex."* New York: Routledge, 1993.

———. *Gender Trouble: Feminism and the Subversion of Identity*. New York: Routledge, 1990.

———. "Imitation and Gender Insubordination." In *Inside/Out: Lesbian Theories, Gay Theories*, edited by Diana Fuss, 13–31. New York; Routledge, 1991.

———. *Undoing Gender*. New York: Routledge, 2004.

Bynum, Caroline Walker. *Jesus as Mother: Studies in the Spirituality of the High Middle Ages*. Berkeley: University of California Press, 1982.

Cadden, Joan. *Meanings of Sex Difference in the Middle Ages: Medicine, Science, and Culture*. Cambridge: Cambridge University Press, 1993.

———. *Nothing Natural Is Shameful: Sodomy and Science in Late Medieval Europe*. Philadelphia: University of Pennsylvania Press, 2013.

Calabrese, Michael A. "'Make a Mark That Shows': Orphean Song, Orphean Sexuality, and the Exile of Chaucer's Pardoner." *Viator* 24 (1993): 269–86.

Calimach, Andrew. *Lovers' Legends: The Gay Greek Myths*. New Rochelle, NY: Haiduk, 2002.

Camille, Michael. "Dr. Witkowski's Anus: French Doctors, German Homosexuals and the Obscene in Medieval Church Art." In *Medieval Obscenities*, edited by Nicola McDonald, 17–38. Woodbridge, UK: York Medieval Press, 2006.

———. "'For Our Devotion and Pleasure': The Sexual Objects of Jean, Duc de Berry." *Art History* 24, no. 2 (2001): 169–94.

———. *The Gothic Idol: Ideology and Image-Making in Late Medieval Art*. Cambridge: Cambridge University Press, 1989.

———. "Gothic Signs and the Surplus: The Kiss on the Cathedral." *Yale French Studies* 80 (1991): 151–70.

———. *Image on the Edge: The Margins of Medieval Art*. London: Reaktion, 1992.

———. *The Medieval Art of Love: Objects and Subjects of Desire*. New York: Abrams, 1998.

———. "The Pose of the Queer: Dante's Gaze, Brunetto Latini's Body." In Burger and Kruger, *Queering the Middle Ages*, 57–86.

Campbell, Emma. "Epistemology of the Cloister: Knowledge, Identity, and Place in Old French Saints' Lives." *Journal of Medieval Religious Cultures* 36, no. 2 (2010): 205–32.

Cannon, Christopher. "Enclosure." In Dinshaw and Wallace, *Cambridge Companion to Medieval Women's Writing*, 109–23.

Carden, Michael. *Sodomy: The History of a Christian Biblical Myth*. London: Equinox, 2004.

Carré, Yannick. *Le baiser sur la bouche au moyen âge: Rites, symboles, mentalités, à travers les textes et les images, XIᵉ–XVᵉ siècles*. Paris: Léopard d'Or, 1992.

Carrier, David. *Principles of Art History Writing*. University Park: Pennsylvania State University Press, 1991.

Carruthers, Mary. *The Book of Memory: A Study of Memory in Medieval Culture*. Cambridge: Cambridge University Press, 1990.

———. "Meditations on the 'Historical Present' and 'Collective Memory' in Chaucer and *Sir Gawain and the Green Knight*." In *Time in the Medieval World*, edited by Chris Humphrey and W. M. Ormrod, 137–55. Woodbridge, UK: York Medieval Press, 2001.

Castle, Terry. *The Apparitional Lesbian: Female Homosexuality and Modern Culture*. New York: Columbia University Press, 1993.

Caviness, Madeline H. *Visualizing Women in the Middle Ages: Sight, Spectacle, and Scopic Economy*. Philadelphia: University of Pennsylvania Press, 2001.

Chance, Jane. *The Mythographic Chaucer: The Fabulation of Sexual Politics*. Minneapolis: University of Minnesota Press, 1995.

Chaplais, Pierre. *Piers Gaveston: Edward II's Adoptive Brother*. Oxford: Clarendon, 1994.

Chiffoleau, Jacques. "Dire l'indicible: Remarques sur la catégorie du *nefandum* du XIIᵉ au XVᵉ siècle." *Annales, Economies, Sociétés, Civilisations* 45, no. 2 (1990): 289–324.

Clark, David. *Between Medieval Men: Male Friendship and Desire in Early Medieval English Literature*. Oxford: Oxford University Press, 2009.

Clark, Robert L. A. "A Heroine's Sexual Itinerary: Incest, Tranvestism, and Same-Sex Marriage in *Yde et Olive*." In *Gender Transgressions: Crossing the Normative Barrier in Old French Literature*, edited by Karen J. Taylor, 89–105. New York: Garland, 1998.

———. "Jousting without a Lance: The Condemnation of Female Homoeroticism in the *Livre des manières*." In Sautman and Sheingorn, *Same Sex Love and Desire among Women*, 143–77.

Clay, Rotha Mary. *The Hermits and Anchorites of England*. London: Methuen, 1914.

Conrad, Lawrence I. "The Biblical Tradition for the Plague of the Philistines." *Journal of American Oriental Society* 104, no. 2 (1984): 281–87.

Cook, Matt, with Robert Mills, Randolph Trumbach, and H. G. Cocks. *A Gay History of Britain: Love and Sex between Men since the Middle Ages*. Oxford: Greenwood, 2007.

Cook, Walter William Spencer, and José Gudiol Ricart. *Pictura e imaginería romanicas*. Vol. 6 of *Ars hispaniae: Historia universal del arte hispánico*. Madrid: Editorial Plus-Ultra, 1950.

Copeland, Rita. *Rhetoric, Hermeneutics, and Translation in the Middle Ages: Academic Traditions and Vernacular Texts*. Cambridge: Cambridge University Press, 1991.

Coulson, Frank T. "Ovid's Transformations in Medieval France (ca. 1100–ca. 1350)." In *Metamorphosis: The Changing Face of Ovid in Medieval and Early Modern Europe*, edited by Alison Keith and Stephen Rupp, 33–60. Toronto: Centre for Reformation and Renaissance Studies, Victoria University in the University of Toronto, 2007.

Crawford, Katherine. *The Sexual Culture of the French Renaissance*. Cambridge: Cambridge University Press, 2010.

Crompton, Louis. *Homosexuality and Civilization*. Cambridge, MA: Harvard University Press, 2003.

———. "The Myth of Lesbian Impunity: Capital Laws from 1270 to 1791." In *The Gay Past*, edited by Salvatore J. Licata and Robert P. Petersen, 11–25. New York: Harrington Park Press, 1985.

Cromwell, Jason. "Passing Women and Female-Bodied Men: (Re)claiming FTM History." In More and Whittle, *Reclaiming Genders*, 34–61.

Curtius, Ernst R. *European Literature and the Latin Middle Ages*. Translated by Willard R. Trask. Princeton, NJ: Princeton University Press, 1953.

Davidson, James. *The Greeks and Greek Love: A Radical Reappraisal of Homosexuality in Ancient Greece*. London: Weidenfeld and Nicholson, 2007.

Day, James, ed. *Queer Sexualities in French and Francophone Literature and Film*. Amsterdam: Rodopi, 2007.

De Jong, Mayke. *In Samuel's Image: Child Oblation in the Early Medieval West*. Leiden: Brill, 1996.

Delany, Sheila. *The Naked Text: Chaucer's* Legend of Good Women. Berkeley: University of California Press, 1994.

Desmond, Marilyn, and Pamela Sheingorn. *Myth, Montage and Visuality in Late Medieval Manuscript Culture: Christine de Pizan's* Epistre Othea. Ann Arbor: University of Michigan Press, 2003.

Despiney, M. le Chanoine. *Guide-Album de Vézelay*. Vézelay: Magasin du Pèlerin de Vézelay, 1930.

Detienne, Marcel. *The Writing of Orpheus: Greek Myth in Cultural Contact*. Translated by Janet Lloyd. Baltimore, MD: Johns Hopkins University Press, 2003.

Devor, Aaron H., and Nicholas Matte. "One Inc. and Reed Erickson: The Uneasy Collaboration of Gay and Trans Activism, 1964-2003." *GLQ* 10, no. 2 (2004): 179-209.

DeVun, Leah. "The Jesus Hermaphrodite: Science and Sex Difference in Premodern Europe." *Journal of the History of Ideas* 69, no. 2 (2008): 193-218.

De Weever, Jacqueline. "The Lady, the Knight, and the Lover: Androgyny and Integration in *La chanson d'Yde et d'Olive*." *Romanic Review* 82 (1991): 371-91.

Dinshaw, Carolyn. *Getting Medieval: Sexualities and Communities, Pre- and Postmodern*. Durham, NC: Duke University Press, 1999.

Dinshaw, Carolyn, and David Wallace, eds. *The Cambridge Companion to Medieval Women's Writing*. Cambridge: Cambridge University Press, 2003.

Doan, Laura. "Topsy-Turvydom: Gender Inversion, Sapphism, and the Great War." *GLQ* 12, no. 4 (2006): 517-42.

Doyle, Thomas P. "Roman Catholic Clericalism, Religious Duress, and Clergy Abuse." *Pastoral Psychology* 51, no. 3 (2003): 189-231.

Dreger, Alice Domurat. *Hermaphrodites and the Medical Invention of Sex*. Cambridge, MA: Harvard University Press, 1998.

Drobinsky, Julia. "La narration iconographique dans l'*Ovide moralisé* de Lyon (BM Ms. 742)." In Harf-Lancner, Mathey-Maille, and Szkilnik, *Ovide métamorphosé*, 223-38.

Dronke, Peter. "The Return of Eurydice." *Classica et Mediaevalia* 23 (1962): 198-215.

Duggan, Lisa. *The Twilight of Equality? Neoliberalism, Cultural Politics, and the Attack on Democracy*. Boston: Beacon Press, 2004.

Dupic, Jeanne. "Ovide moralisé MS du XIVe siècle (Bibl. de Rouen, MS O.4)." Discours de réception. *Précis des travaux de l'Académie des sciences, belles-lettres et arts de Rouen*, 1-12. Rouen, 1952.

Durling, Nancy Vine. "Rewriting Gender: *Yde et Olive* and Ovidian Myth," *Romance Languages Annual* 1 (1989): 256-62.

Dynes, Wayne R., ed. *Encyclopedia of Homosexuality*. 2 vols. New York: Garland, 1990.

Dynes, Wayne R., and Warren Johansson. "London's Medieval Sodomites." *Cabirion* 10 (1984): 5-7, 34.

Easton, Martha. "Uncovering the Meanings of Nudity in the *Belles Heures* of Jean, Duke of Berry." In Lindquist, *Meanings of Nudity in Medieval Art*, 149-81.

Edelman, Lee. *No Future: Queer Theory and the Death Drive*. Durham, NC: Duke University Press, 2005.

Elliott, Dyan. *Fallen Bodies: Pollution, Sexuality, and Demonology in the Middle Ages*. Philadelphia: University of Pennsylvania Press, 1999.

El-Rouayheb, Khaled. *Before Homosexuality in the Arab-Islamic World, 1500-1800*. Chicago: University of Chicago Press, 2005.

Elsner, Jas. "Art History as Ekphrasis." *Art History* 33, no. 1 (2010): 10-27.

Eser, Thomas. "A Different Early Dürer: Three Proposals." In Hess and Eser, *Early Dürer*, 18-28.

Evans, Michael. *The Death of Kings: Royal Deaths in Medieval England.* London: Hambledon & London, 2003.

Evans, Ruth, ed. *A Cultural History of Sexuality in the Middle Ages.* Oxford: Berg, 2011.

———. "Virginity." In Dinshaw and Wallace, *Cambridge Companion to Medieval Women's Writing,* 21–39.

Faderman, Lillian. *Odd Girls and Twilight Lovers: A History of Lesbian Life in Twentieth-Century America.* New York: Penguin, 1992.

Fanous, Samuel, and Henrietta Leyser, eds. *Christina of Markyate: A Twelfth-Century Holy Woman.* Abingdon, UK: Routledge, 2005.

Farina, Lara. *Erotic Discourse and Early English Religious Writing.* New York: Palgrave Macmillan, 2006.

Farmer, Sharon, and Carol Brown Pasternack, eds. *Gender and Difference in the Middle Ages.* Minneapolis: University of Minnesota Press, 2003.

Farnsworth, Jane. "Voicing Female Desire in 'Poem XLIX.'" *Studies in English Literature* 36, no. 1 (1996): 57–72.

Feinberg, Leslie. *Transgender Warriors: Making History from Joan of Arc to Dennis Rodman.* Boston: Beacon, 1996.

Fisher, Will. "Queer Money." *ELH* 66, no. 1 (1999): 1–23.

Flohic, Jean-Luc, ed. *Le patrimoine de la Basilique de Vézelay.* Charenton-le-Pont: Flohic, 1999.

Forsyth, Ilene H. "The Ganymede Capital at Vézelay." *Gesta* 15, nos. 1–2 (1976): 241–46.

———. "Narrative at Moissac: Schapiro's Legacy." *Gesta* 41, no. 2 (2002): 71–94.

Foucault, Michel. *The History of Sexuality,* vol. 1: *An Introduction.* Translated by Robert Hurley. London: Penguin, 1978.

———. "The Thought of the Outside." In *Essential Works of Foucault, 1954–1984,* vol. 2: *Aesthetics,* edited by James D. Faubion, 147–69. London: Penguin, 1998.

Fradenburg, Louise, and Carla Freccero, eds. *Premodern Sexualities.* London: Routledge, 1996.

Frantzen, Allen J. *Before the Closet: Same-Sex Love from* Beowulf *to* Angels in America. Chicago: University of Chicago Press, 1998.

———. "The Disclosure of Sodomy in *Cleanness.*" *PMLA* 111, no. 3 (1996): 451–64.

Frawley-O'Dea, Mary Gail. *Perversion of Power: Sexual Abuse in the Catholic Church.* Nashville, TN: Vanderbilt University Press, 2007.

Frawley-O'Dea, Mary Gail, and Virginia Goldner, eds. *Predatory Priests, Silenced Victims: The Sexual Abuse Crisis and the Catholic Church.* Mahwah, NJ: Analytic Press, 2007.

Freccero, Carla. *Queer/Early/Modern.* Durham, NC: Duke University Press, 2006.

Freeman, Elizabeth. *Time Binds: Queer Temporalities, Queer Histories.* Durham, NC: Duke University Press, 2010.

Friedman, John Block. *Orpheus in the Middle Ages.* 1970; repr. Syracuse, NY: Syracuse University Press, 2000.

Friedman, Mira. "The Falcon and the Hunt: Symbolic Love Imagery in Medieval and Renaissance Art." In *Poetics of Love in the Middle Ages: Texts and Contexts,* edited by Moshe Lazar and Norris J. Lacy, 157–75. Fairfax, VA: George Mason University, 1989.

Galinsky, G. Karl. *Ovid's* Metamorphoses: *An Introduction to the Basic Aspects.* Oxford: Basil Blackwell, 1975.

Gallacher, Patrick J. *Love, the Word, and Mercury: A Reading of John Gower's* Confessio Amantis. Albuquerque: University of New Mexico Press, 1975.

Gastad, Benjamin. "The Interpretation of Ganymede." In *The Berlin Commentary on Martianus Capella's "De nuptiis Philologiae et Mercurii," Book 2,* edited by Haijo Jan Westra and Tanja Kupke, 161–68. Leiden: Brill, 1998.

Gaunt, Simon. "Bel Acueil and the Improper Allegory of the *Romance of the Rose.*" *New Medieval Literatures* 2 (1998): 65–93.

Geddes, Jane. *The St. Albans Psalter: A Book for Christina of Markyate*. London: British Library, 2005.

Giffney, Noreen, Michelle M. Sauer, and Diane Watt, eds. *The Lesbian Premodern*. New York: Palgrave Macmillan, 2011.

Gilbert, Ruth. *Early Modern Hermaphrodites: Sex and Other Stories*. New York: Palgrave, 2002.

Gilmour-Bryson, Anne. "Sodomy and the Knights Templar." *Journal of the History of Sexuality* 7, no. 2 (1996): 151–83.

Ginsberg, Warren. "Ovid and the Problem of Gender." *Medievalia* 13, no. 1 (1987): 9–28.

Godefroy, Frédéric, ed. *Dictionnaire de l'ancienne langue française et de tous ses dialectes du IXe au XVe siècle*. 10 vols. Paris: Émile Bouillon, 1880–1902.

Godfrey, Aaron W. "Rules and Regulations: Monasticism and Chastity." In *Homo Carnalis: The Carnal Aspects of Medieval Human Life*, edited by Helen Rodnite Lemay, 45–57. Binghamton: State University of New York Press, 1990.

Goldberg, Jonathan. *Sodometries: Renaissance Texts, Modern Sexualities*. Stanford, CA: Stanford University Press, 1992.

Goodich, Michael. *The Unmentionable Vice: Homosexuality in the Later Medieval Period*. Santa Barbara, CA: ABC-Clio, 1979.

Goux, Jean-Joseph. "The Phallus: Masculine Identity and the 'Exchange of Women.'" Translated by Maria Amuchastegui, Caroline Benforado, Amy Hendrix, and Eleanor Kaufman. *differences* 4, no. 1 (1992): 40–75.

Gowing, Laura. "The Politics of Women's Friendship in Early Modern England." In *Love, Friendship, and Faith in Europe, 1300–1800*, edited by Laura Gowing, Michael Hunter, and Miri Rubin, 131–49. New York: Palgrave Macmillan, 2005.

Grayson, Saisha. "Disruptive Disguises: The Problem of Transvestite Saints for Medieval Art, Identity, and Identification." *Medieval Feminist Forum* 45, no. 2 (2009): 138–74.

Greenberg, David F., and Marcia H. Bystryn. "Christian Intolerance of Homosexuality." *American Journal of Sociology* 88, no. 3 (1982): 515–47.

Griffin, Miranda. "Translation and Transformation in the *Ovide moralisé*." In *Rethinking Medieval Translation: Ethics, Politics, Theory*, edited by Emma Campbell and Robert Mills, 41–60. Cambridge, UK: D. S. Brewer, 2012.

Griffith-Jones, Robin. *Mary Magdalene: The Woman Who Jesus Loved*. Norwich, UK: Canterbury Press, 2008.

Griffiths, Fiona J. *Garden of Delights: Reform and Renaissance for Women in the Twelfth Century*. Philadelphia: University of Pennsylvania Press, 2007.

Grosse, Peggy. "The Nude." In Hess and Eser, *Early Dürer*, 373–75.

Guest, Gerald B. "'The Darkness and the Obscurity of Sins': Representing Vice in the Thirteenth-Century *Bibles moralisées*." In *In the Garden of Evil: The Vices and Culture in the Middle Ages*, edited by Richard Newhauser, 74–103. Toronto: Pontifical Institute of Mediaeval Studies, 2005.

———. "Picturing Women in the First *Bible moralisée*." In *Insight and Interpretation: Studies in Celebration of the Eighty-Fifth Anniversary of the Index of Christian Art*, edited by Colum Hourihane, 106–30. Princeton, NJ: Princeton University Press, 2002.

Gulden, Sebastian. "Nuremberg's Elites: Dürer's Models and Commissions." In Hess and Eser, *Early Dürer*, 286–88.

Gulley, Alison. "*Heo man ne wæs*: Cross-Dressing, Sex-Change, and Womanhood in Ælfric's Life of Eugenia." *Mediaevalia* 22, no. 1 (1998): 113–31.

Guthrie, W. K. C. *Orpheus and Greek Religion: A Study of the Orphic Movement*. 2nd ed. London: Methuen, 1952.

Guynn, Noah. *Allegory and Sexual Ethics in the High Middle Ages*. New York: Palgrave Macmillan, 2007.

Haaken, Janice. *Pillar of Salt: Gender, Memory, and the Perils of Looking Back*. London: Free Association, 1998.

Halberstam, Judith. *In a Queer Time and Place: Transgender Bodies, Subcultural Lives*. New York: New York University Press, 2005.

———. *The Queer Art of Failure*. Durham, NC: Duke University Press, 2011.

Hallett, Judith P. "Female Homoeroticism and the Denial of Roman Reality in Latin Literature." *Yale Journal of Criticism* 3, no. 1 (1989): 209–27.

Halperin, David. "Forgetting Foucault: Acts, Identities and the History of Sexuality." *Representations* 63 (1998): 93–120.

———. *How to Do the History of Homosexuality*. Chicago: University of Chicago Press, 2002.

Hamann-MacLean, Richard. *Frühe Kunst im Westfränkischen Reich*. Leipzig: Schmidt & Günther, 1939.

Hanna, Ralph. "English Biblical Texts before Lollardy and Their Fate." In *Lollards and Their Influence in Late Medieval England*, edited by Fiona Somerset, Jill C. Havens, and Derrick H. Pitard, 141–53. Woodbridge, UK: Boydell and Brewer, 2003.

Harf-Lancner, Laurence, Laurence Mathey-Maille, and Michelle Szkilnik, eds. *Ovide métamorphosé: Les lecteurs médiévaux d'Ovide*. Paris: Presses Sorbonne Nouvelle, 2009.

Harvey, Karen, ed. *The Kiss in History*. Manchester: Manchester University Press, 2005.

Haskins, Susan. *Mary Magdalen: The Essential History*. London: HarperCollins, 1993.

Hassig, Debra. *Medieval Bestiaries: Text, Image, Ideology*. Cambridge: Cambridge University Press, 1995.

Hausherr, Reiner. *Bible moralisée: Prachthandschriften des Hohen Mittelalters. Gesammelte Schriften von Reiner Hausherr*. Edited by Eberhard König, Christian Tico Seifert, and Guido Siebert. Petersberg: Michael Imhof, 2009.

Head, Thomas. "The Marriages of Christina of Markyate." In Fanous and Leyser, *Christina of Markyate*, 116–37.

Heard, Katy, and Lucy Whitaker. *The Northern Renaissance: Dürer to Holbein*. London: Royal Collection, 2011.

Hedeman, Anne D. "Presenting the Past: Visual Translation in Thirteenth- to Fifteenth-Century France." In *Imagining the Past in France: History in Manuscript Painting, 1250–1500*, edited by Elizabeth Morrison and Anne D. Hedeman, 69–85. Los Angeles: J. Paul Getty Museum, 2010.

———. *Translating the Past: Laurent de Premierfait and Boccaccio's De Casibus*. Los Angeles: J. Paul Getty Museum, 2008.

Heinlen, James Michael. "The Ideology of Reform in the French Moralized Bible." PhD diss., Northwestern University, 1991.

Hellemans, Babette. *La Bible moralisée: Une oeuvre à part entière. Temporalité, sémiotique et création au XIIIᵉ siècle*. Turnhout: Brepols, 2010.

Hergemöller, Bernd-Ulrich. "The Middle Ages." In *Gay Life and Culture: A World History*, edited by Robert Aldrich, 57–77. London: Thames & Hudson, 2006.

———. *Sodom and Gomorrah: On the Everyday Reality and Persecution of Homosexuals in the Middle Ages*. Translated by John Philips. London: Free Association Books, 2001

Hernández, Francisco J. "The 'Bible of Saint Louis' in the Chapels Royal of France and Castile." In Ruiz, *Bible of Saint Louis*, 17–38.

Hess, Daniel, and Thomas Eser, eds. *The Early Dürer*. London: Thames & Hudson, in association with Germanisches Nationalmuseum, Nuremberg, 2012.

Hexter, Ralph. "Ovid in Translation in Medieval Europe." In *Übersetzung—Translation—Traduction: An International Encyclopedia of Translation Studies*, edited by Harald Kittel, Armin Paul Frank, Norbert Greiner, Theo Hermans, Werner Koller, José Lambert, and

Fritz Paul, 2:1311–28. Handbooks of Linguistics and Communication Science 26, part 2. Berlin: Walter de Gruyter, 2007.

Hollis, Stephanie, and Jocelyn Wogan-Browne. "St. Albans and Women's Monasticism: Lives and Their Foundations in Christina's World." In Fanous and Leyser, *Christina of Markyate*, 25–52.

Holsinger, Bruce W. *Music, Body, and Desire in Medieval Culture: Hildegard of Bingen to Chaucer*. Stanford, CA: Stanford University Press, 2001.

———. "Sodomy and Resurrection: The Homoerotic Subject of the Divine Comedy." In Fradenburg and Freccero, *Premodern Sexualities*, 243–74.

Holsinger, Bruce W., and David Townsend. "Ovidian Homoerotics in Twelfth-Century Paris: The Letters of Leoninus, Poet and Polyphone." *GLQ* 8, no. 3 (2002): 389–423.

Horvat, Frank, and Michel Pastoureau. *Figures romanes*. Paris: Seuil, 2001.

Hotchkiss, Valerie R. *Clothes Make the Man: Female Cross Dressing in Medieval Europe*. New York: Garland, 1996.

Howie, Cary. *Claustrophilia: The Erotics of Enclosure in Medieval Literature*. New York: Palgrave Macmillan, 2007.

Hughes, Christopher. "Typology and Its Uses in the Moralized Bible." In *The Mind's Eye: Art and Theological Argument in the Middle Ages*, edited by Jeffrey F. Hamburger and Anne-Marie Bouche, 133–50. Princeton, NJ: Department of Art and Archaeology, Princeton University, 2006.

Hull, Caroline. "Rylands MS French 5: The Form and Function of a Medieval Bible Picture Book." *Bulletin of the John Rylands University Library of Manchester* 77, no. 2 (1995): 3–24.

Hult, David F. "Allégories de la sexualité dans l'*Ovide moralisé*." *Cahiers de recherches médiévales* 9 (2002). http://crm.revues.org/index50.html.

———. "Language and Dismemberment: Abelard, Origen and the Romance of the Rose." In *Rethinking the Romance of the Rose: Text, Image, Reception*, edited by Kevin Brownlee and Sylvia Huot, 101–30. Philadelphia: University of Pennsylvania Press, 1992.

Huot, Sylvia. *Dreams of Lovers and Lies of Poets: Poetry, Knowledge, and Desire in the* Roman de la Rose. Oxford: Legenda, 2010.

Hurttig, Marcus Andrew. *Antiquity Unleashed: Aby Warburg, Dürer and Mantegna*. London: Courtauld Gallery, 2013.

Husband, Timothy B. *The Art of Illumination: The Limbourg Brothers and the Belles Heures of Jean de France, Duc de Berry*. New York: Metropolitan Museum of Art, 2008.

Hutchison, Jane Campbell. *Albrecht Dürer: A Biography*. Princeton, NJ: Princeton University Press, 1990.

Huys-Clavel, Viviane. *Image et discours au XIIe siècle: Les chapiteaux de la basilique Sainte-Marie-Madeleine à Vézelay*. Paris: L'Harmattan, 2009.

———. *La Madeleine de Vézelay: Cohérence du décor sculpté de la nef*. Chambéry: Comp'Act, 1996.

Irwin, Eleanor. "The Songs of Orpheus and the New Song of Christ." In Warden, *Orpheus*, 51–62.

Jaeger, C. Stephen. *Ennobling Love: In Search of a Lost Sensibility*. Philadelphia: University of Pennsylvania Press, 1999.

———. *The Origins of Courtliness: Civilizing Trends and the Formation of Courtly Ideals, 939–1210*. Philadelphia: University of Pennsylvania Press, 1985.

———. "Orpheus in the Eleventh Century." *Mittellateinisches Jahrbuch* 27 (1992): 141–68.

Jager, Eric. *The Tempter's Voice: Language and the Fall in Medieval Literature*. Ithaca, NY: Cornell University Press, 1993.

Jagose, Annamarie. *Inconsequence: Lesbian Representation and the Logic of Sexual Sequence*. Ithaca, NY: Cornell University Press, 2002.

James, M. R. *Illustrations of the Book of Genesis, Being a Complete Reproduction in Facsimile of the Manuscript British Museum, Egerton 1894*. Oxford: Roxburghe Club, 1921.

Jankowski, Theodora A. ". . . In the Lesbian Void: Woman-Woman Eroticism in Shakespeare's Plays." In *A Feminist Companion to Shakespeare*, ed. Dympna Callaghan, 299–319. Malden, MA: Blackwell, 2000.

———. *Pure Resistance: Queer Virginity in Early Modern Drama*. Philadelphia: University of Pennsylvania Press, 2000.

———. "'Virgins' and 'Not-Women': Dissident Gender Positions." In Giffney, Sauer, and Watt, *Lesbian Premodern*, 75–89.

Jansen, Katherine Ludwig. *The Making of the Magdalen: Preaching and Popular Devotion in the Later Middle Ages*. Princeton, NJ: Princeton University Press, 2000.

Jenkins, Philip. *Moral Panic: Changing Concepts of the Child Molester in Modern America*. New Haven, CT: Yale University Press, 1998.

———. *Pedophiles and Priests: Anatomy of a Contemporary Crisis*. New York: Oxford University Press, 1996.

Jennings, Rebecca. *A Lesbian History of Britain: Love and Sex between Women since 1500*. Oxford: Greenwood, 2007.

Johannson, Warren, and William A. Percy. "Homosexuality." In Bullough and Brundage, *Handbook of Sexuality*, 155–90. New York: Garland, 1996.

Jones, Christopher. "Monastic Identity and Sodomitic Danger in the *Occupatio* of Odo of Cluny." *Speculum* 82, no. 1 (2007): 1–53.

Jones, E. A. "A New Look into the *Speculum inclusorum*." In *The Medieval Mystical Tradition: England, Ireland and Wales*, edited by Marion Glasscoe, 123–45. Cambridge, UK: D. S. Brewer, 1999.

Jordan, Mark D. "The Confusion of Priestly Secrets." In Frawley-O'Dea and Goldner, *Predatory Priests, Silenced Victims*, 231–48.

———. *The Invention of Sodomy in Christian Theology*. Chicago: University of Chicago Press, 1997.

———. *The Silence of Sodom: Homosexuality in Modern Catholicism*. Chicago: University of Chicago Press, 2000.

Joslin, Mary Coker, and Carolyn Coker Joslin Watson. *The Egerton Genesis*. London: British Library, 2001.

Jourdan, Fabienne. *Orphée et les chrétiens: La réception du mythe d'Orphée dans la littérature chrétienne grecque des cinq premiers siècles*, vol. 1: *Orphée, du repoussoir au préfigurateur du Christ: Réécriture d'un mythe à des fins protreptiques chez Clément d'Alexandrie*. Paris: Les Belles Lettres, 2009.

Jung, Marc-René. "*Ovide métamorphose* en prose (Bruges, vers 1475)." In *"A l'heure encore de mon escrire": Aspects de la littérature de Bourgogne sous Philippe le Bon et Charles le Téméraire*, edited by Claude Thiry, 99–115. Louvain-la-Neuve: Les Lettres romanes, 1997.

———. "L'*Ovide moralisé*: De l'expérience de mes lectures à quelques propositions de lecture actuelle." In Harf-Lancner, Mathey-Maille, and Szkilnik, *Ovide métamorphosé*, 107–22.

———. "Ovide, texte, translateur et gloses dans les manuscrits de l'*Ovide moralisé*." In *The Romantic Imagination: Literature and Art in England and Germany*, edited by Douglas Kelly, Frederick Burwick, and Jürgen Klein, 75–100. Amsterdam: Rodopi, 1996.

Kao, Wan-Chuan. "The Tomboyism of Faith: Spiritual Tomboyism in the Cult of Sainte Foy." *Journal of Lesbian Studies* 15, no. 4 (2011): 412–49.

Karras, Ruth Mazo. *Sexuality in Medieval Europe: Doing unto Others*. New York: Routledge, 2005.

Kay, Sarah. *The Place of Thought: The Complexity of One in Late Medieval French Didactic Poetry*. Philadelphia: University of Pennsylvania Press, 2007.

————. "Sexual Knowledge: The Once and Future Texts of the *Romance of the Rose*." In *Textuality and Sexuality: Reading Theories and Practices*, edited by Judith Still and Michael Worton, 63–86. Manchester: Manchester University Press, 1993.

Keiser, Elizabeth B. *Courtly Desire and Medieval Homophobia: The Legitimation of Sexual Pleasure in "Cleanness" and Its Contexts*. New Haven, CT: Yale University Press, 1997.

Kelly, Kathleen Coyne. *Performing Virginity and Testing Chastity in the Middle Ages*. London: Routledge, 2000.

Kempter, Gerda. *Ganymed: Studien zur Typologie, Ikonographie und Ikonologie*. Cologne: Böhlau, 1980.

Kennedy, Elizabeth Lapovsky, and Madeline D. Davis. *Boots of Leather, Slippers of Gold: The History of a Lesbian Community*. London: Routledge, 1993.

Kincaid, James R. *Erotic Innocence: The Culture of Child Molesting*. Durham, NC: Duke University Press, 1998.

Kłosowska, Anna. "Medieval Barbie Dolls: *Femme* Figures in Ascetic Collections." In Giffney, Sauer, and Watt, *Lesbian Premodern*, 105–17.

————. *Queer Love in the Middle Ages*. New York: Palgrave Macmillan, 2005.

Knüsel, Christopher, and Kathryn Ripley. "The *Berdache* or Man-Woman in Anglo-Saxon England and Early Medieval Europe." In *Social Identity in Early Medieval Britain*, edited by William O. Frazer and Andrew Tyrrell, 157–91. London: Leicester University Press, 2000.

Koerner, Joseph L. "Albrecht Dürer: A Sixteenth-Century *Influenza*." In *Albrecht Dürer and His Legacy: The Graphic Work of a Renaissance Artist*, edited by Giulia Bartrum, 18–38. London: British Museum, 2002.

Kolve, V. A. "Ganymede / *Son of Getron*: Medieval Monasticism and the Drama of Same-Sex Desire." *Speculum* 73, no. 4 (1998): 1014–67.

König, Eberhard, ed. *Les Belles Heures du Duc de Berry*. Lucerne: Faksimile Verlag Luzern, 2003.

Kuefler, Mathew. "Male Friendship and the Suspicion of Sodomy in Twelfth-Century France." In Farmer and Pasternack, *Gender and Difference in the Middle Ages*, 145–81.

Kuhrt, Amélie. *The Persian Empire: A Corpus of Sources from the Achaemenid Period*. Abingdon, UK: Routledge, 2007.

Kurath, Hans, et al., eds. *Middle English Dictionary*. Ann Arbor: University of Michigan Press, 1952–.

Lansing, Carol. "Donna con Donna? A 1295 Inquest into Female Sodomy." In *Sexuality and Culture in Medieval and Renaissance Europe*, edited by Philip M. Soergel, 109–22. Studies in Medieval and Renaissance History, 3rd ser., 2. New York: AMS Press, 2005.

Leclercq, Jean. *Monks and Love in Twelfth-Century France: Psycho-Historical Essays*. Oxford: Clarendon Press, 1979.

Lee, M. Owen. *Virgil as Orpheus: A Study of the "Georgics."* Albany: State University of New York Press, 1996.

Lees, Clare A. "Engendering Religious Desire: Sex, Knowledge, and Christian Identity in Anglo-Saxon England." *Journal of Medieval and Early Modern Studies* 27, no. 1 (1997): 17–46.

Lefrançois-Pillion, Louis. *Les sculpteurs français du XIIᵉ siècle*. Paris: Plon, 1931.

Leibacher-Ouard, Lise. "Divergences et Queeriosités: *Ovide moralisé* ou les mutations d'Iphis en garçon (XIIe–XVIIIe)." In Day, *Queer Sexualities in French and Francophone Literature and Film*, 13–33.

Levy, Brian J. "Le dernier tabou? Les fabliaux et la perversion sexuelle." In *Sexuelle Perversionen im Mittelalter*, edited by Danielle Buschinger and Wolfgang Spiewok, 107–24. Wodan 46. Greifswald, Germany: Reineke, 1994.

Leyser, Conrad. "Cities of the Plain: The Rhetoric of Sodomy in Peter Damian's 'Book of Gomorrah.'" *Romanic Review* 86, no. 2 (1995): 191–211.

Limbeck, Sven. "'Turpitudo antique passionis': Sodomie im mittelalterlicher Visionslitera-

tur." In *Visio Edmundi monachi de Eynsham: Interdisziplinäre Studien zur mittelalterlichen Visionsliteratur*, edited by Thomas Ehlen, Johannes Mangei, and Elisabeth Stein, 165–226. Tübingen: Gunter Narr, 1998.

Lindquist, Sherry C. M., ed. *The Meanings of Nudity in Medieval Art*. Farnham, UK: Ashgate, 2012.

Lipton, Sara. *Images of Intolerance: The Representation of Jews and Judaism in the* Bible moralisée. Berkeley: University of California Press, 1999.

———. "The Root of All Evil: Jews, Money, and Metaphor in the *Bible moralisée*." *Medieval Encounters* 1, no. 3 (1995): 301–22.

———. "The Un-moralized Bible." *Bible Review* 17, no. 2 (April 2001): 30–37, 48, 50.

Lochrie, Karma. "Between Women." In Dinshaw and Wallace, *Cambridge Companion to Medieval Women's Writing*, 70–88.

———. *Covert Operations: The Medieval Uses of Secrecy*. Philadelphia: University of Pennsylvania Press, 1999.

———. "Heterosexuality." In R. Evans, *Cultural History of Sexuality in the Middle Ages*, 37–56.

———. *Heterosyncrasies: Female Sexuality When Normal Wasn't*. Minneapolis: University of Minnesota Press, 2005.

———. "Mystical Acts, Queer Tendencies." In *Constructing Medieval Sexuality*, edited by Karma Lochrie, Peggy McCracken, and James A. Shultz, 180–200. Minneapolis: University of Minnesota Press, 1999.

———. Preface to Giffney, Sauer, and Watt, *Lesbian Premodern*, xiii–xviii.

———. "Presumptive Sodomy and Its Exclusions." *Textual Practice* 13, no. 2 (1999): 295–310.

Long, Kathleen P. *Hermaphrodites in Renaissance Europe*. Aldershot, UK: Ashgate, 2006.

Loos-Noji, Pamela. "Temptation and Redemption: A Monastic Life in Stone." In *Equally in God's Image: Women in the Middle Ages*, edited by Julia Bolton Holloway, Joan Bechtol, and Constance S. Wright, 220–32. New York: Peter Lang, 1990.

Lord, Carla. "Marks of Ownership in Medieval Manuscripts: The Case of the Rouen *Ovide moralisé*." *Source: Notes in the History of Art* 18, no. 1 (1998): 7–11.

———. "A Survey of Imagery in Medieval Manuscripts of Ovid's Metamorphoses and Related Commentaries." In *Ovid in the Middle Ages*, edited by James G. Clark, Frank T. Coulson, and Kathryn L. McKinley, 257–83. Cambridge: Cambridge University Press, 2011.

———. "Three Manuscripts of the *Ovide moralisé*." *Art Bulletin* 57 (1975): 161–75.

Louis, Kenneth R. R. Gros. "Robert Henryson's *Orpheus and Eurydice* and the Orpheus Traditions of the Middle Ages." *Speculum* 41, no. 4 (1966): 643–55.

Love, Heather. *Feeling Backward: Loss and the Politics of Queer History*. Cambridge, MA: Harvard University Press, 2007.

Lowden, John. "Inventing Biblical Narrative: The Kiss of Cain in the *Bibles moralisées*." In *Image, Memory and Devotion: Liber Amicorum Paul Crossley*, edited by Zoë Opacic and Achim Timmermann, 35–53. Studies in Gothic Art 2. Turnhout: Brepols, 2011.

———. *The Making of the "Bibles moralisées."* 2 vols. University Park: Pennsylvania State University Press, 2000.

———. "'Reading' Images and Texts in the *Bibles moralisées*: Images as Exegesis and the Exegesis of Images." In *Reading Images and Texts: Medieval Images and Texts as Forms of Communication*, edited by Mariëlle Hageman and Marco Mostert, 495–525. Turnhout: Brepols, 2005.

Luber, Katherine Crawford. *Albrecht Dürer and the Venetian Renaissance*. Cambridge: Cambridge University Press, 2005.

MacKendrick, Karmen. *Counterpleasures*. Albany: State University of New York Press, 1999.

MacLehose, William F. *"A Tender Age": Cultural Anxieties over the Child in the Twelfth and Thirteenth Centuries*. New York: Columbia University Press, 2008.

Madden, Ed. "The Anus of Tiresias: Sodomy, Alchemy, Metamorphosis." In Day, *Queer Sexualities in French and Francophone Literature and Film*, 113–27.

Maier, Christopher T. "The *Bible moralisée* and the Crusades." In *The Experience of Crusading*, vol. 1: *Western Approaches*, edited by Marcus Bull and Norman Housely, 209–22. Cambridge: Cambridge University Press, 2003.

Makowski, John F. "Bisexual Orpheus: Pederasty and Parody in Ovid." *Classical Journal* 92, no. 1 (1996): 25–38.

Mâle, Émile. *L'art religieux du XIIᵉ siècle en France: Étude sur les origines de l'iconographie du moyen âge*. 8th ed. Paris: Armand Colin, 1998.

Marshall, John. "Pansies, Perverts and Macho Men: Changing Conceptions of Male Homosexuality." In *The Making of the Modern Homosexual*, edited by Kenneth Plummer, 133–54. London: Hutchinson, 1981.

Matter, E. Ann. "My Sister, My Spouse: Woman-Identified Women in Medieval Christianity." *Journal of Feminist Studies in Religion* 2, no. 2 (1986): 81–92.

———. *The Voice of My Beloved: The Song of Songs in Western Medieval Christianity*. Philadelphia: University of Pennsylvania Press, 1990.

McAlpine, Monica. "The Pardoner's Homosexuality and How It Matters." *PMLA* 95 (1980): 8–22.

McAvoy, Liz Herbert. *Medieval Anchoritisms: Gender, Space and the Solitary Life*. Cambridge, UK: D. S. Brewer, 2011.

McCracken, Peggy. "'The Boy Who Was a Girl': Reading Gender in the *Roman de Silence*." *Romanic Review* 85 (1994): 517–36.

McGuire, Brian Patrick. *Brother and Lover: Aelred of Rievaulx*. New York: Crossroad, 1994.

———. *Friendship and Community: The Monastic Experience, 350–1250*. Cistercian Studies Series 95. Kalamazoo, MI: Cistercian Publications, 1988.

Meiss, Millard. *French Painting in the Time of Jean de Berry: The Limbourgs and Their Contemporaries*. 2 vols. London: Thames & Hudson, 1974.

Merleau-Ponty, Maurice. *Phenomenology of Perception*. Translated by Colin Smith. 1962; repr. London: Routledge, 2002.

Meyerowitz, Joanne. *How Sex Changed: A History of Transsexuality in the United States*. Cambridge, MA: Harvard University Press, 2002.

Millett, Bella. "The Origins of *Ancrene Wisse*: New Answers, New Questions." *Medium Aevum* 61, no. 2 (1992): 206–28.

Mills, Robert. "Ecce Homo." In *Gender and Holiness: Men, Women and Saints in Late Medieval Europe*, edited by Samantha J. E. Riches and Sarah Salih, 152–73. London: Routledge, 2002.

———. "Gender, Sodomy, Friendship, and the Medieval Anchorhold." *Journal of Medieval Religious Cultures* 36, no. 1 (2010): 1–27.

———. "Homosexuality: Specters of Sodom." In R. Evans, *Cultural History of Sexuality in the Middle Ages*, 57–79.

———. "Queer Is Here? Lesbian, Gay, Bisexual and Transgender Histories and Public Culture." *History Workshop Journal* 62 (2006): 253–63.

———. "Queering the Un/Godly: Christ's Humanities and Medieval Sexualities." In *Queering the Non/Human*, edited by Noreen Giffney and Myra J. Hird, 111–35. Aldershot, UK: Ashgate, 2008.

———. "Seeing Sodomy in the *Bibles moralisées*." *Speculum* 87, no. 2 (2012): 413–68.

———. *Suspended Animation: Pain, Pleasure and Punishment in Medieval Culture*. London: Reaktion, 2005.

Mitchell, W. J. T. "Word and Image." In *Critical Terms for Art History*, edited by Robert S. Nelson and Richard Shiff, 47–57. Chicago: University of Chicago Press, 1996.

Moisan, Jean-Claude, and Sabrina Vervacke. "Les *Métamorphoses* d'Ovide et le monde de l'imprimé: La *Bible des Poëtes*, Bruges, Colard Mansion, 1484." In *Lectures d'Ovide publiées à la mémoire de Jean-Pierre Néraudau*, edited by Emmanuel Bury with Mireille Néraudau, 217–37. Paris: Les Belles Lettres, 2003.

Mojsov, Bojana. *Osiris: Death and Afterlife of a God*. Oxford: Blackwell, 2005.

Moore, R. I. *The Formation of a Persecuting Society: Power and Deviance in Western Europe, 990–1250*. Oxford: Blackwell, 1987.

Moore, Stephen D. *God's Beauty Parlor, and Other Queer Spaces in and around the Bible*. Stanford, CA: Stanford University Press, 2001.

Moran, Jo Ann Hoeppner. "Literature and the Medieval Historian." *Medieval Perspectives* 10 (1995): 49–66.

More, Kate, and Stephen Whittle, eds. *Reclaiming Genders: Transsexual Grammars at the Fin de Siècle*. London: Cassell, 1999.

Morey, James H. "Peter Comestor, Biblical Paraphrase, and the Medieval Popular Bible." *Speculum* 68, no. 1 (1993): 6–35.

Mormando, Franco. *The Preacher's Demons: Bernardino of Siena and the Social Underworld of Early Renaissance Italy*. Chicago: University of Chicago Press, 1999.

Morra, Joanne. "Translation into Art History." *Parallax* 6, no. 1 (2000): 129–38.

Morton, Jonathan. "Queer Metaphors and Queerer Reproduction in Alain de Lille's *De planctu naturae* and Jean de Meun's *Roman de la rose*." In *Desire in Dante and the Middle Ages*, edited by Manuele Gragnolati, Tristan Kay, Elena Lombardi, and Francesca Southerden, 208–26. Oxford: Legenda, 2012.

Mouilleron, Véronique Rouchon. *Vézelay: The Great Romanesque Church*. Translated by Laurel Hirsch. New York: Harry N. Abrams, 1999.

Munt, Sally, ed. *Butch/Femme: Inside Lesbian Gender*. London: Cassell, 1998.

Murdoch, Brian. *The Medieval Popular Bible: Expansions of Genesis in the Middle Ages*. Cambridge, UK: D. S. Brewer, 2003.

Murray, Jacqueline. "Twice Marginal and Twice Invisible: Lesbians in the Middle Ages." In Bullough and Brundage, *Handbook of Medieval Sexuality*, 191–222.

Myers, Marshall Neal, and Wayne R. Dynes. *Hieronymus Bosch and the Canticle of Isaiah*. New York: Cabirion, 1987.

Nash, Susie. *Northern Renaissance Art*. Oxford: Oxford University Press, 2008.

Neal, Derek G. *The Masculine Self in Late Medieval England*. Chicago: University of Chicago Press, 2008.

Nederman, Cary J., and Jacqui True. "The Third Sex: The Idea of the Hermaphrodite in Twelfth-Century Europe." *Journal of the History of Sexuality* 6, no. 4 (1996): 497–517.

Newman, Barbara. *From Virile Woman to WomanChrist: Studies in Medieval Religion and Literature*. Philadelphia: University of Pennsylvania Press, 1995.

Norton, Rictor. *The Myth of the Modern Homosexual: Queer History and the Search for Cultural Unity*. London: Cassell, 1997.

Oakley-Brown, Liz. *Ovid and the Cultural Politics of Translation in Early Modern England*. Aldershot, UK: Ashgate, 2006.

Olsen, Glenn W. *Of Sodomites, Effeminates, Hermaphrodites, and Androgynes: Sodomy in the Age of Peter Damian*. Toronto: Pontifical Institute of Mediaeval Studies, 2011.

O'Malley, Patrick R. "Epistemology of the Cloister: Victorian England's Queer Catholicism." *GLQ* 15, no. 4 (2009): 535–64.

Orgel, Stephen. "Ganymede Agonistes." *GLQ* 10, no. 3 (2004): 485–501.

Osborne, Peter, and Lynne Segal. "Gender as Performance: An Interview with Judith Butler." *Radical Philosophy* 67 (1994), 32–39.

Otter, Monika C. "Neither/Neuter: Hildebert's Hermaphrodite and the Medieval Latin Epigram." *Studi Medievali*, 3rd ser., 48 (2007): 789–807.

Panofsky, Erwin. *The Life and Art of Albrecht Dürer.* 4th ed. Princeton, NJ: Princeton University Press, 1955.

———. *Studies in Iconology: Humanistic Themes in the Art of the Renaissance.* New York: Harper and Row, 1962.

Park, Katharine. "The Rediscovery of the Clitoris: French Medicine and the Tribade, 1570–1620." In *The Body in Parts: Fantasies of Corporeality,* edited by David Hillman and Carla Mazzio, 171–93. London: Routledge, 1997.

Park, Katharine, and Lorraine J. Daston. "The Hermaphrodite and the Orders of Nature: Sexual Ambiguity in Early Modern France." *GLQ* 1, no. 4 (1995): 419–38.

Parkinson, R. B. *A Little Gay History: Desire and Diversity across the World.* London: British Museum, 2013.

Patlagean, Évelyne. "L'histoire de la femme déguisée en moine et l'évolution de la sainteté féminine à Byzance." *Studi Medievali*, 3rd ser., 17 (1976): 597–623.

Patricca, Nicholas. Review of John Boswell, *Christianity, Social Tolerance, and Homosexuality. American Journal of Sociology* 88, no. 6 (1982–83): 1333–36.

Patton, Pamela Anne. *Pictorial Narrative in the Romanesque Cloister: Cloister Imagery and Religious Life in Medieval Spain.* New York: Peter Lang, 2004.

Payer, Pierre J. *The Bridling of Desire: Views of Sex in the Later Middle Ages.* Toronto: University of Toronto Press, 1993.

———. *Sex and the Penitentials: The Development of a Sexual Code, 550–1150.* Toronto: University of Toronto Press, 1984.

Perella, Nicholas J. *The Kiss Sacred and Profane: An Interpretative History of Kiss Symbolism and Related Religio-Erotic Themes.* Berkeley: University of California Press, 1969.

Perret, Michelle. "Travesties et transsexuelles: Yde, Silence, Grisandole, Blanchandine." *Romance Notes* 25, no. 3 (1985): 328–40.

Pettitt, Tom. " 'Skreaming like a pigge halfe stickt': Vernacular Topoi in the Carnivalesque Martyrdom of Edward II." *Orbis Litterarum* 60, no. 2 (2005): 79–108.

Phillips, Kim M., and Barry Reay. *Sex before Sexuality: A Premodern History.* Cambridge, UK: Polity, 2011.

Pintabone, Diane. "Ovid's Iphis and Ianthe: When Girls Won't Be Girls." In *Among Women: From the Homosocial to the Homoerotic in the Ancient World,* edited by Nancy Sorkin Rabinowitz and Lisa Auanger, 256–85. Austin: University of Texas Press, 2002.

Pittenger, Elizabeth. "Explicit Ink." In Fradenburg and Freccero, *Premodern Sexualities,* 223–42.

Plante, Thomas G., ed. *Sin against the Innocents: Sexual Abuse by Priests and the Role of the Catholic Church.* Westport, CT: Praeger, 2004.

Porée, Charles. *L'abbaye de Vézelay.* Paris: Henri Laurens, 1909.

Porras, Stephanie. "Dürer's Copies." In *The Young Dürer: Drawing the Figure,* edited by Stephanie Buck and Stephanie Porras, 57–71. London: Courtauld Gallery, 2013.

Possamaï-Pérez, Marylène. *L'Ovide moralisé: Essai d'interprétation.* Paris: Champion, 2006.

Pressouyre, Léon. "St. Bernard to St. Francis: Monastic Ideals and Iconographic Programs in the Cloister." *Gesta* 12, nos. 1–2 (1973): 71–92.

Puff, Helmut. "Female Sodomy: The Trial of Katherina Hetzeldorfer (1477)." *Journal of Medieval and Early Modern Studies* 30, no. 1 (2000): 41–61.

———. "Orpheus after Eurydice (According to Albrecht Dürer)." In *Dead Lovers: Erotic Bonds and the Study of Premodern Europe,* edited by Basil Dufallo and Peggy McCracken, 71–95. Ann Arbor: University of Michigan Press, 2006.

———. *Sodomy in Reformation Germany and Switzerland, 1400–1600.* Chicago: University of Chicago Press, 2003.

———. "Violence, Victimhood, Artistry: Albrecht Dürer's *The Death of Orpheus*." In *Gender Matters: Discourses of Violence in Early Modern Literature and the Arts*, edited by Mara R. Wade, 61–80. Amsterdam: Rodopi, 2014.

Putter, Ad. "Transvestite Knights in Medieval Life and Literature." In *Becoming Male in the Middle Ages*, edited by Jeffrey Jerome Cohen and Bonnie Wheeler, 279–302. New York: Garland, 1997.

Quinn, Patricia A. *Better Than the Sons of Kings: Boys and Monks in the Early Middle Ages*. New York: Peter Lang, 1989.

Rabel, Claudia. "L'illustration de 'l'Ovide moralisé' dans les manuscrits français du XIVᵉ siècle: Essai pour une étude iconographique." Mémoire de maîtrise, Paris IV, 1981.

Rambuss, Richard. *Closet Devotions*. Durham, NC: Duke University Press, 1998.

Raskolnikov, Masha. "Transgendering Pride." *postmedieval: a journal of medieval cultural studies* 1, nos. 1–2 (2010): 157–64.

Reed, Christopher. *Art and Homosexuality: A History of Ideas*. Oxford: Oxford University Press, 2011.

Reinhardt, Klaus. "Texts of the 'Bible of Saint Louis.'" In Ruiz, *Bible of Saint Louis*, 267–321.

Riches, Samantha. *St. George: Hero, Martyr and Myth*. Phoenix Mill, UK: Sutton, 2000.

Ricks, Christopher. "Metamorphosis in Other Words." In *Gower's Confessio Amantis: Responses and Reassessments*, edited by Alistair J. Minnis, 24–49. Cambridge, UK: D. S. Brewer, 1983.

Robbins, Emmet. "Famous Orpheus." In Warden, *Orpheus*, 3–23.

Robertson, Kellie. "Medieval Things: Materiality, Historicism, and the Premodern Object." *Literature Compass* 5/6 (2008): 1060–80.

Robins, William. "Three Tales of Female Same-Sex Marriage: Ovid's 'Iphis and Ianthe,' the Old French *Yde et Olive*, and Antonio Pucci's *Reina d'Oriente*." *Exemplaria* 21, no. 1 (2009): 43–62.

Robinson, David. "The Metamorphosis of Sex(uality): Ovid's 'Iphis and Ianthe' in the Seventeenth and Eighteenth Centuries." In *Presenting Gender: Changing Sex in Early-Modern Culture*, edited by Chris Mounsey, 171–201. Lewisburg, PA: Bucknell University Press, 2001.

Robinson, James. *Masterpieces of Medieval Art*. London: British Museum, 2008.

Rocke, Michael. "The Ambivalence of Policing Sexual Margins: Sodomy and Sodomites in Florence." In *At the Margins: Minority Groups in Premodern Italy*, edited by Stephen J. Milner, 53–70. Minneapolis: University of Minnesota Press, 2005.

———. *Forbidden Friendships: Homosexuality and Male Culture in Renaissance Florence*. Oxford: Oxford University Press, 1996.

Roesler-Friedenthal, Antoinette. "Ein Porträt Andrea Mantegnas als *alter Orpheus* im Kontext seiner Selbstdarstellungen." *Römisches Jahrbuch der Bibliotheca Hertziana* 31 (1996): 149–85.

Rollo, David. *Kiss My Relics: Hermaphroditic Fictions of the Middle Ages*. Chicago: University of Chicago Press, 2011.

Romano, Dennis. "A Depiction of Male Same-Sex Seduction in Ambrogio Lorenzetti's *Effects of Bad Government* Fresco." *Journal of the History of Sexuality* 21, no. 1 (2012): 1–15.

Rosasco, Betsy. "Albrecht Dürer's 'Death of Orpheus': Its Critical Fortunes and a New Interpretation of Its Meaning." *IDEA: Jahrbuch der Hamburger Kunsthalle* 3 (1984): 19–42.

Roth, Norman. "'Deal Gently with the Young Man': Love of Boys in Medieval Hebrew Poetry of Spain." *Speculum* 57, no. 1 (1982): 20–51.

Röver-Kann, Anne. *Albrecht Dürer, "Das Frauenbad" von 1496. Kunsthalle Bremen 11 September bis 4 November 2001*. Bremen: Hauschild, 2001.

Roy, Gopa. "A Virgin Acts Manfully: Ælfric's *Life of St. Eugenia* and the Latin Versions." *Leeds Studies in English* n.s. 23 (1992): 1–27.

Rubin, Gayle S. "Blood under the Bridge: Reflections on 'Thinking Sex.'" *GLQ* 17, no. 1 (2010): 15–48.

———. "Thinking Sex: Notes for a Radical Theory of the Politics of Sexuality." In *Culture, Society and Sexuality: A Reader*, edited by Richard Parker and Peter Aggleton. London: Routledge, 2007.

Rubin, Henry. "Trans Studies: Between a Metaphysics of Presence and Absence." In More and Whittle, *Reclaiming Genders*, 173–92.

Rubin, Miri. "The Person in the Form: Medieval Challenges to Bodily 'Order.'" In *Framing Medieval Bodies*, edited by Sarah Kay and Miri Rubin, 100–123. Manchester: Manchester University Press, 1996.

Ruggiero, Guido. *The Boundaries of Eros: Sex Crime and Sexuality in Renaissance Venice*. Oxford: Oxford University Press, 1985.

Ruiz, Ramón Gonzálvez, ed. *The Bible of Saint Louis*. Barcelona: M. Moleiro, 2004.

———. "The 'Bible of Saint Louis' of Toledo Cathedral." In Ruiz, *Bible of Saint Louis*, 92–106.

———. "Codicological Study of the 'Bible of Saint Louis.'" In Ruiz, *Bible of Saint Louis*, 157–265.

Rutchick, Leah. "Sculpture Programs in the Moissac Cloister: Benedictine Culture, Memory Systems and Liturgical Performance." PhD diss., University of Chicago, 1991.

Salet, Francis, and Jean Adhémar. *La Madeleine de Vézelay*. Melun, France: Librairie d'Argences, 1948.

Salih, Sarah. "Queering *Sponsalia Christi*: Virginity, Gender and Desire in the Early Middle English Anchoritic Texts." *New Medieval Literatures* 5 (2002): 155–75.

———. "Sexual Identities: A Medieval Perspective." In *Sodomy in Early Modern Europe*, edited by Tom Betteridge, 112–30. Manchester: Manchester University Press, 2002.

———. "Transvestism in the Anchorhold." In *The Milieu and Context of the Wooing Group*, edited by Susannah Mary Chewning, 148–64. Cardiff: University of Wales Press, 2009.

———. *Versions of Virginity in Late Medieval England*. Cambridge, UK: D. S. Brewer, 2001.

———. "When Is a Bosom Not a Bosom? Problems with 'Erotic Mysticism.'" In *Medieval Virginities*, ed. Anke Bernau, Ruth Evans, and Sarah Salih, 14–32. Cardiff: University of Wales Press, 2003.

Saslow, James M. *Ganymede in the Renaissance: Homosexuality in Art and Society*. New Haven, CT: Yale University Press, 1986.

———. *Pictures and Passions: A History of Homosexuality in the Visual Arts*. New York: Viking, 1999.

Sauer, Michelle M. "Architecture of Desire: Mediating the Female Gaze in the Medieval English Anchorhold." *Gender and History* 25, no. 3 (2013): 545–64.

———. "Privacy, Exile and the Rhetoric of Solitude in the Medieval English Anchoritic Tradition." In *Rhetoric of the Anchorhold: Space, Place and Body within the Discourses of Enclosure*, edited by Liz Herbert McAvoy, 96–110. Cardiff: University of Wales Press, 2008.

———. "Representing the Negative: Positing the Lesbian Void in Medieval English Anchoritism." *thirdspace: A Journal of Feminist Theory and Culture* 3, no. 2 (2004). http://www.thirdspace.ca/journal/article/view/sauer.

———. "Uncovering Difference: Encoded Homoerotic Anxiety within the Christian Eremitic Tradition in Medieval England." *Journal of the History of Sexuality* 19, no.1 (2010): 133–52.

Saulnier, Lyduire, and Neil Stratford. *La sculpture oubliée de Vézelay*. Bibliothèque de la Société française d'archéologie 17. Geneva: Droz, 1984.

Sautman, Francesca Canadé. "What Can They Possibly Do Together? Queer Epic Performances in *Tristan de Nanteuil*." In Sautman and Sheingorn, *Same Sex Love and Desire among Women*, 199–232.

Sautman, Francesca Canadé, and Pamela Sheingorn. "Introduction: Charting the Field." In Sautman and Sheingorn, *Same Sex Love and Desire among Women*, 1–48.

———, eds. *Same Sex Love and Desire among Women in the Middle Ages*. New York: Palgrave, 2001.

Savage, Anne. "The Communal Authorship of *Ancrene Wisse*." In *A Companion to Ancrene Wisse*, edited by Yoko Wada, 45–56. Cambridge, UK: D. S. Brewer, 2003.

Scanlon, Larry. "Unspeakable Pleasures: Alain de Lille, Sexual Regulation, and the Priesthood of Genius." *Romanic Review* 86, no. 2 (1995): 213–42.

Schaberg, Jane. *The Resurrection of Mary Magdalene: Legends, Apocrypha, and the Christian Testament*. London: Continuum, 2003.

Schecke, Helene. *Reform and Resistance: Formations of Female Subjectivity in Early Medieval Ecclesiastical Culture*. Albany: State University of New York Press, 2008.

Schibanoff, Susan. *Chaucer's Queer Poetics: Rereading the Dream Trio*. Toronto: University of Toronto Press, 2006.

———. "Hildegard of Bingen and Richardis of Stade: The Discourse of Desire." In Sautman and Sheingorn, *Same Sex Love and Desire among Women*, 49–84.

———. "Sodomy's Mark: Alan of Lille, Jean de Meun, and the Medieval Theory of Authorship." In Burger and Kruger, *Queering the Middle Ages*, 28–56.

Schirmann, J. "The Ephebe in Medieval Hebrew Poetry." *Sefarad* 15 (1955): 55–68.

Schultz, James A. *Courtly Love, the Love of Courtliness, and the History of Sexuality*. Chicago: University of Chicago Press, 2006.

———. "Heterosexuality as a Threat to Medieval Studies." *Journal of the History of Sexuality* 15, no. 1 (2006): 14–29.

Sedgwick, Eve Kosofsky. *Epistemology of the Closet*. London: Penguin, 1990.

Segal, Charles. *Orpheus: The Myth of the Poet*. Baltimore, MD: Johns Hopkins University Press, 1989.

Semmelrath, Hannah. *Der Orpheus-Mythos in der Kunst der italienischen Renaissance: Eine Studie zur Interpretationsgeschichte und zur Ikonologie*. PhD diss., University of Cologne, 1994.

Silberman, Lauren. "Mythographic Transformations of Ovid's Hermaphrodite." *Sixteenth Century Journal* 19, no. 4 (1988): 643–52.

Silverman, Kaja. *Flesh of My Flesh*. Stanford, CA: Stanford University Press, 2009.

Simons, Patricia. "Lesbian (In)Visibility in Italian Renaissance Culture: Diana and Other Cases of *donna con donna*." *Journal of Homosexuality* 27, nos. 1–2 (1994): 81–122.

———. *The Sex of Men in Premodern Europe: A Cultural History*. Cambridge: Cambridge University Press, 2011.

Simpson, J. A., et al., eds. *Oxford English Dictionary*. 2nd ed. Oxford: Clarendon, 1989.

Sinfield, Alan. "Transgender and LesBiGay Identities." In *Territories of Desire in Queer Culture*, edited by David Alderson and Linda Anderson, 150–63. Manchester: University of Manchester Press, 2000.

Sipe, A. W. Richard. "The Crisis of Sexual Abuse and the Celibate/Sexual Agenda of the Church." In Plante, *Sin against the Innocents*, 61–72.

Smartt, Daniel. "Cruising Twelfth-Century Pilgrims." *Journal of Homosexuality* 27, nos. 1–2 (1994): 35–55.

Smith, Ali. *Girl Meets Boy*. Edinburgh: Canongate, 2007.

Smith, Alistair. "'Germania' and 'Italia': Albrecht Dürer and Venetian Art." *Royal Society for the Encouragement of Arts, Manufactures and Commerce Journal* 127, no. 5273 (April 1979): 273–90.

Smith, Lesley. *The* Glossa ordinaria: *The Making of a Medieval Bible Commentary*. Leiden: Brill, 2009.

Smith, Robert. "Dürer, Sexuality, Reformation." In *Culture and History: Essays Presented to Jack Lindsay*, edited by Bernard Smith, 304–34. Sydney: Hale & Iremonger, 1984.

Sobczyk, Agata. *L'érotisme des adolescents dans la littérature française du moyen âge*. Louvain: Peeters, 2008.

Stahuljak, Zrinka. *Bloodless Genealogies of the French Middle Ages: Translatio, Kinship, and Metaphor*. Gainesville: University Press of Florida, 2005.

Steel, Karl. *How to Make a Human: Animals and Violence in the Middle Ages*. Columbus: Ohio State University Press, 2011.

Stehling, Thomas. "To Love a Medieval Boy." *Journal of Homosexuality* 8, nos. 3–4 (1983): 151–70.

Stewart, Alan. *Close Readers: Humanism and Sodomy in Early Modern England*. Princeton, NJ: Princeton University Press, 1997.

Stone, Sandy. "The *Empire* Strikes Back: A Posttranssexual Manifesto." In Stryker and Whittle, *Transgender Studies Reader*, 221–35.

Stork, Hans Walter. *Bible moralisée Codex Vindobonensis 2554 der Österreichische Nationalbibliothek: Transkription und Übersetzung*. St. Ingbert, Germany: Werner J. Röhrig, 1988.

Stratford, Neil. "A Cluny Capital in Hartford (Connecticut)." *Gesta* 27, nos. 1–2 (1988): 9–21.

Stryker, Susan. *Transgender History*. Berkeley, CA: Seal Press, 2008.

Stryker, Susan, and Stephen Whittle, eds. *The Transgender Studies Reader*. Oxford: Blackwell, 2006.

Sturges, Robert S. *Chaucer's Pardoner and Gender Theory: Bodies of Discourse*. New York: Palgrave Macmillan, 2000.

Symeonides, Sibilla. *Taddeo di Bartolo*. Siena: Accademia Senese degli Intronati, 1965.

Szarmach, Paul E. "Ælfric's Women Saints: *Eugenia*." In *New Readings on Women in Old English Literature*, edited by Helen Damico and Alexandra Hennessey Olsen, 146–57. Bloomington: Indiana University Press, 1990.

———. "St. Euphrosyne: Holy Transvestite." In *Holy Men and Holy Women: Old English Prose Saints' Lives and Their Contexts*, edited by Paul E. Szarmach, 353–65. Albany: State University of New York Press, 1996.

Tammen, Silke. "Bilder der Sodomie in der *Bible moralisée*." *Frauen Kunst Wissenschaft* 21 (1996): 30–48.

Tervooren, Helmut, and Thomas Bein. "Ein neues Fragment zum Minnesang und zur Sangspruchdichtung: Reinman von Zweter, Neidhart, Kelin, Rumzlant und Unbekanntes." *Zeitschrift für deutsche Philologie* 107 (1988): 1–26.

Thompson, John Jay. "Medea in Christine de Pizan's *Mutacion de Fortune*, or How to Be a Better Mother." *Forum for Modern Language Studies* 35 (1999): 158–74.

Thuillier, Jacques. "Études sur le cercle des Dinteville: L'énigme de Felix Chrestien." *Art de France* 1 (1961): 57–75.

Tietze-Conrat, Erika. "Intorno ad un disegno 'già attribuito ad Andrea Mantegna.'" *Bolletino d'arte* 43, no. 4 (1958): 341–42.

Toscan, Jean. *Le carnaval du langage: Le lexique érotique des poètes de l'équivoque de Burchiello à Marino (XVᵉ–XVIIᵉ siècles)*. 4 vols. Lille: Presses universitaires de Lille, 1981.

Traub, Valerie. "Friendship's Loss: Alan Bray's Making of History." *GLQ* 10, no. 3 (2004): 339–65.

———. *The Renaissance of Lesbianism in Early Modern England*. Cambridge: Cambridge University Press, 2002.

———. "The Rewards of Lesbian History." *Feminist Studies* 25, no. 2 (1999): 363–94.

Trumbach, Randolph. *Sex and the Gender Revolution*, vol. 1: *Heterosexuality and the Third Gender in Enlightenment London*, vol. 2: *The Origins of Modern Homosexuality*. Chicago: University of Chicago Press, 2008.

Valentine, David. *Imagining Transgender: An Ethnography of a Category*. Durham, NC: Duke University Press, 2007.

Venturi, Adolfo. *Storia dell'arte italiana*, vol. 3: *L'arte romanica*. Milan: Ulrico Hoepli, 1904.

Venuti, Lawrence. *The Translator's Invisibility: A History of Translation*. 2nd ed. London: Routledge, 2008.

Vicari, Patricia. "*Sparagmos*: Orpheus among the Christians." In Warden, *Orpheus*, 63–83.

Waldman, Thomas G. "Abbot Suger and the Nuns of Argenteuil." *Traditio* 41 (1985): 239–72.

Walker, Jonathan. "Before the Name: Ovid's Deformulated Lesbianism." *Comparative Literature* 58, no. 3 (2006): 205–22.

Walters, Jonathan. "'No More Than a Boy': The Shifting Construction of Masculinity from Ancient Greece to the Middle Ages." *Gender and History* 5, no. 1 (1993): 20–33.

Walters, Lori J. "Fortune's Double Face: Gender and the Transformations of Christine de Pizan, Augustine and Perpetua." *Fifteenth Century Studies* 25 (2000): 97–114.

Warburg, Aby. "Dürer and Italian Antiquity" (1905). In *The Renewal of Pagan Antiquity: Contributions to the Cultural History of the European Renaissance*, translated by David Britt, 552–58. Los Angeles: Getty Research Institute for the History of Art and the Humanities, 1999.

Warden, John, ed. *Orpheus: The Metamorphoses of a Myth*. Toronto: University of Toronto Press, 1982.

Warner, Marina. *Monuments and Maidens: The Allegory of the Female Form*. Berkeley: University of California Press, 2000.

Warren, Ann K. *Anchorites and Their Patrons in Medieval England*. Berkeley: University of California Press, 1985.

Watt, Diane. *Amoral Gower: Language, Sex, and Politics*. Minneapolis: University of Minnesota Press, 2003.

———. "Behaving like a Man? Incest, Lesbian Desire, and Gender Play in *Yde et Olive* and Its Adaptations." *Comparative Literature* 50, no. 4 (1998): 265–85.

———. *Medieval Women's Writing: Works by and for Women in England, 1100–1500*. Cambridge, UK: Polity, 2007.

Wei, Ian P. *Intellectual Culture in Medieval Paris: Theologians and the University c. 1100–1330*. Cambridge: Cambridge University Press, 2012.

Weir, Anthony, and James Jerman. *Images of Lust: Sexual Carvings on Medieval Churches*. 1986; repr. London: Routledge, 1999.

Weisbach, Werner. *Religiöse Reform und mittelalterliche Kunst*. Zürich: Benziger, 1945.

Welles, Elizabeth B. "Orpheus and Arion as Symbols of Music in Mantegna's 'Camera degli Sposi.'" *Studies in Iconography* 13 (1989–90): 113–44.

Weston, Lisa M. C. "*Sanctimoniales cum Sanctimonilae*: Particular Friendships and Female Community in Anglo-Saxon England." In *Sex and Sexuality in Anglo-Saxon England: Essays in Memory of Daniel Gillmore Calder*, edited by Carol Braun Pasternack and Lisa M. C. Weston, 35–62. Tempe: Arizona Center for Medieval and Renaissance Studies, Arizona State University, 2004.

———. "Virgin Desires: Reading a Homoerotics of Female Monastic Community." In Giffney, Sauer, and Watt, *Lesbian Premodern*, 93–104.

Wetherbee, Winthrop. "The Literal and the Allegorical: Jean de Meun and the *De planctu naturae*." *Mediaeval Studies* 33 (1971): 264–91.

Whatley, E. Gordon. "Eugenia before Ælfric: A Preliminary Report on the Transmission of an Early Medieval Legend." In *Intertexts: Studies in Anglo-Saxon Culture Presented to Paul Szarmach*, edited by Virginia Blanton and Helene Scheck, 349–67. Tempe: Arizona Center for Medieval and Renaissance Studies, 2008.

———. "More Than a Female Joseph: The Sources of the Late-Fifth-Century *Passio Sanctae Eugeniae*." In *Saints and Scholars: New Perspectives on Anglo-Saxon Literature and Culture in Honour of Hugh Magennis*, edited by Stuart McWilliams, 87–111. Cambridge, UK: D. S. Brewer, 2012.

Wheeler, Stephen M. "Changing Names: The Miracle of Iphis in Ovid's *Metamorphoses* 9." *Phoenix* 51, no. 2 (1997): 190–202.

Whitehead, Christiana. *Castles of the Mind: A Study of Medieval Architectural Allegory*. Cardiff: University of Wales Press, 2003.

Whittington, Karl. "Queer." *Studies in Iconography* 33 (2012): 157-68.

Wiethaus, Ulrike. "Female Homoerotic Discourse and Religion in Medieval Germanic Culture." In Farmer and Pasternack, *Gender and Difference in the Middle Ages*, 288-321.

———. "In Search of Medieval Women's Friendships: Hildegard of Bingen's Letters to Her Female Contemporaries." In *Maps of Flesh and Light: The Religious Experience of Medieval Women Mystics*, edited by Ulrike Wiethaus, 93-111. Syracuse, NY: Syracuse University Press, 1993.

Williams, Craig A. *Roman Homosexuality*. 2nd ed. Oxford: Oxford University Press, 2010.

Wind, Edgar. "Dürer's *Männerbad*: A Dionysian Mystery." *Journal of the Warburg Institute* 2, no. 3 (1939): 269-71.

———. "'Hercules' and 'Orpheus': Two Mock-Heroic Designs by Dürer." *Journal of the Warburg Institute* 2, no. 3 (1939): 206-18.

Wirth, Jean. *L'image à l'époque romane*. Paris: Éditions du Cerf, 1999.

Wolf, Norbert. *Dürer*. Translated by Cynthia Hall. Munich: Prestel, 2010.

Wolfthal, Diane. "An Art Historical Response to 'Gay Studies and Feminism: A Medievalist's Perspective.'" *Medieval Feminist Newsletter* 14 (Fall 1992): 16-19.

———. "'A Hue and a Cry': Medieval Rape Imagery and Its Transformation." *Art Bulletin* 75, no. 1 (1993): 39-64.

———. *Images of Rape: The "Heroic" Tradition and Its Alternatives*. Cambridge: Cambridge University Press, 1999.

———. *In and Out of the Marital Bed: Seeing Sex in Renaissance Europe*. New Haven, CT: Yale University Press, 2010.

Woods, Christopher. "Albrecht Dürer." In *Gay Histories and Cultures: An Encyclopedia*, ed. George E. Haggerty, 262-63. New York: Garland, 2000.

Woolf, Rosemary. "Moral Chaucer and Kindly Gower." In *J. R. R. Tolkien, Scholar and Storyteller: Essays in Memoriam*, edited by Mary Salu and Robert T. Farrell, 221-45. Ithaca, NY: Cornell University Press, 1979.

Wright, J. W., and Everett K. Rowson, eds. *Homoeroticism in Classical Arabic Literature*. New York: Columbia University Press, 1997.

Wunderli, Richard M. *London Church Courts and Society on the Eve of the Reformation*. Cambridge, MA: Medieval Academy of America, 1981.

Yallop, David. *Beyond Belief: The Catholic Church and the Child Abuse Scandal*. London: Constable, 2011.

Zapperi, Roberto. *The Pregnant Man*. Translated by Brian Williams. 4th ed. Chur, Switzerland: Harwood Academic, 1991.

Zarnecki, George. *Romanesque Lincoln: The Sculpture of the Cathedral*. Lincoln, UK: Honeywood Press, 1988.

Ziogas, Ioannis. *Ovid and Hesiod: The Metamorphosis of the "Catalogue of Women."* Cambridge: Cambridge University Press, 2013.

Ziolkowski, Jan. *Alan of Lille's Grammar of Sex: The Meaning of Grammar to a Twelfth-Century Intellectual*. Cambridge, MA: Medieval Academy of America, 1985.

INDEX

Abel, 48-50

Abelard, Pierre, 263

Abraham, 58, 135, 179, 314n81, 332n102, 343n127

Achilles, 150-51, 225-26, 312n62, 338n71

Adam: and Eve, 32-34, 43, 51, 147, 183, 205, 310n19; expelled, 35; tempted, 14, 28, 38, 202, 243

Adenolfo IV d'Aquino, 291-92

adolescents, 26, 314n79; lovers of clerics, 65-69, 216, 235-41; lovers of God, 144-46, 161-64, 238; lovers of Orpheus, 138, 143-46, 149, 155-64, 170-71; receptive partners, 239, 288-89, 293; temptation, 195, 216. *See also under* Ganymede

Adonis, 146

adultery, 93, 95, 217, 238, 241, 282

Ælfric of Eynsham, 207-8

Aelred of Rievaulx, 161, 193, 261, 265

Aeneas, 226

age difference, 245; in Arab-Islamic world, 239-40; in Florence, 288-89; and modern sexual ethics, 23, 235-41; as sodomitical trait, 26, 138, 157, 236-37, 301, 344n131. *See also* adolescents; children; pederasty

Ahmed, Sara, 24, 246, 249, 253, 293-94

AIDS, 238

Aix-en-Provence, 199

Alan of Lille, 27, 328n41; on deviance, 244, 294-95; on female homoeroticism, 254-55; on Ganymede, 214, 233-34; on gender inversion, 5, 34, 81-82, 84, 94, 150-54, 181, 252; on heretics and cats, 276; on money, 294-95; on narcissism, 35, 42, 81, 151; on Orpheus, 151-54, 187-88; on sexual mingling, 282

Albert the Great, 318n35

Albigensians, 71

alchemy, 106

Aldhelm, 341n96

Aldrich, Robert, 28

Alexandria, 200

Alfonso X, king of Castile and León, 76, 79, 295

Almodóvar, Pedro, 236

Altercatio Ganimedis et Helene, 214-15

Amazons, 84

Ambrose, Kirk, 200, 202, 204, 218

Ambrose, Saint, 207, 251

Amer, Sahar, 17-18, 99

Amphion, 152

Chalon-sur-Saône, 217

Charlemagne, 46

Charles Martel of Anjou, 291

Charles of Anjou (Charles II of Naples), 291–92

Chartres, 27, 74, 223

chastity: allegorical figure, 255; for androgynes, 25–26, 82; for monks, 6, 19, 23, 152–54, 191–201, 208, 215, 222, 235; for priests, 91, 152–54, 193; for Vesta, 124–25; for women, 92, 97, 206–7, 249, 257, 261. *See also* virginity

Châteaumeillant, 279–80

Chaucer, Geoffrey: *Canterbury Tales*, 84, 110–11, 277–78, 329n51, 334n6, 348n53; *House of Fame*, 226–27

Chauvigny, 223–24

chess, 177

children, 108, 161, 206, 248, 253, 264; abuse of, 145–46, 155–56, 170–71, 186, 227–29, 235–41; in art, 35, 65–69, 116, 118, 229; gender identity, 98–99, 101, 116, 123; as innocent, 27, 240–41; as monstrous, 83; as objects of desire, 214–17; oblation, 197, 215–16. *See also* adolescents; *and under* Christ

Christ: adviser, 253, 268; bridegroom, 7, 33–35, 43, 141, 192, 248–50, 299; child, 250, 252, 255; figures for, 272, 325n118; gender identity, 207; God-man, 106, 117, 127, 146–47, 228, 321n66; in Gospels, 50, 143, 177, 198, 206–7, 261; harrower of hell, 141, 146, 159, 163; hermaphrodite, 106; and Orpheus, 140–41, 146, 155, 181; pilgrim, 250; punisher, 35; sacrifice of, 91, 93–94, 97; suffering, 59, 163–64, 171. *See also* incarnation

Christina of Markyate, 248–55, 258, 262, 268

Christine de Pizan: *Epistre Othea*, 142–43, 167, 324n96, 330n75, 342n115; *Le livre de la mutacion de Fortune*, 22, 86, 121–28, 130, 143

Church (allegorical figure): abandonment of, 52–55, 65; bride of Christ, 7, 33–34, 43, 192; gender identity, 119; as intercessor, 111

church (institution): androgynes within, 82, 107; and Bible, 41, 50; celibacy, 4, 91, 193, 205, 348n51; corrupted, 67–68, 236; sodomy regulations, 4, 27, 83, 192–93, 216, 296

Cicero, 193

Ciconian women, 136–37, 141–42, 155, 157–59, 165, 171

Cinyras, 146

Cistercians, 191, 195

Clark, David, 207

Cleanness, 272

Clemence of Hungary, 116

Clement of Alexandria, 140–41, 143

clerics. *See* hermits; monks; priests

clitoris, 110–11

closet, 85, 143, 192, 269–70, 349n76

clothing: breeches, 258; clerical, 36, 307n47; courtly, 64, 82–83; dresses, on men, 1–2, 5, 7, 15, 92, 206, 225–26; dresses, on women, 2, 15, 36, 117, 202, 208; fashionable male, 82–83, 168; heretical, 36, 48, 70; monastic, 1–2, 7, 59, 202, 208, 222; of Sodomites, 58; tight, 58, 82, 202, 307n47; tunics, 36, 102, 115, 117, 162, 251; underwear, 36. *See also* cross-dressing; hats; nudity; shoes

Cluny Abbey, 199, 217

Commodus, Emperor, 200

Compludo, 216

Confessio Amantis. See Gower, John

confession: discretion during, 27, 33, 75, 265–66, 270; by female religious, 112, 265–66, 270–71; by laity, 27–28, 54–55, 112, 267; by monks, 3–4

conversion, 198–99, 201, 218

Copeland, Rita, 50, 223

cosmetics, 146, 322n74, 323n95

Council of Ancyra, 35

Council of London, 193

Council of Paris, 46

Council of Toulouse, 50

countereroticism, 23, 193–95, 214, 219, 222, 235

courtliness, 6–7, 64, 82, 118, 141–43, 167

Crete, 105, 137, 227, 229

cross-dressing: as disguise, 99–103, 151, 225–26, 256–58; and female homoeroticism, 83, 103, 109–10, 115–16, 126, 252, 255–58; and male homoeroticism, 83, 105; religious proscriptions against, 92; by saints, 1–2, 5–7, 15, 83, 92, 201–8, 251, 300; as sanctioned activity, 92, 201, 251–54; and sexual identity, 2, 11–12; terms for, 84; and translation, 19; as unnatural, 92, 146

crusades, 71–72, 275

Ctesias, 26

Cyparissus, 209

Daedalus, 104, 113, 324n97

Dante Alighieri, 342nn104–5; *Inferno*, 279, 295; *Purgatorio*, 224–27, 322n76

Dathan and Abiron, 313n76

David, 141, 175, 310n22, 312n62

Davidson, James, 301

Deidamia, 225–26

demons. *See* devils

De planctu Naturae. See Alan of Lille

derivation. *See* imitation

Desmond, Marilynn, 143

devils: exorcism, 198; inhabitants of hell, 35, 159, 166–67, 284; as men, 217; punishers of sodomites, 8, 59, 213, 286–88, 291, 294; sodomizers, 281–82, 286–88, 300; tempters, 15, 33, 36–39, 42, 47, 195; as women, 195, 208, 219–22. *See also* Satan

Diana, 256–58

Dido, 226

dildos: for female couples, 83, 109–13, 115, 125–26, 132; for masturbation, 91, 112, 262

Dinah, 175–76

Dinshaw, Carolyn, 184

disease, 35. *See also* leprosy; plague

Dominicans, 150, 264, 319n52

dreams, 15

Dunbar, William, 282–83

Dürer, Albrecht, 133, 138, 167–75, 186, 237, 332n93

eagles. *See under* birds

eating: by devils, 290–91; of genitals, 67, 113, 202–3, 282; as metaphor, 93–94; sinful, 28, 141, 263; and sodomy, 28, 58, 263–64

Ecclesia. *See* Church (allegorical figure)

education. *See* schools; universities

Edward II, king of England, 277–78

effeminacy: in court, 6, 82–83; and male homoeroticism, 4–6, 12, 26, 205, 272, 282–83; and sexual identity, 87–88, 95, 292–93; of womanizers, 6, 82–83, 225–26, 251–52, 254, 300, 316n5

Eleanor of Provence, 76

Elijah, 234, 343n127

Elizabeth, mother of John the Baptist, 255, 262

El-Rouayheb, Khaled, 245

embodiment: female, 26, 32, 42, 101, 115, 200–204, 250; male, 2, 15, 32, 87–88, 102, 124–27, 163; trans, 84–85, 90, 128, 204. *See also* androgynes

embracing, 79, 226, 279; female, 28, 36, 54–56, 59–65, 118–19, 166, 254–57, 262; male, 8, 28, 36, 59–65, 160–62, 279–80; male/female, 8, 55–56, 63–64

enclosure. *See* monastaries

Etienne de Fougères, 323n93

Eucharist, 67, 93, 146

Eugenia, Saint, 92, 200–209, 215, 251, 335n37, 335–36nn42–43

eunuchs, 201

Eurydice, 22–23, 243; in ancient literature, 133–37, 182–83, 185; in art, 158–59, 166–67, 182, 186–87; in medieval literature, 138–45, 155–57; as symbol of sensuality, 144–45, 155–57

Eusebius, 227

Eve: and Adam, 32–34, 43, 51, 147, 183, 205–6; expelled, 35; and female Serpent, 42, 56, 134, 265; and Lot's wife, 23, 175; secondary, 34, 38, 183, 310n19; tempted, 14, 28, 133–35, 202, 243

exile, 114–16

Eynsham Abbey, 280

fall (biblical), 14, 28, 31–40, 202, 243; exegesis of, 50; gender after, 32–34, 38, 42, 133–35, 147, 300; sex after, 14, 28, 36–40, 42–43, 265

female homoeroticism: in art, 28–31, 36–37, 42–43, 59–64, 76, 166, 173, 257–59; as backward, 127; as impossible, 104, 111, 116, 124–26, 258–59, 268–70, 301–2; legal status, 83, 109–10, 114, 126, 322n85; in literature, 98–116, 128–32, 207–8, 254–55, 265–66, 285–86, 312n62, 323n93; as secondary, 111–12; sources for, 16–18, 260; terms applied to, 3, 11–12, 86, 91, 94; as unthreatening, 97, 128. *See also* homosexuality; lesbian; male homoeroticism

female masculinity: as deceitful, 101, 109–10, 120, 126; and homoeroticism, 12–13, 15–16, 88, 94–97, 109–16, 181; legal status, 83, 109–10, 270; in literature, 84, 110–16, 201–8; sanctioned activity, 6, 92, 251–52, 258

femininity: as carnal, 15, 126, 134, 148, 154, 182, 186, 204–5, 300; of femme, 86, 96–97, 125–

femininity (*cont.*)

26, 131, 255, 260; grammatical, 5, 102, 127, 291; and Jews, 155; as performative, 15, 258; rejected by God, 144–45; rejected by men, 87–88, 143, 148, 154–55, 182, 187–88, 208; of Serpent, 42, 134, 265, 311n40; as sodomitical trait, 26, 83, 95, 144, 283; as spiritual metaphor, 7, 239; as threat to chastity, 7, 201–2, 208, 251–53. *See also* effeminacy; female masculinity; gender

feminism, 23, 98, 183, 317n29, 332n95

feminization. *See* effeminacy

femme: definitions, 15, 84, 96–97, 302, 318nn45–46; (in)visibility of, 97, 126–27, 131–32, 255. *See also* butch

fidelity, 19, 303

Filarete (Antonio di Pietro Averlino), 342n117

Filius Getronis, 215

Flambard, Ranulf, 248

Flamstead, 251, 253

Fleury Abbey, 215

Florence, 83, 288–90, 292, 296, 353n131

food. *See* eating

fornication. *See under* sex acts

Fortune (allegorical figure), 122, 128

Foucault, Michel: on homosexuality, 24, 244–45, 250, 252, 291; on Orpheus, 333n119; on repressive hypothesis, 30; on sodomy as "utterly confused," 11, 271, 301

Four Daughters of God, 255, 260

Franciscans, 156, 329n56

Friedman, John Block, 140

friendship: female, 16–17, 97, 126, 254–55; male, 16, 87–88, 148, 157, 161, 191–93, 238–40; male/female, 264; and sodomy, 16, 226, 238, 264–70, 278

Froissart, Jean, 8

Fructuosus of Braga, Saint, 216

Fulgentius, 228

Fulk le Rechin, 82

Ganymede, 23, 146, 148, 188; as adolescent, 210, 229–34, 237, 240–41; in ancient art, 210; in ancient literature, 209–10; in medieval art, 211–14, 218, 220–24, 229–31, 234–35, 279, 314n79, 337n62; in medieval literature, 151, 170, 214–15, 224–34; spiritual significance, 224–35, 239

Gaunt, Simon, 162

Gaveston, Piers, 278

gay: identity, 245–46; and lesbian, 13, 17; people in Middle Ages, 12, 75, 214; politics, 121, 185–86, 297; and queer, 21; and transgender, 90, 131

gender: equality, 118; fluidity, 89–90, 129–30; performativity, 89, 129, 249; and sex, 102, 128, 131–32, 148; and sexuality, 2, 12–13, 80, 86–90, 98, 109, 128, 131–32, 188, 300–302, 307n40; visibility of, 3, 7, 34. *See also* effeminacy; female masculinity; femininity; gender binaries; gender identity; gender trouble; masculinity; transgender

gender binaries: conformity to, 25, 89–90, 95, 133; and courtliness, 6–7; disruption of, 14, 25–26, 33–34, 89, 92, 95, 202; in medicine, 107; metaphorical significance of, 154, 183; and temporality, 89–90, 129. *See also* androgynes; gender trouble

gender identity, 11–12, 89, 92, 123, 188, 252; of modern scholars, 16; and naming, 101, 320n55; neuter, 81, 102, 107; of Serpent, 40, 42, 134, 265, 311n40; sodomy's effect on, 25–26, 81–83, 151–52, 288–89, 291–94, 300–301; of virgins, 250–53. *See also* butch; femme; transgender

gender trouble: courtly, 7, 162; of Eve, 33–34, 38; saintly, 1–2, 5–7, 15, 92, 188–89, 200–208, 251–52; as sexual sign, 2–3, 12, 33, 86, 93–97; as social sign, 91–92; sodomitical, 3–5, 15, 25–26; willful, 89. *See also* effeminacy; female masculinity

genitals: demonic, 284; devoured, 67, 113, 202–3, 282; fondled, 77–79, 83, 272; hermaphroditic, 25, 107; punished, 67, 202–3, 286; substitutes for, 109–13, 125; words for, 38, 67, 71, 73, 110–11, 157. *See also* clitoris; penis; testicles; vagina

Gibeah, 45–46

Giotto, 290

Giovanni da Modena, 290

Giovanni dei Bonsignori, 257

Giovanni del Virgilio, 157, 257

Girona, 282

Glossa ordinaria, 176–77

God, 54, 58, 201, 265; abandoned, 48; angry, 65–67, 193; attacked, 5; as bridegroom, 7; as creator, 25, 32–35, 38, 43, 51, 294; as father, 106, 111, 146, 228; grace of, 111, 141, 176, 200, 224, 228; laws of, 33, 91–94,

112, 197, 238, 243, 296; love for humanity, 231; love for males, 144-48, 154, 161, 188, 229, 238-39, 301; men's likeness to, 34; miracles of, 199; as object of desire, 239, 247, 249, 252, 261, 269; sodomy as affront to, 26-27, 114, 149; word of, 19

Golden Legend. See Legenda aurea

Gomorrah, 91, 292, 348n62

gossip. *See* slander

Gower, John, 107-11, 243

grammar: curriculum, 233; gender in, 102, 104, 119; as sexual metaphor, 34-35, 81-82, 152, 244

Gregorian Reform, 193

Gregory I, Pope ("the Great"), 28, 198, 218-21, 305n5

Gregory III, Pope, 339n81

Guibert of Nogent, 71, 193

Guillaume de Lorris, 162

Hades, 135-37, 140, 155, 164-67, 176, 182. *See also* hell

hairstyles: androgynous, 62, 258; feminine, 59, 62, 92, 195, 208, 220, 257; masculine, 47, 64, 82, 201-3, 208, 293; prelapsarian, 32; of Serpent, 42, 56; tonsure, 36, 53-54, 61, 64, 77, 177, 202, 208, 216, 222, 275, 336n51

Halberstam, Judith, 84-85, 90, 101, 184, 268

Halperin, David, 87-89, 131, 148, 245-46, 253-54, 307n40

harp, 142-43, 162-64, 170, 227; as sexual metaphor, 149-50, 157-59, 327n39. *See also* lyre

hats, 47-48, 54, 70, 177, 180, 310n26

heaven, 25, 147, 177, 223-24, 228-29, 233-34, 280, 292

Hector, 142

Helen of Troy, 150, 214-15

Helenus, Saint, 201

hell, 225; harrowing of, 141, 146, 159, 163; mouth of, 8, 35, 56, 62, 164; sinners in, 38, 212, 223, 243, 287-88, 293-95, 300; sodomites in, 8, 24, 79, 82, 159, 247, 271, 278-97. *See also* Hades

Heloise of Argenteuil, 263

Henry I, king of England, 316n5

Henry II, king of England, 76

Hercules, 170, 330n79

heretics: clothing of, 36, 48, 70; persecution of, 79; sexual practices of, 36, 67-68, 71, 75, 275-76, 314n76, 314n81. *See also* Albigensians; Cathars; Lollards; Templars

hermaphrodites, 81-82, 106-7, 321n72, 322n74, 322n76

Hermaphroditus, 106, 322n74, 323n95

hermits, 7, 249, 253, 261-62, 348n48. *See also* anchorites

Herrad of Landsberg, 279

heterosexuality: as modern concept, 84, 88, 192, 235, 245, 247, 300-302; as normative, 21, 84, 96, 253, 270, 300, 302; as primary, 13, 133; as way of life, 268

Hetzeldorfer, Katherina, 109-10, 181, 252

Hilary of Poitiers, 314n76

Hildegard of Bingen, 22, 86, 107; on anal sex, 93-94; on cross-dressing, 91-92, 201, 251; on female homoeroticism, 94-97, 104, 126, 181; on male homoeroticism, 91-93, 95-96

Hildemar of Corbie, 339n82

Hincmar of Reims, 3, 112, 305n5

Hohenburg Abbey, 279

Holcot, Robert, 150

Holy Land, 6, 199, 275

homoeroticism. *See* female homoeroticism; male homoeroticism

homophobia, 2, 127, 129, 131, 237-38

homosexuality: history of, 28-29, 87-90, 131; as modern concept, 2-3, 192, 245-46, 268, 270, 293, 300-302; nineteenth-century definitions, 24, 30, 88, 244-45, 252, 274, 291, 297; as normative, 187; and pedophilia, 236-38; and queer, 21, 108, 246; as secondary, 13; situational, 311n35; and sodomy, 31, 88; and transgender, 84-85, 87-90, 125, 302; as way of life, 250

homosociality, 23, 112, 139, 154, 156, 187, 279. *See also* friendship

Hortus deliciarum, 279

Horus, 113

hospitality, 18, 263-64. *See also* inhospitality

Hospitallers, 276

Housebook Master, 332n101

Howie, Cary, 194

Hugh of Flavigny, 83

Hult, David, 148

humor, 1, 6, 10, 272-77

Huntingdon, 248, 255

Husserl, Edmund, 253

Huys-Clavel, Viviane, 218
Hyacinthus (lover of Apollo), 210, 229
Hyacinthus, Saint, 201
Hyginus, 323n94, 326n13, 335n37
Hymenaeus, 123, 137, 166–67

Ianthe, 22, 86–87; in ancient literature, 98–99, 103–4, 136; in art, 117, 159, 166; and femme (in)visibility, 125–27, 131–32; in medieval literature, 101–2, 108–11, 243; in modern literature, 128–30
Ibykos, 135–36
idolatry, 28, 56, 65, 73, 262, 333n105
imitation: in art, 18, 162–64, 227; of Christ, 33, 127, 171; of Satan, 93–94; and sexuality, 13–14, 16, 90–96, 125–26, 138; and sodomy, 27–28, 151–52, 316n5
incarnation, 106, 146–47, 171, 187, 228
incest, 28, 105, 135, 146–47, 216
infamy, 141, 171, 272, 274–75, 295
inhospitality, 40, 45–47, 58–59, 179, 238
intersex, 89, 106. See also androgynes; her-maphrodites
Inverness, 129
Iphis, 22, 86, 188; in ancient literature, 98–99, 101–4, 113, 136; in art, 116–20, 159, 166; in medieval literature, 100–105, 107–11, 114–16, 121–28, 130–32, 143, 243; in modern literature, 128–31; name, 101–2, 320n55; unnatural desires of, 111, 146
Isaac, 314n79
Isis, 99, 113–14, 125
Islam, 65–67, 71, 239–40, 245, 271, 282
Israel, 43–45
Israelites, 64–65
Ixion, 136

Jacob, 175
Jacobus de Voragine. See Legenda aurea
Jacques de Longuyon, 274–76
Jaeger, Stephen C., 16
Jager, Eric, 50, 73
Jagose, Annamarie, 13, 18
James, M. R., 312n64
James the Great, Saint, 199
Jean de Berry: as patron, 1, 6, 8, 54, 167, 231, 306n27; as victim of slander, 8, 10, 284, 292, 352n113
Jean de Meun, 152–54, 272
Jeremiah, 26, 68–69

Jerome, Saint: as cross-dresser, 1–2, 5–7, 15, 83, 195, 206, 300, 306n14; on sin of Sodom, 264; as translator, 19–21, 41–43, 65; on women, 205–7, 251
Jerusalem, 275
Jews: anti-Jewish stereotypes, 54, 155, 317n20; as child abusers, 241; clothing, 36, 48, 70, 310n26; conversion, 320n66; sexual practices, 36, 75, 79, 106
Joan of Burgundy, 100
John of Salisbury, 338n69
John the Baptist, Saint, 255, 261
John the Evangelist, Saint, 223, 228, 343n127
Jonah, 338n71
Jordan, Mark, 236
Judas, 50
Juno, 105, 210, 257
Jupiter: and Callisto, 256–58; and Ganymede, 146, 148, 151, 170, 209–15, 226–34, 237, 239; and Leda, 343n124; and Tiresias, 105

Karras, Ruth Mazo, 81
kinaidos, 87–88
kings, 69, 76, 123, 215, 227, 229. See also names of individual monarchs
kissing, 79, 191, 226, 279; anal, 274–76; female, 28, 52, 254–57, 262; feudal, 161; male, 8, 36, 48–50, 61–62, 160–62, 216; male/female, 8, 151
Kolve, V. A., 215
Koran, 240, 271
Kuefler, Mathew, 260

Lactantius, 228
Last Judgment, 279, 284, 286, 289–94
Lateran Councils, 193, 328n41
Lazarus, 343n127
Leclercq, Jean, 191–92, 195–97
Leda, 343n124
Legenda aurea, 5–6, 19, 306n14
Leo IX, Pope, 4, 216, 271
Leochares, 210
Leonessa, 290
leprosy, 35, 310n22
lesbian: and gay, 13, 17; (in)visibility, 13–14, 16–18, 96–98, 130–32, 260, 267, 302; as modern category, 21, 85–87, 97, 128–32, 249, 301; politics, 185–86, 297; in premo-dernity, 28, 97–98, 260, 267; as second-ary, 13, 18, 96; and transgender, 90,

97–98. *See also* butch; female homoeroticism; femme; homosexuality

Lesbos, 159, 182

Leucothoe, 321n66

Liberius, Pope, 2

libido, 197

Ligdus, 98, 101, 111, 123

Limbourg brothers, 1–2, 8–10, 54, 63, 195, 231

Lincoln, 282, 295

Lipton, Sara, 70

Lochrie, Karma, 11, 81, 84, 263, 268, 300

Lollards, 262–64, 349n65

London, 83, 85

Lorenzetti, Ambrogio, 344n142

Lot: appearance, 179; confronted by Sodomites, 26, 59; host in Sodom, 8, 36, 58, 74, 175; as incestuous, 135, 332n102; as otherworldly, 177

Lothair II, king of Lotharingia, 3, 112

Lot's wife: as idolatrous, 333n105; punished for looking back, 23, 26, 56–59, 135, 138–39, 175–86, 243; as sodomite, 180–81; as worldly, 59, 177

Louis VIII, king of France, 30

Louis IX, king of France, 30, 79

Louis X, king of France, 116

Love, Heather, 139, 183–86

Lowden, John, 48, 51–52, 76

Lucifer. *See* Satan

Lucy, Saint, 225

lust: allegorical figure, 35, 202–3, 282–83; biblical, 45, 91; courtly, 82–83; as demonic, 15, 39; as feminizing, 251–52; of gods, 181; and sloth, 263; of women, 105, 113, 115, 207–8, 261, 265. See also *luxuria*

Luxemburg, 191

luxuria: and androgyny, 26, 28; as courtly, 82; as female, 195, 203, 279; and Ganymede's rape, 227–28, 237; as male couple, 279; as male/female couple, 282; punishments for, 286–88; as sin of Sodom, 59, 264. *See also* lust

Lycomedes, king, 151, 225

Lydgate, John, 167, 330n75

lyre, 151–52, 157, 187, 244. *See also* harp

MacKendrick, Karmen, 194, 219

MacLehose, William F., 241

Macrobius, 155

Magdalene, Mary. *See* Mary Magdalene

magic, 5, 113–14, 125, 150–51

Mâle, Émile, 218

male femininity. *See* effeminacy

male homoeroticism: in art, *Bible moralisée*, 8, 28–31, 35–40, 47–48, 56, 59–64, 67–73, 76, 177, 313n76; in art, *Ovide moralisé*, 159–64, 229–32, 237; in art, various, 59, 77–79, 157–59, 162, 173–75, 279–97, 344n142; and effeminacy, 6, 12, 26, 82–83, 94, 139, 144, 150–54, 272, 292–93; legal status, 83, 114–15, 159, 239, 271, 275–76, 288, 292, 296; in literature, 138–57, 162, 208–10, 217, 233–35, 279; terms applied to, 5, 11–12, 81–82, 91, 240, 286–87. *See also* female homoeroticism; gay; homosexuality

Maniacoria, Nicholas, 306n14

Mansion, Colard, 100, 319n53; on Iphis, 101, 114; on Orpheus, 155, 157–59, 168, 182, 188

Mantegna, Andrea, 171, 331n88

Mantua, 171

manuscripts: Baltimore, Walters Art Museum W.88, 77–79, 272, 315n97, 350n86; Bergamo, Biblioteca Civica CF.3.4, 333n106; Cambridge, Corpus Christi College 402, 267; Cambridge, Magdalene College, Pepys 2498, 266–67, 271; Chantilly, Musée Condé 65 [Très Riches Heures], 231; Dombibliothek Hildesheim, St Godehard 1 [St. Albans Psalter], 255; London, British Library, Additional 18719, 56, 62–63; London, British Library, Additional 62925 [Rutland Psalter], 272; London, British Library, Egerton 881, 162; London, British Library, Egerton 1894 [Egerton Genesis], 58–59, 179, 280, 312n64, 332n102, 333n104; London, British Library, Harley 1526 and 1527, 30, 51, 67; London, British Library, Harley 1766, 330n75; London, British Library, Harley 4431, 330n75, 342n115; London, British Library, Royal 17.E.iv, 330n75; Lyon, Bibliothèque municipale 742, 166–67, 182, 230, 257–58; Manchester, John Rylands Library, French 5, 180–81, 309n16; New York, Cloisters Collection 54.1.1a, b [Belles Heures of Jean de Berry], 1–2, 5–7, 15, 19, 195, 206; New York, Pierpont Morgan Library, G.24, 274–76, 350n91; New York, Pierpont Morgan Library, M.756 [Cuerden Psalter], 77; Oxford, Bodleian

penance, 117, 198, 248, 250, 275, 315n97; for female homoeroticism, 91, 112; for sodomitic practices, 3, 216, 241, 271. *See also* penitentials

penis: absence of, 103, 124, 127, 129, 323n93; clitoris likened to, 110; euphemisms for, 38, 103, 111, 271, 282; as sign of power, 110–11, 126, 274; substitutes for, 103, 112–13, 116; visual allusions to, 157, 174, 279, 352n122

penitentials: on age difference, 240–41; *Ancrene Wisse* reworked as, 266; coyness of, 27–28, 33, 75, 270–71; on female homoeroticism, 91, 112, 193; on habitual sodomy, 245; on male homoeroticism, 3, 193, 241, 264, 271, 291

Pentheus, 171

Perugia, 291

Peter Cantor ("the Chanter"): biblical citations by, 26, 69, 91, 264, 292; on foreigners, 72; on gender inversion, 25–27, 36–38, 81–82, 107; on (in)visibility, 26–27, 56, 75; on spilling of seed, 59

Peter Comestor, 42, 311n40

Peter Damian: on age difference, 216–17, 236, 344n131; on anal sex, 4, 271; on animals, 320n64; on demons, 38–39; on disorientation, 244; on female homoeroticism, 91, 323n92; on gender inversion, 4–5, 81–82, 251–52; on imitation, 14; on leprosy, 35; on masturbation, 4, 348n48; on "natural" sex, 302; on punishment of Sodomites, 292; on vision, 10

Peter of Roissy, 27

Peter the Venerable, 217, 241

Petrarch, Francesco, 228, 230

Petrus Christus, 332n101

phallocentrism, 126, 128–30

Phanocles, 326n13

pharaoh, 26, 314n81

phenomenology, 24, 246, 253

Philippe de Beaumanoir, 315n100

Philip IV ("the Fair"), king of France, 275

Philip VI ("the Fortunate"), king of France, 100

Philip the Bold, 9–10, 54

Philistines, 64–67, 73–74

Phillips, Kim M., 245

Phoebus, 151, 159, 209–10, 229

pilgrimage, 199–201, 222, 234, 280

Pirckheimer, Willibald, 332n93

Pisa, 290–91

plague, 35, 65–67, 307n33, 313n70

Plato, 321n71

pleasure: carnal, 8, 145, 161, 177, 201–2, 219, 243, 249, 271; divine, 145, 238; sexual, 103, 197, 222; sodomitical, 26, 142–43, 193, 263–64, 271; spiritual, 235, 249; women's, 105, 110. *See also* countereroticism

Pliny the Elder, 106

plowing, 152–54, 277

Pluto, 137, 166

Poliziano, Angelo, 331n79

pollution: in Bible, 26, 67; of church, 4, 216; of homoeroticism, 38–39, 91–93, 216, 261, 265; of women, 195, 265

preaching, 28, 141, 151, 198

pregnancy: female, 257, 265; male, 83, 282, 310n19, 316n6. *See also* motherhood

priests: chastity of, 91, 152–54, 193; as child abusers, 235–41; as confessors, 27, 30, 33, 75–76, 117, 269, 271; lust for females, 56, 119, 251–52, 254; lust for males, 4–5, 36, 65–68, 193, 216–17, 344n144; punishment of, 284; satire about, 77, 192, 236; as translators, 156–57, 197; as virtuous, 53–54

Problemata, 271

procreation. *See under* sex acts

Proserpina, 137

prostitution, 71, 83, 146, 198, 219

Proteus, 136

Protus, Saint, 201

Pucci, Antonio, 325n116

Puff, Helmut, 167, 170

punishment: divine, 26–27, 35, 46, 64–73, 111, 135–36, 231, 316n6; infernal, 8, 79, 82, 149, 156, 159, 247, 278–97, 299; judicial, 46, 79, 114, 126, 154, 159, 292, 353n131; purgatorial, 79, 271, 278, 280–81. *See also* penance

purgatory, 224–25, 247, 271, 278, 280–81

purity, 4, 91, 147–48, 154. *See also* chastity; virginity

Pygmalion, 324n97

Pyramus, 150–51

queens, 5, 112, 123–24, 254

queer: gender, 89, 204, 226; history, 183–86; and homosexuality, 21, 108, 246; phe-

nomenclature, 246, 294; poetics, 226–27; terminology, 21, 84, 87; things, 107–9

rape: attempted, 136, 201, 248; figurative, 259, 277, 282, 288–89, 294, 300, 343n124, 344n144; of Ganymede, 209–13, 220, 233–35; of Leda, 343n124; of Levite's wife, 45–47, 179, 276, 311n44; as natural, 71; as sin of Sodom, 46, 238, 282
Reay, Barry, 245
redemption, 147, 176, 200, 214, 218, 224, 234–35
Regularis concordia, 216
Renaissance, 17, 168–71, 210, 260, 326n18
René of Anjou, 319n51
repentance, 67, 141, 147, 198–200, 215, 218
repression. *See* sexual repression
Revelation of the Monk of Eynsham. See Visio Monachi de Eynsham
Richardis of Stade, 94
Richard III, king of England, 351n98
Richard of Devizes, 317n20
Robert I, Count of Flanders, 71
Robert of Flamborough, 27, 33, 75, 270
Rocke, Michael, 288, 296
Rolle, Richard, 7, 105
Roman de la Rose, 152–54, 161–62, 272, 277, 329n51
Roman de Trubert, 276–77
Rome, 6, 124, 127, 193, 234, 291, 342n117
Rottweil, 270
Rubin, Gayle, 236–37, 307n40
Rule of Saint Benedict, 216, 218, 263, 339n82
Rule of St. Celestine, 347n48
Ruth, 52–56, 312n62
Rykener, John/Eleanor, 83, 105

Salih, Sarah, 253
Salmacis, 106, 146, 322n74, 323n95
San Gimignano, 286–97
Santiago de Compostela, 199, 201, 280
Saracens, 65–67, 71, 73, 199
Sardanapalus, 26, 72
Saslow, James, 28
Satan: fall of, 34, 39, 212; heretical worship of, 71, 276; as Mohammed, 282; as murderer, 141; as punisher, 149, 291; as seducer, 38, 197, 265, 300; as Serpent, 42, 50; as woman, 208
Sauer, Michelle, 267

Schibanoff, Susan, 225–26
schools, 27, 157, 217, 233, 340n86. *See also* universities
Schultz, James, 7, 245, 270, 307n40
Scylla bowl, 210, 231, 333n106
Sedgwick, Eve Kosofsky, 192, 269
semen, 3, 59, 215, 295, 310n22, 348n48
Sens, 74
sequence: and gender hierarchy, 14–15, 94–96, 183; and history of sexuality, 13, 18, 98, 132; and sodomy, 14, 90–97, 135, 138–39, 170, 302
Serpent (biblical), 33–34, 38, 50, 202; gender identity of, 40, 42, 134, 265, 311n40. *See also under* animals
Seth, 113
sex: bodily, 6, 15, 115, 151, 204, 207, 251, 254; as category, 15, 90, 98, 109; and gender, 102, 128, 131–32, 148; and sexuality, 245, 252. *See also* embodiment; gender
sex acts: anal, 3, 4, 11, 24, 39, 77, 94, 247, 271–74, 282–84, 287–93; *coitus interruptus*, 59; copulation between men and women, 25–26, 162, 267, 288; fellatio, 287–89; fisting, 284; fornication, 3, 67, 91, 93–94, 112, 161, 217, 271, 292; intercrural/femoral, 4, 14, 77, 271, 282, 288; necrophilia, 262, 264; with objects, 91, 109–13, 262; postlapsarian, 14; procreative, 3–4, 25, 83, 99, 302. *See also* adultery; bestiality; female homoeroticism; incest; male homoeroticism; masturbation; rape
sex change: in animals, 106; in art, 116–20, 202–4; as literary motif, 83–86, 99, 104–6, 122–28, 162, 200–208, 225–26; as medical procedure, 84–85, 106–7, 130, 317n22, 321n68; spiritual, 205–7
sexual fluids, 103, 282. *See also* semen
sexual identity, 3, 87–88, 244–45, 254, 292–93, 296–97. *See also* gay; heterosexuality; homosexuality; lesbian; sexual orientation; virginity
sexuality: as fluid, 186; and gender, 2, 12–13, 80, 86–90, 98, 109, 128, 131–32, 188, 300–302, 307n40; history of, 11, 86–90, 98, 197, 244–46, 293, 300–303; and sanctity, 194–95; and sequence, 13, 90–98; visibility of, 3. *See also* bisexuality; countereroticism; heterosexuality; homosexuality; sex acts; sexual identity; sexual orientation

sexual orientation: as fixed, 186; and gender, 2, 11; as modern concept, 244–46, 293, 302; of sodomites, 23–24, 293–97, 299–300; of virgins, 246–54, 266–70, 299–300

sexual repression: in Middle Ages, 189, 195, 197, 222–23, 235, 250, 334n16; as modern concept, 30, 192, 194

sexual roles: active/passive, 26, 36, 75, 81–84, 87–88, 126, 149–52, 231, 237–39, 271, 287–89, 292, 297, 321n66; ambiguity of, 281–82; and gender, 25–26, 82–83, 93–97, 104–5, 126, 150–52, 214–15, 237, 284, 297. *See also* age difference; pederasty

shame: of gender inversion, 2, 6, 91–95, 124–25; of homoeroticism, 94–96, 103, 149, 210–12, 216, 233, 265, 285; sexual, 149, 208

Shanley, John Patrick, 236

Sheingorn, Pamela, 143

shoes, 82

Silverman, Kaja, 139, 183–87

Simon Magus, 341n94

simony, 67

sin against nature: bestiality as, 112, 146; in Bible, 26, 45, 91; cosmetic use as, 146; as demonic, 38–39; female homoeroticism as, 111, 146, 265, 285–86, 300; as fluid category, 3, 8–10, 28; incest as, 146–47; legal status of, 79, 193; male homoeroticism as, 26, 144–46, 148–56, 160, 162, 227, 285, 291, 299; unspeakability of, 27–28; worldliness as, 264

sins: anger, 240, 279; avarice, 35, 54–55, 152, 294–95; deadly, 198, 267, 282; despair, 202, 279; envy, 67, 155, 240; fleshly, 5–6, 9, 55–56, 161, 199, 205, 243, 263–64; gluttony, 58–59, 261, 263–64, 270; pride, 263–64; sloth, 261, 263–64, 270; as spatial, 296–97. *See also* adultery; apostasy; inhospitality; lust; *luxuria*; murder; rape; simony; usury; *and under* Sodom

Sirens, 184, 338n71

Sir Orfeo, 141

Sithon, 321n66

slander, 1–2, 5, 7–8, 10, 264, 275–78

Smith, Ali, 22, 86, 128–31

Sodom, 237, 240, 262, 271, 280; destruction of, 23, 26–27, 36, 40, 44, 46, 56–64, 73–74, 175–80, 185, 193, 243; as feminized figure, 5, 263; inhabitants of, 8–10, 17, 28, 43–48, 58–59, 73–74, 82, 135, 178–80, 215, 244, 271, 276, 282, 292, 300, 332n102; sins of, 9, 17, 26, 36, 40, 56–59, 69, 74, 91, 139, 176–80, 263–64, 272, 300

sodomia, 10, 150, 216, 226, 238, 300; earliest uses of word, 3–4, 93, 305n5; grammatical gender of, 4–5; as translation, 17, 74; and women, 91, 316n35

sodomites (non-biblical): blinded, 244; in church, 4, 244; Edward II, 278; effeminacy of, 25, 316n5; female, 109, 285; in hell/purgatory, 247, 271, 281, 289–97, 299. *See also* Sodom: inhabitants of

sodomitry, 65–67, 71–73, 237, 300

sodomy: as abusive, 26, 39, 45, 68–69, 145–46, 170–71, 178–79, 229, 237–42, 344n144; and age difference, 26, 67, 73, 138, 156, 160–61, 170, 179, 215–17, 237–38, 288–89, 332n102, 351n109; and animals, 39, 83, 149, 276, 291, 320n64; and clerics, 8–9, 14, 36, 38–39, 59–70, 73, 75, 83, 192–93, 216–17, 344n144; as demonic, 39, 94, 323n92; and directional language, 23, 244; and disease, 35, 67, 74, 313n74; divine punishments for, 10, 26–27, 73; ecclesiastical regulation of, 193; as fluid category, 3, 40, 58–59, 75, 88, 297, 300–301; and foreigners, 71–72, 172, 282–83; and friendship, 16, 226, 260, 264–70; and gender inversion, 4–5, 25–26, 81–84, 92–96, 106–7, 148–56, 187, 205, 272, 282–83, 288–89, 291–94, 300–301, 316n5; and heresy, 4, 36, 48, 69–73, 75, 79, 149, 275–76, 314n76, 314n81, 315n100; infernal punishments for, 8, 79, 82, 156, 159, 247, 271, 278–97, 299; (in)visibility of, 12, 23, 27–30, 33, 56–59, 75, 80, 135, 140, 186–88, 237, 301–2; and Jews, 36, 48, 69–70, 75; judicial punishments for, 46, 79, 114, 154, 292, 315n100, 353n131; and kings, 69, 76, 212, 227, 229, 277–78, 314n81; medical views on, 6, 271, 296, 353n142; as metaphor, 17; in modernity, 21; and Muslims, 71–72; political uses of, 4, 8; and race, 4, 71–72, 282–83, 301; as secondary, 90–91, 167, 170–72; as sin identity, 294–96, 299; as sterile, 81–82, 144, 148, 152–54, 170, 215, 295; trials for, 83, 109–10, 114–15, 239, 270–71, 275–76; as universal, 39, 268, 296; as unmentionable, 3–4, 26–30, 67, 81, 83, 105, 150, 215, 261, 265, 270–71, 281; and urban growth, 74–75; as "utterly

confused," 11, 13, 69, 72–73, 157, 260, 271, 301; and vision, 10, 26, 303; as way of life, 82, 296; and women, 11, 16, 91, 109–10, 114, 179–80, 260–70, 285–86, 301, 318n35. *See also* buggery; sex acts; sin against nature; Sodom; *sodomia*; sodomites

Songe véritable, 8, 284, 292

Souillac Abbey, 314n79

soul: and body, 147–48, 206, 250; gender of, 7, 252, 254; salvation of, 111, 119, 141, 176, 223–25; sensuality of, 144, 155, 157; of sinners, 117, 141, 164–65, 223; of virgins, 250–54

Speculum inclusorum. See Myrour of Recluses

Speyer, 110

spit-roasting, 284, 286–94, 299, 352n122

sponsalia Christi, 7, 111, 161; chastity and, 91, 249, 252, 346n25; human love/marriage and, 33, 43, 141, 192

Stahuljak, Zrinka, 41

St. Albans, 248, 253

Statius, 151, 225

Stewart, Alan, 269

St. Gall Plan, 340n83

straightness, 23, 253, 268, 294. *See also* sexual orientation

symmetry, 32, 35, 38

Synod of Winchester, 216

Taddeo di Bartolo, 286, 290

Tantalus, king, 212

Telethusa, 98, 101–2, 111, 118

Templars, 275–76

terminology, 3, 21, 84, 87–90, 96–97, 302–3

Testamentum Porcelli, 271–72

testicles, 109, 321n70

theologians, 5, 25–28, 81–83, 91, 150–52, 161, 216–17, 252

Theutberga of Lotharingia, 3, 112

thing: theory, 109; words for, 107–12

Thisbe, 150–51

Thracians, 138, 142–43, 145, 155, 157, 164, 172

time: biblical, 41–42, 44, 73; and eternity, 181–85, 292–94; and gender identity, 129, 204, 249, 285–86; queer, 268; of things, 108–9; transgender, 22, 86–90, 98, 116, 121, 130–31, 317n29. *See also* anachronism; sequence

Tiresias, 105, 123, 125, 152, 154, 320n66

tomboyism, 318n45

transgender, 81–132, 205; as backward, 89–90, 116, 121; history of, 85–90, 325n122; and homoeroticism, 84–85, 125–28; as modern term, 12, 22, 84–86, 98, 101, 131–32, 301–2; and temporality, 85–86; and translation, 18; as umbrella term, 84–85

translatio: cultural, 17–18, 40–41, 50–51, 172, 223, 235; sacred, 199; textual, 17–18, 74, 80, 209, 233–35, 244

translation: in art history, 18; biblical, 8, 19, 40–74; cultural, 17–18, 170–72, 301, 303; and gender, 95, 98, 130, 151–52; invisibility of, 18; as metaphor, 17, 41; sexual, 23, 138, 157; spiritual, 195–200, 224–25, 228–29, 233–35, 241–42, 249–50; temporal, 17, 41–44, 170–72; textual, 100–105, 108, 138–57, 187, 223–29, 266–67, 301; visual, 17–18, 48–50, 170–72, 187–88, 200, 217–18, 223, 301. *See also translatio*; untranslatability

transsexualism, 89, 96, 226, 317n22. *See also* sex change

transvestism. *See* cross-dressing

Traub, Valerie, 17, 85, 245, 255, 260

tribades, 260, 319n48

Tros, king of Troy, 227

"Tugentschrîber" (virtue-scribe), 148–50, 158, 162

Turks, 71, 282–83

Ulysses, 151, 338n71

universities, 27, 156–57. *See also* schools

unspeakable, 23, 30, 81, 138, 157; as rhetorical trope, 5, 27–28, 67, 142, 147, 150–51, 261, 265–67, 281

untranslatability, 41, 73–74, 233–35, 267, 303

usury, 54, 294–95

vagina: euphemisms for, 38, 110, 151, 267, 272; likened to anus, 272, 277; visual allusions to, 288, 336n51, 352n122

Varzy, 201

Vatican Mythographers, 231–33, 342n106, 342n109, 343n124

Venice, 172, 257, 271, 353n131

Venus, 5, 34, 81, 150–52, 181, 244, 274

Venuti, Lawrence, 18

Vesta, 124–25

Vézelay, 23, 188–89, 198–209, 212–24, 231–35, 279–80

Viollet-le-Duc, Eugène, 340n94

Virgil, 136–37, 139–40, 152, 209–10, 213, 226; as
 literary figure, 225

virginity, 6, 59; as sexual orientation, 246–58,
 266–70, 299–300; as virile, 206–7, 251–53,
 262. *See also* chastity

Virgin Mary, 7, 19, 106, 146, 241, 249, 252, 262

visibility politics, 10–11, 13–14, 86, 98, 325n122

Visio Monachi de Eynsham, 280–82, 285–86

Voeux du paon. See Jacques de Longuyon

voyeurism, 173–74

Warburg, Aby, 168–71

Warner, Marina, 336n51

Watt, Diane, 99

whore of Babylon, 223

widows, 128, 201, 207–8, 219, 263

Wielant, Philippe, 114

Wife of Bath, 84, 110–11

will: and gender identity, 2, 85, 89; of sinner,
 95, 112, 150, 294; of virgin, 248–50, 253, 299

William II, king of England, 82–83

William of Auvergne, 27–28, 30, 291

William of Conches, 140

William of Norwich, Saint, 241

William of Saliceto, 110–11

Wind, Edgar, 170

witchcraft. *See* magic

Witkowski, G. J. A., 274

women: bathers, 173, 257–59; as carnal, 142,
 157, 203, 265, 288; as deceitful, 109–13, 115;
 as evil, 113, 141, 155, 208, 219; history of,
 13, 16–17; labor of, 125; looks of, 175–83;
 as murderers, 136–37, 141–42, 157–59,
 165, 171; pleasure of, 105, 110; as priests/
 teachers, 34, 91–92; secondary status
 of, 34, 89, 91–92, 260; and sodomy as
 term, 11, 22, 91, 109–10, 114, 270, 285–86,
 301, 318n35; as tempters, 111, 175, 195,
 201–2, 218–22, 248, 263–65. *See also* butch;
 female masculinity; femininity; femme;
 lesbian; misogyny

wrestling, 59, 280, 314n79, 315n97

Yde and Olive, 99, 127

youths. *See* adolescents

Zarnecki, George, 282

Zeus. *See* Jupiter

Zoppo, Marco, 171